America

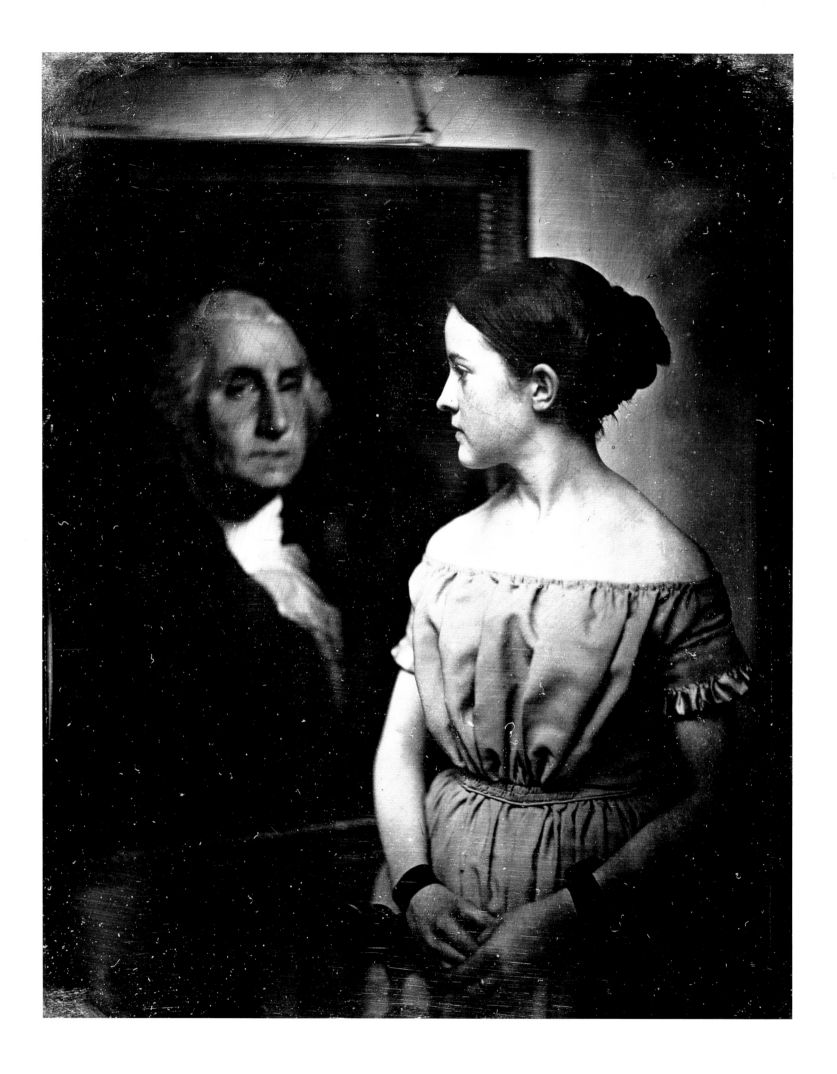

AMERICA

The New World in 19th-Century Painting

Edited by Stephan Koja

With contributions by Nicolai Cikovsky, Jr., Charles C. Eldredge,
Linda S. Ferber, Barbara Gallati, Neil Harris, Erica E. Hirshler,
Franklin Kelly, Maria Antonella Pelizzari, Marc Simpson,
Martina Sitt, H. Barbara Weinberg, and Stephan Koja

Prestel Munich · London · New York

This book was published on the occasion of the exhibition
America: The New World in 19th-Century Painting
in the Österreichische Galerie Belvedere, Vienna
(17 March–20 June 1999)

On the front cover: Frederic Edwin Church, *Twilight in the Wilderness*, 1860 (plate 45);
On the back cover: William Michael Harnett, *The Faithful Colt*, 1890 (plate 95)

Endpapers (front): Albert Bierstadt, *Looking Down Yosemite Valley, California*, 1865,
oil on canvas, 162.6 x 244.5 cm, Collection of the Birmingham Museum of Art, Birmingham, Alabama,
gift of the Birmingham Public Library

Endpapers (back): Benjamin West, *The Death of General Wolfe*, 1770,
oil on canvas, 152.6 x 214.5 cm, National Gallery of Canada, Ottawa

Frontispiece: Albert Sands Southworth and Josiah Johnson Hawes, *Girl with Portrait
of George Washington*, c. 1850, daguerreotype, 20 x 14.8 cm,
The Metropolitan Museum of Art, gift of I. N. Phelps Stokes, Edward S. Hawes,
Alice Mary Hawes, and Marion Augusta Hawes (1937)

Translations from the German: Jenny Marsh, Dorset (contributions by Stephan Koja
and Gerbert Frodl, biography of Arthur F. Tait); Michael Ashdown, Munich
(contribution by Martina Sitt); Julia Fuchshuber, Munich (Historical Maps)

English edited by Judith Gilbert with Susanne Reece

© Prestel Verlag, Munich · London · New York 1999

Prestel Verlag, Mandlstraße 26, D–80802 Munich, Germany
Tel. +49 (89) 38 1709-0, Fax +49 (89) 38 1709-35
4 Bloomsbury Place, London WC1A 2QA
Tel. +44 (171) 323–5004, Fax +44 (171) 636–8004
and 16 West 22nd Street, New York, NY 10010, USA
Tel. +1 (212) 627–8199, Fax +1 (212) 627–9866

Prestel books are available worldwide.
Please contact your nearest bookseller or write to any
of the above addresses for information concerning
your local distributor.

Library of Congress Cataloging-in-Publication
Data is available

Die Deutsche Bibliothek – CIP-Einheitsaufnahme
America: The New World in 19th-Century Painting
(Exhibition in the Österreichische Galerie Belvedere, Vienna, 17 March–20 June 1999)
ed. by Stephan Koja — Munich · London · New York / Prestel 1999
ISBN 3-7913-2088-2
NE: Koja, Stephan, America: The New World in 19th-Century Painting

Design by Iris von Hoesslin

Production editing by Danko Szabó
Historical Maps pp. 250, 251 by Anneli Nau

Typesetting by Setzerei Vornehm, Munich
Lithography, printing, and binding by Grasl Druck und Neue Medien, Bad Vöslau
Printed on Magno Satin, made by Sappi

Printed in Austria

ISBN 3-7913-2088-2 (English edition)
ISBN 3-7913-2051-3 (German edition)

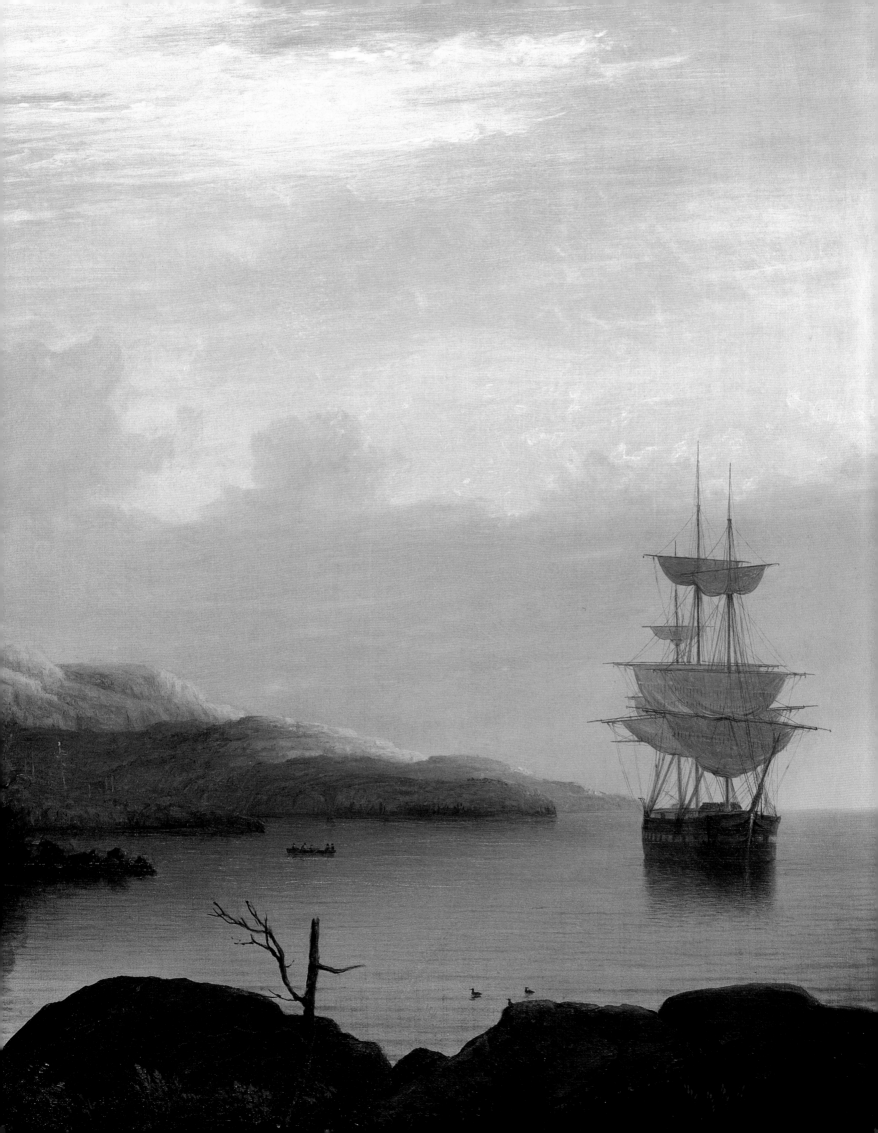

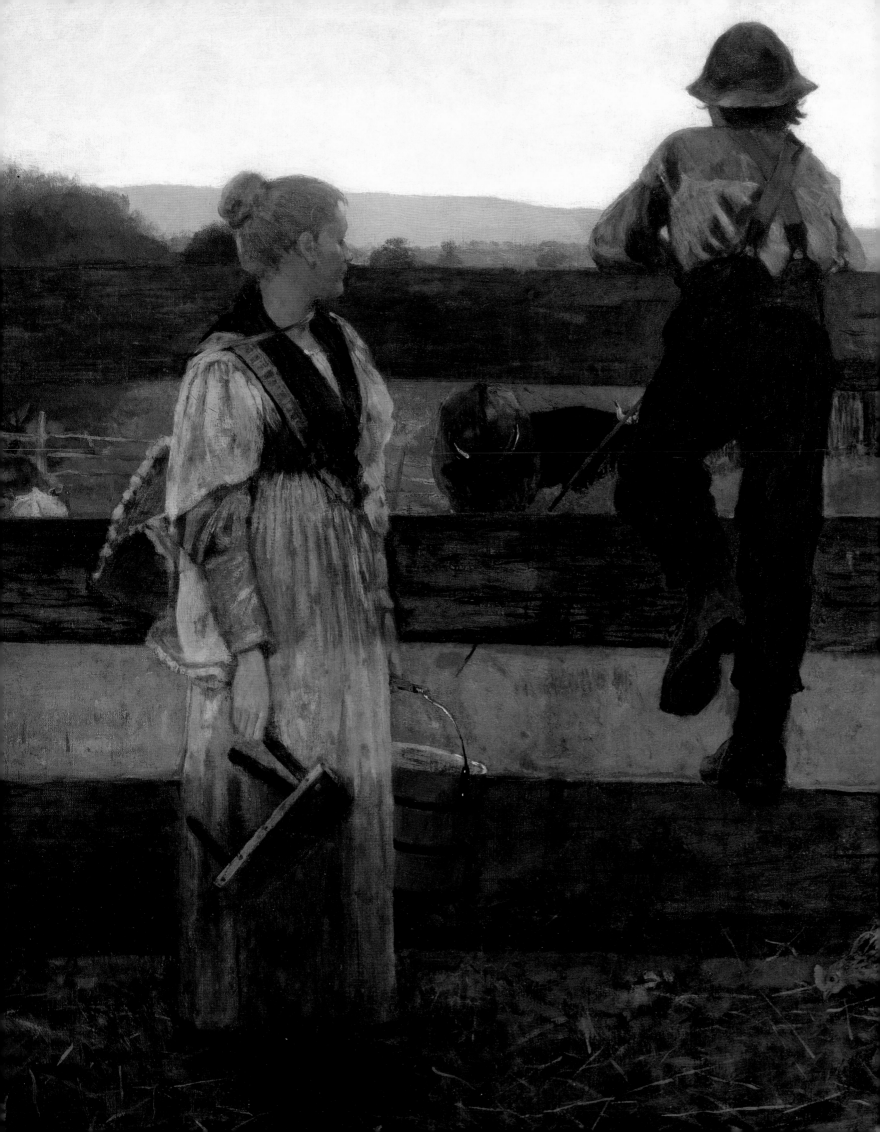

STEPHAN KOJA

Introduction

Europeans today are fascinated more than ever before by North America. Thus, it is surprising that the interest in really getting to know its culture remains rather cautious. Native Americans have always been of interest to Europeans and with them, in the form of a totally superficial genre of exciting films and television entertainment, the Wild West. In art-historical terms, the United States was always regarded as a colony of Europe, and only in the 1950s was it conceded that New York had long since overtaken European art capitals in importance. This may have something to do with the prevalent Eurocentrism that only seems to display an interest in non-European cultures when they have some connection with European culture or affect it in some way.

But the American art of the late eighteenth century and the nineteenth century was essentially made by Americans for Americans—often in an attempt to interpret their new living conditions and give answers to the question of the young nation's identity. How American painters reacted to the New World and its beauties of landscape, as well as to the opportunities and challenges of building a just society—this was the main focus of interest in preparing the present project. On what formal repertoire, on what visual and cultural experience could painters draw? What were the influences on them, and how did they see things differently than their European counterparts?

Four of the studies in this book are devoted to singling out four of the major European countries whose artistic traditions were taken to the United States or to which American artists were exposed during training. We also investigate the question of the extent to which painters were in a position to shape the image of America. How and where were their pictures distributed, how were they received, and who collected them? Was it painting alone or also, decisively, photography which recorded America's image of itself? And what were the connections between the two? These are the types of questions around which the essays in this book revolve and to which answers are sought from a number of different perspectives.

In all of these considerations it is not a matter of demonstrating dependence nor, once again, of straining the term "avant-garde" (which in the meantime seems ever more dubious) and establishing where things were slower and where they were advanced or even revolutionary. Such matters did not concern the artists of the time. This kind of evaluation nowadays often only serves to foster superficial judgments and classifications. Interestingly enough, however, there is a tendency in Europe to downplay the importance of the European roots of American painting after 1945 and exaggerate its originality.

Our concern here is to trace the emergence of an autonomous aesthetic impulse from among the myriad influences and stimuli and the simultaneous challenges posed by the fundamental newness of American society, politics, and landscape. Perhaps awareness gained in this way, free from prejudice, will reveal the fascinating artistic output and result in a deeper understanding of American art.

Winslow Homer, *Milking Time*, detail, 1913 (plate 67)

American themes were already to be seen in 1869 at the International Art Exhibition in Vienna in pictures by the painter Theodor Kaufmann, who had emigrated from Dresden to the United States, including *Attack on the Pacific Railroad* and *Freed Slaves Going to the Land of Freedom*. In 1873, Albert Bierstadt circumvented the boycott of American artists at the World Exhibition in Vienna and exhibited two pictures, *Emerald Pool* of 1870 (see fig. p. 10) and *Donner Lake from the Summit* of 1873 (see fig. 3, p. 202); he won a medal for the first of these. James McNeill Whistler, whose art fascinated the European avant-garde, was represented at the same exhibition with six etchings and, in 1898, at the first exhibition of the Vienna Secession with a series of lithographs. In 1903, at the sixteenth Secession exhibition, he showed *The Violin Player*. His portraiture would have a lasting influence on the stylistic development of Gustav Klimt and marked the latter's work around the turn of the century. From his childhood days, John Singer Sargent, who was also represented with *An Egyptian Woman* at the first Secession exhibition in 1898, had always spent time in the Tirol during the summer months and recorded his impressions in fluidly painted pictures (see fig. p. 11).

The present project was intended to continue a series of exhibitions which the then director of the Österreichische Galerie, Fritz Novotny, had made his concern years ago: to see the art of the nineteenth century as an overall phenomenon, as a great variety of continual exchanges, not comprehensible in terms of national borders, and to understand local developments better against this horizon. Indeed, the observation of comparable and yet independent developments, such as the painting of George Inness and Austrian Impressionism (in both cases inspired by the Barbizon school), throws new light on local painting traditions and, at the same time, reveals much more clearly the specific conditions that in each case led to their development and shaping.

As a young nation which first had to learn about its environment, its land, and to find its place among the world's nations and in history, America created an unquestionably descriptive art, an art that depicted reality. This becomes particularly obvious in the second half of the nineteenth century, when problems of form came into the foreground of European artistic interest. Europe's identity, including the status of its artists and their role in the fabric of society, was already consolidated at that time. In the United States, on the contrary, there were still no answers in many respects. Here, as with all young nations, the very first necessity was to cope with the realities, and this preceded all questions of form—a phenomenon that can be observed today in many recently established African countries. This was formulated quite programatically by Thomas Cole: "The language of art should have the subserviency of a vehicle. It is not art itself. Chiaroscuro, color, form, should always be subservient to the subject, and never raised to the dignity of an end." Thus, for a long time, American art retained a preference for realism: in terms of style for the exact, the documentary, and in terms of content for the material, the concrete. Also because there was a fear of the sensuous, a style of directness, honesty, and simplicity was encouraged. After all, Puritanism had initially regarded fine art with great skepticism, and this fear of worldliness, flaunting of splendor, and permissiveness, voiced or unvoiced, would continue to define the thinking of the century. Moral

Albert Bierstadt, *Emerald Pool*, 1870, oil on canvas, 194.3 x 302.3 cm,
The Chrysler Museum, Norfolk, VA

standards were demanded of art throughout the nineteenth century and
with them the expectation that it would have an edifying effect, could
contribute to an increase in virtue. At the same time, people were trying
to disassociate America from Europe both in political-cultural terms and
in basic conditions, trying to do things better in order to make a repub-
lican, democratic type of art possible. "We cannot—as did Napoleon—
make, by a few imperial edicts, an army of battle painters," as Horatio
Greenough expressed it in 1843. "Nor can we, in the life-time of an indi-
vidual, make a Walhalla start from a republican soil. The monuments,
the pictures, the statues of the republic will represent what the people
love and wish for—not what they can be made to accept, not how much
taxation they can bear. We believe that there is at present no country
where the development and growth of an artist is more free, healthful,
and happy than it is in the United States."

This endeavor to give art an ethical dimension, probably at times lit-
tle more than unreflected molding by a general social ideal, also explains
the undeniable tendency of American art toward idealization (which can
go hand in hand with faithful depiction of the material world). Fine art
thus embodied standards or ideals which were inseparably linked with
the history of the country's founding and expansion, and with the virtues
needed for this. Only John Singleton Copley and Thomas Eakins were
able to free themselves to any considerable degree from this excessive
emphasis on the ideal in terms of content. The tendency toward ideal-
ization also probably explains the partial denial of reality in American
painting. Themes such as war, industrialization, the destruction of land-
scape, urbanization, and topics with a similar socially critical content
found hardly any expression in fine art and were only taken up toward
the end of the century. American painting of the nineteenth century in
particular makes it clear that art depicts not reality but concepts,
dreams, and convictions.

Religious painting in the true sense of the term was extremely rare in
the United States—partly as a result of the banning of images by many
Protestant religious communities. Landscape, however, was largely—
and with great passion—conveyed in religious terms. While Europe had
a history going back thousands of years as well as innumerable monu-
ments and references to establish its historical identity, the new Ameri-
can nation first had to create its own myths, which it found in the
sublimity and purity of nature, particularly that of the West. The beauty
of this incomparable landscape stood as the unifying factor over all the
races, cultural origins, and religions of its inhabitants and of the people
who were pouring into the land in a constant stream. As its own history
was short and not very rich, people sought their identity in geography.
Thus, Americans began to conceive of their country as the visible token
of God's hand on earth, of the grandiose wilderness scenery as a distin-
guishing mark before all other nations, the New World as a chosen place.
It was essentially painting that formulated this conviction. To the pres-
ent day this conception, anchored in Romanticism, of the country
as "nature's nation" is a firm component of America's image of itself.

The question of the relationship between man and nature dominated
the entire nineteenth century, running through the work of American
painters from Thomas Cole to Winslow Homer. Landscape might stand
in the foreground in its sublime aspect, evoking reverence, or in its force
and unfettered power, demanding heroism. In its aspect as a cultivated
garden, it might extoll prosperity on which people could look with
pride, as the many genre pictures depicting rural life emphasize. It was
awe in the face of nature's beauty in this "promised land," as well as the
desire to portray such magnificence appropriately and to a generally
valid standard, that elicited from painting a new, panoramic, broad
format which enabled painters to portray "world landscapes."

Even though the conventions of European painting were known and
its visual customs retained, in America people felt free to discard these
since their experiences seemed so much more intense and the realities
of the landscape made greater demands. It is no surprise that Cinema-
scope was invented in the United States and not in Europe. Increasingly,
"purity" became a projection, an ideal that people believed they could
find in nature and could use to counter the rampant, ruthless advance of
civilization. It was intact even if—or perhaps precisely because—it was
wild and untamed.

In its sacredness, its untouched virgin state after Creation, nature
remained a measure and a standard. Even if at times there may be sty-
listic similarities, this is what distinguishes the American depiction of
nature so profoundly from the art of the German Romantics, particularly
someone like Caspar David Friedrich. The latter essentially had other
concerns: landscape was not seen as such, for its own sake, but as a
metaphor, a reflection of the soul.

To the present day, the projected wilderness still serves as self-
definition for Americans and has something mythical about it. The
advertising industry is well aware of how to cash in on this successfully,
as the boom in all-terrain vehicles or the Marlboro Man figure, embody-
ing an American ideal of life, prove. And yet we should not overlook the
fact that the American awareness of nature and preservation of natural
wonders is due, to a not inconsiderable degree, to painters. Artists such
as Church, Bierstadt, and Moran were among those who traveled the
land, exploring its splendors with enthusiasm. They contributed to their
discovery by becoming some of the first advocates for the protection of
nature. Moran, for example, instigated the creation of a state park and,
a few years later, a national park to preserve the Yellowstone region.

Naturally, the initial view of the New World was European—and one
that for many decades continued to measure itself against the model of
Europe and sought recognition there: think of Copley, Church, or
Eakins. And, just like elsewhere in the western world, art in the United
States reflected the pluralism of style of the nineteenth century. But
whereas fine art became part of everyday life in Europe in the late eight-
eenth and early nineteenth centuries, the underlying conditions in the
New World were very different. Energies were needed for other things;
the settlers were preoccupied with cultivating the land. An educated,
sophisticated form of culture was only known to a few families on the
East Coast, particularly in cities such as Boston and Philadelphia.

The young republic had emerged from European statehood theories of the eighteenth century, and the fine arts also had their roots there. But the subject matter was new, and the American manner of responding to it rapidly became less constrained than in the Old World. This was already expressed in the empirical realism, unconcerned with any beautification, of an artist such as John Singleton Copley. More or less self-taught, he was able to approach his themes free from the burden of tradition. Thus, many a stylistic innovation was introduced—most lastingly perhaps in the reinterpretation of the history picture and the consequent development of the portrayal of contemporary events. Independence did not signify disconnection, but offered artists recourse to an incessant influx of stimuli through which they could face an often novel reality in a suitable way.

This uninhibited approach to reality, this directness of grasp, always inherent in American painting, would find particularly impressive expression in the art of the Ashcan School at the beginning of the twentieth century. Partly influenced in style by the European Baroque, partly by Impressionism, this was painting that placed value on the greatest possible directness of expression and the painter's manner, thereby developing a social realism that had no counterpart in Europe. Whereas European art of that time was primarily concerned with problems of form—within Fauvism, Expressionism, Cubism, Orphism, and, later, Constructivism—American painting, which throughout the nineteenth century had been concerned with objects, with reality, turned enthusiastically to deal with social realities, the seamy side of society, and urban life. It thus preceded the verism of the art between the wars in Central Europe by many years. Here again it was photography that paved the way. Nineteenth-century American culture was equally influenced by fine art and photography, to a greater degree than was the case in Europe.

The Armory Show of 1913 marked a decisive break in the history of American art. Confronted with modern European art, American painting and the way in which it saw itself were shaken to the core. If up until that point it had been predominantly a national art, it now became international in idiom and orientation. This was the beginning of the development of modern art in America.

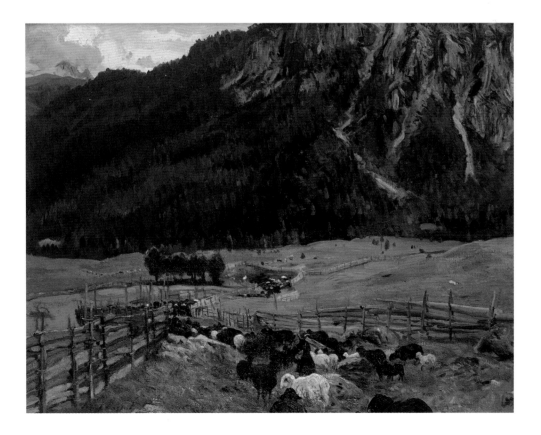

John Singer Sargent, *Sheepfold in the Tirol*, 1915,
oil on canvas, 71.1 x 91.4 cm, private collection

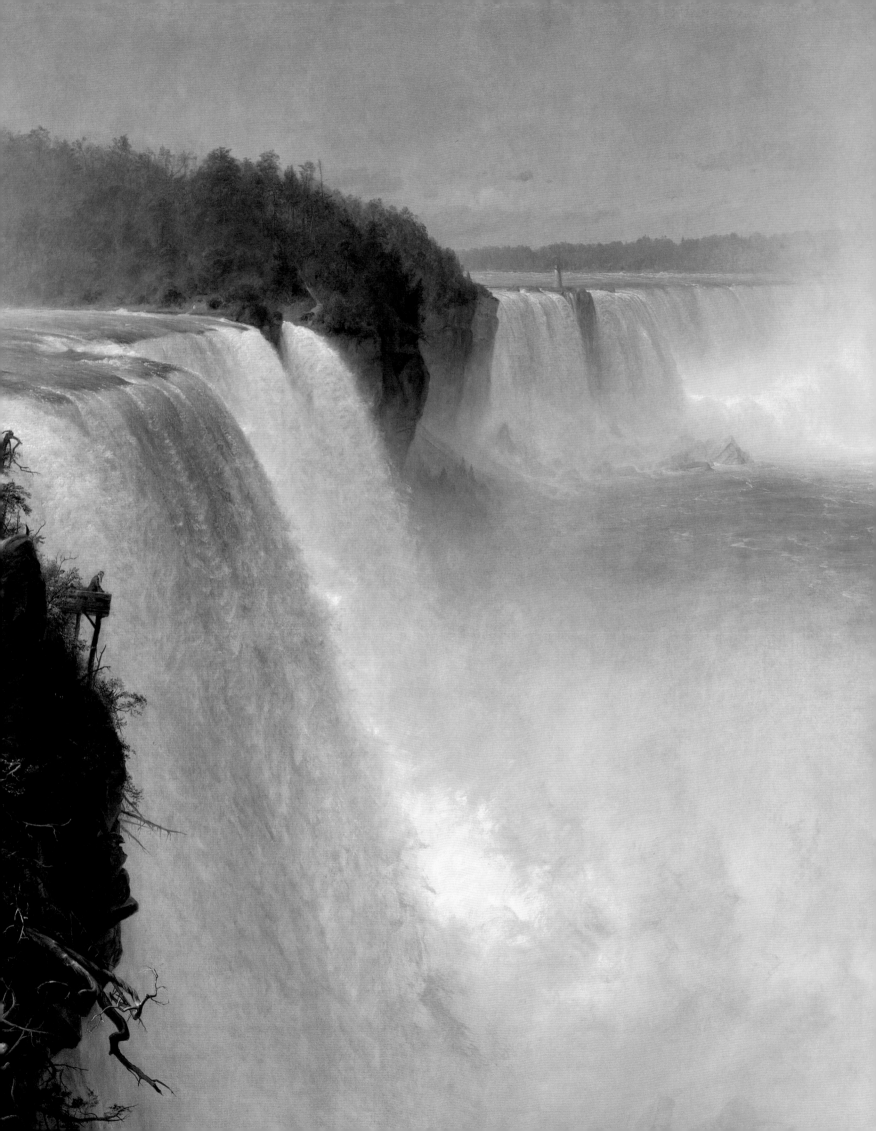

In Search of Identity

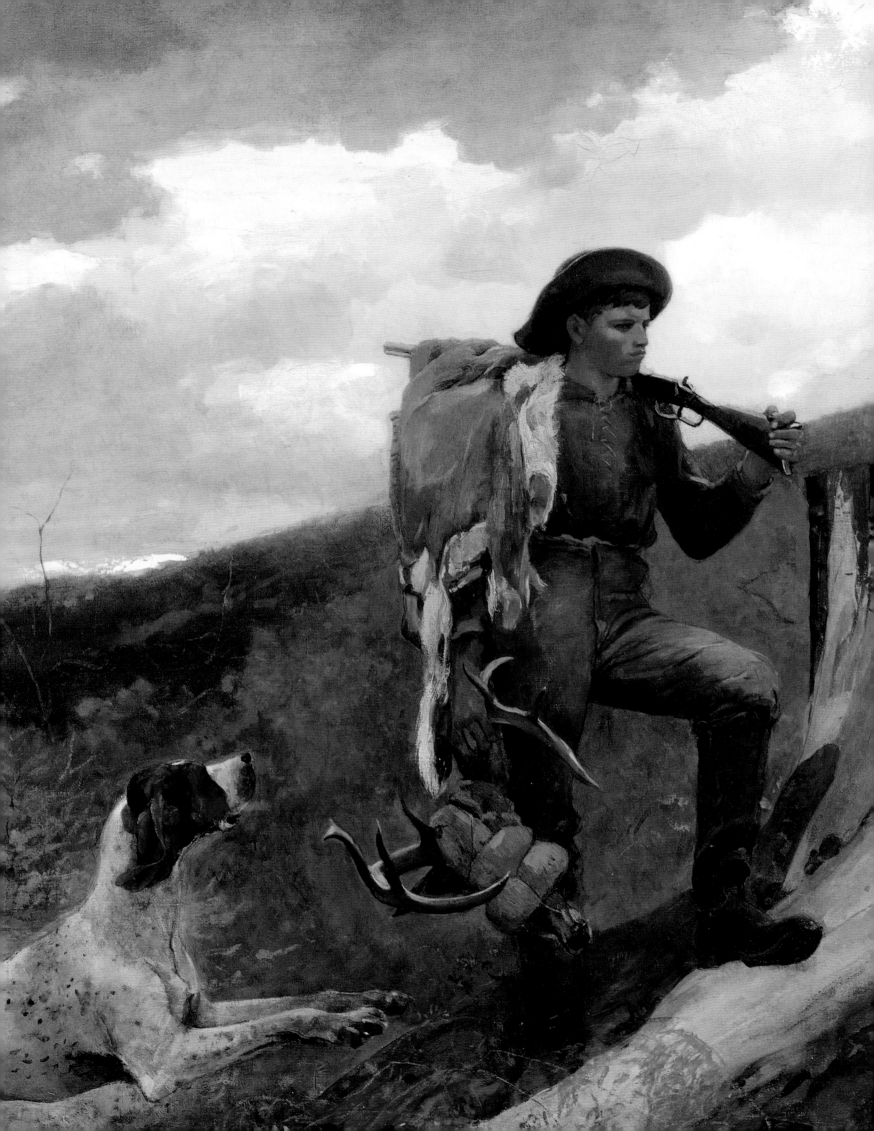

NEIL HARRIS

Making Sense of America

How to understand the American experience? This sweeping question shaped one of the major ongoing intellectual projects of the nineteenth century. Americans and Europeans alike—intellectuals, artists, journalists, and ordinary citizens—sought to grasp the meaning of what seemed, alternatively, to be a vast and novel experiment in democratic self-government and personal fulfillment, or an expansionist, plutocratic, self-indulgent, and repressive exercise in state-making. What were the elements that helped the American experience assume so portentous a role? And what themes emerged to mold impressions of the Great Republic, as the United States was so often called in a world of kingdoms and empires?

The first, and, for much of the nineteenth century the overwhelming motif, explored the meaning of social equality. The construction of a new political system in the 1770s and 1780s that accompanied independence from Britain set in motion a long chain of events and expectations. If power flowed from the people rather than a sovereign, if birth—or white male birth—itself guaranteed a series of natural rights protected by law, what would remain of classes and social hierarchy? How were people to relate to one another or acknowledge differences of wealth and status? Did democratic citizenship mean the obliteration of social distinction, of caste, of that ancient system of valuations which prized gentle birth, inherited wealth, learning, refinement, titles, professions? Could any system of deference survive this onslaught?

Artists and writers, concerned with social commentary (and many were), confronted a condition of extraordinary fluidity and change. Americans could not be depicted or described with the same sets of conventions that had been applied to Europeans. "No king will voluntarily lay down his sceptre," Frances Wright, a young Scotswoman wrote on visiting America, "and in a democracy all men are kings."[1] American claims to respect and attention were ambitious and universal. Americans refused even to dress in ways that would clarify their social status; newly organized municipal policemen and railway conductors often protested the wearing of official livery. The years before the Civil War hosted more aggressive claims to equality than the years that followed, but throughout the century Americans insistently demanded respectful treatment from so-called superiors and frequently voiced contempt for gaudy monarchies and aristocratic pretensions.

Such contempt, however, did not hide fascination with titles, decorations, and court rituals. Again, visitors were continually bemused by the simultaneous presence of egalitarian enthusiasm and delight in signs of social distinction. No people followed more avidly news of the courts of Europe, or employed so many personal labels and titles: colonels, judges, honorables, were bandied about with extraordinary generosity. Perhaps because there was no clearly demarcated lineage for aristocracy in America, a cult of celebrity flourished from an early date. Actors, athletes, politicians, clergy, writers, businessmen, lawyers, doctors, showmen, inventors, academics, all enjoyed or suffered from an appetite for

Winslow Homer, *Huntsman and Dogs*, detail, 1891, (plate 79)

1 John Neagle, *Dr. William Potts Dewees*, 1833, oil on canvas, 144.1 x 113.7 cm, University of Pennsylvania School of Medicine, Philadelphia, PA

fame or a reputation for eminence. And they cultivated or suffered from aggressive journalists in pursuit of such reputation.

Artists formed one instrument to connect the powerful egalitarian commitments of the national mission with these efforts at differentiation. Painters and sculptors managed this in several ways. First, as portraitists, as celebrants, as interpreters of their human subjects, paying homage to their special talents or nobility of character (fig. 1). And second, as objects of patronage and support, demonstrating the munificence, generosity, or cultivation of those Americans who were willing to spend money on artistic enterprise. Numerous ambitious merchants, bankers, and attorneys in the first half of the century sought out the company of artists, visited their studios, at home and abroad, and adorned their homes with the landscapes and portraits their protégés produced.

Art patronage, of course, was only one way that successful Americans could demonstrate their own achievements and their continued adherence

to common goals. Philanthropy was another. Religious and humanitarian values had long animated charity, and the fact that wealthy Americans gave money for purposes of education, healing, easing hardship, and spreading the gospel was not in itself remarkable. It was rather that so many of them linked their philanthropy to an interest in national reputation and accomplishment. George Peabody, merchant-financier who spent much of his life in London (where he donated millions for tenement construction), financed the American display at the Crystal Palace of 1851, after Congress refused to support it; he also created institutes in Maryland and Massachusetts. Peter Cooper established an institute in New York to help educate artisans and mechanics. Like their counterparts in England, such philanthropists had available the language of evangelical Protestantism to justify their interventions. Wealthy donors, bent on advancing the arts and sciences, shared a sense of collective mission, convinced they were on a divinely sanctioned errand.

Such ideals, however, did not always work to the advantage of living artists. For along with the dreams of egalitarianism and the considerable pride in national achievement (leading at moments to inordinate boasting of American accomplishments in every sphere of human life), another widely held vision conceived of America as a gathering place for the cultures of the world. Part asylum, part paradise, part virtuous retreat from a corrupt world, this dream included widely assorted models and trophies. From Greece, from Rome, from Renaissance Italy, even from medieval France and England would come artifacts, styles, and settings welcomed by American consumers. The national capital itself, Washington, which fused Enlightened rationalism with classical references, captured the American enchantment with cosmopolitanism, with a physical culture that was not tied to any specific time or place. So did Jefferson's Monticello home, and his plan for the University of Virginia (fig. 2). The domed legislatures, the pillared courthouses, the very Greco-Roman nomenclature of towns, cities, and individuals shared space with Gothic and Egyptian revivalism. Near the classical Capitol stood the Norman-inspired Smithsonian Institution, and not far from that rose the obelisk celebrating the heroic first president, George Washington. Swiss chalets, Rhenish castles, and Venetian palazzi could all find their place within the national landscape. Apologists for these styles

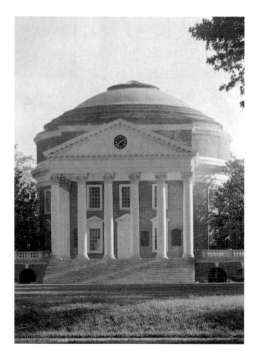

2 Thomas Jefferson and Benjamin Latrobe, *Rotunda at the University of Virginia*, 1822–26, Charlottesville, VA

found ready audiences. The glories of world literature were equally accessible to Americans, both as food for thought and as models for form. Indeed, the impulse to plunder was made easier by the fact that until the 1890s foreign authors enjoyed no American copyright protection.

Of course, throughout the century voices such as Ralph Waldo Emerson and Walt Whitman would call upon Americans to curb excessive deference to foreign taste and established traditions in favor of an art, an architecture, a literature, and a philosophy that built upon native grounds. Was cosmopolitanism a betrayal of a unique American taste? An affectation of what was deemed to be refinement? Or a fulfillment of something still broader than national identity itself? Were art and nationhood at war with one another? In 1820, a witty English clergyman, the Reverend Sidney Smith, dared to bait Americans by asking: "In the four quarters of the globe, who reads an American book? or goes to an American play? or looks at an American picture or statue?"[2] Fifty years later, another Englishman, Matthew Arnold, declared that the United States still lacked any capacity for satisfying a love for the beautiful. A "great void exists in the civilization over there; a want of what is elevated and beautiful."[3] Americans suffered from a sense of guilt about their own cultural achievements even while they responded to foreign critics with fierce and caustic rejoinders. But this rhetoric did not hide a sense of doubt about accomplishment, and a nagging feeling of inferiority.

Such meditations, while they certainly surfaced occasionally in other western societies during these same years, rarely did so with the repetitive energy they exhibited in the United States. If this country represented a repudiation of worn-out formulas and old-fashioned conventions, then it could not easily accept European art traditions without violating its center of being. Despite its well-established claims to glory, European culture often seemed out of place in America. According to many European visitors, polite culture and the arts generally suffered from widespread denigration, particularly by American businessmen. Museums, opera houses, theaters, literature itself, however much they were run by male managers, nonetheless seemed female-oriented; they aroused the enthusiasm of women rather than men. Male energy seemed better reserved for the marketplace, for making money, an activity that would ultimately benefit society more than the fancies of artists. Despite their desire for universal respect and admiration for their larger culture, many Americans hedged the arts with restrictions, remained suspicious of their patronage and their power, and seemed bent on eliminating, through informal censorship or active opposition, expressions deemed salacious, seditious, or distracting. Intellectual egalitarianism, political nationalism, and eclectic cosmopolitanism made for an uneasy union.

There were other American values that fascinated (or repelled) social commentators. One was the deference paid to youth and the young generally, an association of the country itself with innocence, inexperience, and egalitarianism. "There is seldom any very great restraint imposed upon the youth of America," wrote Francis Wyse, a British visitor in the 1840s.[4] Deference paid the "democratic sucklings," declared another Britisher fifty years later, "hardly tends to make the American child an attractive object to the stranger from without"[5] (fig. 3).

Another supposed value attracting widespread commentary was the notion that materialism and physical desire could form an acceptable basis for social action, a sense that happiness was best achieved by acknowledging human needs for comfort, for possessions, even for wealth. Despite high levels of misery and poverty among portions of the population, and dramatic contrasts of living standards, particularly in cities, the United States was associated, at home and abroad, with fecundity, with plenty, with unprecedented levels of prosperity. People were

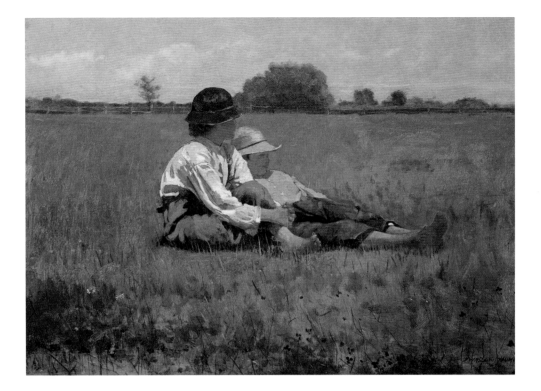

3 Winslow Homer, *Boys in a Pasture*, 1874, oil on canvas, 38.7 x 57.2 cm, Museum of Fine Arts, Boston, MA, The Hayden Collection

presumed to eat better, to dress better, to build better than anywhere else. The rich soil, deep harbors, broad rivers, the expansively beckoning continent promised rewards for work and ambition that could not be limited by humanity's previous experience. Prevailing scarcity was not the American way. A golden vision of opulence dazzled the hearts and minds of contemporaries.

Such dreams of prosperity were praised by some Americans as an appropriate response to life's challenges. Was it wrong to define human happiness in the prosaic terms of food and clothing and furniture? No, they replied, the quest for better living stimulated the imagination of inventors, the capital of investors, the energy of workers. Conservatives might dismiss materialism as vulgar and coarsening, religious leaders might condemn it as heretical and soul destroying. But apologists for American industry found few problems in what critics called "the restless desire to be better off."[6]

But even sympathizers with the urge toward self-improvement grew concerned about its implications for social harmony and political stability. The ideal of a nation of yeomen farmers—independent, uncorrupted, absorbed by domesticity and love of virtue—remained attractive. It was championed by generations of American agrarian leaders from Thomas Jefferson to populist reformers at the very end of the nineteenth century. But this social model was endangered by personal ambition and appeals to individual appetite. Self-restraint became increasingly implausible as Americans were urged to risk life and fortune in the pursuit of economic success, and as consumer goods multiplied. Entrepreneurial ambitions inspired—or infected—every level of society, farmers and workers included. The American middle classes accepted severe codes of personal discipline in the interests of economic advancement, a condition that some of their own artists protested as repressive and barbarous. Consequently, as the nineteenth century proceeded, the easy relations between patrons and artists that had characterized the decades before the Civil War became more strained. Cosmopolites and wealthy art lovers, with some exceptions, gravitated toward the purchase and display of more prestigious European painting and sculpture, while many of those lower down the economic scale viewed artists with some skepticism, concerned about their difficulty making a living or with life-styles that appeared to challenge prevailing moral codes. Artistic bohemianism, though mild compared with its counterpart in Europe, attracted its bourgeois critics. Artists, in turn, generally endorsing the majority's social values for most of the century, became increasingly disenchanted with the social and economic system around them. The materialism that many of them had celebrated in portraiture and genre in the middle years was now examined with greater condescension and even hostility, although it was not until the twentieth century that artistic alienation would become pervasive, and the strongest attacks were launched by cartoonists and caricaturists rather than painters. And even while artists such as the Ashcan Painters of New York focused some attention on urban misery, muralists and sculptors reveled in the chance to tackle grand themes and quote major art traditions in the allegories that decorated public buildings and spaces.

The notion that happiness could be found in consumption, that a man was what he owned, was not, of course, held everywhere in America. There was strong religious as well as artistic resistance, and from the earliest years those Americans concerned about the religion of money-making turned to standards of value that transcended human society. The most persuasive seemed to be those attached to nature, and the most accessible reservoir of examples could be found in the natural landscape. The role of landscape in defining American identity became powerful and pervasive. The physical confrontation between European settlers and an unknown continent had set off mingled expressions of fear, rhapsody, and exultation even in the seventeenth century, but affection for and attachment to the specific character of North America grew slowly. This was partly because the task of clearing the land in the interest of human development assumed such priority. Even during the 1830s and 1840s, some Americans expressed their hostility to trees and forests, obstacles in the way of settlement and productive farming.

But by this time, painters, poets, and philosophers were extolling the unrivaled beauty of the river valleys, the mountain ranges, and the

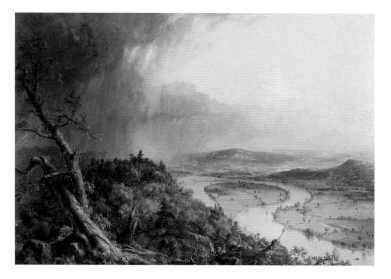

4 Thomas Cole, *View from Mount Holyoke, Northampton, Massachusetts, after a Thunderstorm—The Oxbow*, 1836, oil on canvas, 130.8 x 193 cm, The Metropolitan Museum of Art, New York, NY, gift of Mrs. Russell Sage, 1908

cataracts of New England and the middle colonies. Particular spots—the Hudson and Connecticut rivers, the Catskill Mountains, Niagara Falls—became particularly celebrated as tourist shrines and subjects for artists. Added to this was growing concern about economic development, threatening the pristine beauty of the landscape and slowly reducing the restorative power of nature (fig. 4).

That American nature had a special role to play in the national consciousness was an increasingly popular belief. It was not only that city dwellers and factory workers needed relief from the congestion and routines of daily life. It was rather a sense that nature in America was grander, more inspiring, more dramatic than it was in Europe. Since Americans had little to compare with the historical associations or art collections of Europe, nature was a more promising ground on which to compete for national greatness. As the century progressed, and the natural wonders of the Far West became known—the Rocky Mountains, Yosemite (fig. 5), the Grand Canyon of the Colorado, Yellowstone, the Pacific Coast—emphasis on the power of the natural landscape to heal social divisions and restore spiritual health grew stronger.

Natural wonders, to be sure, increased because of an expanding nation state, and the redrawing of national boundaries was accomplished through war and dispossession. Native American tribes and Mexicans were apt to take a gloomier view of the course of continental expansion. What many Americans perceived as a divine command to spread their civilization from ocean to ocean, and from the Great Lakes to the Gulf of Mexico, could be interpreted by others as an imperial program of conquest. Martial images and slogans were employed by promoters of expansion, and it was this issue which, to a large extent, underwrote the coming of the Civil War. The problem of assigning new territories and ultimately new states to the ranks of slave or free states proved a boiling point of contention in Congress, and in the nation at large. Southerners felt an increasing sense of doom and isolation as they previewed the growing strength of hostile elements within the Union. Northerners, on the other hand, charged Southerners with conspiring to expand slavery's realm, not merely by limiting the addition of free states but by making it legally impossible to prevent slave-holding in states that were already free. This was the heart of the infamous Dred Scott case, the Supreme Court decision that radicalized northern political

opinion and prepared the way for the election of Abraham Lincoln and the 1861 secession.

In the years after the Civil War, opinion leaders tried to bring attention to the threats economic development posed to popular landscape wonders, and the need to protect rather than assail a suddenly vulnerable nature. The creation of national and state parks, the growing conservation movement, campaigns against outdoor advertising and a squadron of specialist landscape photographers evidenced the new levels of concern. The greatest symbol of natural beauty in the country, Niagara Falls, was gripped in debates over electrical power development. Special organizations promoted the cause of birds and animals, whose decimation by hunters and haberdashers raised fears of their extinction. Even Native Americans, still battling American army troops during the centennial of American independence in 1876, aroused among some white Americans sentiments of nostalgic attachment. The Indian, like the buffalo, or the treeless prairies, or the Adirondacks, evoked nostalgia for a society that had preceded urbanization and industrialization.

Indeed, it must be acknowledged that this most advanced and materialistic of western societies in the late nineteenth century shared a larger transatlantic experience. A whole series of movements and organizations was shaped by longings for an irretrievable past. For some, this meant hearkening back to the golden years of the eighteenth century, when American statesmanship and social restraint served as standards for the world. A so-called colonial revival swept everything from architecture and furniture making to printing and children's literature. The apparent simplicity of stylistic taste served as a counterweight in a world of Victorian opulence. Others turned to very different civilizations—Japan, China, India—or to very different historical moments—the Middle Ages and Renaissance Italy. Greece and Rome continued, of course, to serve many as fixed models of art and life, but other fin de siècle Americans, like their contemporaries in Western Europe, evinced desires to abandon their historical setting in favor of exotic alternatives. Even that most colloquial of national writers, Mark Twain, whose novels captured the very essence of western America, played with romances of King Arthur, Tudor England, and Bourbon France. These new adventurings might be seen as modern examples of American cosmopolitanism, which, as we have seen, was long established by this time. But the

5 Albert Bierstadt, *Looking Down Yosemite Valley, California*, 1865, oil on canvas, 162.6 x 244.5 cm, Collection of the Birmingham Museum of Art, Birmingham, AL, gift of the Birmingham Public Library

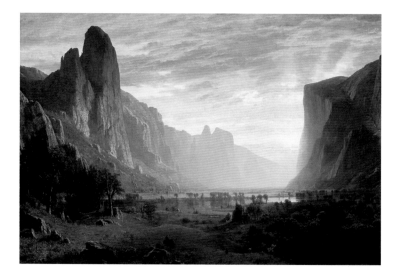

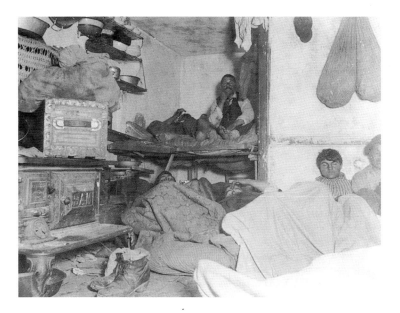

6 Jacob Riis, *Lodgers in a Crowded Bayard Street Tenement—Five Cents a Spot*, c. 1890 (photograph), Museum of the City of New York, Jacob A. Riis Collection

fantasies of the late nineteenth century went well beyond earlier interests in mining the cultures of the world to create a new national synthesis. Whole lives were now lived, philosophies promulgated, and structures built in accordance with visions of an alternative way of life. Totalizing aesthetic, religious, social, and economic ideals were floated to a curious public, proposing answers to many problems. They were no longer accents, but comprehensive alternatives.

Some were economic. Fictionalized utopias multiplied after the enormous success of Edward Bellamy's celebrated novel, *Looking Backward*, in 1888. While a series of utopian communities—many inspired by Fourier, others by Saint Simon—appeared in America before the Civil War, the later novels mingled a concern with economic conflict, modern technology, and religious afterlife. By the 1870s and 1880s, the specter of class warfare, which earlier Americans associated only with the Old World, hovered above political discussions. Lengthy and sometimes violent strikes, military responses, armory building, lockouts, protest marches, private armies, and armed clashes all punctuated these decades. Few American painters chose to focus upon contemporary labor problems, but the illustrators of popular journals such as *Harper's* and *Leslie's*, some of whom were gifted graphic artists, depicted the confrontations between capital and labor, and a generation of cartoonists, many of them born in Europe, lampooned both the tycoons and the labor leaders. The contrast between rich and poor, again once assumed to be primarily a European problem, attracted guilt-ridden attention. "How the Other Half Lives," the subject of Danish-born journalist Jacob Riis' exploration into the New York slums, became more than a title; it summed up continuing voyages of discovery, aided by the spread of photographic journalism, which exposed, almost equally, the high-living styles of the very rich and the squalor of the urban slums (fig. 6).

In general, as the nineteenth century drew to a close, the sense of special exemption that many Americans had long believed they possessed, associated with a feeling of divine favor, a privileged ocean-protected isolation, an apparently permanent prosperity, a green and forgiving youth, and a wondrous landscape, all dissipated as a host of social problems brought on by rapid industrialization and urbanization forced their way into consciousness.

The creation of classes and masses was only one part of the problem. Indeed, the challenges seemed almost unending. Burgeoning cities formed obstacles to the power of nature's redemption. Manufacturing expansion highlighted the impact of pollution (fig. 7). Foreign immigration was challenging the primacy of old patterns of religious and ethnic domination. Members of established professions and well-born social leaders feared displacement and demoralizing competition from brash upstarts, more successful at mastering business than they were. Concentrations of capital and monopolists threatened the role played by competition in leveling the playing field for aspiring entrepreneurs; gouged consumers faced few alternatives. Agrarian radicals formed political parties that seemed prepared to subvert established monetary practices in the interests of inflation. Racist attitudes continued, even intensified, in the years after the Civil War, resulting in comprehensive segregation legislation in the South and a cycle of vicious lynchings. Corruption stalked political practices on every level: local, state, and federal. So rich a medley of problems invited the satires of the cynical and the panaceas of the miracle workers.

But while growing awareness of these ills saturated American thought and rhetoric, there remained opposed to it strains of optimism, which in various ways reaffirmed many of the dreams of one hundred years earlier. These more optimistic visions found a particularly hospitable setting in the great international expositions which sprouted across America at the turn of the century—as indeed they did in Europe.

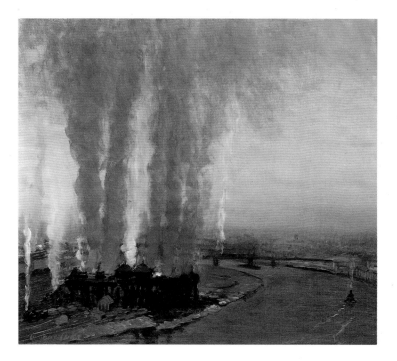

7 George Luks, *Roundhouse at High Bridge*, 1909–10, oil on canvas, 77.2 x 92.1 cm, Munson-Williams-Proctor Institute Museum of Art, Utica, NY

In Chicago, St. Louis, Buffalo, Nashville, Seattle, and elsewhere, temporary cities were built filled with the manufactures of the world, along with its art and entertainment. The fairs were, for many, another form of utopia, their physical appearance marrying the latest in technology to grandiose if highly conservative visions of architecture and landscape design. Athens, Rome, and Paris leapt to the lips of their enthusiasts (fig. 8). Tens of millions of Americans absorbed the lessons of the fairs,

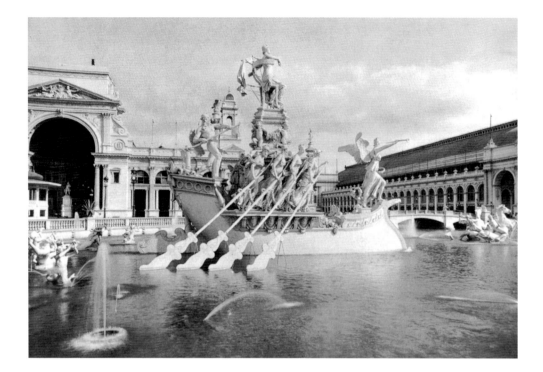

8　Frederick MacMonnie, *Columbian Fountain,
World's Columbian Exposition, Chicago,* 1893
(photograph), MacMonnie Collection, Avery
Architectural and Fine Arts Library, Columbia
University, New York, NY

including the argument that their own nation, along with some sister European states, presided at the apex of a racial pyramid. The progress of the world was identified with the civilization that Americans knew as their own, and democracy itself linked to the array of products and services that inventive genius had produced. Materialistic in their glorification of the wonders of contemporary civilization, the fairs projected a spiritualizing rhetoric that justified economic development and the dispossession of backward native populations in the name of a benevolent deity. Comprehensively planned to meet the needs of large numbers of visitors, the fairs extended an apparently tolerant welcome to the world's population, which was represented in the palaces and entertainment concessions dotting the grounds. But these were organized in such a way that they fed prevailing stereotypes, gender as well as racial, to a point where the exotic and the familiar merged identities.

Stereotypical views of otherness also prepared many Americans to accept a more active international role. At the very end of the century, this produced a series of overseas Imperial adventures, in the Pacific and the Caribbean. Proponents of American involvement insisted that the United States had become, like it or not, a player on the world stage; its economic prosperity and spheres of influence depended on sustaining certain levels of military, especially naval preparedness. Presidential and congressional elections were now fought, in part, around the ethics and advisability of American intervention in distant places. Grover Cleveland, William McKinley, and Theodore Roosevelt, the dominating presidential figures at the turn of the century, were all drawn into the debates. Expansionists and imperialists tapped into an optimistic vision of the future; doubters and dissenters were dismissed as peddlers of gloom.

The United States, which had entered the nineteenth century weak in the conventional national institutions—no single established church, no court, no aristocracy, no great universities, libraries, museums, professional establishments, aristocracy—was ending it with an extraordinary array of powerful organizations and associations. Some of them were professional and commercial, voluntary in many respects but providing credentials necessary in a specializing society. Others were educational, cultural, and charitable, many of them powered by the philanthropy of

fantastically rich individuals such as John D. Rockefeller, Andrew Carnegie, J. P. Morgan, and Leland Stanford. Carnegie, for example, left in his wake hundreds of public libraries, including the New York City branch system, and a great cultural complex in Pittsburgh. Rockefeller founded the University of Chicago. Morgan enriched the Metropolitan Museum of Art. Their benefactions as well as their collections had begun to compete with counterparts abroad for reputation and influence. Huge fortunes, untrammeled by any income tax, had provoked reflections on the functions of wealth in the modern world. Some tycoons, notably Andrew Carnegie, argued that, properly channeled, great fortunes could benefit society far more than could indiscriminate charitable giving. Rich men, Carnegie wrote, were trustees for their poorer brethren, "doing for them better than they would or could do for themselves."[7] Even the federal government, notoriously reluctant to nurture education, the arts, and sciences, had, through its support of the Library of Congress and the Smithsonian Institution, begun to achieve a degree of respect among scholars and scientists throughout the world.

Artists, again, personally gained few tangible benefits from this institutional expansion, although they were hired to adorn the palatial new structures built to house the libraries, museums, and universities, as well as the ambitious public and private structures that wealth made possible. Enthusiasm for and interest in the social benefits of society could also enhance the status of artists, as they became participants in an ongoing effort to objectify a sense of nationality. At the turn of the century, America stood on the eve of a great pageant explosion, an attempt to harness the art of the stage to great moral callings, to create outdoor spectacles evoking history and patriotic ideals. Enormous in scale, gorgeous in costuming, complete with music and dance and choral chanting, the spectacles suggested how far American republicanism had come from the austerity of one hundred years earlier, when it had proudly repudiated the pomp of church and state as devices to dazzle the senses and numb the mind.

Americans, in short, were struggling with the burdens of maturity and the temptations of power, burdened or blessed with an ideological inheritance that emphasized personal independence, self-sufficiency,

practicality, limited government, and religious mission. The modern age appeared to welcome secularism, specialization, collectivization, and bigger government. Political leaders such as Theodore Roosevelt and Woodrow Wilson in the early twentieth century, along with groups of efficiency-oriented academics, businessmen, and scientists, sought to provide the rest of the country with newly packaged programs and pithy mottos. Some of them accepted bigness and concentration as necessity, others argued for expanding public control in the interest of maintaining competition. The Progressive Movement, for many historians, marked the inauguration of a new kind of political-economic system, one better suited to the demands of the twentieth century, which abandoned as sentimental anachronisms emphasizing voluntarism, personal independence, egalitarianism, and agrarianism. Realist and naturalist novelists turned their attention to exposing the hard and unrelenting world of farm labor, the fearsome toil exacted by daily work in the fields, and the often bitter personal relationships that were created as a result. The city, by contrast, with all its danger, congestion, and pollution, offered escape routes to a very different kind of life, one in which pleasure was not so sparingly controlled, and where energy, diversity, and surprise could be encountered. The city was also a place where new kinds of ethnic identity were being defined, blends of tastes and loyalties. While native-born or Anglo-Saxon types might dominate traditional industrial, financial, and professional concerns, the new ethnic groups were quietly challenging older American merchandising, entertainment, eating, and dress habits. New York, Chicago, Philadelphia, St. Louis, San Francisco, with large Catholic and Jewish populations from Southern and Eastern Europe, fit rather uncomfortably into the older national models. Franker materialism, philistinism, and the servicing of hedonistic needs coexisted with tradition-bound religious and family rituals. Painters and sculptors had still not come to terms with this new America, but architects and engineers such as Louis Sullivan had, producing exhilarating and sometimes fantastic structures for play, for work, for travel, that owed little to European precedents (fig. 9). The multiplication of skyscrapers, electric amusement parks, bathing beaches, college campuses, huge department stores, enormous churches and tabernacles, entertainment complexes, athletic stadia, and factory assembly lines testified to a country that still confounded easy generalization.

What *were* Americans actually like? What did they believe or want or need? How were they different from Europeans? Did they really worship money or novelty? Were they more relaxed, daring, and outlandish than any other people, or more worried, depressed, and anxious? *American Nervousness*, after all, was the title of a popular book published by a well-known physician, George Beard, in the late years of the century. Were Americans instinctive conservatives, as Alexis de Tocqueville suggested, or did a native radicalism lie just beneath the surface? So many questions, and so many answers.

Visitors to America have kept on coming, describing, explaining, praising, and complaining, from Crèvecoeur, Tocqueville, and Dickens to Waugh, Baudrillard, and Eco. What does seem clear, however, from one

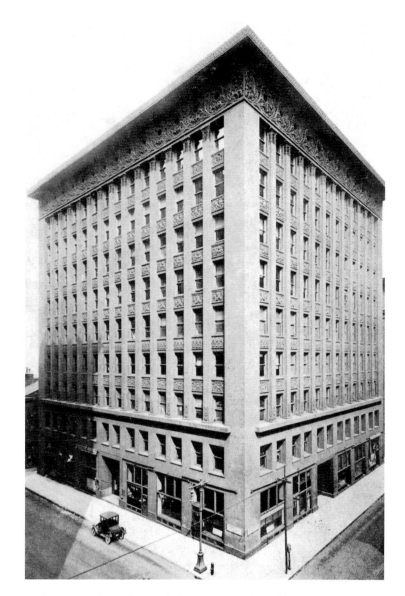

9 Dankmar Adler and Louis Sullivan, *Wainwright Building*, 1890–91, St. Louis, MO

century to the other, is that the United States remains one of the world's dream-makers. In the early nineteenth century, it was a vision of a youthful, self-governing, egalitarian, risk-taking, pluralistic society that promised prosperity to hard-working newcomers. The twentieth century brought still broader, more mediated dreams, born or at least expressed in Hollywood, associated with primal conflict, personal violence, high glamour, and apocalyptic visions. Experiencing these no longer required ocean travel, simply the act of spectatorship. But real or virtual, making sense of America remains on the international agenda, a long-running act with an apparently unlimited audience.

1 Frances Wright, *Views of Society and Manners in America*, 2nd ed. (London, 1822), 331.
2 Sidney Smith, review of Adam Seybert, "Statistical Annals of the United States of America," *Edinburgh Review*, no. 33 (January 1820): 79.
3 Matthew Arnold, *Civilization in the United States:* *First and Last Impressions of America* (Boston, 1888).
4 Francis Wyse, *America: Its Realities and Resources*, vol. I (London, 1846), 294.
5 James Fullarton Muirhead, *America The Land of Contrasts: A Briton's View of His American Kin*, 3rd ed. (London and New York, 1907), 65.
6 "The Influence of the Trading Spirit on the Social and Moral Life in America," *The American Review*, no. 1 (January 1845): 95.
7 Andrew Carnegie, "Wealth," *North American Review*, no. 148 (June 1889): 62.

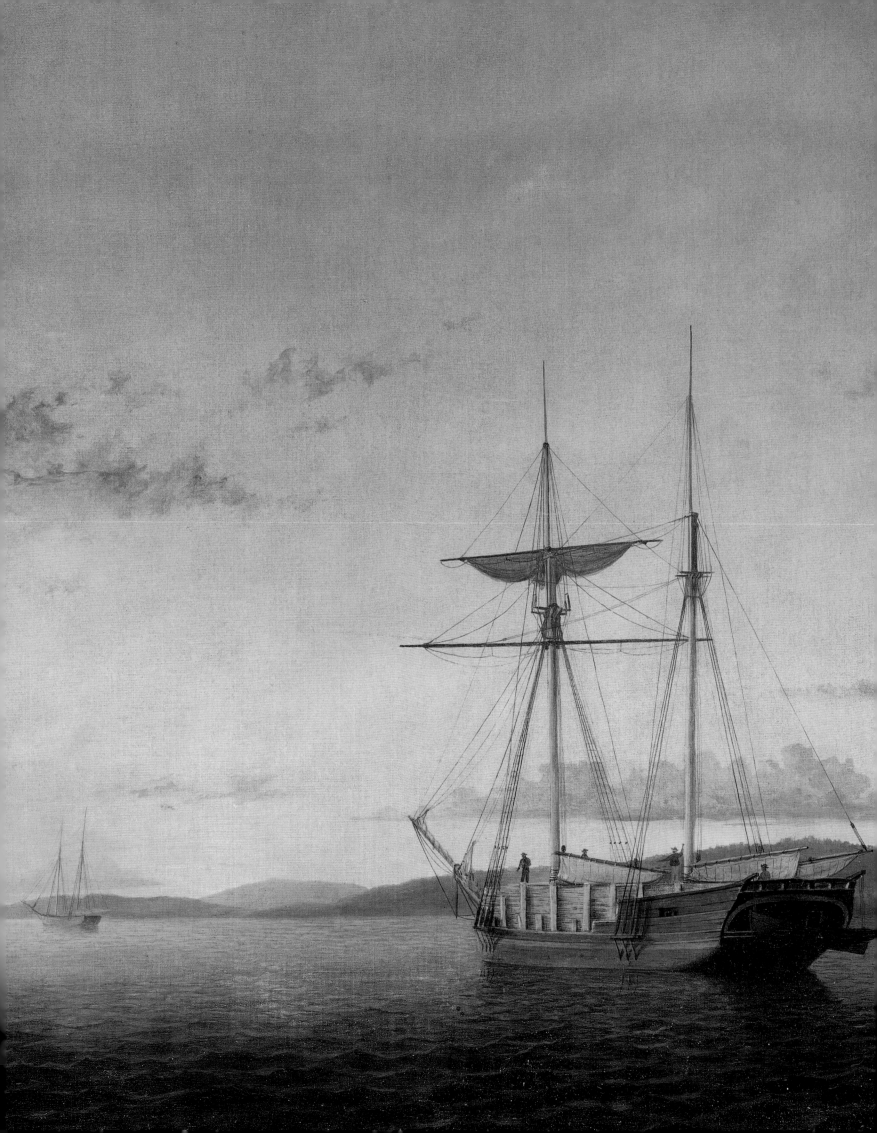

BARBARA GALLATI

Mapping a National Identity

American Painting before the Civil War

In 1879, shortly after the United States celebrated the centenary of the Declaration of Independence, the noted art commentator S.G.W. Benjamin wrote in his influential volume *American Painters*: "But when we come to the subject of landscape-painting, we enter upon a field in which originality of style is apparent, and a certain consistency and harmony of effort. Minds of large reserve power meet us at the outset, moved by strong and earnest convictions and often expressing their thoughts in methods entirely their own. Thoroughly, almost fanatically, national by nature, even when their art shows traces of foreign influence, and drawing their subjects from their native soil, they have created an art which can fairly claim to be ranked as a school."[1]

Benjamin took obvious pride in declaring that the United States had managed to develop its own national school in such a brief time. What he did not do, was point out the ironies of the situation—namely that in the eighteenth century, no self-respecting artist would have set out to specialize in landscape, so low was that branch of the arts in the academic hierarchy of subject matter. Thus, in significant ways, the formation of

curious about the otherwise unknown features of distant North America. More rarely, oil paintings portrayed the ordering of the New World according to established European models. Topographical and, in turn, picturesque in design, these early endeavors by mostly English-born artists were appropriately designated as "views" and were inspired by visual traditions imported from Britain.[2] Thus, as shown by Francis Guy's ambitiously scaled *View of Baltimore from Chapel Hill* (fig. 1), early American landscape paintings revealed little to separate them from their English prototypes.

Colonial artists' reliance on European visual modes was a purely logical outcome inasmuch as colonial American culture was essentially a distillation of the values held by the first generations of European settlers (although those values were skewed by the fact that only certain population groups were motivated to take on the challenges of the New World). Thus, the colonies cannot be interpreted as mirror reflections of European cultures, but were, instead, small geographic arenas in which the local customs of discrete politically or economically inspired parties

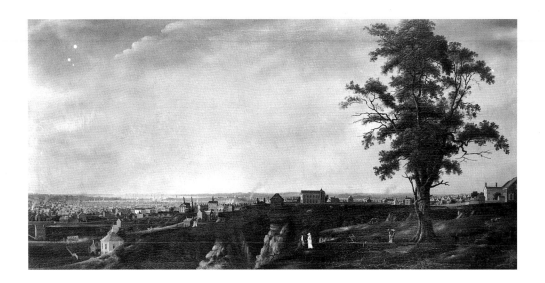

1 Francis Guy, *View of Baltimore from Chapel Hill*, c. 1803, oil on canvas, 120.6 x 234.6 cm, The Brooklyn Museum of Art, Brooklyn, NY, gift of George Dobbin Brown

an American national school founded on landscape may be seen as the product of a coincidental and unique conjunction of events and tastes that permitted American artists to see the dramatic features of an almost virgin landscape through eyes newly attuned to Romantic habits of vision.

Painters had recorded the American landscape from the first years of colonial activity, yet most of their efforts had resulted in relatively humble works executed on the spot in watercolor by artists stationed at military outposts for the purpose of collecting strategic geographic information. Other artists produced watercolors that were the basis for serialized print portfolios destined for consumption by Europeans who were

Fitz Hugh Lane, *Lumber Schooners at Evening on Penobscot Bay*, detail, 1863 (plate 36)

were activated. Portraiture, above all other genres, demonstrates the accuracy of this observation and it is in this light that the American works of the Boston-born portraitist John Singleton Copley should be examined. Raised in a family that occupied the lower rungs of the merchant classes, Copley was imbued with the idea of the arts by his English stepfather, Peter Pelham, who earned his living by providing a variety of goods and services (including instruction in English etiquette, French, reading, writing, and painting on glass) as well as producing mezzotints. Copley's precocious artistic talents and hearty ambition were also encouraged by the example of the successful Scottish painter John Smibert, whose studio was in the vicinity of the Pelham home. By virtue of dedicated study of European art available from print sources, and through his knowledge of Smibert's large collection of paintings and those of other foreign-trained artists who periodically resided in Boston,

2 Thomas Cole, *Falls of Kaaterskill*, 1826, oil on canvas, 109.2 x 91.4 cm, The Warner Collection of Gulf States Paper Corporation, Tuscaloosa, AL

American origins, the cumulative meaning of these portraits (and other contemporaneous colonial portrait production) rests not so much in the quest for a national identity, but in the material realization of individual power and achievement asserted in a visual language based on the hierarchical models of British portraiture. Like many of his sitters, Copley left the colonies during the Revolution and established himself in London, where his art changed largely in terms of technical maturation and not iconographic renovation. In fact, Copley was easily assimilated into the mainstream of English culture, since his work had originally aspired to the standards of the British school and simply acquired greater flair and polish once the opportunity to study other more refined works presented itself.

The orientation of portraiture to the individual (and how that individual desires to be perceived) is, of course, a primary character of the genre. And, while national values may sometimes be embodied in the portrait idiom (in, for example, the multitude of images of George Washington that proliferated during and after the Revolution), privately commissioned portraiture remained rooted, then as now, in personal motives and not necessarily in service of cultural nationalism. Just as Copley portrayed his sitters according to fashionable British modes regardless of their "Americanness," so too did his contemporary Benjamin West. West, a Pennsylvanian, had gone to Italy in 1760 to improve his skills and ultimately set up permanent residence in London after recognizing that it promised a more conducive atmosphere for his career than the backwaters of the colonies. His decision had less to do with his sentiments for his native land than it did with his pragmatic drive for professional success, which was accompanied by his need to participate in the grand traditions of European art before an appreciative and knowledgeable audience. West's prominence in England (as the second president of London's Royal Academy of Arts and as History Painter to King George III), and his well-known role as mentor to a number of young American artistic hopefuls (including Charles Willson Peale, whose portrait West painted in London around 1769; plate 1), shaped the course of American art in that his influence (and therefore English taste) was carried back to the colonies by his students.[5] Again, however, these issues superceded politics and were primarily lodged in the realities of making a living as an artist. For most American colonials, English art stood at the pinnacle of aesthetic accomplishment and to paint in the English manner simply indicated the possession of the appropriate professional credentials. Two generations later, Thomas Sully would enhance his artistic currency by adopting the suave fluidity of English brushwork and grand manner portrait style that earned him the title of the "American Lawrence" (in reference to the closeness of his work to that of Sir Thomas Lawrence, the leading British portraitist in Sully's time; see plates 7–9). Indeed, Sully's greatest claim to international fame was his 1838 full-length portrait of the young Queen Victoria.

In short, several decades into the nineteenth century, "American" portraiture remained mainly a product of social and artistic choices made by commissioners and painters. For the artists in particular, it was a matter of inserting themselves into a perceived cultural continuum and not perpetuating nationalist imagery for its own sake. Their sitters may have been American, but they can hardly be identified as such given that the artists maintained their stylistic allegiance to the British school.

However, as the newly established United States emerged from its colonial origins into self-conscious nationhood in the first quarter of the nineteenth century, landscape imagery began to supplant portraiture as the principal subject matter of the country's visual arts. From the late 1820s until the Civil War era, American painters sought and expressed a deep sense of national identity by depicting the variety and splendor of

Copley developed into a remarkably skilled painter who nevertheless hungered for the exalted status of the likes of Sir Joshua Reynolds, or at least a fellow colonial such as Benjamin West, who had already made a mark for himself in England. Yet Copley's success was not merely dependent on skill. Whether or not his career would flourish was also contingent on the market demand for works of art. As Paul Staiti has pointed out, such a demand resulted from the simultaneous emergence in Boston of a bourgeois merchant society that cast off the old Puritan distaste for items denoting luxury and leisure, and adopted, instead, "an unabashed taste for things English."[3] Tied to that social phenomenon was the desire on the part of this powerful but small segment of the population to delineate and solidify for itself an identity. The taste for English manners and styles, in combination with the need of the monied mercantile class to attain a (relatively) public visibility affirming its status, made the cultural ground fertile for a robust portrait market.

Copley's *Mary and Elizabeth Royall* (plate 2) confirms this specific relationship between colonial portraiture and a society in flux. Commissioned by the wealthy young Loyalist Isaac Royall, this portrait of Royall's daughters, Mary and Elizabeth, at once declares the family's wealth, social position, and political affiliation as gained through a profitable legacy of trade in the West Indies that enabled Royall to furnish his home with luxury items from England. Likewise, the elegant image of the Boston importer Nicholas Boylston (plate 3) summons notions of gentlemanly ease, privilege, and wealth expressed in the current English fashion. Ironically, Boylston was among the businessmen condemned by Samuel Adams as "enemies of their country" because they opposed the 1769 non-importation agreement of British goods.[4] Regardless of their

the New World. That the shape of the land should so capture the minds of artists is of no surprise since the openness (or emptiness) that confronted them must have been simultaneously terrifying and inspiring, offering to all who beheld it the dreams of an unknown future cast in the shadow of the European past. Indeed, from the very beginning of the colonial period, America had been seen through a veil of memory. Regardless (or perhaps because) of how foreign the terrain was, European explorers and settlers were inevitably compelled to compare it with the Old World, whether with respect to what it lacked or what it offered.

As aesthetic requirements overtook the practical in landscape imaging, the visual constructs that artists used relied on familiar (mainly British) modes: the sublime and the beautiful. At this juncture it must be noted that art training in the United States during the first part of the nineteenth century remained negligible and unsystematic. Without academic instruction, self-taught American landscapists created images that were the products of their direct observations of nature grounded in their independent readings of literary, philosophical, and scientific publications ranging from Edmund Burke's *Philosophical Inquiry into the Origins of Our Ideas of the Sublime and the Beautiful* (1757–59) to the novels of James Fenimore Cooper and Washington Irving. As the century matured, the works of Alexander von Humboldt, John Ruskin, and Ralph Waldo Emerson also exerted considerable influence on the formation of American landscape aesthetics.[6]

Despite formal continuities with the art of European forebears, American landscape paintings began to diverge radically from existing models in terms of meaning, beginning in the 1820s. The change registered most strongly in the work of Thomas Cole, and the crux of the matter was history.[7] The timing of Cole's entry into the New York art community in 1825 was critical for the reception of an art that went beyond providing merely scenic representations of the American landscape. His canvases featuring the Catskill Mountains located not far north of the fast-growing city of New York were romantic reminders of the already vanishing wilderness, and thus the passage of time. This is borne out by his *Falls of Kaaterskill* (fig. 2) in which a lone American Indian stands on the rock ledge almost at the center of the composition. The small, albeit heroically posed, figure exists as a solitary token of a once thriving civilization which was by then exiled to lands further west,

pushed out by settlements and the burgeoning tourist industry that had already drawn urbanites up the Hudson River to spend their holidays in the area. Following Cole's discovery by three established artists (the history painter John Trumbull, the portraitist William Dunlap, and the engraver Asher B. Durand) in 1825, his rapid rise as a landscape specialist signaled the art audience's readiness to embrace the "higher style of landscape" which he aspired to paint. Buoyed by nationalistic attitudes, fueled in part by the 1803 Louisiana Purchase, the 1823 Monroe Doctrine (which essentially closed North and South America from further colonization and barred foreign powers from interfering in U.S. affairs), and accelerated economic growth, American patrons (a small and elite segment of the population) were primed for an art that referred to their own experiences—or, rather, an art that manufactured a native experience for them. By drawing on the time-honored art of Claude Lorrain and Salvator Rosa and contemporary English art (that of John Martin and J.M.W. Turner in particular), and by applying the aesthetic principles of English landscape to a distinctly American geography, Cole developed—or invented—a uniquely American content that acknowledged the pre-discovery history of the North American continent and alluded to contemporary expansion. In doing so, he was instrumental in constructing visual mythic narratives that at once glorified the nation's natural riches and questioned the notion of progress. Furthermore, Cole's works invoked the widespread sensibility that endowed rural scenery with the power of proving Divine presence. His 1835 "Essay on American Scenery" reinforced these ideas. Having referred to the civilized state of Europe, Cole wrote about America: "And to this cultivated state our western world is fast approaching; but nature is still predominant, and there are those who regret that with the improvements of cultivation the sublimity of the wilderness should pass away.... Nature has spread for us a rich and delightful banquet. Shall we turn from it? We are still in Eden; the wall that shuts us out of the garden is our own ignorance and folly."[8]

Cole's words mirrored the prevailing themes of his art in which the panorama of natural abundance was at once a second Paradise to be lost or gained. While his canvases focused on the Romantic aspects of American scenery, they were also cautionary in tone. The monitory role the artist assumed is most overtly revealed in his remarkable series of five

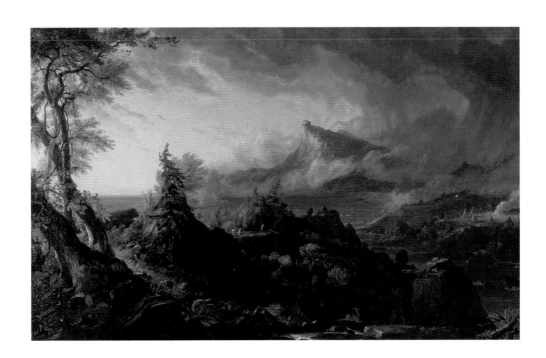

3 Thomas Cole, *The Course of Empire: The Savage State*, 1834, oil on canvas, 99.7 x 160.6 cm, New-York Historical Society, gift of the New York Gallery of Fine Arts, NY

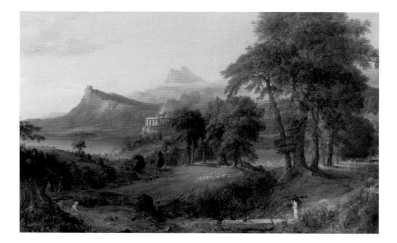

4　Thomas Cole, *The Course of Empire: The Pastoral or Arcadian State*, 1834, oil on canvas, 99.7 x 160.6 cm, New-York Historical Society, gift of the New York Gallery of Fine Arts, NY

paintings, *The Course of Empire* (figs. 3–7), in which the rise and fall of an unidentified, but clearly Euro-American, civilization is outlined. In all five works, the same fictive landscape functions as the theater within which the evolution of mankind's cultural development is performed, delineated by parallels between changes in human activity and the changes wrought by that activity on the natural environment. Nature's triumph is shown in the final canvas of the series which pictures the abandoned ruins of a great civilization, the ultimate failure of which is owed to the severing of its formerly harmonious relationship with nature.

Cole's ambivalence about progress (for he admitted progress was necessary) indicates his involvement with a community of thought promulgated within the circle of his close friends which included the poet and (later) newspaper editor William Cullen Bryant and novelist James Fenimore Cooper, both of whom called for a watchful eye in the harvesting of natural resources. Cooper's *The Pioneers*, published in 1823, may be looked to as a direct inspiration for Cole, for both men—writer and painter—construed their wilderness subjects as essentially nostalgic

5　Thomas Cole, *The Course of Empire: The Consummation of Empire*, 1835–36, oil on canvas, 130.2 x 193 cm, New-York Historical Society, gift of the New York Gallery of Fine Arts, NY

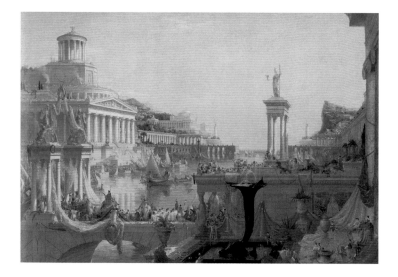

images of a landscape and experiences already lost to possibility. The best-selling novel contains vivid descriptions of the countryside surrounding the fictional upstate New York town of Templeton. Written in pictorial terms, which supply templates for visual landscape imagery and for the range of characters that would eventually constitute the major types that populated American genre paintings, Cooper used the device of memory as a thematic framework by establishing the time of his narrative forty years in the past. Even then (1793), the novel's young heroine Elizabeth was able to observe on returning to her native town, that she looked "on a scene which was so rapidly altering under the hands of man, that it only resembled, in its outlines, the picture she had so often studied, with delight, in childhood."[9]

In brief, Cole and like-minded artists and writers of his generation historicized the American landscape in order to predict a number of probable futures which, for the most part, promised a positive outcome based on the providential overtones of nature-based philosophies. If America was the new Eden, then the pioneer was the new Adam, armed this time with the foreknowledge of his possible destinies. Implicit in Cole's content was the message that nature, as a revelation of the Divine on earth, could not be conquered; man's success was a matter of negotiating a reconciliation between material ambitions and universal truths.

Few of Cole's younger contemporaries attempted to match the sometimes strident pitch of his message. As the influential chronicler of American art, Henry T. Tuckerman, observed in 1867, it was Jasper Francis Cropsey whose work displayed "a moral interest frequently imparted to his landscapes by their historical or allegorical significance, in which as in other respects he reminded his countrymen of Cole."[10] Degrees of emulation aside, the younger contingent of landscape painters working in the 1840s and early 1850s generally tended to eschew imagery evocative of the past and placed their landscape visions firmly in the present. The hunters, woodsmen, and Native Americans who had provided the thematic structure for much of Cole's content gave way to scenes of rustic gentility, where small villages and church spires signified the transformation of rude settlements into comfortable communities, and farmers and casual travelers replaced pioneers. The thematic modulation noted here is exhibited in two works in the present exhibition: Frederic Edwin Church's *New England Scenery* (plate 38), Jasper Francis Cropsey's *American Harvesting* (1851), and John F. Kensett's *The White Mountains (Mount Washington from the Valley of Conway)* (plate 33). Each is infused with a mood of peace and security, indicating that the requisite balance has been achieved between man and nature. Emblems of national well-being and values, these paintings proclaimed Americans' possession of the land. In the case of Kensett's painting, this meaning was buttressed by his focus on a site already familiar to viewers by virtue of its sustained attention from artists who, for nearly two decades, had made summer pilgrimages to Conway, New Hampshire, where the White Mountain scenery was a key area of artistic interest and delight. In this way alone, a national tradition in the arts was referenced without the freight of historicizing allegory. What is more, as John Driscoll has noted, "[t]he nationalistic element comes through quite clearly in *The White Mountains—From North Conway*. Rising in patriarchal glory above the scene is the image of the great snow-covered mountain that bears the name of the *pater patriae* of the United States: Washington."[11] Here was a natural scene that met the requirements of traditional landscape theory without the need for artistic manipulation. Its visual perfection conferred a like sense of perfection on the society that occupied it and, thus, validated America and its ways.

The three paintings mentioned above share in the generally optimistic mood that permeated American culture in the decade preceding the Civil

War. Strong nationalistic sentiments had been nurtured by a number of events, including the United States' 1848 victory in the Mexican War (which resulted in the annexation of vast tracts of land—Arizona, California, Nevada, New Mexico, Utah, and parts of Colorado and Texas) and the 1849 discovery of gold in California (which prompted the famed Gold Rush). The frontier was rapidly moving westward, propelled by an expansionist fervor encouraged and ratified by the doctrine of Manifest Destiny, which proclaimed mankind's entitlement to the lands spanning the continent. The highly politicized rhetoric centering on expansionist issues was emotional, extreme, and effective. And it was aimed at a largely eastern audience that stood to profit substantially from the economic development that expansion entailed. A report delivered to the U.S. Senate in 1846 by journalist William Gilpin demonstrates the ideas and tenor of the Manifest Destiny platform: "From nothing we have become 20,000,000. From nothing we are grown to be in agriculture, in commerce, in civilization, and in natural strength, the first among nations existing or in history.... The untransacted destiny of the American people is to subdue the continent—to rush over this vast field to the Pacific Ocean—to animate the many hundred millions of its people, and to cheer them upward ... to teach old nations a new civilization—to confirm the destiny of the human race ... to emblazon history with the conquest of peace ... and to shed blessings round the world.... Divine task! Immortal mission! Let us tread fast and joyfully open the trail before us! Let every American heart open wide for patriotism to glow undimmed, and confide with religious faith in the sublime and prodigious destiny of his well-loved country."[12]

Ironically, as demonstrated by the paintings of Church, Cropsey, and Kensett noted here, the landscape artists of the eastern cultural establishment (now grouped under the broad heading of the Hudson River School) did not adopt explicitly expansionist imagery in their work. Indeed, the iconography of the frontier became mainly the territory of genre painters who mythologized the western course of civilization for consumption on the eastern art market. The distance between east and west was not only a physical reality, it was psychological as well. Citing the theory of "bifurcated geography" expounded by Richard Slotkin, William Truettner accounts for the conservative nature of eastern patronage: "On the western side of the imaginary line [was] a 'dream-world' in which personal greed and the national good became magically associated. The urban East, however, operated under a different set of guidelines. Rampant development could and did produce conditions that were immediately apparent: rural land overrun by industry, squalid urban areas, and labor unrest, all of which constituted a rebuke to capitalists, who were also major art patrons. A western scene signaling progress was tolerable because in that fictional space the implications of progress hurt no one (except Indians, foreign powers, and others who were expendable in the eyes of an expansionist society). But the same subject set in more familiar circumstances in the East range a warning bell ... Eastern patrons instinctively chose subjects created to preserve stereotypes for representing (or modifying) social change on both sides of the frontier. These tactfully diluted the more obvious manifestations of progress in the East."[13]

The inability or unwillingness to recognize the negative social harvest that accompanied progress partially accounts for the popularity of the placid visions of harmony and prosperity that characterized representations of the landscape of the Atlantic states at mid-century. The widespread belief that art was to be an educational and elevating force in the life of the nation must also be considered, however. Thus, such stereotypes promoted a dual reading: not only could they deflect attention from coarse realities, but they could also remind viewers of essential national ideals.

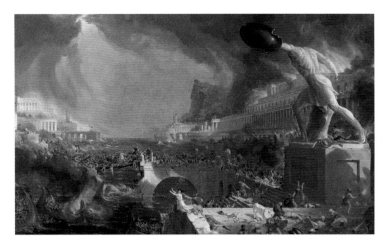

6 Thomas Cole, *The Course of Empire: Destruction*, 1836, oil on canvas, 84.5 x 160.6 cm, New-York Historical Society, gift of the New York Gallery of Fine Arts, NY

7 Thomas Cole, *The Course of Empire: Desolation*, 1836, oil on canvas, 99.7 x 160 cm, New-York Historical Society, gift of the New York Gallery of Fine Arts, NY

In contrast to the homely depictions of modest farmers living in rapport with nature, more often than not, nineteenth-century high-art images of frontier life register strongly today as blatant fictions. At the same time they serve to identify a pictorial shift that de-emphasized the rigors of nature and, instead, referred either to cultural conflict or stabilization. With respect to the former, perhaps the greatest conflict was that of the removal (a euphemism applied in the nineteenth century) of Native Americans from their lands. As witnessed by John Vanderlyn's *The Death of Jane McCrea* (plate 5), the hostilities between European settlers and Native Americans (here in the pay of the British) had already provided dramatic material for the young artist making his bid for recognition in the politically charged atmosphere of Paris, where anti-British feeling ran high. Yet despite its negative portrayal of Native Americans, Vanderlyn's work was not originally intended to arouse American sentiments concerning tribal violence, but was (as a commission from Joel Barlow, a United States representative to the French government) designed to curry favor with Parisian Salon audiences by trading on Franco-British animosities.

It was not until the middle of the century that works such as Charles Wimar's *The Abduction of Daniel Boone's Daughter by the Indians* (plate 60) not only buttressed long harbored racial fears, but also provided "historic"

evidence *aimed specifically* toward justifying U.S. government policy against tribal nations. Less inflammatory images proliferated at mid-century as well, exemplified by Tomkins H. Matteson's *The Last of the Race* (fig. 8), in which a doomed Indian family is shown at the edge of a precipice overlooking the Pacific at sunset. Sympathetic or otherwise, depictions of American Indians engaged narratives that shared the same, inevitable outcome—the elimination of an indigenous culture.

Almost invariably the romanticized episodes of savagery, bloodshed, and doom were portrayed in richly painted landscapes that promised the fulfillment of Manifest Destiny. Although these were undeniably genre and/or history paintings, landscape nonetheless played a key role in conveying content. This was particularly true for George Caleb Bingham's series of paintings featuring Missouri boatmen (see plate 58), exemplified here by *The Jolly Flatboatmen* (fig. 9). Bathed in the golden light of cloudless skies, robust rivermen glorified the notion of commerce as their flatboats (already nostalgic relics of the past since replaced by the steamboat) transported raw goods (the spoils of expansion) toward eastern markets on the broad, tranquil waters of the Missouri River. The calm, classicizing symmetries of Bingham's style and the obvious camaraderie among the men he portrayed contradicted reports of the lawlessness and violence of frontier existence that molded easterners' perceptions of the West. In the face of the growing sectionalism (prompted in large part by the slavery debates) that defined the political atmosphere of the period, *The Jolly Flatboatmen* advanced the belief that expansion was a communal enterprise that united men by encouraging harmonious interaction among themselves (as symbolized by their music making) and within the natural world. In this way the positive aspects of expansionism and frontier life were vigorously promoted in Bingham's art. A westerner himself, he depended on eastern patronage for his livelihood, which he gained primarily through the American Art-Union, a New York-based lottery system that purchased works of art to be awarded as prizes to winning ticket holders. An ancillary but important feature of the system was that many of the paintings acquired by the Art-Union were reproduced as prints and distributed to lottery subscribers. By making American genre and landscape images widely available (among them were Kensett's *The White Mountains [Mount Washington from the Valley of Conway]*, Matteson's *The Last of the Race* and Bingham's *The Jolly Flatboatmen*) and by

mounting regular New York exhibitions of the paintings it acquired, the American Art-Union not only encouraged a taste for the arts in America, but also disseminated an iconography of progress that was eminently palatable.[14]

The Art-Union also featured more modest (in terms of both scale and subject) genre paintings by such artists as James Goodwyn Clonney and Richard Caton Woodville, the appeal of which probably dwelled in their more direct connections with the common experience of their viewers. This is not to say, however, that paintings of the likes of Clonney's were without serious thematic undertones. *Waking Up* (plate 25), which depicts two white boys tickling the nose of a sleeping black man, might have registered with its audience at the 1851 National Academy exhibition merely as yet another variation on a humorous motif that had become popular in the 1830s. While the thematic trope of the black man as victim of a childish joke was superficially harmless, it also possessed a cautionary message for those viewers concerned with the possibility of blacks' "awakening" to marshal their collective strength against oppression. (Alternatively, the image may have assuaged whites' fears by portraying blacks as innocuous.) From his more detached vantage point in Europe, the expatriate Richard Caton Woodville also addressed the subject of political divisions on the home front in a number of works, among them *Politics in an Oyster House* (plate 26), which focused on the role of newspapers in communicating the recent developments in affairs ranging from the Mexican War to slavery debates.

The growth of an American school of genre painting coincided with an increasing tendency to apply scientific theory in interpreting landscape. As genre painting took over primary narrative function in the visual arts, landscapists began to concentrate on nature alone. This shift is exemplified in the art of Asher B. Durand who, by Cole's example, had been persuaded to abandon his lucrative career as an engraver to take up landscape painting in 1837. In 1855, Durand painted *The First Harvest in the Wilderness* (plate 24), which depicts a solitary farmer harvesting a small field of grain set in the midst of the American wilderness. The painting was the first commissioned by the Brooklyn Institute from the bequest of Augustus Graham, a wealthy businessman and founding member of the Institute, whose efforts to bring cultural advantages to the citizenry of Brooklyn were well known at the time and whose legacy included the rare mandate to obtain works from living American artists

8 Tompkins Harrison Matteson, *The Last of the Race*, 1847, oil on canvas, 101 x 127 cm, New-York Historical Society, NY

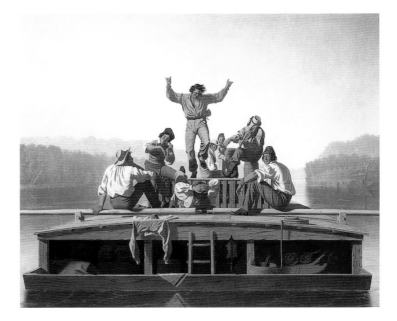

9 George Caleb Bingham, *The Jolly Flatboatmen*, 1846, oil on canvas, 96.5 x 123.2 cm, Manoogian Collection, Taylor, MI

for the purpose of forming a public collection. The Institute's selection of Durand was carefully calculated: the artist was not only the president of the National Academy of Design (the nation's most prestigious art organization), but also the titular head of the country's landscape school (a position he had assumed after Cole's death in 1848).

The work is a fine example of the allegorical landscape mode in which the American wilderness is cast as both backdrop and obstacle to civilization's triumphant advance. Although the same narrative had been enacted in similar compositions in previous decades, Durand translated it into a timely metaphor specific to Graham, who would be remembered for his work in carving out an oasis of learning and moral uplift in the cultural wilderness of Brooklyn. Durand presumed the contemporary audience's power to recognize the well-established aesthetic constructs of the sublime and the beautiful, which, by that time, had found their American equivalents in the opposition of wilderness and domesticated scenery. To ensure that there would be no mistaking the painting's immediate message, Durand inscribed Graham's name on the massive boulder in the lower right foreground of the composition so that it would function not only as a road marker leading from the forest to the clearing, but also as a rustic memorial tablet.

The language of visual metaphor that Durand used for this painting was, by 1855, relatively antiquated. Indeed, Durand's markedly programmatic approach separated *The First Harvest in the Wilderness* from another type of landscape that he was then exhibiting at the National Academy of Design, for example *In the Woods* (fig. 10), a work which garnered critical praise because it proclaimed the "modern spirit, based on reality, and admitting no sentiment which is not entirely drawn from nature."[15] The modernity that critics discerned in Durand's ostensibly unselective depictions of the American forest, however, was not without its own metaphorical meaning that connected it with the general attitudes informing the genre: rather than offering merely veristic records of wooded interiors, the painter also undertook to express in such works the presence of God in nature. This content is confirmed in Durand's series of articles written in the form of letters to a fictional student, which were published that same year in the influential art periodical *The Crayon*. Disclosing attitudes that paralleled those of the English critic John Ruskin, Durand wrote about the didactic capacity of landscape to substantiate and illuminate the nature of the Creator: "The external

appearance of this our dwelling-place, apart from its wondrous structure and functions that minister to our well-being, is fraught with lessons of high and holy meaning, only surpassed by the light of Revelation. It is impossible to contemplate ... without arriving at the conviction ... that the Great Designer of these glorious pictures has placed them before us as types of the Divine attributes."[16]

In the Woods signals the reorientation of American landscape painting in the mid-1850s, a conceptual process that divorced landscape from the historicizing allegorical mode that had been the principal means of conveying content in previous decades. A significant result of this reorientation was the disappearance of human activity from a substantial portion of the landscape paintings created during the period. The question of why Durand chose to use a determinedly *retardataire* manner for a commission as important as *The First Harvest in the Wilderness* remains unanswered. It may be speculated that, as a memorial to Graham, a cultural pioneer, the painting acknowledged that the task of settlement was accomplished and that the image and role of the pioneer (so resonant in the cultural identity of America) demanded transformation. Such transformation entailed the recognition that as time had unfolded, the initial challenge presented by the inhospitable wilderness encountered by the colonists had been met and the new challenge for America lay in the cultivation of the moral and spiritual states of its populace. By the same token, the painting may be interpreted as Durand's simultaneous homage to Cole (the father of the American landscape school) and his declaration that Cole's visual language rooted in historicizing allegory (like the pioneer) was a thing of the past.

But *In the Woods* also demonstrates the revised concerns of American landscape painters. Nature in its purest state, untouched by the ax of the pioneer, became the primary subject. Spurred by the writings of such men as Humboldt, Ruskin, and Emerson, who advocated the intense investigation of the natural world, American painters applied a scientific approach to their transcriptions of the physical environment, often giving as much attention to the smallest blade of grass as they did to the sweep of the clouds across the sky. Durand's Ruskinian dedication to discovering the spiritual in nature embraced the more serene aspects of American forest and mountain regions, where the arching branches of aged trees transform the inner reaches of the forest into natural equivalents of vaulted cathedral spaces.

In contrast to the quietude of Durand's art is the majestic drama captured in the mature work of Frederic Edwin Church, whose readings of Humboldt are thought to be at the foundation of his operatic landscape visions. Humboldt's writings, although scientific, were not devoid of humanist concerns: "In considering the study of physical phenomena, not merely in its bearings on the material wants of life, but in its general influence on the intellectual advancement of mankind, we find its noblest and most important result to be a knowledge of the chain of connection, by which all natural forces are linked together, and made mutually dependent upon each other; and it is the perception of these relations that exalts our views and ennobles our enjoyments."[17]

In accordance with Humboldt's attitudes, Church's grand visions of North and South American landscapes recorded natural spectacles, the scientific understanding of which would reveal the Divine order of the universe and the eternal generation and regeneration of cosmic forces that occurred regardless of man's presence or actions. Paintings such as

Church's *Twilight in the Wilderness* (fig. 11 and plate 45) are suggestive of the ever-changing character of the universe, yet the transitory twilight is permanently stilled by the artist at the moment that darkness is imminent. It is this imminence or expectancy that comes to dominate the mood of American landscape in the years leading up to the Civil War, whether it is expressed in the powerful canvases of Church or in the quietist works of Fitz Hugh Lane.

Over the three or so decades following the birth of American landscape at the hands of Thomas Cole, Americans had continued to invest landscape with metaphorical capacity. But the urge to validate history as represented in the landscapes of Cole had been nullified by 1850, and was soon replaced by an ominous (or at least neutral) set of vistas that blended the insistent vagaries of the future with the hope for an ordered world. Throughout each of these phases, the American landscape was the medium for interpreting the nation's identity.

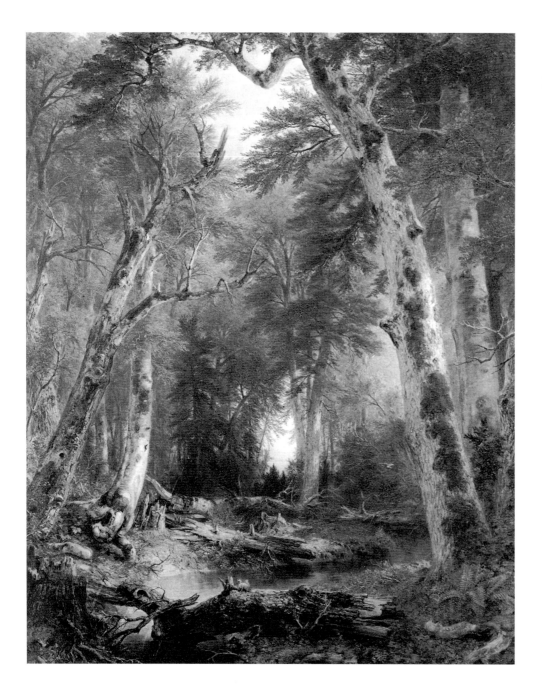

10 Asher Brown Durand, *In the Woods*, 1855, oil on canvas, 153.5 x 124.5 cm, The Metropolitan Museum of Art, New York, NY, gift in memory of Johathan Sturges by his children, 1895

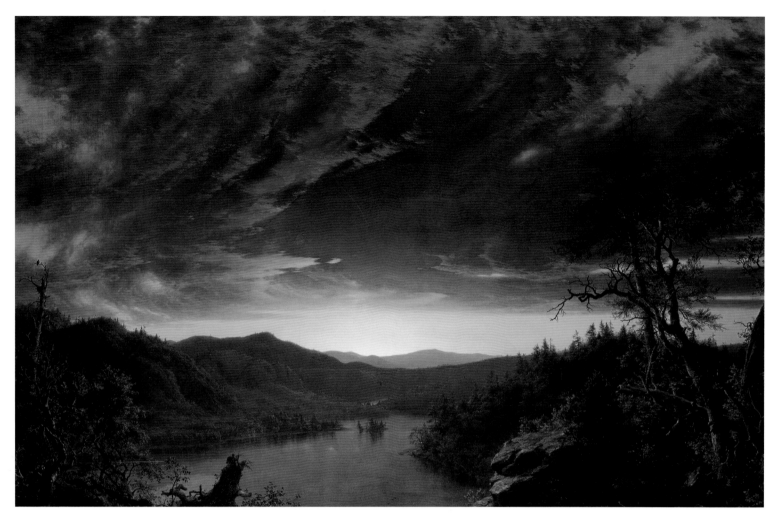

11 Frederic Edwin Church, *Twilight in the Wilderness*, 1860, oil on canvas, 101.6 x 162.6 cm,
The Cleveland Museum of Art, Cleveland, OH, Mr. and Mrs. William H. Marlatt Fund

1 S.G.W. Benjamin, *Art in America: A Critical and Historical Sketch* (New York: Harper & Brothers, Publishers, 1880), 55–56.

2 For a fine survey of American landscape painting before 1830, see Edward J. Nygren with Bruce Robertson, *Views and Visions: American Landscape before 1830*, exhib. cat. (Washington, D.C.: The Corcoran Gallery of Art, 1986).

3 Paul Staiti, "Accounting for Copley," in *Copley in America*, exhib. cat. (New York: The Metropolitan Museum of Art, 1995), 32.

4 For a full discussion of Copley's portraits of Nicholas Boylston, see Carol Troyen's entry for this painting in *Copley in America*, 224–29, where Boylston's politics are outlined.

5 For West's influence on American art, see Dorinda Evans, *Benjamin West and His American Students*, exhib. cat. (Washington, D.C.: National Portrait Gallery, 1980).

6 For discussions of American landscape in relation to the works of these writers and others, see Barbara Novak, *Nature and Culture: American Landscape and Painting, 1825–1875* (New York and Toronto: Oxford University Press, 1980) and Angela Miller, *The Empire of the Eye: Landscape Representation and American Cultural Politics, 1825–1875* (Ithaca and London: Cornell University Press, 1993).

7 For the most recent interpretations of Thomas Cole's art, see William H. Truettner and Alan Wallach, eds., *Thomas Cole: Landscape into History*, exhib. cat. (New Haven and London: Yale University Press and Washington, D.C.: National Museum of American Art, Smithsonian Institution, 1994).

8 Thomas Cole, "Essay on American Scenery," in John W. McCoubrey, *American Art, 1700–1960: Sources and Documents* (Englewood Cliffs, New Jersey: Prentice-Hall, Inc., 1965).

9 James Fenimore Cooper, *The Pioneers* (1823; New York: Penguin Books, 1988), 40.

10 Henry T. Tuckerman, *Book of the Artists: American Artist Life Comprising Biographical and Critical Sketches of American Artists: Preceded by An Historical Account of the Rise & Progress of Art in America*, 1867, repr. (New York: James F. Carr, 1966), 532–33.

11 John Paul Driscoll, "From Burin to Brush," in John Paul Driscoll and John K. Howat, *John Frederick Kensett: An American Master*, exhib. cat. (New York and London: Worcester Art Museum in association with W. W. Norton & Company, 1985), 67.

12 Gilpin quoted in Patricia Hills, "Picturing Progress in the Era of Westward Expansion," in William H. Truettner, ed., *The West as America: Reinterpreting Images of the Frontier, 1820–1920*, exhib. cat. (Washington, D.C., and London: Smithsonian Institution Press for the National Museum of American Art, 1991), 101.

13 Truettner, "Ideology and Image," Ibid., 31.

14 Maybelle Mann, *The American Art-Union*, exhib. cat. (Otisville, New York: ALM Associates, Inc., 1977).

15 *Putnam's Monthly* 5 (May 1855): 505–7.

16 Asher B. Durand, "Letter II," *The Crayon* I, no. 3 (17 January, 1855): 34.

17 Alexander von Humboldt, *Cosmos*, trans. E. C. Otté, 2 vols. (New York: Harper & Brothers, 1850), I: 23, quoted in Novak, *Nature and Culture*, 67.

NICOLAI CIKOVSKY, JR.

Democratic Illusionism

In, roughly speaking, the fifty years following the American revolution, that is, the fifty years surrounding the turn of the eighteenth century, the two most vexing and difficult problems American artists faced were those posed by nationality and democracy. Both, they found, were intensely troubling and problematic—innately so because of their novelty as issues of serious artistic concern, but also because during this period American artists wrestled with those issues for the first time, though often less from wanting to than having to.

Of the two problems, nationality proved to be the most manageable, particularly after Thomas Cole's invention in about 1825 of American wilderness nature as the definitive national subject. (It was not self-evident before Cole that it could be so: the "grand defect of American nature," John Galt wrote in the late eighteenth century, was that it was "but composed of trees.")

Democracy was a thornier problem by far. Few historical precedents and nothing in the theoretical literature of art helped in guiding what kind of art was possible for, or incumbent upon, an American artist to make in the new circumstances of republican government and democratic society. Nothing indicated which subjects were most appropriate or which audience art should address. Nor was there any indication of which language and in which style that address should be made, or which social and economic class, and which mechanism of patronage should support it.

There were no easy answers, in other words, to the serious questions that the social and economic consequences of political democracy posed for American artists. And the persistent disappointment, if not failure, of American artists in this period shows just how difficult the situation was. All the major artistic figures of the early republic (those, at any rate, who were not, like Gilbert Stuart, content simply to paint portraits)—John Trumbull, John Vanderlyn, Washington Allston, and Samuel F.B. Morse —were thwarted in their ambitions and embittered by failure to a degree that is singular to this period.

All the same, they did attempt in various ways to adjust to these new and difficult circumstances. And by their very attempts—however disappointing most of them proved to be—they showed a precocious awareness of the forms those adjustments might take and the strategies by which those circumstances could find pictorial expression.

This was deeply problematic because the circumstances in which these artists found themselves were utterly—and, for some of them, distastefully—new and different. What made their newness and difference so clear was that, deeply imbedded in their artistic understanding were inherited ideas about nobility of subject matter and ideality of style that were fundamentally incompatible with, if not actually hostile to, the political, social, and economic order of a middle-class, democratic republic. For theirs was, collectively speaking, an aristocratically ordered program of belief, codified and promulgated in the seventeenth and eighteenth centuries by the royal academies of France and England, and enshrined in the literature of art that constituted for all of them the source of theoretical and intellectual guidance. Samuel F.B. Morse said in a public lecture in New York, delivered as late as 1835, "The truth is, the Fine Arts are addressed not to the great mass of the community, but to the majority of the well educated and refined in Society."[1] With this, Morse showed just how strong—how undiluted, unexamined, and unaltered—that theoretical and intellectual inheritance could be. A different and almost pathetic example of just how remote these artists could be from the new order of things in republican America was Washington

1 John Trumbull, *The Declaration of Independence, 4 July 1776*, 1787–1820, oil on canvas, 53.7 x 79.1 cm, Yale University Art Gallery, New Haven, CT, Trumbull Collection

Raphaelle Peale, *Venus Rising from the Sea— A Deception*, detail, 1823 (plate 16)

2 Samuel F. B. Morse, *The Old House of Representatives*, 1822, 220 x 332 cm, The Corcoran Gallery of Art, Washington, D.C.

Allston's proposal of the "Three Maries at the Tomb" as a subject for a mural in the United States Capitol.[2]

That said, some of the artists tried their hands at explicitly national subject matter: both Trumbull (*The Declaration of Independence* [fig. 1] and a scene of battles in the War of Independence) and Vanderlyn (*The Death of Jane McCrea;* plate 5) painted events of the American Revolution, and they both painted what was at the turn of the century already perceived to be the canonically national landscape subject, Niagara Falls. But more tellingly, Trumbull, Vanderlyn, and Morse all painted purposely *popular* pictures, that is, ones designed in forms and exhibited in ways that represented concessions to popular (democratic) taste and understanding. Trumbull and Vanderlyn explored the popular form of the panorama (Trumbull planned, but never completed, a panorama of Niagara; Vanderlyn painted and exhibited in New York a panorama of Versailles). And Morse made two large pictures designed specifically for public exhibition and aimed at popular taste, *The Old House of Representatives* (fig. 2) and *Gallery of the Louvre* (fig. 3)—this despite what he said, and in fact was saying at virtually the time he was painting them, about the fine arts not being addressed to "the great mass of the community." It is hard to find a better illustration than this of how ideologically conflicted

3 Samuel F. B. Morse, *Gallery of the Louvre*, 1831–33, oil on canvas, 187.3 x 274.3 cm, Terra Foundation of the Arts, Daniel J. Terra Collection, Chicago, IL

Morse, and by extension his contemporaries, could be—a conflict, ultimately, that Morse could not endure, driving him to abandon painting (though he said it had abandoned him) for the telegraph. And it is deeply ironic, too, that these two paintings, generated by opportunism, not conviction, were Morse's best.

It is not customary to think of Raphaelle Peale in the company of Trumbull, Allston, Vanderlyn, and Morse. He did not, like them, paint figural and historical subjects—he was a still-life painter, said to be America's first—and he did not, or did not seem to, address the issues with which they wrestled. His delicate, precious still lifes (fig. 4, plates 14–17) seem wholly distant from their often troubled and intractable enterprise. But delicate and precious as they undeniably are, Raphaelle Peale's beautiful still lifes, more deeply than paintings of other kinds, were engaged in the artistic, social, political, and economic issues of their time.

Raphaelle was the eldest son of Charles Willson Peale. Raphaelle was named, America's first art historian, William Dunlap, said, according to his father's "whim" of "naming his numerous family after illustrious characters of by-gone ages, particularly painters. A dangerous and sometimes ludicrous experiment. Raphael [*sic*], Angelica Kauffman, Rembrandt, Rubens, and Titian, and many other great folks, were all his children."[3] Charles Willson Peale was a man of many interests and boundless curiosity, which he indulged with tireless enthusiasm up until the end of a very long life (he died in 1827 at the age of eighty-six, outliving Raphaelle by two years). Dunlap summarized some of his "trades, employments, and professions" this way: "He was a saddler; harness-maker; clock and watch-maker; silver-smith; painter in oils, crayons, and miniature; modeler in clay, wax, and plaster; ... he was a soldier; a legislator; a lecturer; a preserver of animals...."[4] Even this long list does not do him justice. As an artist, Charles Willson Peale was the best portrait painter in America during the twenty-odd years between John Singleton Copley's departure for Europe in 1774 and Gilbert Stuart's return to America in 1793. And much more than merely a "preserver of animals," he founded in Philadelphia America's first systematically and scientifically arranged museum of art and natural history. The large self-portrait he painted in 1822, *The Artist in His Museum* (fig. 5), is a virtual inventory of his interests and achievements.

Charles Willson Peale had an enormous influence on all his children, but most on his eldest, Raphaelle. Much of Raphaelle's professional life was decisively shaped by his father's influence. In his teens, Raphaelle began working in the museum, traveling to gather specimens, and becoming an accomplished taxidermist in a method developed by his father. By the age of twenty, Raphaelle, like his father, was a professional portrait painter. He also shared his father's scientific and mechanical interests, sometimes as a collaborator, writing papers on stoves and fireplaces, carriage wheels, and lightning rods, patenting a process for preserving pilings and ships' bottoms, and even publishing a theory of the universe.

Pampered as a child, Raphaelle did not otherwise have a happy life. He lived in uncertain times of war and revolution, profound social and political change, shifting values and changing tastes. Given the name of the greatest artist of modern times, he was burdened by his father with an impossible standard of perfection. His marriage was unhappy and contracted against his father's wishes. He was irresponsible as a parent, and chronically unsuccessful as an artist, unable by his efforts either to support his family or to please his father. By the age of thirty he was crippled with gout. He was so seriously ill from alcoholism and other ailments that he was committed for "delirium," and it was from its effects that he died in 1825 at the age of fifty-one.

4 Raphaelle Peale, *Blackberries*, c. 1813, oil on wood, 18.4 x 26 cm, The Fine Arts Museums of San Francisco, CA

Professionally and personally, Raphaelle Peale was a disappointment to his father. Yet, despite his many frailties and failures, he was, of all the Peales (his father not excepted), the greatest and truest artist. He had the finest artistic sensibility and intelligence, and he was the most daring. And it may be that, in the end, his art had the most lasting influence.

What is most remarkable about Raphaelle Peale is the kind of paintings he chose to make. In his professional debut in the Columbian exhibition of 1795, in Philadelphia, he already showed his artistic inclination, for while he listed himself in its catalogue as "portrait painter at the museum," only five of the thirteen works he exhibited were portraits. The rest were still lifes. We do not know why—with what purpose or by what policy—Raphaelle Peale chose to paint still lifes. But it is clear that he *chose* to. He painted still lifes not as a private diversion, but as a purposeful, publicly significant undertaking: of the approximately one hundred paintings Raphaelle Peale exhibited at the Pennsylvania Academy during his lifetime, fewer than fifteen were portraits.

Raphaelle Peale knew, as every serious artist knew at the turn of the century, that painting still lifes professionally, rather than as an amateur pastime, went directly against the grain of received artistic belief. It ignored or deliberately flaunted the low regard in which still life was almost universally held. For still life was assigned the lowest place in the academic classification, first promulgated in the seventeenth century and still binding, at least upon conventional artistic thought, well into the nineteenth. Its "low and confined" subjects[5] lacked the human interest, moral force, and intellectual substance that, according to this ranking of subject matter, was contained in the most superior way in the depiction of heroic historical events on the model of Classical antiquity.

At issue in this system of classification was the insignificance and inarticulateness of still-life subjects—the muteness and commonness of fruits and vegetables, fish and flesh, glasses and dishes, bowls and pots. But equally at issue was the *style* of still-life painting, for its style was inseparable from its subject matter. In the discourses he delivered to the students of the English Royal Academy in the late eighteenth century, Sir Joshua Reynolds linked the two: the "highest ambition" of the still-life painter, he said, "is to give *a minute representation* [emphasis added] of every part of those low objects which he sets before him...."[6] The painter Benjamin Robert Haydon, who was fanatically devoted to High Art, made the same connection almost forty years later: "To hear terms that would be applicable to the highest beauties of Art applied to a tame, insipid, smooth, flat, mindless imitation of carrots—Good God, is this the end of art, is this the use of Painting?"[7]

Still life, in other words, was inferior not just because of the low subjects it depicted but because of the kind and degree of imitation, of deceptive *illusion*, implicit in their depiction. Nothing was censured as severely in the ruling theoretical literature as imitation that faithfully copied particular objects—"the mere imitation of individual ordinary nature," as the painter James Barry put it in his Royal Academy discourses—and the kind of artist who pleased by the deceptiveness of his painted illusions: Barry's "mere sordid mechanic, divested of intellectual capacity," or the "petty kind of imitative, monkey-talent" the painter John Opie scorned in his Academy discourses.[8] The copying of nature's "forms and colours exactly and conscientiously," as Goethe expressed it more gently though no less emphatically, is the "sort of imitation ... practised by quiet, honest, limited artists on so-called still-lives."[9] To paint still lifes and to practice deceptive imitation, therefore, was to

disregard, and even openly defy, the accumulated weight of orthodox artistic belief. Yet it is possible to think Raphaelle Peale did exactly that; his father before him had done the same. Charles Willson Peale pursued an artistic policy so distinctly flavored, so different from established belief, and so dynastically influential on his family (particularly but not exclusively on Raphaelle) that it might almost be called Pealism. For in his father's example, and more accessible in that place than in any other, Raphaelle found precedents and the permission for the subject of still life, and for his still-life style.

No pure still lifes by Charles Willson Peale survive. However, in about 1772, soon after he returned to America after three years in the studio of the American-born Benjamin West in London—that is, at the very beginning of his professional artistic life—Charles Willson Peale painted a group portrait of his family that included the artist himself (holding his palette at the left), his two brothers, two sisters, wife and two children, mother, the children's nurse, and (added later) the family dog (fig. 6). Its subject is private, of course, but it is not a private picture. It is of public size (on the order of five by seven feet), and during the artist's life it hung in the public space of the artist's painting room, as a specimen of his ability and equally of his ambition, and also as an exemplum of his ideal of domestic and artistic felicity. Prominently and almost centrally placed in the painting, unmistakable as one of its principle elements, is a fruit still life. Now fruit is a symbol of fertility and fecundity, so the still life pertains

5 Charles Willson Peale, *The Artist in His Museum*, 1822, oil on canvas, 263.5 x 202.9 cm, Pennsylvania Academy of the Fine Arts, PA, gift of Mrs. Sarah Harrison (The Joseph Harrison, Jr., Collection)

6 Charles Willson Peale, *The Peale Family*, 1771–73, oil on canvas, 143.5 x 227.3 cm, New-York Historical Society, NY

to the painting's domestic meaning. But to locate a still life so prominently in a painting that systematically represents the principal mediums of art (painting, drawing, and sculpture) and its principal subjects (allegory, history, and portraiture) allows it an uncustomary place in the accepted hierarchies of art. If Peale gave it that position because the twisted peel can be read as a pun on the artist's name, then it becomes, quite literally, the painting's signature motif.

Although no other still lifes by Charles Willson Peale have survived, we know that he painted, or thought of painting, still lifes. In letters to his daughter Angelica in 1808, he wrote that he "contemplated" painting "some pieces of deception of still life" for his museum, and in 1815 that he "painted a piece of still life, a basket of apples & pears on a round stand."[10] A few years later he exhibited *Still Life—Apples, &c.* at the Pennsylvania Academy of the Fine Arts. Charles Willson Peale's clear interest in still life—especially in *deceptive* still life—no matter how many he actually painted, gave license to his son Raphaelle to paint still life, as contemporary theory and practice did not, and no other artist could or would.

Charles Willson Peale was in many respects a creature of his time, one who, in virtually every aspect of his being, thought, and action—in his moral principles, religious belief, faith in reason, and devotion to science—embodied the principles of Enlightenment thought. Yet no artist of his time as willfully disobeyed its artistic rules and principles. This was not because of ignorance or provincialism. As a pupil of West, Peale knew perfectly well what those rules and principles were and what they required of an artist of high calling. Yet, a few years after his return from England, Peale wrote: "What little I do is by mere imitation of what is before.... A good painter of either portrait or history, must be well acquainted with the Grecian and Roman statues to be able to draw them at pleasure from memory—and to account for every beauty, must know the original cause of beauty in all he sees—these are some of the requisites of a good painter...." However, he went on, "these are more than I shall ever have time or opportunity to know, but as I have a variety of characters to paint I must as Rembrandt did make these my antiques...."[11]

Here, at the beginning of his career, Peale dissented boldly from received artistic authority, which held that knowledge of the sculpture of antiquity "shortened the road," as Reynolds put it, to the perception of "perfect form."[12] But Peale followed the example of Rembrandt in the imitation of more commonplace models. And in doing so he took as a

paradigm the chief example of artistic error. If an artist "takes individual nature just as he finds it," Reynolds said, "he is like Rembrandt," or, as James Barry put it more strongly, "a mere vulgar and uninteresting Dutch copyist."[13] Peale, though, perversely saw nothing wrong in copying ("mere imitation") or in finding his subjects in individual nature: "nature is the best picture to copy, and I do not regret the loss of the antiques."[14]

About a decade later he avowed his regard for imitation more publicly. In an elaborate scheme of historical and allegorical subjects that Peale made in the form of illuminated transparencies for the celebration of George Washington's arrival in Philadelphia in 1781 were figurations of the arts: around the neck of the figuration of Painting was a medal on which was inscribed "Imitation." For Charles Willson Peale, in other words, imitation was Painting's identifying attribute.

Imitation meant several things and took several forms, but in its highest form for him it meant an illusion so convincing that it could deceive the eye. He pursued deceptive illusionism in different ways. In 1785, he held an exhibition of moving pictures on the model of Loutherbourg's Eidophusikon ("image of nature"). Using moving pictures, colored light, and sound, Peale represented such conditions and effects as dawn and nightfall, a rainstorm with thunder and lightning and a rainbow, and rushing and falling water. A couple of years later, a visitor to his studio described another form of Peale's illusionism that he experienced there with startling effect: a wax imitation of Peale himself "so perfectly alike" that it appeared to him "*absolutely* alive" and indistinguishable from the original.[15] In a more orthodox medium, Peale made painted illusions enacting his conviction that "illusive likeness [was the] perfection of art."[16] The most important and ambitious of them was *The Staircase Group* of 1795 (fig. 7). It depicts full-size figures of his sons Raphaelle and Titian. The former is climbing a curved flight of stairs and looking back into the room he has left, and the latter is peering at the viewer around the door frame. To make the illusion more convincing, Peale extended the painted space into literal space by setting the canvas in an actual door frame and adding a real step at the bottom.

In 1795, *The Staircase Group* was exhibited in the one and only exhibition of the Columbianum, or American Academy of Painting, Sculpture, Architecture, and Engraving. Largely the creation of Charles Willson Peale, the Columbianum was the first serious attempt in America to establish an academy of art based on prototypes such as the English Royal Academy, but, as its name indicates, on distinctly American terms. In this exhibition in the first American academy of art, for the benefit of its students, and for that of professional artists, discerning amateurs, and prospective patrons, Peale offered *The Staircase Group* as a demonstration, unambiguous in its meaning, of his theory of painting. As he knew, it placed itself diametrically in opposition to the theory of imitation that ruled artistic thought in the eighteenth and early nineteenth century. Sir Joshua Reynolds expressed it eloquently and canonically: "There are excellencies in the art of painting beyond what is commonly called the imitation of nature.... A mere copier of nature can never produce anything great.... The wish of the genuine painter must be more extensive: instead of endeavoring to amuse mankind with the minute neatness of his imitations, he must endeavor to improve them by the grandeur of his ideas; instead of seeking praise, by deceiving the superficial sense of the spectator, he must strive for fame, by captivating the imagination.

"The principle now laid down, that the perfection of this art does not consist in mere imitation, is far from being new or singular. It is, indeed, supported by the general opinion of the enlightened part of mankind. The poets, orators, and rhetoricians of antiquity, are continually enforcing this position; that all the arts receive their perfection from an ideal beauty, superior to what is to be found in individual nature."

Peale argued against this theory of ideal imitation—the imitation of an ideal and general beauty formed in the mind of the artist and addressed to the ideas and imagination of the spectator—a theory, supported as Reynolds said, by "the enlightened part of mankind." Peale argued, not by words but by the visible example of *The Staircase Group*, for an art that described individual objects and appealed to the beholder by the illusionistic convincingness of that description.

The syntactics, the formal order, of Raphaelle Peale's still lifes was naturally shaped by things he saw—though never having traveled abroad he could not have seen a great deal. But their grammar, the deeper theoretical rules of their artistic language and the principles of their artistic purpose, had a more direct source in the work of his father, Charles Willson Peale. There, more than in any outside influence, Raphaelle Peale found ratification for still-life painting and for illusionistic imitation.

Illusionism was the inheritance of all Charles Willson Peale's artistic progeny, but Raphaelle Peale carried it to its highest level of quality and in its most radical form of *deceptive* illusionism. At the Pennsylvania Academy in 1812, he exhibited *Catalogue for the Use of the Room. A Deception*, in 1813 *A Catalogue and Papers Filed* (neither survive), and in 1822 *Venus Rising From the Sea—A Deception* (plate 16), in which a figure of Venus after a painting by James Barry is covered by an illusionistically painted cloth, and which for a long time was mistakenly titled *After the Bath*. It is one of the masterpieces of illusionistic, trompe l'oeil deception.

7 Charles Willson Peale, *The Staircase Group*, 1795, oil on canvas, 227.3 x 100 cm, Philadelphia Museum of Art, The George W. Elkins Collection

Still life is in many ways a private subject, depicting objects of personal use and painted for an artist's own pleasure. But Raphaelle Peale's still lifes were not private paintings made for his own use and pleasure alone. He painted them for public exhibition, and he sold and traded them when he could. More important, difficult as it might be to believe of paintings of such delicacy and reticence by an artist of such apparently modest ambition, they seem to have addressed the artistic issues of their time more intelligently, subtly, and, certainly in terms of their quality, successfully than did the work of any of his contemporaries at the turn of the eighteenth century.

Choosing to paint still life around 1800 with the seriousness and sense of calling—the degree of professional consciousness and standard of painterly aptitude—that Raphaelle Peale evidently brought to the subject had the quality of a revolutionary act. It was a deliberate, relatively sudden, radical inversion of an artistic order in which a subject long relegated to the bottom of the artistic scale was raised to its top. It was also part of a larger revolutionary process by which other once lowly subjects such as landscape and genre were similarly raised to a higher station, and part of the even more profound and pervasive remaking of political, economic, and social order that dominated the time in which Raphaelle Peale lived and worked.

To speak of this as revolutionary is, of course, to speak figuratively. But the change was revolutionary in certain real social and political senses, as well. The artistic reclassification that gave new significance to subjects such as landscape, genre, and still life was a function (and not merely a reflection) of the social reclassification that the revolutionarily transformation of the late eighteenth century set in motion. These subjects were available to the experience of new aesthetically enfranchised social classes in ways that "noble" subjects from ancient history were not, as those artists who persisted in producing them discovered. Derived from ordinary, direct, and shared experience rather than from privileged educated experience, each of these subjects was democratically accessible, popular, in a way that historical subjects were not and, on the whole, did not attempt to be.

In certain respects, Raphaelle Peale's still lifes are the clearest case among these new subjects of what seems to be purposeful social and political relevance. The very fact that professional still-life painting in America had its beginning in Raphaelle Peale's work about 1790, as though it were a deliberated invention possible only at that historical moment, suggests a conscious response on his part to its special circumstances. Certainly the everyday commonness of still-life subjects and the depiction in still life of simple and humble objects had an intrinsically, socially classifiable diction. But the social and political address of Raphaelle Peale's still lifes was clearest of all, and most deliberately pursued, in their style.

Imitative illusion was the visual language of Raphaelle Peale's still lifes. Its extreme form was the trompe l'oeil illusionism of his deceptions, such as *Venus Rising from the Sea—A Deception,* but all his still lifes solicited consent to the reality of their illusions, the believability of their painted imitations of reflected and refracted light, texture and tactility, volume and substance. And the public appeal of still life, as Raphaelle Peale surely knew, rested primarily upon the convincing accomplishment of illusion.

The English painter Benjamin Robert Haydon, out of his passionate devotion to high art, was deeply distressed by the power of illusionistic painting to command the kind of admiration he believed only history painting deserved. He confided to his diary in 1808 (on the eve of the period Raphaelle Peale produced and exhibited still lifes most prolifically), "With the people of England, all their ambition and all their delight, and all their ideas of art go not beyond [the] immediate object of their sense; the exact copy of a pound of butter or china cup." What troubled Haydon most deeply was that illusionistic copies appealed to people of a social class who should know better: "People ... see only the individual likeness to the thing and there their delight ends and their notions of art are confined.... [U]neducated people might be forgiven—but noblemen, the ministers of the country, the government of England ... instead of being ambitious of having their souls elevated, and their minds expanded ... [utter] exclamations of ravishment and rapture, at a smutty crock, or a brass candlestick."[17]

Here, the social classification of illusionism—and, into the bargain, still-life subject matter, such as crocks (not china) and brass (not silver) candlesticks—cannot be mistaken: still life appeals, as Haydon put it, to the "uneducated," to people, that is, of inferior social class. Haydon was not alone in this belief. Reynolds, for example, said, "When the arts were in their infancy, the power of merely drawing the likeness of any object, was considered as one of its greatest efforts. The common people, ignorant of the principles of art, talk the same language, even to this day."[18] "[T]he Vulgar," he also said, "will always be pleased with what is natural, in the confined and misunderstood sense of the word."[19] This prejudice was more frequently expressed by the terms "servile" and "mechanical"

8 John Vanderlyn, *The Palace and Gardens of Versailles,* 1814/19, oil on canvas, 3.6 x 50 m (panorama), The Metropolitan Museum of Art, New York, NY, gift of the Senate House Association, Kingston, NY, 1952

by which illusionistic imitation was usually described—Haydon's "Mere mechanic deception," for instance—for these were terms of social value, ones that still bore in their usage meanings traceable to the belief that art, like any other manual work, was to be assigned to servants and mechanics.[20] Lower forms of painting, Reynolds said, were a "mechanical trade," and so durable was this association that it survived in America well into the nineteenth century: "The painter who copies such things [as brass kettles and dead game]," wrote a critic of the 1831 Boston Atheneum exhibition catalogue, is only "somewhat more refined than the tinker or cook who handles the originals...."[21]

By about the time of Raphaelle Peale's death in 1825, the social stigmatization of illusion, though it never really disappeared, was losing force both as a doctrine of criticism and a prejudice of practice. Reynolds told the students of the Royal Academy in the late eighteenth century that a serious artist "will disdain the humbler walks of painting, which however profitable, can never assure him a permanent reputation. He will leave the meaner artist servilely to suppose that those are the best pictures which are most likely to deceive the spectator."[22] In America in the early nineteenth century, however, some serious artists began to suppose exactly that. Both of Morse's most ambitious public painting projects *The Old House of Representatives* and *Gallery of the Louvre* staked their success largely on forms of overt illusionism—contrived effects of light in one and replicated paintings in the other—even though Morse believed that "description or accurate likeness of objects" held a low artistic station.[23] In 1814, John Vanderlyn began a panorama of the gardens of Versailles that he finally exhibited in New York in 1819 (fig. 8). Invented in the 1790s, panoramas were large paintings exhibited in circular buildings that, by filling the viewer's field of vision, produced illusions of convincingly complete reality. They were frankly made for a popular audience, and their success depended largely on deceptive imitation. In a biographical memoir of Vanderlyn, their popular character was described precisely: "panoramic exhibitions possess so much of the magic deceptions of the art, as irresistibly to captivate all classes of spectators, which gives them a decided advantage over every other description of pictures, for no study or cultivated taste is required fully to appreciate the merits of such representations."[24]

This passage on panoramas parallels in its strategy of explanation the nearly contemporary discussion of the still lifes in the National Academy of Design exhibition of 1827: "The particular merit of this class of pictures consists in the *exactness of the imitation*. A single glance proves their success in this excellence; it is one that is always so striking, that most persons think it to be the great end and most difficult attainment of painting.... The department we are considering, although it ranks thus low in the scale of works of art, has always been popular, and for the very obvious reason, that its chief merit is intelligible to all."[25]

The "exactness of the imitation" of still lifes made them "intelligible to all," available, like panoramas, to "all classes of spectators" because "no study or cultivated taste" was needed to appreciate them.

During the first quarter of the nineteenth century, it is almost as if both a consensual understanding of the nature and function of popular style and, under the pressure of democratized social and political reality, a policy of its upward revaluation were being formed, however provisionally and pragmatically. The compact clarity of the discussion of still-life style and its social meaning in the review of the 1827 National Academy of Design exhibition is a symptom of that revaluation. Although its low ranking of still life is entirely conventional, what is not, in this first serious consideration of the subject in American criticism, is its identification of still life with imitation, and imitation with popular (democratic) intelligibility. Speaking of subject matter rather than style,

another comment on Vanderlyn's panorama describes this revaluation and its social justification more exactly: "Although it was not to have been expected that Mr. Vanderlyn would have left the higher department of historical painting, in which he is so eminent, to devote his time to the more humble ... pursuit of painting cities and landscapes—yet, in a new country, taste must be graduated according to the scale of intellect and education, and where only the scientific connoisseur would admire his [history paintings]... hundreds flock to his panoramas.... This is to 'catch the manners living as they rise,' and with them catch the means to promote a taste for the fine arts."[26]

Here, in 1818, the readjustment from high subjects to humble, popular ones is described not as an opportunistic descent or degenerative decline (as Reynolds might have described it), but as a matter of positively desirable democratic sociocultural policy.

Some such policy, we have argued, guided Raphaelle Peale's artistic purpose as a still-life painter. If this seems to overwhelm still lifes with undue responsibilities of meaning and purpose, one should remember that still life, with landscape and genre, formed that phalanx of subjects through which, beginning about 1800, the revolutionary forms and claims of modern painting were first explored and expressed. Also, Raphaelle Peale was close enough to the origins of still life in the seventeenth century to know or sense the relationship of still life to real life. Palomino Velasco's account of Velázquez tells how close, in terms of both optical and sociological descriptiveness, that relationship was: "He took to representing, with the most singular fancy and notable genius, beasts, birds, fishes, fish-markets and tippling-houses, with a perfect imitation of nature ... differences of meats and drinks, fruits of every sort and kind; all manner of furniture, household goods, or any other necessaries which poor beggarly people, and others in low life make use of; with so much strength, and such coloring, that it seemed to be nature itself."[27]

In America about a half a century after Raphaelle Peale's death, a school of illusionistic still-life painting came into being, its major figures (but not by any means its only ones) being William Michael Harnett, John Haberle, and John Frederick Peto. Whether they received any direct stylistic influence from Raphaelle Peale is unclear; he was, by the late nineteenth century, long dead and largely forgotten. But they revived what Raphaelle Peale first proposed and represented. In no other country in the nineteenth century were there as many illusionistic still-life painters at work as in America; in no other was trompe l'oeil deception as widely practiced and encouraged. And one reason that was so was because of its popular, democratic accessibility. It was still censured, in language Reynolds might have used, as a low form of art to which "few artists of merit have ever condescended to apply their skill." But when Harnett's *The Social Club* (fig. 9) was shown at the National Academy of Design in 1879, it "attracted the attention," a critic wrote snootily (because it did attract attention that should have gone elsewhere), "that is always given to curiosities, to works in which the skill of the human hand is ostentatiously displayed working in deceptive imitation of Nature." When another of Harnett's still lifes was shown in a less decorous, more popular setting where it could be more properly understood, I.N. Reed's drugstore in Toledo, Ohio, its reception was very different: it was "so perfect—so like the real—that in looking upon it you are likely to forget that it is a picture.... The higher triumph of artistic genius is in approaching the actual—in the perfect reproduction of the subject presented."[28]

The perception that American democracy could be expressed in a language of style and not only, as it was most frequently, by subject matter was, it seems, shared by two other artists. One was George Caleb Bingham.

He was preeminently a painter of American subjects: of life on the frontier, and of American institutions, as in his election pictures (which drew heavily, of course, on Hogarth). But at the end of his life, when he was professor of drawing at the University of Missouri in the later 1870s, Bingham delivered a lecture entitled, "Art, the Ideal of Art, and the Utility of Art."[29] It is neither a very good lecture nor a terribly original one, except in one important respect: in it, Bingham gave a place, very much larger and more favorable than was usually done in formal lectures on art in the late nineteenth century, to the issue of imitation. In particular, he cited two *topoi* of illusionistic imitation: the famous story, told in the Elder Pliny's *Natural History*, of the competition between Zeuxis and Parrhasius, and the one, given in many different forms, of animals and humans being deceived by painted images.[30] Zeuxis painted a bunch of grapes so deceptively perfect that birds pecked at them, and Parrhasius, in response, painted a curtain that, when Zeuxis reached to draw it back to see what lay behind it, turned out to be a still more perfect deception (a *topos*, by the way, that Raphaelle Peale referred to in *Venus Rising from the Sea—A Deception*). And, as Bingham reported, "More than once in my own experience portraits painted by myself and placed in windows facing the sun to expedite their drying, have been mistaken for the originals by persons outside, and spoken to as such."[31] These stories have one thing in common: the erasure of the separation between real and fictive space. Or, to put it differently, they have the accessibility, in a direct and perhaps democratic way, of picture space that is by convention usually insulated—closed off by devices of composition, distanced by being understood as invented or imagined, or debarred by the decorums of public exhibition—from that sort of entry and engagement made possible by in one case touch and, in the other, speech. Trompe l'oeil paintings encouraged exactly that sort of engagement, so much so that when Harnett's *Old Violin* was shown at an Industrial Exposition in Cincinnati, Ohio, an armed guard was stationed to prevent people from touching it, and, when another of Harnett's trompe l'oeil paintings was shown in New York, disputes about reality and illusion were settled by touch. Now, Bingham was neither a trompe l'oeil nor even an illusionistic painter. But there recur in almost all his greatest paintings—with a singular frequency that cannot go unnoticed—one or more figures who with urgent steadiness look out of the picture space directly at the beholder and into the beholder's space: in *Fur Traders Descending the*

Missouri, *Boatman on the Missouri*, *The Jolly Flatboatmen* (see fig. 9, p. 29), *Shooting for Beef*, *Watching the Cargo*, *The Wood-Boat*, *The Squatters*. The result of this reiterated device is to break down the barrier separating real space and pictorial space, and to allow, as a result, a free passage or exchange between the two so that it is possible to think of it in terms of a stylistically or formally created, unhieratic, democratic equality between these two classes of experience that are more usually kept separate.

From the beginning of his career, Winslow Homer was the subject of intense and, on the whole, positive critical examination. One aspect his critics were especially attentive to was his style. And the property of his style they noticed more than any other was what they took to be its crudity and lack of finish. They spoke of "slap-dash execution," "roughness," "want of delicate painting," lack of "refinement in color and expression," and rudeness.[32] Again and again, Homer's style was criticized in this way, by those who otherwise admired and frequently praised his paintings. This is of importance because it shows that these critics' quarrel was with his style and not with other aspects of his work.

It may well be that the roughness, rudeness, and incompleteness of Homer's style, especially in his early paintings, was a matter of technical inadequacy and a reflection in that respect of Homer's lack of rigorous training as a painter; so far as we know, he was largely self-taught. That said, nothing indicates that Homer heeded his critics or that greater experience on his part made him more accomplished in their eyes. It is possible, therefore, that something else, something more positive than technical inadequacy, actively and purposely shaped Homer's stylistic language; possible, more exactly, that it was shaped by Homer to enact visibly a national ideological meaning (fig. 10).

Someone who beyond doubt conceived and enacted that possibility was the poet Walt Whitman. Whitman deliberately fashioned a similarly rough and incomplete poetic language and a mode of national literary style. His own description of it—in, to locate it ideologically, *Democratic Vistas* (1871)—as a style not "correct, regular, familiar with precedents, made for matters of outside propriety, fine words, thoughts definitely told out," but a style rather that "tallies life and character, and seldomer tells a thing than suggests it," could serve as well as a description of Homer's (national and democratic) style. Like Whitman, Homer rejected artistic precedent, propriety, correctness, and fineness, and instead of objects and their arrangements being "definitely told out,"

9 William M. Harnett, *The Social Club*, 1879, oil on canvas, 33 x 50.8 cm, Manoogian Collection, Taylor, MI

Homer kept an openness and suggestiveness of form in order to "tally" the shifting, unresolved, and perhaps never resolvable configurations of American national, political, and ideological life—what a friend of Homer's called "the hybrid and half-developed but virile civilization of our own land."[33] The same friend, the artist and critic Eugene Benson, said, in language much like Whitman's and applicable as a description of Homer's stylistic posture, that writers who "would face and report the myriad life of this most complicated age ... are flexible, varied, individual, independent...."[34]

Homer's critics came to understand the meaning of his style. One, who complained of its "ravellings and loose ends of execution," saw also that it was "sharply redolent of the soil."[35] "He is wholly in sympathy with the rude and uncouth conditions of American life" another saw, "wholly en rapport with American life" still another wrote.[36] As Samuel G.W. Benjamin put it summarily in 1880: "The freshness, the crudity, and the solid worth of American civilization are well typified in the thoroughly native art of Mr. Homer."[37]

10 Winslow Homer, *The Veteran in a New Field*, 1865, oil on canvas, 61.3 x 96.8 cm, The Metropolitan Museum of Art, New York, NY, estate of Adelaide Milton de Groot, 1967

1 Samuel F.B. Morse, *Lectures on the Affinity of Painting with the Other Fine Arts*, Nicolai Cikovsky, Jr., ed. (Columbia, Missouri, 1983), 28–29, n. 63.

2 Jared B. Flagg, *Life and Letters of Washington Allston* (New York, 1892), 230–34.

3 William Dunlap, *History of the Rise and Progress of the Arts of Design in the United States* (New York, 1834), vol. 1, 140.

4 Ibid., 140–41.

5 The phrase is Sir Joshua Reynolds', applied by him to what was almost (but not quite) as bad as still life, the "low and vulgar" characters of Hogarth. R.R. Wark, ed., *Discourses on Art* (California, 1959), 51.

6 Ibid., 52.

7 Willard Bissell Pope, ed., *The Diary of Benjamin Robert Haydon*, 2 vols. (Cambridge, Massachusetts, 1960), 1: 7.

8 James Barry and John Opie, in Ralph N. Wornum, ed., *Lectures on Painting by the Royal Academicians* (London, 1848), 93, 97, 248.

9 John Gage, ed., *Goethe on Art* (Berkeley and Los Angeles, 1980), 21.

10 Charles Willson Peale to Angelica Peale Robinson, Philadelphia, 16 June 1808, Lillian B. Miller, ed., *The Selected Papers of Charles Willson Peale and His Family*, 2 vols. (New Haven, 1988), 2: 1087; and Belfield, 22 November 1815, Lillian B. Miller, ed., *The Collected Papers of Charles Willson Peale and His Family* (Millwood, New York, 1980, microfiche edition), series II–A/59.

11 Charles Willson Peale to John Beale Bordley,

Philadelphia, November 1772, *Selected Papers*, 1: 127.

12 Reynolds in Wark, 45.

13 Ibid., 103; Barry in Wornum, 100.

14 Letter to John Beale Bordley, Annapolis, 1770–1771, *Selected Papers*, 1: 86.

15 Mannaseh Cutler, *Selected Papers* 1: 483.

16 Charles Willson Peale, *Autobiography*, typescript by Horace Wells Sellers (American Philosophical Society, Philadelphia), 338.

17 Pope, 1: 5.

18 Reynolds in Wark, 96.

19 Ibid., 89.

20 John Barrell, *The Political Theory of Painting from Reynolds to Hazlitt* (New Haven, 1986), introduction, 13.

21 "Exhibition of Pictures at the Athenaeum Gallery: Remarks upon the Athenaeum Gallery of Paintings for 1831," *The North American Review* 33 (October 1831): 512.

22 Reynolds in Wark, 50.

23 Morse, 109.

24 Dunlap, 239.

25 D. Fanshow, "Review: The Exhibition of the National Academy of Design," *The United States Review and Literary Gazette* 2 (July 1827): 258.

26 *The National Advocate* (21 April 1818), in John W. McCoubrey, *American Art 1700–1960: Sources and Documents* (Englewood Cliffs, New Jersey, 1965), 43–44.

27 Palomino Velasco, *Account of the Lives and Works of the Most Eminent Spanish Painters, Sculptors and Architects* (London: 1739), 50.

28 Alfred V. Frankenstein, *After the Hunt: William Harnett and Other American Still Life Painters, 1870–1900* (Berkeley and Los Angeles, 1969), 7, 50.

29 In John Francis McDermott, *George Caleb Bingham: River Portraitist* (Norman, Oklahoma, 1959), 394–401.

30 Ibid., 395, 396.

31 Dogs are also said to have licked the faces of their painted masters.

32 "Fine Arts: The Sixth Annual Exhibition of the Artists' Fund Society." *The Nation* 1 (23 November 1863): 663–64; "Art. Exhibition of the National Academy of Design," *The Round Table* 1 (7 May 1863): 327; "National Academy of Design: Fortieth Annual Exhibition," *New York Commercial Advertiser* (22 May 1865).

33 Eugene Benson, "Literature and the People," *The Galaxy* 3 (15 April 1867): 871.

34 "About the Literary Spirit," *The Galaxy* 1 (15 July 1866): 492.

35 "Fine Arts. Close of the Academy Exhibition. The Last Sunday," *New York Evening Post*, 6 July 1872.

36 "The Academy Exhibition," *The Art Journal* 3 (1877): 159; "Editor's Table," *Appleton's Journal* 6 (May 1879): 471.

37 *Art in America: A Critical and Historical Sketch* (New York, 1880), 117.

ERICA E. HIRSHLER

"Claiming our property wherever we find it"

American Art After 1865

"It's a complex fate, being an American," wrote the novelist Henry James in 1872. "And one of the responsibilities it entails is fighting against a superstitious valuation of Europe."[1] It is perhaps especially revealing that James, regarded by many as the most eloquent analyst of American life in the decades after the Civil War, settled permanently in England in 1876 (fig. 1). He took as his major literary theme the contrast and conflict between American and European culture, and while he admired the vitality and confidence of his native land, he despaired of its innocence and lack of cultural sophistication. The story of American art during this period corresponds to the fiction of James, for it is a tale of opposition and comparison, of artists who tried to ignore so-called "foreign influences" and of those who aspired to compete in the international arena. Regardless of which path they selected, American painters were always shadowed by the tradition of European art.

Artists in the United States constantly compared themselves, or were compared by critics, to their colleagues abroad. Some, like John Singer Sargent, were praised for their cosmopolitanism and their mastery of a European (usually French) stylistic vocabulary. Other painters, most notably Winslow Homer, were admired for their self-proclaimed insularity and devotion to American subjects. This combination of bravura and cultural insecurity was demonstrated after the Civil War in 1867, when a New York-based committee selected around seventy-five paintings to represent the United States at the Exposition Universelle in Paris.[2] The display was intended to be the aesthetic equivalent of the great technological achievements the Americans were demonstrating at the fair, which included the McCormick reaper and the Corliss engine (the latter so impressive that by the turn of the century historian Henry Adams would compare the power of such machines to that of the Madonna in the Middle Ages). The paintings chosen for the 1867 exhibition emphasized American themes. Landscapes were given special prominence, for the selection committee agreed that American artists were most proficient in that subject. The display included Frederic Church's dramatic *Niagara* (fig. 2), Albert Bierstadt's *Rocky Mountains* (fig. 3), and Sanford Gifford's *Hunter Mountain, Twilight* (1866, Terra Museum of American Art)—all paintings that demonstrated not only their maker's skill, but also the superiority of their subject matter. No European landscape could compete with the raw power of the American wilderness, and its strength was felt to be conferred upon the art, the artist, and the nation; the critic Henry Tuckerman wrote of Bierstadt's *Rocky Mountains* that "its subject is eminently national."[3] Landscape was not the only subject represented at the fair, however. The increasingly technological society that had produced the prize-winning inventions on display in the Palace of Industry was portrayed in John Ferguson Weir's *The Gun Foundry* (1866, Putnam County Historical Society), a scene of a New York munitions factory, while the recently concluded Civil War—the most mechanized conflict to date—was documented with restraint in such pictures as Winslow Homer's *Prisoners from the Front* (fig. 4; see also plates 62–64) and Edwin White's *Thoughts of*

Thomas Eakins, *The Oarsmen (The Schreiber Brothers)*, detail, 1874 (plate 85)

Liberia: Emancipation (plate 69). These particularly "American" paintings were balanced in the selection by a few that offered a more cosmopolitan view, most notably James McNeill Whistler's notorious *The White Girl (Symphony in White)* (plate 125), which had been rejected from the Paris Salon in 1863.

The critics of the 1867 exhibition considered Whistler an anomaly and the matter of his American identity open to question (as the artist likely preferred; in other such international exhibitions he had shown his work in the British section). But of the rest of the American artists there was no doubt; most French critics found them provincial—not without promise, but as yet unformed. As a society always preoccupied with competition and quantity, Americans found it hardly worth celebrating the single silver medal that was bestowed upon Church's *Niagara* when the French paintings had received thirty-two. As the critic James Jackson Jarves remarked, "the Great Exposition of 1867 at Paris taught us a salutary lesson by placing the average American sculpture and painting in direct comparison with the European, thereby proving our actual

1 John Singer Sargent, *Henry James*, 1913, oil on canvas, 85.1 x 67.3 cm, National Portrait Gallery, London

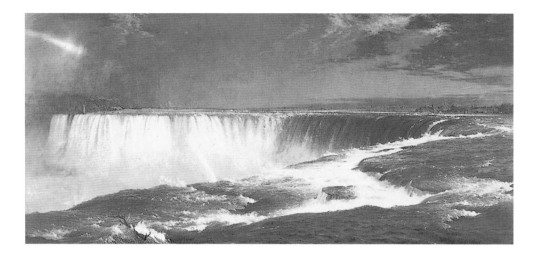

2 Frederic Edwin Church, *Niagara*, 1857, oil on canvas, 107.3 x 229.9 cm, The Corcoran Gallery of Art, Washington, D.C.

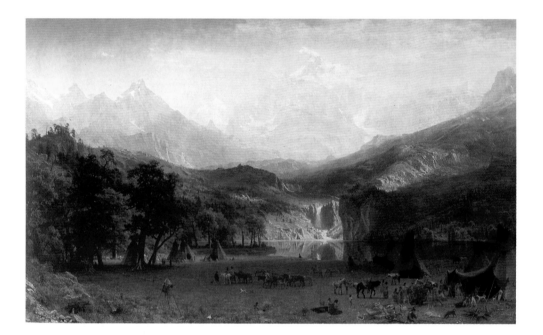

3 Albert Bierstadt, *Rocky Mountains, Lander's Peak*, 1863, oil on canvas, 186.7 x 306.7 cm, The Metropolitan Museum of Art, New York, NY, Rogers Fund, 1907

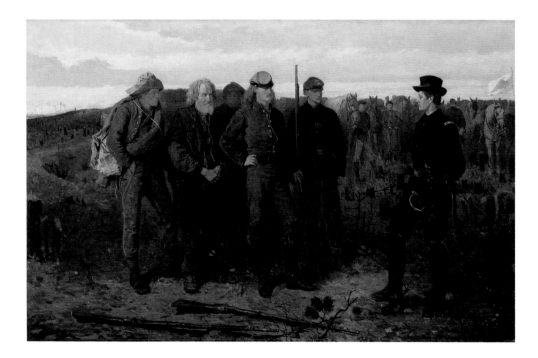

4 Winslow Homer, *Prisoners from the Front*, 1866, oil on canvas, 61 x 96.5 cm, The Metropolitan Museum of Art, New York, NY, gift of Mrs. Frank B. Porter

mediocrity."[4] While national self-assurance in technical, financial, political, and scientific matters was both validated and enhanced by the experience of the exposition, certainty in a national artistic style, up to this time represented by the Hudson River School, began to crumble. For the rest of the century, painters sought to regain their collective confidence and to redefine modern American art.

They took a variety of paths and adopted a number of different styles and subjects, but many American painters were united by their desire to travel and to study abroad, most often in Paris. Dissatisfied with the limited education available to them in the United States, aspiring artists went to Europe in record numbers after 1867. As they had done earlier in the century in Rome, they studied both Classical art and the paintings of the Old Masters. Now, however, they also absorbed the lessons of contemporary art and trained under the masters who created it. As Henry James explained, "when today we look for 'American Art' we find it mainly in Paris. When we find it out of Paris, we at least find a great deal of Paris in it."[5] Whatever French method they adapted, from Gérôme's Classicism to Monet's Impressionism, American painters came home confident that they had absorbed the best Europe had to offer and that they would put their lessons to work to create a new American style.

When they returned, they worked in an artistic climate that was quite different than that of Europe. Dictated by a free-market economy (which would soon also transform European art markets), there was no state-sponsored national school in the United States, no single academy to set standards of style or preferences in subject matter. Nor was there a federal program to acquire works of art like that of the Palais du Luxembourg in Paris, which bought contemporary paintings and in consequence lent considerable imprimatur to their creators. A painter in America proved his or her success by private sales, not by acceptance into an academic establishment. When one of the oldest art academies in the United States, the National Academy of Design in New York, failed to accept the more European-inspired paintings of young artists, it was simply ignored in favor of a new association, the Society of American Artists, founded in 1877. When that organization ceased to keep pace with developments in modern art, it too was rejected, this time by an Impressionist group dubbed "The Ten," which first exhibited together in 1898. If an artist found one institution inhospitable to his work, there were others from which to choose, and the annual exhibition circuit grew to include not only New York, Boston, and Philadelphia, but also such new cultural centers as Washington, D.C., Cincinnati, Chicago, St. Louis, and San Francisco.

This lack of an official government style engendered diversity, and distinctive regional schools developed throughout the country.[6] In Boston, which had demonstrated a taste for modern French art of the Barbizon School in the 1850s, young painters were quick to embrace an Impressionist vocabulary, adapting it to American subjects. As Barbara Weinberg points out in her essay in this volume, this American Impressionism was markedly different than that of the French; it maintained certain academic standards of figure drawing, finish, and meaningful subject matter. Thus the Boston painter Edmund Tarbell reinterpreted Renoir's images of casual conviviality, using a French stylistic vocabulary to depict his family and friends enjoying a moment of leisure out-of-doors in his painting *Three Sisters—A Study in June Sunlight* (fig. 5). In Cincinnati, where there was a large German community, young painters were more inclined to study in Munich than in Paris, and their work reveals an affinity with that school. Frank Duveneck favored a rich dark palette and lively brushwork; his *Whistling Boy* (fig. 6) displays an earthiness and painterly virtuosity that has its roots in the paintings of Frans Hals. Further west, the so-called Hoosier School experimented with a

5 Edmund Tarbell, *Three Sisters—A Study in June Sunlight*, 1890, oil on canvas, 89.2 x 102.2 cm, Milwaukee Art Museum, WI, gift of Mrs. Montgomery Sears

6 Frank Duveneck, *Whistling Boy*, 1872, oil on canvas, 70.8 x 53.7 cm, Cincinnati Art Museum, OH

The formation of art museums, symphony orchestras, and other cultural organizations in the United States proclaimed another American doctrine as well, the democratization of luxury. "Formerly the private property of sovereigns ... the museums of today open their doors to all the world, and the scope of their collections has broadened to meet the public needs," declared Martin Brimmer, one of the first trustees of the Museum of Fine Arts in Boston (also founded in 1870).[8] When its doors opened on the centennial of American independence, 4 July 1876, a small sign bravely proclaimed "open free." It was a remarkable act of public philanthropy on the part of the museum's trustees, for like its sister institutions in New York and in Washington, D.C. (where the Corcoran Gallery of Art was founded in 1870), the Boston museum was private, and received no significant support from state or federal government.

This dedication to public education through the fine arts reached beyond objects displayed in museum galleries to include organized training programs for artists.[9] Aspiring American painters at last had practical opportunities for professional instruction in the United States, and while many of them continued to polish their education in Europe, they believed strongly in the promise of these native efforts. In consequence, many of America's leading painters in the late nineteenth century were also teachers, including Thomas Eakins, William Merritt Chase, Cecilia Beaux (plates 84–88, 110, 112–115, 119), and Edmund Tarbell. These domestic art schools, which provided relief from the financial or social constraints that years of foreign study could entail, helped to foster a dramatic increase in the numbers of artists active in the United States, and to some extent also increased their diversity, as women (excluded from many European programs) and students of a variety of economic backgrounds took advantage of the new courses of study available to them.

For some, making art became an act of patriotism, fueled by the belief that Americans could and would rise to the challenge of European culture.

7 Thomas Wilmer Dewing, *Lady with a Lute*, 1886, oil on wood, 50.8 x 38.1 cm, National Gallery of Art, Washington, D.C., gift of Dr. and Mrs. Walter Timme

8 Marsden Hartley, *Cosmos*, 1908–9, oil on canvas, 76.2 x 76.5 cm, Columbus Museum of Art, OH

high-keyed Impressionism to explore the rural landscape of their native Indiana. Even New York, which more than any other city claimed a leading role in American art, supported a variety of artistic styles that reached an apogee in the early years of the twentieth century, when Thomas Wilmer Dewing, Marsden Hartley, and George Bellows were all working simultaneously (figs. 7, 8, and plates 135, 138–146).

The late nineteenth century also saw a shift in American attitudes about the fine arts. With the inspiration of the British South Kensington plan, which advocated the idea that fine art could provide a model to improve the products of industry, Americans began to accept an increasingly public and educational role for paintings and sculpture. As the prominent New York lawyer Joseph Choate explained in 1880, art "in its higher forms of beauty would tend directly to humanize, to educate, and refine a practical and laborious people."[7] In 1870, Choate had been one of the founders of the Metropolitan Museum, one of a number of important cultural institutions founded in the decade after the Civil War. Art gained status as a civilizing force at just the time when there was a great call for national healing, when the country strove to put behind it the recent savagery of the war. Significantly, art was endorsed not so much for its sensory delights but rather for its educational and enriching value. In this way, Americans reconciled their latent Puritanism with their increased interest in art. As long as art could be assigned an altruistic purpose, free from sensual or prurient pleasure, it could play an increased role in American life.

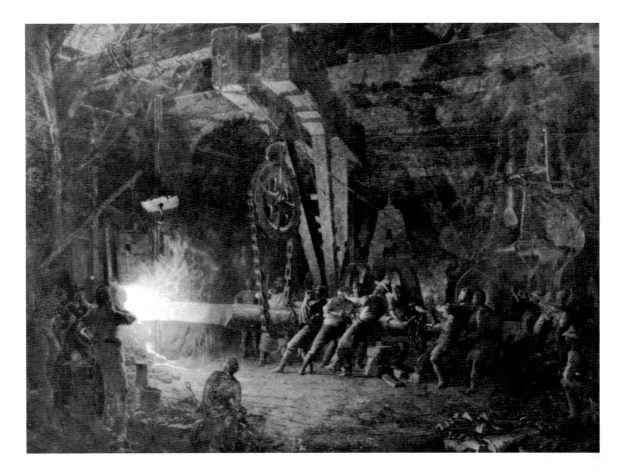

9 John Ferguson Weir, *Forging the Shaft*, 1877, oil on canvas, 132.1 x 191.7 cm, The Metropolitan Museum of Art, New York, NY, purchase, Lyman G. Bloomingdale Gift, 1901

There was a renewed surge of interest in American themes and subjects. These paintings were no longer the majestic wilderness scenes of the Hudson River School or the popular genre pictures of such artists as George Caleb Bingham and William Sydney Mount, but were rather a sentimental gloss on such imagery. At first driven by the urge to overlook the shattering events of the recent Civil War and to return to a mythic American Arcadia—when citizens returned their swords to ploughshares and lived in harmony with the land—the movement toward native themes was given additional impetus by the centennial of the American Revolution in 1876. This event was marked with another great international fair, this time in Philadelphia rather than in Paris. The exhibition included not only such recent American innovations as an elevated monorail, a telephone, and a typewriter, but also historical displays intended to remind spectators from north and south alike of the history they shared, particularly the colonial past. Among the most popular displays was the "New England Farmer's Home and Modern Kitchen" (a picturesque—but historically inaccurate—log cabin complete with costumed guides and a restaurant featuring Boston baked beans). The centennial celebration helped to intensify a popular market for nostalgic images of American life, motifs that took a leading role in American visual culture through the 1950s and beyond.[10]

Painters responded to the centennial with images of colonial houses nestled in rural edens, scenes of women engaged in such domestic pursuits as spinning and knitting, courting couples arranged before an old-fashioned hearth, children picking berries, gathering eggs, or making maple sugar, old men whittling or making clocks. Few American artists ignored such themes, no matter what technique they used to create them. Childe Hassam, for example, one of the most accomplished American practitioners of the Impressionist style (plates 116–118, 122, 123), rendered the seventeenth-century Fairbanks House in Dedham, Massachusetts;

the crooked gravestones of a colonial graveyard in Lexington, Massachusetts; a New England country fair; and many other similar motifs. His Philadelphia contemporary, Thomas Eakins, drew his inspiration from the opposite side of the French artistic spectrum, favoring the example of his own Parisian instructor, the academician Jean-Léon Gérôme (plates 84–88). But Eakins also found subjects in America's colonial past that sparked his imagination, and he produced images of women knitting and spinning—activities that became less and less critical as manufactured goods became readily available—as well as an important series of paintings depicting Philadelphia's great eighteenth-century sculptor, William Rush. Even Winslow Homer, whose mythic status in American art has tended to preclude a complete understanding of his art in context, based his early career on such images, painting popular and marketable images of rustic childhood, picturesque milk-maids (see plates 67, 68), and one-room country schoolhouses. Homer's *Snap the Whip* (plate 65), for example, depicts a popular game taking place before a rural school; the painting combines a nostalgia both for the carefree nature of childhood and for a rapidly disappearing bucolic American paradise. Homer posed his rambunctious children as if they were part of a Classical frieze, modernizing and Americanizing a compositional formula that was widely regarded as an ideal. As historian Celia Betsky has written, "Americans dusted off the facts and artifacts of their history and overlaid them with a new coat of fantasy."[11]

It is one of the great conundrums of American art during this period that a society that asked its painters to represent the world around them truthfully and "place[d] a high value on the faculty of imitation," as critic Charles Caffin phrased it in 1907,[12] seems to have so steadfastly refused representations of the real world. There are exceptions, of course—John Ferguson Weir's *Forging the Shaft* of 1877 (fig. 9), Thomas Anshutz's *Ironworkers' Noontime* (1880, The Fine Arts Museums of San Francisco), and

Robert Koehler's *The Strike* (1886, Manoogian Collection, Taylor, Michigan), for example, all treat the subject of labor and industry. While Anshutz was able to sell *Ironworkers' Noontime* to the important New York collector Thomas B. Clarke, he never repeated the theme, moving instead to a lighter, more Impressionist-inspired palette and more decorative subjects. The other two paintings were not sold until after the turn of the century; both *Forging the Shaft* and *The Strike* remained with their makers until 1901. Although during this period the United States was transformed into an industrial society criss-crossed by a booming railroad enterprise that served an unprecedented number of people moving from country to city, Americans did not want their art to show it. They embraced technology in their homes—welcoming gas and then electric lights, sewing machines, lawn-mowers, and so on—but they did not want it in their art, and few painters succeeded in marketing images of urban life. Those who did most often invested them with enough sentimentality to make them appealing; thus John George Brown built his career upon likenesses of city urchins, bootblacks, and newspaper boys, each one charmingly disheveled and suspiciously well-fed. With ambition and hard work, they might turn into the heroes of the popular rags-to-riches novels of the contemporary writer Horatio Alger. Urban architectural views are relatively rare in the fine arts, although Childe Hassam created a number of them in both Boston and New York. Hassam most often veiled the distasteful aspects of the metropolitan scene with either an Impressionist veil of snow or fog or by concentrating upon the fashionable upper classes as they strode the boulevards (plates 118, 122, 123); his characters might come from the novels of James or Edith Wharton. Despite his French technique, Hassam largely ignored the realism of his European colleagues, never producing an American equivalent of the café and brothel scenes of Edgar Degas or of other French painters who reveled in the more unsavory aspects of city life. Reality was left to reformers and journalists, like Jacob Riis, who documented tenement life in *How the Other Half Lives* (see fig. 6, p. 19), published in 1890, or Upton Sinclair, who wrote *The Jungle*, a shockingly grim tale of the Chicago stockyards, in 1906. Corresponding paintings are rare until after 1905, when the artists of the Ashcan School turned to such imagery.

American politics, aside from portraits of leaders, was also largely ignored by her painters, who once again left such subjects to be covered in the illustrations and caricatures of the popular press. Manifest Destiny, an ideology rooted in the 1840s that called for Anglo-Saxon Americans to expand their civilization across the continent, had become a national philosophy, and by the end of the century had extended to include American dominance over territories in both the Caribbean and the Pacific. It found artistic expression in architecture, particularly in the Beaux-Arts Classicism of the late century, which not only borrowed from European sources but also promulgated America as the new Rome. While such topics appear in the mural paintings that often decorated these buildings, allegorical easel paintings are rare after mid-century, and the most successful were often created by artists outside the mainstream, such as Erastus Salisbury Field, whose enormous *Historical Monument of the American Republic* (c. 1876, Museum of Fine Arts, Springfield, Massachusetts) extolled the nation's past and its future. Albert Bierstadt's grand images of the American West, with their omnipotent viewpoint and sense of divine discovery (plates 50, 51, 61), seem clearly rooted in expansionist policy. Although he remained active throughout the century, the market for his work diminished significantly during the 1880s.

It seems clear that until after the turn of the century the realism Americans most admired in paintings was restricted to the verisimilitude with which objects were rendered on canvas. Among the most accomplished artists at this sort of illusionism was William Michael Harnett, who produced a remarkable series of still lifes during the 1870s and 1880s (plates 89–93, 95). So skillfully rendered that their most obvious appeal lies in their deception, Harnett capitalized on a middle-class enthusiasm for magic and spectacle: "A policeman stands by [*Old Violin*] constantly, lest people reach over and attempt to see if the newspaper clipping is genuine by tearing it off," reported a Cincinnati newspaper in 1886.[13] As recent scholars have observed, Harnett can be equated with the great circus entrepreneur P. T. Barnum, who made no pretense about his profitable policy of gratifying the desires of the general public. Harnett also carefully selected the things he painted, constructing images that, with the exception of dated letters and newspapers, generally ignored the modern world. He favored old, well-worn objects, painting violins and horseshoes instead of such recent innovations as phonographs (patented in 1878) or bicycle wheels. Even within his mimetic aesthetic, Harnett evoked the simple pleasures of the past and fulfilled the contemporary taste for nostalgia.[14]

Some artists of this period chose to remove themselves from contemporary reality altogether, believing that the purpose of art was to raise the viewer from the routine of daily existence toward Joseph Choate's "higher form of beauty." Among the best-known practitioners of this high-minded philosophy was Thomas Wilmer Dewing. Dewing, trained at the Académie Julian in Paris, began his career in Boston, and moved to New York in 1880. His early work emulated the academic exoticism of his teachers Gustave Boulanger and Jules-Joseph Lefebvre, but he soon developed a personal vocabulary that suited his artistic and intellectual goals. His subjects were almost exclusively women, posed either in indeterminate landscapes or in harmoniously arranged interiors (fig. 7). Dewing's images are exquisite and aristocratic, so carefully designed in both arrangement and color that they seem to shimmer and dissolve with intensity. They are removed from reality, and while they include the same ingredients as the fashionable interiors populated by women crafted by such painters in Europe as Alfred Stevens, Dewing's subjects seem compelled by spiritual, not material, concerns.

Dewing was at the center of a group of American artists—painters, architects, sculptors, and writers—who strove to infuse their work with an intellectual ideal of beauty. They drew upon the enhanced aestheticism of Whistler and the Arts and Crafts Movement, and sought to create both harmonious compositions and complete interior designs that would elevate and enlighten the viewer. That one of Dewing's major patrons (and Whistler's as well) was Charles Lang Freer, the Detroit industrialist who made a fortune in the manufacture of railway cars, represents the extent to which some Americans sought to separate art from daily life. It was a respite, a contrast, and even a cure for the rapacity of business and the mechanization of the modern world.

For some patrons and critics, however, the ethereal mannerism and intensely intellectual aestheticism of Dewing and his associates was too precious, too cerebral, too decorative, and too feminine to define the essence of American culture. Furthermore, it seemed too European. While they also sought to distance themselves from modernity, their chosen retreat was not the interior world of the spirit but the outside world of nature. Their painter was Winslow Homer—and Homer was elected to embody the strength, the masculinity, and the Americanness that his compatriots seemed to lack. By the turn of the century, Homer's paintings were the symbolic equivalent of a mythic American, of Davy Crockett and the Marlboro man. His work, as historian Bruce Robertson has noted, was described as "honest, virile and rugged ... as American in character as Abraham Lincoln."[15]

Homer, of course, was not the reclusive native genius of his legend. He had been to Paris, most likely visiting the great international art display

at the 1867 exhibition, which included two of his own paintings. He went to the Louvre and familiarized himself with the Barbizon School, whose paintings he probably first had seen in his youth during the 1850s in Boston (plate 66; *Man with a Scythe*). He spent the early years of his career as an illustrator for the popular press, and his work in both wood engraving and oil on canvas reveals his knowledge of contemporary art; he employed both colonial revival imagery and the harmonious Japonesque decorations of his Aesthetic Movement contemporaries (plate 77; *Promenade on the Beach*). He traveled to Europe again in 1881–82, and although he worked in relative isolation on the northern coast of England, the large-scale watercolors he produced there are akin to contemporary British works. Homer did not forget everything he had seen when he moved permanently to Prout's Neck, Maine in 1883, nor was his seclusion as complete as legend would have it. But the myth-makers had already begun their task and as early as 1884 the press began to describe his studio as a "hermitage ... [where] the artist passes summer and winter in profound and guarded solitude."[16]

Homer's compositions, with their broad brushstrokes and big themes, struck a responsive chord. His shipwrecks, hunting scenes, and stormy seas all spoke of power and struggle, life and death, beauty and danger (plates 78–83). Such bold masculine subjects held great appeal for the businessmen who acquired them; they were about primeval force and strength. While their own personal battles were more likely to be in the boardroom than on the sea or in the forest, Homer's patrons admired the rugged individualism of his protagonists. Homer's paintings, with their reverence for the untamed power of nature, embody a frontier spirit that had always been a key part of the American identity. Even though the historian Frederick Jackson Turner had declared in 1893 that the frontier was closed, the idea of the frontier, of the balance of power between man and nature and the restorative power of the wilderness, remained integral to the definition of an American.

That truth did not play as large a role as myth in the American character is documented by the relative lack of success of Homer's contemporary Thomas Eakins. Eakins' response to nature was scientific rather than emotional, and even though America was already known for its interest in science, technology, and psychology, once again those interests were held separate from the world of art. Despite his skill at depicting the human face, form, and emotional circumstance, Eakins painted relatively few commissioned portraits, for he would not flatter his sitters (plates 86, 87); many apparently shared painter Edwin Austin Abbey's fear that Eakins would "bring out all those traits of my character I have been trying to conceal from the public for years."[17] Even the individuals whom Eakins most admired were painted with an accuracy that made most onlookers cringe, a reaction documented most thoroughly early in Eakins' career, in his 1875 masterwork, *The Gross Clinic* (fig. 10). There Dr. Samuel Gross, a Philadelphia surgeon, was shown in the midst of a new medical procedure he had developed to relieve the effects of osteomyelitis. Eakins portrayed Gross as a champion of modern science, a hero in the midst of a successful battle. But he failed to account for his non-scientific audience, viewers who had no desire to see the blood dripping from Gross' hands or the limp foreshortened body of his patient. Eakins' career is a history of disregard for his public, whom he refused to accommodate by glossing over the unpleasant or the ugly. His world was as masculine as Homer's and perhaps less cruel, but his penetrating realism, undisguised by sensuous paint, would not be admired until the twentieth century.

Eakins' contemporary, John Singer Sargent, was also credited with an unusual talent for psychological discovery. In 1899, when a large exhibition of his work was held in Boston's Copley Hall, the periodical

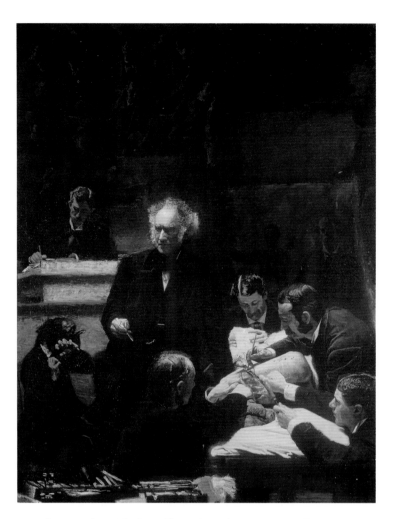

10 Thomas Eakins, *The Gross Clinic*, 1875, oil on canvas, 243.8 x 198.1 cm, Jefferson Medical College of Thomas Jefferson University, Philadelphia, PA

The Art Interchange declared that Sargent's portraits "seem more alive than do the spectators, since the power of the artist has gathered up their characteristic traits and revealed them for all to see in these striking syntheses of individuality."[18] Yet, unlike Eakins, Sargent managed to make his studies of character immensely popular and appealing, so much so that the demand for his portraits exceeded his willingness to supply them and he generally stopped accepting such commissions after about 1907. What Sargent provided for his sitters that Eakins did not was theater—he allowed them to remove themselves from the ordinary and everyday. He disguised his psychological insights with the glamour of both high fashion and high art, reveling in the luxurious fabrics of their Worth gowns, borrowing poses from Old Master paintings, and rendering both with such facility that critics described his work as the epitome of style (plates 126–128 and fig. 11).[19]

Sargent also offered something else, a cosmopolitan sophistication that equated his American sitters with the most fashionable figures in Paris, the most aristocratic in London. At last there was an American painter who could provide an international standard of quality that had always been missing from American art. But was Sargent American? He was born in Florence, trained in Paris, and from 1884 until about 1916, centered his career in London. Henry James asked a similar question when he introduced the painter to the American public in an article he wrote for *Harper's New Monthly Magazine* in 1887: "Is Mr. Sargent in very fact an American painter?" James answered the query himself, declaring

that "the proper answer to such a question is doubtless that we shall be well advised to claim him."[20] Americans did indeed pronounce Sargent their own, repeatedly consecrating him as the country's greatest painter. As for Sargent himself, he wrote to Whistler in 1894, "I keep my twang. If you should ever hear anything to the contrary, please state ... that I am an American."[21]

Despite his proclamation and his immense popularity, in the early decades of the twentieth century Sargent began to be dismissed by modernist critics as too clever, too facile, and in a familiar refrain, too European. In an article for the magazine *The Craftsman* in 1908, Mary Fanton Roberts discussed the work of a new school of painters led by the Philadelphia artist Robert Henri. She explained that America's art was still tainted by the "blight of imitation," and suggested that Henri and his followers would, with their emphasis on realism and the contemporary urban experience, create a new "national art."[22] Henri, the son of a riverboat gambler, had grown up in circumstances more colorful and unsettled than those of most of his fellow art students at the Pennsylvania

Academy, but he followed a typical course of training in Philadelphia and Paris. By 1902, he had established himself in New York and begun to teach. A charismatic instructor, Henri gathered around him a group of younger painters, including John Sloan and George Bellows (plates 133–146), who sought to rescue American art from "a deceitful age, drugged in the monotony of pretty falsification ... sugary and perfumed with the heavy odor of preservatives."[23] Sloan (who had begun his career as an illustrator), Bellows, and their colleagues took as their subjects the work and leisure activities of the city, particularly as viewed from the street. They favored images of middle and lower-class life, rendering them with lively, fluid brushstrokes. They did not disguise the inherent ugliness of the streets, slums, and machinery they depicted but also found beauty in the play of light and smoke on a construction site (plates 139, 140) or the breezy oasis of a sunny rooftop (plates 136, 137).

That these painters may only have selected a different social class of model (people of the street rather than of the parlor) and another kind of European prototype (Hals, Goya, and Daumier instead of Hals,

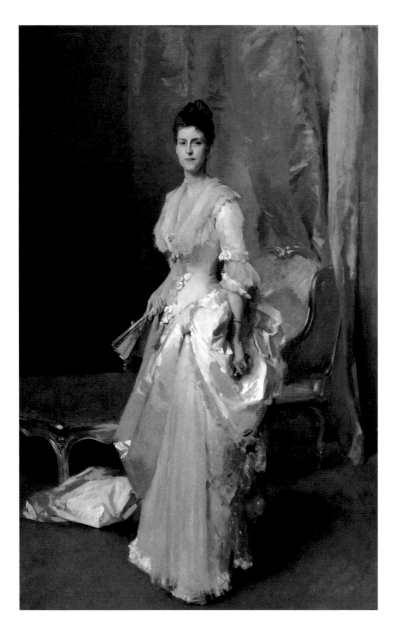

11 John Singer Sargent, *Mrs. Henry White*, 1883, oil on canvas, 221 x 139.7 cm, The Corcoran Gallery of Art, Washington, D.C.

Velázquez, and Van Dyck) from the ones chosen by their predecessors was downplayed; even in the 1950s, Henri's group was credited with restoring the "self-confidence and joy of life to American painting."[24] Some observers felt that American artists demonstrated more self-assurance by favoring distinctly native subjects, and others preferred painters who competed in the same arena as their European colleagues. The truth is elusive; what seems certain is that each successive generation of painters defined itself both by reacting against the artists who preceded them and by responding directly to European art.

The debate over what defined "American" art during the period after the Civil War reflects many concerns: the changing economy of the country, which forced a re-examination of the appropriateness of the national symbol of the citizen-farmer; technological developments in transportation and communication, which increased the speed with which new ideas and artistic styles entered the national vocabulary; and especially the shifting demographics of American society, which incorporated hundreds of thousands of new immigrants every year. From the mid-nineteenth century on, these newcomers were no longer predominantly the Anglo-Saxon Protestants who had initially shaped the United States, but people from many countries and of many religions whose presence caused a constant evolution in the definition of an American. Some citizens, artists among them, sought to reinforce the hegemony of white Anglo-Saxon culture and others were more inclusive, but few failed to respond to this transformation of American life.

Against this pattern of change was always the shadow of Europe and the traditions and innovations of European art. "I hardly know what will take [the] place of my weekly visit to the Louvre," wrote the American Impressionist John Twachtman in 1885, just before his return to the United States. "Perhaps patriotism," he continued.[25] It is Henry James once again who gracefully articulated the essence of late nineteenth and early twentieth-century American culture when he presciently stated that the country's unique advantage was that it was not bound by the weight of history and tradition. In an 1867 letter to his childhood friend Thomas Sargeant Perry (the grandnephew of the commodore who had opened Japan to the West), James wrote that Americans "can deal freely with forms of civilization not our own, can pick and choose and assimilate and in short (aesthetically, etc.) claim our property wherever we find it. To have no national stamp has hitherto been a great regret and a drawback, but I think it not unlikely that ... a vast intellectual fusion and synthesis of various National tendencies of the world is the condition of more important achievements than any we have seen."[26]

1 Quoted in Percy Lubbock, *Letters of Henry James*, vol. 1 (New York, 1920), biographical note.

2 For a complete discussion of the fair, see Carol Troyen, "Innocents Abroad: American Painters at the 1867 Exposition Universelle, Paris," *The American Art Journal* 16 (Autumn 1984): 2–29.

3 Henry T. Tuckerman, *Galaxy* 1 (15 August 1866): 682.

4 James Jackson Jarves, *Art-Thoughts* (New York, 1869): 298.

5 Henry James, "John S. Sargent," (1893), quoted in John L. Sweeney, ed., *The Painter's Eye* (Madison, Wisc., 1989), 216.

6 The most complete discussion is William H. Gerdts, *Art Across America* (New York, 1990).

7 Joseph Choate, *New York Herald*, 31 March 1880, quoted in Lawrence W. Levine, *Highbrow/Lowbrow: The Emergence of Cultural Hierarchy in America* (Cambridge, Mass., 1988), 201.

8 Martin Brimmer in *The American Art and Building News*, 30 October 1880, quoted in Walter Muir Whitehill, *Museum of Fine Arts, Boston: A Centennial History* (Cambridge, Mass., 1970), 12.

9 The Museum of Fine Arts, Boston and the Corcoran Gallery of Art still incorporate art schools. The Metropolitan Museum of Art offered artistic training from 1880 to 1894.

10 Sarah Burns has pointed out that this nostalgic taste for a simpler rural past began well before the Civil War and can be traced to the 1830s; see Sarah Burns, *Pastoral Inventions: Rural Life in Nineteenth-Century American Art and Culture* (Philadelphia, 1989).

11 Celia Betsky, "Inside the Past: The Interior and the Colonial Revival in American Art and Literature, 1860–1914," in Alan Axelrod, ed., *The Colonial Revival in America* (New York, 1985), 254.

12 Charles Caffin, *The Story of American Painting* (New York, 1907), 100.

13 Unidentified clipping, Blemly scrapbook, Alfred Frankenstein Papers, Archives of American Art, Smithsonian Institution, Washington, D.C., 1374: 281.

14 For a discussion of Harnett's popular appeal, marketing strategy, and the comparison to Barnum, see Paul J. Staiti, "Illusionism, Trompe l'Oeil, and the Perils of Viewership;" for Harnett's nostalgic subjects, see David M. Lubin, "Permanent Objects in a Changing World: Harnett's Still Lifes as a Hold on the Past;" both essays appear in Doreen Bolger et al., eds., *William M. Harnett* (New York, 1992).

15 Charles Vezen, letter to the editor, *The Herald*, 4 April 1907, quoted in Bruce Robertson, *Reckoning with Winslow Homer: His Late Paintings and Their Influence* (Cleveland, 1990), 69.

16 *Boston Herald*, December 1884, quoted in Nicolai Cikovsky, Jr., and Franklin Kelly, *Winslow Homer* (Washington, D.C., 1995), 397.

17 Quoted in Lloyd Goodrich, *Thomas Eakins* (Cambridge, Mass., 1982), 77.

18 Arthur Chamberlain, "Boston Notes," *The Art Interchange* 42 (April 1899): 78.

19 See for example the *Boston Evening Transcript*, 30 January 1888, 4.

20 Henry James, "John S. Sargent," *Harper's New Monthly Magazine* 75 (October 1887): 683.

21 John Singer Sargent to James McNeill Whistler [1894], Birnie Philip Collection, Glasgow University Library, Glasgow, quoted in Trevor Fairbrother, *John Singer Sargent and America* (New York, 1986), 366. See also Stanley Olson, "On the Question of Sargent's Nationality," in Patricia Hills, *John Singer Sargent* (New York, 1986).

22 Giles Edgerton [Mary Fanton Roberts], "The Younger Painters of America: Are They Creating a National Art?," *The Craftsman* 13 (February 1908): 531.

23 Everett Shinn, "Recollections of the Eight," 1943–44, quoted in Elizabeth Milroy, *Painters of a New Century: The Eight and American Art* (Milwaukee, 1991), 15.

24 E.P. Richardson, *Painting in America* (New York, 1956), 362.

25 John Twachtman to J. Alden Weir, 2 January 1885, Weir Family Papers, quoted in H. Barbara Weinberg et al., *American Impressionism and Realism: The Painting of Modern Life, 1885–1915* (New York, 1994), 31.

26 Henry James to Thomas Sargeant Perry, 20 September 1867, quoted in Fairbrother, 365.

Plates

The Colonial Period and Early Republic

Fine art initially had a hard time becoming established in the colonies. It was considered superfluous and unseemly at a time when a practical approach was needed to open up the New World and, later, expand the young republic. Thus, for instance, Thomas Jefferson thought in 1788: "Painting. Statuary. Too expensive for the state of wealth among us. It would be useless, therefore, and preposterous, for us to make ourselves connoisseurs in those arts. They are worth seeing, but not studying." And even in 1817, John Adams wrote: "Where the 'fine arts' are studied and practiced there should be a tribunal of criticism always in session, before which every new production should be arraigned and tried; by no other laws however than truth or nature, and no other penalty than reputation in the public opinion. Is it possible to enlist the 'fine arts' on the side of truth, of virtue, of piety, or even of honor? From the dawn of history they have been prostituted to the service of superstition and despotism. History and epic poetry are worse than architecture, sculpture, and painting, because they are more lasting deceptions."

Thus, artists such as John Trumbull, who had made it their task to prevent important events in the young history from being forgotten, found themselves very much confronted with a necessity to justify their conduct. In 1879, he wrote to Thomas Jefferson: "The greatest motives I had … for continuing my persuit of painting has been the wish of commemorating the great events of our country's revolution. I am fully aware that the profession as generally practiced is frivolous, little useful to society, and unworthy of a man who has talents for more serious pursuits. But, to preserve and diffuse the memory of the noblest series of actions which have ever presented themselves to the history of man; … [and to preserve] the personal resemblance of those who have been the great actors in those illustrious scenes, were objects which gave a dignity to the profession, peculiar to my situation."

In addition, in the early days, the great skepticism that all Puritans felt toward fine art, with its perceived constant danger of sensuality, luxury, and idleness, did not allow a climate conducive to the arts to develop. This would only come about gradually through wealthy merchants who wished to have their portraits painted. Thus, it seems all the more astonishing that self-taught painters such as Benjamin West and John Singleton Copley succeeded in producing works of astonishing quality. Because there were no training establishments and hardly any good paintings (let alone public art collections) from which young talents might have learned something, they had to resort to the aid of prints.

West had realized that he would not be able to develop his talent sufficiently in the colonies and had gone to Europe in 1760 at the age of twenty-two. After three years in Italy, he finally settled in London. There he was very successful and was soon the most celebrated painter in London, becoming the second president of the Royal Academy, after Sir Joshua Reynolds, and was held in high esteem at court. West became an artistic father figure for several generations of American painters who visited him in London, for example Charles Willson Peale (see plate 1), Gilbert Stuart, and John Trumbull.

Copley had come into contact with pictorial representations through his step-father Peter Pelham's engraving workshop. Prints would continue to be the sole orientation for the young painter. "In this Country as You rightly observe, there is no examples of Art, except what is to [be] met with in a few prints indiferently exicuted, from which it is not possable to learn much." But his patrons too were not especially cultivated people. As he noted with resignation: "The people generally regard it as no more than any other useful trade, as they sometimes term it, like that of a Carpenter, tailor or shew maker, not as one of the most Noble arts in the world. Which is more than a little Mortifying to me."

Copley was essentially self-taught. With extreme diligence he picked up modes of expression and developed his stylistic vocabulary from accessible engravings, books, and from the pictures that he was able to view in the houses of European artists staying temporarily in Boston. His most important training, however, came from accurate observation. Copley, who needed countless sittings to complete his portraits, did not generalize; he wanted to reproduce reality as precisely as possible. He developed his style of hard outlines, clearly modeled bodies, and masterfully observed surfaces, a style which set the truthfulness of the depiction, the objectivity of what was seen, above any flattering gloss. Such empirical realism would only reappear with comparable acuity later in the century with Thomas Eakins. Copley had thus realized a basic trait of American art. Soon he was one of the most sought-after portraitists in Boston. The mastery of his work could not be overlooked, so that Reynolds too, faced with Copley's *Boy with a Squirrel (Henry Pelham)*, shown in 1766 at the exhibition of the Society of Artists in London, had to recognize, "considering the Disadvantages" under which Copley had to work, "that it was a very wonderful Performance." Only at a late stage, and after repeated requests from the great English painter, did Copley finally decide in 1774 to seek further training in Europe. After journeying through Italy he remained in London for the rest of his life.

In his painting *The Death of General Wolfe* (fig. 4, p. 211), West had already revolutionized the historical picture by freeing the action from the obligation to include antique draperies and timeless classical exaggeration, and instead giving it topicality by using contemporary uniforms. Copley was able to do something comparable with a commission for the businessman Brook Watson. He elevated a personal story — something that would never previously have been felt to be worthy of a picture — into the subject of a large painting. He took what West had begun in *The Death of General Wolfe* a step further; it was no longer heroes of old who should serve as models, but the heroes of his time. It was thus also possible to uncouple moral messages from history and the myths of antiquity and draw on the experiences of modern people. Watson later had Copley's picture hung in a school in order to provide young people with the edifying example of his own story. When he was a young sailor, while swimming in the harbor at Havana, Watson had been attacked by a shark. Although he lost his foot and lower leg, he survived, thanks to the courageous

John Singleton Copley
Watson and the Shark,
1778, oil on canvas,
182.1 x 229.7 cm
National Gallery of Art,
Washington, D.C.,
Ferdinand Lammot
Belin Fund

intervention of his comrades and fortuitous circumstances. Subsequently (and despite that fact that he henceforth had to wear an artificial leg), he gained a great reputation as a businessman, and became a member of parliament, mayor of London, and president of the Bank of England. The message intended for young people was that great things can be achieved even from the most adverse circumstances.

The picture made Copley immediately famous in London. He painted two more versions, and the one shown here, smaller in format, captivates us through its liveliness and drama (plate 4). Innovations of the type that West and Copley developed in their pictures would have an effect on the Old World and transform history painting, which now received a new topicality.

In the early republic, paintings such as Trumbull's battle scenes or the frequently reproduced portraits of national heroes created the foundations for an iconography of great Americans. Skillful, flattering portraits, like those by Thomas Sully, in which one can see

the influence of the English style, reflected the growing self-assurance and status of the prospering middle classes. The spirit of the new nation, its desire to take up an important and independent position among modern nation states, not just economically but also culturally and scientifically, was embodied in no one more impressively than in Charles Willson Peale and his dynasty. Peale, who was an inventor, precision engineer, scientist, artist, and much more, can be considered the father of American cultural and museum history. He invented the first American museum. His original intention was to open a public gallery to display his portraits of heroes of the Revolution. Because of a lack of visitors, however, he expanded it to include stuffed animal specimens from the New World. The museum ultimately became a systematic collection of the empirical world of America, in the spirit of the Enlightenment. This scientific interest would also be inherited by many of his offspring, like Rembrandt Peale, who helped him excavate the skeleton of a mastodon, or Rubens Peale, who involved

himself intensively with botany (see plate 18). Peale also ensured that future generations of painters would have adequate training by founding the American Academy of Fine Arts in Philadelphia.

Charles Willson Peale was an excellent portraitist, particularly when portraying members of his family. The portrait of his brother James (plate 12) is among the most true-to-life and sensitive likenesses of the time. At the same time he was the founder of American still-life painting, which was continued by his brother James and particularly by his son Raphaelle (see plates 14–17). And with pictures like *The Staircase Group* (see fig. 7, p. 37), he became the pioneer of American trompe l'oeil painting.

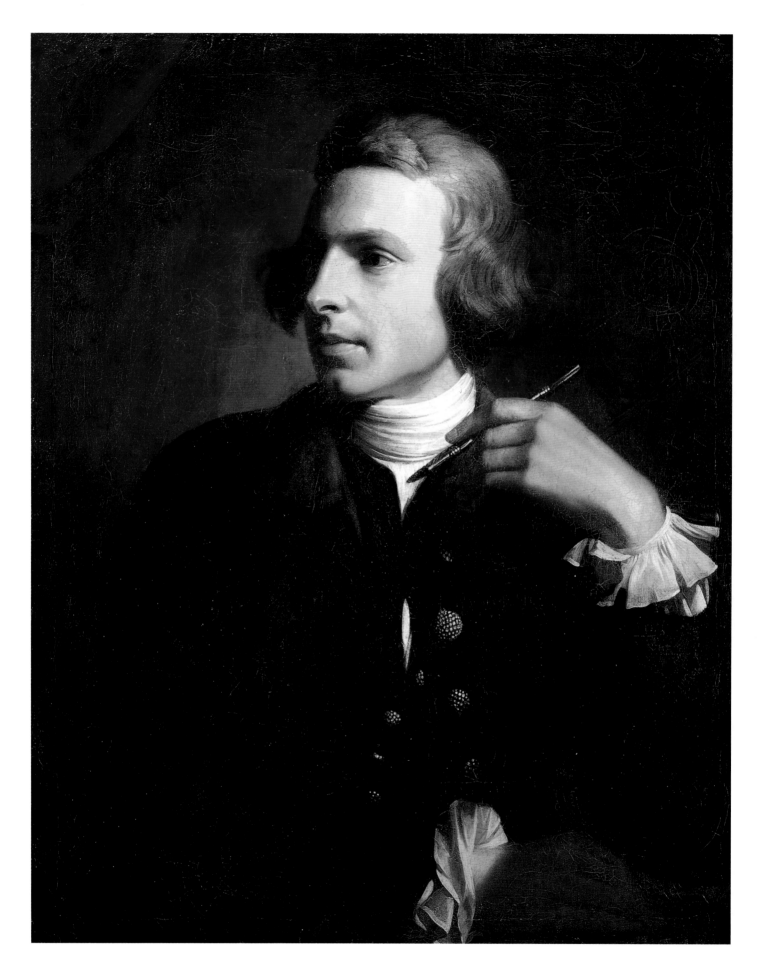

1 Benjamin West, *Charles Willson Peale*, 1767/69

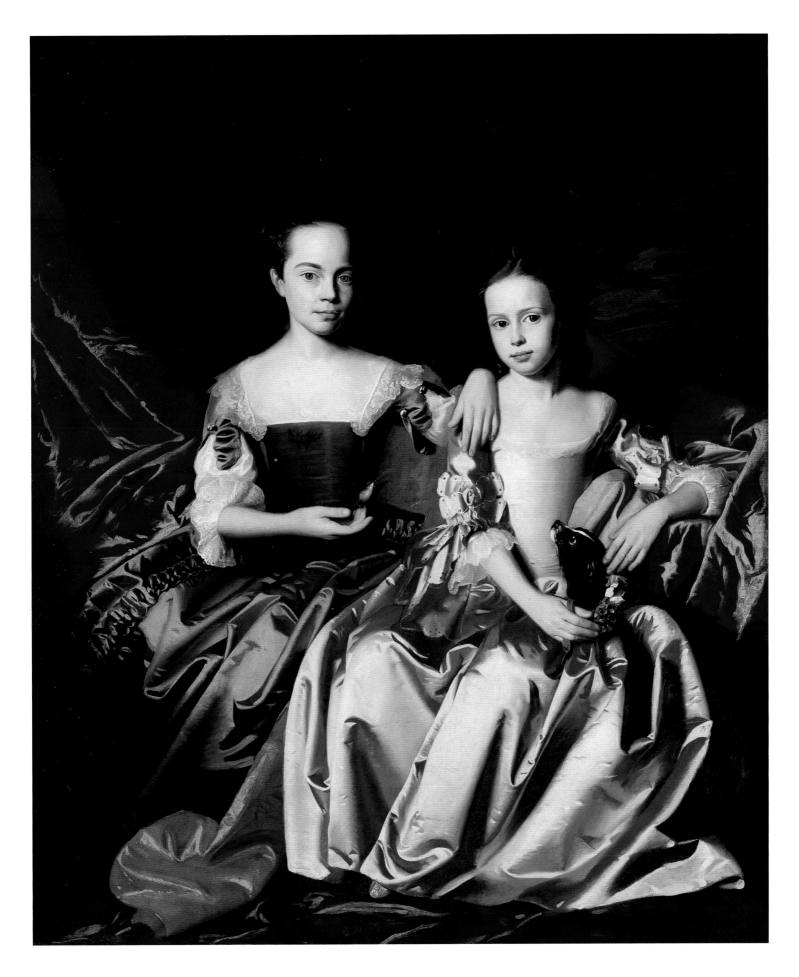

2 John Singleton Copley, *Mary and Elizabeth Royall*, c. 1758

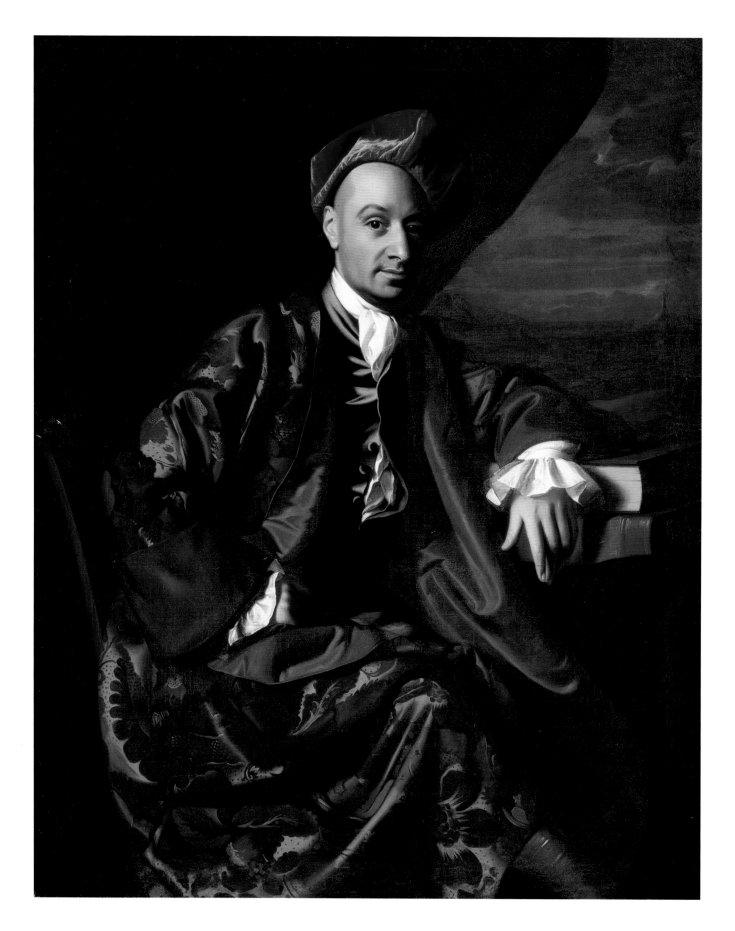

3 John Singleton Copley, *Nicholas Boylston*, c. 1769

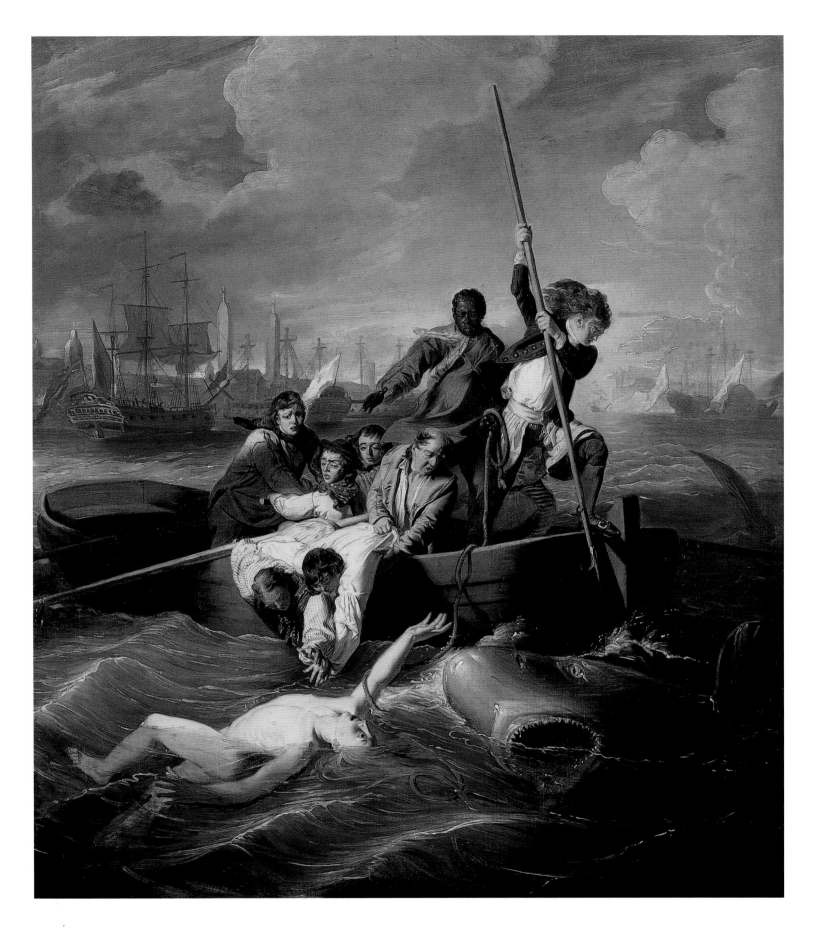

4 John Singleton Copley, *Watson and the Shark*, 1782

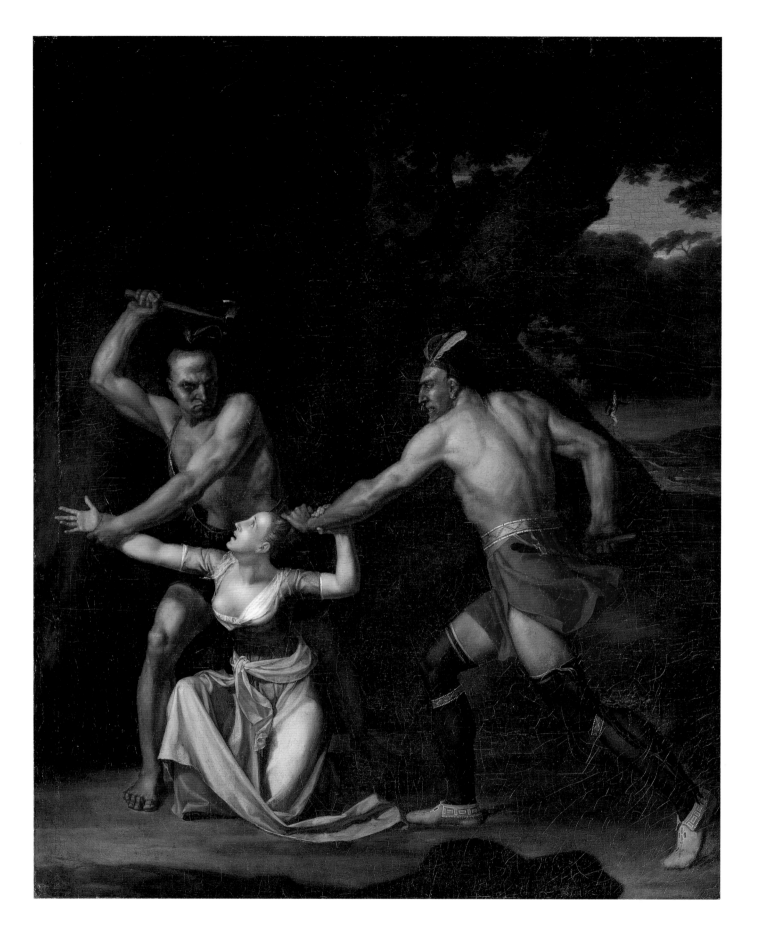

5 John Vanderlyn, *The Death of Jane McCrea*, 1804

6 Gilbert Stuart, *George Washington*, after 1796

7 Thomas Sully, *Mary McKean Hoffman*, 1821

8 Thomas Sully, *Major Thomas Biddle*, 1818

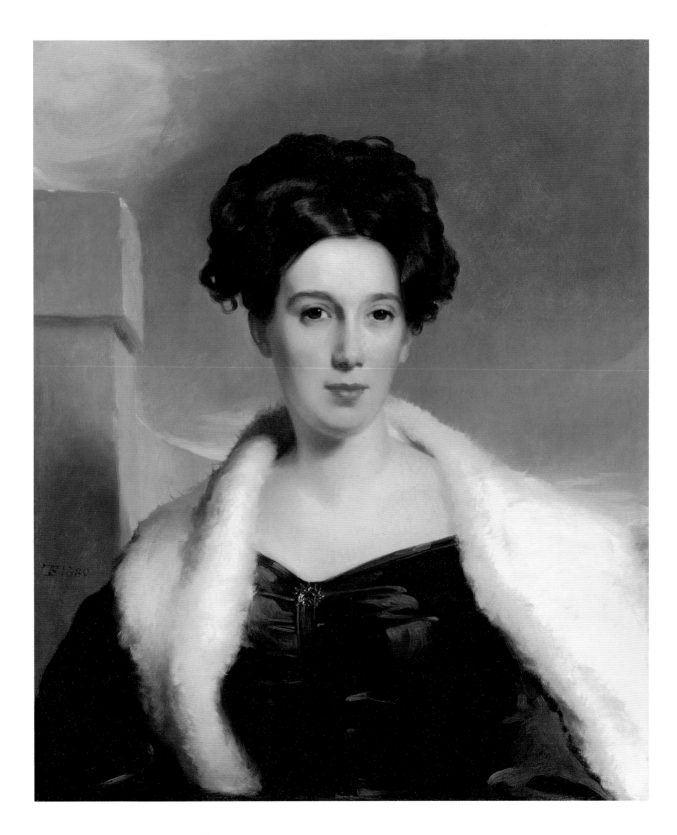

9 Thomas Sully, *Mary Anne Heide Norris*, 1830

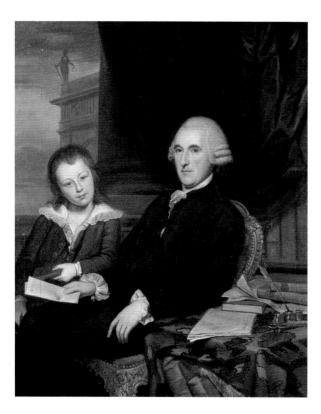

10 Charles Willson Peale, *Portrait of Governor Thomas McKean and His Son, Thomas McKean, Jr.*, 1787

11 Charles Willson Peale, *Mother Caressing her Convalescent Daughter (Angelica Peale [Mrs. Alexander] Robinson and her Daughter Charlotte)*, 1818

12 Charles Willson Peale, *James Peale Painting a Miniature*, 1789/90

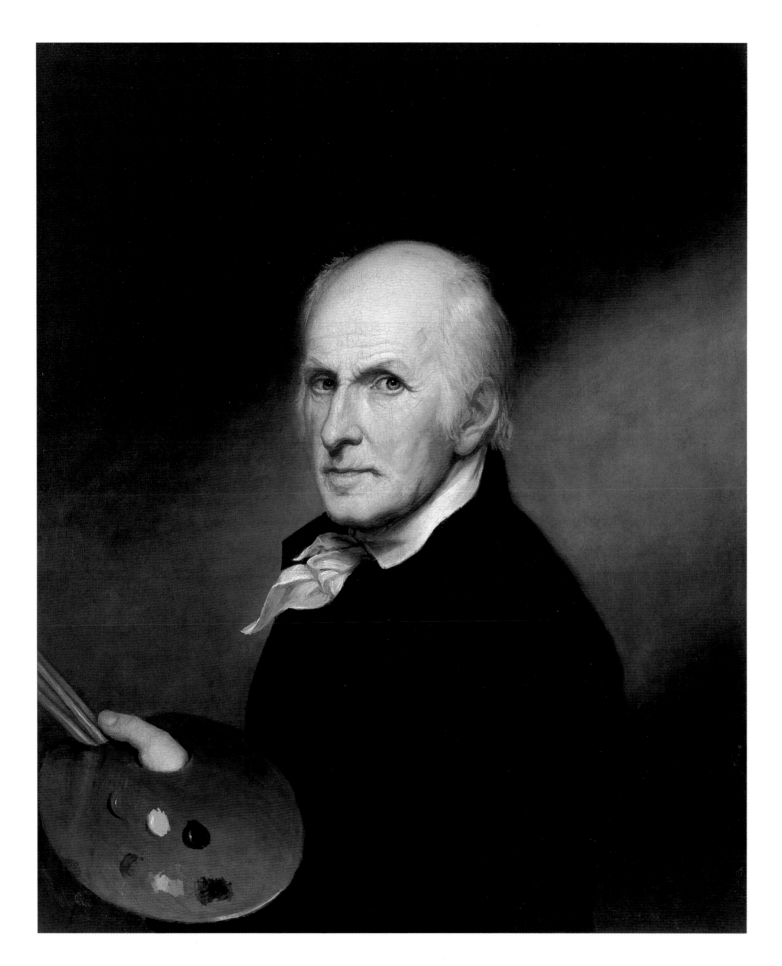

13 Charles Willson Peale, *Self-Portrait*, 1822

14 Raphaelle Peale,
Still Life with Peach, c. 1816

15 Raphaelle Peale,
Still Life with Peach, c. 1816

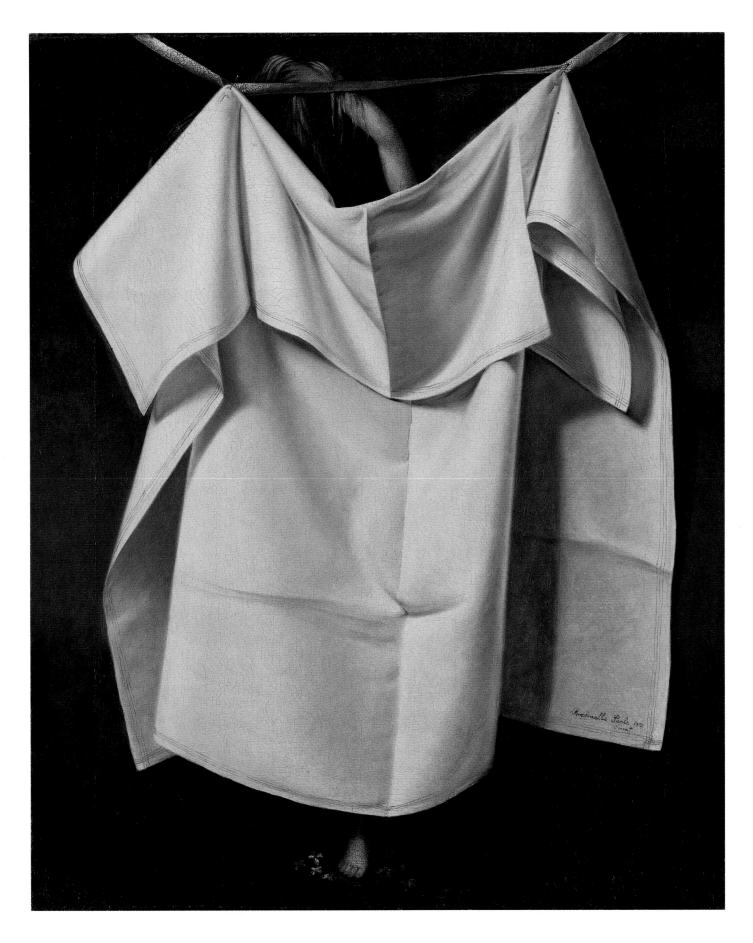

16 Raphaelle Peale, *Venus Rising from the Sea—A Deception*, 1823

17 Raphaelle Peale, *Still Life with Orange and Book*, c. 1815

18 Rembrandt Peale, *Rubens Peale with a Geranium*, 1801

Opening Up the Land

The beginning of the nineteenth century would change the United States decisively. With the Louisiana Purchase in 1803—the acquisition from Napoleon of 515,000 square miles between the Mississippi and the Rocky Mountains—the territory of the country doubled at once and space was created for further settlement in the West.

The result was immigration on a massive scale. By 1861, the United States, which at the beginning of the century consisted of seventeen states and four million people, had grown to thirty-five states and thirty-one million people. At the end of the century, the country had forty-seven states and a population of ninety million.

A dynamism developed that would shape America's identity and continue to determine it up to the present. The feeling of unlimited potential prevailed, and the task of cultivating the wilderness and transforming it into a productive garden was now at hand. In the beginning, people regarded the wildness of the land with suspicion and fear. By the end of the eighteenth century, it was felt that the "grand defect of American nature" was that it was "but composed of trees."

The Puritans had conceived of the new continent's forests as the "desert" of the Bible, a place of temptation inhabited by demons. The wilderness was filled with all kinds of dangers, including those posed by the indigenous inhabitants. Viewed as a threat, the wilderness therefore tended to be avoided or was pushed back by claiming it for agricultural use. Taking possession of the land, opening it up and civilizing it, was invested with an ethical aspect in which two ideological currents came together. For some the task was a divine one, and so had to be accomplished. For others, motivated by the spirit of the Enlightenment, the task was to convert a raw land into a refined culture. The landscape painting of the first half of the century (disparagingly termed the "Hudson River School" in the 1870s) therefore dealt primarily with the contrast between the wilderness and domesticated nature.

Again and again we find views of villages and small towns, fields and the harvests reaped from them, log cabins and the first forest settlers—images which document cultivation, display successes and the fruits of labor, and, as it were, render account of all that has been achieved. The man with the ax who often appears in such pictures became a symbol of progress and control of the land. The fact that all this went hand in hand with the ousting of the Native Americans, who had to move ever further west, disturbed only a few people. Seldom was there any genuine interest in Native Americans when they were encountered. People had transported their own convictions and ways of life with them from Europe to the New World.

Thus, landscape painting began to overtake portraiture in importance. The academies founded at the beginning of the century grew in significance, and, in addition to the aristocracy, businessmen began to collect pictures by American painters and to develop a preference for landscapes. From 1835 onward, landscape painting was the major genre in American painting—and would remain so for the rest of the nineteenth century.

The beauties of the country increasingly offered the young nation possibilities for identification and self-definition. Wonders of nature such as the Niagara Falls were taken, so to speak, as divine proofs of America's destiny as "God's own country."

People began to take pride in an authentically American art. In 1837, Ralph Waldo Emerson wrote in *The American Scholar*: "Our day of dependence, our long apprenticeship to the learning of other lands, draws to a close. We have listened too long to the courtly muses of Europe. What is the remedy? We will walk on our own feet; we will work with our own hands; we will speak our own minds. A nation of men will for the first time exist, because each believes himself inspired by the Divine Soul which also inspires all men."

Yet this change in attitudes toward nature, even the revaluation of landscape painting (traditionally ranked as a minor genre), would have been unthinkable in the United States without the work of Thomas Cole and an interest in landscape painting that originated in England. The average American at the beginning of the nineteenth century conceived of the land as having potential for practical exploitation, as a source of prosperity, but not as "landscape" in its distinctive beauty, let alone as a basis for identity. Writings by William Oram, Edmund Burke, William Gilpin, and Joshua Reynolds on landscape painting, the "Arcadian" and the "sublime," and the aesthetic power of the terrible, had prepared the intellectual ground in the United States for a new evaluation of landscape painting.

Thomas Cole, who would stamp his mark on an entire generation of landscape painters, had brought the concept of landscape with him from England and began to focus on the conflict between nature in its original state and the human exploitation of it, which became one of the central themes of his work. Born in Bolton, Lancashire, in 1801, the son of a textile manufacturer, he had witnessed the destruction of nature as a consequence of advancing industrialization. He felt a yearning for the original America. The landscape seemed to him to be pure, uncorrupted, and marked by the hand of God. All through his life, his romantic conception fluctuated between idealization and realism.

It was Cole who introduced Edmund Burke's concept of the sublime into American landscape painting and employed the idiom of Salvatore Rosa when seeking to portray the elemental forces of nature. But it was also Cole who introduced to the United States Claude Lorrain's concept of landscape: the interaction of nature and human civilization, and the resulting beauty of cultivated nature (see plates 19-21).

The landscapes of the Hudson River and the Catskill Mountains created after this fashion were essentially already nostalgic, as Alexis de Tocqueville's report of his journey, written in 1832, makes clear: "It is the consciousness of destruction, of quick and inevitable change, that gives such a touching beauty to the solitudes of America. One sees them with a sort of melancholy pleasure; one is in some sort of a hurry to admire them."

Cole saw the danger of excessive exploitation. He wrote, embittered, that every hill and valley had become an altar to Mammon and the gods of idolatry, and that the people themselves were the victims. In his eyes, only a life lived in harmony with nature promised

William Sidney Mount, *Coming to the Point*, 1854, oil on canvas, 63.5 x 76.2 cm,
New-York Historical Society

intellectual renewal and healthy progress. In
this he was close to the thinking of Ralph
Waldo Emerson, who trusted that the healing
power of nature would bring everything back
into proper balance, would return human
activities to their original scale, and that the
beauty pervading nature would also affect all
fields of human endeavor.

Although Cole's pictures were composed
according to a preconceived idea and were
basically nostalgic in attitude, the work of the
next generation of landscape painters sought
a stronger connection to the present, even if
this was sometimes rendered in idyllic terms.
In their predominantly Arcadian panoramic
views, such painters as Durand, Kensett,
Heade, Lane, and Church in his early works,
conjured up an all-prevailing harmony, a

balance between human activities and nature.
Until the 1840s, nature remained the exclu-
sive vehicle of the American identity when
genre painting emerged, with painters such as
Bingham, Clonney, and Mount and their
depictions of rural life and American virtues.

19 Thomas Cole, *Summer Twilight: A Recollection of a Scene in New England*, 1834

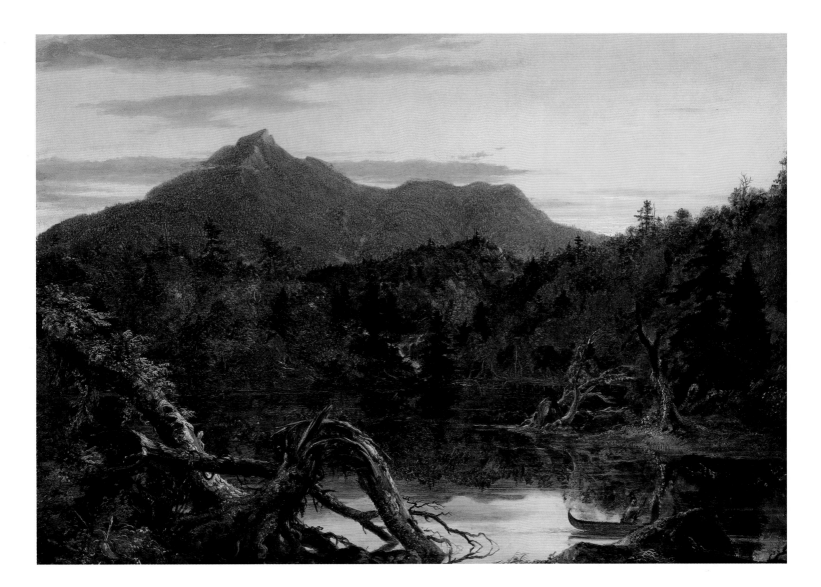

20 Thomas Cole, *Autumn Twilight: View of Corway Peak (Mount Chocorua, New Hampshire)*, 1834

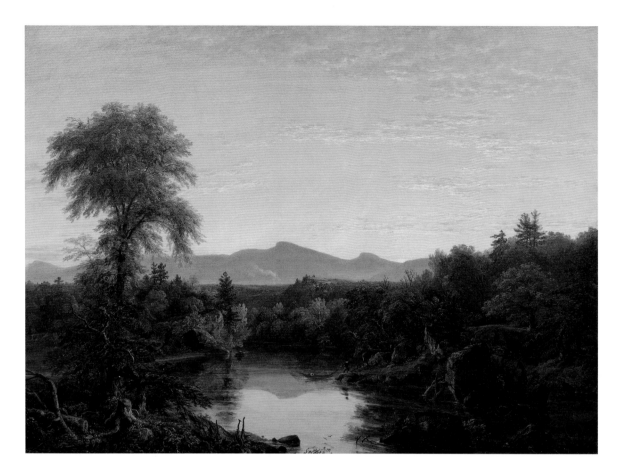

21 Thomas Cole,
Catskill Creek, New York, 1845

22 Asher Brown Durand,
*Study from Nature, Stratton
Notch, Vermont,* 1853

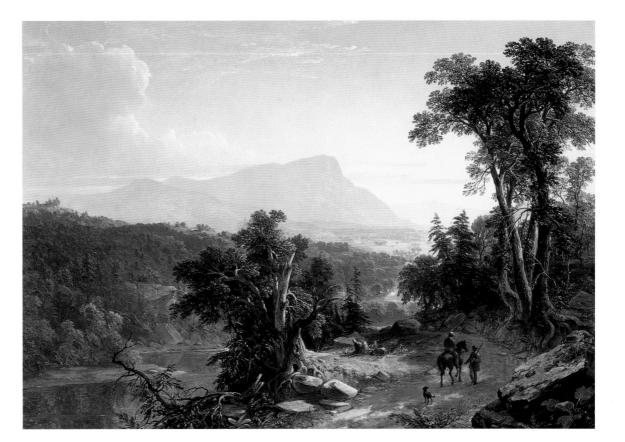

23 Asher Brown Durand,
*Landscape—Composition:
In the Catskills*, 1848

24 Asher Brown Durand,
*The First Harvest in
the Wilderness*, 1855

26 Richard Caton Woodville, *Politics in an Oysterhouse*, 1848

25 James Goodwyn Clonney,
Waking Up, 1851

27 Martin Johnson Heade, *Marsh Scene: Two Cattle in a Field*, 1869

28 Martin Johnson Heade, *Hazy Day on the Marshes, New Jersey*, 1862

29 Martin Johnson Heade, *Sunset, Haywagon in the Distance*, c. 1875

30 John Frederick Kensett, *White Mountain Scenery*, 1859

31 John Frederick Kensett, *Camel's Hump from the Western Shore of Lake Champlain*, 1852

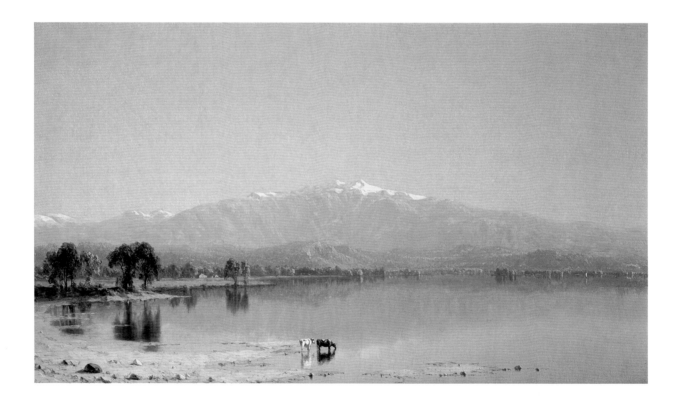

32 Sanford Robinson Gifford,
Early October in the White Mountains, 1860

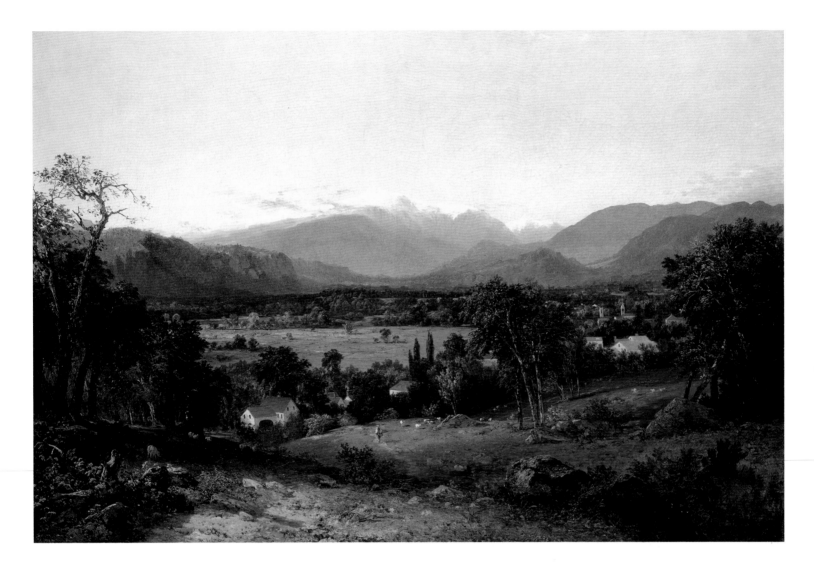

33 John Frederick Kensett, *The White Mountains (Mount Washington from the Valley of Conway)*, 1851

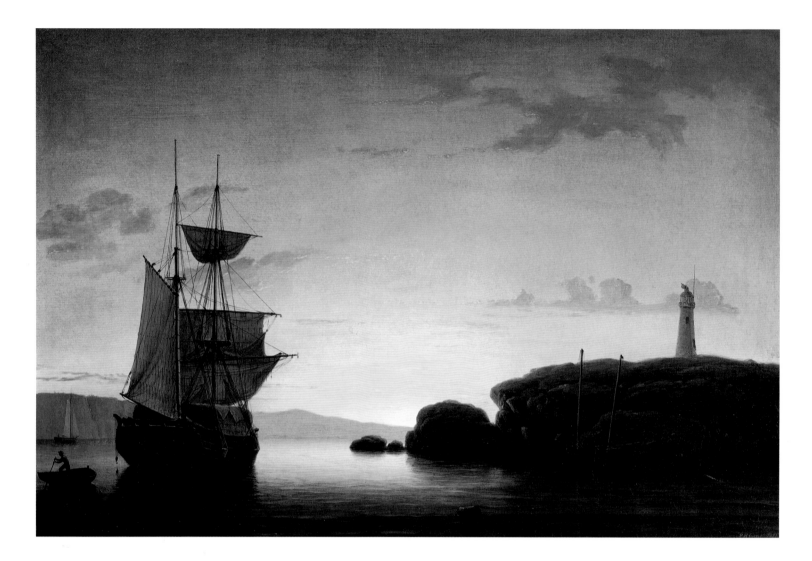

34 Fitz Hugh Lane, *Light House at Camden, Maine,* 1851

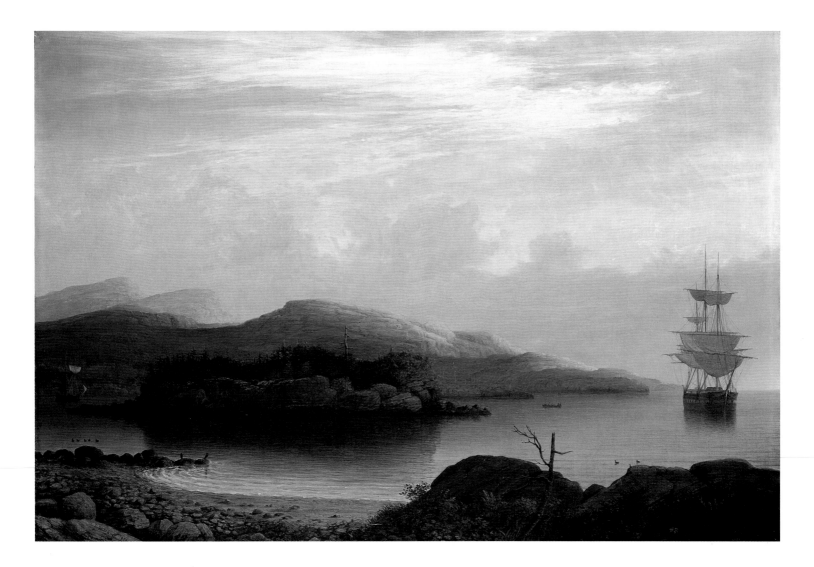

35 Fitz Hugh Lane, *Off Mount Desert Island*, 1856

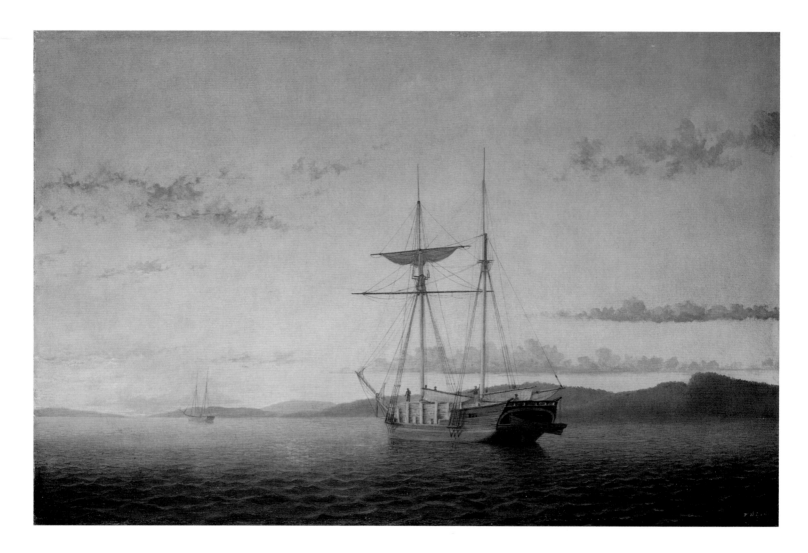

36 Fitz Hugh Lane, *Lumber Schooners at Evening on Penobscot Bay*, 1863

37 Frederic Edwin Church, *The Abandoned Skiff*, 1850

38 Frederic Edwin Church, *New England Scenery*, 1851

39 Frederic Edwin Church, *A Country Home*, 1854

40 Albert Bierstadt, *Moat Mountain,*
 Intervale, New Hampshire, c. 1862

The Wilderness as a Source of American Identity

If Thomas Cole had given visible expression to an enthusiasm for nature in the United States and Europe that reached from Rousseau, by way of Schelling, to Emerson, it would be the duty of his student Frederic Edwin Church to portray this nature in its untouched state, as wilderness. And if, for Cole, nature was the revelation of God, this was even more the case for Church, who saw in it the reflection of divine order and harmony. Church was Cole's first and best student; he was exceptionally talented, especially in terms of his drawing skills and his gift for observation.

Cole had pointed out the gulf between original nature reflecting God's purity and its destruction through man's acquisitive greed. In this he was in agreement with the thinking of his time. Literary figures, philosophers, and theoreticians of his generation such as James Fenimore Cooper, Ralph Waldo Emerson, John Ruskin, and later Alexander von Humboldt, had a considerable influence on the aesthetic development of American landscape painting. They were all convinced that God's presence pervaded the wilderness and that it would thus be sacrilege to destroy it. The philosopher and essayist Emerson expressed this view in an impressive passage in *Nature,* a work of 1836: "In the woods, is perpetual youth. Within these plantations of God, a decorum and sanctity reign, a perennial festival is dressed.... In the woods, we return to reason and faith. There I feel that nothing can befall me in life,—no disgrace, no calamity, (leaving me my eyes,) which nature cannot repair. Standing on the bare ground,—my head bathed by the blithe air, and uplifted into infinite space,—all mean egotism vanishes. I become a transparent eye-ball; I am nothing; I see all; the currents of the Universal Being circulate through me; I am part or particle of God."

But Cole took it a step further. Even if America had no monuments—ancient ruins, dilapidated Gothic churches or medieval castles—that made a picturesque or sublime impression in the sense of the Romantics, it could nevertheless offer unspoiled nature of a magnificence that Europe could not match. Dramas of nature such as Niagara Falls and the picturesque Catskill Mountains were God's visible traces on earth and only to be found in the New World, these two specifically in the breathtaking landscape of northern New York State.

In 1835, Cole wrote, fascinated, wrote: "The painter of American Scenery has indeed privileges superior to any other; all nature here is new to Art. No Tivolis, Ternis, Mont Blancs, Plinlimmons, hackneyed and worn by the daily pencils of hundreds, but virgin forests, lakes & waterfalls feast his eye with new delights, fill his portfolio with their features of beauty ... because they had been preserved untouched from the time of creation for his heaven-favoured pencil."

Cole raised the wilderness into a symbol of national identity, made of it a myth that has lost nothing of its potency in the twentieth century: think, for instance, of Ansel Adams' photographs. America thus had something that made it stand out from all other nations. It was precisely that wilderness which had been feared and pushed back some decades earlier that now represented the proof of God's special favor.

However much Cole believed in the splendor and uniqueness of the American landscape and its natural phenomena, he could not help exaggerating them in line with his ideas of the picturesque or the awe-inspiring sublime. "In the terrible and the grand ... when the mind is astonished, the eye does not dwell upon the minute but seizes the whole. In the forest, during an hour of tempest, it is not the bough playing in the wind, but the whole mass stooping to the blast that absorbs the attention: the detail, however fine, is comparatively unobserved. In a picture of such a subject detail should not attract the eye, but the whole. It should be, in this case, the aim of the artist to impress the spirit of the entire scene upon the mind of the beholder.... The finest scene in the world, one most fitted to awaken sensations of the sublime, is made up of minutest parts. These ought all to be given, but so given as to render them subordinate and ministrative to one effect."

However, Cole's wilderness was highly idealized, since he never painted in truly remote regions but in recently opened up areas such as the Catskills or along the Hudson River. And when he included the occasional Native American (who by that time had long since been slaughtered or driven out of the area) in his pictures, it was merely as a prop to represent a vanishing virgin world. By the 1830s, untouched landscape could only be found on the other side of the Missouri.

Throughout his life, Cole preferred compositions (see *Landscape Composition, Saint John in the Wilderness*, plate 41) rather than observed panoramic views, something which repeatedly led his work to be criticized as mannerist. This preference also rubbed off on Church, who in his large-format pictures composed "world landscapes" which, with their wealth of minutely observed detail, represented an expanse of land or a geographical zone rather than some particular view.

When, around the middle of the century, people began to grasp that the wilderness, the picturesque "otherness" of this great and diverse country, was actually its characteristic feature and to draw their identity from it, increasingly the desire was expressed that it should be portrayed with greater awe and reverence, but at the same time with meticulous accuracy. Painters now took part in a variety of expeditions and exploratory trips or followed the reports of discoverers.

New York became an artistic center and the focus of the art market at an early date. Almost all painters lived and worked there, indeed many of them had their studios in the same buildings, as, for instance, in the Tenth Street Studio Building. From there, in the summer, they undertook exploratory trips into the interior (often following the course of the Hudson into the Catskill Mountains or the Adirondacks), from which they returned with sketches and studies that then often served as the basis for monumental studio paintings. Since the breadth and sublimity of nature's drama demanded an adequate setting, picture formats also grew: the "great picture," a large, usually oblong-format painting, came into being. Church, probably the most significant American landscape painter of the nineteenth century, also undertook expeditions to New England and New York State in the summer, where he made sketches and studies in pencil and oil, the results of which he then worked up into massive compositions in the

studio during the winter months. Church was convinced of the spiritual dimension of this "sacred land," where nature possessed a history thousands of years old and was largely untouched by white people. At the same time, he wanted to understand its internal order better. The ideas of Ruskin and Humboldt influenced his artistic thinking. As a result of Ruskin's demand that physical conditions should be depicted faithfully in landscape painting, Church found himself compelled toward a stronger realism than his teacher, Thomas Cole, including a more precise rendering of details.

Church was fascinated by Humboldt's interpretation of the world as a "unity in diversity of phenomena: a harmony, blending together all created things, however dissimilar in form and attributes; one great whole animated by the breath of life." The first two volumes of Humboldt's book on the cosmos had appeared in English in the early 1840s; Church began to read them around 1850. A summation of Humboldt's extended journeys of exploration (including a five-year scientific expedition to South America) and earlier work, they expounded the divine order of the world. One of the book's chapters dealing with landscape painting prompted Church to lay out broad, panorama-like landscape pictures which tried to present the "essence" of a region rather than a particular place. He also meticulously reproduced atmospheric moods and carefully observed animals and plants.

Humboldt's reports on South America, where he had traveled through the tropics and praised them as wonderful subject matter for a great painter, also encouraged Church to undertake his first journey there in 1853. He traveled by way of Colombia and the Andes to Ecuador and returned via Panama. While there, he climbed a volcano in order to be able to walk in Humboldt's footsteps. He made a second journey to South America in 1857, and two years later he went to the Arctic. Church had thus covered the continent from north to south. His fame grew with every picture. By 1851, his *New England Scenery* (plate 38) had fetched 1,300 dollars, the highest price paid thus far for an American painting. His *The Andes of Ecuador* (1855),

Niagara (1857), and *Heart of the Andes* (1859) were spectacularly successful with the public. Visitors to Church's studio for the presentation of *Heart of the Andes* were carefully briefed and stage-managed; they were urged to take their place on benches in front of the painting and study every detail through opera glasses or metal tubes, thereby taking a walk, so to speak, through the picture without distractions. Twelve thousand visitors paid a quarter each to see the picture.

The constant distinguishing feature of Church's pictures was the precise representation—prepared in countless preliminary studies—of reality and its individual phenomena, which he was able to subordinate in an ingenious fashion to the intended overall impression and to the overlying message about the unity of the world. Even in the gigantic formats that he occasionally chose in order to bring out the sheer immensity of a natural scene (see plate 46), the intensity of his vision does not diminish, and every part of the picture remains full of tension. One of the loveliest and most impressive examples of this is *Twilight in the Wilderness* (plate 45), which he painted in 1860 at the height of his career. This is no realistic landscape, but is Church's attempt to distill the essence of his experiences of nature in North America into a polished composition. And it had to be an untouched landscape, since in his eyes this was where America's being lay. The picture was praised by the public and critics alike, because, with its almost ceremonial atmosphere, it struck a chord with the contemporary feeling for nature. Also, it was painted on the eve of the Civil War, when conflict hung tangibly in the air. It is known that Church and his friends discussed the situation. The picture conveys to the viewer something of this oppressive sense of foreboding.

Even if none of his contemporaries could compare with Church in the production of breathtaking panoramic landscapes, they nevertheless referred to him, as demonstrated, for example, by Worthington Whittredge with his *Twilight on the Shawangunk Mountains* (plate 49).

In later years, depicting the wilderness could be a profitable business, although some

paintings degenerated into purely decorative pieces. Albert Bierstadt in particular discovered that the grandiose scenery of the West could be worthwhile for a painter. Bierstadt skillfully combined the realism he had learnt in Düsseldorf with the drama of well-established props of the sublime. He took part in several expeditions to the West. Although the resulting monumental paintings, such as *Rocky Mountains*, portrayed invented landscapes, they were immediately successful. Bierstadt later endeavored to paint more true-to-life landscapes, but not without dramatic lighting or an atmospheric mood.

In 1871, Thomas Moran accompanied an expedition into the Yellowstone region. He and the directors of the Northern Pacific Railroad, who hoped to gain a new tourist destination, later succeeded in persuading the Government to buy the region and declare it a national park. The Government also bought Moran's huge painting *The Grand Canyon of the Yellowstone* for the proud price of 10,000 dollars and had it hung in the Capitol. Moran went on to paint a plethora of over-emotive panoramic views of this region and of the Grand Canyon well into the twentieth century.

41 Thomas Cole,
Landscape Composition,
St. John in the Wilderness, 1827

42 John Frederick Kensett,
A Woodland Waterfall, c. 1855

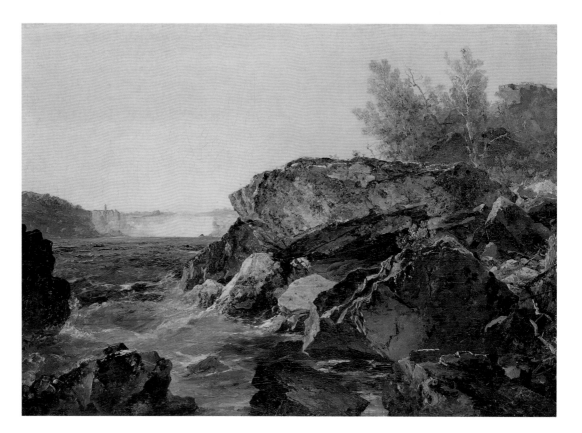

43 John Frederick Kensett,
Niagara Falls, 1851/52

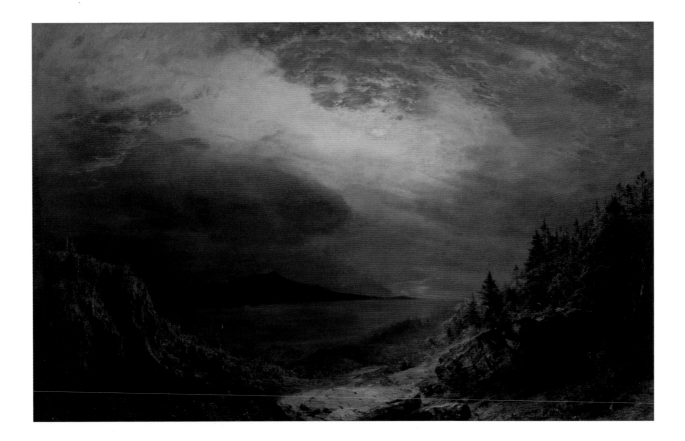

44 Frederic Edwin Church, *Twilight Mount Desert Island, Maine,* 1865

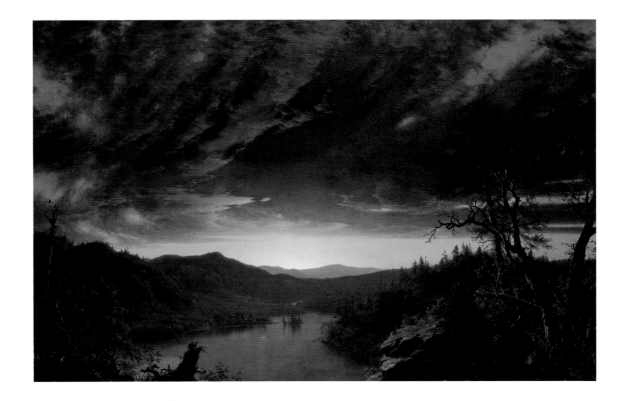

45 Frederic Edwin Church, *Twilight in the Wilderness,* 1860

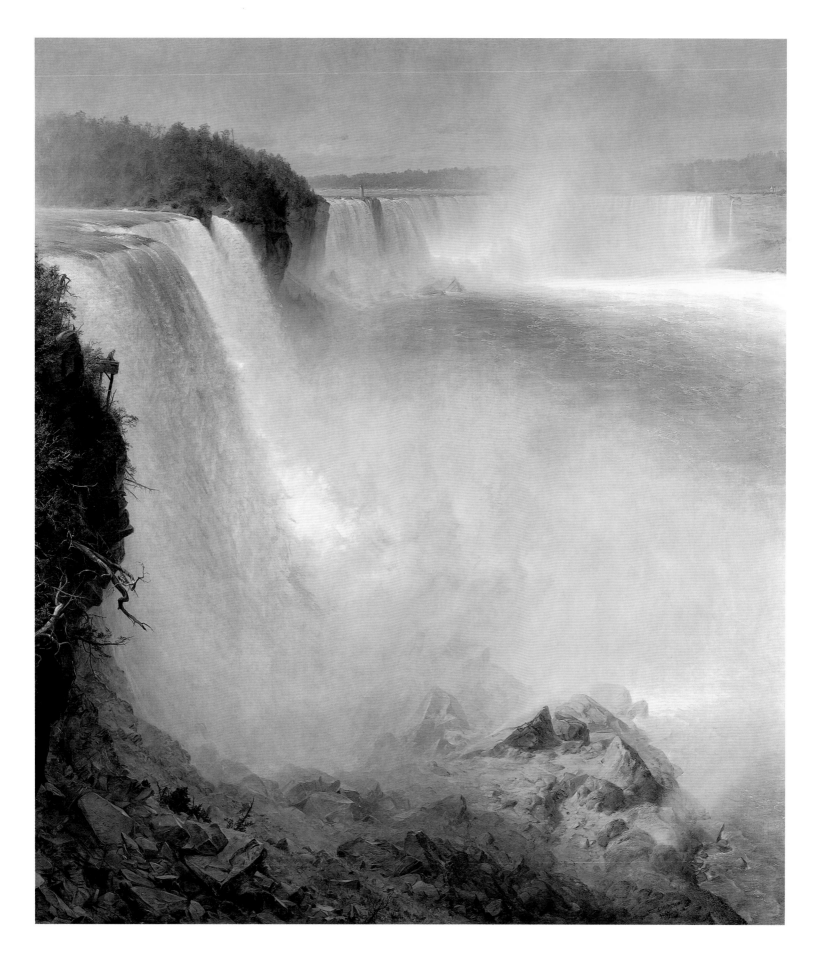

46 Frederic Edwin Church, *Niagara Falls from the American Side*, 1867

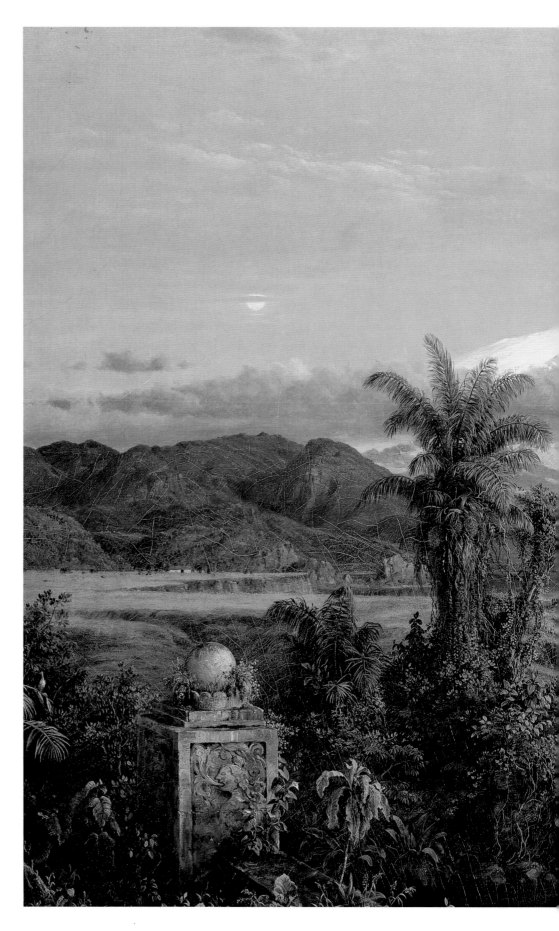

47 Frederic Edwin Church, *Cayambe*, 1858

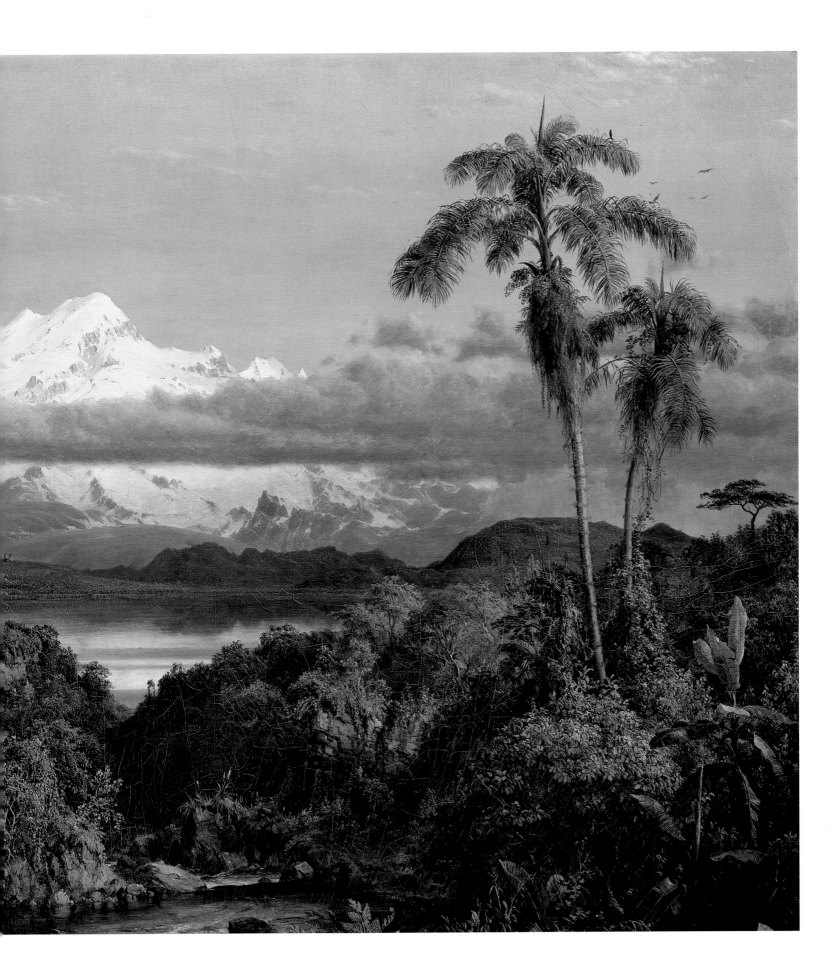

48 Frederic Edwin Church, *The Iceberg*, 1891

49 Thomas Worthington Whittredge, *Twilight in the Shawangunk Mountains*, 1865

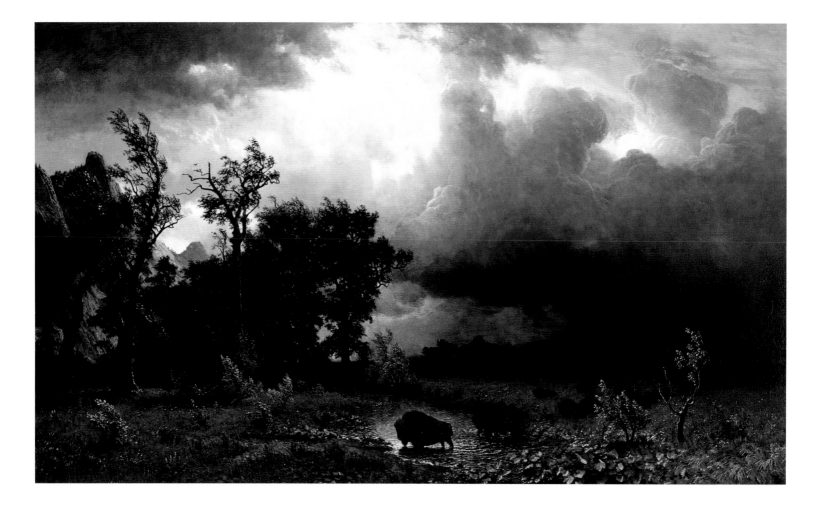

50 Albert Bierstadt, *Buffalo Trail: The Impending Storm (The Last of the Buffalo)*, 1869

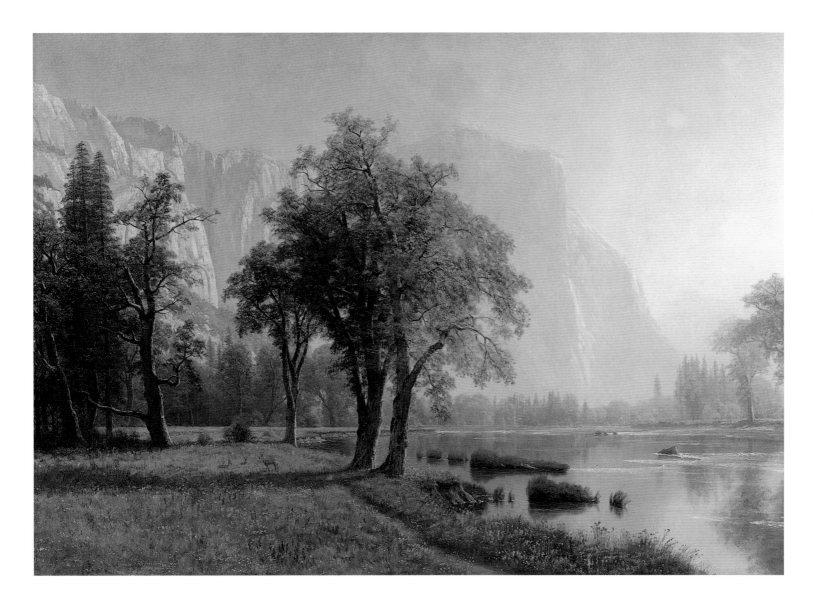

51 Albert Bierstadt, *El Capitan, Yosemite Valley, California*, 1875

The Myth of the West

As a promise of progress and of future happiness, the West made a lasting impression on American thinking from the beginning of the settlement of North America and is linked inseparably with the development of the United States. Whereas the old and often corrupt was to be found in the East in the colonial period (with reference to England or Europe) as well as later periods (with reference to cities and cultivated territories on the East Coast)—the West offered inexhaustible abundance, the promise of new beginnings and realization of the boldest dreams and ideals. Henry David Thoreau wrote that he only went east if he was forced to, but that he went west of his own free will; that people were going west because they were going toward the future in a spirit of enterprise and adventure. The world was the new continent, and its potential infinity toward the west determined thoughts and feelings.

In the eyes of Americans, the new continent was waiting to be transformed into a blossoming garden. Thus, the frontier, and with it the mythical West and the wilderness, shifted ever further westward. Once the Adirondacks, Catskills, and Alleghenys had been settled, the frontier was seen as lying further to the west. Then the Mississippi—which had initially seemed a natural limit—was crossed, and finally, with the help of the railroad, the step across the Great Plains and Rocky Mountains to the far coast of the continent was taken.

If, initially, the new land represented promise and its exploitation a divine gift, in the late 1830s and the 1840s there was a growing conviction that this was divine destiny, the fulfillment of a sacred duty. Alexis de Toqueville quoted an American in the mid-1830s as believing that, since God had denied the original inhabitants the capacity for civilization, he had predestined them to inevitable decline, and that the true owners of the continent were those who knew how to use its riches. In 1845, the publisher John O'Sullivan coined the term "manifest destiny" for this conviction. And emotionalism about the legitimacy of acquisition of the land and the wiping out of its indigenous peoples began to become heated. In 1846, the journalist William Gilpin

wrote in a report for the American Senate: "From nothing we have become 20,000,000. From nothing we are grown to be in agriculture, in commerce, in civilization, and in natural strength, the first among nations existing or in history.… The untransacted destiny of the American people is to subdue the continent—to rush over this vast field to the Pacific Ocean—to animate the many hundred millions of its people, and to cheer them upward … to teach old nations a new civilization—to confirm the destiny of the human race … to emblazon history with the conquest of peace … and to shed blessings round the world.… Divine task! Immortal mission! Let us tread fast and joyfully open the trail before us! Let every American heart open wide for patriotism to glow undimmed, and confide with religious faith in the sublime and prodigious destiny of his well-loved country."

In the first half of the nineteenth century, fine art had tried to present achievements in the cultivation of the land. The fact that the expansion westward was accompanied by considerable destruction of nature and by the expulsion or extermination of Native Americans was ignored for the most part in art. At most, Native Americans were included as props to indicate wilderness. Yet we owe a major part of current knowledge about indigenous culture and forms of life to a few painters from the first half of the century. Paradoxically, this is also the only way that the present-day descendants of many tribes know anything about the traditions of their ancestors. Apart from John Wesley Jarvis, Charles Bird King, and the Swiss Karl Bodmer, who accompanied Prince Maximilian zu Wied on an expedition through North America from 1833 to 1835, it was primarily the American George Catlin who recorded the dress, customs, and prominent personalities of many Native American tribes along the Missouri in his pictures. Catlin was the first painter to go to the West. In 1826, in Philadelphia, he saw Plains Indians for the first time—a delegation en route to Washington—and under the fascination of this impression wrote that the history and customs of these people were subjects worthy of a man's lifelong labor. He was fully aware of the decline in native culture. As he

wrote, the white settlers had interfered with their rights, undermined their moral code, grabbed their land, and changed their way of life, which was thus lost to the world. He wanted to do everything he could, using his artistic skills, to record as much as possible of their life for posterity.

Catlin made inquiries of William Clark, who together with Meriwether Lewis had undertaken the famous expedition to discover a land route to the Pacific coast in 1803–04, and Clark took him along on a trip to Wisconsin. In 1832, Catlin finally went on his first painting expedition. For three months, he traveled aboard the paddle-steamer *Yellowstone* as it followed its route almost a thousand miles up the Missouri, and worked feverishly, recording portraits, buffalo hunts, and religious ceremonies, as well as keeping a diary. The fruits of this and further journeys (he had already visited forty-eight tribes by 1840) were hundreds of pictures which he later took around the country as his touring "Indian Gallery." In 1839 he showed them in London, in 1844 in Paris, and two years later he again exhibited two of his pictures at the Salon in Paris with great success: they made a big impression on Charles Baudelaire and Eugène Delacroix.

Catlin's painting style was still entirely that of early American portrait painters such as Thomas Sully. Whereas Bodmer was more concerned with recording details of clothing, body paint, or settlement forms because of his patron's ethnographic interests, Catlin tried to produce likenesses of the leading Indian figures he encountered and convey their "quiet and stoic dignity," which had always impressed him.

Around mid-century, however, pictures of the noble savage were no longer in demand. Instead the distorted image of the brutish, lying Indian with whom there was no point in concluding treaties because of his unreliability was now disseminated. A good example of this is Charles Wimar's *Abduction of Daniel Boone's Daughter by the Indians* (plate 60). Wimar followed the worst sort of propaganda, namely the allegation that Native Americans carried off white women and raped them, forcing their way of life on them so that such women

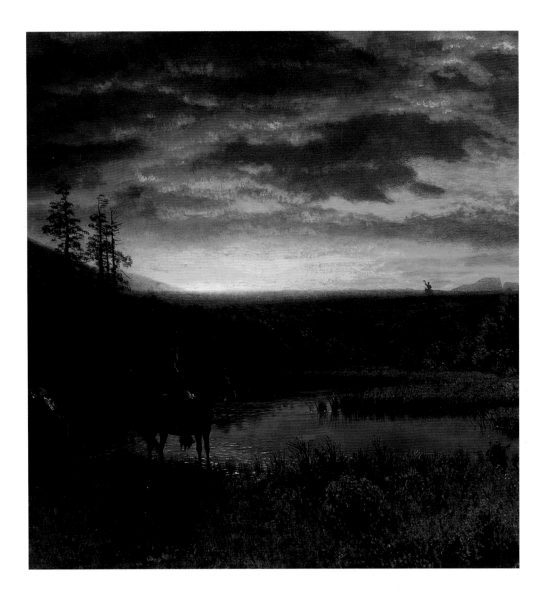

Albert Bierstadt,
Evening on the Prairie,
detail, c. 1870

not only lost all shame but also their language. Recent publications have pointed out that this picture contains indications of an imminent rape. Thus, her entreaties can be understood not just as a plea for mercy but also as a prayer to be saved from violation.

Catlin's Indian Gallery had paved the way and brought this subject to the attention of other painters. Charles Deas, too, went west to paint pictures of Native Americans. But usually their treatment in art had other intentions, diametrically opposed to Catlin's concerns: one reason was that this was an increasingly popular theme; another, often blatant, reason was legitimation of the extermination of the indigenous tribes. Thus, from mid-century, there also existed the cliché of the doomed Indian, usually portrayed with false and pitiless emotion (see fig. 8, p. 28).

It was otherwise with the white people living on the frontier: trappers and scouts, settlers on the dangerous route to the new settlement areas in the West, and raftsmen

on the Missouri and the Mississippi became personifications of the American pioneer spirit. For decades, such figures served as vehicles for self-interpretation, at a time when the country was seeking a collectively valid image of what was authentically American as a consequence of far-reaching social turmoil following the Civil War and galloping industrialization. Thus, the buyers of Bingham's pictures of life in the West (see plate 58) were affluent East Coast businessmen who nostalgically looked to the past to answer the question as to their identity. When Bingham painted his raftsmen, they had already disappeared from the rivers, their work now carried out by steamers.

Arthur Fitzwilliam Tait, who grew up in England, had probably already seen Catlin's Indian Gallery in Liverpool in 1843 and was later able to study prints of the latter's paintings in the New York Public Library. He never set foot in the West, basing his pictures on the work of other painters or on the stories and travel descriptions of those who had seen the West.

Thus, it was not only in 1893, when the historian Frederick Jackson Turner declared the western frontier closed and the conquest of the continent completed, that the West became merely a matter for nostalgia. Painters such as Frederic Remington or Charles Schreyvogel could still live well from the myth of the West. For the nation which until then had seen itself as an organism in constant expansion, the wilderness continued to be significant.

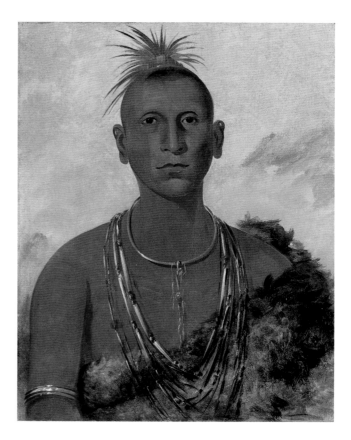

52 George Catlin, *Steep Wind,*
a Brave of the Bad Arrow Points Band, 1832

53 George Catlin, *Whirling Thunder,*
Eldest Son of Black Hawk, 1832

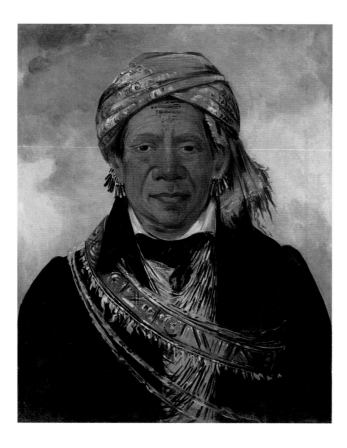

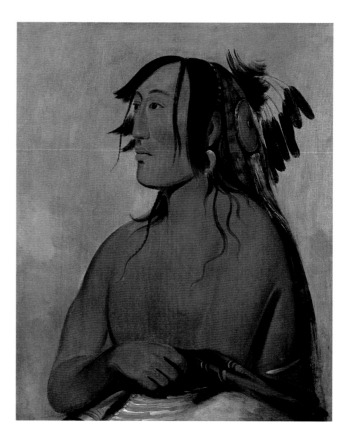

54 George Catlin, *Bód-a-Sin, Chief of the Tribe,* 1830

55 George Catlin, *Two Crows, the Younger,* 1832

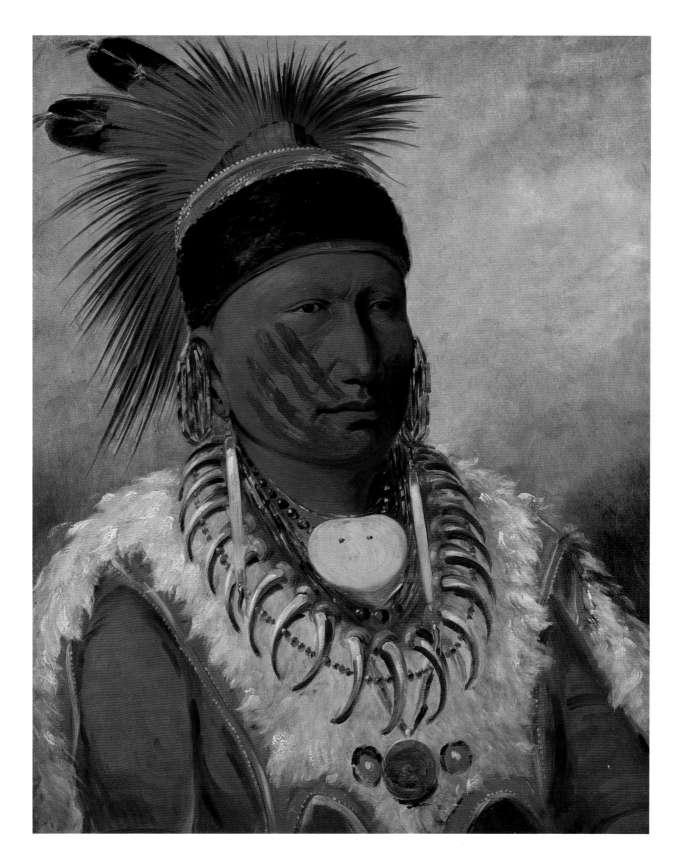

56 George Catlin, *The White Cloud, Head Chief of the Iowas*, 1844/45

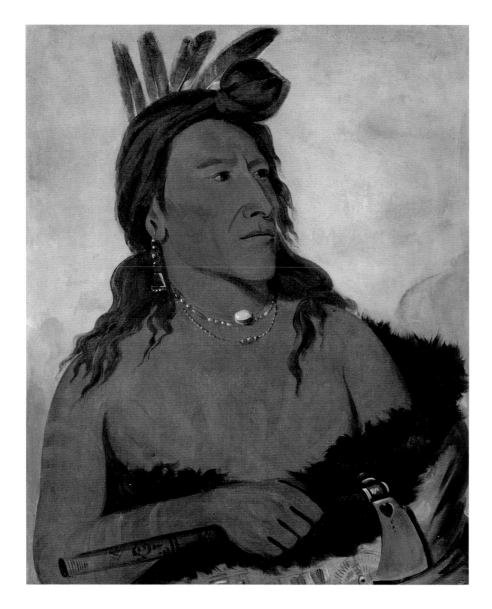

57 George Catlin,
Little Bear, a Hunkpapa Brave, 1832

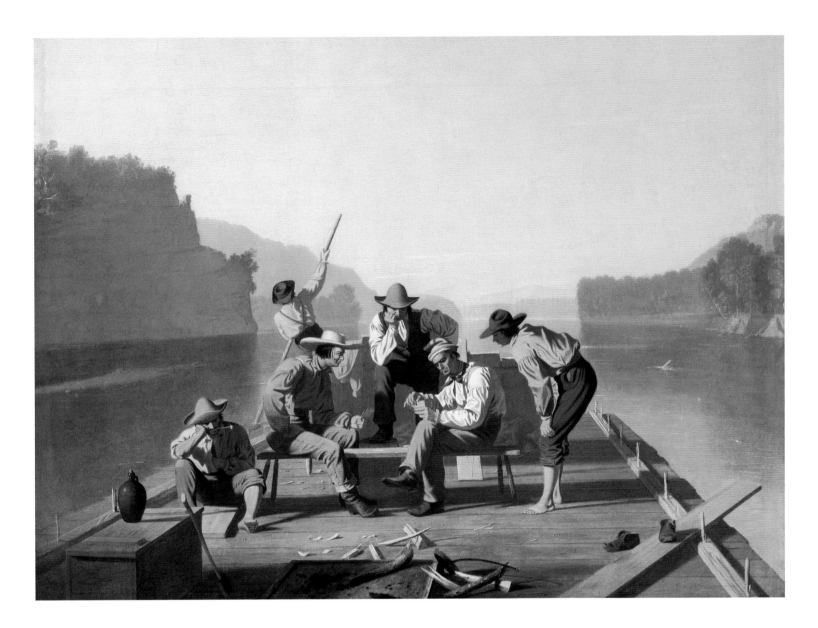

58 George Caleb Bingham, *Raftsmen Playing Cards*, 1847

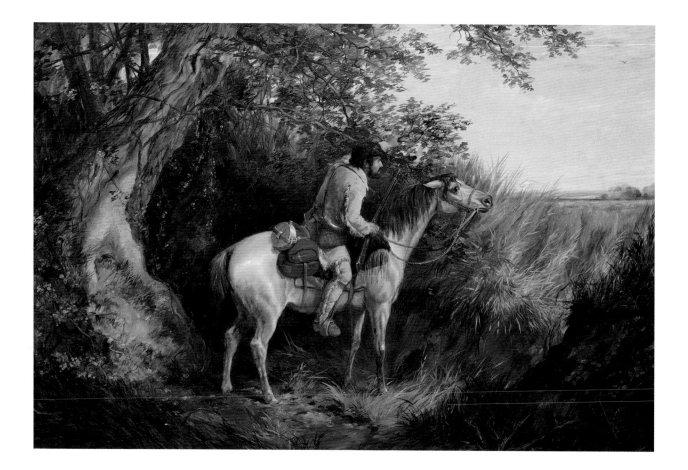

59 Arthur Fitzwilliam Tait,
Trapper Looking Out, 1853

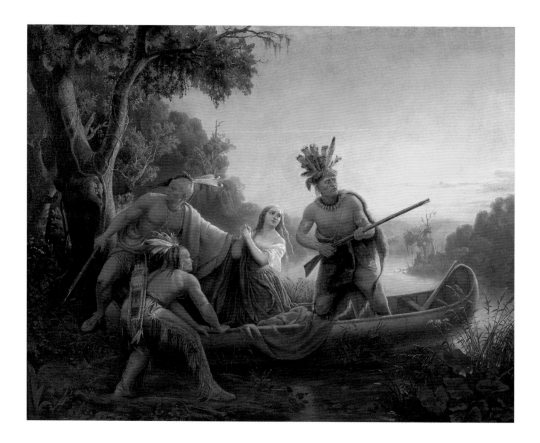

60 Charles F. Wimar, *The Abduction of
Daniel Boone's Daughter by the Indians*, 1853

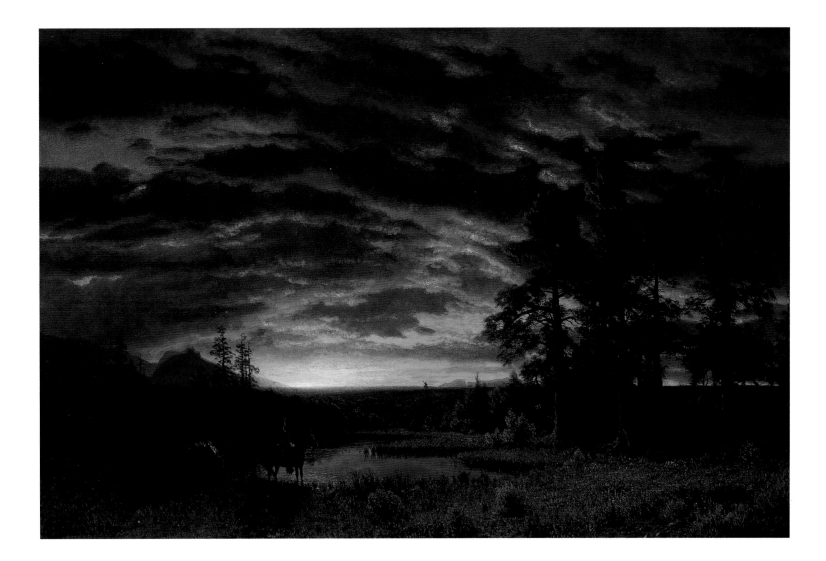

61　Albert Bierstadt, *Evening on the Prairie*, c. 1870

The Civil War and the Brown Decades

The dimensions of the American Civil War remain inconceivable. The conflict between the southern states, which founded their own confederation, and the northern states, which did not want to permit any such secession, brought about the death of 600,000 people and thus claimed more victims than all other American wars together up to the present.

The war was waged with an inexorability that has not yet fully allowed the wounds to heal. It was not just that new arms technologies such as rapid-fire rifles, or technical aids such as the railroad were used strategically, resulting in a higher death toll and a greater radius affected. Toward the end, the war became an out-and-out annihilation of the South. There were horrific destructive rampages such as that of General Philip Henry Sheridan in the Shenandoah Valley, or that of General William Tecumseh Sherman through Georgia.

The latter, with his 60,000 men, razed all dwellings, agricultural equipment, and factories from Atlanta to the sea, in a strip just sixty miles wide and three hundred miles long.

In the fine arts there was hardly any reflection of the Civil War. It was largely left to photography to document the horror in its after-effects following battles.

One exception was the work of Winslow Homer, who had trained as a commercial artist and was sent by *Harper's Weekly* as a war reporter to the arenas of the Civil War in 1861.

His pictures mostly present scenes from behind the lines, with a few powerful figures and little action. But *Sharpshooter*, probably Homer's earliest oil painting, in its objective, unheroic representation, conveys a sense of shock at the increasing anonymity of killing and dying. Homer wrote of it that sharp-shooting "struck me as being as near murder

as anything I could ever think of in connection with the army & I always had a horror of that branch of the service."

The slave question was undoubtedly one of the most important of the many factors leading to the Civil War. Painting had tackled this subject repeatedly prior to its outbreak. It is true that artists usually avoided addressing the misery of the slaves' living conditions or the injustice of it all, but there are allusions to it in the ripped clothes in the pictures of Richard Caton Woodville or later Eastman Johnson (plate 71), as well as in portrayals of flight to the North and similar themes.

Genre painting in particular frequently dreamed up a situation in which the racial separation had been overcome. This is seen particularly impressively in William Sidney Mount's *The Power of Music* (below), in which the power and beauty of music unite people

William Sidney Mount,
The Power of Music, 1847,
oil on canvas, 45.2 x 53.3 cm,
The Cleveland Museum of Art,
Leonard C. Hanna Jr. Fund

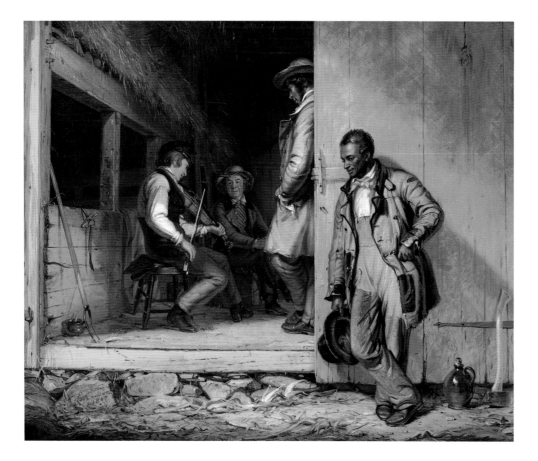

in its honor even though they are still separated by unjust barriers.

After the war it was again Homer who, in contrast to the existing pictorial tradition, portrayed blacks for the first time in monumental form and with dignity. Here again he benefited from his acutely observant eye, drawing the figures with great naturalness and without prejudice.

America would have to suffer the consequences of the Civil War for a long time. The gulf between North and South was now economically greater than ever; hundreds of thousands of mercenaries were suddenly out of a job, and liberated slaves were faced with increasing racism.

At the same time, the entire country began to undergo dramatic changes. Cities grew at an enormous speed, ever longer railroad networks crisscrossed the land, and a lightning-fast process of industrialization commenced, in its turn uprooting many people or leaving them spiritually homeless.

It was a time that Lewis Mumford christened the "Brown Decades," in reference to the predominantly dark, often brown, tones of contemporary pictures, the massive, imposing buildings, but also the brooding mood of the thinking of those decades. It was a time which laid increasing value on material affluence and also liked to display it.

Fine art reacted to all of this with nostalgia, with a retreat into the private domain and, initially, with a thorough screening-out of the changing reality (in contrast to what was happening in literature). Obviously, no one had any immediate answers to urgent questions of new orientation, other than a return to established life-styles which embodied the American virtues and in which, people assumed, lay the roots of a common American identity. People believed they had again found a direction to follow in the recollection of traditional values, such as those of farmers, who lived at one with nature and in harmony with one another, and who had built up the New World as an ideal counter-image to the old, corrupt one, in their sense of family, their patriotic loyalty, and their modesty. A series of pictures of rural life such as Homer's *Man*

with a Scythe (plate 66), *Milking Time* (plate 67), and, to a certain extent, *Watermelon Boys* (plate 68), personify this spirit, partly as a result of their sense of great peace and harmony—particularly impressive in *Milking Time,* in the still of evening.

Besides this "golden age of farming," it was the safe world of children which evoked an untarnished era before the loss of innocence and left its mark on a large number of pictures: see, for example, *Snap the Whip* (plate 65), *The Boyhood of Abraham Lincoln* (plate 70), *Watermelon Boys, Beach Scene* (plate 76), *Back from the Orchard* (plate 72), *In the Hayloft* (plate 73), as well as *Milking Time.* At the same time, these presented the new generation as America's hope.

This was simultaneously a time of sensitivity, in which idealization of the female, a feature of American art up until the turn of the century, had its beginnings: a counter-image to the martial male capable of causing so much damage.

The greater the time elapsed since the Civil War, the greater became the pluralism of styles (undoubtedly also reflecting European tastes), and individual, clearly divergent interpretations took the place of great, uniform movements. One need only think of such diverse artistic personalities and their work as Homer and Thomas Eakins. A new optimism was expressed in their paintings, whether through the frontier spirit being kept alive, as in Homer's work, and man regaining his proper dignity in the confrontation with nature, or through the belief in good progress finding its expression in the fascination with science.

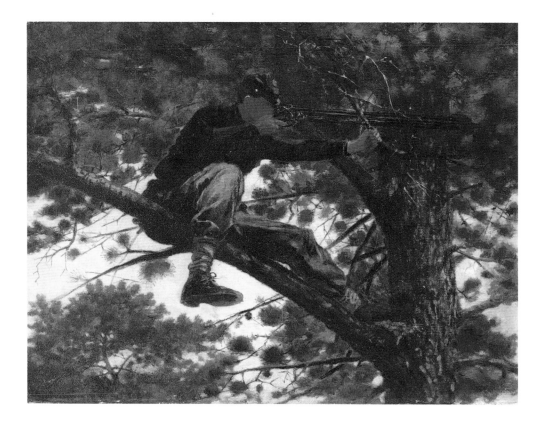

62 Winslow Homer, *Sharpshooter*, 1863

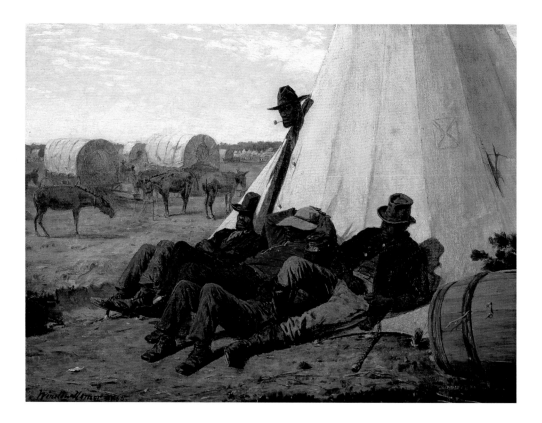

63 Winslow Homer, *The Bright Side*, 1865

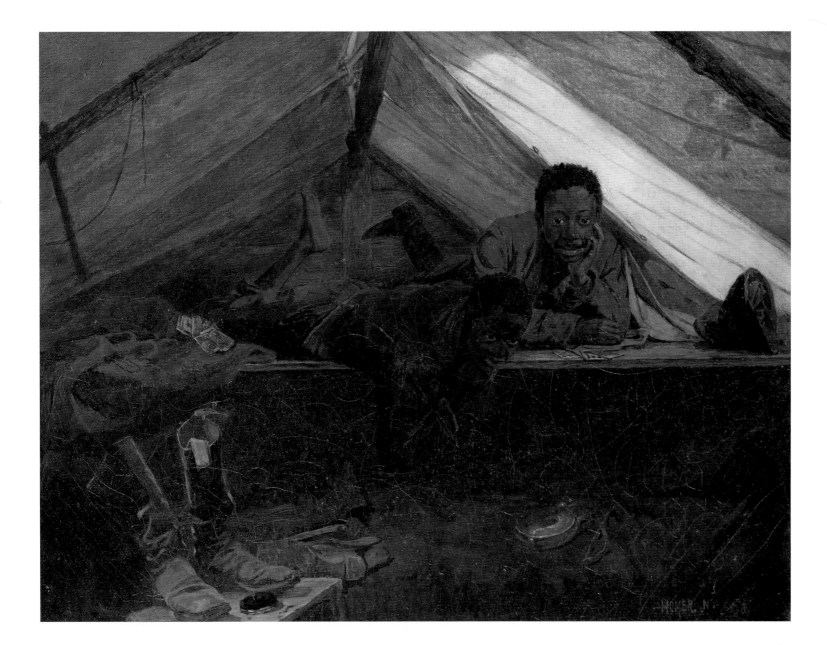

64 Winslow Homer, *Army Boots*, 1865

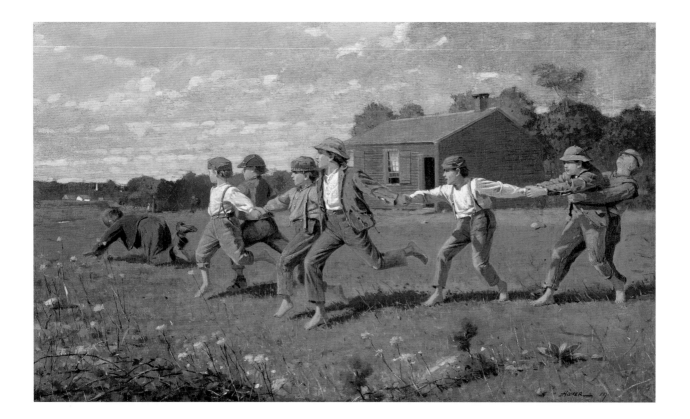

65 Winslow Homer, *Snap the Whip*, 1872

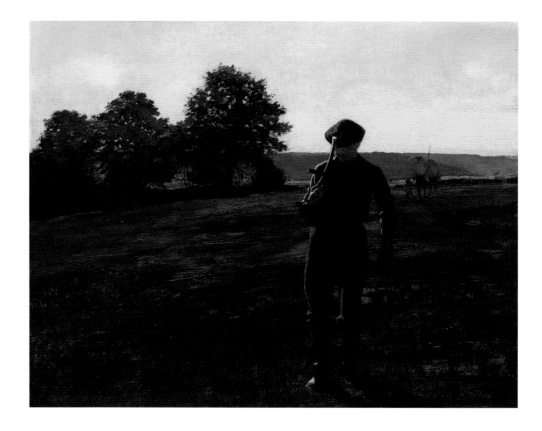

66 Winslow Homer, *Man with a Scythe*, c. 1867

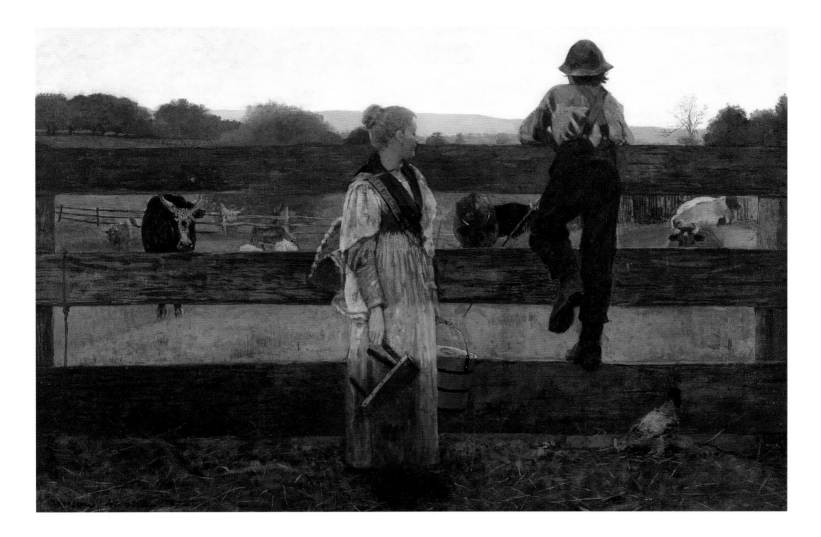

67 Winslow Homer, *Milking Time*, 1875

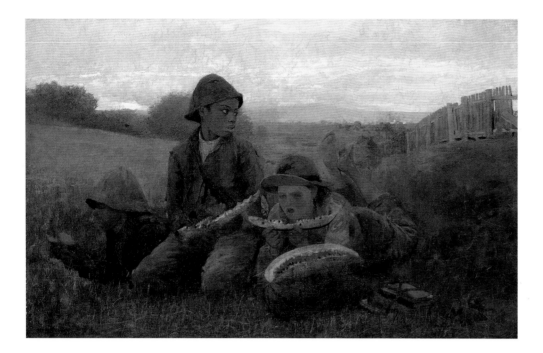

68 Winslow Homer, *Watermelon Boys*, 1876

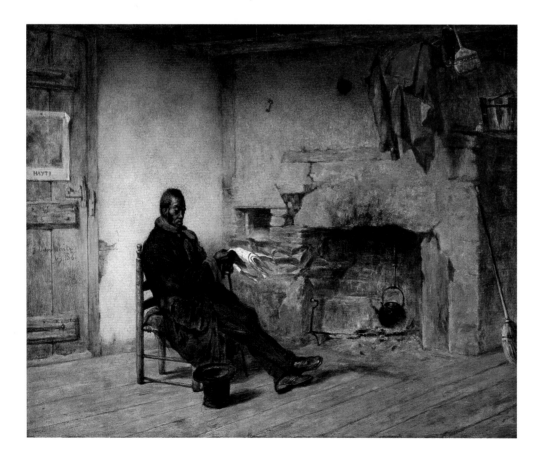

69 Edwin White, *Thoughts of Liberia: Emancipation*, 1861

70 Eastman Johnson,
*The Boyhood of Abraham
Lincoln*, 1868

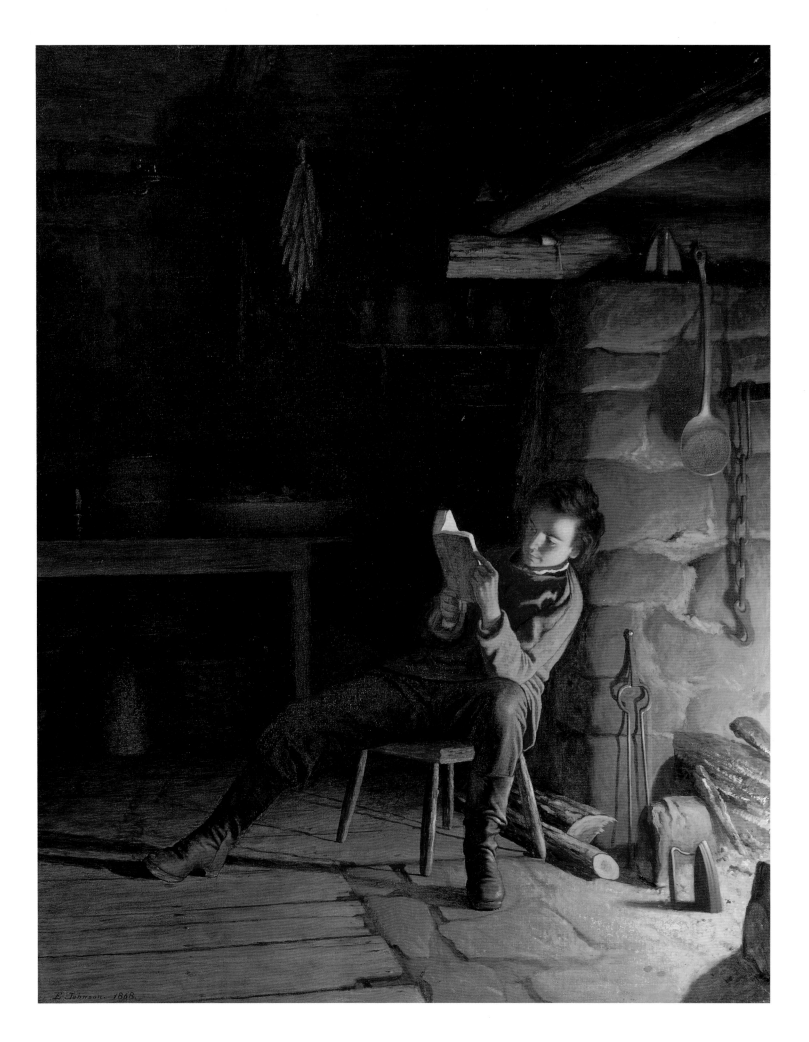

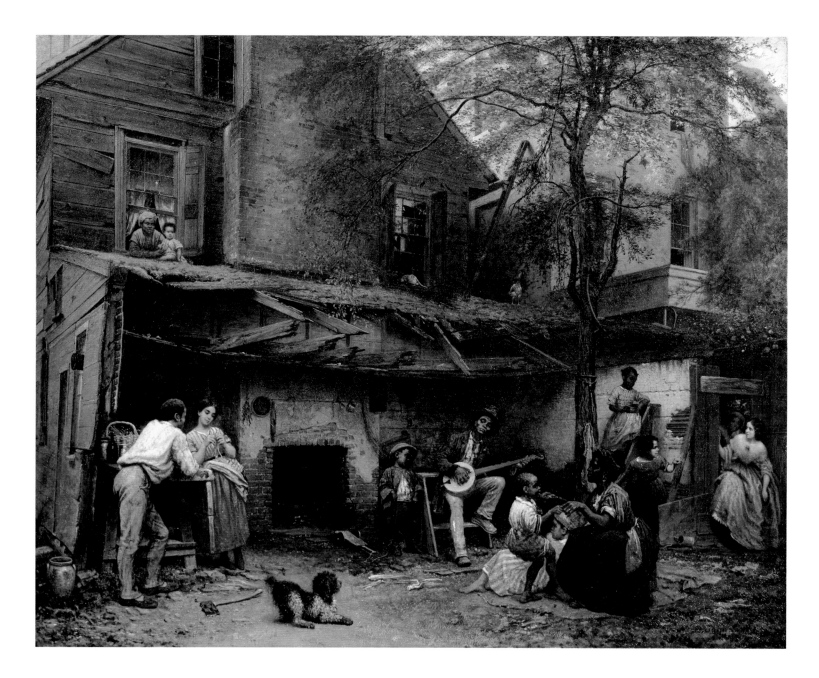

71 Eastman Johnson, *Old Kentucky Home—Life in the South*, 1859

73 Eastman Johnson, *In the Hayloft*, c. 1877/78

72 Eastman Johnson,
Back from the Orchard, 1876

74 Winslow Homer, *Portrait of Helena de Kay*, c. 1873

75 Thomas Worthington Whittredge,
A Window, House on the Hudson River, 1863

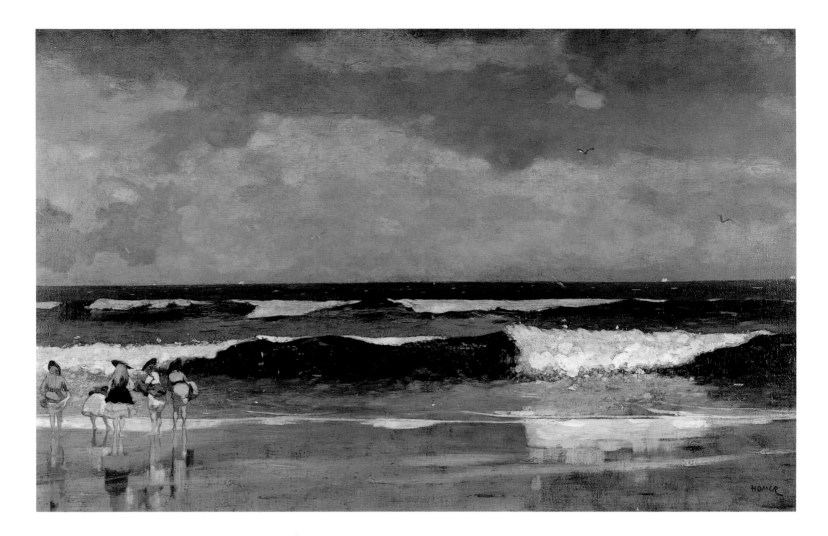

76　Winslow Homer, *Beach Scene (On the Beach)*, 1869

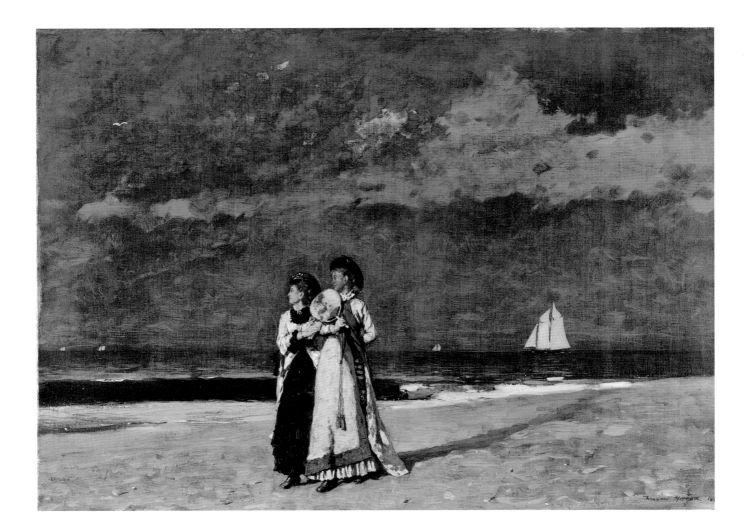

77　Winslow Homer, *Promenade on the Beach*, 1880

Man and Nature in the Work of Winslow Homer

The work of Winslow Homer, probably the most important American painter besides Frederic Edwin Church and Thomas Eakins, reflects the ambivalences and the longings of Americans—particularly through the image of him that the American public has created for itself since the end of the nineteenth century. For Americans, Homer epitomizes a strong, nature-loving individualist who tried to get close to the forces of nature and withdrew from the noise and ambition of the cities to the solitude of the rough Atlantic coast of Maine in order to observe the elementary forces of the sea, devoting himself completely to the artist's life.

Homer's art is rarely sentimental, and in many cases it is full of a great calm or inner equilibrium, whether portraying a boy lying in a meadow, lost in reverie, women sitting at a window, or the tumult of the Atlantic's gigantic breakers.

Even if his pictures following the Civil War were primarily portrayals of American life, often conceived with a completely new kind of directness, over the course of the years they became ever stronger existential statements. They dealt with life as a stand against nature that was powerful, at times heroic, at times indifferent, but always magnificent.

Homer's eighteen-month stay in the English fishing village of Cullercoats near Tynemouth from 1881 to 1882 marks a departure from his earlier work. There he became familiar with the arduous life of the fishermen, the ever-present dangers of their occupation, as well as the courage of these seamen and their wives. Their constant struggle with the sea became the subject matter that Homer would pursue for the last three decades of his life. Whereas he had previously taken the figures in his pictures from life and shown them in natural movement, he now began to monumentalize them.

On returning to the United States, Homer continued in this vein until in 1875. In that year, his brother drew his attention to Prout's Neck, a tiny fishing village on the Atlantic seaboard of Maine, where the former had spent his honeymoon. Finally, in 1883, Homer made the decision to relinquish his studio in New York and move to Prout's Neck, where

he lived until his death. He had a shed by the family house converted into his studio and a broad balcony running around two sides added to the first story so that he could always see the sea. Only occasionally was his life on the coast interrupted by hunting excursions with the North Woods Club in the Adirondacks or by journeys to the Caribbean, Florida, or New York. As Prout's Neck became increasingly frequented by Bostonians seeking rest and relaxation, Homer was probably only able to enjoy relative solitude during the winter months.

People or animals struggling for existence—these were the themes that he depicted repeatedly: rescue operations for seamen in distress, the peril of approaching fog for a solitary fisherman, the agitated wanderings of a starving fox in a winter landscape under deep snow, with black crows, just as hungry, over its head. And, always, Homer created images of the sea in its inexhaustible new moods—the surf of November storms particularly impressive among them.

Here, in the depiction of water and its sundry phenomena, Homer achieved a mastery that would never be emulated. He knew the sea like no other, since he observed it incessantly, and could therefore capture its glitter, its menacingly rough surface, its transparency, or the compact power of its breakers with supreme skill, reproducing the quiet tones of shimmering water on a moonlit night or the heroic thunder of towering spray on a wild and merciless night in lyrical paintings. It was as if he were studying a beauty that constantly presented new images of itself.

Homer's oil paintings were executed directly beside the sea, which also explains the detailed foregrounds. The painter understood his work as faithfully reproducing naturalism and therefore answered decisively in the negative when asked whether he had ever altered colors for the sake of the composition of a picture.

He often chose a lower viewpoint, near the surface of the water, in order to bring the viewer even closer to the action. Towards the sides of his paintings there are no compositional limits, so the picture seems wider and the intensity is deepened through the effect of cropping. To increase the tension of the

picture structure, there are frequently dramatic angles in the foreground.

Homer's pictures are much more subtle than they might appear at first glance. They arise from an extremely precise observation of nature, and their color nuances continue to amaze, even when the viewer encounters pictures believed to be already familiar. The images often also possess several levels of meaning which go beyond the pure representation of nature. Yet the sea does not stand for anything else but the empirically experienced world and the challenge of mastering it. At the same time, the pictures are marked by the artist's conviction that courageous action in the face of this indifferent natural force will be crowned with success. There could hardly be a greater contrast to the religious landscapes of such painters as Frederic Edwin Church or George Inness.

Winslow Homer, *Summer Squall*, detail, 1904

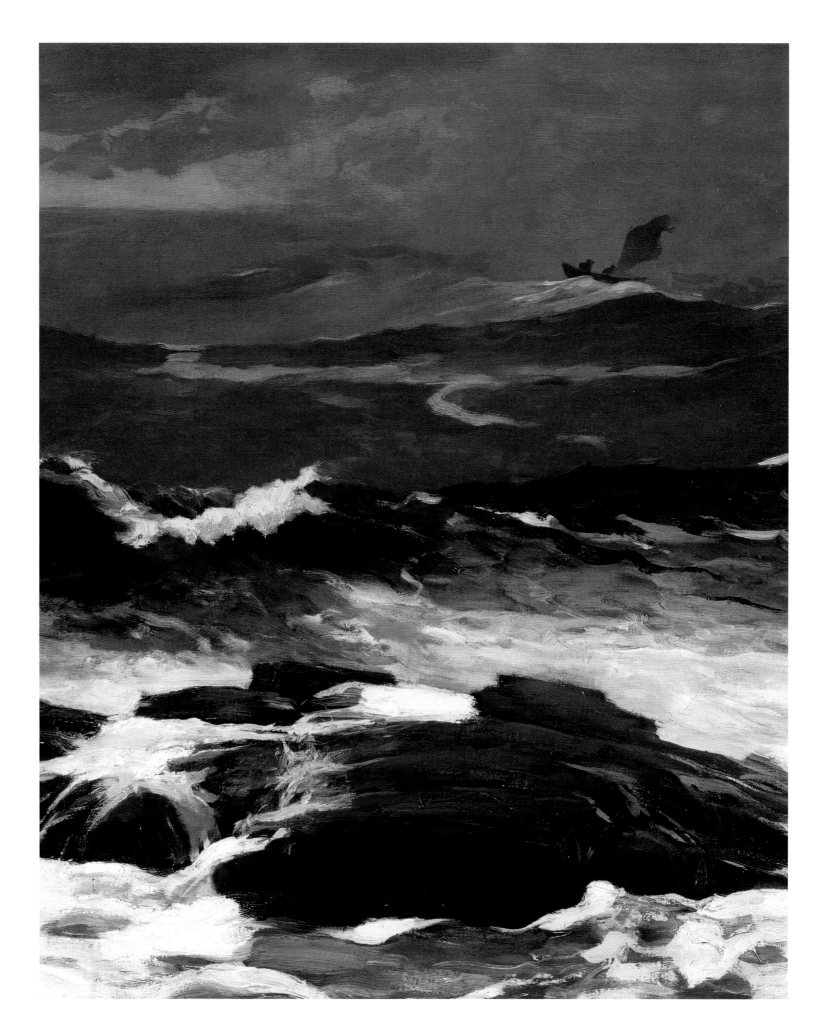

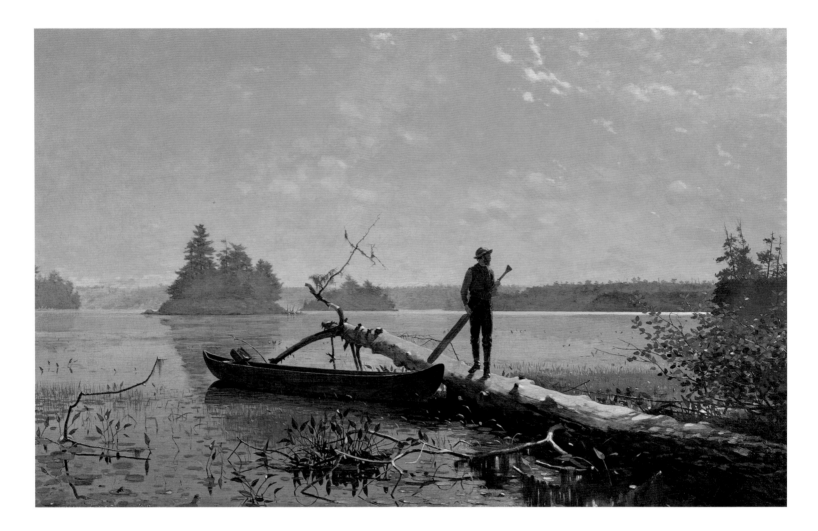

78 Winslow Homer, *An Adirondack Lake*, 1870

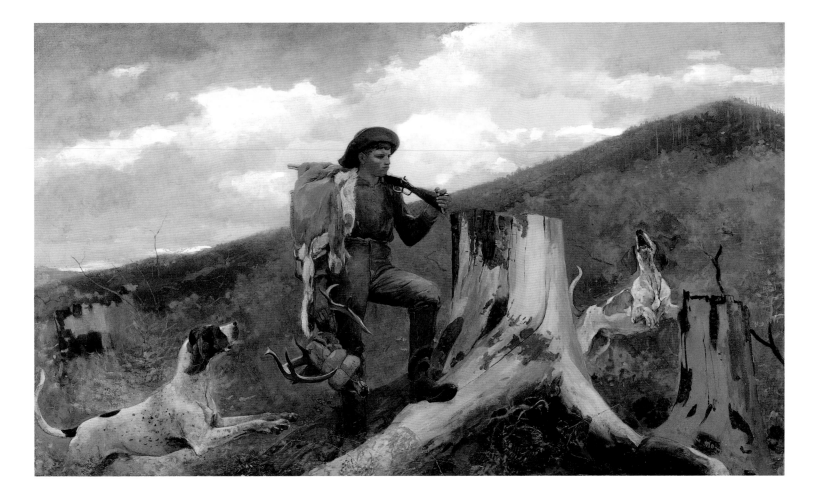

79 Winslow Homer, *Huntsman and Dogs*, 1891

80 Winslow Homer, *To the Rescue*, 1886

81 Winslow Homer, *Weatherbeaten*, 1894

82 Winslow Homer, *West Point, Prout's Neck*, 1900

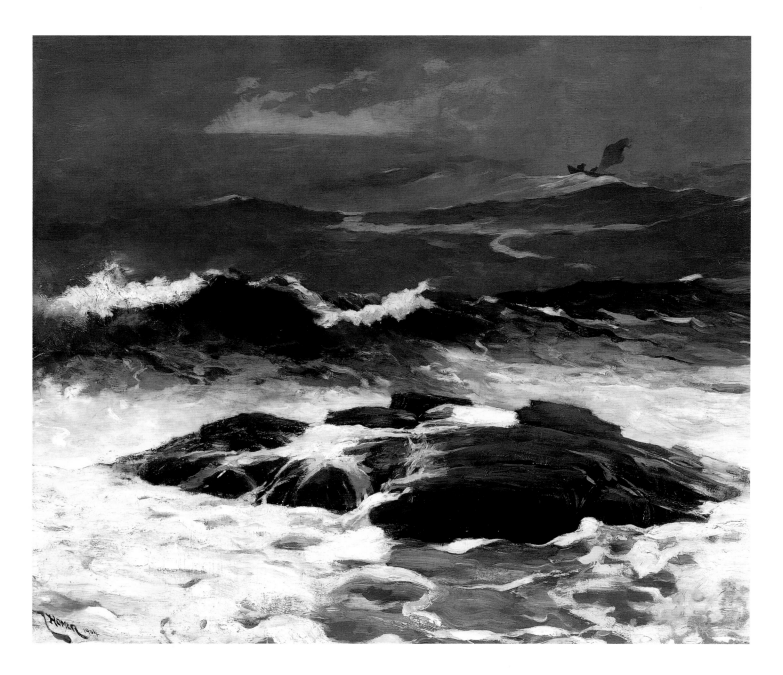

83 Winslow Homer, *Summer Squall*, 1904

The Fascination of the Empirical

Whereas Winslow Homer was successful in his own lifetime and eventually achieved fame in the 1890s, Thomas Eakins was denied general recognition all his life. This was partly due to his uncompromising artistic concept. Homer and Eakins, the two great realists of the late nineteenth century, stood at opposite poles: one was an individualist, pitting himself against nature, pursuing the old frontier ideal, while the other remained associated with the sophisticated, educated classes of Philadelphia (from which he came) and was interested in science, culture, and sports. Roughness and directness of style based on precise observation determined the one; cool and precise construction, exact calculation, and the belief in science and in rationality determined the other.

For Eakins, realism had the status of a creed. With scientific solemnity he devoted himself to his subjects, constructed his pictures meticulously, and reproduced surfaces with extreme accuracy. "Painting is an essentially concrete art and can only consist of the presentation of real and existing things. It is a completely physical language, the words of which consist of all visible objects; an object which is abstract, not visible, nonexistent, is not within the realm of painting."

Eakins had become interested in the natural sciences during his schooldays. Besides his artistic training at the Pennsylvania Academy of the Fine Arts, he later also studied at the Medical College, took anatomy courses, and became a pathologist.

As a result of his studies with Jean-Léon Gérôme in Paris, he eventually acquired the necessary academic rules to work his knowledge and earlier studies into a picture.

Eakins' carefully laid out pictures were detailed to the last degree and had nothing of the anecdotal about them. The painter was solely striving to achieve a greater truthfulness by means of their accuracy. "The big artist does not sit down monkey-like & copy a coal-scuttle or an ugly old woman," he said in 1868, "but he keeps a sharp eye on Nature & steals her tools. In a good painting you can see what o'clock it is afternoon or morning, if it's hot or cold, winter or summer, & what kind of people are there & what they are doing & why they are doing it."

The poet Walt Whitman, whom Eakins both painted and photographed, and who eventually became his close friend, expressed in *Leaves of Grass* of 1891–92 in essence what determined Eakins' work: "The Old World has had the poems of myths, fictions, feudalism, conquest, caste, dynastic wars, and splendid exceptional characters and affairs, which have been great; but the New World needs the poems of realities and sciences and of the democratic average and basic equality, which shall be greater. In the center of all, and object of all, stands the Human Being, towards whose heroic and spiritual evolution poems and everything directly or indirectly tend, Old World or New."

It was painting of the present day, of modern life, that Eakins wanted to create, like a documentary, correct, and unsentimental. Again and again he painted scientists and doctors, often in their work setting. His most famous picture remains *The Gross Clinic*, a hymn of praise to modern science and, at the same time, one of the most impressive examples of an unconditional realism that reported everything and hid nothing (see fig. 10, p. 49).

This was also true of his teaching methods. Tirelessly he encouraged his students to paint from the living model. In life classes he did not follow the customary rules of decency, getting nude models to pose in front of mixed-gender classes, for which he was reprimanded on several occasions. When, in 1886, he removed a male model's loincloth in front of a mixed class, he was forced to resign his post as director of the teaching department. He was not reinstated, despite the protests of fifty-five of his students.

Eakins wanted to offer a valid picture of modern America. He advised his students in Philadelphia: "If America is to produce great painters and if young art students wish to assume a place in the history of the art of their country, their first desire should be to remain in America to peer deeper into the heart of American life."

Apart from his studies in Paris and a study trip to Spain on which he studied works by Ribera and Velázquez, Eakins lived, worked, and taught exclusively in Philadelphia. A generation later, the young painters of the Ashcan school would take such ideas further and create a decidedly contemporary and American art through depicting everyday life.

For Eakins, painting signified conscientious construction. This was particularly the case for his pictures of ocean-going yachts or rowboats. An enthusiastic sportsman who went sailing on the Delaware, hunted in the marshes, and was also a member of a rowing club on the Schuylkill River in Philadelphia, he expended a great deal of energy in preparing his depictions of sailing boats or his famous oarsmen. He attempted to capture every detail, reflections and mirror-images, in innumerable sketches and to understand problems of perspective in meticulous constructional drawings that were the result of exact calculation. "I know of no prettier problem in perspective, than to draw a yacht sailing," he once told his students. ". . . [A] boat is the hardest thing I know to put into perspective. It is so much like the human figure, there is something alive about it. It requires a heap of thinking and calculating to build a boat."

Thomas Eakins was undoubtedly the most important American portraitist of the nineteenth century, and this is no coincidence, since man always stood at the center of his creative art and formed the core of his analysis of reality. Only about a tenth of the more than 240 portraits that he painted were done on commission. The rest were the result of his own initiative, as he asked friends or acquaintances to sit for him. Usually he offered the sitter the finished picture, but frequently they were rejected or later destroyed because of their directness. In many of his portrayals of people, there prevailed a distant rationality, an almost scientific observation of the physiognomy, that went hand in hand with an uncompromising realism. Eakins denied his models the then customary protective arsenal of beautiful fabrics, splendid poses, or imposing interiors. Nobody could paint thinking, musing, reflecting people—the dignity of the human mind—like he did. This also applies to his portraits of women, which did not just fall back on the sensibility or aestheticism favored in those days but sought here, too, to capture personality.

In every respect, Eakins' art represented an irritation for his contemporaries: the people

Thomas Eakins, *Portrait of Henry O'Tanner*, detail, 1902

whose portraits he painted because, instead of glossing them over, he illuminated their weaknesses; and the affluent and the decision-makers because they did not want the realism of his depictions of modern life and science at a time when society was increasingly drifting apart, showing less solidarity, becoming more marked by social contrasts. Suppression in a prettifying and undemanding impressionistic style was dictated from all sides.

It was Eakins' tragedy that, despite all his efforts, he ultimately did not understand how to find a language appropriate to modern life. His concern—the validity of appearance and the real, and its precise construction using technical and scientific means—was outdated. The new era had developed technology, such as photography, which could achieve this perfectly. At the same time, the modern age was marked by movement, change, and intensity.

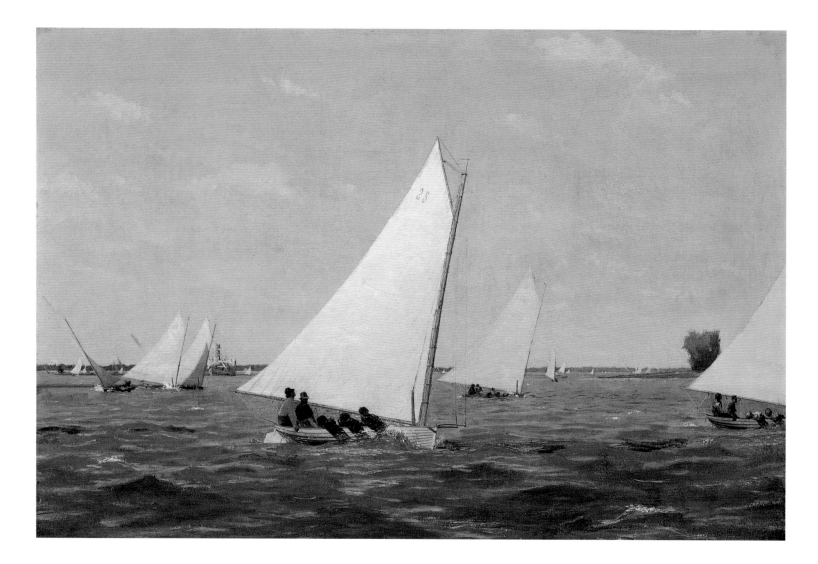

84 Thomas Eakins, *Sailboats Racing on the Delaware*, 1874

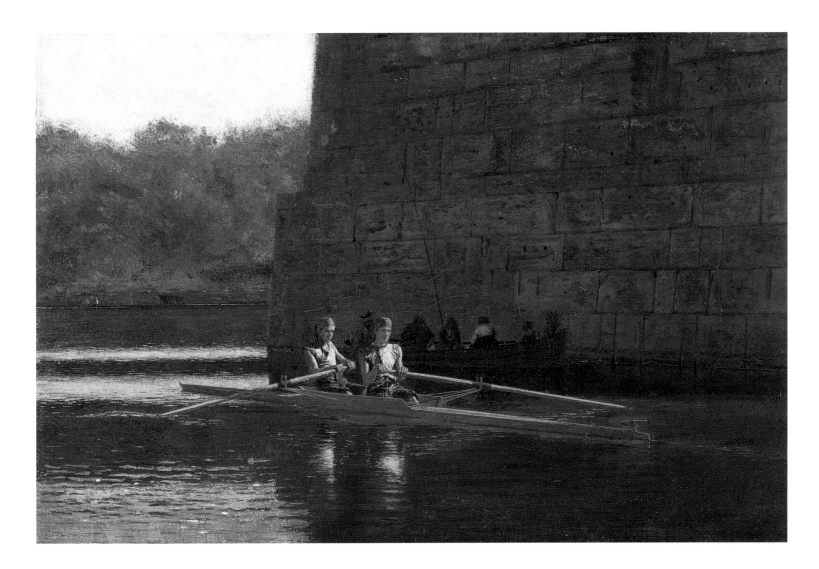

85 Thomas Eakins, *The Oarsmen (The Schreiber Brothers)*, 1874

86 Thomas Eakins, *Portrait of Charles Linford, The Artist*, c. 1895

87 Thomas Eakins, *Portrait of Henry O'Tanner*, 1902

88 Thomas Eakins, *Music*, 1904

Materiality and Illusion

Charles Willson Peale's *The Staircase Group* (see fig. 7, p. 37) had introduced a tradition of American art dedicated to a remarkable illusionism. Legend tells how George Washington, on entering the room, greeted Peale's two (painted) sons on the staircase, but there are reliable reports in the daily newspapers about the truly remarkable impression made by the still lifes of William Michael Harnett and his contemporaries.

These painters paid homage to an illusionism to which middle-class people who had only recently become prosperous were particularly receptive. These rising businessmen had no pronounced cultural taste trained in the styles of the past and found great aesthetic pleasure in this easily accessible manner of painting and its artistically deceptive reproduction. People loved the play with optical deceptions, and painters such as Harnett knew how to exploit this. It was therefore all part of the stage-management when a painting by Harnett was put under guard, as for example a journalist from Cincinnati reported in 1886 at the time *Old Violin* was exhibited: "So real is it, that [a guard] has been detailed to stand beside the picture and suppress any attempts to take down the fiddle and the bow.... Mr. Harnett is of the Munich school, and takes a wicked delight in defying the possibilities."

These still lifes were quite deliberately intended to deceive and impress. Unlike the simplicity and the often great intensity of American still lifes of the early nineteenth century, these were pieces done purely for show—brilliant trick pictures. Since painting that relied solely on optical illusion was not highly regarded at art exhibitions, Harnett, who had had this painful experience a few times, chose an unusual setting for the presentation of his pictures, in which they could display their full power of illusion. In order to reach an audience that was favorably disposed toward him and to reach potential buyers, he henceforth displayed them in department stores, bars, and jewelry shops. And the public was impressed. "The possession of this masterpiece alone should stamp its home as the 'Mecca' of art worshippers for many leagues around," wrote a journalist enthusiastically after

visiting Theodore Stewart's bar at 8 Warren Street, where *After the Hunt* (plate 91) was on display. "Hundreds of prominent citizens—artists, journalists, judges, lawyers, men about town and actors—visit this wonderful work of art daily, and wildly wager and express opinions as to its being an optical illusion or real painting."

The pictures by all the painters in this genre present simple, unpretentious, everyday objects, usually things that were used or were favorite possessions. Only very rarely, with the exception of savings bonds and banknotes, did the artists include props that were valuable or elaborate, as was the case with European still lifes of earlier centuries.

Quite deliberately, these were objects showing signs of wear and tear: "The chief difficulty I have found has not been the grouping of my models, but their choice," Harnett said on one occasion. "To find a subject that paints well is not an easy task. As a rule, new things do not paint well.... I want my models to have . . . the rich effect that age and usage gives."

Even though the objects depicted were only a few decades old, they already belonged to a past era, like *The Faithful Colt* (plate 95) hanging from a nail, which had been made in the 1860s, the time of the Civil War, and must have played a considerable role in the conquest of the West.

And yet it was more than just a picturesque patina that led to the selection of such objects. Harnett's pictures and those of his colleagues in this field appealed to the nostalgic feelings of a public that, in a rapidly changing society, felt the need for a spiritual home: the pictures conjure up a good old time, even if this was not so very long ago. At the same time, with their objects evoking leisurely enjoyment (letters, pipe, books, musical instruments), they correspond to a retreat into the world of domesticity, of self-contained prosperity, following the horrors of the Civil War.

Harnett was the least cryptic but, technically, the most complete trompe-l'oeil painter. He had studied in Philadelphia, the city with a still-life tradition marked by the Peale family, and had developed a certain skill in this genre. But only a period of study in Munich in the mid-1880s turned him into that for which he

achieved fame: a painter of meticulously executed still lifes, primarily trompe-l'oeil works, that reproduce surface qualities to perfection. The brush stroke has vanished in their finely modulated objects. To foster the illusion still further, things are depicted life-size, in flat spaces which appear to be continuations of the actual room.

Harnett's pictures invoke no excessive sensuality, nothing of suggestion, merely an ethos of directness and simplicity. He became known through a series of four pictures, mostly painted in Munich between 1883 and 1885, which he entitled *After the Hunt* (see plate 91). But he really became famous—with that notorious fame that boosts sales—when the tax authorities felt obliged to take steps against him and forced their way into his studio. In 1877, Harnett had created the first trompe-l'oeil portrayal of a banknote with his picture *Still Life—Five Dollar Bill*, which was followed by at least five others in subsequent years. The tax authorities suspected him of producing counterfeit money and, in 1886, instigated a raid on one of Theodore Stewart's New York bars in order to impound Harnett's picture of a five-dollar bill that was on display there. They then went to the artist's studio to arrest him, but Harnett succeeded in convincing the gentlemen of his innocence and avoided being taken into custody.

This event, however, motivated John Haberle, whom the idea of the artist as counterfeiter must have pleased greatly, to depict a series of banknotes in paintings himself. Although he, too, was threatened with imprisonment on several occasions, this did not stop him, since the choice of subject meant he could still play on a special covetousness and valuation on the part of the public. Without exception, Haberle's works are amusing and often have an ironic undertone.

Like Haberle's pictures, John Frederick Peto's paintings tell encoded stories. Peto often asked riddles and, in diverse paintings containing allusions to the murder of President Lincoln, dared a darker prognosis of a society drifting increasingly apart.

Peto, a fellow student of Harnett at the Pennsylvania Academy of the Fine Arts, was clearly influenced by Harnett initially but soon

William Michael Harnett,
Still Life—Violin and Music,
detail, 1888

developed his own style characterized by softer modulations and warmer colors. The preference for things that are old or marked by decay is seen particularly strongly in his work.

The Cup We All Race 4 (plate 97) is one of his most splendid works. This is not only because it apparently satirizes the vanity of human aspirations in a refreshing symbol but also because, apart from meticulously describing the surfaces of a pewter mug and wooden board, it achieves the quality of an abstract composition in its strict structure of colored surfaces. At the same time, it plays ingeniously with different levels of reality and the viewer's expectations: an extravagantly broad frame holds the various elements of the painting, as well as most of the carved inscription and the remaining corners of a note that had once been tacked on. In order to increase the confusion still further, Peto nailed on to the upper edge of the frame a small metal plate with his signature on it, thus forcing the viewer, who is inclined to accept that this, too, is painted, to take a second look.

89 William Michael Harnett, *Plucked Clean*, 1882

90 William Michael Harnett, *Merganser*, 1883

91 William Michael Harnett, *After the Hunt*, 1883

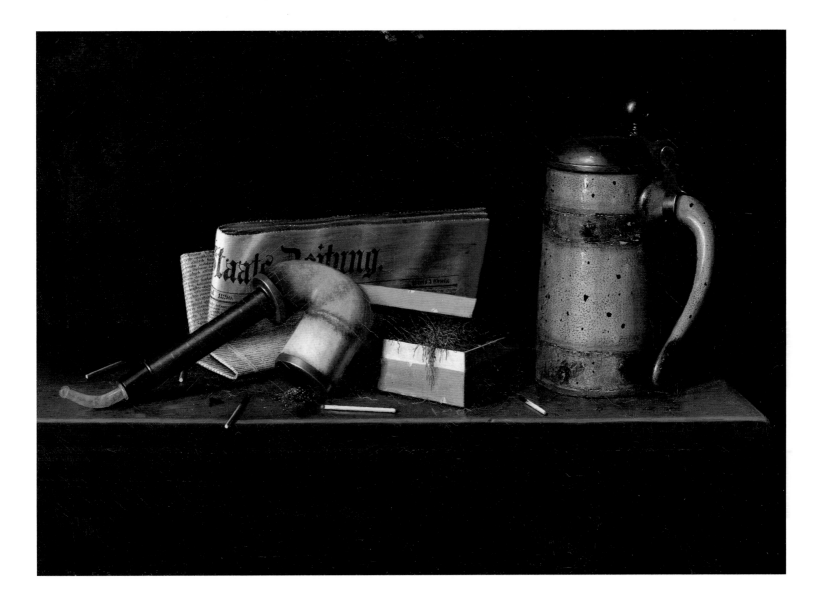

93 William Michael Harnett, *With the Staatszeitung (With the Staats Zeitung)*, 1890

92 William Michael Harnett,
Still Life—Violin and Music, 1888

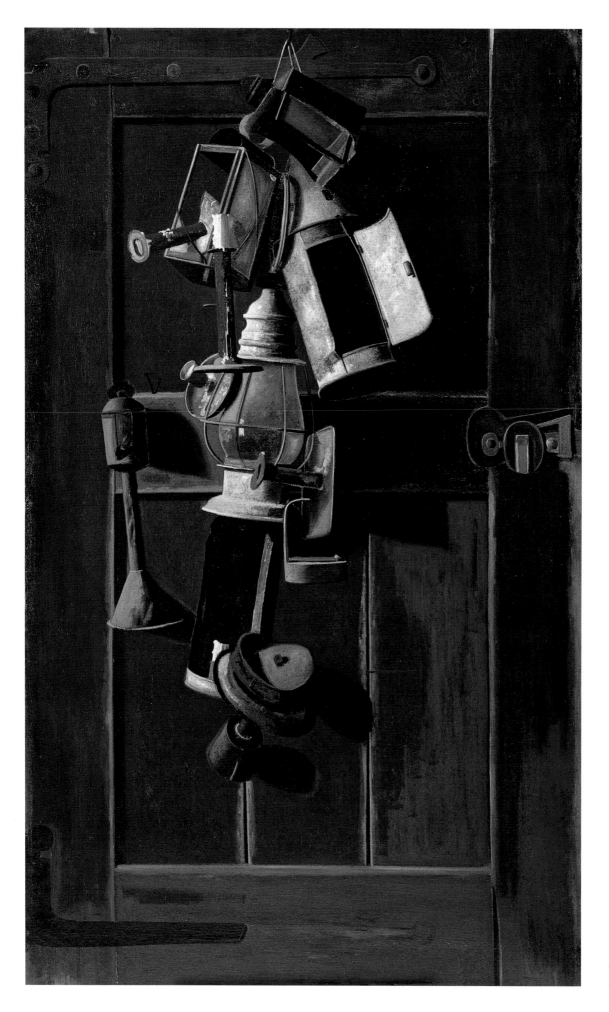

94 John Frederick Peto,
Still Life with Lanterns, after 1889

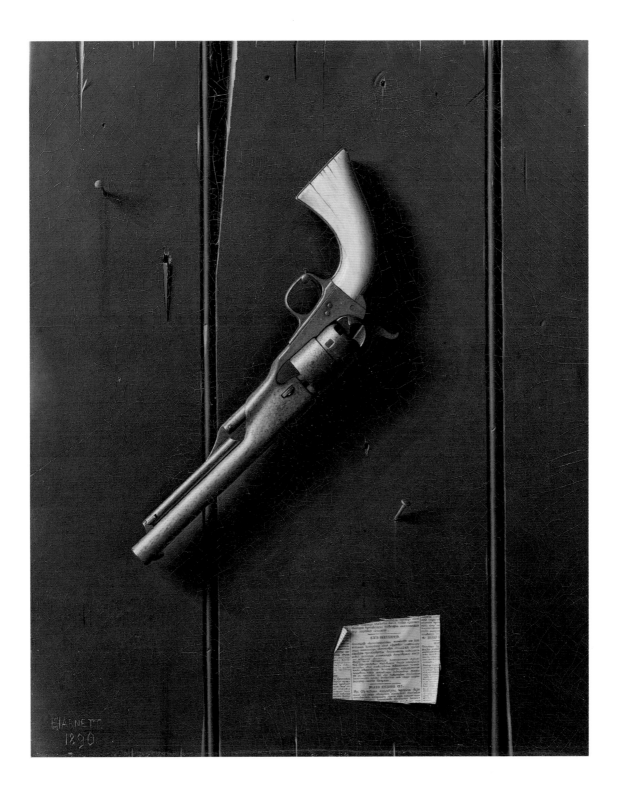

95 William Michael Harnett, *The Faithful Colt*, 1890

96 John Haberle, *A Favorite*, c. 1890

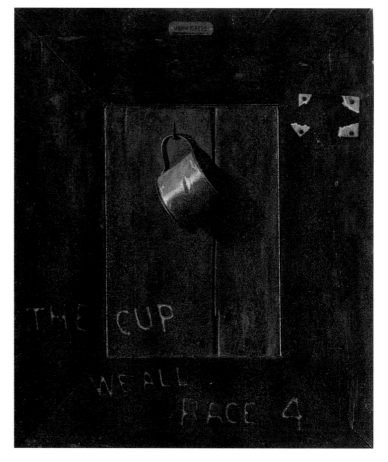

97 John Frederick Peto, *The Cup We All Race 4*, c. 1900

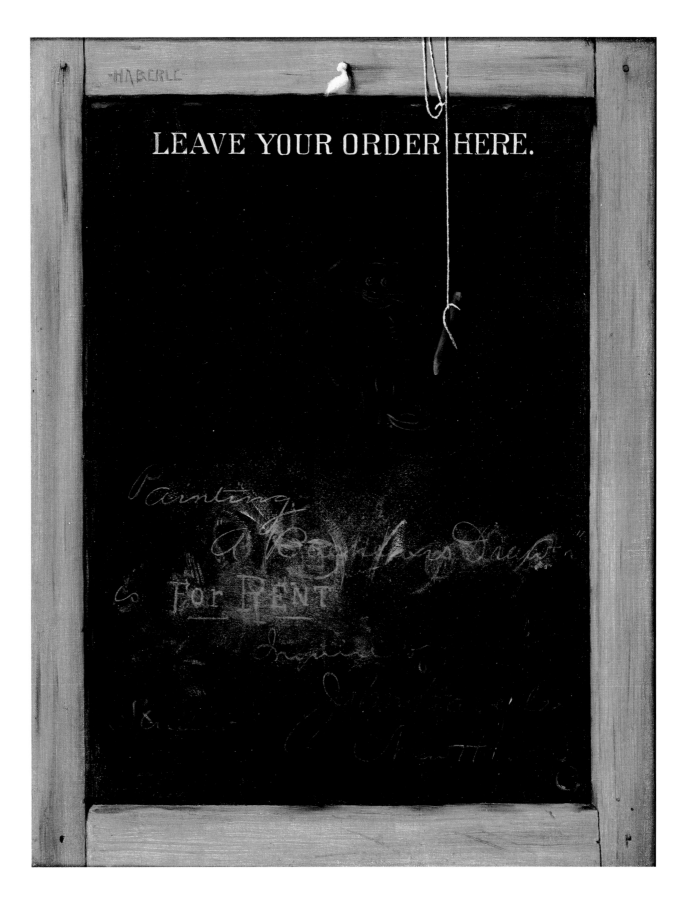

98 John Haberle, *The Slate Memoranda*, c. 1895

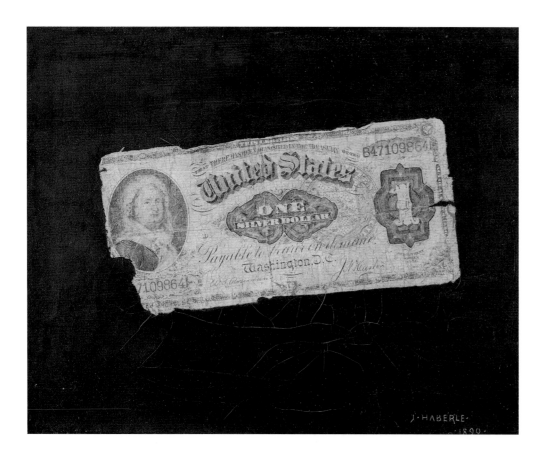

99 John Haberle,
One Dollar Bill, 1890

100 John Haberle,
Twenty Dollar Bill, 1890

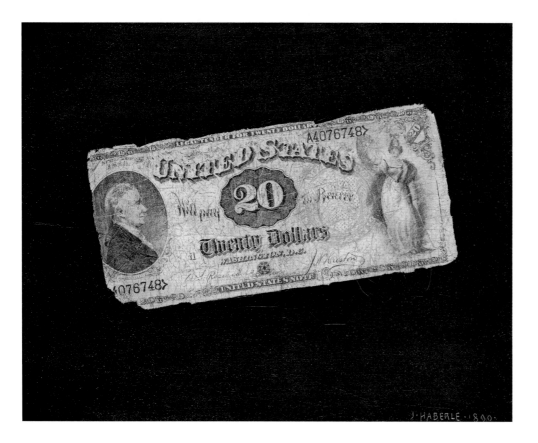

101 De Scott Evans,
A New Variety, Try One, c. 1890

149

On the Inner Unity of the World

The Landscape Painting of George Inness

The most eminent American landscape painter of the late nineteenth century (excepting Winslow Homer and his coastal pictures) was George Inness. In the eyes of contemporaries, he was the best landscape painter in America, if not in the whole world. His painting was no longer characterized by a realism that portrayed the beauties of nature but by an empathy with the moods of nature and the sensations they aroused, which was inspired by the Barbizon school.

Inness' artistic thinking was determined by the Old Masters from an early stage. In the late 1840s and early 1850s, he had become familiar with the Dutch landscape art of the seventeenth century through prints, and in this manner came across the works of Claude Lorrain and Nicolas Poussin. He encountered the prints in the studio of his teacher, the Frenchman Régis F. Gignoux, who had moved to New York, as well as at various dealers. The art that he encountered there would be

decisive for his artistic development. What continued to fascinate him about this art was the perceptible order and intermeshed harmony to which the individual phenomena were subordinated. Years later he recalled: "There was a power of motive, a bigness of grasp, in them. They were nature, rendered grand instead of being belittled by trifling details and puny execution. I began to take them out with me to compare them with nature as she really appeared, and the light

George Inness, *October*, detail, 1886

150

began to dawn. I had no originals to study, but I found some of their qualities in Cole and Durand ... There was in Durand a more intimate feeling. 'If,' thought I, 'these two can only be combined.'"

What so clearly differentiated Inness from painters of the Hudson River School was his relative independence from the theme of landscape and its exact depiction. Instead of reproducing regions and views in faithful detail, he used them as a starting point for his compositions, which were subject to a higher concept of art, to the extent that a critic felt obliged to warn the painter not to "lose sight of Nature in the Old Masters."

But it would be doing Inness little justice were one to see in him merely a traditionalist who shut himself off from the new realism in the contemplation of nature. These were no empty compositional schemes, no established framework of the old, that Inness used. Rather, they served as a means for him to express the world's inner unity.

"Long before I ever heard of impressionism, I had settled to my mind the underlying law of what may properly be called an impression of nature, and I felt satisfied that whatever is painted truly according to any idea of unity, will as it is perfectly done possess both the subjective sentiment—the poetry of nature—and the objective fact sufficiently to give the commonest mind a feeling of satisfaction and through that satisfaction elevate to an idea higher—that is more certain than its own. Just as I have fought Pre-Raphaelitism I fight what I consider the error of what is called impressionism."

The "subjective sentiment"—this was something that Inness had learned from the painters of the Barbizon school during a stay in France in 1854: nature as a mirror of the soul, landscape as a vehicle of mood, an inner image turned outward. It was a stylistic vocabulary which, with its soft transitions, generous treatment of objects, and few large forms, had an expressive power that was very much in line with his intentions.

In 1878, Inness wrote that he preferred "civilized landscape" to wilderness "untouched by human sentiment." Yet even this landscape usually had a bucolic character—threatened at most by thunderstorms. But the spiritual battle for landscape as divine and thus to be kept in its virginal state, which concerned other landscape painters, was not an issue for Inness. Only very rarely does a smoking chimney appear on the horizon and remind the viewer of the economic utilization, or even exploitation, of the land. For Inness, there was only an *inner image* of landscape, a reflection on the seen, just as the present-day traveler often sees only the historic, valuable, and picturesque and does not notice until he reaches for a camera how much of that which is ugly, crumbling, and discordant that will also necessarily be recorded.

Inness' painting may also be seen as a response to the impact of photography, particularly strong in the United States, since painting, released from the obligation to reproduce things precisely, was now able to go further and pursue increasingly interpretative goals.

In 1867, Inness had allied himself with the mysticism of the Swedish visionary Emanuel Swedenborg and subsequently tried to illustrate in his pictures the spiritual beauty and harmony that distinguished Swedenborg's paradise. The last years of Inness' life in particular reflect his search for appropriate ways of expressing this influence. He was striving for an art that would draw its strength from "the great spiritual principle of unity," the "fundamental principle of all Art," and that should "appeal to the mind through the senses." From earlier, more expressive works such as *The Coming Storm* (plate 105), Inness progressed to soft transitions, a quiet harmony in which the colors pulsate only gently.

When, in his late years, through a dissolving of contours and a soft, toned blending of the objects in a picture, Inness created a fluidity, an aura that connected everything, he was attempting to illustrate "the subtle essence which exists in all things of the material world." This was because, in his eyes, it was not possible to show the true reality that underlay everything: "You must suggest to me reality, you can never show me reality."

The way in which Inness pictured the Apocalypse is therefore also characteristic: "When John saw the vision of the Apocalypse, he *saw* it. He did not see emasculation, or weakness, or gaseous representation. He saw *things*, and those things represented ideas."

Inness' late works are allegories rather than realistic representations of nature, metaphysical reflections on the underlying source of the created world.

He thus stands in a tradition that runs through American landscape painting: in the reflection on man's relationship with nature and in the debate about the religious dimension of the experiencing of nature.

A few of Inness' late pictures are abstract to the highest degree—often consisting merely of color zones conveying the proportionate strengths and valences of tones—and thus point the way toward American painting in the twentieth century.

102 George Inness, *A Passing Shower*, 1860

103 George Inness, *Landscape with Farmhouse*, 1869

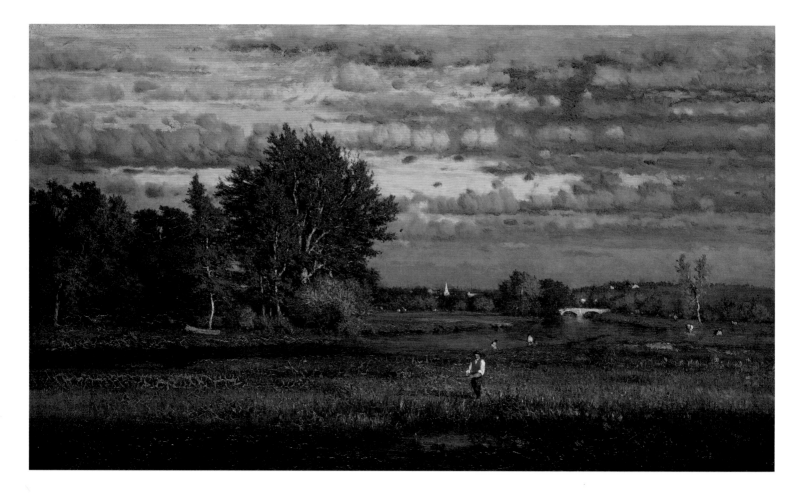

104 George Inness, *Clearing Up*, 1860

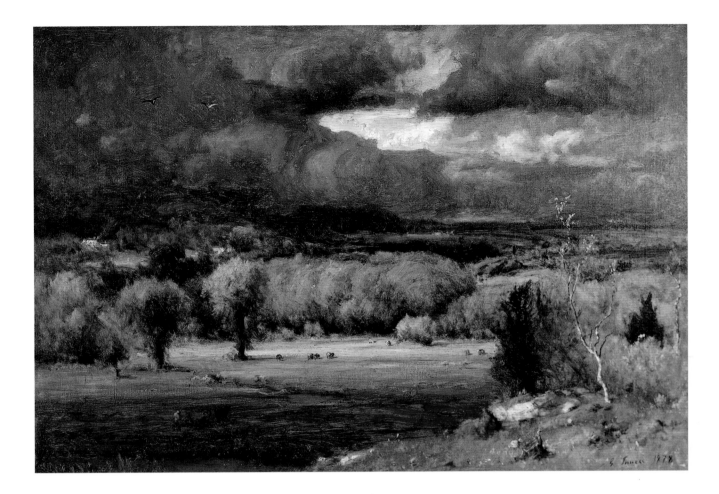

105 George Inness, *The Coming Storm*, 1878

106 George Inness,
Saco Ford:
Conway Meadows, 1876

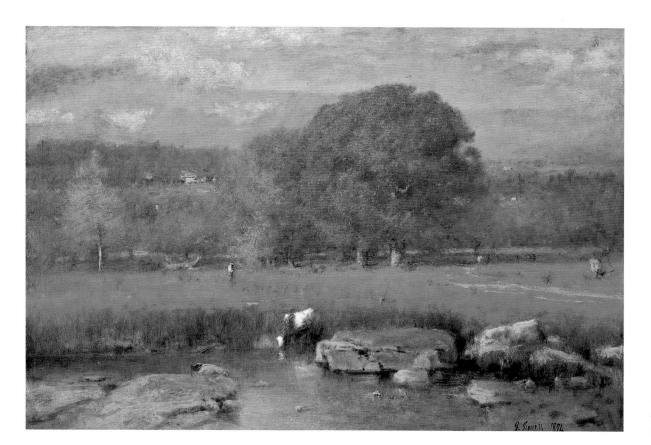

107 George Inness,
Morning, Catskill Valley
(The Red Oaks), 1894

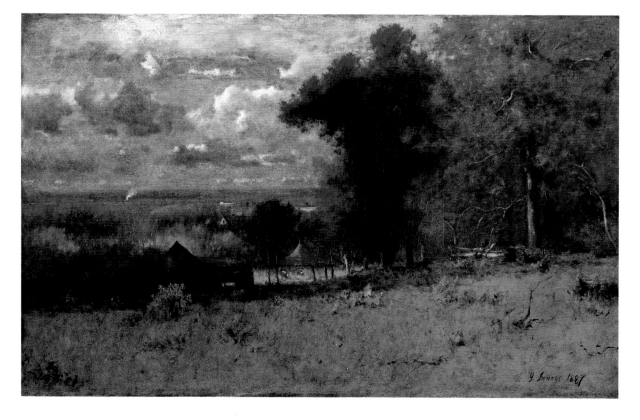

108 George Inness,
A Breezy Autumn, 1887

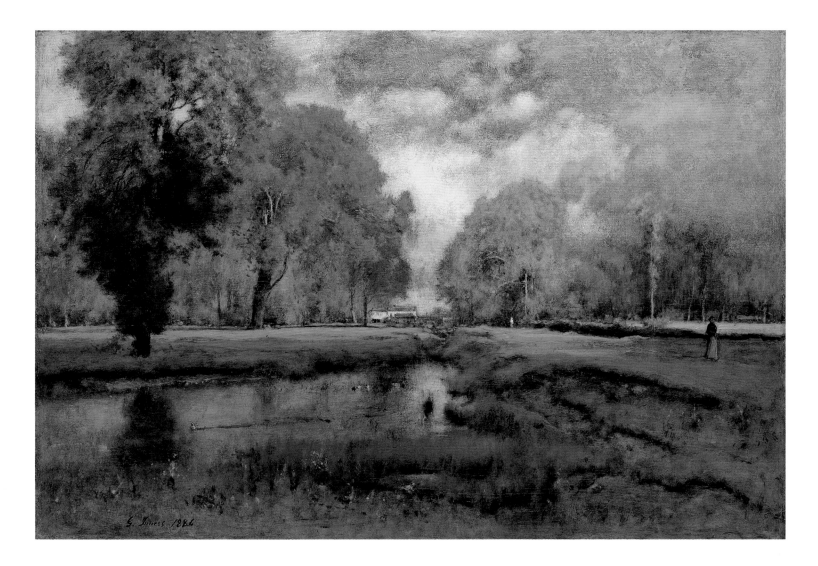

109 George Inness, *October*, 1886

Modern Life

In the years following the Civil War, American painters had increasingly begun to study in Europe. The main focus of interest had now shifted from England to Germany and France, and in particular to Paris. There Americans came into contact with French Impressionism, although it took some time before the style was able to establish itself in America. Julian Alden Weir, who saw the third exhibition of the Impressionists in Paris, could still write home in 1877: "worse than a chamber of horrors."

It is thanks to Mary Cassatt that, long before the French public had begun to warm to Impressionism, a veritable enthusiasm for the new style broke out among American collectors—a circumstance which explains why many French Impressionist masterpieces can today be admired in American museums. Cassatt lived in Paris and belonged to the circle of the Impressionists. In the late 1870s, she was able to persuade her collector friends, the husband and wife Henry and Louisine Havemeyer, to buy pictures from her French fellow artists.

An additional factor was that Paul Durand-Ruel, one of the most important dealers in Impressionist paintings, opened up a branch in New York. He had earlier gained the trust of collectors by always being able to satisfy the constant demand for works by popular painters of the Barbizon school and provide pictures of consistently high quality. His exhibition of works by French Impressionists, including around forty works by Monet, proved to be the ultimate turning point (1886).

American painters subsequently adopted stylistic elements from Impressionism but immediately adapted them in line with their own artistic character and the prevailing manner of seeing things. Although at first the newly acquired style was used primarily on portraits, French Impressionism—hand in hand with photography—soon triggered off a movement toward contemporary themes, to "modern life" and the theme of the city, which American art had avoided for a long time. A new, worldly America, whose great cities were attempting to compete with their European counterparts, was now depicted.

Impressionism had been accepted timidly, and it was dealt with only superficially. It was not its dimension of dissolving form and purely describing phenomena of light and color that found its way into American painting, but rather its "technique" of producing partial views of popular subjects with a brightened palette and short, dabbed brushstrokes (which occasionally was taken so far that it was employed for nostalgic "colonial revival" themes or used to carry on the prevailing reverence for the female with a slight alteration in stylistic idiom).

Overall, American Impressionism remained an aestheticizing art which showed the attractive aspects of life—leisure and relaxation— but ignored the social realism that French Impressionism at times revealed in its depictions of women ironing, bars, or the urban *demi-monde*.

After Impressionism became established, a series of young American painters sought proximity to the leading master of French Impressionism, Claude Monet, so that an American colony soon sprang up at Giverny. Metcalf's *The Ten Cent Breakfast* (plate 111) relates to this. Monet, however, was not at all enthusiastic about the invasion of painters hungry for knowledge (and not all particularly talented) and tried to shield himself so that he could devote himself to his art in peace. The fact that the American Theodore Robinson eventually became his son-in-law was even a problem for him initially.

In 1898, a few American Impressionists combined to form a group which they called "The Ten" and, under this name, undertook several exhibitions together up until 1919. The aim was to find new forms of presentation of art instead of hanging as many pictures as possible in gallery rooms, as was the existing practice. Their first exhibition took place in 1898 at Durand-Ruel's New York gallery.

The two most important representatives of American Impressionism were Childe Hassam and William Merrit Chase. Childe Hassam, who traveled around Europe for a year in 1883 and from 1886 spent just under three years in France, came closest to Monet stylistically. He copied the latter's technique of closely juxtaposed strokes of color in varying tones, the quick, open brushstroke, and the bright palette. Thematically, he depicted modern life, with the grandeur of the avenues and the leisure pastimes of refined society. It was "humanity in motion," the artist said, that he wished to capture in his pictures of city life.

Hassam later also favored landscapes flooded with light, which he executed in a glowing palette, and atmospheric moods which he rendered in delicate tones. He, too, was interested in the sophisticated two-dimensional art of Japanese colored woodblock prints. After the entry of America into the First World War in 1917, he adopted from the French the motif of flag-decked streets and created an entire work group based on this.

But Hassam always remained wedded to corporeal solidity, clarity of outline, clearly defined contrasts, including the use of dark colors, and thus to the recognizability of what he was depicting. Therein lay his limits. Hassam was lastingly influenced by Whistler's aestheticism and thus subordinated the visual impression to his ideas about harmony. He repeatedly spoke of a picture as a "beautiful object."

However, the logical consistency with which Monet had pursued the representation of "pure seeing" and, at the same time, had developed his own technique of dissolving form, detaching himself from everything previously known and trusting sensory impressions, was granted to him alone—even within French painting. This is why any borrowing or adaptation of Monet's idiom by a painter such as Hassam, who was never able to detach himself from knowing, judging, or describing content, would ultimately remain borrowing. Hassam was also always in danger of veering off into purely decorative painting.

William Merrit Chase was dealt a more fortunate hand. He was more independent in his choice of themes and adopted elements of Impressionism with greater assurance in order to develop his own personal style later on. Having studied in Munich and having used the dark tonality that was customary there, he had further to go in terms of color but not in technique. What Chase had learned in Munich, apart from Academy skills

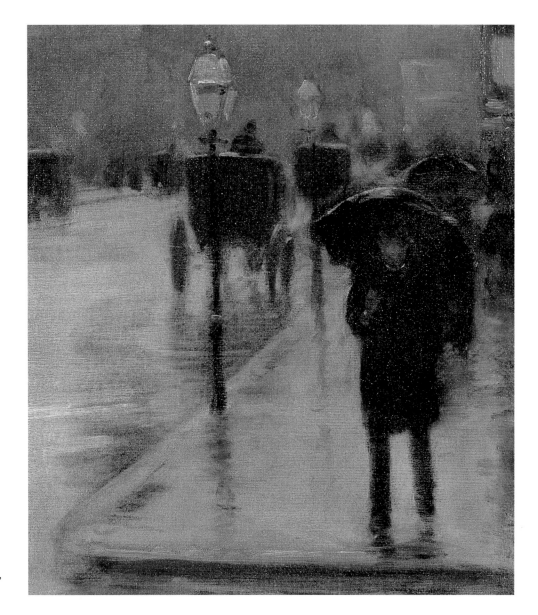

Childe Hassam,
Columbus Avenue, Rainy Day,
detail, 1885

in Wilhelm Leibl's circle, was "good painting," wet-on-wet painting as a unified whole, without subsequent corrections.

At the end of the 1880s, Chase had begun to work with the play of sunlight and resultant changes in color values in a series of park views, with which he opened up a new pictorial theme that branched out from existing landscape painting. "How much light there is out-of-doors," he confessed to himself in astonishment.

After moving to Shinnecock on Long Island in 1891, he mastered his observation of nature. It was there, exposed to the clear coastal light, that he developed that fine feel for nuances, the subtlest color values, that distinguishes him from his contemporaries. Pictures such as *Over the Hills and Far Away* (plate 115) reveal an astonishing sensitivity towards color tones, the finest gradations,

but at the same time in the simplicity of their subject matter display the great skill of a painter who is no longer seeking the superficially sensational or the pleasing, but the quiet beauty of a landscape.

Yet Impressionism was always only just one aspect of his enigmatic artistic presentation. Chase kept a grandiosely appointed studio in the Tenth Street Studio Building, that in its swanky effect, historicist implements, and occupant's fame rivaled those of European artist-princes. In his personal appearance, too, he celebrated the exalted, dandy-like artist. It is no coincidence that he was friendly for some time with Whistler.

Fascinatingly, as though in a parallel tradition, Chase retained his Munich palette and fluid, bravura brushstrokes in his still lifes. It is reported that he was able to paint fish so quickly that he could take them back to

the fishmonger before they started to smell. The brilliance with which the iridescent colors, the reflections on porcelain, metal, polished wood, and fish bodies are captured in just a few, skillfully positioned brushstrokes in these works—which should be regarded as more than mere studies—never fails to amaze the viewer. The voice of Wilhelm Trübner or Wilhelm Leibl is heard when Chase says: "It is never the subject of a picture which makes it great, it is the brush treatment, the color, the form. There is no great art without a great technique in back of it."

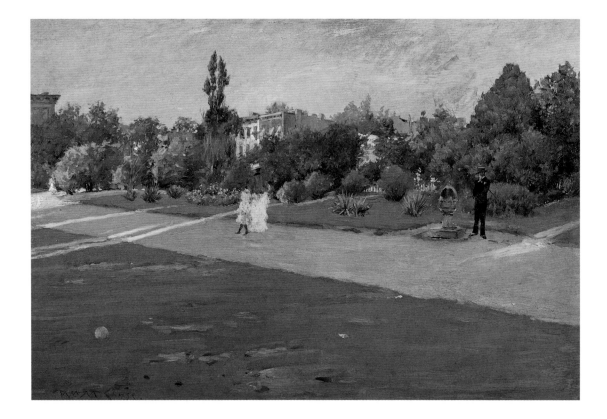

110 William Merritt Chase, *Prospect Park, Brooklyn*, c. 1887

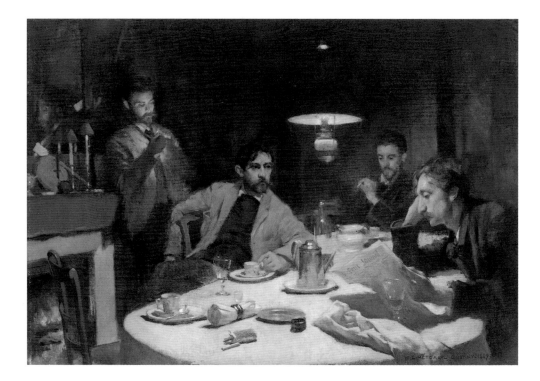

111 Willard Metcalf, *The Ten Cent Breakfast*, 1887

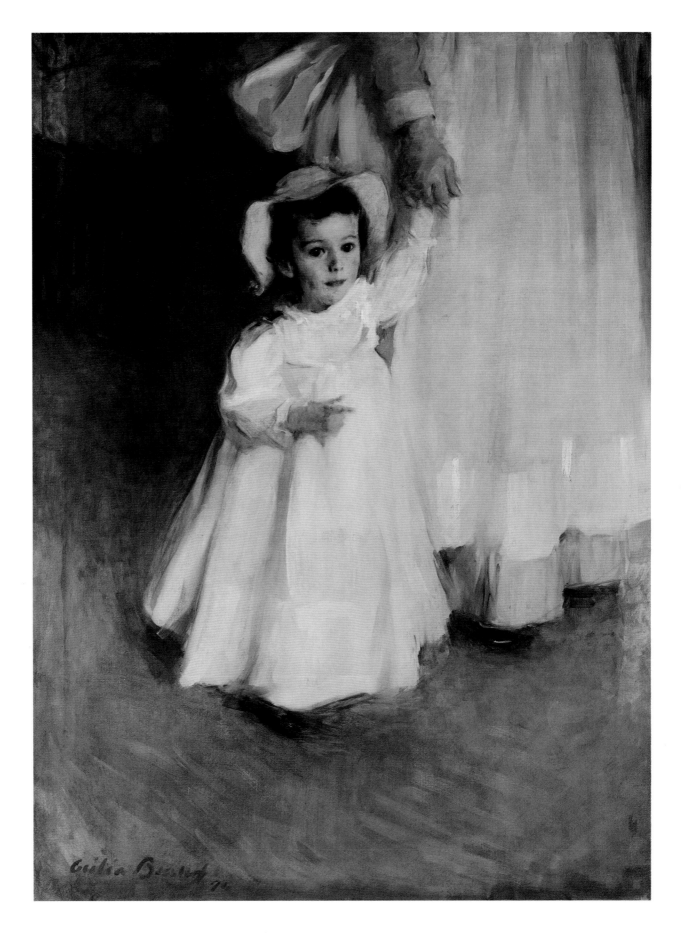

112 Cecilia Beaux, *Ernesta (Child with a Nurse)*, 1894

113 William Merritt Chase,
The Lone Fisherman, 1890 or later

114 William Merritt Chase,
*Shinnecock Landscape with
Figures*, c. 1895

115 William Merritt Chase, *Over the Hills and Far Away*, c. 1897

117 Childe Hassam, *Sunset at the Sea*, 1911

116 Childe Hassam, *Dock Scene,*
Gloucester, 1894

118 Childe Hassam, *Columbus Avenue, Rainy Day,* 1885

119 William Merritt Chase, *Still Life with Fish,* c. 1908

120 Thomas Wilmer Dewing, *Before the Mirror*, 1916

121 Julian Alden Weir, *The Bridge: Nocturne (Nocturne: Queensboro Bridge)*, 1910

122 Childe Hassam,
*Flags on 57th Street,
Winter of 1918*, 1918

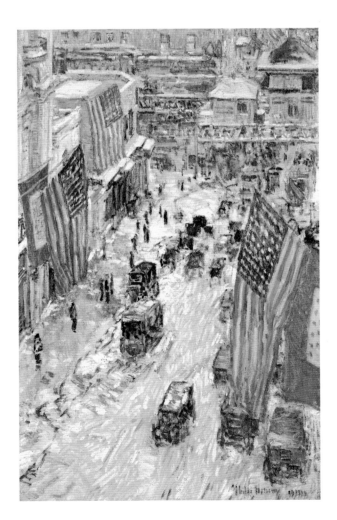

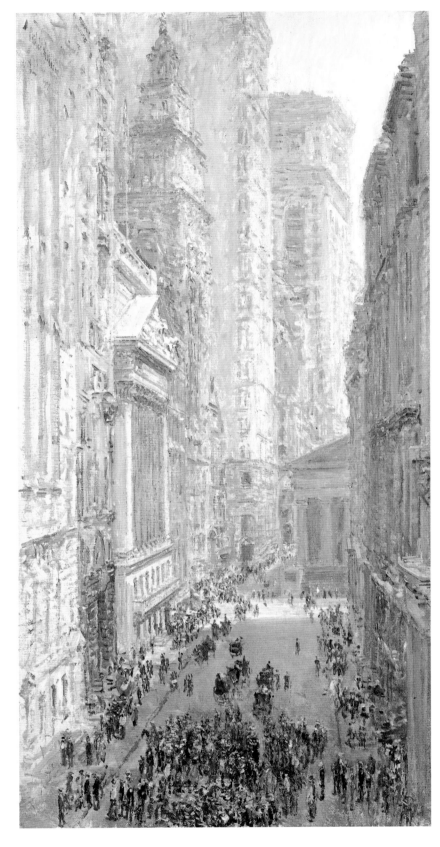

123　Childe Hassam, *Lower Manhattan (View down Broad Street)*, 1907

The Cosmopolitans

The last decades of the nineteenth century saw an increased turn toward Europe. It was not just that collectors—industrialists, business people, and railroad magnates who had often only recently achieved great wealth—frequently traveled to Europe and purchased European art in the grand style. Artists, too, now preferred to study in the great European art capitals and strove for success and recognition there. A cosmopolitan artist type developed, the "expatriate"—probably most impressively exemplified by John Singer Sargent and James Abbott McNeill Whistler, both of whom spent the greater part of their lives in Europe.

Mary Cassatt, who had also settled in Paris, is considered more of a French painter, although she never relinquished her American citizenship and in her French environment was known as "une américaine." Encouraged by Edgar Degas and fully integrated into the circle of the Impressionists, she lived her entire life in the metropolis on the Seine, where she developed her original, always clearly lyrical style inspired by Degas' figural representations and Japanese woodblock prints (see fig. p. 173).

Just two months before he died, James Abbott McNeill Whistler spoke of America as his home and retained links all his life to his native land although he had left it at the age of twenty-one and never returned. Whistler was a phenomenon who impressed the art worlds of Paris and London with his stylized appearance. He knew how to present himself as the descendant of a type of Southern aristocracy and emphasized the self-made myth even more by his extravagant dress. By celebrating a nobility that supposedly transcended all national borders, he gained entry into the high society and aristocracy of France and England, as well as recognition in artistic circles. Painters in Paris such as Courbet, Degas, or Manet were fascinated by him and extended their admiration. Marcel Proust based the painter Elstir in his seven-part novel *A la recherche du temps perdu* on Whistler's person.

Whistler's fame, which far exceeded his actual importance, elicited a response everywhere in Europe as well as the United States, and his life-style and artistic creed had a considerable influence on an entire generation of artists. When, in 1881, *The White Girl (Symphony in White)* (plate 125) and, a year later, *Arrangement in Grey and Black no. 1: Portrait of the Painter's Mother* (1871) (fig. 6, p. 223) were exhibited at the Society of American Artists in New York, they caused a great sensation and triggered off a whole series of works by American painters influenced by them, such as Julian Alden Weir, William Merritt Chase, Cecilia Beaux, and Thomas Eakins. An exhibition of Whistler's works entitled *Arrangement in Yellow and White*, shown in New York in 1883 and subsequently in Baltimore, Boston, Philadelphia, Chicago, and Detroit, which included the famous *Nocturne in Black and Gold: The Falling Rocket* (fig. 9, p. 215), had a still greater impact. This was not just because once again a series of American painters reacted to it in their art, but because Whistler was henceforth a celebrity in the United States and would find most of his collectors in America, selling the majority of his pictures there during his lifetime.

How could Whistler excite this level of attention? And what artistic concept did he represent that was capable of producing an impact of this kind? Whistler did not just lead an aestheticized life-style, he was the very embodiment of a utilitarian age's aesthetic need for purposeless beauty. The picture which made him famous and which expressed his concept of art for art's sake with great resoluteness was *The White Girl (Symphony in White)*. As the title alone indicates, this was less a depiction of a girl than a symphony of color, a harmony in white. The model, the young Irishwoman Jo Hiffernan, who was Whistler's sweetheart at the time, merely provided the opportunity to create a picture from purely aesthetic standpoints, to devote it completely to the varied nuances of a white dress and a light curtain. In an artistic milieu characterized by strictly descriptive and frequently narrative pictures, a picture such as this one, which told no story at all, issued no moral statement, was not even really supposed to be a portrait (Whistler quite deliberately intended her face to have no emotional expression), was for many a provocation, for others a revelation.

Throughout his life, Whistler displayed a penchant for Asian art, primarily Chinese porcelain and Japanese woodblock prints, and was interested not in spatial depth but in meaningful outline. In his later works, he took reduction of the descriptive even further, beginning to dissolve forms in softly modulated transitions and to transform the overall depiction in a painting, which suggested more than it stated, into an aesthetic whole of uniform color.

He was convinced that: "Nature contains the elements, in color and form, of all pictures, as the keyboard contains the notes of all music. But the artist is born to pick, and choose, and group with science, these elements, that the result may be beautiful—as the musician gathers his notes, and forms his chords, until he brings forth from chaos glorious harmony." Painting should not be direct reproduction but a distillation of reflection, memory, and considerations of form.

This was particularly true of his *Nocturnes* (see fig. 7, p. 238), about which Whistler said: "I have perhaps meant rather to indicate an artistic interest alone in the work, divesting the picture from any outside anecdotal sort of interest which might have been otherwise attached to it. It is an arrangement of line, form and color first; and I make use of any incident of it which shall bring about a symmetrical result." But portraits such as *The Little Rose of Lyme Regis* (plate 124) also reveal the same concern in the flowing transitions and the reduced palette attuned to a basic color.

If in Whistler's case it was his consistent self-promotion which contributed to his impact, John Singer Sargent amazed his contemporaries even as a young man by his bravura brushstroke and, as the American novelist Henry James, who was a friend of Sargent, expressed it, the rather uncanny sight of a talent that had nothing more to learn, even on the threshold of a great breakthrough. Whereas Whistler tried to filter out from the fleeting phenomena of nature a harmony that had become independent, Sargent's art was filled with the effort to respond directly to visual phenomena via a rapid, brilliant brushstroke.

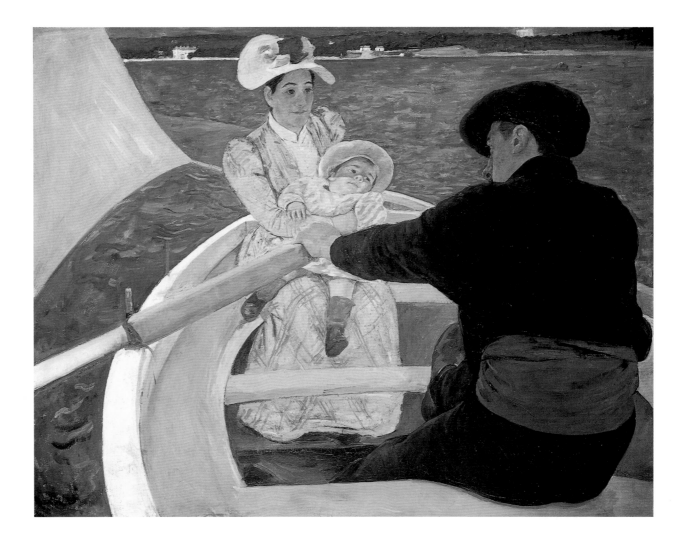

Mary Cassatt,
The Boating Party,
1893–94,
oil on canvas,
90.2 x 117.1 cm,
National Gallery of
Art, Chester Dale
Collection

Opinions about him varied widely. For Mary Cassatt, he was too polished and superficial. Whistler considered him a "shrine of tedium and propriety," and Rodin regarded him admiringly as the van Dyck of his day.

Sargent was even more cosmopolitan than Whistler (who liked to play on the confusion about his nationality and did not go to the United States only because he was afraid he would not be held in esteem in his native land). The child of Americans interested in culture and enthusiastic about Europe, Sargent was born in Florence, traveled across Europe with his parents in his youth, and studied in Florence, Dresden, Berlin, and Paris. This intellectual agility and readiness to travel would stay with him throughout his life. But Sargent always felt himself to be American and was consequently not prepared to give up his citizenship when it was proposed he should be knighted.

Sargent had studied with Carolus-Duran in Paris and found there a preference for the free and skillfully placed brushstroke that accorded very well with his talent. At the same time, he was confronted with Carolus-Duran's admiration for Velázquez, which also left obvious traces on his own work.

Nevertheless Sargent was a painter who evaded any stylistic classification. A friend of Monet, he adopted the bright palette of the Impressionists, the spontaneity of depiction of the snatched moment (see *A Gust of Wind*, plate 128), but could also paint with the lighting and coloration of an Old Master when the subject seemed to demand it (see *Portrait of Whitcomb Riley*, plate 132). In particular, his fluid, spontaneously painted landscapes and townscapes—the fruits of his many journeys—reveal his confidence in the direct capturing of color tones, since Sargent painted quickly and "alla prima" (see plates 129–131). Yet the objects in his pictures always remained more clearly defined than was the case with French painters; the virtuosity of the brushstroke retained its great importance.

At the age of thirty-four, Sargent produced a masterpiece which aroused general admiration: *El Jaleo*, a brilliant portrayal of an Andalusian dance scene, with a flamenco dancer in ecstatic motion, her pose and attire describing an arabesque. At thirty-six, he caused a scandal when he exhibited *Madame X*, a lascivious portrait of a beauty from the Southern states named Virginie Gautreau, at the Salon.

Sargent retreated from the general excitement and went to England. Here he would enjoy his greatest triumphs as a portraitist, painting the aristocracy as well as the *nouveaux riches*. He was greatly sought after and could demand horrendous sums since he gave his subjects what they wanted: glamour and beauty. He hardly accepted any further portrait commissions after 1907.

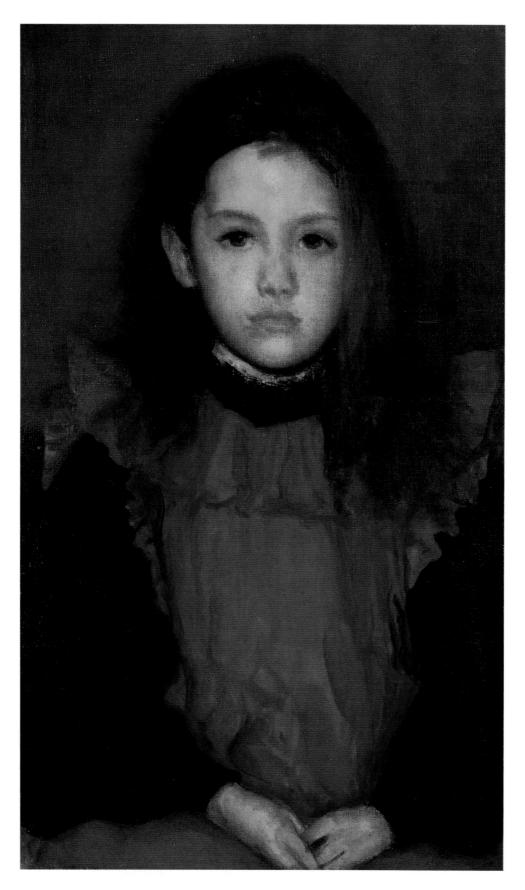

124 James Abbott McNeill Whistler,
The Little Rose of Lyme Regis, 1895

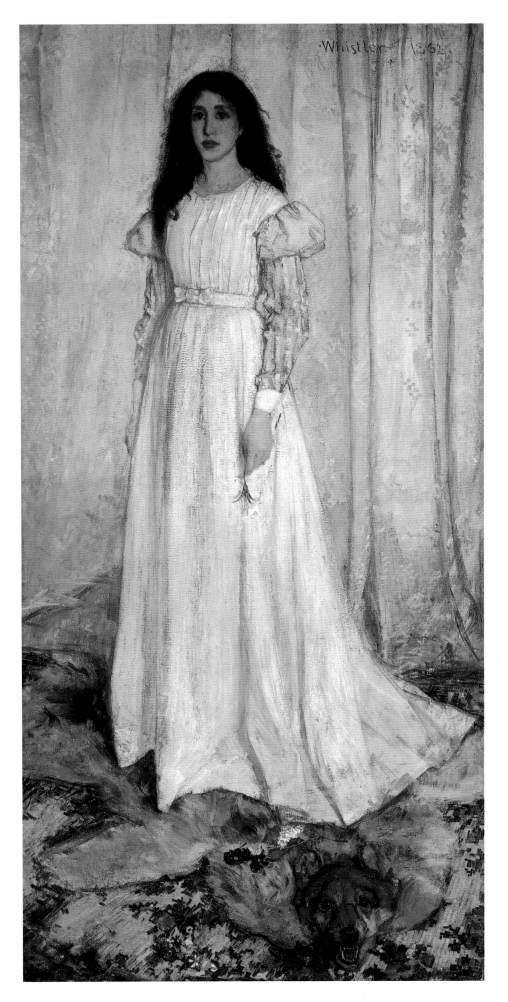

125 James Abbott McNeill Whistler,
The White Girl (Symphony in White, no. 1), 1862

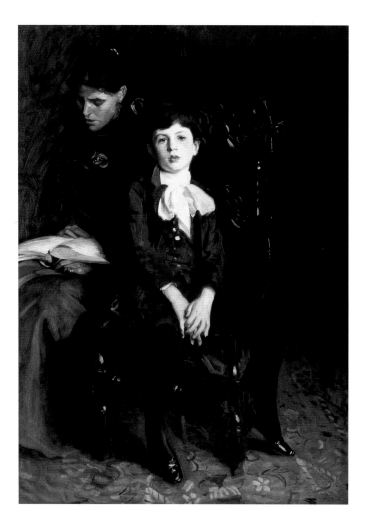

126 John Singer Sargent, *Portrait of a Boy
(Homer Saint-Gaudens and His Mother)*, 1890

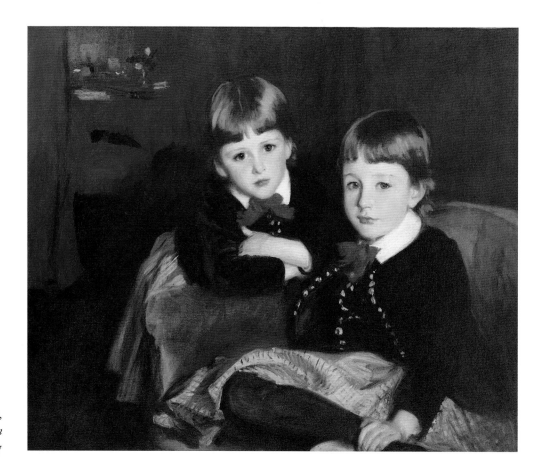

127 John Singer Sargent,
*Portrait of Two Children
(The Forbes Brothers)*, 1887

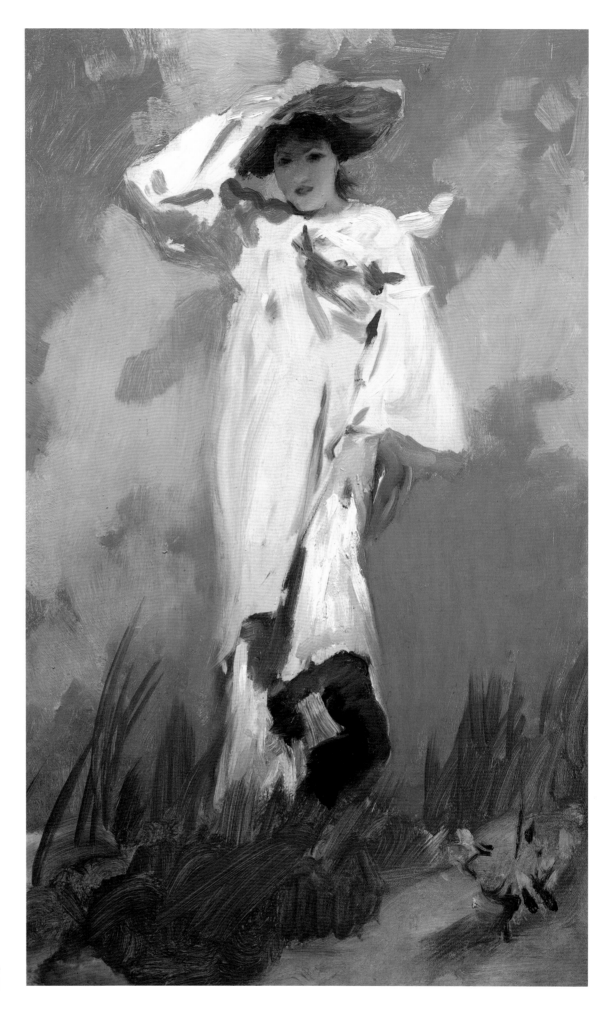

128 John Singer Sargent,
A Gust of Wind, c. 1883–85

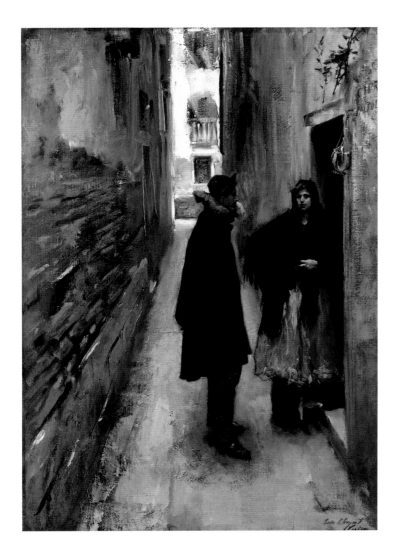

129 John Singer Sargent, *Street in Venice*, c. 1880–82

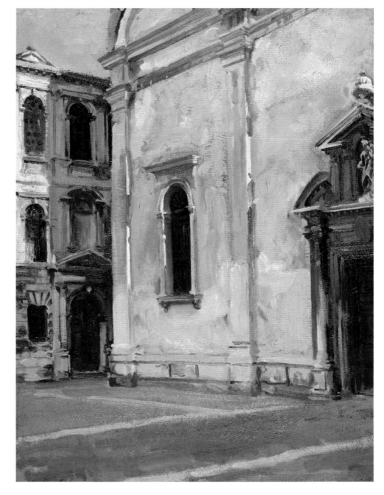

130 John Singer Sargent,
*Santa Maria del Carmelo and Scuola
Grande dei Carmini*, 1910

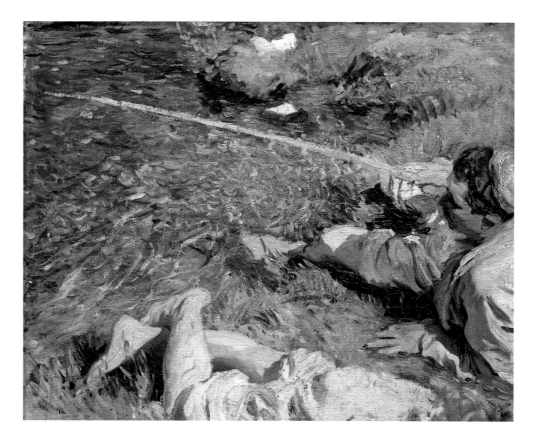

131 John Singer Sargent,
*Val d'Aosta—
A Man Fishing*, 1910

132 John Singer Sargent,
Portrait of James Whitcomb Riley, 1903

179

In the Gorges of the City

The Painters of the Ashcan School

The start of the twentieth century was felt by many to be a time of unlimited technical possibilities and the United States its focal point. As an example, they could cite a city such as New York, with its new skyscraper architecture, the Brooklyn Bridge (built in the early 1880s), the subway and elevated train networks which could rapidly transport enormous numbers of people, the electric street lights and billboards, and so on. This was new and different from Europe. In his euphoria, Lewis Mumford went so far as to say that "the New World expanded the human imagination."

Few saw or wanted to see that the rapidly growing cities of North America also had their seamy sides, indeed held hopeless misery. Initially, it was sensation-seeking journalists and photographers who ventured into the immigrant slums of Manhattan and exploited the plight of their inhabitants in reportages intended to increase their paper's circulation. But soon a group of painters gathered together who, despite all their enthusiasm for the bustling, glittering urban life, also directed their attention to the other side of the coin: the backyards, the dirt, the cramped conditions of family life, the improvisational skills of housewives, and the poverty of immigrants. They showed a city that never slept, a place of gigantic construction sites, smoking chimneys, tugboats in the harbor, steaming locomotives, but also neglected plots of land under the new bridges, the crowds at election platforms, and the gray, daily life of commuters on the ferry.

These artists now countered Impressionism, which to them seemed superficial and decorative, with pictures that were intended to have a direct and strong effect. As a result of their sketch-like pictorial idiom, the open brushstroke with an often dark palette, and pictures of the gutter, this group of painters was known disparagingly as the Ashcan School. Despite their social commitment, its representatives did not assume the moralizing tone of nineteenth-century naturalism, with its depictions of laborers and farmers. They did not condemn or sympathize but acted cheerfully and benevolently as citizens who loved their city despite its darker sides. Sometimes even they experienced the atmosphere of social distinctions as thoroughly picturesque, for example, in pictures of women at three o'clock in the morning, dressed in nightgowns, lighting a cigarette as they gossip in the kitchen, cooking or hanging their laundry up on the roof or drying their hair, or in pictures of people marveling at shop windows, or going out to eat. Finally, there are the scenes of nightlife and its pleasures, banned back-room performances, and bars.

They depicted the city as a highly intensive living space. George Bellows called his painting of a Manhattan street bursting with inhabitants and their various occupations *Cliff Dwellers*, crammed in, as they are, among the gorges or cliffs of the city.

The leading figure and thinker of the Ashcan School was Robert Henri, who attracted younger painters such as William Glackens, George Luks, Everett Shinn, and John Sloan. He went drinking with them, held discussions, read texts by Walt Whitman and intellectually dominated the group, which soon called itself "The Eight" because of its number of members. They were later joined by Henri's student George Bellows, the most talented of them all and probably the one who thought most strongly in terms of painting—a man of intuition who had need of Henri's intellectual power and guidance. Bellows was never a formal member of The Eight but belonged to the group intellectually, stylistically, and as a friend.

What these painters wanted is impressively illustrated in Henri's words on the occasion of the Independent Exhibition, which the painters organized together with like-minded people in 1910 and which was a huge success with the public: "Freedom to think and to show what you are thinking about, that is what the exhibition stands for. Freedom to study and experiment and to present the results of such essay, not in any way being retarded by the standards which are the fashion of the time, and not to be exempted from public view because of such individuality or strangeness in the manner of expression. What such an exhibition desires is all the new evidence, all the new opinions, that the artists have, and then their work must either succeed by its integrity or fail from lack of it. We want to know the ideas of young men. We do not want to coerce them into accepting ours...

As I see it, there is only one reason for the development of Art in America, and that is that the people of America learn the means of expressing themselves in their own time and their own land. In this country we have no need of art as a culture; no need of art for poetry's sake, or any of these things for their own sake. What we do need is art that expresses the *spirit* of the people of today..."

Henri was a person of strong charisma, a superb teacher who encouraged the talents of young people; among others, George Bellows, William Gropper, Edward Hopper, and Rockwell Kent passed through his school. Henri's penchant for realism was stamped by his training in Philadelphia, where he had studied with Thomas Anshutz. Although Thomas Eakins had been forced to leave the school a term earlier, his rigorous realism was continued by Anshutz and would have an influence on the next generation, too. Yet Henri had also always been fascinated by Dutch Baroque painting— especially the virtuosity of brushstroke and the imposing chiaroscuro of Frans Hals. He assiduously studied the work of the latter as well as paintings by Rembrandt, Velázquez, Courbet, and Manet during his second stay in Paris from 1895 to the turn of the century.

Drawing on their structural methods, Henri attempted to develop a new, American, contemporary style with expressive, fluid handling of the brush, strong contrasts, and spontaneously grasped observation. His friends and students would take this further. Even though Henri himself remained primarily a portraitist, and the quality of his work was highly variable, it was he who gave the group its decisive direction: a realism that can almost be termed ethical, consistently confronting his time, his surroundings, the people around him and their living conditions—an uncompromising affirmation of reality even when the latter had its ugly side.

The new direction would reach its peak with Sloan and Bellows. It was also they who subsequently introduced a stronger social element. Most of Henri's friends and students

had been active as journalists or still were journalists. Sloan, who was enthusiastic about Daumier and Steinlen, was a caricaturist and newspaper illustrator in Philadelphia before going to New York to work with Henri. "I never mingled with the people, and the sympathy and understanding I have for the common people, as they are meanly called, I feel as a spectator of life." His genre paintings of urban life always remained full of humor and kindness—in complete contrast to the occasional bite of his satirical political drawings and prints. Sloan was a highly gifted observer and often also recorded those moments of relaxation in which people feel they are unobserved—whether on sunlit house roofs or in his local pub, McSorley's Ale House, an Irish workingmen's tavern with a floor strewn with sawdust, where he met his friends and where women were not admitted.

Bellows' visual idiom also had something of the journalist about it, and its drama, often achieved through the effective lighting of his scenes, brought him fame even as a young painter. His frequent depictions of building sites, including seven of the one at Pennsylvania Station, express his enthusiasm for New York's conversion into a city of the twentieth century, with its new technologies. Bellows thus painted admiring images of America as active and powerful, and of its pioneering, inventive, and entrepreneurial spirit.

His most vivid pictures of the city, however, are his portrayals of boxing contests—images of violence and the fight for supremacy by the stronger that everyday life also offered, in the opinion of many Americans. Public boxing matches were prohibited in New York on the grounds of brutality, but they were still allowed in private clubs—which is why many a bar fitted out a back room for this purpose and made people who wanted to watch a fight club members for the evening. One bar in which Bellows found themes for several of his paintings was that of Tom Sharkey, an Irish rogue. The way in which Bellows, through forceful brushstrokes and dramatic chiaroscuro, portrayed the muscular bodies wedged together or punching each other, the grinning masks— reminiscent of Goya—of the audience watching in the

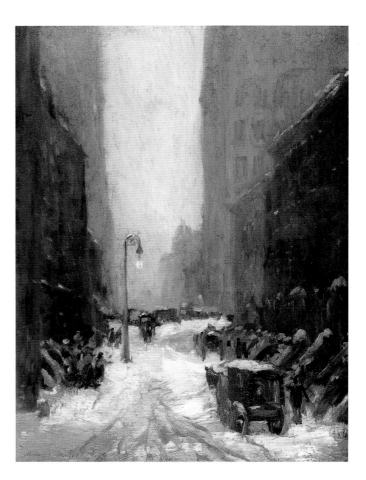

Robert Henri,
Snow in New York, 1902,
oil on canvas, 81.3 x 65.5 cm,
National Gallery of Art,
Washington, D.C.,
gift of Chester Dale, 1954

semi-darkness, and the heated atmosphere remains without equal to the present day.

But Bellows also discovered suitable subject matter for his powerful style in landscapes. In 1911, the painter spent the summer on Monhegan Island on the Atlantic coast of Maine and two years later returned to spend the summer and autumn there. Inspired by the island, he tried to match Winslow Homer, the great model for all Ashcan painters, painting the sea and its crashing waves with a perceptibly brighter palette.

From 1913, however, the Ashcan School was outstripped by modern European painting, which hit Americans with the force of a shock at the Armory Show. Bellows, too, was thrown completely off balance by the Armory Show and began to take an interest in art theory since he also now wanted to become a "modern" painter. In early 1914, he came across the writings of Denman Ross, who had devised an intricate system of color values, matching palettes, pictorial arrangements, and lines. Thus, Bellows altered his technique. He laid out the portraits that would henceforth be his main subject with great consideration and planning, with clearly defined color zones and a calculated division of the forces within

the pictorial space. This, however, destroyed the spontaneity of his work.

Although it only flourished for a few years, the painting of the Ashcan School is one of the most original, most authentic achievements of American art before the advent of Abstract Expressionism. Whereas in Europe at the beginning of the twentieth century people were primarily concerned with formal aspects, as in Fauvism, Expressionism, and Cubism, American painters with their expressiveness and especially their choice of themes created a social realism that had no parallel in Europe at that time.

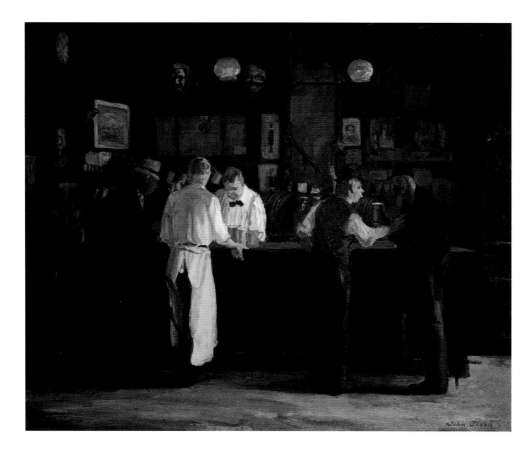

133 John Sloan, *McSorley's Bar*, 1912

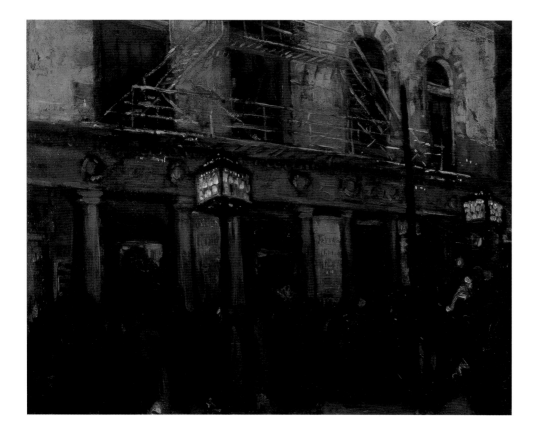

134 John Sloan, *Walnut Street Theater, Philadelphia*, 1900

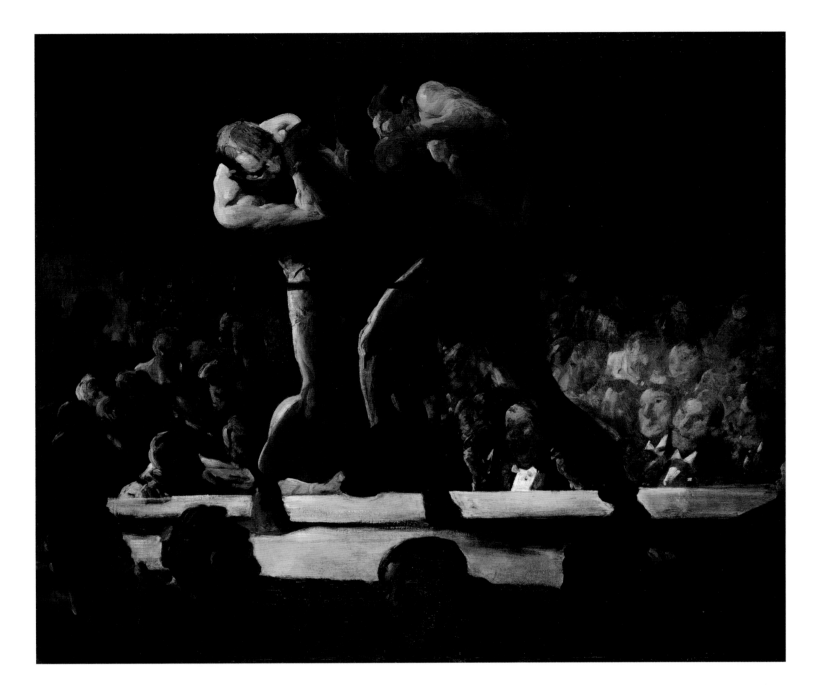

135 George Wesley Bellows, *Club Night*, 1907

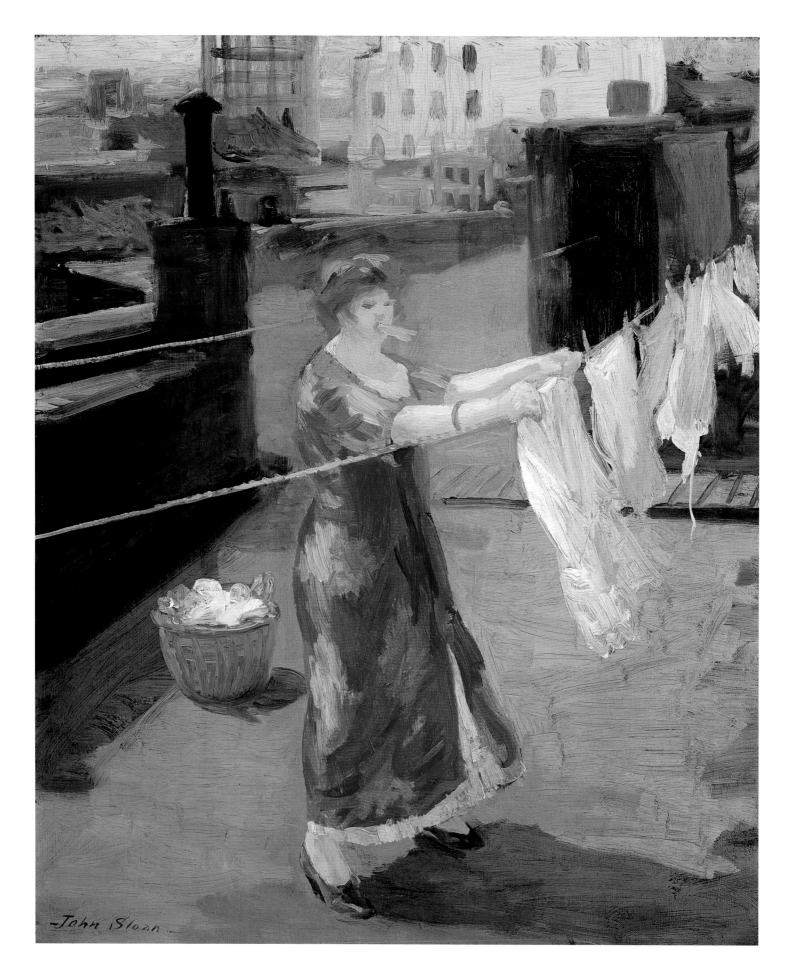

136 John Sloan, *Red Kimono on the Roof*, 1912

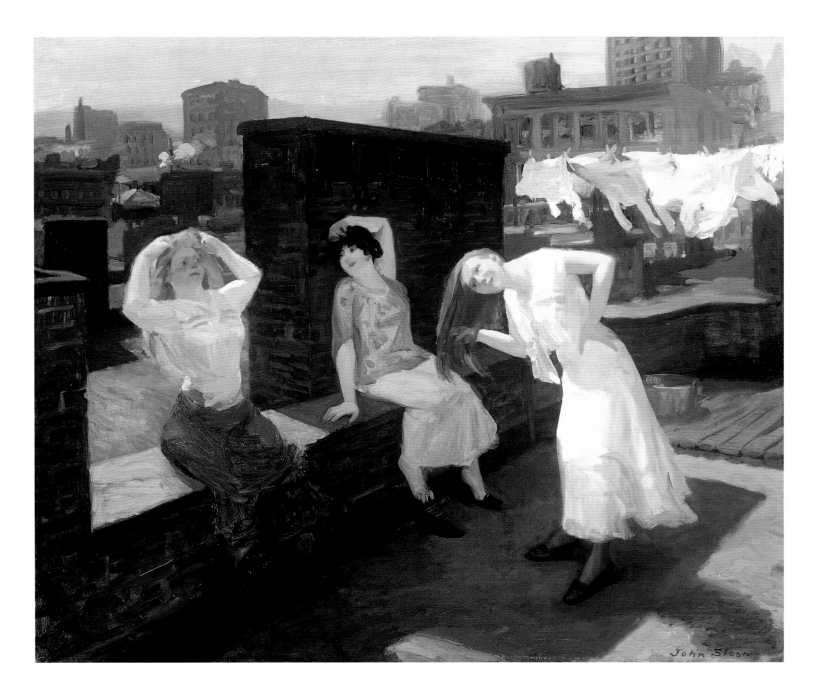

137 John Sloan, *Sunday: Women Drying Their Hair*, 1912

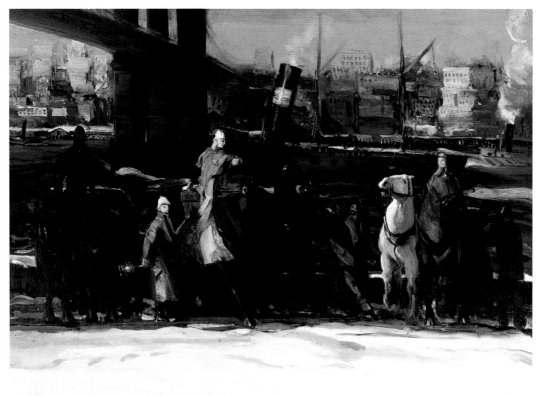

138 George Wesley Bellows,
Snow Dumpers, 1912

139 George Wesley Bellows,
Excavation at Night, 1908

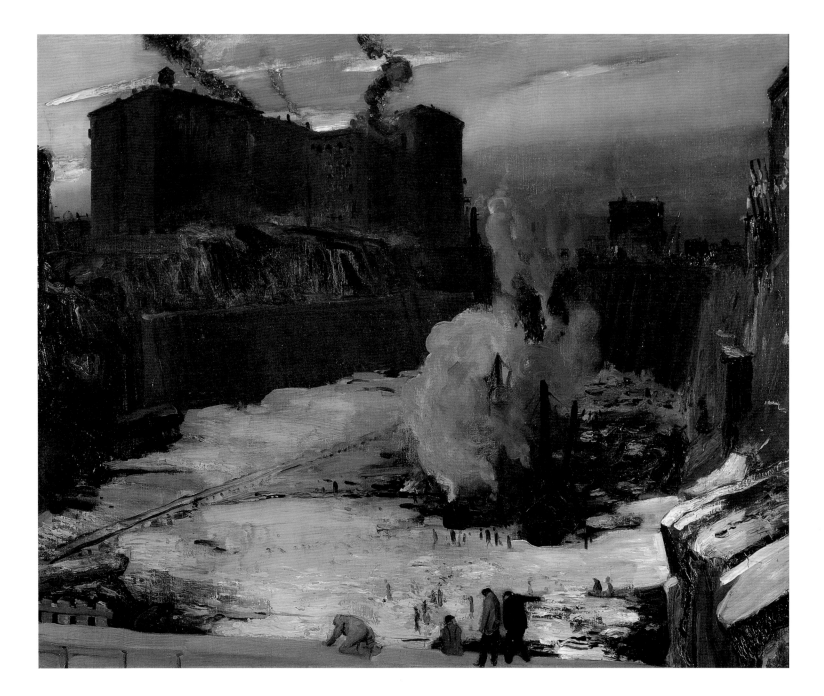

140 George Wesley Bellows, *Pennsylvania Station Excavation*, 1909

141 George Wesley Bellows,
North River, 1908

142 George Wesley Bellows,
Winter Road, 1912

143 George Wesley Bellows, *Portrait of Anne*, 1915

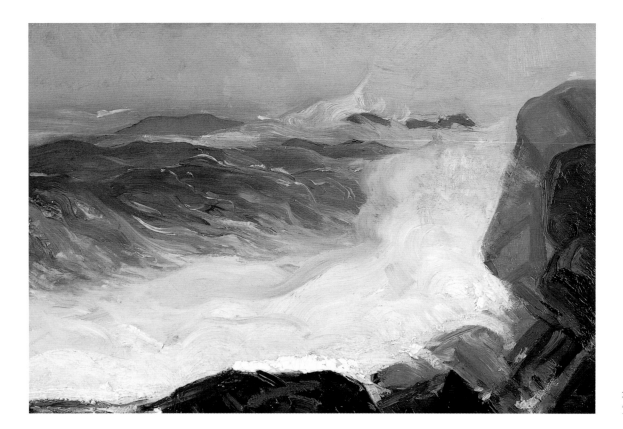

144 George Wesley Bellows,
The Grey Sea, 1913

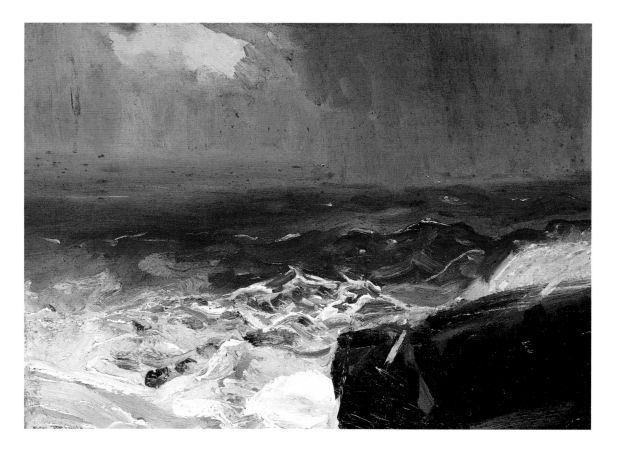

145 George Wesley Bellows,
 Approach of Rain, 1913

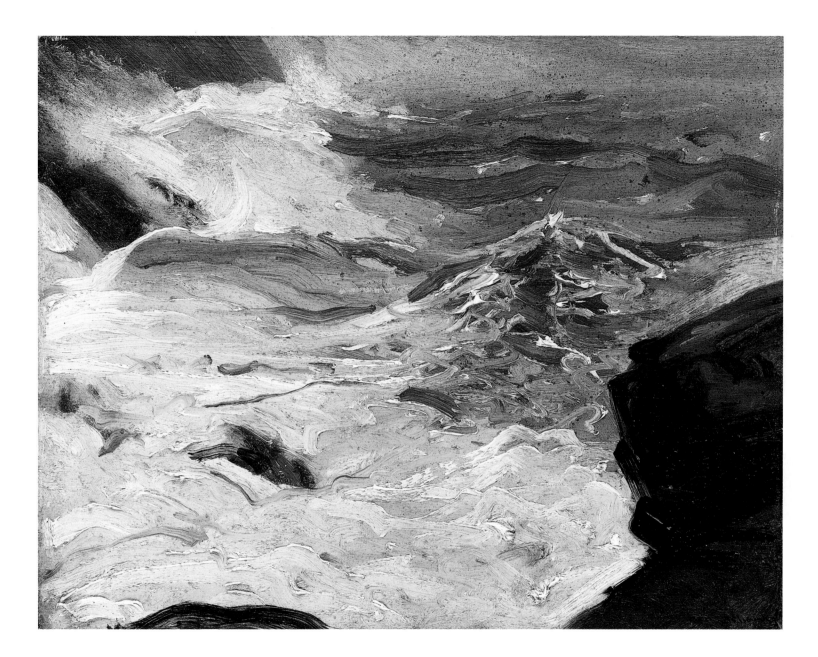

146 George Wesley Bellows, *From Rock Top, Monhegan*, 1913

American Art and its Audience in the Nineteenth Century

John Singer Sargent, *Street in Venice*, detail,
c. 1880–82 (plate 129)

Nineteenth-Century Collections of American Paintings

Art collectors were rare in colonial America, and the formation of substantial collections of paintings—particularly paintings by contemporary American artists—did not occur until the nineteenth century.[1] To be sure, there were the exceptional cases such as Thomas Jefferson (1743–1826), who by 1810 had assembled a large collection of paintings, including several by contemporary Americans. But, on the whole, portrait painter John Singleton Copley's complaint that his fellow colonials considered painting equivalent to "any other usefull trade ... like that of a Carpenter tailor or shew [sic; i.e., shoe] maker, not as one of the most noble Arts in the World," was an apt assessment.[2] Or, as John Adams (1735–1826), second President of the United States, put it: "It is not the fine arts which our country requires: the useful, the mechanic arts are those which we have occasion for in a young country."[3] His generation, Adams felt, had to study war and politics so that the next generation would be free to practice commerce and farming; appreciation and enjoyment of the fine arts would have to wait.

During the nineteenth century, the collecting of art by Americans increased dramatically and, as it did, underwent many changes. A full history of American collecting in this period has yet to be written, and this essay can only provide an outline of its general patterns and highlight a very few individuals. America experienced enormous political, social, and

1 Thomas Sully, *Daniel Wadsworth*, 1807, oil on canvas, 71.4 x 55.6 cm, Wadsworth Atheneum, Hartford, CT, gift of William P. Wadsworth

cultural changes in the nineteenth century, and it is not possible to isolate a single and relatively small aspect of history—such as the collecting of American paintings—and provide a definitive reading of it. Nevertheless, even though those who bought American paintings during the nineteenth century came from a variety of social and cultural backgrounds, and were driven by many different motivations, they did have certain things in common. First of all, they had wealth. American paintings may have been inexpensive compared to Old Master and contemporary European works, but they were still beyond the means of most citizens. Second, virtually all of the important collectors in this period were from the Northeast, which is where the principal venues for seeing and acquiring works of art were located. There was certainly interest in the arts in the south and in newer communities further west, such as Cincinnati, but as the century wore on New York City became the unrivaled center of the American art market.

In the early decades of the century a number of factors contributed to the development of significant collections. After the upheavals of the War of Independence and the War of 1812, America enjoyed a relatively stable period during which important urban centers underwent substantial growth. Sizeable fortunes were made (not just inherited) through commerce, land speculation, the development of industries and railroads, and other means. And as the financial means to acquire art increased, social attitudes increasingly cast doing so in a highly positive light. In this new democratic society collecting works of art, like owning property generally, became a prime way through which to establish and advance social standing. Further, many Americans who were proud of their own accomplishments and those of their young nation were sensitive to the fact that the country had not yet developed its own vital artistic culture. A number of widely-read accounts of visits to the United States by foreigners such as Frances Trollope, Harriet Martineau, and Alexis de Toqueville made precisely that point.

Initially, an old guard aristocratic elite—conservative patrons such as Philip Hone, Giulian Verplanck, Charles Wilkes, David Hosack, and others in New York, Robert Gilmor, Jr. in Baltimore, Maryland, and Daniel Wadsworth in Hartford, Connecticut (fig. 1)—maintained a strong grip on cultural authority.[4] Modeling their collecting on European patterns, these patrons tended to regard artists as social inferiors who needed their benevolent support in order to flourish. The artist John Trumbull, who played an important role in advising patrons such as Daniel Wadsworth and Robert Gilmor, Jr., summed up the situation in an address to the American Academy of the Fine Arts in New York in 1833: "It has been proved by all experience and, indeed, it is a truism,

2 Thomas Sully, *Robert Gilmor, Jr.*, 1823, oil on canvas, 74.6 x 62.9 cm, The Baltimore Museum of Art, Baltimore, MD

that the arts cannot flourish without patronage in some form; it is manifest, that artists cannot interchangeably purchase the works of each other and prosper; they are necessarily dependent upon the protection of the rich and the great."[5] Such patronage by "the rich and the great," of course, assumed a stable social order in which the aristocratic elite could comfortably inhabit the upper realm while encouraging and supporting the efforts of artists they considered worthy.[6] Their efforts offered multiple rewards: feelings of altruism and good citizenship, the acquisition of fine works of art, and honor and prestige amongst their fellow elite.

Robert Gilmor, Jr. (1774–1848) of Baltimore epitomized the aristocratic American collector in the first half of the nineteenth century (fig. 2). Having inherited his father's profitable shipping business, he substantially expanded it and his personal fortune. Well-educated and well-traveled, Gilmor was one of the most knowledgeable connoisseurs in America during the first half of the nineteenth century, and the collection he formed was extremely wide-ranging, embracing European Old Master paintings, decorative arts and sculpture, manuscripts, and contemporary American paintings.[7] Like other aristocratic collectors, he felt he could play a positive role in the development of art in this country by supporting artists he deemed worthy; he also clearly enjoyed interacting with them, corresponding with them, and critiquing their works. Gilmor had a fondness for landscape painting, and was an early patron of the pioneering

American landscape painter Thomas Doughty, to whom he gave a number of commissions. He also was a early supporter of Thomas Cole, from whom he commissioned four pictures.

Gilmor, like other members of his social class, was proud of the role he felt he was playing in the encouragement of American-born artists. By the late 1830s and early 1840s, however, tensions between old aristocratic patrons and the increasingly powerful bourgeois collectors were building, and men like Gilmor began to see themselves cast as embodiments of all that was wrong with the traditional system of patronage. In 1844, the *New York Herald* published an article that spoke glowingly of the philanthropic spirit of Benjamin Coleman Ward.[8] Gilmor, in this same article, was characterized as one who did not open his house and collection to artists and other interested parties and who had obtained his pictures not by paying fair prices, but by "haggling with the artist, or by an attempt to exchange some worthless daub." Incensed, Gilmor wrote a long letter to a friend and business associate in which he vehemently defended his reputation as a collector: "This was the reward for patronising when no one else in their native city would do it, Cole, Weir, Mount, Ingham, Inman, Dunlap, Trumbull & to all of whom I could refer to show that I had paid them large sums in advance & told them to paint me a picture *such as they care*...."[9] Gilmor had some reason to protest, because records show that he paid prices that were perfectly in line with those paid by other patrons, and he did often allow painters to paint subjects of their own choosing for him. Gilmor clearly hoped that other prominent aristocrats with influence in cultural circles, such as Philip Hone of New York, would help vindicate him, but what Gilmor doubtless could not know was the tide had turned against him and others of his class.

For artists, the reward of aristocratic patronage was first and foremost income, but that was accompanied by the inherent drawbacks. The prime danger lay in the capacity for economic and social abuse and the creation of an environment that encouraged interference (usually in the form of the patron offering paternalistic "advice"). Working for "the rich and the great" need not necessarily result in improper compensation, humiliation, and creative stifling, but the very fact that it might seemed increasingly intolerable in American democratic society. For art to flourish, artists needed to find ways to attract new patrons, and to do that they needed opportunities to exhibit their works to the public. The first important art organizations, the American Academy of Fine Arts, founded in New York in 1802, and the Pennsylvania Academy of the Fine Arts, founded in Philadelphia in 1805, offered artists at least minimal opportunities for study and for exhibiting their works. But in the early years of the century such organizations did relatively little to promote artists beyond the limited confines of their membership. The National Academy of Design, organized in New York in 1826 by artists dissatisfied with the American Academy, and supported by wealthy businessmen, flourished during the 1830s as the fortunes of the American Academy waned. That the National Academy stood in direct opposition to the elite's idea of patronage was clear from the beginning. As an article from 1831 observed: "The individuals who have fostered and reared the Academy of Design have been threatened with the loss of patronage; they have been told that an Academy must be supported by gentlemen of fortune; and that artists are incapable of conducting an institution of the kind ... the founders of the Academy are assailed ... as fools for not pretending to yield to the possessors of wealth ... But the National Academy seeks no patron but the public...."[10]

The National Academy offered many advantages to its artist members, not the least of which were its annual exhibitions, which provided much needed exposure for new works of art and a market for selling them. Thus, during the 1830s and 1840s the National Academy helped artists escape "the paternalism of the patrician elite, while simultaneously avoiding a fall into the clutches of an aggressive democracy bent on denying the existence of privilege or distinction, whether economic or intellectual."[11]

Even more democratic in outlook was the American Art-Union, also in New York, (founded as the Apollo Association in 1839), an organization that purchased and exhibited works by American artists and then distributed paintings to its membership by lottery. Until its dissolution in 1852, the Art-Union would serve as a major force in shaping American taste. For a fee of five dollars, members received a monthly bulletin discussing art topics, a steel engraving after one of the paintings purchased that year, and the chance to win an actual painting (fig. 3). During the years of its existence, the Art-Union distributed some 150,000 engravings and 2,400 paintings, with membership peaking around 19,000.[12] The quality of the works tended to be quite high, as is evidenced by Bingham's *Raftsmen Playing Cards* (plate 58), Church's *New England Scenery* (plate 38), Clonney's *Waking Up* (plate 25), Cropsey's *Janetta*

3 Francis d'Avignon, after Tompkins H. Matteson, *Distribution of the American Art-Union Prizes, At the Tabernacle-Broadway, New York, 24th Dec, 1847*, 1847, lithograph, 49.3 x 64.5 cm, Museum of Fine Arts, Boston, MA, Karolik Collection

4 James Smillie, after John Kensett, *The White Mountains—Mount Washington*, 1851, etching, 17.8 x 26.4 cm, American Antiquarian Society, Worcester, MA

Falls, New Jersey, and Kensett's *The White Mountains* (*Mount Washington from the Valley of Conway*) (plate 33) (which was engraved for the membership in 1851; see fig. 4); all in the present exhibition and all originally purchased by the Art-Union directly from the artists. The monthly *Bulletin of the American Art-Union* was the first periodical devoted to the fine arts in America, and included articles and essays on a wide range of topics. Exhibitions, including those of other institutions like the National Academy, were reviewed, and although serious critical writing about American art was scarce before the second half of the century, the critiques in the *Bulletin* (and in some New York newspapers) were often insightful.

Gradually during the 1830s and 1840s the cultural power of the aristocratic elite shifted in favor of an ascendant class of wealthy bourgeois merchants and businessmen. By the middle of the century the dominance of the aristocracy had come to an end.[13] The shift toward bourgeois patronage did not, of course, change the patterns of collecting overnight. Not only did many members of the aristocracy continue to commission works of art during this period, but also the new patrons tended to emulate the cultural activities of the old elite.[14] There were, of course, important differences: men who had not grown up in cultured circumstances felt a sense of inferiority when it came to making aesthetic judgements, and were less inclined to impose their will on artists. They also more often dealt with artists as social equals.

If Gilmor epitomized the aristocratic elite, Luman Reed (1785–1836) equally embodied the newly-monied collector (fig. 5).[15] Reed was born in rural New York to a farming family. Reed opened his own produce and freight business and in 1815 set up a store in New York. He prospered in the dry goods trade and his business interests expanded rapidly. Considered by his contemporaries the very model of an honest, hard-working, straightforward self-made man, Reed had by 1832 amassed a fortune large enough to allow him to retire. He built a fine three-story house and set about filling it with art; although he was initially attracted to European Old Masters, Reed soon began concentrating on works by contemporary Americans. His shift in his collecting was not so much the result of a disenchantment with European art, but rather of a strong feeling of cultural nationalism that made him believe that American artists were capable of creating works at least as good as those of their foreign counterparts. As he would write to the genre painter William Sidney Mount in 1835: "This is a new era in the fine arts in this Country, we have native talent and it is coming out as rapidly as is necessary."[16] And Reed's ambitions were to have the finest collection of works by his contemporaries: "The fact is, I must have the best pictures in the Country...."[17] The artists Reed was particularly interested in commissioning works from were Thomas Cole, Asher B. Durand (later famous as a landscape painter, but in the 1830s painting primarily portraits and literary subjects), George W. Flagg (a painter of historical and literary subjects), and Mount (fig. 6). Reed's premature death in 1836 was a serious blow to these artists, but his business partner Jonathan Sturges (1802–1874) took up collecting works by these same painters and others, eventually amassing a substantial collection of his own.[18]

Most collectors acquired art for their own enjoyment, but some had other motivations. In Philadelphia, a book publisher named Edward L. Carey (1805–1845) formed an important collection (eventually bequeathed to the Pennsylvania Academy of Fine Arts), and had a particular purpose in doing so (fig. 7).[19] Although born to wealth—his father had emigrated from Ireland to Philadelphia in 1784 and founded the family's successful publishing business—and well-connected in artistic and literary circles, Carey's interest in collecting developed from a different perspective than that of traditional aristocratic patrons. Influenced by his father's taste and by that of his brother-in-law, the American

5 Asher B. Durand, *Luman Reed*, c. 1836, oil on canvas, 77.2 x 64.5 cm, The Fine Arts Museums of San Francisco, CA

6 William Sidney Mount, *The Truant Gamblers (Undutiful Boys)*, 1835, oil on canvas, 61 x 76.2 cm, New-York Historical Society, NY

painter Charles Robert Leslie, who was living and working in London, Carey acquired a number of important English pictures. But he also firmly believed in promoting the work of contemporary American artists, and early on realized that his publishing business could play an important role. Given his literary background, it is hardly surprising that Carey would be drawn to works with a story-telling or narrative focus. He especially liked genre paintings (he commissioned three from William Sidney Mount, for example), which were ideally suited for use as illustrations in "gift books," one of the mainstays of his publishing firm. These illustrated volumes of short stories and poetry generally came out at Christmas time and were enormously popular in nineteenth-century America; Carey's *The Gift* was one of the most admired of them all. For it he used works from his own collection and from others as the basis for illustrations, and he also commissioned stories that went with them.

Charles M. Leupp (1807–1845), whose collection was one of the very finest from the first half of the nineteenth century, came from a background similar to that of Luman Reed.[20] Like Reed, he was considered by his contemporaries a model self-made man, hard-working and honest, and generous in his support and encouragement of others. Leupp was born in Brunswick, New Jersey, and came to New York at an early age to apprentice in the leather business. He prospered and rose in the business world, eventually serving as a director of the New York and Erie Railroad and on the board of directors of two banks. In the 1840s and 1850s he was very wealthy and his elegant house at 25th Street and Madison Avenue was considered one of the city's finest. He formed a large art collection that was primarily of works by American artists, with about one third of the paintings by Europeans. In quality and scope Leupp's collection in many ways prefigured the enormous holdings that would be formed by New York's merchant princes of the second half of the nineteenth century. His tastes ran from historical scenes, such as Emmanuel Leutze's *Mrs. Schuyler Burning Her Wheat Fields on the Approach of the British* (fig. 8), landscapes, such as Thomas Cole's *The Mountain Ford* (1846, The Metropolitan

Museum of Art, New York), and John F. Kensett's *The Upper Mississippi*, (1855, Saint Louis Art Museum), and genre and literary subjects, such as Francis Edmonds' *Gil Blas and the Archbishop*, (1849, private collection). According to an article published just after his death, "the patronage bestowed by Mr. Leupp on American art was as judicious as it was generous. He strove to realize the capacity of native painters to illustrate the brilliant scenery and rich physical life of the land, and succeeded in grouping within a select circle, as many charming and characteristic pictures as are to be found, perhaps, in any gallery extant."[21] Leupp also, like his close friend Sturges, personally knew many of the artists represented in his collection and enjoyed socializing with them.[22]

Following the upheavals of the Civil War (1861–1865), collecting patterns changed decisively in America. In 1866 Henry T. Tuckerman included an appendix in his *Book of the Artists*, in which he proudly listed the major public and private collections of American art then in existence.[23] Running some thirteen pages and citing hundreds of individual works of art, the appendix was clearly intended by Tuckerman as evidence of a solidly established appreciation and respect for American art. He doubtless believed that respect and appreciation would continue and grow in the coming years, but that would not entirely be the case. One of the driving forces influencing collectors in the pre-war years was national pride and a strong belief in the validity of native art. American art was seen as different, as distinctly *American*, and not merely a provincial, colonial derivative of European art. This was especially true of how landscape and genre paintings were viewed. New World scenery was different from that of the Old World and required a new and different artistic vision—the vision of a Church or a Kensett. American customs and mores were also different, and it took an artist like Bingham to express that difference. Much was made of the fact that many of America's most admired painters, including Church and Bingham, had not been to Europe for study and thus remained purely national in their artistic outlook.[24]

Still, it should be remembered that the America portrayed in landscape and genre paintings was, in many ways, a fiction created by the artists. Their audience, as they knew perfectly well, was not made up of farmers, trappers, pioneers, or woodsmen. They painted for city dwellers and sold their work to rich businessmen who might have fond memories of a rural childhood, but who now lived in a very different reality. For such individuals there was a certain measure of comfort to be taken in the belief that beyond the cities there still thrived a land of yeoman farmers and adventurous pioneers, and that the special character of American wild landscape was, at least somewhere, still intact.

In the years immediately following the Civil War virtually everything changed. America's national identity, its image of itself, had not just been shaken, it had been ripped apart. No longer was it possible for a particular kind of art to lay claim to the embodiment of national identity the way landscape painting had before the War. Artistic isolationism quickly came to be seen as a defect, not a virtue. American painters, sculptors, and architects, like American writers and intellectuals, flocked to Europe in the last decades of the century. Cosmopolitanism replaced nationalism.

Art collecting changed dramatically in the post Civil War years, especially during the 1870s, 1880s, and 1890s, the height of the Gilded Era. Unprecedented fortunes were amassed by real estate tycoons, merchants, and captains of industry and transportation, and they spent freely, building lavish mansions and filling them with works of art. It was the era of "conspicuous consumption" and "conspicuous waste," as Thorstein Veblen so memorably put it in *The Theory of the Leisure Class*, published in 1899. Most collectors of the time concentrated on fashionable European salon pictures, and those who also collected American art tended not to purchase new works by contemporaries. Railroad magnate John

7 Thomas Sully, *Edward L. Carey*, 1859, oil on canvas, 76.8 x 64.1 cm, Museum of American Art of the Pennsylvania Academy of the Fine Arts, Philadelphia, PA, gift of Maria Carey

Taylor Johnston (1820–1893) had by the 1870s put together an unequalled collection of almost three hundred paintings, one third of which were American.[25] Included were a number of works that are today considered masterpieces of American art: Thomas Cole's four-part allegorical series, *The Voyage of Life* (1839, Munson-Williams-Proctor Institute of Art, Utica, New York; a second version completed in 1842 is in the National Gallery of Art, Washington, D.C.), Frederic Church's *Niagara* (fig. 2, p. 44), and *Twilight in the Wilderness* (which was originally owned by another great collector, William T. Walters of Baltimore; plate 45), and Winslow Homer's *Prisoners from the Front* (fig. 4, p. 44). Unfortunately, financial difficulties forced Johnston to sell the entire collection in 1876. Although American paintings did fairly well at the sale, their prices were far eclipsed by those brought by Johnston's European pictures. The following year, the collection of Robert M. Olyphant (1824–1918), another New Yorker who made his fortune in railroads, was sold at auction. Among the more than 160 American paintings were many of great quality and importance, including Church's *New England Scenery* (plate 38), but the prices were generally low.

Indeed, even though gilded Age millionaires such as William B. Astor and A.T. Stewart in New York and Henry Clay Frick in Pittsburgh, acquired American works, the greatest prizes that filled their enormous picture galleries were invariably contemporary European pictures by popular artists like William Bouguereau and Ernest Meissonier. Stewart did not balk at paying some $80,000 for Meissonier's *Friedland: 1807* (1875, The Metropolitan Museum of Art, New York), but almost certainly would have considered it absurd to spend even one-tenth that amount on a contemporary American painting. Even in Boston, where collectors were not as unabashedly enthralled by Salon painting, the sums paid for French Barbizon paintings were generally much greater than what would have been consider reasonable for an American work.

One of the few collectors of the late nineteenth century to focus on American art was Thomas B. Clarke (1848–1931).[26] Clarke bought voraciously and owned more American pictures than any other collector in nineteenth-century America. He was fond of certain artists in particular, and acquired as many examples of their work as he could. By 1899, for example, he owned thirty-nine paintings by George Inness (fig. 9), and fifteen oils and sixteen watercolors by Winslow Homer (including *To the Rescue;* plate 80). Clarke was a vigorous promoter of American artists, but he was also attracted to the business of buying and selling art and had no qualms about making a profit. At times he was as much a dealer as a collector, and his keen sense of the market was proven when he sold his entire collection at auction in 1899 for almost $235,000.[27]

By the end of the century there were more opportunities to see and acquire American paintings than even would have been dreamed of 100 years earlier. New York had numerous commercial galleries and the National Academy of Design was no longer the only such institution in town. The Society of American Artists, founded in 1877 by younger artists who felt the Academy was too conservative, held important annual exhibitions for almost thirty years (it merged with the Academy in 1906). The Metropolitan Museum of Art, founded by businessmen and artists (Frederic Edwin Church among them) in 1870, included American paintings in its collections from its inception. Elsewhere throughout the country museums were founded, almost always with American art as part of their core collections. In Washington, William Wilson Corcoran (1798–1888), a successful banker and collector of American and European art, wanted to establish a public art gallery in the nation's capital. That ambition was fulfilled with the founding of the Corcoran Gallery of Art in 1869. In 1870 the Museum of Fine Arts, Boston was founded, followed in 1876 by the Philadelphia Museum of Art, the Art Institute of Chicago in 1879, and the Detroit Institute of Arts in 1885. As these museums and others grew in the twentieth century and as interest in historical American art increased, more and more paintings moved from the private to the public realm, a process that continues to this day.

8 Emanuel Leutze, *Mrs. Schuyler Burning Her Wheat Fields on the Approach of the British*, 1852, oil on canvas, 81.3 x 101.6 cm, Los Angeles County Museum of Art, CA, bicentennial gift of Mr. and Mrs. J. M. Schaaf, Mr. and Mrs. William D. Witherspoon, Mr. and Mrs. Charles Shoemaker, and Mr. and Mrs. Julian Ganz, Jr.

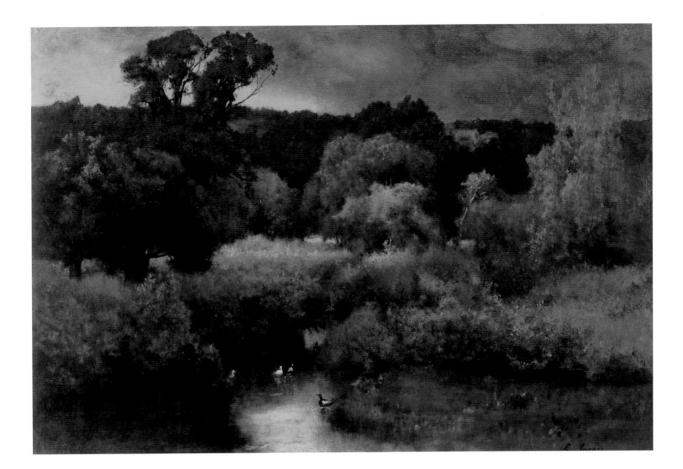

9 George Inness,
Gray Lowery Day,
c. 1877, oil on canvas,
40.6 x 61 cm, The
Wellesley College
Museum, MA

1 On the general history of collecting in America, see W. G. Constable, *Art Collecting in the United States of America: An Outline of a History* (London, 1964); Lillian B. Miller, *Patrons and Patriotism: The Encouragement of the Fine Arts in the United States, 1790–1860* (Chicago and London, 1966); Neil Harris, *The Artist in American Society: The Formative Years, 1790–1860* (New York, 1966); Frederick Baekeland, "Collectors of American Painting, 1813 to 1913," *American Art Review* 3 (November-December 1976): 120–66; and Wayne Craven, "Introduction: Patronage and Collecting in America, 1800–1835," in Ella M. Foshay, *Mr. Luman Reed's Picture Gallery: A Pioneer Collection of American Art* (New York, 1990), 11–18.

2 Copley to Benjamin West or Captain R. G. Bruce (?), in Gurnsey Jones, ed., *Letters and Papers of John Singleton Copley and Henry Pelham* (Boston, 1914; 1972), 65–66; quoted in Emily Ballew Neff, *John Singleton Copley in England*, exhib. cat., Museum of Fine Arts, Houston (London, 1995), 12.

3 Constable, 11.

4 See William H. Truettner and Alan Wallach, eds., *Thomas Cole: Landscape into History*, exhib. cat. (Washington, D.C.: National Museum of Art, 1994); Wallach, "Thomas Cole and the Aristocracy," *Arts Magazine* 56 (November 1981): 94–106.

5 Quoted in Charles E. Baker, "The American Art-Union," in Mary Bartlett Cowdrey, *American Academy of Fine Arts and American Art-Union* (New York, 1953), 95; see also Constable, 3.

6 See the discussion in Truettner and Wallach, *Cole*, 33–34.

7 On Gilmor and his collection, see Anna Wells Rutledge, "One early American's precocious taste," *Art News* 48 (March 1949): 28–29, 51; ibid, "Robert Gilmor, Jr. Baltimore Collector," *Journal of the Walters Art Gallery* 12 (1949): 18–39; Barbara Novak, "Thomas Cole and Robert Gilmor," *Art Quarterly* 25 (Spring 1962): 41–53; and *The Taste of Maryland: Art Collecting in Maryland, 1800–1934*, exhib. cat. (Baltimore: Walters Art Gallery, 1984), 1–7.

8 Ariel, "An Account of the Grand Musical Soirée which took place on the night of the 14th inst.," *New York Herald*, 27 March 1844; quoted and discussed in Alan Wallach, "'This is the Reward of Patronising the Arts': A Letter from Robert Gilmor, Jr., to Jonathan Meredith, April 2, 1844," *The American Art Journal* 21 (1989): 76–77. Ariel actually referred to Henry Carey of Philadelphia, but he surely meant his brother Edward, whose collecting is discussed in this essay. Upon Edward's death in 1845 Henry and his sister received the bulk of Edward's collection.

9 Quoted in Wallach, "This is the Reward," 76.

10 T., "The Progress of the Arts in our country," *The New York Evening Post*, 9 May 1831.

11 Thomas Bender, *New York Intellect* (New York, 1987), 130; quoted in Truettner and Wallach, *Cole*, 38.

12 Baekeland, 123.

13 Truettner and Wallach, *Cole*, 34.

14 Truettner and Wallach, *Cole*, 38.

15 Reed's activities as a collector of American painting have been extensively discussed; see most recently Foshay, *Mr. Luman Reed's Picture Gallery*, and "Luman Reed, a New York patron of American art," *Antiques* 138 (November 1990): 1074–85; Wayne Craven, "Luman Reed, Patron: His Collection and Gallery," *The American Art Journal* 12 (Spring 1980): 40–59; and Russell Lynes, "Luman Reed, a New York Patron," *Apollo* 107 (February 1978): 124–29.

16 Letter of 23 November 1835, Collection of The Museums at Stony Brook, New York.

17 Letter to Mount of 24 September 1835, Collection of The Museums at Stony Brook, New York.

18 On Sturges and his collecting, see "Our Private Collections, No. 11," *The Crayon* 3 (February 1856): 57–58; Benson J. Lossing, *History of New York City* (New York, 1884), 618–19; Joanne August Dickson, "Patronage of Nineteenth-Century American Painters: Jonathan Sturges and His Associates," (unpublished paper, 1973; copy in curatorial files, National Gallery of Art, Washington, D.C.). Also useful is *Complimentary Dinner to Jonathan Sturges* (privately printed, 1868), which includes testimonials to Sturges and a personal reminiscence of his life in business.

19 On Carey see Susan Danly, "The Carey Collection at the Pennsylvania Academy of the Fine Arts," *Antiques* 140 (November 1991): 839–45.

20 See James T. Callow, "American Art in the Collection of Charles M. Leupp," *Antiques* 118 (November 1980): 998–1009.

21 "Sale of Works of Art," *New York Daily Tribune*, 14 November 1860.

22 Callow, 998.

23 *Book of the Artists: American Artist Life* (New York, 1867), 621–33.

24 Both Church and Bingham did eventually visit Europe, but it was after the peak of their careers.

25 "Pictures in the Private Galleries of New York, II: John Taylor Johnston," *Putnam's Magazine* 6 (July 1870): 81–87.

26 See H. Barbara Weinberg, "Thomas B. Clarke: Foremost Patron of American Art from 1872 to 1899," *American Art Journal* 8 (1976): 52–83.

27 Weinberg, 67.

LINDA S. FERBER

Constructing a Past

Nineteenth-Century Histories of American Art

There is great interest among scholars today in the historiography of American art and in the principles and theories that have animated nineteenth and early twentieth-century narratives of this relatively recent chapter in art history. Substantial articles by Elizabeth Johns and Wanda Corn have offered outlines and interpretations of the broadest developments in the field. More narrowly focused topics have also been explored such as Kevin Avery's historiography of the Hudson River School and William Truettner's account of evolving interpretations of Thomas Cole's oeuvre.[1] These endeavors have greatly enriched our understanding of the development of historical consciousness while reminding us that today's methodologies and theories of interpretation will also yield in time to new concerns and approaches. What emerges clearly from these recent studies is that the outline of an American art history is a project begun early in the nineteenth century and that it reflects modulations in both historical consciousness and cultural nationalism. This short article will explore these themes as expressed in several volumes published at thirty-year intervals and in a pioneering art exhibition organized in 1872. A brief look at these projects devoted solely to American art offers insight to the shifts that occurred during the century in historical consciousness as well as in perceptions of artist identity.

We begin with William Dunlap's *History of the Rise and Progress of the Arts of Design in the United States.* Published in 1834 as two volumes, Dunlap chronicled a span from the beginning of the eighteenth century to the early careers of William Sidney Mount and Thomas Cole. Next is Henry T. Tuckerman's mid-century *Book of the Artists* (1867) in which the text is divided between a retrospective view modeled on Dunlap and several hundred pages devoted to contemporary production in the antebellum period and the years immediately after the American Civil War. While these two publications are unique for their time in scale and scope, a number of art-historical surveys were issued at the turn of the century. Samuel Isham's volume on *The History of American Painting* of 1905 is pre-eminent among these providing, as Johns notes, the general model for subsequent

efforts. Isham's highly organized and systematic "text-book" approach introduced a new level of periodization, organizing material chronologically and thematically into twenty-eight chapters supported by an annotated bibliography. Perhaps most important, the 573-page text was the first to be richly illustrated with a dozen photogravures and 121 photographs. Another endeavor that cast a long look back at the history of American painting was "The First Chronological Exhibition of American Art." This large exhibition of some 252 paintings by artists ranging from John Smibert (1688–1751) to John F. Kensett was displayed in 1872 at the Brooklyn Art Association. The organizers, led by businessman and amateur artist John Mackie Falconer, sought to relocate the experience of art-historical consciousness from the private realm of the text to the public arena of didactic spectacle. Their ambitious, now largely forgotten enterprise provided precedent and, probably, the model for the smaller "Retrospective Exhibit of American Painting" organized twenty years later at the Chicago World's Columbian Exposition of 1893.

All of these enterprises shared certain agendas. Each project was devoted to building a canon of academically viable and historically resonant "masterworks" that would be widely accepted as a national visual patrimony. Each also posited a mode of acknowledging and participating in the larger European tradition, always recognized (although often resisted) as a critical context for defining national culture. Equally important to each scheme was a prescriptive subtext seeking to construct an ideal model for American artist identity. Important to note is that fact that none of our principals was a professional historian or curator. Dunlap and Isham were practicing painters, trained respectively in London and Paris, the academic meccas of their day for American students. Tuckerman was a critic, essayist, and poet who had enjoyed the Grand Tour after two years at Harvard, returning to become a popular chronicler-critic of New York artist life. All three writers shared a significant experience of European culture as well as a future-oriented approach to American developments in the visual arts. Falconer was a hardware merchant, art collector, and amateur artist who was involved in nearly every artist organization in New York and Brooklyn at mid-century. All were active participants in the artistic circles of their moment, gaining their authority on contemporary production largely from first-hand knowledge. All three histories were published in New York City, focusing primarily upon the busy studio life and dominant art market of that metropolis with nods to the historical importance of other urban centers such as Boston and Philadelphia. In keeping with the cosmopolitanism of Isham's artist generation, apparently, his volume on American

1 Charles C. Ingham, *William Dunlap (1766–1839)*, oil on canvas, 76.2 x 63.5 cm, National Academy of Design, New York, NY

painting was largely written as an expatriate during an extended residence in Paris![2] We will investigate each to discern the prevalent form of historical consciousness and the prevailing ideal for artist identity.

Dunlap's chronicle demonstrated his stalwart republican principles, interpreting the past, present, and future in ideological terms and proclaiming his thesis in the title (fig. 1). While "History" is retrospective, the idea of "Rise and Progress" implies both the engine of change and the assumption that the arts would move along a continuum of steadily improving circumstances. Dunlap was keenly aware of the importance of historical outcomes and of the future role his work would play. "When I undertook the task," he wrote in the preface, "I had no notion of the importance or magnitude of what I had undertaken." He stated his credentials, his method, and its drawbacks. "The author calls this work a history, without presuming to place himself in the rank of professed historians. His history shall be given by a chain of biographical notices, with all the discursiveness and license of biography."[3] Dunlap's models for this structure were the works of earlier historiographers Giorgio Vasari and George Vertue.

Understanding his "moment," less than sixty years after independence, Dunlap argued for inclusiveness because it was too early for canonical choices: "In our mode of giving the history of the progress of art in this country, principally by a chronological series of biographical notices, we shall undoubtedly speak of men who in no wise aided that progress; but, we hope, by giving as complete a view of the subject as can now be obtained, to place in the hands of the future historian, many valuable facts, which would otherwise have been lost; and to leave information respecting those professors of the arts who have failed, as well as those who have attained to honourable distinctions—information which may guide the present and future student on his way to the wished-for goal."[4] His text served its purpose, quickly assuming canonical status as the essential foundation document compiled by the "American Vasari."

Dunlap's proposed model for the artist was equally well-defined. The American artist was a "public man"; a citizen-artist newly freed, in the author's idealistic view, from the obligations of class and social subordination associated with traditional patronage systems in Europe. He wrote "... from the very first settlement of this country, the germs of republican equality were planted in our soil; they grew with the growth of the colonies, and were nursed into maturity by the blood of our fathers. The laws are here the only protectors. Industry, virtue, and talents, the only patrons."[5] Dunlap was, of course, proposing an ideal. He was keenly aware of the reality in the New York of his day when "industry, virtue, and talent" were, in fact, still very much in service to social and mercantile elites and the status of the artist was tenuous. Dunlap himself had been affiliated with the American Academy of Fine Arts, founded in 1803 and dominated by the older elite, including the irascible "gentleman-artist" John Trumbull (1756–1843). Dunlap's politics had aligned him in 1826 with the artist-founders of the breakaway National Academy of Design of which he was vice president at the time of the book's publication.

Nevertheless, the ideal of equating American political independence and artistic freedom would be long-lived. Twenty years later, Asher B. Durand, then President of the National Academy of Design, who succeeded Thomas Cole as premier interpreter of North American scenery, applied the republican metaphor in his "Letters on Landscape Painting" published in the first volume of *The Crayon* in 1855. He encouraged cultural nationalism in terms of artist-resistance to the European subject hierarchy that held landscape in only moderate esteem: "... untrammelled as he is, and free from academic or other restraints by virtue of his position, why should not the American landscape painter, in accordance with the principle of self-government, boldly originate a high and independent style, based on his native resources?"[6] Not long after Durand's "Letter" appeared, a lengthy review in *The Crayon* interpreted his 1855 painting *The First Harvest in the Wilderness* as a complex allegory of Manifest Destiny enacting the drama of landscape resistance (plate 24).[7]

The eight volumes of this highly regarded periodical, published between 1855 and 1861, were largely devoted to contemporary issues. However, articles on historical subjects appeared frequently. These included the serialized "Reminiscences" of Rembrandt Peale—an American "Old Master"—as well as extracts from publications on the history of European and American art. During these same years, the *Cosmopolitan Art Journal*, a periodical serving the membership of the Cosmopolitan Art Union, also surveyed the contemporary art world. In a long article appearing in the December 1858 issue, Henry T. Tuckerman took stock of "Art in America: Its History, Condition, and Prospects"[8] (fig. 2). The article was expanded a decade later to serve as the preamble introducing his *Book of the Artists*. Tuckerman's introduction preceded a long text largely composed, like Dunlap's, biographically, but with an effort to group many figures into four chapters organized by subject matter. Twenty-seven artists, from Copley to Bierstadt, also received treatment in separate chapters. Tuckerman made the obligatory acknowledgment of "our country's [brief] career in art" and noted: "Within the last few years the advance of public taste and the increased recognition of art in this country, have been among the most interesting phenomena of the times."[9]

Like Dunlap, he proposed that a new order fueled patronage in the United States. "The whole history of what may be termed the conventional nurture of Art in America is as remarkable a contrast to the means thus employed in Europe as it is illustrative of the democratic tendencies of our professional, not less than our political life." Tuckerman believed that: "He [the American painter] looked to individuals for support, and the early and later history of American Art honorably identifies commercial success with tasteful liberality." He cautiously applauded the new patrons with new money who appreciated the "increased value of Art, as a commodity" and who embraced it "as an element of luxury, if not of culture."[10] Nevertheless, the entrepreneurial energies so efficient in producing widely distributed material wealth also seemed suspect to Tuckerman as a proper catalyst for cultural production. The consistent ambivalence of his authorial voice between

optimism and doubt about this matter is a fascinating subtext. Moreover, Tuckerman did not perceive the forces driving his own times as Dunlap's stately march forward of "progress," but, rather, as a hectic race. "Art, like everything else here," he wrote, "is in a transition state."[11]

The transitional state also induced certain confusion about artist models. The artist should be a priest-like figure, Tuckerman proposed at one point, bestowing "a singlular balm and a blessing" upon a population infected with "the fever and hurry bred by commerce, political strife, and social ambition." Unlike Dunlap's citizen-artist, Tuckerman argued for a contemplative figure withdrawn from the arena of business and public life. "Who in this land of railroads and elections," he argued, "stands apart rapt in solemn visions such as absorbed of old a Dürer or an Angelo?"[12] On another occasion, however, he endorsed an entrepreneurial model: "And yet our atmosphere of Freedom, of material activity, of freshness and prosperity, should animate the manly artist. He has a vantage-ground here unknown in the Old World, and should work confidently therein for the reason given by Agassiz in regard to science—*the absence of routine.*" Nevertheless, at another point, he contradicted himself once again, complaining: "It is evident that Art in America, as a social and aesthetic element, has formidable obstacles wherewith to contend; the spirit of trade often degrades its legitimate claims."[13]

Albert Bierstadt's career, then at its zenith and to which Tuckerman devoted a full chapter, is the perfect case study of the tensions implicit in an entrepreneurial model that was animated by the "spirit of trade." In 1873, for example, Bierstadt defied an American artist boycott of the International Exposition held in Vienna. Interpreting the meager amount of exhibition space allotted to the United States as an insult to the national school, American artists as a body had declined to participate. "It is now a settled,

2 Daniel Huntington, *Henry Theodore Tuckerman (1813–1871)*, 1866, oil on canvas, 68.8 x 56.2 cm, National Gallery of Art, Washington, D.C., Andrew W. Mellon Collection

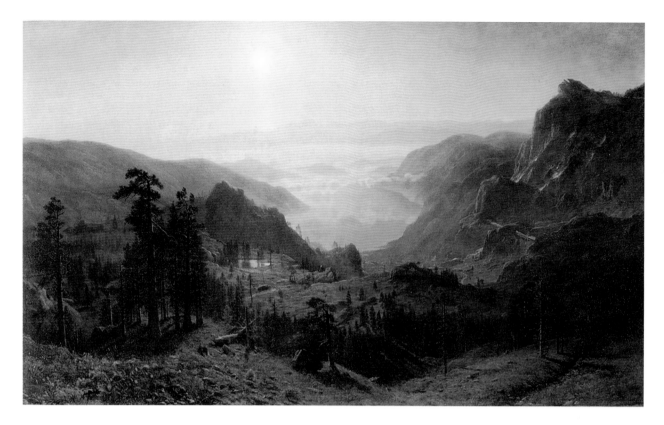

3 Albert Bierstadt, *Donner Lake from the Summit*, 1867, oil on canvas, 182.9 x 304.8 cm, New-York Historical Society, New York, NY

unchangeable fact that the United States will send no pictures to the Exhibition at Vienna" reported the *New York Times*, "[because] the Austrian estimation of our artistic efforts is so low." Acting "independently of the profession," however, Bierstadt sent two panoramic landscapes to Vienna: *Donner Lake from the Summit*, 1873 (fig. 3), and *The Emerald Pool*, 1870 (Norfolk Museum of Art, Virginia). This act of cultural disloyalty provoked public retaliation: "We may safely conclude," the *Times* charged, "that Europeans will judge us by Mr. Bierstadt, and will assert that there is no true art in America."[14] The Vienna incident is typical of the competition for markets and flair for self-promotion that made Bierstadt a famous and wealthy man, but that provoked severe reproach from the artist community.

Perhaps the collective anxiety around these conflicted models for artist identity—priest and seer or entrepreneur—played some role in Tuckerman's choice of a title for his 633-page volume. Dunlap's extolled the "Arts of Design" in the newly-founded United States and Isham's title referenced a body of painting that was recognized by the end of the century as "American." Tuckerman's nomenclature, however, was modeled on the business directories documenting American occupations at mid-century.[15] The primary title, *Book of the Artists*, as well as the subtitle, *American Artist Life*, reinforced the collective claim of this body to professional status, just as inclusion in the book itself was part of the machinery for constructing an individual artist's identity. Additionally, Tuckerman's volume mentioned many patrons in the text and included a lengthy appendix of American private and institutional collections from Baltimore to Boston.

These lists undoubtedly served as a critical reference to John Mackie Falconer several years later in

planning his survey project, "The First Chronological Exhibition of American Art" (fig. 4). Tuckerman himself also was asked to lend his name to this pioneering effort in Brooklyn to introduce a wide audience to the history of American art. New York's neighboring metropolis was booming, undergoing rapid growth and change in the post-Civil War years. In March 1872, the Brooklyn Art Association commemorated completion of a new building by organizing a large historical survey exhibition. This ambitious project was an important exercise in public art-historical consciousness. The impresario of this event was the remarkable Falconer, a businessman, art collector, and amateur artist. Falconer, who was also an Association officer, possessed just the combination of interests and skills to assume the role of organizing curator.[16]

The Art Association had been founded by artists in 1859, but was afterward dominated by a lay board of prominent Brooklyn businessmen. The Association worked to promote the sales and reputations of contemporary American painters with two annual exhibitions and operated an art school. By 1870, despite ongoing tensions with the artist community, the Association boasted over four hundred members as well as a nearly completed capital fund to finance the construction of a building designed in the Italianate Gothic style. Though not a museum per se, the Association initially hoped to establish a permanent collection at the site. The new galleries opened with "The First Chronological Exhibition of American Art," which was a great popular success, attracting sustained press attention and some twenty thousand visitors during a three-week run. Visitor response indicated that the themed exhibition format was a powerful instrument, not only for commemoration, entertainment and education, but also for making history.

In addition to a liberally annotated catalogue, visitors could purchase photographs of the installation (figs. 5–7). The set of panoramic photographs signaled the organizers' recognition at the time of the landmark status of the exhibition. A distinguished honorary Consulting Committee consisted of prominent New York artists—John F. Kensett, Daniel Huntington (1816–1906), and Worthington Whittredge—as well as a trio of influential non-artists: dealer Samuel P. Avery, John Durand (former publisher of *The Crayon*), and Tuckerman. In a remarkably short period of about three months, the Association secured the loan of more than two hundred works from private and institutional collections in Brooklyn, New York, Philadelphia, New Haven, Ipswich, and Boston. The Art Association's printed circular appealing for loans offered a powerful combination of enticements still used today. The organizers promised a form of cultural immortality by locating lenders in a grand European tradition of noblesse oblige. Lending was not a risk, the organizers insisted, but a sound investment. The return would be potential gain in value of works enhanced by such public exposure and an exhibition pedigree. Today, we understand the loan exhibition as ritual plunder; the temporary capture of out-of-town treasures for local public display. Their language suggests that the organizers of the Chronological Exhibition recognized their project as an exercise in political and institutional power. Their audience was in tune. Even before the exhibition opened, the [Brooklyn] *Daily Eagle* proclaimed the message of the exhibition: "Taking the two facts together—the fact of a new and superb Home of the Arts, and the fact of a large and brilliant display of paintings ... means that Brooklyn has attained maturity ... they are the incidents of a great city. They are initial achievements of the greater city of the future."[17]

Falconer intended to assemble "almost a complete history of American Art, by a Chronological series of pictures on our walls." In the act of identifying and securing the loans of key works for this public display, he and his committee consciously participated in canon-building, shaping in public for the first time a broadly conceived visual national patrimony. Their effort had some precedent in the large art exhibitions at the Sanitary Fairs held in 1864 to raise medical funds for the Union army. The New York fair had displayed a few "venerable" works by Gilbert Stuart, John Trumbull, and Benjamin West with those of the American and European "moderns." In this wartime atmosphere, portraits of Founding Fathers functioned primarily as patriotic icons embellishing a benefit exhibition of contemporary painting. In contrast, Falconer made a strenuous effort to introduce the concept of a systematic historical overview, from a 1715 drawing by John Watson, cited in Dunlap and Tuckerman as the first artist to practice in North America, to contemporary paintings completed around 1870. The very choice of title, proudly claiming precedent for the innovation—"The First Chronological Exhibition of American Art"—declares a highly developed historical consciousness. Nevertheless, the haste with which the exhibition was assembled apparently precluded imposing any chronological sequence upon the installation itself although one review indicated that it had been considered. The album sequence of thirteen panoramic installation photographs does open, however, with the earliest painting in the exhibition, Yale University's large group portrait of 1729–31 by John Smibert, *Dean Berkeley and His Entourage (The Bermuda Group)* (fig. 5).

The skill and power of curatorial selection lay not only in recognizing significance but also in bestowing value. This process continued in the act of installation. Densely stacked registers of canvases, defined from one another only by the architecture of heavy frames, commanded the viewer's attention by the imposition of visual hierarchies depending upon size, placement, and context. In planning the exhibition, Falconer had consulted the literature of American art; many of these volumes were in his own extensive library. The exhibition catalogue was liberally annotated with citations from Dunlap, Tuckerman, and others. In an ingenious gesture, Falconer also paid public tribute to these important sources by including images of their authors in the exhibition. Portraits of Dunlap, Tuckerman, and Thomas Seir Cummings, chronicler of the National Academy of Design, functioned as part of a curatorial agenda to present, not only the history of American art, but also the history of American art history. Pride of place above the central painting in Thomas Cole's three-part allegory *The Cross and the World* (location unknown) was given to Tuckerman, who had just died three months earlier, and to Cummings. Their portraits flanked F. B. Carpenter's (1830–1900) likeness of the late critic, journalist, and author, Fitz Hugh Ludlow, who had died in 1870. Visitors would have likely associated Ludlow with Cole's ill-fated *Pilgrim of the World* (location unknown) because of that writer's recent death as a result of fast living, drugs, and alcohol.

Chroniclers and critics were not alone on the walls of the gallery. Some seventeen portraits of artists, including Stuart, Sully, and Durand, also vied for the visitor's attention. Falconer was devoted to many organizations that supported and nurtured artist life in New York and Brooklyn. Thus it is not surprising to discover a curatorial program celebrating American artist identity in the "who's who" assembly of portraits and self-portraits on the Art Association's gallery walls. One also suspects a sly comment on Falconer's part about the oft-debated and unwelcome lay domination of the Association in lacing the exhibition with visages of art makers as well as art historians.

The dense visual matrix of the installation also presented liberal doses of textbook American history. Revolutionary heroes were given places of honor. John Trumbull's and Gilbert Stuart's imposing life-size portraits of George Washington as statesman and as warrior (figs. 6, 7) were commanding presences at each end of the long gallery. The General was also present in a medallion portrait by Charles Willson Peale (joining Peale's of Benjamin Franklin in flanking Stuart's Lansdowne portrayal) and in one of Rembrandt Peale's many *Pater Patriae* images. The Trumbull portrait was neatly flanked by two large contemporary landscape paintings. General Washington mediated a new and old world dialogue: Jervis McEntee's Catskill subject, *Autumn in the Ashocan Woods*, c. 1865–66 (location unknown), and Sanford R. Gifford's Italian panorama *Tivoli* (1870, The Metropolitan Museum of Art, New York).

The Chronological Exhibition's history lesson, however, stopped at about 1790. Events of the Revolution were commemorated in Trumbull's dramatic battle scenes of 1786: *The Death of General Warren at the Battle of Bunker's Hill, 17 June 1775* (see fig. 7, p. 213) and *The Death of General Montgomery in the Attack on Quebec, December 31, 1775*, (Yale University Art Gallery, New Haven), both conceived as modern history paintings. For the public in 1872, these events were timeless foundation myths. In contrast, the Civil War, which had already inspired several famous paintings, was still too close for comfort.

4 Unknown photographer, *John Mackie Falconer (1820–1903)*, c. 1863, *carte de visite*, courtesy of Susan Herzig and Paul Hertzmann, Paul M. Hertzmann, Inc., San Francisco, CA

5 Photograph attributed to John Williamson (1826–1885), view of the Brooklyn Art Association Gallery with John Smibert's *Dean Berkeley and His Entourage (The Bermuda Group)* of 1729–31, 1872. Photograph taken from: *Catalogue of the Works of Art ... Being The First Chronological Exhibition of American Art of the Brooklyn Art Association*, The Brooklyn Museum of Art Archives

6 Photograph attributed to John Williamson (1826–1885), view of the Brooklyn Art Association Gallery with Gilbert Stuart's *Portrait of George Washington* of 1796, 1872. Photograph taken from: *Catalogue of the Works of Art ... Being The First Chronological Exhibition of American Art of the Brooklyn Art Association*, The Brooklyn Museum of Art Archives

Falconer undoubtedly knew Bierstadt's *Guerrilla Warfare (Picket Duty in Virginia)* (1862, The Century Association, New York), and Homer's *Sharpshooter* (plate 62), both of which had been exhibited at the Brooklyn Art Association in the 1860s. Homer's celebrated *Prisoners from the Front* (fig. 4, p. 44), then belonged to New York collector John Taylor Johnston, who loaned other works to the Chronological Exhibition. Nevertheless, images of the recent civil conflict were excluded from the Brooklyn exhibition.

Historical consciousness in the Chronological Exhibition also operated as a catalyst for popular nostalgia. The handsome costumes and furniture of Copley's Colonial portraits and the rococo charm of Trumbull's miniature portraits of Revolutionary notables, sixty of which were lent by Yale, embodied an imaginary genteel past. The appeal of such representations reflected the growing power of the Colonial Revival. Contemporary costume pictures such as Worthington Whittredge's *One Hundred Years Ago*, around 1864 (location unknown), also elicited enthusiastic response. One reviewer summed up the way in which Whittredge's image, like those of Copley and Trumbull, invoked nostalgia in a contemporary audience, commenting: "Sweet, sunny, tranquil—the picture carries the beholder away from the dizzy rush and whirl of the present to the restful past."[18] The organizers of the Chronological Exhibition demonstrated a precocious intuition about the power of exhibition practice to mediate public anxieties about rapid change by assembling a visual patrimony identifying the institutional agendas of the Association with the public's interest in a collectively imagined romantic past. At the same time, the exhibition celebrated artist life and conferred an aura of permanence upon the "new" Brooklyn Art Association by positioning the organization securely within a visual continuum of art history and, by extension, American history.

Several works from the Chronological Exhibition appeared three years later at the Philadelphia Centennial Exposition. While there was no formal historical survey component, the American fine art department displayed a liberal selection of works by "our older portrait painters" whose function was to "link the present with the past century."[19] The "past century" was, of course, acknowledged everywhere as the central commemorative theme of the exposition, providing powerful impetus for the sustained Colonial Revival still vital in American popular culture. Planners of the next international exposition held in the United States in 1893 replaced colonial fantasies with the classical vocabulary of imperial Rome and the Renaissance as the prevailing visual form of collective historical consciousness. Nevertheless, a "Retrospective Exhibit of American Painting" was organized for the international audience that attended the Chicago fair. Assembled by a special committee chaired by Charles Henry Hart, a Philadelphia lawyer and a noted authority on early American portrait painting, the display of 107 works by deceased American artists offered an introduction to the art history of the host nation "from its beginning to the year 1876." Clarence Cook hailed the project as not only a public history lesson but also as a demonstration of cultural nationalism "in these times of change, and of the supposed crowding out of Americans by immigration."[20]

As in Brooklyn, Smibert's *Dean Berkeley and His Entourage (The Bermuda Group)* held precedent as the earliest painting (see fig. 2, p. 211). Yet history paintings and grand manner portraits, which had been a commanding presence at Brooklyn, were fewer in number in Chicago. Historical figures appeared mostly in miniature and bust-length portraits. Thomas Cole and Asher B. Durand were now represented as landscape painters rather than by history,

genre, and portrait subjects. The canon was expanded by inclusion of George Caleb Bingham's three-part election series of 1852–55 (Boatmen's Bancshares, Inc., St. Louis, Missouri), which flanked the Smibert, as well as *The Jolly Flatboatmen* (fig. 9, p. 29). Perhaps in response to Chicago's frontier orientation, George Catlin, John Mix Stanley (1814–1872), Seth Eastman (1808–1875), Charles Bird King (1785–1862), and Charles Wimar also made appearances as interpreters of Native American and western subjects. *The Nation* lauded the effort because "it suffices to show that the United States has an honorable if not brilliant past in art," and demonstrated "that the excellence of the work of American artists in our day dates almost as clearly and cleanly from 1876–1877 [the Centennial Exposition] as if it were an actual beginning."[21] Indeed, the United States' display of contemporary work on exhibition elsewhere in The Art Palace was committed to the present. Many older living artists such as Bierstadt were consigned to art-historical limbo as "that pre-historic crowd."[22] The American contribution was dominated by the postwar generation of painters and sculptors trained in European (especially French) academies and ateliers.

Among these was Samuel Isham, whose stylish *Portrait of a Lady* (location unknown) was shown. The Paris-trained painter was in many ways a model artist of the moment (fig. 8). With a Yale degree and French training, Isham was well educated, both intellectually and as a painter. Perhaps he saw the Retrospective Exhibit in Chicago; he remembered the Smibert group portrait well from his student days at Yale. Isham's *The History of American Painting*, published just after the turn of the century, was organized as what is now the classic survey model beginning with Theodor DeBry's fifteenth-century discovery imagery and concluding with a chapter on American mural painting. Isham's goal was to produce a more

sweeping retrospective than those of his predecessors; a lengthy critical overview of two centuries of American production compared and contrasted to European visual traditions and standards of execution. A trained academic painter and professed Francophile, Isham employed French painting as his benchmark. Leutze, for example, was characterized as "a sort of Teutonic Paul Delaroche, without the finer French taste."[23] Despite this prejudice, however, Isham also recognized the historical importance of local culture and conditions in the formation of American art.

An instructive example of Isham's approach is his discussion of mid-century landscape in a chapter on "The Hudson River School."[24] He wrote, these artists "did at their best good work" comparable in quality to that of their European contemporaries. To be fully understood, however, Isham argued that these paintings must also be interpreted within the local cultural context of the artists and their audience, "seen sympathetically, from their own point of view, and with allowance made for their limitations." In Isham's opinion, these limitations lay primarily in the absence of any "mastery of noble traditions"; a failure which had robbed American work of "the indefinable quality of style inseparable from great painting." The "saving merit of the school" he believed was to be found in local color depicted so faithfully by the artists, "a native flavor of the soil," and in the cultural nationalism of their audience who embraced what Isham saw as "a pious error as to the artistic importance of our national characteristics." The most talented artists of the school, he held, intuitively realized the gaps in their education. Durand, he reported, confessed "at the end of his long life ... sitting in the studio of a younger painter ... saying quite simply how much he regretted that he could

not have done other and better work." George Inness, according to Isham, denied himself the congenial *plein-air* comradeship of the landscape school by bringing "engravings of landscape by the old masters" with him on sketching expeditions to mediate the influence of "the paintings produced about him." Predictably, Isham found "culmination" of the school's achievement in the work of the American Barbizon and Tonalist painters, Inness, Alexander H. Wyant (1836–1892), and Homer D. Martin (1836–1897), whose work qualified, in his estimation, for comparison with that of Corot, Rousseau, and Daubigny.

Isham departed from his predecessors' conflation of political independence and artistic freedom by characterizing the early "art life" of the United States, which he designated as the Colonial and Provincial phases, as "the old period of isolation," which was impoverished, not emancipated, by separation from European tradition. He saw the past as a prelude to his own Cosmopolitan phase when "American painting had become an integral part of the painting of the worlds." Isham shared Dunlap's and Tuckerman's optimism in outlining the "possibility of a splendid future."[25] Employing "Primitives" as the term to characterize pre-Copley production, he introduced the concept of a well-known art-historical sequence associated with the beginning stages of a golden age in Italian art. His due deference to Dunlap as "our American Vasari" would also have been especially meaningful in the larger context of an American Renaissance.

Isham represented the model establishment artist type of his pre-Ashcan and Armory Show moment, a well-trained and well-educated professional whose works were conceived in the context of an international audience and marketplace. Writing at the begin-

ning of a new century, Isham envisioned an American artist community as comfortably cosmopolitan as the body politic itself. The engine for production of visual culture would be the marshaling of political, economic, and cultural resources epitomized by the "White City" built for the 1893 Chicago World's Columbian Exposition. Vast civic improvement projects such as the Boston Public Library, the Library of Congress, and New York's Pennsylvania Station would continue to employ painters, sculptors, decorators, and architects working in a classical and Beaux-Arts vocabulary. From our historical vantage point nearly a century later, we know that this is not the way things worked out. In rapid succession after Isham's volume appeared in 1905, a series of controversial exhibitions held in New York captured national attention: The Eight (1908), the Independents (1910), and, in 1913, the European avant-garde arrived in the United States with the Armory Show. Organizers of each exhibition made skillful use of mass-media campaigns to launch new so-called radical movements and anti-academic artist types into the public and popular consciousness. The United States' entry into World War I in 1917 effectively ended the era of the American Renaissance.

Charles Henry Hart's review of Isham's book appeared in the August 1906 issue of *The Dial*. Hart praised Isham's book as a "delightfully sane, scholarly, catholic, and intelligent criticism" enhanced by the fact that the author was himself a painter. Praising Isham as a critic, nevertheless, Hart faulted him severely as a historian, citing the book's "many serious errors in dates" and "misstatements of fact." Isham's volume was a welcome contribution to the "sound criticism of American painting," Hart concluded, but left "the *history* of American painting yet to be

7 Photograph attributed to John Williamson (1826–1885), view of the Brooklyn Art Association Gallery with John Trumbull's *George Washington* of 1792, 1872. Photograph taken from: *Catalogue of the Works of Art ... Being The First Chronological Exhibition of American Art of the Brooklyn Art Association*, The Brooklyn Museum of Art Archives

written."[26] We recall, in fact, that neither Dunlap, Tuckerman, Falconer, Isham (nor Hart himself) were professional historians or curators. While scholars today continue to mine their volumes for historical information, these surveys also functioned as didactic texts that reflected many of the cultural and ideological concerns of their moment. Each writer was to some degree an apologist invested in demonstrating a pressing need for visual culture in the United States. Each narrative acknowledged the brevity of American art history and extolled the ensuing rapid development. Each glorified the potential of the national locus and acknowledged the connection to larger western traditions albeit sometimes in an ambivalent and defensive manner. Each embraced to a greater or lesser degree the need to participate in international trends.

The nation-state framework served as the focus for the practice of American art history and chronicles of seventeenth and eighteenth-century art often conflated the two. Politics and recent history vividly colored Dunlap's art-historical opinions. His discussion of *Watson and the Shark* demonstrates the point (plate 4). When "removed to England," Dunlap wrote, Copley was "no longer an American painter in feeling." Copley's extraordinary painting of Brooke Watson's rescue was primarily "memorable" to Dunlap for its portrayal of a traitor: "an American adventurer" who had been "arrayed with our enemies in opposition to our independence."

"To immortalize such a man," Dunlap lamented, "was the pencil of Copley employed."[27] In a milder vein, Tuckerman acknowledged that early production was inextricably linked first to the "aristocratic and obsolete toilet ... of the subjects of Britain, who were the oracles of Society in Provincial America" and then to "the features of our Revolutionary heroes and statesmen."[28] The installation of "The First Chronological Exhibition of American Art" was anchored in national history by monumental portraits of George Washington presiding over the gallery spaces (figs. 5–7). Isham also acknowledged a long tradition in 1905 by opening the first richly illustrated survey text with a frontispiece of Stuart's *Portrait of George Washington*, (1795, The Metropolitan Museum of Art, New York), positioning the "Pater Patriae" as the Founding Father of American Art.

Some of their ideas have continued to influence— by accommodation or resistance—the practice of art history well into this century. The articles in this volume offer ample evidence that foreign study and influence have been facts of American culture from its beginning and form a frequent theme in artist biography. In 1829, William Cullen Bryant issued a poet's warning admonition to Cole in "To Cole, the Painter, Departing for Europe," presenting the painter's expatriation as a necessary but dangerous artistic rite of passage. Mount's reluctance to travel abroad was explained as a defensive gesture of cultural nationalism: "... a visit to Europe would be gratifying to me, but I have had a desire to do something in art worthy of being remembered before leaving for fear I might be induced by the splendor of European art to tarry too long, and thus lose my nationality." Conversely, Washington Allston's final return in 1818 to Boston after years in England set in motion what his biographer interpreted as "a process of retrogression" which ultimately "brought to an untimely end his great career."[29]

Artist expatriation has always presented special problems for art historians as well. For example, the enduring bifurcation of Copley's American and English careers was most recently documented by a two-exhibition, two-catalogue and two-museum format for the 1996 retrospective of that artist's career. The classic late nineteenth-century case study demonstrating the tension between cultural nationalism and cosmopolitanism is the waxing and waning of lifelong expatriate John Singer Sargent's "American" reputation. Sargent has been often set as a deliberate foil to Winslow Homer, cast as a nativist hero, in a popular and academic contest of preferred artist identities: home-grown or foreign. These few examples demonstrate how important it is to gain some historiographical insight into the methods and agendas of those nineteenth-century commentators who set the stage for much of what we still see and read. They not only chronicled many of these works as contemporary productions, but also assembled a pantheon of artist-ancestors whose practice preceded and validated that of their particular moment. Each of these projects—whether text or exhibition— was driven by prevailing sets of assumptions about the operation of historical forces and about artist-identity. Each of them reflected the larger values prevalent in the national culture. Their projects have determined many of the issues, topics, and problems that scholars continue to address today.

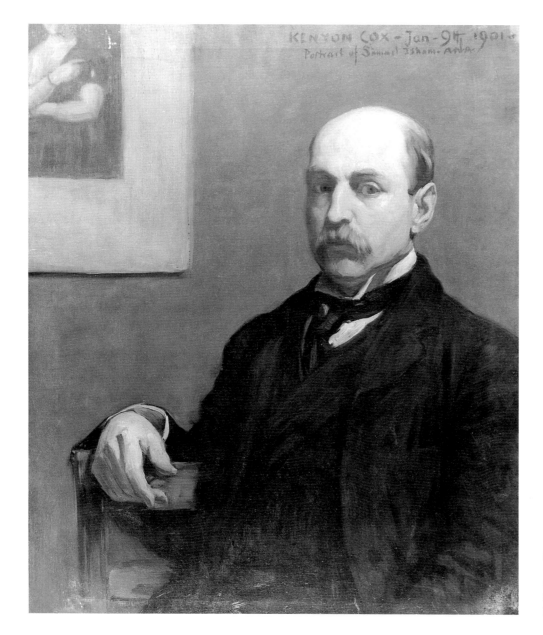

8 Kenyon Cox, *Samuel Isham (1855–1914)*, 1901, oil on canvas, 76.2 x 63.5 cm, National Academy of Design, New York, NY

1 Elizabeth Johns, "Scholarship in American Art: Its History and Recent Developments," *American Studies International* XXIII (October 1984): 3–40. Wanda M. Corn, "Coming of Age: Historical Scholarship in American Art," *Art Bulletin* 70 (June 1988): 188–207. Kevin J. Avery, "A Historiography of the Hudson River School," in John K. Howat et al., *American Paradise: The World of the Hudson River School* (New York: The Metropolitan Museum of Art, 1987), 3–20. William Truettner, "Nature and the Native Tradition: The Problem of Two Thomas Coles," in Alan Wallach and William Truettner, eds., *Thomas Cole: Landscape into History* (New Haven: Yale University Press, 1994), 137–58.

2 William Dunlap, *A History of the Rise and Progress of the Arts of Design in the United States*, a reprint of the original 1834 edition as published by George P. Scott and Company with a new introduction by James Thomas Flexner in two volumes bound as three (New York: Dover Publications, Inc., 1969). Henry T. Tuckerman, *Book of the Artists: American Artist Life. Comprising biographical and critical sketches of American artists: Preceded by an historical account of the rise & progress of art in America*, a reprint of the original 1867 edition as published by G. P. Putnam & Son (New York: James F. Carr, 1967). Samuel Isham, *The History of American Painting* (New York: The Macmillan Company, 1905). Isham's Paris interlude is recorded in the *Dictionary of American Biography* (New York: Charles Scribner's Sons, 1946).

3 Dunlap, 9.

4 Ibid., 13.

5 Ibid., 16.

6 Durand, "Letter 11," cited in John W. McCoubrey, *American Art: 1700–1960* (Englewood Cliffs, New Jersey: Prentice-Hall, Inc., 1965), 113.

7 "Domestic Art Gossip," *The Crayon* 2, no. 1 (4 July 1855): 9–10.

8 *The Cosmopolitan Art Journal*, 3 (December 1858): 1–8.

9 Tuckerman, 9, 11.

10 Ibid., 15, 20.

11 Ibid., 30.

12 Ibid., 29, 30.

13 Ibid., 28, 23.

14 Bierstadt's Vienna adventure is discussed in Linda S. Ferber, "Albert Bierstadt: The History of a Reputation," in Nancy K. Anderson and Linda S. Ferber, *Albert Bierstadt: Art & Enterprise* (New York: Hudson Hills Press, 1991), 58–59.

15 I am indebted for this insight to Paul Staiti's excellent lecture, "Great Men or Big Men: The American Portrait up to 1860," given on 10 October 1998 at the conference *This Golden Land: American Antebellum Painting and Sculpture, 1810–1861* organized by the New York University School of Continuing and Professional Studies.

16 Falconer's life and career are treated in Linda S. Ferber, "Our Mr. John M. Falconer," in *Brooklyn before the Bridge: American Paintings from the Long Island Historical Society* (Brooklyn: The Brooklyn Museum of Art, 1982), 16–23 and "'A Taste Awakened': The American Watercolor Movement in Brooklyn," in Linda S. Ferber and Barbara Dayer Gallati, *Masters of Color and Light: Homer, Sargent, and the American Watercolor Movement* (Washington, D.C.: Smithsonian Institution Press, 1998), 1–39. The First Chronological Exhibition of American Art is discussed in Clark Marlor, *The History of the Brooklyn Art Association* (New York: James F. Carr, 1970), 36–40; Ferber, 1982, 19–20

and Kate Nearpass, "The First Chronological Exhibition of American Art, 1872," *Archives of American Art Journal* 23, no. 3 (1983): 21–30. The discussion here is drawn from the author's paper given at the College Art Association 81st Annual Conference: "John Mackie Falconer and the First Chronological Exhibition of American Art" for the session *Toward a History and a Critical Language for the Art Exhibition* (5 February 1993).

17 *Brooklyn Daily Eagle*, 7 March 1872.

18 *New York Evening Mail*, 30 April 1872.

19 United States Commission to the Philadelphia Exhibition, 1876. Reports and Awards (Philadelphia: J.B. Lippincott, 1877–78), vol. 5, group 27, 24.

20 World's Columbian Exposition Official Publications, *Revised Catalogue: Department of Fine Arts* (Chicago: W.B. Conkey Company, 1893), 32–38. Victor Nehlig's *Pocahontas Saving the Life of Captain John Smith*, a large history painting, was the only "production of a living artist" in the retrospective exhibition. [Clarence Cook], "The Projected Exhibition at Chicago of Early American Art," *The Studio: A Weekly Journal of the Fine Arts* 7 (7 May 1892): 205. I am indebted to William H. Gerdts for allowing me access to his files on the exhibition and to Sarah Elizabeth Kelly, Mellon Research Associate at the Brooklyn Museum of Art, for her research conducted in support of this article.

21 William A. Coffin, "The Columbian Exposition 111," *The Nation* 57 (17 August 1893): 116.

22 Carolyn Kinder Carr, "Prejudice and Pride: Presenting American Art at the 1893 Chicago World's Columbian Exposition," in *Revisiting the White City: American Art at the 1893 World's Fair* (Washington, D.C.: National Museum of American Art and National Portrait Gallery, 1993), 86.

23 Isham, 295.

24 Ibid., 254, 255, 271.

25 Ibid., xvii, xvi, 72.

26 Charles Henry Hart, "A Critical Account of American Painting," *The Dial* 41 (16 August 1906): 86–88.

27 Dunlap, 117.

28 Tuckerman, 8.

29 Bryant's poem is cited in McCoubrey, 95–96. Mount's letter is cited in Barbara Novak, *American Painting of the Nineteenth Century: Realism, Idealism, and the American Experience* (New York: Praeger Publishers, 1969), 144. Jared B. Flagg, *The Life and Letters of Washington Allston*, reprint of the 1892 edition published by Charles Scribner's Sons (New York: Kennedy Galleries and DaCapo Press, 1969), 137, 423.

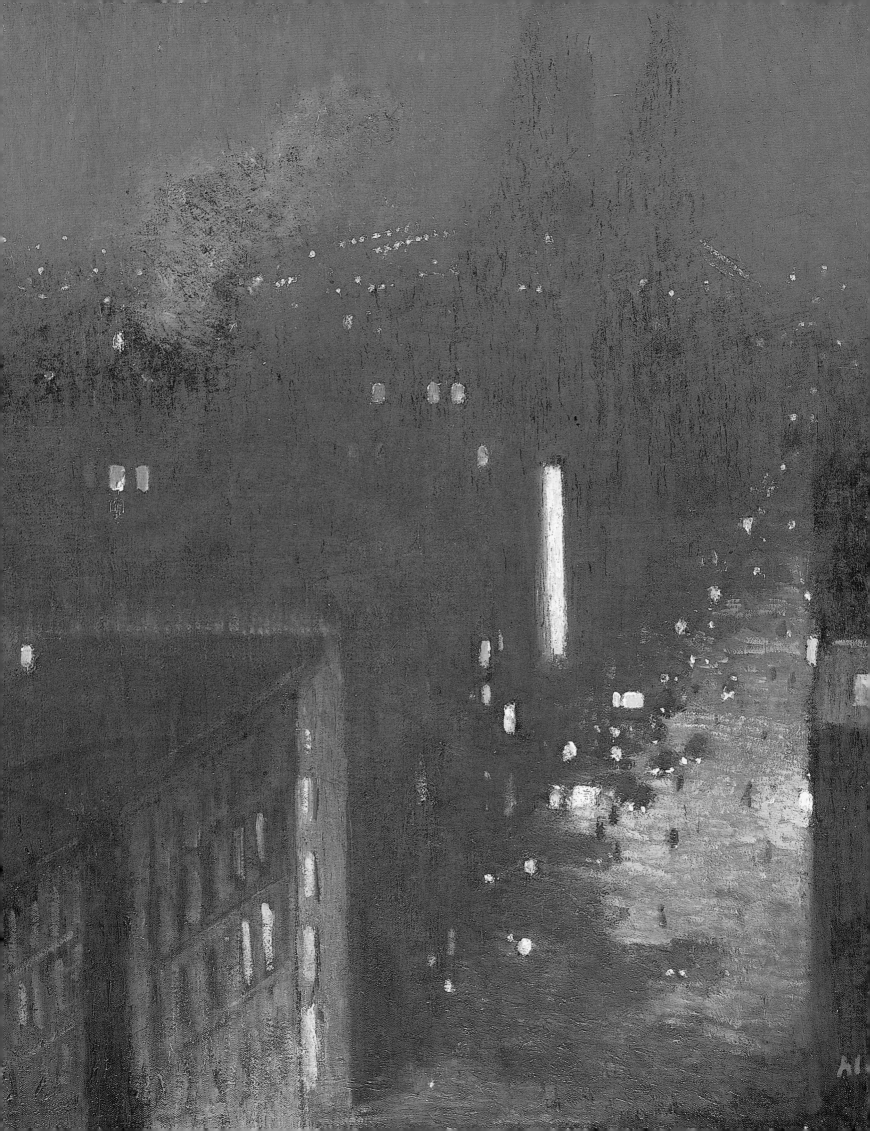

Between Influence and Independence

MARC SIMPSON

"A big Anglo-Saxon total"

American and British Painting, 1670–1890

The connections between American and British painting, from the seventeenth through at least the late nineteenth century, are pervasive and complex. This reflects the entwined political and cultural histories of the two countries, as does a simple fact related to the current project. The American contributors to the present catalogue are descended from a variety of European immigrants: German, Irish, Italian, Russian, San Marinese, Scottish, as well as English and others. They live in states that include Maryland (called after the French-born queen of Charles 1, Henrietta Maria), Massachusetts (its name derives from a Native American word meaning "large hill place"), New York (formerly Nieuw Nederlandt, but rechristened in honor of the English Duke of York after the Dutch lost the colony in 1664), Vermont (from the French for "green mountain"), and in the District of Columbia (a North American neologism honoring the Italian-born, Spanish-ennobled discoverer—at least by popular reputation—of the continent). Yet in spite of this motley background all jumbled together on the continent of North America, each writes in a language called English.

This shared language alone inclines Americans to posit a united culture with the island across the sea. But there is more. From the mid-eighteenth century, when Boston, New York, and Philadelphia were but some of the larger cities in the British Empire, to the "special relationship" promoted by Franklin Delano Roosevelt and Winston Churchill in the 1940s and rejuvenated in our own day by Reagan-Thatcher and Clinton-Blair, Britons and Americans have frequently looked at one another and thought that they saw a distorted but essentially identifiable reflection of themselves (the truth of this is what makes potent the witticism, often attributed to George Bernard Shaw, that Britain and America are indeed two countries separated by a common language). In spite of massive efforts of settlement and colonization throughout North America in the seventeenth and eighteenth centuries by non-Anglophones (the Dutch, French, Germans, Russians, and Spanish most particularly), enforced transportation of slaves from Africa, later waves of immigration from across the globe, and sporadic (but only rarely effective) efforts of American Indians to resist these waves of appropriation, the dominant national characterization of

America's elite was and remains—even with recent advances by the civil-rights movement and various identity politics—white, Anglo-Saxon, and Protestant: WASP, to use the acronym coined in 1960 to denote the political, economic, and cultural hegemony of this country's powerful. The English art critic John Ruskin wrote in his later, cantankerous years: "this dying England taught the Americans all they have of speech, or thought, hitherto. What thoughts they have not learned from England are foolish thoughts; what words they have not learned from England, unseemly words."[1] Many Americans, over the years, would have agreed.

Westward the Course of Empire: The 1660s to the 1750s

For the first century and a half of settlement along the eastern seaboard, the flow of artistic influence between England and America was one way: westward. The vast majority of pictures on display in the New World's English colonies were portraits—many painted in England and transported with the settlers, the others done in North America by those born and trained in England.[2] Among the earliest of those recognized as being painted in America are anonymous portraits of ministers, merchants, and their families done in Massachusetts in the 1660s and 1670s. Epitomized by *Elizabeth Freake and Baby Mary* (fig. 1), these directly follow Elizabethan-Jacobean practice popular outside the English court from the 1630s through the 1680s. Slightly later works by Thomas Smith and other, still unknown painters of the Pierpont and Cooke families are likewise provincial examples of English models.[3]

The arrival of John Smibert—Scots-born, Italian-traveled, and London-trained—in New England in 1729 heralded the beginning of a professional, documentable fine-arts practice in North America.[4] Smibert (1688–1751) brought with him a fully developed style derived chiefly from that of England's most fashionable portraitists, Sir Godfrey Kneller and Sir Peter Lely (themselves, admittedly, both born and trained on the Continent), along with a bounty of prints, drawings, plaster statues after various antiquities, and his copies after Old Master works. Among the earliest and most impressive of the 241 portraits Smibert painted during his seventeen active years in Rhode Island and Massachusetts is his large *Dean Berkeley and His Entourage (The Bermuda Group)* (fig. 2). The ambitious portrait, showing the party intent on founding a seat of learning and civilization in the New World, dressed in all the trappings of the old, exemplifies the hope of Berkeley's famous text of 1752, "On the Prospect of Planting Arts and Learning in America":

1 Freake-Gibbs Painter, *Elizabeth Freake and Baby Mary*, c. 1671, reworked 1674, oil on canvas, 108 x 93.4 cm, Worcester Art Museum, Worcester, MA, gift of Mr. and Mrs. Albert W. Rice

2 John Smibert, *Dean Berkeley and His Entourage (The Bermuda Group)*, 1729, oil on canvas, 176 x 236.2 cm, Yale University Art Gallery, New Haven, CT, gift of Isaac Lathrop

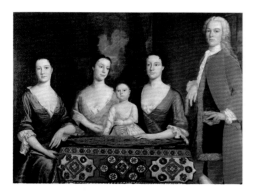

3 Robert Feke, *Isaac Royall and His Family*, 1741, Harvard University Portrait Collection, Cambridge, MA, gift of Dr. George Stevens Jones

Westward the course of empire takes its way;
The first four acts already past,
A fifth shall close the drama with the day:
Time's noblest offspring is the last.

Smibert's complex amalgam of fashion, aesthetics, and historical purpose was to exert a significant influence on the artistic life of New England. His works and those of most of his colleagues working elsewhere in the colonies during this early part of the eighteenth century—among them Charles Bridges (1670–1747), William Dering (act. 1735–51), John Watson (1685–1768), and Henrietta Johnston (act. c. 1707–28/29)—reflected the influence of English models, not only through the artists' birth and training but with poses and costumes often adapted from British mezzotint portraits.[5]

Even the man often called the first native-born genius in American art, Robert Feke (c. 1707–1752), absorbed the English art lessons offered by Smibert. His *Isaac Royall and His Family* (fig. 3), demonstrates his English affinity when compared with Smibert's *Bermuda Group*: figures posed around a carpet-covered table, a principal male standing to the right, a child at center, a figure to left making direct eye contact. But if composition and even the women's costumes (despite an eleven-year gap between the two paintings) are similar, the method of painting is not. Feke's is a direct technique, without the studio sophistication that Smibert had learned in, and brought from, England and Italy. Feke holds this in

common with other such American-born artists of the time as John Greenwood (1727–1792) and Joseph Badger (1708–1765), and with the Swiss-born but American-trained Jeremiah Theus (c. 1719–1774). Sometimes the naivete shown by these artists can work to aesthetic advantage: we often prefer the bold rustic to the mediocre sophisticate. Yet while some scholars have posited that Feke's is the beginning of a truly American style,[6] his painterly vocabulary and ambition are largely English, limited in fluency by a paucity of schooling and a lack of firsthand acquaintance with the magical illusions of which painting is capable. He was, in spite of his real gifts, a provincial, hampered in the craft of his art by living at a great remove from the center of his culture.

Periodically, the center sent emissaries to the peripheries. During the 1750s, two of the most important of these were Joseph Blackburn (act. c. 1750–80) and John Wollaston (act. 1736–after 1775). They brought with them the mannerisms and formulas of such British painters of solid accomplishment as Allan Ramsay and Thomas Hudson but, of course, not their grace and skill. Neither the most gifted British painters of that era—Ramsay, Hudson, not to mention Joshua Reynolds and Thomas Gainsborough—nor, by and large, even their paintings, traveled westward across the ocean. Yet even the drapery-emphasizing Blackburn or the consistently almond-eyed Wollaston, working often in collusion with patrons who were themselves familiar with English fashions through their own education and travels, were more than sufficient to bring the London rococo to the American colonies, where it set the fashion for the decades just before the Revolution.

"I am at last arrived at the mother country": West and Copley

John Singleton Copley and Benjamin West initiated a more complex artistic interaction between the Old and the New Worlds.[7] These two immensely gifted men—Copley born in Boston, West outside Philadelphia—retraced Smibert's path in reverse, spending time in Italy and eventually settling in

England, leading, ultimately, the majority of their productive lives there.

West went first. Two history paintings (the only one now known modeled after a British book illustration by Hubert Gravelot), a handful of landscape works, and a series of portraits patterned after those that Wollaston had painted in Philadelphia and its environs demonstrate the young man's ambition and talent. His emulation of Wollaston was deliberate, ambitious, noted, and encouraged. As the poet Francis Hopkinson urged him in 1758:

Hail sacred Genius! May'st thou ever tread,
The pleasing path your Wollaston has lead.
Let his just precepts all your works refine,
Copy each grace, and learn like him to shine,
So shall some future muse her sweeter lays,
Swell with your name, and give you all *his* praise.[8]

Hopkinson's words were prophetic: Wollaston is today largely consigned to footnotes, whereas West is prominent in every history of the era's American and British art. West achieved this by leaving North America. He was, according to his early biographer, "profoundly sensible … that he could not hope to attain eminence in his profession, without inspecting the great master-pieces of art in Europe, and comparing them with his own works in order to ascertain the extent of his own powers."[9] In 1760, he sailed to Italy and stayed for three years. There he studied with Anton Raphael Mengs and, reportedly, made a notable impression on the Italian *cognoscenti* by, on first seeing the Vatican Apollo Belvedere, exclaiming, "My God, how like it is to a young Mohawk warrior!"[10] In the summer of 1763, he traveled to London, writing on 1 September: "I am at last arrived at the mother country, which we Americans are all so desirous to see, and which I could not but desire as much, or more than Italy itself."[11] He remained there the rest of his life, becoming the second president of the Royal Academy, Historical Painter to the King of England, and, by the time of his death nearly sixty years later, the best-known painter in the English-speaking world.

When West first arrived in Great Britain, his portraits emulated aspects drawn from the foremost

4 Benjamin West, *The Death of General Wolfe*, 1770, oil on canvas, 152.6 x 214.5 cm, National Gallery of Canada, Ottawa

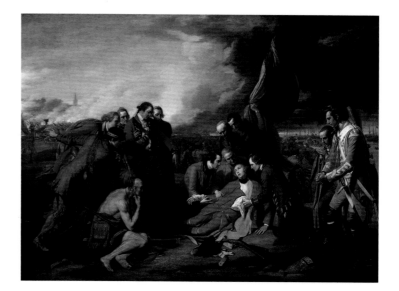

British artists of the day—Gainsborough, Reynolds, George Romney, Nathaniel Dance, Johann Zoffany. Yet while portraiture would be an important source of income for at least the following two decades, his greatest fame lay with the development of a new kind of history painting, one that merged a contemporary event with all the pomposity of myth and clothed it in the garb of daily life. The most startling and influential of these was the earliest, *The Death of General Wolfe* (fig. 4).[12] Showing a glorified version of the British general's death in 1759 on the Plains of Abraham outside the city of Quebec, and replete with quotations from a variety of Old Masters, the work and its many reproductions prompted an astonishing fame and fortune to fall upon West, so notable that George Washington could write to Thomas Jefferson in 1786 that "the taste, which has been introduced in painting by West is received with applause, and prevails extensively."[13] An American had at last brought something ineffable rather than material to Great Britain—an openness to the radical emendation of tradition—and altered the course of that nation's art.

West's greatest of compatriots and exact contemporary did not wait to journey to London to seek his tutelage. John Singleton Copley's opportunities for art instruction in Boston were limited largely to what he could see in books, prints (his stepfather, Peter Pelham, was, among many other things, a mezzotint engraver and possessed a sizable collection), and paintings by Smibert, Blackburn, and such of their native-born followers as Joseph Badger. It is

all the more remarkable, then, that in 1758 he was able to produce a work such as *Mary and Elizabeth Royall* (plate 2). The poses of the two girls are natural, their flesh seemingly observed rather than formulaic, the satin of their dresses a simulacrum of visual reality, the conceits of the hummingbird, spaniel, and mounds of draped satin both a delight to the eye and an announcement of the sitters' wealth and gentility. The whole is an accomplishment without precedent in American painting. And as it was a unicum, Copley, too, soon came to feel as one himself. He wrote of Boston: "A taste of painting is too much Wanting to afford any kind of helps; and was it not for preserving the resembla[n]ce of particular persons, painting would not be known in the plac[e]. The people generally regard it no more than any other useful trade, as they sometimes term it, like that of a Carpenter tailor or shoemaker, not as one of the most noble Arts in the World. Which is not a little Mortifying to me…. [A]nd be my improvements what they will, I shall not be benefitted by them in this country, neither in point of fortune or fame."[14]

It was the art world of London—as he imagined it—that Copley held as his standard. He resolved to test himself by submitting his *Boy with a Squirrel (Henry Pelham)* (fig. 5), to the 1766 exhibition of the Society of Artists in London. Showing his half-brother in profile, the work is another amazing performance of summation and verisimilitude—a "fancy picture" to evoke mood and dazzle the eye with its varying textures, ingenious reflections, and appealing

subject. The painting drew the attention of the two men whom Copley would most have desired, Reynolds and West. Reynolds' comments were relayed in a letter of 4 August from Copley's agent:

"It was universally allowed to be the best Picture of its kind that appeared on that occasion, but the sentiments of Mr. Reynolds, will, I suppose, weight more with You than those of other Critics. He says of it, 'that in any Collection of Painting it will pass for an excellent Picture, but considering the Disadvantages' I told him 'you had labored under, that *it was a very wonderful Performance*.' 'That it exceeded any Portrait that Mr. West ever drew.' … '[I]f you are capable of producing such a Piece by the mere Efforts of your own Genius, with the advantages of the Example and Instruction which you could have in Europe, You would be a valuable Acquisition to the Art, and one of the first Painters in the World, provided you could receive these Aids before it was too late in Life, and before your Manner and Taste were corrupted or fixed by working in your little way at Boston….' 'But still,' he added, *'it is a wonderful Picture* to be sent by a Young Man who was never out of New England, and had only some bad Copies to study.'"[15]

Copley did not immediately heed the warning about the corruption of his taste and manner, continuing to reside in Boston at the acme of professional success; marrying in 1769 into an extremely wealthy family, acquiring a significant estate on Beacon Hill, and being in every way one of the first men of the city. A multitude of solid, singularly effective

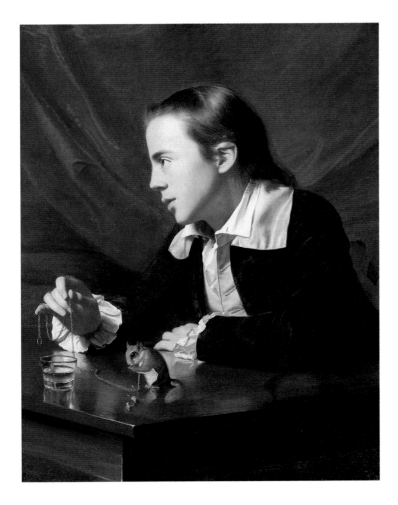

5 John Singleton Copley, *Boy with a Squirrel (Henry Pelham)*, 1765, oil on canvas, 76.8 x 63.5 cm, Museum of Fine Arts, Boston, MA, gift of the artist's great granddaughter

6 John Singleton Copley, *The Copley Family*, 1776/77, National Gallery of Art, Washington, D.C., Andrew W. Mellon Fund

portraits came from his studio, including the handsome portrayal of Nicholas Boylston (plate 3), the second of three paintings by Copley of this exceedingly wealthy merchant and benefactor.

Only in 1774, with the tensions of the impending American Revolution growing palpable, did Copley leave for Europe. He, too, went to Italy, as had West (stopping in London on the way and staying long enough to meet both West and Reynolds). After a single year, he was again in London, where his family joined him. He announced his presence in the city with the exhibition of *The Copley Family* (fig. 6), at the Royal Academy of 1777.[16] The painting—the fruit of his exposure to European masterworks and the art atmosphere of Italy and England—combines all the strength of character of his American works (and an echo of Smibert's *Bermuda Group* in the pose and position of the self-portrait at the left), but with a greater complexity of composition and suavity of finish, wherein the brushwork is a presence on the canvas, and the whole seems awash in light and air. The work met every possible expectation as an introduction and initiated for Copley a successful portrait practice that he maintained in London until his death. So dominant in the field of portraiture were the two Americans, Copley and West, that at least one British critic saw a threatening national conspiracy: "Mr. West paints for the Court and Mr. Copley for the City. Thus the artists of America are fostered in England."[17] With the aristocracy and financiers patronizing the Americans, where was the native British painter to turn for support?

Copley, too, not content with being merely a successful painter of faces, followed West in the ambition of creating history paintings. These noble displays of historical or religious anecdote, technical prowess, and knowledge of past art were seen as the pinnacle of painterly achievement throughout the Western world. As West had done so memorably

with the death of General Wolfe, Copley, too, melded contemporary event and costume with the noblest of emotions, developing such grand historical compositions as *The Collapse of the Earl of Chatham in the House of Lords, 7 July 1778* (1779–80) and *The Death of Major Peirson, 6 January 1781* (1782–84; both in the Tate Gallery, London), which are viewed today as major achievements in the story of British painting.[18]

Copley's innovation in this process, which went beyond what West had done, was to adapt the conventions of the "contemporary history" painting to depict personal narratives. The high point of this transition is *Watson and the Shark* (plate 4).[19] The Detroit version of the painting—the third and smallest rendition of a work originally exhibited at the Royal Academy in 1778—shows the moment just before the fourteen-year-old Brook Watson was rescued from a shark attack in Havana Harbor, Cuba, in 1749. Interpretations ranging from Christian salvation to critiques of Britain's colonial policy have been advanced to explain the painting, and a variety of Old Master sources can be cited to clarify the derivation of various figures (most of these, ranging from Raphael to Rubens, connected to the theme of salvation). Even without these, the trauma of the pale-skinned boy already bitten twice (his right leg below the knee has been stripped of flesh), literally facing death headfirst and upside down, is sufficient to strike chords of romantic terror in nearly every viewer. Watson—rescued and trained to use a wooden leg—went on to a career as merchant and government official, receiving high honors. Copley's personalization of the grandest gestures of history painting proved innovative and successful.

Copley and West were but two, albeit the most successful, of many American-born artists active in England at the end of the eighteenth and the beginning of the nineteenth century.[20] Indeed, one aspect

7 John Trumbull, *The Death of General Warren at the Battle of Bunker's Hill, 17 June 1775*, 1786, oil on canvas, 63.5 x 86.4 cm, Yale University Art Gallery, New Haven, CT

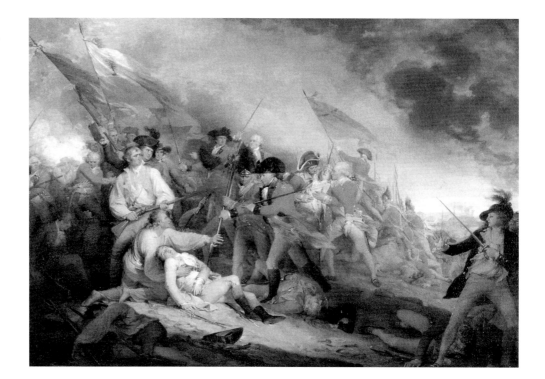

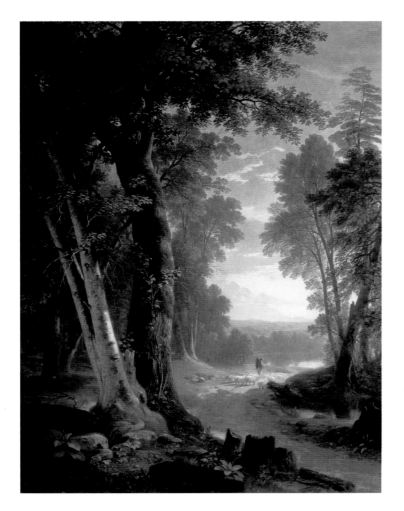

8 Asher B. Durand, *The Beeches*, 1845, oil on canvas, 153.4 x 122.2 cm, The Metropolitan Museum of Art, New York, NY, bequest of Maria De Witt Jesup

that he became known as the "American Lawrence." The smooth technique used for idealized flesh, lustrous eyes, and regularized features can be seen to advantage in his portrayals of men and women alike (plates 7–9). Sully returned again to London in 1837 to paint the young Queen Victoria, who posed for him in 1838 before she was formally anointed, pleasing the artist to the extent that he wrote: "How smoothly has Providence thus far shaped my course!!... Introduced to distinguished people, and kind friends, enabled to converse familiarly with the Sovereign of the present greatest Empire in the world—and if I succeed in painting an approved portrait of her, the firm reputation it will give me in my adopted country and home."[26] The portrait (private collection) was indeed approved, won for Sully further praises, and allows us to learn that, no matter the years in America, Sully felt his home to be in England.

Rembrandt Peale, too, son of Charles Willson Peale, absorbed both scientific interests and British portrait conventions from his father (these can be seen most beautifully in *Rubens Peale with a Geranium* [plate 18]) even before he made his own first trip to England in 1802, where he studied at the Royal Academy and—with such giant historical works as his *The Court of Death* (1819–20, The Detroit Institute of Arts)—showed himself to be one of West's most ambitious followers. The list goes on to include Washington Allston (1779–1843), who, during two extended stays, was close friends with Samuel Coleridge and dependent, in his most ambitious works, on seeing such treasures in England as the Elgin marbles and various Old Master works in English collections.[27] Samuel F.B. Morse (1791–1872), as well, who eventually abandoned painting for telegraphy, and Charles Robert Leslie (1794–1859), who forsook the United States for England, ought to be counted among the Americans influenced by the lure of England. As Henry Tuckerman, one of the earliest chroniclers of American art, wrote in 1867, "all our early painters ... sought and found in [West] their patient teacher and most efficient friend." He continued: "Their success, indeed, was long dependent upon foreign, and especially English recognition."[28]

"That earlier, wilder image"

For many traditional historians of American painting, the landscape painters of the native scene initiated the first bold, indigenous school of American art.[29] Recent scholars have come to realize, however, that not only the painters but also the cultural climate for this first flowering of landscape art grew directly from British roots.[30] In spite of two wars between them—the Revolution and the War of 1812—a majority of the era's tastemakers in the United States looked to England for a model of ambition and achievement. A proliferation of drawing and painting manuals—some, such as those by Scots-born Archibald Robertson and the Englishman William Oram, aimed specifically at landscape practitioners—appeared from the 1790s onward and were key to raising the possibility of a native school of landscape painting and the market, the taste for

of West's success of crucial importance for the development of art in America was his role as a teacher. Virtually every important American painter active from the 1770s through 1820 journeyed to London and studied with, or at least found informal support from, West. The Revolutionary War (1776–83) notwithstanding, American artists looked to London and its fashions to set the level of their ambitions and achievements.[21] Chief among these were Charles Willson Peale, Gilbert Stuart, and John Trumbull (1756–1843). Peale (whose portrait by West, painted in London, is plate 1) was a polymath who is today nearly as famous for his science (he excavated and assembled a mastodon skeleton) and museum founding as for his painting. He begot a dynasty—he and the first two of his three wives had seventeen children, eleven of whom reached maturity, who were mostly named after famous artists and scientists—that dominated Philadelphian art life for much of the next century.[22] Given this latter fact, it is not surprising that among his most satisfying portraits are those showing his own family members, as in the portrait of his brother or the group of his daughter and granddaughter (plates 11, 12), or those that portray other parents and their children (plate 10). Stuart, who was in England and Ireland from 1775 through 1792, and who had probably the greatest gift for thinking in a painterly fashion of all his compatriots, found enduring fame for his portrayal of the founding fathers of the United States, including several versions of the nation's first presi-

dent, George Washington. Plate 6 derives from the most famous of these, the *Athenaeum Portrait* (Museum of Fine Arts, Boston, and National Portrait Gallery, Washington, D.C.), which has found wide circulation as the image, in reverse, on the face of the American dollar bill.[23] Trumbull, who went to study under West in 1780 after a military career serving against the British, was arrested, imprisoned for almost eight months, and deported as a spy; undeterred, he returned to study under West and in the Royal Academy schools between 1784 and 1789— making a series of small history paintings, which have since become American national icons celebrating the nation's establishment and early battles (as in *The Death of General Warren at the Battle of Bunker's Hill, June 17, 1775* [fig. 7], where the influence of West's and Copley's scenes are evident).[24] And, of course, while these men worked under West, they were in contact with British artists and the art world of London, influences that would impress their works when once they returned home.

Virtually every significant figure painter of ambition from the next generation, too, whether they were concerned with portraiture or history painting, felt the need for study in Great Britain.[25] Thomas Sully, born in England in 1783 and made an American citizen only in 1809, was back in England that same year, where he, too, studied under West and imbibed especially the style of Thomas Lawrence, with which he portrayed the American mid-Atlantic gentry for the next several decades so successfully

landscape among collectors, on which it depended.[31] The American landscape (at least that of the eastern seaboard) itself was judged by some to echo that of England: "Certainly the similarity of the two countries is strikingly great, though the features of this are on a larger scale.... Were [numerous gentlemen's houses] here, the resemblance would be perfect."[32] Most importantly, the philosophical considerations of Archibald Alison, Edmund Burke, William Gilpin, Uvedale Price, and Sir Joshua Reynolds—with their notions of the sublime, the terrible, the picturesque, the appreciation of landscape in light of human emotion and experience, and the hierarchies of art—were known throughout the English-speaking world.[33]

And, of course, there was the impact of landscapes and allegories by such British painters as Richard Wilson, Joseph Wright of Derby, and John Martin (whose works, known through mezzotint prints, seem to have been especially popular in the United States).[34] These images gave form to expanding vocabularies and sensibilities, revealing a range of endeavor from topographic view to cataclysmic vision. Of these, it was above all J.M.W. Turner who sat atop the school of English landscape painting and who commanded the admiration of American painters. Allston articulated this sentiment in a letter of 1827 advising an aspiring artist on a course of European study:

"I want to recommend his going first to England, where I would have him remain at least half the time he proposes to remain abroad. The present English school comprises a great body of excellent artists, and many eminent in every branch. At the head of your friend's department he will find Turner, who, 'take him in all,' has no superior of any age.... I find no modern school of landscape equally capable with the English; in my judgment it has no living rival; many of them having attained to high excellence, and all knowing, even those who cannot reach it, in what it consists. On quitting England a short time may be spent in France, two or three months in Switzerland, and the remainder of the time in Italy."[35]

Indeed, many of the painters who first specialized in views of the American landscape—the father-son painters William and Thomas Birch (1755–1834, 1779–1851), Francis Guy (1760–1820), Joshua Shaw (c. 1777–1860), William Guy Wall (1792–after 1863)—were themselves British painters, transplanted to the United States.[36]

Thomas Cole, another American painter born in England, was not the first to specialize and become famous for his views of America; he was, nonetheless, the one who is credited with being the founder of the Hudson River School and with making the most powerful paintings of the American landscape in the first half of the nineteenth century.[37] He came to the United States, with his family, in 1818. Starting in the mid-1820s, Cole went into nature and painted the distinctive and characteristic landscapes of Pennsylvania, upstate New York, and New England. Finding fame and patronage in the increasingly bourgeois New York society of Jacksonian America, Cole, too, as had West and Copley before him, sought to move beyond creating straightforward portraits of places and began instead to paint works of history.

In some instances, such as his *Saint John in the Wilderness* (plate 41) or his series *The Voyage of Life* (1842, National Gallery of Art, Washington, D.C.), and *The Course of Empire* (figs. 3–7, pp. 25–27), the moralizing ambition of a history painting is overt. In other, less clearly allegorical works, however, the intent can be as great. Sometimes it can be achieved by a pairing of works, such as *Summer Twilight: A Recollection of a Scene in New England* and *Autumn Twilight: View of Corway Peak (Mount Chocorua, New Hampshire)* (plates 19, 20), both reflecting an acquaintance with the work of John Constable, that together portray the tokens of Western civilization or untouched wilderness in generalized visions of

America and so initiate reflections on the coming of Europeans to the continent. In other instances, such as *View from Mount Holyoke, Northampton, Massachusetts, after a Thunderstorm—The Oxbow* (fig. 4, p. 18), Cole uses the local topography to much the same effect as Copley had used contemporary dress in *Watson and the Shark*: to establish the immediacy of time and place, and to assert the effect of witness, augmented by the figure of the artist and his paraphernalia in the work's central foreground. It is the painting's grandiloquent meteorological effects—thunderstorm with blasted tree to the left, clearing and radiant sunshine falling on the verdant valley to the right—that serve as the equivalent to

9 James A. McNeill Whistler, *Nocturne in Black and Gold: The Falling Rocket*, c. 1875, oil on canvas, 62.9 x 46.7 cm, The Detroit Institute of Arts, MI, gift of Dexter M. Ferry, Jr.

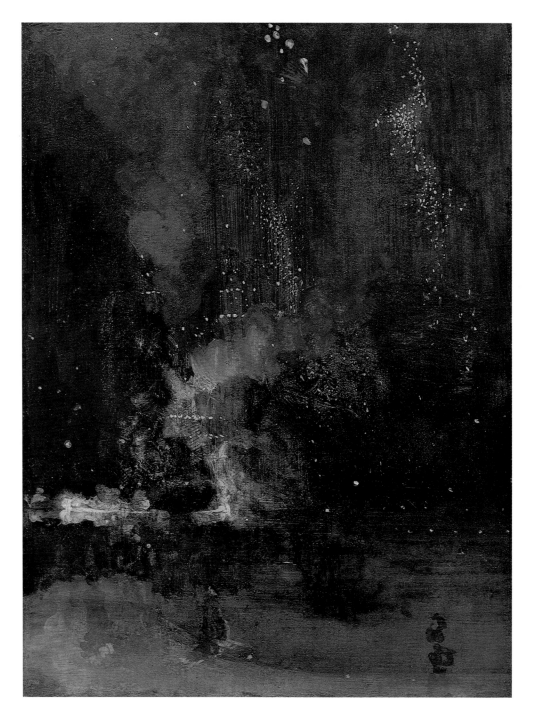

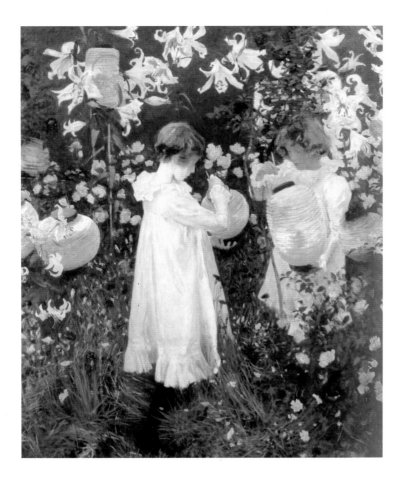

10 John Singer Sargent, *Carnation, Lily, Lily, Rose*, 1885–87, oil on canvas, 174 x 153.7 cm, Tate Gallery, London

history painting's operatic gesture and composition, testimony to clashing forces beyond the ken of individual men. The implication of passing time, of the artist's selection of a crucial moment that reveals the actions of the past while foretelling the resolutions of the future, the panoramic view (panoramic used both in the sense of a vast scene and with reference to the moving roll of canvas so popular in the nineteenth century), all reveal the awareness of British landscape art and aesthetic theories.

Cole had first revisited England in 1829, prompting his friend the poet William Cullen Bryant to write:

Thine eyes shall see the light of distant skies:
Yet, Cole! thy heart shall bear to Europe's strand
A living image of our own bright land,
Such as upon thy glorious canvas lies.
. . .
Fair scenes shall greet thee where thou goest—fair
But different—everywhere the trace of men.
Paths, homes, graves, ruins, from the lowest glen
To where life shrinks from the fierce Alpine air.
Gaze on them, till the tears shall dim thy sight,
But keep that earlier, wilder image bright.[38]

Over the course of his two-year stay, Cole met Turner, Martin, and Lawrence; apparently struck up a friendship with Constable; looked at as many collections and exhibitions as he possibly could; and painted works of history and of scenery, mostly North American, based on sketches he took with him.[39] As with numerous others before him, Cole found the environment of England conducive to his

work: "I think I shall improve very fast here, having the advantage of seeing so many fine pictures, both ancient and modern."[40] His response to British painting itself, seen in quantity, was more ambiguous: "Although, in many respects, I was pleased with the English school of painting, yet, on the whole, I was disappointed," he wrote. "My natural eye was disgusted with its gaud and ostentation. To colour and chiaroscuro all else is sacrificed. Design is forgotten. To catch the eye by some dazzling display seems to be the grand aim. The English have a mania for what *they* call generalizing, which is nothing more nor less than the idle art of making a little study go a great way; and their pictures are usually things 'full of sound and fury signifying nothing.'"[41] The fact that he uses the words of Shakespeare to criticize the English national school is a telling indication of how closely wrapped the English and the American cultures were.[42]

Many American figure painters did not need to contend with the color and painterly effects that so troubled Cole. Instead, as had been true of their colleagues of an earlier generation, they worked much from prints of British works. By this measure, the genre painters William Hogarth, David Wilkie, and George Morland had a considerable influence on such American artists as George Caleb Bingham, William Sidney Mount (1807–1868), and Francis W. Edmonds (1806–1863).[43]

"We love Ruskin's glowing style"

Travel back and forth between Great Britain and America became ever easier and surer as the nineteenth century progressed. Many American painters, even those best known for views of native or exotic scenery, made the journey: Asher Brown Durand, Frederic Edwin Church, Sanford Robinson Gifford, John Frederick Kensett, Albert Bierstadt, Jasper Francis Cropsey, and many others. These men—like Cole, all landscape painters—made the trip to England not as youths seeking training and advice, but as mature, well-established artists looking to round out their experiences or, in several important and effective examples, to expand their markets. Yet even middle-aged men can alter themselves fairly dramatically, as was the case with Durand who, when confronted with the achievements of Constable, was able to invigorate his outdoor sketching habit by working directly in oil, as well as finding inspiration for such major paintings as *The Beeches* (fig. 8), in the vertical format and pastoral conventions of Constable's *Cornfield* (1826, National Gallery, London).[44]

London was a great market—the largest city in the world, head of a vast empire, and rich. Submitting works for view at the Royal Academy summer exhibition was one excellent way of gaining notice, and many American painters did so. Even better were single-picture exhibitions. Church's *Niagara*, (fig. 2, p. 44), and his *Heart of the Andes* (1859, The Metropolitan Museum of Art, New York), Cropsey's *Autumn—On the Hudson River* (1860, National Gallery of Art, Washington, D.C.),

itself painted in England on the basis of studies taken abroad and its veracity testified to by autumnal foliage shipped from America for the purpose, along with Bierstadt's *Rocky Mountains* (fig. 3, p. 44) and *Storm in the Rocky Mountains, Mt. Rosalie* (1866, The Brooklyn Museum of Art), were each the center of an extravaganza organized by American painters to display their immense and gloriously colored works to the British public. As *The Times* of London reported: "American artists are rapidly making the untravelled portion of the English public familiar with the scenery of the great Western continent."[45] Praise by British critics, commissions by and sales to British collectors (including some of Church's and Bierstadt's most lucrative sales), widely reported meetings with British royalty, all increased American artists' reputations and boosted their careers.[46]

The most notable transfer in the other direction, from England to America, at mid-century involved, not art or artists, but art criticism. The writings of John Ruskin, champion of Turner and the Pre-Raphaelites, Gothic revival architecture, and of the truth of the detail, experienced a phenomenal popularity in the United States.[47] Nearly every American interested in art read each available text avidly. As one wrote in 1855: "We love Ruskin's glowing style, we love his love of nature, we love his love of God. He carries us along with him by his enthusiasm."[48] His loose entwining of art, religion, and nature made an immediate and popular impact: American periodicals sprang up to promote his causes (*The Crayon* [1855–56] and *The New Path* [1863–65]); some artists began to work in a tightly controlled fashion, especially in watercolor and the graphic arts; still-life subjects gained respect and prestige in various exhibitions; and American art critics, such as Clarence Cook, Russell Sturges, and James Jackson Jarves, fell under his sway.

The ground was well laid for the impact that nineteenth-century British art itself could have by the time it was seen in quantity on these shores. It came in such painting exhibitions as the 1857–58 Exhibition of English Art, a commercial venture that brought English Pre-Raphaelite painting to New York, Philadelphia, and Boston,[49] and then more crucially at the English art exhibit that was part of the American centennial celebrations in Philadelphia in 1876.

"All good Americans should live in England"

Americans of the last third of the nineteenth century were predisposed to respond to things British, for there was a widespread fascination with England that prevailed throughout the United States—an American Anglomania (a word used in the press of the time).[50] Leaders of American society looked to England to provide a stable social hierarchy that comforted Anglo-descended Americans facing an increasingly heterogeneous, immigrant-filled country.[51] *Harper's Magazine*—one of the era's largest circulating journals in the English-speaking world—reveled rhetorically in the fact that "Plymouth Rock is but a stepping-stone in the progress of English civilization" and went on to proclaim "a true Holy

Alliance ... composed of the English-speaking races on both sides of the sea."[52] The perception of the common stock uniting Englishmen and Americans was trenchantly clear:

"At Christmas-time, therefore, the greatest nation which sprang from English stock, and which is founded upon English principles and practices of liberty, naturally turns to the mother country with that instinct of kindred which made the typical New-Englander, Hawthorne, call England 'our old home,' and that genuine Englishman, Gladstone, describe Americans as 'our kin beyond the sea.'

... [W]e felt the common kindred, the long descent, the mysterious instinct of race, and in perfect sympathy our accordant hearts beat the refrain, We too are Englishmen."[53]

Elsewhere in the journal, the American sentiment was summarized: "At bottom we feel ourselves to be the Greater Britain."[54] Thus the Englishmen of a Newer England in North America modeled their clubs, schools, and colleges (hence many of their social relationships) after English counterparts. When they could, they married their children into the English aristocracy, making the Anglo-American assimilation complete.[55] "To be English today is to be in good form," observed a writer for the *Nation* in early 1882.[56] And such popular periodicals as *Harper's* and *Scribner's* attempted to be in very good form, providing their readers with a high percentage of articles about things English.[57] Works by English authors enjoyed a booming popularity;[58] to capitalize on this, British literary celebrities traveled to the United States, often receiving warm, even crazed, receptions.[59] England's heritage—Chaucer to Shakespeare to Dickens—became a comfortable, shared past that Americans could experience and feel. Indeed, Americans were able to appreciate things English even more than the English did, or so thought Richard Watson Gilder, who proclaimed in 1883, "It is part of our 'spread-eagleism' doubtless, that we *think* we have a keener relish for old England than its very natives have."[60]

As was so often the case with things cosmopolitan, Henry James expressed it best: "I can't look at the English and American worlds, or feel about them, any more, save as a big Anglo-Saxon total, destined to such an amount of melting together that an insistence on their differences becomes more and more idle and pedantic."[61] And the sentiment was, at least on occasion, shared by those on the eastern strand of the Atlantic. Ruskin wrote to his close friend, the American art writer and professor Charles Eliot Norton: "I think you *will* like, as nobody yet has liked, going over the schools, when you come *home*—to England. It's absurd to think of yourself as an American any more; but even if you do, all good Americans should live in England, for America's sake, to make her love her father's country—if not in the past, at least now."[62]

It is within this Anglo-American fabric that we can best understand the generation of American painters that straddled the close of the nineteenth century. A number of the country's most talented and best-trained painters lived for years abroad. Winslow Homer, in most accounts of the period seen as the great American painter of native subjects, established himself in the North Sea fishing village of

Cullercoats for over a year in 1881–82. Most historians view the period as crucial for the development of such great sea paintings of the Maine coast as plates 80–83, which began almost immediately on his return to the United States.[63]

James McNeill Whistler, after schooling at the American military academy at West Point and artistic training in Paris, settled in London in 1859 and never returned to the United States. He moved in the most advanced artistic circles in both Paris and London, placing himself, in the latter city, directly in the Chelsea late Pre-Raphaelite milieu of Dante Gabriel Rossetti, Algernon Swinburne, and others. British citizens are the principal characters of many of his most important works, from the early portraits of his Irish mistress Jo Hiffernan, such as the magnificently provocative *The White Girl (Symphony in White)* (plate 125), to the iconic image of the Scottish sage Thomas Carlyle, *Arrangement in Grey and Black, No. 2: Portrait of Thomas Carlyle* (1872–73, Glasgow Museum and Art Gallery), to the late portrayals of children appreciated for a look or costume, as in *The Little Rose of Lyme Regis* (a portrait of Rosie Randall, daughter of the mayor of the Dorset resort [plate 124]). The city of London, however, was probably his greatest sitter, with its bridges, its river, its pleasure gardens. *Nocturne in Black and Gold: The Falling Rocket* (fig. 9)—a view of fireworks in Cremorne Gardens—provoked one of the nineteenth century's greatest legal farces. The critic Ruskin called it "Cockney impudence" to ask "two hundred guineas for flinging a pot of paint in the public's face." Whistler sued him for libel. The trial allowed Whistler to articulate his artistic credo to a wide audience. Asked if he charged such a price for two days' work, he responded: "No. I ask it for the knowledge I have gained in the work of a lifetime." This was a brave salvo announcing the traumas of abstraction/craft/effect that were to come in the next century. Whistler won his suit but was awarded only a farthing's damages and had to pay his own costs, which forced him to declare bankruptcy. Even so, amid a British philistinism against which he repeatedly railed, and with extended respites in Paris and the elsewhere on the continent, it was as a proud American citizen living in England that Whistler made his life.

John Singer Sargent, too, went to London after spending his student years and early maturity in Paris; he settled there in 1886 and made it his lifelong home. Sargent had exhibited a number of his French paintings in England from 1882 onward, garnering generally favorable, albeit suspicious and fearful-of-French-modernism critical responses. But the work that won him a place in the hearts of English society was *Carnation, Lily, Lily, Rose* (fig. 10), one of his two Royal Academy exhibition paintings for 1887. The work, inspired by a light effect seen while boating along the Thames and painted largely in the Worcestershire village of Broadway, seems a homage to English contemporary sentiment (especially as manifested in the works of Sir John Everett Millais, Frederick Walker, and many others) and English traditional paintings (by artists as diverse as Thomas Gainsborough and Sir Thomas Lawrence)—all overlaid, of course, with modern French concerns of surface abstraction and veristic lighting effects.[64]

Followed by such accomplished portraits as *Gertrude, Lady Agnew* (1893, The National Gallery of Scotland, Edinburgh), Sargent was soon to rise to the pinnacle of the English and American art worlds; when he died in London in 1925, he (as had been the case with West before him) was the most famous of English-speaking painters.

That Sargent, Whistler, and several others—such as Edwin Austin Abbey (1852–1911), George Henry Boughton (1833–1905), and Frank Millet (1846–1912)—resided in England can be ascribed to motives of professional advancement and status as well as personal sympathy. The *Art Amateur* of May 1884 put it tersely: "But it might not be amiss to remark that no American of [any] ability has yet gone to England without, in a short time, more than doubling his New York or Boston studio prices."[65] Nor was the concern merely mercenary. The designer Candace Wheeler summarized the era neatly when she wrote: "The admiration of an English public, once gained, can be permanently counted on, and as London still sets the fashion for us in art, as in all luxurious expenditure, the acquirement by an artist of a London reputation means the appreciation of the English-speaking world. This accounts for the fact that some of the most brilliant painters of America have elected to remain permanently in England."[66]

A nation's art reflects its culture and history—at least as it wishes them to be seen. Through most of the nineteenth century, America's arbiters of taste and culture aspired largely to follow British models in matters social, cultural, and artistic. Great American collections of British art testify to the lure of things British even as late as the turn of the century and beyond. Given the knitting together of British and American culture and language for much of the seventeenth, eighteenth, and nineteenth centuries, this is not a surprise. The wonder of British-American artistic relations is not that it was once as dominant as it was, but that its apparent lessening in our own century—and with the careers of such artists as David Hockney and R.B. Kitaj the diminution is open to debate—in favor of French-influenced or stridently independent action had the audacity to occur at all.

1 John Ruskin, "Fors Clavigera: Letter 42 (June 1874)," *The Works of John Ruskin*, 39 vols. (London: George Allen, 1907), 28:92.

2 Although there were religious paintings, landscapes, and even genre scenes, they were outweighed dramatically by the bulk of the portraits. For examples of these other formats, see Roderic H. Blackburn and Ruth Piwonka et al., *Remembrance of Patria: Dutch Arts and Culture in Colonial America, 1609–1776* (Albany: Institute of History and Art, 1988), 209–55; Edward J. Nygren et al., *Views and Visions: American Landscape before 1830* (Washington, D.C.: The Corcoran Gallery of Art, 1986), 291.

3 An excellent introduction to the art and material culture of seventeenth-century New England is *New England Begins: The Seventeenth Century*, 3 vols. (Boston: Museum of Fine Arts, 1982). For a survey of colonial portraiture throughout the North American colonies, see Wayne Craven, *Colonial American Portraiture* (Cambridge: Cambridge University Press, 1986).

4 For Smibert, see Richard H. Saunders, *John Smibert: Colonial America's First Portrait Painter* (New Haven: Yale University Press, 1995).

5 The English look of the works holds true even for such native-born painters as Nehemiah Partridge (1683–after 1729), Gerardus Duyckinck I (1695–1753), the German Justus Engelhardt Kühn (act. c. 1708–17), and Swede Gustavus Hesselius (1682–1755). A thorough review is available in Richard H. Saunders and Ellen G. Miles, *American Colonial Portraits: 1700–1776* (Washington, D.C.: National Portrait Gallery, 1987).

6 Craven, 295.

7 The principal source on West is Helmut von Erffa and Allen Staley, *The Paintings of Benjamin West* (New Haven and London: Yale University Press, 1986). For Copley, see Jules David Prown, *John Singleton Copley*, 2 vols. (Cambridge, Mass.: Harvard University Press, 1966); Carrie Rebora et al., *John Singleton Copley in America* (New York: The Metropolitan Museum of Art, 1995); Emily Ballew Neff and William L. Pressly, *John Singleton Copley in England* (London: Merrell Holberton, 1995).

8 Francis Hopkinson, "Verses inscribed to Mr. Wollaston," *American Magazine and Monthly Chronicle for the British Colonies* 1, no. 12 (September 1758), quoted in von Erffa and Staley, 6.

9 John Galt, *The Life and Studies of Benjamin West, Esq., President of the Royal Academy of London* (1816); quoted in von Erffa and Staley, 13.

10 Galt, quoted in John W. McCoubrey, *American Art, 1700–1960: Sources and Documents* (Englewood Cliffs, New Jersey: Prentice-Hall, 1965), 39.

11 West to Joseph Shippen, 1 September 1763; quoted in von Erffa and Staley, 23.

12 For one of the most interesting recent interpretations of West's career as a history painter, see Ann Uhry Abrams, *The Valiant Hero: Benjamin West and Grand-Style History Painting* (Washington, D.C.: Smithsonian Institution Press, 1985).

13 Quoted in Dorinda Evans, *Benjamin West and His American Students* (Washington, D.C.: National Portrait Gallery, 1980), 13.

14 Copley to [West or R.G. Bruce], c. 1767; quoted in McCoubrey, 18.

15 Captain R.G. Bruce to Copley, 4 August 1766; quoted in McCoubrey, 10–11.

16 See Ellen G. Miles, *American Paintings of the Eighteenth Century* (Washington, D.C.: National Gallery of Art, 1995), 43–54.

17 William T. Whitley, *Artists and Their Friends in England*, 2 vols. (1968), quoted in Evans, 81–83.

18 Ellis Waterhouse, *Painting in Britain 1530 to 1790*, 4th ed. (Harmondsworth: Penguin, 1978), 280.

19 For the most recent examination of the painting and overview of previous literature, see Miles, 1995, 54–71.

20 See Neil Harris, *The Artist in American Society: The Formative Years, 1790–1860* (1966; New York: Clarion, 1970), 78–81.

21 For a thorough overview, see Evans.

22 See Edgar P. Richardson et al., *Charles Willson Peale and His World* (New York: Harry N. Abrams, 1983).

23 See Richard McLanathan, *Gilbert Stuart* (New York: Harry N. Abrams, 1986).

24 See Helen A. Cooper et al., *John Trumbull: The Hand and Spirit of a Painter* (New Haven: Yale University Art Gallery, 1982).

25 The striking exception to this was John Vanderlyn who, alone among all his compatriots, chose in 1796 to forgo London and instead settled on France for training as an artist; he is the exception who proves the rule (and the decision was likely made for him by his patron, Aaron Burr, who was fiercely anti-British).

26 See Monroe H. Fabian, *Mr. Sully, Portrait Painter: The Works of Thomas Sully (1783–1872)* (Washington, D.C.: National Portrait Gallery, 1983). Sully's journal entry for 4 April 1838 is quoted on p. 98.

27 See William H. Gerdts and Theodore E. Stebbins, Jr., *"A Man of Genius": The Art of Washington Allston (1779–1843)* (Boston: Museum of Fine Arts, 1979).

28 Henry T. Tuckerman, "Introduction," *Book of the Artists* (1867; New York: James F. Carr, 1966), 14.

29 For a good historiographic review, see William H. Truettner, "Nature and the Native Tradition: The Problem of Two Thomas Coles," *Thomas Cole: Landscape into History* (New Haven and Washington, D.C.: Yale University Press and National Museum of American Art, 1994), 136–58.

30 Nygren et al., 1986.

31 See, for example, Archibald Robertson, *Elements of the Graphic Arts* (New York, 1802) and William Oram, *Precepts and Observations on the Art of Colouring in Landscape Painting* (London, 1810).

32 William Strickland, *Journal of a Tour in the United States of America, 1794–1795*; quoted in Bruce Robertson, "The Picturesque Traveler in America," in Nygren et al., 209.

33 Archibald Alison, *Essay on the Nature and Principles of Taste* (Edinburgh, 1825); Edmund Burke, *A Philosophical Enquiry into the Origin of Our Ideas of the Sublime and Beautiful* (London, 1757); William Gilpin, *Three Essays: On Picturesque Beauty; On Picturesque Travel; and On Sketching Landscape* (London, 1803); Richard Payne Knight, *An Analytical Inquiry into the Principles of Taste* (London, 1805); Uvedale Price, *An Essay on the Picturesque As Compared with the Sublime and the Beautiful* (London, 1842); Sir Joshua Reynolds, *Discourses on Art* (London, 1797).

34 For a brief discussion, see Ellwood C. Parry III, *The Art of Thomas Cole* (Newark: University of Delaware Press, 1988), 87–89.

35 Ibid., 95.

36 For a particularly good overview, see Nygren et al.

37 For Cole, see Parry III, and Truettner.

38 William Cullen Bryant, "To Cole, the Painter, Departing for Europe" (1829); reprinted in McCoubrey, 96.

39 For an account of this English sojourn, see Parry III, 95–115.

40 Quoted in Parry III, 97.

41 Quoted in Oswaldo Rodriquez Roque, "The Exaltation of American Landscape Painting," in *American Paradise: The World of the Hudson River School* (New York: The Metropolitan Museum of Art, 1987), 27.

42 But the harshness could be reciprocated, as when the British traveler and observer Fanny Trollope wrote in her *Domestic Manners of the Americans*: "From all the conversations on painting, which I listened to in

America, I found that the finish of drapery was considered as the highest excellence, and next to this, the resemblance in a portrait; I do not remember ever to have heard the words *drawing* or *composition* used in any conversation on the subject" (*Domestic Manners of the Americans* [1832; Oxford: Oxford University Press, 1984], 228). She did later amend this, in terms that Copley would have appreciated: "With regard to the fine arts, their paintings, I think, are quite as good, or rather better, than might be expected from the patronage they receive; the wonder is that any man can be found with courage enough to devote himself to a profession in which he has so little chance of finding a maintenance. The trade of a carpenter opens an infinitely better prospect" (282).

43 See Elizabeth Johns, *American Genre Painting: The Politics of Everyday Life* (New Haven and London: Yale University Press, 1991), 24, 139.

44 See Barbara Dayer Gallati, "Asher B. Durand (1796–1886)," in John K. Howat et al., *American Paradise: The World of the Hudson River School* (New York: The Metropolitan Museum of Art, 1987), 103–18.

45 30 April 1860; quoted by Carrie Rebora, ibid., 206.

46 See Franklin Kelly et al., *Frederic Edwin Church* (Washington, D.C.: National Gallery of Art, 1989), 55–57, 163–64; Nancy K. Anderson and Linda S. Ferber, *Albert Bierstadt: Art & Enterprise* (New York: Hudson Hills Press, 1991), 45–47, 92–94.

47 For a thorough overview, see Roger B. Stein, *John Ruskin and Aesthetic Thought in America, 1840–1900* (Cambridge, Mass.: Harvard University Press, 1967).

48 Clarence Cook in the *New York Quarterly* 4 (April 1855); quoted in Linda Ferber, "'Determined Realists': The American Pre-Raphaelites and the Association for the Advancement of Truth in Art," in *The New Path: Ruskin and the American Pre-Raphaelites* (New York: The Brooklyn Museum of Art, 1985), 15.

49 See Susan P. Casteras, "The 1857–58 Exhibition of English Art in America and the Critical Responses to Pre-Raphaelitism," ibid., 108–33.

50 See, for example, *The Nation* (5 January 1882), deploring "the Anglomania which has done so much to change the social tone of New York," quoted in Lloyd Lewis and Henry Justin Smith, *Oscar Wilde Discovers America [1882]* (1936; New York: Benjamin Blom, 1967), 149; and Constance Cary Harrison, "Notes on Dress," *Art Amateur* 6, no. 3 (February 1882): 59.

51 T. J. Jackson Lears, *No Place of Grace: Antimodernism and the Transformation of American Culture, 1880–1920* (New York: Pantheon Books, 1981), 26–30.

52 "Editor's Easy Chair," *Harper's Magazine* 70, no. 415 (December 1884): 167.

53 Ibid., 165–68.

54 George William Curtis, "Editor's Study," *Harper's Magazine* 81, no. 484 (September 1890): 634–35. For other American fictions of Anglo-Saxon unity, and the social fears underlying them, see Lears, 26–32.

55 Richard Kenin, *Return to Albion: Americans in England, 1760–1940* (Washington, D.C.: National Portrait Gallery, 1979), 139–63, 195–219.

56 5 January 1882, quoted in Lewis and Smith, 150.

57 A review of the contents pages of *Harper's Magazine* from 1876 to 1892 reveals a preponderance of British fiction, poetry, and articles connected with things English. This was as it had been traditionally: "The house of book-taker and book-seller, Harper, of New York, is largely a house built on the skulls of English authors.... Harper has his daily four meals in the bones of English penmen" (*Punch*, 1851, quoted in Frank Luther Mott, *A History of American Magazines, 1850–1865* [Cambridge, Mass.: Harvard University Press, 1938], 128).

58 A poll of American readers in 1891 revealed that in nine of the ten categories, English poems were thought of more highly than the American product: most dramatic, Browning; most humorous, Cowper; most pathetic, Hood; most romantic, Scott; most popular quote, Gray; noblest male character, Tennyson; most musical line, Shelley; most beautiful simile, Byron; most beautiful poem of all, Gray's "Elegy Written in a Country Churchyard." Only Longfellow, with "Evangeline," was found to have triumphed in any category—most lovable female (reprinted in the *Evesham Journal and Four Shires Advertiser*, 29 August 1891).

59 Charles Dickens, William M. Thackeray, James Anthony Froude, Charles Kingsley, Wilkie Collins, Robert Louis Stevenson, Thomas Huxley, Matthew Arnold, George Augustus Sala, G. P. R. James, Oscar Wilde, Edmund Gosse, and other literary men toured the United States, generally receiving plaudits and cash. See, for example, Mott, *A History of American Magazines, 1850–1865*, 159–62 and *A History of American Magazines, 1865–1885*, 248–53. The strength

of a movement is often evidenced by the reactions to it. Wrote the *Current* in 1884: "It is time to stop the opening of our purses, our houses, and our hearts to distinguished English tramps who come over here to rob us!" (quoted in Mott, *A History of American Magazines, 1865–1885*, 250).

60 Gilder to Austin Dobson, 25 January 1883; reprinted in Alban Dobson, ed., *An Austin Dobson Letterbook* (Cleveland: The Rowfant Club, 1935), 49.

61 James to William James, 29 October 1888, in Leon Edel, ed., *Henry James Letters, 1883–1895* (Cambridge, Mass.: Belknap Press of Harvard University Press, 1980), 244.

62 Ruskin to Charles Eliot Norton, 14 February 1872; quoted in *The Works of John Ruskin*, 37: 51.

63 For Homer, see Nicolai Cikovsky, Jr., and Franklin Kelly, *Winslow Homer* (Washington, D.C.: National Gallery of Art, 1995), esp. 171–245.

64 For full discussions of the work, see Richard Ormond, "Carnation, Lily, Lily, Rose," in Stanley Olson et al., *Sargent at Broadway: The Impressionist Years* (New York: Coe Kerr Gallery, 1986), 62–75; Marc Simpson, "Reconstructing the Golden Age: American Artists in Worcestershire, 1885–1889" (Ph.D. dissertation, Yale University, 1993).

65 Montezuma [Montague Marks], "My Note-Book," *Art Amateur* 10, no. 6 (May 1884): 123.

66 Candace Wheeler, *Yesterdays in a Busy Life* (New York: Harper & Brothers, 1918), 372.

"When to-day we look for 'American art' we find it mainly in Paris"

The Training of American Painters in France and the Influence of French Art on American Painting

Before the 1850s, American painters rarely sought training in Europe, contenting themselves with informal contact with foreign contemporaries and with study of the Old Masters on Grand Tours. Paris was a stop on those tours, but visiting American painters merely absorbed the city's artistic atmosphere and avoided instruction. They shared the English antipathy to French neoclassicism and found little support for their interest in landscape among French masters. Nationalist critics who claimed that French art was lascivious, as well as Jacksonian populist resistance to abstruse academic narratives, reinforced American painters' indifference to Parisian study.

Fortuitous circumstances led a few early nineteenth-century American art students to Paris. For example, John Vanderlyn, the first American painter to study there, went to Paris in autumn 1796 because his patron, Aaron Burr, was an ardent Francophile. Vanderlyn found that the Parisian art scene under the Directory was dominated by four able academic painters with studios in the Louvre—Jacques-Louis David, Jean-Baptiste Regnault, Joseph-Benoît Suvée,

and François-André Vincent. Vanderlyn enrolled in Vincent's atelier for practical instruction and, in November 1796, passed the semi-annual entrance examination for matriculation in the Ecole des Beaux-Arts. As a matriculant, he had access to daily drawing instruction, the foundation of the French academic system and a supplement to Vincent's practical instruction. He could also audit courses in anatomy, perspective, and history and antiquities, and he could compete in regular *concours*, though not in the competition for the Prix de Rome, open only to the French.

Vanderlyn's letters home during two years of academic study note his enthusiasm for copying works by the Old Masters; drawing after chalk drawings, after plaster casts of male nudes, and after the live model; and, finally, painting from life. Because Vincent painted portraits and encouraged portrait studies, it is not surprising that most of Vanderlyn's early Parisian works are portraits. In its muted coloring, projection of the figure in low relief against a blank background, and probing realism, his *Self-Portrait* (fig. 1) echoed the fashionable Parisian portrait

mode. Vanderlyn included the canvas among a group of portraits that he submitted to the Salon in 1800, when he became the first American to show in that august forum.

During his second trip abroad, beginning in 1803, Vanderlyn undertook several ambitious history paintings that encode late eighteenth-century French academic standards of subject, composition, and execution: *The Death of Jane McCrae* (Salon 1804, plate 5), *Caius Marius amid the Ruins of Carthage* (fig. 2, p. 235), and *Ariadne Asleep on the Island of Naxos* (1809–14, Salon 1812; fig. 2). Vanderlyn's French experience also informed his grand panorama *The Palace and Gardens of Versailles* (fig. 8, p. 38), for which he made sketches before he left France in 1815 and completed in New York in 1819.

American painters' contacts with the next generation of French teachers—artists who had been trained by David and Vincent, among others—were rare until a small group elected to study under François-Edouard Picot in the 1850s. The leading American pupil of Baron Antoine-Jean Gros, David's famous pupil, was George Peter Alexander Healy, who would succeed as an expatriate portraitist in France. Healy entered Gros' studio in 1835, shortly before the French artist's suicide, but he was more influenced by fellow pupil Thomas Couture, whose style defied rigid academic principles.

Paul Delaroche, who took over many of Gros' students, enjoyed great popularity in the United States, where his paintings were acclaimed and widely circulated in the form of engravings. Although Delaroche's style was academic, he avoided antique themes and instead depicted modern history in a journalistic, highly factual way. His anecdotal history paintings appealed to American patrons impressed by technical finesse and accustomed to accessible subjects.

Delaroche taught more than 355 pupils, including Couture, Jean-Léon Gérôme, and Jean-François Millet. Although he had five American-born students, the pupil who would most effectively transmit his lessons to the United States was an Alsatian émigré, Christian Schussele, who studied briefly under Delaroche in 1843 and settled in 1847 or 1848 in Philadelphia. There, Schussele executed American genre scenes and journalistic history paintings that were widely exhibited, favorably reviewed, and popularized though engravings. Schussele influenced the art life of Philadelphia by teaching in his own studio and at the Pennsylvania Academy of the Fine Arts, where he was chairman of drawing and painting from 1868 until his death in 1879. Schussele's curriculum emphasized drawing from antique casts, according to the French academic tradition.

In the late 1840s and 1850s, French ateliers began to attract small groups of American pupils,

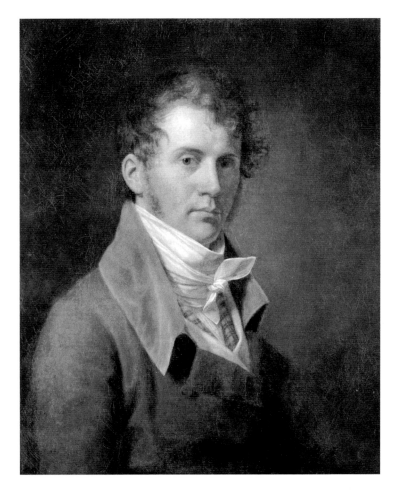

1 John Vanderlyn, *Self-Portrait*, 1800, oil on canvas, 64.1 x 53 cm, The Metropolitan Museum of Art, New York, NY, bequest of Ann S. Stevens, in memory of his mother, Mrs. Ann S. Stevens, 1918

peripatetic students who combined study in Paris with instruction in Düsseldorf, Florence, and Rome. American collectors were still devoted to American views and genre scenes, and remained indifferent to the intellectual conceits of French academic art. However, as the journalistic approach to history painting that Delaroche espoused gained ground among French painters, American patrons found French art more engaging and American painters were prompted to study in Paris.

At mid-century, the most popular Parisian teacher among Americans was Couture, who opened an atelier for instruction in 1846. Couture advocated an anti-academic style in which the generative stages of his paintings enlivened their final surfaces. His technique, based on Venetian High Renaissance art, was simple, rapid, and expressive. He would exploit the *ébauche*, the initial laying in of broad tonal masses, and would refrain from scraping down the *ébauche* and bringing the surface to a high degree of finish.

Couture's emphasis on the sketchy underpainting allowed his students to acquire a sophisticated manner quite rapidly. Unusually sympathetic to American students, Couture also provided for several of them an artistic bridge to the painterly Barbizon style. William Morris Hunt was the most prominent American to have a dual affiliation with Couture and Barbizon. Having tried and despised study in Düsseldorf, Hunt worked in Couture's atelier from 1846 until about 1851, and then spent three years with Millet in Barbizon. As his *Girl at the Fountain* (fig. 3) suggests, Hunt would adhere to Couture's technique and precepts while he adopted Millet's interest in rural types (as well as Camille Corot's interest in poetic landscapes). Hunt's taste would affect many Boston collectors, who acquired Barbizon paintings by the score at his recommendation. Ultimately, American artists such as George Inness could examine numerous works by Millet, Corot, Théodore Rousseau, and other Barbizon painters in American collections, even before they visited France.

Of the three leading Parisian teachers active at mid-century, the most orthodox was Picot, a member, with Gros, of the generation of French masters who had been trained by David and Vincent. Picot imparted academic lessons to such artists as Alexandre Cabanel and Isidore Pils, who later oversaw ateliers at the Ecole des Beaux-Arts, and to many other reputed French painters. His best-known American pupil, Elihu Vedder, noted that during his eight-month stay in Picot's studio, beginning in 1856, he had learned nothing and had just wasted time copying antique casts. Vedder also mocked Picot's attentiveness: "The instruction consisted in a little old man with a decoration coming twice a week and saying to each one of us, '*Pas mal! Pas mal!*' and going away again."[1] Although Vedder disdained Picot's tutelage, its residue is obvious in many of his works such as *The Pleiades* (fig. 4), which invokes the academic tradition in its classical subject, wiry outlines, sculpturesque figures, and restrained, chalky palette.

The third important teacher to whom Americans turned at mid-century was Swiss-born Marc-Charles-Gabriel Gleyre, who traced his artistic heritage through Louis Hersent to Regnault. Gleyre tempered

his immersion in academic procedures with study under the English watercolorist Richard Parkes Bonington. Arriving in Rome in 1828, he entered the circle of Horace Vernet, whose interest in Roman and Near Eastern subjects affected him, as did a trip to Greece, Turkey, and Egypt. After 1838, Gleyre lived in Paris where he painted religious, classical, and modern historical works in a *juste milieu* manner that combined polished technique with romantic sentiment. Gleyre's most successful painting was *Lost Illusions* (fig. 5), which exemplifies his conjoining academic style with intimations of prosaic human experience in portraying an old man who meditates on the passage of youthful pleasure.

At the invitation of Delaroche, who closed his studio in 1843 and left for Rome, Gleyre took over many of his pupils and began a teaching career that lasted twenty-one years. Gleyre's fluid approach to his subject matter made him an attractive resource for more than five hundred students, among whom were ten Americans. The first American to study under Gleyre and the most important was James McNeill Whistler, who arrived in June 1856 for two years of study. Although Whistler seems to have done little work during his student years in Paris, his later yearnings for academic foundations as he struggled with the *Six Projects* (1867–72, Freer Gallery of Art, Washington, D.C.) suggest that Gleyre's lessons were not lost on him.

Whistler resolved the challenges posed by the *Six Projects* by retreating from multi-figured compositions into single-figure *Arrangements*. The best known of these is *Arrangement in Grey and Black no. 1, Portrait of the Painter's Mother* (fig. 6), in which the profile pose, melancholy mood, and monochromatic

2 John Vanderlyn, *Ariadne Asleep on the Island of Naxos*, 1809–14, oil on canvas, 174 x 221 cm, Museum of American Art of the Pennsylvania Academy of the Fine Arts, Philadelphia, PA, gift of Sarah Harrison

3 William Morris Hunt, *Girl at the Fountain*, c. 1852–54, oil on canvas, 116.8 x 90.2 cm, The Metropolitan Museum of Art, New York, NY, bequest of Jane Hunt

4 Elihu Vedder, *The Pleiades*, 1885, oil on canvas, 61.3 x 95.6 cm, The Metropolitan Museum of Art, New York, NY, gift of George A. Hearn, 1910

palette echo Gleyre's *Lost Illusions*.[2] Struggling to establish a new style some ten years after his period of study with Gleyre, Whistler seems to have become a student again. Generally, Whistler's allegiance to an anti-naturalistic style, which made him a forerunner of Post-Impressionism, may also have derived from Gleyre's principles, which the future Impressionists among Gleyre's students—Claude Monet, Pierre-Auguste Renoir, Alfred Sisley—had detested. Whistler's own teaching at his Académie Carmen, founded in Paris in 1898, echoed his French teacher's precepts. As Whistler's biographers noted: "To anyone familiar with art schools Whistler's idea appeared revolutionary, but he knew he was carrying on the tradition of Gleyre."[3]

Other American pupils of Gleyre's echoed his monochromatic palette, technique, and even his subject preferences. Daniel Ridgway Knight studied under Gleyre in the early 1860s, returned to Paris in 1871 or 1872, and worked under Ernst Meissonier at Poissy in 1874 or 1875. His mature works such as *Hailing the Ferry* (fig. 7) adapt Gleyre's interest in exotic genre to the peasants of Poissy, where Knight settled. Knight's interest in peasant subjects also reflects the influence of Jules Breton and Jules Bastien-Lepage, whose works became popular among American patrons in the late nineteenth century.

At mid-century, American resistance to contemporary French painting eroded. This is reflected in the growing number of American artists who went to Paris to study in the studios of Couture, Picot, Gleyre, and others, and in the increasing coverage of Parisian culture and art scene in American journals. And by the late 1860s, after the end of the Civil War, American painters' reluctance to pursue foreign training essentially disappeared. As the United States became more fully engaged in international political, economic, scientific, and social affairs, cultural internationalism was inevitable. Technological advances, including completion of transatlantic cables and improvements in transportation, assisted the new internationalism.

In the late nineteenth century, aspiring artists from all over the world went to Paris. The city, aesthetically improved and more habitable than ever before as a result of Second-Empire renovations,

was a storehouse of old art treasures, like London and Rome. But Paris exuded a unique and pervasive artistic atmosphere and took an unusual interest in contemporary creative developments. French authorities encouraged art students and artists, supported tuition-free art education, and organized Salons and Expositions Universelles. These exhibitions, which allowed comparisons among the national schools, provoked a growing consensus that French art was superior. They also generated official and private purchases and commissions, a system of honors, and critical debate, all of which could enhance an exhibitor's reputation, justify the expense of his foreign training, and increase his patronage.

Other factors that made Paris an irresistible magnet for late nineteenth-century painters was the picturesqueness and intimate scale of the surrounding countryside, the opportunity to meet artists of various nationalities, and cheap accommodation and modest living costs. More and more professionalized facilities for art training also emerged as a result of crucial administrative and curriculum reforms at the Ecole des Beaux-Arts in 1863. These reforms created a third order of teaching, aside from the lecture courses and the drawing instruction that was restricted to matriculants. This new teaching was practical and was conducted in three ateliers established for the first time under the roof of the Ecole. The most popular early *chefs d'atelier* among the Americans at the Ecole would be Jean-Léon Gérôme and Alexandre Cabanel. Competing private art schools such as the Académie Julian were also founded. These schools, which ultimately had studios throughout Paris, charged fees and provided Beaux-Arts training for students including women, who would be excluded from the Ecole until 1897.

Although the government school and the private academies served hundreds of late nineteenth-century art students in Paris, independent studios continued to flourish. Among the newer ateliers were those of portraitist Léon Bonnat, who blended the academic French and painterly Spanish modes in a technical *juste milieu* that helped the development of American students such as Thomas Eakins' and Carolus-Duran, whose debt to Spanish painting was greater than Bonnat's and who inspired John Singer Sargent to adopt a style based on the traits of Velázquez. Such independent facilities were also important to men and women who wished to avoid the academies' overcrowded studios and their stylistic strictures.

American artists were especially motivated to undertake study in Paris because they needed to learn how to emulate the academic, Barbizon, and Impressionist painters whose canvases were increasingly attractive to American collectors. These collectors, especially northern urban industrialists and financiers who had profited from the Civil War, encoded their new-found wealth in works of art. They were assisted by European dealers who established American branches and by American dealers who used French-trained American painters as agents. Boston collectors found in Barbizon landscapes an echo of the city's transcendentalist tradition of nature worship. Collectors in New York, Philadelphia, and other cities preferred French academic paintings, particulary if they depicted accessible subjects, were

5 Charles Gleyre, *Lost Illusions*, 1843, oil on canvas, 156 x 238 cm, Musée du Louvre, Paris

6
James McNeill Whistler,
*Arrangement in Grey and
Black no. 1, Portrait of the
Painter's Mother*, 1871,
oil on canvas,
144.3 x 165.2 cm,
Musée d'Orsay, Paris

rather than the moralistic aspects of historical narratives. He moved easily from intimate, journalistic history painting to straightforward historical genre, usually classical (known as Néo-Grec), and then to exotic contemporary genre, usually orientalist. His emphasis on disciplined investigation and transcription of natural forms, especially the human figure, and on lucid composition, affected his many American students, whatever their individual subject preferences. Some, such as Frederick Bridgman, pursued their careers abroad and emulated Gérôme's interests. Others, such as Eakins and George de Forest Brush, adapted Gérôme's subject choices to American themes.

Bridgman studied under Gérôme from 1867 to 1871. In Morocco, Algeria, and Egypt in 1872–73, he discovered the North African types who were to populate his paintings. Typically, in *The Burial of a Mummy on the Nile* (1877, J.B. Speed Art Museum, Louisville, Kentucky), Bridgman echoes Gérôme's *The Prisoner* (1861, Musée des Beaux-Arts, Nantes), and *Excursion of the Harem* (fig. 8), re-creating curious and elaborate obsequies with an ethnographic realist's loving attention to detail. In light of the approbation that greeted Gérôme's works in the late nineteenth century, it is not surprising that one of his most devout American disciples enjoyed substantial popularity and patronage both in the United States and in France, where he resided until his death.

Eakins' contact with Schussele and the general "Beaux-Arts" spirit of the Pennsylvania Academy of the Fine Arts probably prompted him to pursue Parisian training. He must have been aware of Gérôme's commercial and critical success and may

technically impressive, and appeared to be good investments. By 1886, American purchases of French paintings were so extensive that the French government sent an investigator to consider the situation. His report, published in the *Gazette des Beaux-Arts* in July and September 1887, verified official worries about the exodus of contemporary French canvases to America: "I would never have believed, had I not confirmed it myself, that the United States, so young a country, could be so rich in works of painting, especially works of the French school. It is not by the hundreds but by the thousands that one must count them."[4]

To secure patronage, American artists went abroad in unprecedented numbers to learn their craft and they followed in their teachers' footsteps or domesticated their lessons. Thus, the crucial identifying trait of the art experience in late nineteenth-century America was the acquisition and emulation of foreign art—especially contemporary French art. Writing in 1887 about Sargent, Henry James characterized the situation: "It sounds like a paradox, but it is a very simple truth, that when to-day we look for 'American art' we find it mainly in Paris. When we find it out of Paris, we at least find a great deal of Paris in it."[5]

The truth of James' observation, and of similar comments by other contemporary critics, is confirmed in catalogues of the annual Paris Salons and the Expositions Universelles of 1878, 1889, and 1900. These document the increase in number of American artists, their affiliations with French masters, and their new devotion to international subjects. Ultimately, younger American artists would be able to experience "French" training at home, under such teachers as Schussele, Hunt, Eakins, and others who reinvented American art education along Parisian lines. In the last decades of the nineteenth century, the United States would also develop a newly rich and serious artistic milieu, which included expanded exhibition and studio facilities,

unprecedented commissions for public art, and the growth of a sophisticated art criticism. All of these had been stimulated by French models.

Jean-Léon Gérôme, who established a following among American collectors, had more American pupils than any other French master. A student of Delaroche from 1840 to 1843, and then of Gleyre, Gérôme often explored the psychological or erotic

7 Daniel Ridgway Knight, *Hailing the Ferry*, 1888, oil on canvas, 163.8 x 211.1 cm, Museum of American Art of the Pennsylvania Academy of the Fine Arts, Philadelphia, PA

8 Jean-Léon Gérôme, *Excursion of the Harem*, 1869, oil on canvas, 78.7 x 134.6 cm, The Chrysler Museum, Norfolk, VA

have been attracted by the documentary quality of his works. Eakins' correspondence from Paris after his enrollment in Gérôme's atelier in October 1866 suggests the beginnings of a lasting respect for his teacher, with whom he spent two-and-a-half years. Even after his return home in 1870, Eakins carried on a cordial correspondence with Gérôme, seeking his advice on paintings and enlisting his aid in conveying them to dealers and Salon juries.

Eakins' mature works reflect the powerful impact of his academic lessons. As Gerald Ackerman pointed out in a seminal article on Eakins' relationship with his Parisian teachers, published in 1969, the American reiterated motifs and compositional strategies that appear in Gérôme's works, reconfiguring in Philadelphia terms orientalist paintings such as *The Prisoner* or *Excursion of the Harem* to create *The Champion Single Sculls (Max Schmitt in a Single Scull)* (fig. 9) and *The Biglin Brothers Turning the Stake* (1873, Cleveland Museum of Art).[6] Both artists' river paintings share careful arrangements of forms and their interrelationships, a concern with meticulous detail, glowing light emanating from the horizon, and refined surfaces.

Eakins' academic tendencies are also apparent in such paintings as *Swimming* (1885, Amon Carter Museum, Fort Worth). His related Arcadian images of the early 1880s recall the idyllic visions of antique life that were the benchmark of Gérôme's Néo-Grec works. His William Rush series is an American equivalent of the historical images of artists in their studios that French painters produced throughout the nineteenth century. Although Eakins repudiated the Ecole's emphasis on draftsmanship by encouraging his students to paint rather than to draw, the curriculum that he developed at the Pennsylvania Academy when he took over from Schussele in 1879 otherwise emulated the Parisian model.

Other American pupils of Gérôme displayed their academic skills, especially their command of human anatomy, without painting either the exotic subjects that expatriate Bridgman chose or the prosaic local subjects that Eakins preferred. For example, Brush, who entered Gérôme's atelier in October 1873, concentrated on Native Americans, with whom he lived in the West in the 1880s. These models, seen in Brush's works such as *The Moose Chase* (1888, National Museum of American Art, Smithsonian

Institution, Washington, D.C.), were the counterparts of the North Africans whom Gérôme had studied in their exoticism, their dramatic activities, and their fascinating paraphernalia.

Several of Gérôme's American pupils turned to Impressionism later in their careers. As they added this perceptual mode to a conceptual, academic one, it is not surprising that their allegiance to Impressionism was cautious and intermittent. Typical was J. Alden Weir, who arrived in Paris in the fall of 1873 after two years at the National Academy of Design in New York, studied in Gérôme's atelier for four years, and was matriculated in the Ecole des Beaux-Arts for three semesters. Academic principles were fundamental to Weir's student works and are reflected in the young American's contempt for Impressionism, which made its debut in Paris while he was a student. For example, Weir commented in a letter to his parents on 15 April 1877, on the show of a "new school which call themselves 'Impressionalists.' I never in my life saw more horrible things.... They do not observe drawing nor form but give you an impression of what they call nature. It was worse than the Chamber of Horrors. I was there about a quarter of an hour and left with a head ache.... I was mad for two or three days, not only having paid the money but for the demoralizing effect it must have on many."[7]

9 Thomas Eakins, *The Champion Single Sculls (Max Schmitt in a Single Scull)*, 1871, oil on canvas, 81.9 x 177.5 cm, The Metropolitan Museum of Art, New York, Alfred N. Punnett Endowment Fund and George D. Pratt Gift

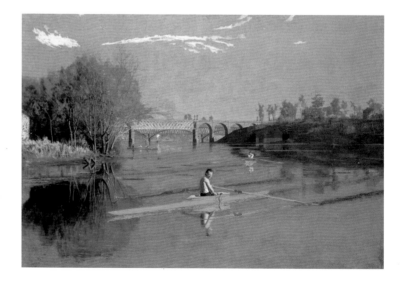

Although Weir detested Impressionism in the late 1870s, he was sympathetic to partisans of other new tendencies, particularly to Bastien-Lepage, the conservative realist, with whom he was friendly, and Edouard Manet, two of whose works he acquired in 1880–81, together with one by Bastien, as agent for an American collector. Weir's figure paintings of the 1880s betray a debt to both academic and more modern styles. For example, the compositional simplicity, expressive contours, and graceful restraint of *Idle Hours* (1888, The Metropolitan Museum of Art) suggest a domestication of Gérôme's Néo-Grec works; its monochromatic tonalities echo Bastien's palette; and its informal subject, creamy brushwork, and flattened space reflect Manet's influence.

Weir's antipathy to Impressionism subsided by the 1890s, when he experimented with a lighter palette and broken brushstrokes, but he was a restrained devotee. Like his compatriots, most of whom had experienced academic training and discovered Impressionism after it was no longer radical, Weir was indebted to Impressionist surfaces, rather than Impressionist principles. He painted works such as *The Red Bridge* (fig. 10), which are chastened by geometric control in composition, by linear definition of forms, and by a tonal palette.

In general, American painters who first absorbed academic lessons created an Impressionism that was hesitant and occasional in comparison with orthodox French Impressionism, exemplified by Claude Monet's paintings of 1873–80. Members of the great wave of American art students in Paris during the 1870s and 1880s, many of the future American Impressionists, worked at the Académie Julian under teachers such as Gustave Boulanger and Jules-Joseph Lefebvre. Julian's pervasive influence is signaled by the fact that eight members of "The Ten American Painters," the most conspicuous organization of American Impressionists at the turn of the century, were trained there, in large part by Boulanger and Lefebvre.

Whether they had studied at the Ecole des Beaux-Arts, as Weir had, or at Julian's, the American Impressionists were interested in the figure and were devoted to portraiture and to a certain "portrait quality," even in depicting anonymous figures. When the Americans paint landscapes, they often produce

10 Julian Alden Weir,
The Red Bridge, c. 1895,
oil on canvas,
61.6 x 85.7 cm, The
Metropolitan Museum
of Art, New York, gift of
Mrs. John A. Rutherford

"portraits" of domesticated sites—beaches, urban parks, city views—instead of amorphous vignettes of untamed nature. Inherent form and local color, and careful arrangement are usually more conspicuous than fluid, rapid technique. In painting both figures and landscapes, the Americans often appear to be "impressionizers," rather than Impressionists, applying chromatic veneers of broken strokes to solid forms that depend on preliminary studies and some studio retouching. The Salon scale of many of the American Impressionists' works, the existence of artists' replicas of some of them, and their many still-life subjects suggest a dependence on studio procedures.

Robert Reid was the youngest of "The Ten American Painters" and the last—except for Childe Hassam—to enter Julian's to work under Boulanger and Lefebvre. Reid's Parisian correspondence from 1887 to 1889, when he was an enthusiastic student and had three ambitious sentimental genre paintings accepted in the Salons, signals the likelihood of academic residues in his later works. After a flirtation with Impressionism in the early 1890s, Reid

was drawn into mural decoration at the World's Columbian Exposition, Chicago, the Library of Congress, Washington, D.C., and the Appellate Division Court House, New York. When Reid directed his attention again to easel painting at the end of the 1890s, he achieved a balance between Impressionism and decoration. His characteristic canvases depict young women, studied with a portrait painter's care, dominating landscape settings and often carrying flowers that give the works their titles such as *Fleur de Lis* (fig. 11). Carefully constructed solid figures, dressed in swathes of bright color and seen against flat, Impressionistic backgrounds, and the implication of an allegorical message recall both Reid's student works and his murals.

American scholars, collectors, and dealers have always been reluctant to acknowledge that what was "American" about much nineteenth-century American art, especially that of the late nineteenth century, was how French it was. This is because the development of American art history was stimulated by progressivist, and ultimately isolationist, thinking between the World Wars. Searching for a "usable"

American past to abet nationalistic impulses in the art of the 1920s and 1930s, cultural-nationalist commentators concentrated on Hudson River School landscape painting and colonial portraiture and found little to cherish in cosmopolitan late nineteenth-century American art.

Cultural-nationalist commentators condemned late nineteenth-century cosmopolitanism as effete and they attributed its emergence to a putative loss of self-confidence in the wake of the Civil War. They discounted the testimony of earlier critics such as S.G.W. Benjamin, George William Sheldon, and Mariana Griswold Van Rensselaer, and French-trained artist-writers such as John La Farge, Kenyon Cox, and Edwin Blashfield, that cultural internationalism was as desirable as industrial, technological, and scientific internationalism. They ignored evidence that Parisian art and art training had attracted Americans because they were deemed the world's best. They marginalized Knight, Bridgman, and other expatriates, and severed the French connections of Gallicized American painters such as Eakins. They attributed the stylistic cautiousness of American Impressionism to the residual power of the limner tradition rather than to the impact of French academic training. Cultural-nationalist prejudices were reinforced by modernist disdain for the French academic and Barbizon painters who had been the avatars of quality in the decades after the Civil War.

Although cultural nationalism has been challenged in recent decades,[8] its tenacious hold on American self-perception is still reflected in market values for American paintings, the continuing emphasis on the most "American" aspects of nineteenth-century American painting among scholars, and the way in which American art is presented to most national and international museum audiences. If Gallicized nineteenth-century American art were shown more widely, especially in international forums, it would be possible to make meaningful comparisons among the various national schools that experienced Parisian influence and that may have responded to it in significantly different ways.

1 Elihu Vedder, *The Digressions of V* (Boston and New York: Houghton Mifflin, 1910), 129.

2 This connection was proposed in Albert Boime, "The Instruction of Charles Gleyre and the Evolution of Painting in the Nineteenth Century," in Rudolf Koella, René Berger, Michel Thévoz, et al., *Charles Gleyre ou les illusions perdues* (Winterthur, Switzerland: Kunstmuseum, 1974), 114.

3 E[lizabeth] R. and J[oseph] Pennell, *The Life of James McNeill Whistler*, 6th ed. (Philadelphia: J.B. Lippincott; London: William Heinemann, 1911), 389.

4 E. Durand-Gréville, "La Peinture aux Etats-Unis: Les Galeries privées," *Gazette des Beaux-Arts*, ser. 2, 36 (July 1887); translation from Alexandra R. Murphy, "French Paintings in Boston, 1800–1900," in Anne L. Poulet, *Corot to Braque: French Paintings from the Museum of Fine Arts, Boston*, exhib. cat. (Boston: Museum of Fine Arts, 1979), xvii.

5 Henry James, "John S. Sargent," *Harper's Magazine* (October 1887), reprinted with emendations in *Picture*

and Text (1893); reprinted in John L. Sweeney, ed., *The Painter's Eye: Notes and Essays on the Pictorial Arts by Henry James* (London, 1956), 216.

6 Gerald M. Ackerman, "Thomas Eakins and His Parisian Masters Gérôme and Bonnat," *Gazette des Beaux-Arts*, ser. 6, 73 (April 1969): 235–56.

7 Weir to Father and Mother, Paris, 15 April 1877, quoted in Dorothy Weir Young, *The Life and Letters of J. Alden Weir* (New Haven: Yale University Press, 1960; reprint ed., New York: Kennedy Graphics, Inc., DaCapo Press, 1971), 123.

8 See, for example, Michael Quick, *American Expatriate Painters of the Late Nineteenth Century*, exhib. cat. (Dayton, Ohio: Dayton Art Institute, 1976); Lois Marie Fink, *American Art at the Nineteenth-Century Paris Salons* (Washington, D.C.: Smithsonian Institution; Cambridge: Cambridge University Press, 1990); and H. Barbara Weinberg, *The Lure of Paris: Nineteenth-Century American Painters and Their French Teachers* (New York: Abbeville Press Publishers, 1991).

11 Robert Reid, *Fleur de Lis*, c. 1896, oil on canvas, 112.1 x 108.6 cm, The Metropolitan Museum of Art, New York, George A. Hearn Fund, 1907

Between Influence and Independence

The Relationship of American and German Painters in the Nineteenth Century

The number of American painters who perfected their skills at German art academies in the mid-nineteenth century ran into the hundreds. They were initially attracted by the good reputation of the Cosmopolitan School in Düsseldorf, as the world-renowned Prussian academy was still known in 1880[1] (fig. 1); later, they became more and more attracted to Munich. The newly emerging American art journals reported frequently on the experiences of and the influences on the "students." Thus, painters such as Achenbach, Lessing, Piloty, or Kaulbach were in no way unknown to readers in the United States. Over the years, the acceptance of the European origins of American painting nevertheless declined. Interest became increasingly directed toward the special quality of American art and its definition.

In art-historical literature, too, it is possible to identify changing phases of recognition or rejection of a possible influence by German artists and schools on American painting. The genre of landscape painting can serve here as the starting point for a critical comparison and study of the specific form of such influence.

One Viewpoint—Two Ways of Seeing

One summer morning in 1852, two painters packed their equipment and ventured out into nature. One had been born in Breslau and for a quarter of a century had lived and worked in Düsseldorf, near the art academy there. The other, twelve years younger, had been born in Springfield, Ohio, and had lived in the city on the Rhine for four years. He now spoke German fairly well[2] and accompanied the experienced painter, who had already traversed the contrast-rich landscapes of the Harz many times for study purposes. They now traveled to a place near Regenstein that they had perhaps considered remarkable on a previous walking tour. This was a lonely tract of land and largely uninhabited. Upon their arrival, the sun was already high, the air had quickly warmed up, and the light seemed to shimmer. Both artists chose almost identical viewpoints to record their impressions.

A watercolor by the American Worthington Whittredge shows, from a raised position, a dried-up path that runs through the picture from the left in the background toward the right in the foreground, corresponding to the potential direction of movement (fig. 2). To the left of the path, some rocky outcrops can be seen on the slope that gently falls away at this point. The foreground on the left-hand side is not characterized any further in the picture. A dark, rocky massif is visible in the middle of the picture. With its sharply angular relief, it delimits the field of view to the right toward the background.

A painting by Carl Friedrich Lessing of the same place is known, completed in 1853 in his Düsseldorf studio (fig. 3). Lessing shifts this particular formation of the path, the washed-out and dried-up channels, and even wheel tracks almost to the center of the picture. He slightly exaggerates the prominent corner point of the rocky outcrop. In doing so, he isolates it, placing it to the right of the middle of the picture, accentuated for the eye of the viewer. Thus, it is given a very different weight for the composition as a whole. The foreground is finely detailed, yet in such a way that any sense of scale is forfeited, Lessing removing the points of reference that would allow it to be appraised. He takes the apparently secondary and focuses on the botanical or even geological details of the foreground.[3] In his composition, he graduates the landscape into four different zones of space and light. The latter, too, is only barely used as a point of orientation for time and space; instead, it seems for both the painter and the viewer to be imposing from behind. The landscape is dramatized only by the accentuation of the rocky outcrop, the general lack of scale, and the harsh lighting. It is not the endless tracts of land, the wide-open spaces, which are captured here. On the contrary, isolated elements have been determined as significant for the appearance of nature, as if they were dissociated from their function in the pictorial space.[4]

Here, Lessing extended a way of treating the landscape that his friend Friedrich von Uechtritz characterized in 1839 as follows, with a certain degree of surprise: "The painter seems to assemble about himself only as much nature as is necessary to express the lyric poetry of his feelings."[5] With these words, Uechtritz indicated that the lyrical element does not arise from relational references or the symbolic power of accessories, but rather from the sublimity of nature in its singular phenomena.[6]

The watercolor by Whittredge mentioned above (now in an American private collection) must be regarded as a preliminary study for a painting from 1852 (fig. 4).[7] In this painting, he has introduced a group of riders who are racing along the sandy path.[8] In so doing, he has simultaneously animated the landscape with a "narrative element" to which the viewer can devise a story. At the same time, a measure of scale has been introduced. Here, the sublimity of nature arises not just from the lack of scale of the figures in space.

A pencil drawing by Whittredge depicts a further, comparable view from a slightly raised viewpoint (fig. 5). In this picture, the foreground on the right-hand side is characterized by a dark zone; one is reminded of the shadows cast by trees that are invisible here. In the right-hand middle ground, Whittredge depicts a dense group of trees that runs like a triangle up a slope. This must be the hill that is only suggested at the right-hand margin in the previously described works. The marked rocky outcrop that dominates those now seems to have disappeared behind the trees. Instead, a more distant hill in the background lends the composition an accent. Its top is set slightly to the left of the middle of the picture. It is simultaneously the point that catches the viewer's eye after he has recognized a painter (perhaps Lessing) who has positioned himself beneath a parasol. The contrast-rich delimitation of the trees in the middle ground also lies along this line and

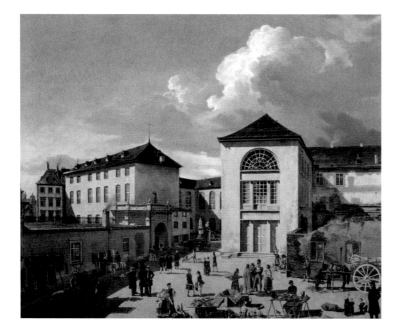

1 Andreas Achenbach, *The Old Academy in Düsseldorf*, 1831, oil on canvas, 65 x 81 cm, Kunstmuseum Düsseldorf im Ehrenhof

underlines the axis. In order to lend his composition dramatic accents, Whittredge resorted to completely different means compared to those of Lessing. The chosen overview from a raised standpoint and the rigid structuring of a particularly expansive tract of land, in which a measure of scale has been integrated by the use of figures, characterize his composition.

In interpreting the treatment of the observations made simultaneously by Whittredge and Lessing, it is not so much the features common to both paintings that can be emphasized, but rather the fundamental differences in approach that must be considered. As Otto Pächt wrote, "the less the distance between what is compared, the more evident the peculiarities become that set apart this image from its nearest relative, and the more evident the particular, unique characteristics of the work or artist in question becomes."[9]

2
Worthington Whittredge, *Landscape in the Harz Mountains*, 1852, watercolor and pencil on paper, 33.6 x 48.9 cm, Mr. and Mrs. E. P. Richardson, Philadelphia, PA

"Parrhasius was among the Buffaloes": Common Experience—Different Goals

In conventional literature, it is said that Lessing's "influence" is clear in any work by Whittredge from those years.[10] In 1851, an American judged Lessing to be the highest-ranking and best landscape painter, with the exception of Thomas Cole.[11] Lessing knew this region, and Whittredge accompanied him in order to learn from him, although—like virtually all American "students"—he had already been able to look back on his first successes at home before his sojourn in Europe. If we now examine the consequences of this experience for the young American, we can also say that the similarity of compared visions is insufficient for a reliable interpretation, because the same manifestations do not have to be based on the same idea.[12]

At this time, landscapists such as Whittredge held opinions that corresponded to those of Lessing: nature can be experienced in every landscape, in America in any case a prevailing view. Indeed, Lessing stated: "I do not understand why people venture so far away to paint studies; if I had the time and money, I would first travel thoroughly throughout Germany, where there are still many interesting and unknown regions." (Letter to his brother, March 1853). In 1853, William C. Bryant wrote from Europe in his letter to the *Evening Post*: "For my part, I can hardly understand what an American landscape painter, after satisfying a natural curiosity to see the works of the great masters of his art, should do in Italy. He can study nature to quite as much advantage at home ... a fresh and new nature ..."[13] Whittredge, too, later stressed this view in his autobiography. He took his "tools" from Lessing and later traveled—not without "taking Italy with him"—through the endless wide-open spaces of his American homeland. There, he built on the experience he had gained in Europe, in a manner comparable to that of his American contemporaries, such as Albert Bierstadt.

This experience initially concerned painting technique. When, on 18 April 1849, the Düsseldorf Gallery in New York (fig. 6) opened its doors for the first time, the American press praised the "strict discipline" to which painters were subject in Düsseldorf.

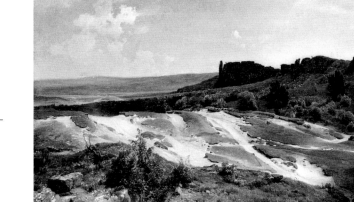

3 Carl Friedrich Lessing, *Landscape in the Harz Mountains near Regenstein*, 1853, oil on canvas, 58 x 89 cm, Kunstmuseum Düsseldorf im Ehrenhof

The Bulletin of the American Art-Union reported that "the assured treatment of the outline, the firmness, and exactness of the brushstroke, lend to the ideas on the canvas a perfection and uniformity that an insufficiently trained artist, no matter how ingenious, will never attain with insecure and tentative experiments."[14] In addition to aspects of painting technique, certain formal elements of composition in genre and history painting are meant in particular. These include the organization of space and light, the gestures of the figures, their integration and ordering into the space, and the degree of crossover of foreground, middle ground, and background, to name the most obvious characteristics to which even the artists in Düsseldorf had to conform to a certain extent. These elements apply in particular to the scenes of genre painting— and how strictly they were adhered to there can be elucidated by comparisons of, for example, Eastman Johnson's *The Card Players* with those of Ludwig Knaus, or Caleb Bingham's *Order No. 11* with Hübner's painting *The Silesian Weavers* (figs. 7–10).[15] It would be too general to speak of "adopting a motif," "reminiscence," "borrowing," "reflex," or "citation."[16] The identification of possible comparable qualities in genre or even history painting cannot be taken as far as is often intimated. With respect to the concept of adopting a motif, Norman Bryson warned that "a source is not simply a block of imagery from image x to image y."[17]

In 1859, the correspondent of the *Cosmopolitan Art Journal* summarized the situation too optimistically: the influence of Europeans, in particular the Düsseldorf artists, was very obvious. The introduction and the matter of how compositions should appear, especially in genre painting, was now completed. The army of painters, critics, and the public had learned their lesson, developed their taste further, and were now able to appreciate good works produced by the "genius of this country."[18] From the American point of view, it was necessary to develop an independent visual language, especially in the field of landscape painting. In 1855, Asher B. Durand asked in his *Letters on Landscape Painting*: "... why should not the American landscape painter, in accordance with the principle of self-government, boldly originate a high and independent style, based on his native resources ... ?"[19]

In 1867, Henry T. Tuckerman, whose critiques and reports on the relationship between European and American artists were enjoyed by a broad public, characterized in his *Book of Artists* (in Albert Bierstadt's biography) the important steps a painter must take upon his return to become an "American" painter. The key word here is "adventure." Like the battle painters of the continent, the American painter had to go directly into the gunpowder smoke and beyond into the imponderabilities of untamed

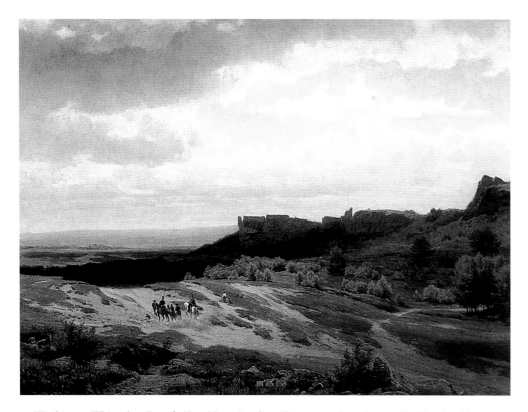

4　Worthington Whittredge, *From the Harz Mountains*, 1853, oil on canvas, 62.2 x 83.2 cm, The Fine Arts Museums of San Francisco, CA, Rockefeller Collection

nature.[20] This included participation in adventurous and dangerous expeditions. Soon, some good American artists thus saw themselves as "Parrhasius ... among the Buffaloes" and, far from civilization, studied physiognomies, plants, Indian costumes, and atmospheric effects (see plates 50–51).[21] Motivated by new impressions, it was effectively only the (painting) technique that was adopted in landscape painting, for the compositional form had changed decisively. For example, any focus of the gaze on a small, defined area, as recognizable in Lessing's work, was avoided. The view, as determined by the format, had to be generous and the pictorial landscape space sufficiently open and vast to leave room for atmospheric movements or the like. Phenomena such as the calm before a thunderstorm or the impending storm were the new "heroes." Not only the conquest of the territories in the battle against people (Leutze's *Washington Crossing the Delaware* or maybe Wimar's paintings of Indians; see plate 60), but also the still unknown nature in the occupied territories could be depicted. This was certainly a more profound experience in the life of this nation than the depiction of the battles in the War of Independence.[22] Geographical, national, and aesthetic interests came together. For just there—in the semantic void but optical fullness of the landscape view—appeared "the American sublime,"[23] associated as it was with pride.

In a land that would gradually have to be "domesticated," it was essential to appropriate nature and to integrate successfully new elements with those that were already there. In her 1980 study *Nature and Culture*, Barbara Novak stressed: "Yet in the final analysis, what emerged was precisely what Whittredge

was looking for, 'something distinctive to the art of our country.'"[24] The visual focus also had to be distinctive, as Albert Boime emphasized in his view of the *Magisterial Gaze*, 1991.[25] Most importantly he refers to the "view from above." The highest point is the one that first reveals new horizons. Conquest, dominance, the freedom from spatial restrictions and pacification are simultaneously expressed in landscape views that are open and vast. According to Boime, what is also distinctive is the relationship between spatial developments and temporal progress, revealed in art criticism and in poetry, and the effects these have on the future development in space ... to a progress in time.[26] "These distinctive cultural formations are inseparably linked to American national self-consciousness and its political expression in the form of Manifest Destiny."[27]

In landscape painting—and the following is applicable only to this genre—the common experience of nature against the background of disparate origins leads to very different forms of representation, since the goal, too, the interest of representation, is different.[28]

The Beginning of a New Genre

"In the taste of the public and in the way the artist sees himself, the 'democratic' genre and the landscape painting increasingly supplanted the interpretative history painting."[29] This description of the gradual change in the value attributed to the genres is expressed in all works concerning American painting.[30] The landscape painting, long held in low regard at European academies, assumed the dominant role here compared to the history painting,

highly valued in Europe. This, too, had consequences for the composition of landscape painting. Here, loading the landscape with symbolism gave way to liberating it from such signification, making landscape painting suitable for assuming the role of history painting. American painters reduced "the possibilities of literalism and conceptualization," "emanated" a silence, and did not evoke an interpretation of encrypted messages of goodwill; they initiated a new, special experience.[31] Thus, the painters were not so much observers as active participants in an inexorable process. They also attempted to transform the dynamics inherent in the process into a grandiose standstill, thereby lending their works a particular dramatic element. The movement of the "conquest," the view, and the time were played against one another. While the same artists still recorded the dream of untouched nature with their pencil and sketchbook, others already contemplated the vision of a cultivated region crossed by railroads. Whittredge characterized the situation in his autobiography: "Everybody talked of our wonderful mountains, rivers, lakes, and forests, and the artists thought the only way to get along was to paint the *scenery*. This led to much wandering of our artists. Simplicity of subject was not what was demanded. It must be some great display on a big canvas to suit the taste of the times. Great railroads were opened through the most magnificent *scenery* the world ever saw, and the brush of the landscape painter was needed immediately."[32]

What appeared virginal to the painters was soon to be cultivated and utilized, and was ultimately to belong to the past for all those involved but, in the moment of painting, was to make them witnesses of the time. In this way alone, the landscape painting became a historic document. Yet, participation in the expeditions had a fatal consequence: "The realization of the American dream implied the total corruption of the dreamer," Boime noted.[33]

A National Understanding of Art?

It was not just in landscape painting that artists increasingly took from the Continent only what was needed in order to amalgamate it with American ideas: as there was the theory of proportion, anatomical and dress studies, costume painting, refined painting techniques, and design variations. This is shown not only by the works of Charles Wimar but also by those of the artists in Munich around Frank Duveneck.

Wimar, who had come to Düsseldorf in 1852, adopted Leutze's compositional model for *Washington*, for example in *The Abduction of Daniel Boone's Daughter by the Indians* (plate 60). As in other cases, he transferred the great history to the American Wild West, with the great approval of the European public as well.[34] A generation later, Duveneck was to spend two important periods of his life in Munich. During the first, from 1870 to 1873, he was influenced by Wilhelm Leibl, although Duveneck had never studied under him.[35] The second period, from 1875 to 1879, is interestingly enough characterized more by encounters with like minds from the American colony there.[36] Even his friend Robert Koehler,

who was more influenced by Leibl, acted as an intermediary for arranging exhibitions for the American artists in Munich. He was also the president of the American Arts Association in Munich (1879–1886), then the head of a private art school for Americans (also in Munich), and finally the director of the Minneapolis School of Fine Arts (1893–1914). He, too, used his energies to promote American art.[37] A series of institutional facilities had already been established in the United States with this aim. Samuel F. B. Morse, known not only as the later inventor of the Morse code, but also as the founder and director of the National Academy of Design in New York (1826–1845), did this as well. He was renowned as a champion of American art.[38]

Duveneck and Koehler are characteristic of many other representatives of a generation of American painters for whom origin ultimately seemed to be more enduring an influence than any new environment. This is also shown by the reverse case, a chapter still largely ignored in European art-historical literature, that of the attempted European artistic colonization in the American West. There, Hermann Lungkwitz of Dresden, who came to Texas in 1851, is counted as one of the founders of landscape painting.[39] Arriving via New York, where he avoided any contact with the artists of the East Coast, he traveled with his family on to Fredericksburg. In 1856, he painted a version of the theme of *Marriage Proposal on Heligoland* for the German Casino-Club there, a theme which had become famous in the 1834 painting by Rudolf Jordan. Lungkwitz's work was regarded as "the best of the current Texas landscape art" in the large German colony there.[40] Ultimately, he opened a school of drawing and a photographic studio in San Antonio, and received late honors as one of the first pioneer artists in Texas.[41] With a certain degree of frustration, he was nevertheless forced to recognize that his German training could not be more to him there than a memory and technical education.[42] The landscape itself presented other challenges to him which, in his isolation compared to Bierstadt, he was not really able to meet.[43]

The challenges to American artists were, however, in a dual sense external. Not only the environment but also the public and clients had certain expectations. With the concepts of freedom—predominantly spatial freedom such as the expansion of already civilized areas—new pictorial heroes (Columbus, the Vikings, etc.) could be envisaged.[44] Here, even a Johannes Huss or Martin Luther still fit into the concept as embodiments of an awakening. Tropical motifs became increasingly important in the artists' thematic repertoire. In 1873, the dedicated collector Robert Hoe, who had nine rooms for his collection on 11 East 36th Street, New York, alone, commissioned Frederic Edwin Church to paint a tropical scene for him. The expansion of new pictorial themes was also promoted. Church, who was initially also influenced by Andreas Achenbach, had already achieved a major breakthrough in 1859 with his *Heart of the Andes*, the exhibition of this painting having attracted 12,000 visitors in only three weeks.[45] An extensive tour was organized in several American cities and in London. Ultimately, the painting was exhibited at the New York Sanitary Fair in 1864, together with Bierstadt's *Rocky Mountains* from 1863

5
Worthington Whittredge, *Harz Mountains Landscape with Artist Drawing under a Parasol*, c. 1852/53, pencil, washed, 34 x 50 cm, Addison Gallery of American Art, Phillips Academy, Andover, MA

(fig. 3, p. 44) and Leutze's *Washington Crossing the Delaware* from 1851.[46] This combination is most revealing in terms of the increasingly difficult situation of the European-influenced painters in the New World. The esteemed values of the 1850s, such as solid European training and reciprocal artistic stimulation, lost their positive status, and thus it became opportune to negate their origin. William Gerdts is correct in referring to the harsh criticism of *The Crayon* of 1856, which represented a sort of prelude to the more disparaging judgment of the Düsseldorf artists in New York.[47]

The Adoption of Organizational Structures and the Rejection of Visual Language

After a series of differences over content, mention must also be made of the conditions under which European (here, specifically German) art was able to influence art in New York. For there, too, conditions changed unexpectedly.

New York was no longer an annex of European activity. Konsul Boker, who for several years starting in 1849 had acted successfully as an intermediary for the American Art-Union with his Düsseldorf Gallery, sold his collection in 1857 in Sandusky, Ohio, and died in 1860.[48] Thus, in the latter half of the century, only the Düsseldorf gallerist Eduard Schulte (Edward Shulte) had a dependance in America. The Frenchman Adolphe Goupil, who had been highly successful in collaboration with the International Art Union, sold his American gallery in 1857, to Michael Knoedler.[49] Furthermore, a series of new art dealers and auction houses had meanwhile become established: David Leavitt, Hermann Schaus, Samuel P. Avery, Edwin Earle Derby, Hiram Parke & Otto Bernet Galleries. Most of them had neither Düsseldorf nor German painters, nor works by Americans working in Europe in their program.[50]

This was to have consequences, not only for the up-and-coming talents, but also predominantly for the "returned" Americans, who after their return from Europe had it doubly hard in the native market. Since they could not deny the previous identifying characteristics of the Düsseldorf or Munich artists, up to this time useful as a kind of trademark, they had to

develop a special form of marketing. Hence, upon Leutze's return to New York in 1859, organizational and distribution structures as known from Düsseldorf were adopted, but not the associated basic concepts. Nearly all the "Düsseldorf" Americans ended up at the Tenth Street Studio Building in New York (fig. 11).[51] Located near the Academy of Design, it was an exceptional building for which the New York businessman and collector James B. Johnston commissioned the American architect Richard Morris Hunt in 1857. While visiting Leutze in Düsseldorf in 1852, Hunt had discussed the necessity of creating a forum in New York, as in Düsseldorf, where the native artists could present their work directly. The studio, on three floors surrounding a central gallery, provided optimal lighting conditions. At the same time,

6 Robert Thew, *The Düsseldorf Gallery, New York*, engraving from *The Cosmopolitan Art Journal*, December 1857, opposite p. 40

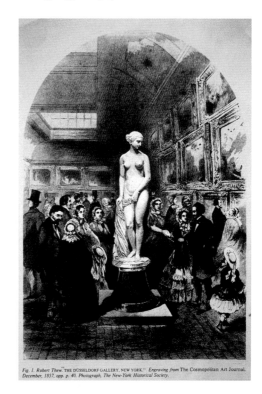

Fig. 1. Robert Thew. "THE DÜSSELDORF GALLERY, NEW YORK." Engraving from The Cosmopolitan Art Journal, December, 1857, opp. p. 40. Photograph, The New-York Historical Society.

7 Eastman Johnson,
The Card Players, 1853,
oil on canvas,
55.2 x 72.4 cm,
private collection, USA

8 Ludwig Knaus,
*The Card Players (The
Cheaters)*, 1851, oil on
canvas, 81 x 104 cm,
Kunstmuseum Düssel-
dorf im Ehrenhof

intimate receptions were intended to guarantee a proximity to clients, who meanwhile had had enough of overfilled exhibitions. Friedrich von Uechtritz described these humorously in 1839, in terms of the consequences for the "products" on offer: "I would like to compare the unhappy situation of the paintings in such an exhibition almost to that of the drivers of the omnibuses to Lüttich who, by order of the police, are not permitted to leave the place next to their vehicle and are obliged to outdo each other by unruly screaming and conspicuous gestures in order to attract those arriving by train."[52] Neither the gaudy characteristics of what was presented nor the impatience of the viewer was to carry any weight here. Without the gallery owners as mediators, the artists now returned to the proven method of "direct marketing."

The aim of the Tenth Street Studio Building was also ultimately to support friendships and contact between the artists, as had been the case in Düsseldorf. In the face of the great financial pressures on the artists in New York, these friendships did not last very long, however. In any case, some sectors of the

(puritanical) press placed little value on sociability as being part of an artistic life-style, as reported about the Düsseldorf artists' association "Malkasten" (paint-box). Founded in 1848, the "Malkasten" was an integrating hub of artistic existence for the multinational community of artists there, with its numerous events, theater performances, processions, and costume balls. A correspondent for the *Bulletin of the American Art-Union* called it a "childlike, brotherly sort of union" and, in the Boston newspaper *To Day*, a report in 1852 on one of the legendary artists' festivals met with a lack of appreciation.[53] Only from the 1880s on were there reports on such American "event culture" at the Boston Museum of Fine Arts.[54] Even Vivant's tableaux, staged to commemorate twenty-five years of service on the part of the academy director Schadow, met with little appreciation by the critics of the *Art Journal* in 1855.[55] On the whole, a certain puritanical, often extremely prudish undertone is unmistakable in the critiques. J. P. Hasenclever's *Wine Drinkers* and *Diana with the Nymphs* by C. F. Sohn met with an indignant response, and the humor, too, is in no way the same.[56]

A further element similarly had no equivalent in the New World: the form of artistic collaboration that was usual in Düsseldorf. In this particular form of artistic cooperation however, it was not only a case of a form of friendship as exemplified by *The Bendemann Family and Their Friends*, on which a total of five artists worked, but rather that of regular communal works made on the basis of complementary abilities.[57] These originated initially from fresco paintings in public buildings. One of the first examples of this, in Düsseldorf, is certainly the project of the Palais of Grafen Spee, with works by Heinrich August Mücke, Carl Friedrich Lessing, Hermann Freihold Plüddermann, and others. Yet, they also established themselves with commonly composed genre, landscape, and history paintings.[58] For example, the *Prize Picture of the Neuss Men's Singing Association* from 1854 was a collaborative work by Emanual Leutze and Andreas Achenbach. Similarly, Achenbach and Whittredge contributed to Leutze's final version of *Washington Crossing the Delaware*. *Susanna and the Elders* was a collaborative work by Gottfried Eybe and Achenbach. Alfred Rethel integrated the accessories into Achenbach's Frankfurt work *Great Navy* in 1835, and the genre painting *The Return Home* even bears the dual signature "Carl Mücke. Ddf. L. Fay."[59] The American press also commented in detail on the 1844 work by C. F. Lessing and C. F. Boser, *The Düsseldorf Artists' Bird Hunt at Grafenberg*, in which Boser painted the portraits and Lessing the landscape background.[60] It is obvious that this is truly a companion piece that in no way was conceived under the pressure of having to be convivial.[61]

This phenomenon of cooperation, very important for Düsseldorf, had up until then hardly been recognized in art-historical literature. In 1857, an American correspondent from the *The Crayon* noted, with some astonishment, that the artists in the Düsseldorf community continuously used the word "we."[62] This he found quite worthy of imitation. In the New World, however, this did not fit into the concept of up-and-coming individualism. Local pressure on artists from the USA was already considerable in the 1850s. Even Americans in Düsseldorf (or, soon after, in Munich) were affected.[63] The process of "finding the 'real' American artist," which Sarah Burns, in her study *Inventing the Modern Artist*, first observes in America in the 1870s, was already a phenomenon of the German cities of the 1850s.[64]

Here, two tendencies competed against one another. One of these, the formation of an extensive network, was well known, not only from Düsseldorf but also from the other leading German art centers such as Munich, Karlsruhe, Dachau, or Weimar. The other tendency, the isolation of the artistic "star," was known more from Berlin.

Two Tendencies: Unification and Isolation

The first tendency can be regarded as the unification of those of like mind. Upon his return from Düsseldorf, John R. Tait (see plate 59) confronted his countrymen with the Düsseldorf distribution model as an

idea worthy of imitation. In this way, an artist could first become "universally known."[65] Morse, with an eye on his American colleagues, had noted early on that the will to proceed in a unified fashion with respect to public affairs of the artists was "regretfully" not very pronounced.[66] Hence, in addition to the National Academy, and comparable to the Düsseldorf "Verein zur gegenseitigen Unterstützung und Hilfe" (association for mutual support and aid, founded in 1844 as an alternative to the official art academy), there was only a series of smaller interest groups in the cities of the American East Coast.[67] On top of the numerous art associations founded from 1839 on, as well as the American Art-Union (1838–51), in 1847 still with 9,666 members, and the New York Gallery of the Fine Arts (founded on the basis of Luman Reed's collection[68]), there was a series of further foundings up to that of the Art Students League of 1875[69] and the Society of American Artists of 1877, mostly with the aim "to provide an alternative venue for exhibitions and sales."[70] This was, however, only a way to manage the rapid increase in artists and art teachers active in the arts sector, in 1870 numbering 4,081 across America. At the same time, the artist "masses" increasingly organized themselves into clubs of particular abilities and interests, for example for watercolor or pastel painting, as well as for graphics.[71]

The other tendency that prevailed in the long term was the targeted promotion of individual artists as singular stars. At the same time, these were the "products of shifting networks of discourse on the questions of who and what an artist was to be in a changing and rapidly modernizing world, and what it meant to be modern and American."[72] Here, the personality counted more than the group, technical perfection, or common artistic ideas.[73] The public wanted "to see the man itself," as Henry Blake Fuller summarized this development for American artistic life at the end the century.[74]

Many publications, such as *The Art Journal, The Cosmopolitan, The Crayon,*[75] *Harper's Monthly,* or *The Literary World,* satisfied these needs, which they themselves had initiated. Each of these presented, in continuous succession, pictures from the painter's studio.[76] The Tenth Street Studio Building willingly satisfied this need for an inspection of the artist's workshop, which proved to be the guiding tendency.[77]

Diminishing Esteem and Reception

The art market similarly advocated this. After a great loss in demand owing to the outbreak of the American Civil War, and when the political situation in Germany failed to convey a positive atmosphere, many dealers decided largely to eschew German imports. It was only the major collectors, such as Robert L. Stuart or John Longworth, who remained faithful to the Germans, although, like A. T. Stewart, they had also begun to buy from the French.[78]

In 1871, the auctions staged as benefit events for Chicago—which was in need of assistance after a major fire—showed that Düsseldorf was in no way good for business, although some good paintings were also represented.[79] In a way that could not be ignored, political events—such as the founding of

9 George Caleb Bingham, *Order No. 11*, c. 1865–70, oil on canvas, 141 x 199.4 cm, Cincinnati Art Museum, Cincinnati, OH, The Edwin and Virginia Irwin Memorial

the German Kaiserreich and the provoked humiliation of the French—influenced the positive climate for an intensification of contacts with France.[80]

In this context, however, the general debate over American art had remained almost unchanged. On the occasion of the Exposition Universelle in 1900, it was criticized that the "U.S. exhibition was un-American," while Ellis T. Clarke wrote in *Alien Element in American Art*: "American artists go to Europe and especially to Paris, to complete their education, and are not strong enough to resist the dominating influence of their masters in after-work."[81] From the point of view of the critics, however, the fundamental problem of how to advance real American art remained, only with another national characteristic. For the presence of German art, the decline after 1870 nonetheless had enduring consequences.

A willingness to receive German painting and exhibit it at all remained in the USA for the time being, accompanied by some sympathy, until World War 1. One of the last exhibitions of German contemporary art at this time—with 161 works quite comprehensive—took place in 1909 in New York, Boston, and Chicago.[82] The catalogue of paintings featured painters from all over Germany. The Dachau school of painting was represented, as were the Düsseldorf, Karlsruhe, Weimar, and Munich schools, whereby artists from the capital Berlin nevertheless dominated. The exhibition was compiled in Berlin, by Wilhelm von Bode among others, and financed by the German-American entrepreneur Hugo Reisinger, after the German commercial attaché in New York had for years referred to the increasing catastrophic attitude: "Most Americans regarded us Germans as art barbarians."[83] Apart from the thematic narrowness of the exhibited works (thirty-nine portraits[84]), the work generally appeared

to be balanced. Even relevant literature today hardly reveals anything about the fifty-two artists (one-third of the exhibition), which cannot in all cases be attributed to a lack of their quality. The only artist ever to have been exhibited in a one-man show since was Adolph Menzel, who, however, had to be made presentable by labeling him an Impressionist.[85]

Europeans had served their purpose as influencing factors—at least if one believes a series of American commentators active following the turn of the century. On the occasion of the exhibition of American painters in 1910, the Berlin Museum director Wilhelm von Bode declared that Americans had been unable to emancipate themselves from European ideas. Bode was disappointed over the "unenterprising character of American painting," as commented on by an American reporter.[86] Anyone who had hoped to see paintings depicting the "throbbing life

10 Carl Wilhelm Hübner, *The Silesian Weavers*, 1844, oil on canvas, 78 x 104.9 cm, Kunstmuseum Düsseldorf im Ehrenhof

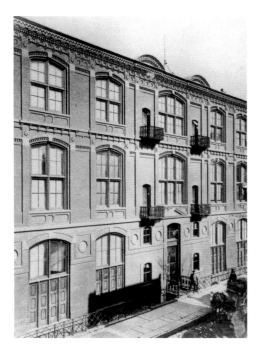

11 Unknown photographer, *Tenth Street Studio Building*, c. 1858, American Institute of Architects, Washington, D.C.

of New York Harbor" and the life of the big city was just as disappointed at the 1910 exhibition as those who exclusively expected scenes depicting buffalo hunts and Indian life as pictorial themes.

The reception of European influences occurred with far more reflection than one might initially think. A good idea for a painting was occasionally so profound that it overlaid possible national influences. But origin was so influential that it amalgamated with good composition. In order to be an American painter, one in no way needed to meet the criteria set by the critics in 1910, namely to have been born in America and never to have studied in Europe.[87] The characteristics are exhibited rather in the treatment of details. Upon closer examination, the common experience of the two painters in the year 1852 did not yield identical results. Ultimately, any originality is reflective, wrote Ralph Waldo Emerson in 1876, on the problem of originality between influence and independence.[88]

1 J. Beavington Atkinson, "Düsseldorf: Its Old School and Its New Academy," *The Art Journal*, no. 253 (June 1880): 100. I am indebted to William Gerdts for granting me access to a series of American literary sources in his extensive archive.

2 Worthington Whittredge, *The Autobiography of W. Whittredge*, John Baur, ed., in *Brooklyn Museums Journal* 1 (1942): 24.

3 As in Friedrich von Uechtritz, *Blicke in das Düsseldorfer Kunst- und Künstlerleben*, vol. 1 (Düsseldorf, 1839), 398, already noted for Lessing's Eifel landscapes, Lessing also read the treatise by Jakob Weber Nöggerath, *Das Gebirge im Rheinland-Westphalen nach mineralogischem und chemischem Bezuge*.

4 On the landscape paintings by C.F. Lessing, see also *Angesichts der Natur*, exhib. cat. (Düsseldorf: Kunstmuseum Düsseldorf, 1995), adapted by Martina Sitt and Bettina Baumgärtel, 118 ff.

5 von Uechtritz, 397.

6 Ibid., 398.

7 To date, the painting has not been associated with this study. Even Anthony Janson, in his dissertation *W. Whittredge* (Cambridge, 1975; abridged version publ. Cambridge, 1989), was unable to make a connection.

8 I consider the classification of watercolor and picture in *The Hudson and the Rhine, Die amerikanische Malerkolonie in Düsseldorf im 19. Jahrhundert*, exhib. cat. (Düsseldorf: Kunstmuseum Düsseldorf, 1976), in which the plate nos. 176 and 178 are associated with one another, to be very far-fetched.

9 Otto Pächt, "Methodisches zur kunsthistorischen Praxis," in *Methodisches zur kunsthistorischen Praxis* (Munich, 1977), 187–300, here p. 252.

10 I do not share Barbara Gaehtgens' opinion of these works by Whittredge. See Barbara Gaehtgens, "Amerikanische Künstler und die Düsseldorfer Malerschule," in Thomas W. Gaehtgens, ed., *Bilder aus der neuen Welt: Amerikanische Malerei des 18. und 19. Jahrhunderts*, exhib. cat. (Munich, 1988), 76–77. See also *The Düsseldorf Academy and the Americans: An Exhibition of Drawings and Watercolors*, exhib. cat. (Atlanta: The High Museum of Art, 1972), plate no. 137, and *The Hudson and the Rhine*, 89 ff.

11 *The Crayon*, no. 4 (1851): 373.

12 Although expressed in ethnological terms, this notion seems to be just as appropriate here. Fritz Graebner, *Methode der Ethnologie* (Heidelberg, 1911), 63.

13 See also letter of 4 October 1845, William C. Bryant, *Letters of a Traveler* (New York, 1850), 232.

14 *Bulletin of the American Art-Union* 2 (June 1849): 8–17, cited here according to *The Hudson and the Rhine*, 22.

15 This comparison is also made inadequately in B. Groseclose, *E. Leutze: Freedom Is the Only King* (Washington, 1975). Moreover, Nancy Rush, *The Paintings and Politics of G.C. Bingham* (New Haven, 1991), 184–207, interestingly enough cites the pictorial inspirations for all the artists except Hübner, including Masaccio's *Expulsion from Paradise*.

16 For a discussion on this set of problems from a methodical point of view, see Martina Sitt and A. Horányi, "Kunsthistorische Suite über das Thema des Zitats in der Kunst," in *Diskurse der Bilder, Photokünstlerische Reprisen kunsthistorischer Werke*, exhib. cat.

(Vienna: Kunsthistorisches Museum, 1993), 9–22.

17 Norman Bryson, *Tradition and Desire: From David to Delacroix* (Cambridge, Massachusetts, 1981), 37.

18 "Influence on our Taste and Judgement," *Cosmopolitan Art Journal* 2, no. 5 (December 1859): 256. As early as 1856, the *Home Journal* reported in a similarly optimistic fashion that American painters still traveled to Europe "as sojourners only, to avail themselves of the advantages which the galleries and schools afford." *The Home Journal* (22 March 1856).

19 Cited according to Asher B. Durand, "Letters on Landscape Painting, Letter 11," *The Crayon* (1855): 34 ff.

20 Henry T. Tuckerman, *Book of the Artists: American Artist Life* (New York, 1867), 389.

21 Ibid., 390, 392.

22 See also James T. Flexner, "That Wilder Image: The Native School from Thomas Cole to Winslow Horner," in *History of American Paintings Series*, vol. 3 (New York, 1970).

23 Albert Boime, *Magisterial Gaze: Manifest Destiny and American Landscape Painting 1830–1865* (Washington, D.C., and London, 1991), 2. See also the essay by Kathleen Pyne, "Amerikas Verständnis der eigenen nationalen Kunst" in *Bilder aus der neuen Welt* (especially 121).

24 Barbara Novak, *Nature and Culture* (New York, 1980), 273: "That 'something' raised nature above art or ego, and subsumed self in spirit. Where the French had stressed means, the Americans stressed ends; where the Germans injected feelings, the Americans distilled it to a more impersonal essence."

25 Boime, 21.

26 Ibid., 7.

27 Ibid., 3.

28 This does not apply to Americans who studied in Düsseldorf with respect to their experience in other genres, such as genre, history and portrait painting, nor to landscapists who went to Karlsruhe or Munich. See the following explanations and also *Vice Versa. Deutsche Maler in Amerika—Amerikanische Maler in Deutschland, 1813–1913*, exhib. cat. (Berlin, 1996).

29 As representative of numerous additional publications, a text from a non-art-historian is cited here: Martin Christadler, "Heilsgeschichte und Offenbarung: Sinnzuschreibung an Landschaft in der Malerei der amerikanischen Romantik," in Manfred Smuda, ed., *Landschaft* (Frankfurt, 1986), 135–38 (here 138). See also Kathleen Pyne in *Bilder aus der neuen Welt*, 121.

30 Not the least, Lessing's at times huge success in New York was due to his amalgamation of romantic landscape with 'democratic' history. Hence, contemporary American publications refer mainly to his qualities as a landscapist, although he ultimately enjoyed his greatest success in the USA with a classical historical picture in 1851. See also the indications by Barbara Groseclose, "Andreas Achenbach und die amerikanischen Künstler in Düsseldorf," in Martina Sitt, ed., *Andreas and Oswald Achenbach: "Das A und O der Landschaft"* (Cologne, 1997), 174–75, as well as *Bilder aus der neuen Welt*, 73.

31 I share Martin Christadler's rejection of Barbara Novak's interpretation, in which she wants to recognize an idealistic religious interpretation, in this "silence" (Christadler, 155). See Boime, 21.

32 Whittredge, 56.

33 Boime, 8.

34 See Joseph D. Ketner II, "The Indian Painter in Düsseldorf," in *Carl Wimar, Chronicle of the Missouri River Frontier* (Fort Worth, 1991), 40. Wimar is depicted in *Vice Versa*, 334.

35 "This man [Leibl] has more influence on me than any other artist, although I have never studied under him." Cited according to Josephine Duveneck, *Frank Duveneck: Painter-Teacher* (San Francisco, 1970), 38.

36 See Michael Quick, *An American Painter Abroad: Frank Duveneck's European Years* (Cincinnati, 1988), 36–37. This group of initially six Americans grew into a whole colony of more than a hundred by 1878. See also article by Anne Rosseter Norcross, "Amerikanische Malerschulen' in Deutschland: Der Einfluß von Emanuel Leutze und Frank Duveneck," in *Vice Versa*, 37–43.

37 See Peter C. Merill, *German-American Artists* (Wisconsin, 1997), 52–54.

38 See Paul Staiti in *S.F.B. Morse*, exhib. cat. (New York, 1982). Morse also owned German paintings, however; in the 1867 exhibition of the National Academy and subsequently in the Yale School of Fine Arts, he exhibited his painting by Oswald Achenbach, *Approaching Storm—View near Naples*, which, with its theme of the impending storm, fulfilled American requirements well.

39 See also *Vice Versa*, 34.

40 See article of 14 October 1859 in the *Neu-Braunfelser Zeitung*, cited according to James P. McGuire, *Hermann Lungkwitz: Romantic Landscapist on the Texas Frontier* (San Antonio, 1983), 20. I am grateful to David Eisermann for referring me to this publication.

41 Samuel E. Gideon, "Two Pioneer Artists in Texas," in *American Magazine of Art* (September 1918).

42 See letter of 1864, cited in McGuire, 25.

43 Ibid., 59.

44 See *Bilder aus der neuen Welt*, 41, 51.

45 D.C. Huntington, *The Landscapes of Frederic Edwin Church. Vision of an American Eye* (New York, 1966), 35.

46 Annette Blaugrund, *The Tenth Street Studio Building—Artist-Entrepreneurs from the Hudson River School to the American Impressionists*, exhib. cat. (Southampton and New York, 1997), 62, 89. Leutze and Church received $10,000 respectively for the sale of their paintings, Bierstadt $25,000.

47 William Gerdts, in *Vice Versa*, 54. *The Crayon*, no. 3 (3 January 1856): 21–23.

48 See also R. Stehle, "The Düsseldorf Gallery of New York," in *The New-York Historical Society Quarterly* 58 (October 1974): 305.

49 See also Wesley Towner, *The Elegant Auctioneers* (New York, 1959).

50 See also Blaugrund, 34.

51 Interestingly enough, the catchword "Düsseldorf" does not appear in the very comprehensive index of Blaugrund's book, although it is in no way absent from the text.

52 von Uechtritz, 403.

53 *To Day*, 2 July 1852. This is in part a report taken from the *Leipziger Illustrierte Zeitung*.

54 A series of informative documents on this topic may be found in the files on Frederic Porter Vinton (1846–1911) in the Archive of American Art in Washington, D.C. The comment on the Artists Festival of 1893 is comparable to the Düsseldorf activities.

55 *The Art Journal* (1855): 13–14.

56 *The Crayon* (3 January 1856): 23.

57 This was painted in 1832 by Eduard Bendemann, Theodor Hildebrandt, Julius Benno Hübner, Carl Ferdinand Sohn, and Wilhelm von Schadow (Kaiser Wilhelm Museum, Krefeld).

58 A separate report will deal with the phenomenon of a "Komponierverein," which should also be noted here; publication in preparation.

59 These collaborative studio works were not necessarily produced by colleagues of the same age: Achenbach/Rethel; B. Budde/T. Mintrop, etc. Artistic cooperation was generally on the basis of complementary abilities: Boser *1808/Lessing *1818; Ludwig Fay *1859/C. Mücke *1847, etc., whereby the traditional teacher-student relationship similarly led to collaboration. The extent of this cooperation (in the Age of Individualism) has never been given credence in the literature; moreover, it can mostly only be demonstrated by an intensive study of primary literature (letters, contemporary reports). The *Lexikon der Düsseldorfer Malerschule*, vols. 1–2 (Munich, 1997–98) makes explicit and repeated reference to collaboration in the individual entries—as far as it can be demonstrated to date. An independent study on this topic would be desirable.

60 It is symptomatic that the attribution of the respective contributions in the various exhibition catalogues varies, Lessing ultimately being wrongly identified as the portrait painter; see *Bulletin of the American Art-Union*, 1852–57, in series.

61 See also *The Literary World* (22 May 1852): 364ff.

62 "The artists when speaking of the exhibitions and the sale of their pictures, use commonly the word *we*, meaning the contributors as a whole. 'We sent there so many pictures,' 'We have received there so much money.'" *The Crayon* (4 August 1857): 250.

63 In 1857, Leutze declared the Munich Academy to be "the best school of painting in the world," noting Düsseldorf's loss of significance; see Groseclose, 23.

64 Sarah Burns, *Inventing the Modern Artist, Art and Culture in the Gilded Age America* (New Haven, 1996), 19ff.

65 John R. Tait, *European Life, Legend, and Landscape* (Philadelphia, 1858), 93–94. Tait intended "to suggest a benefit … that might profitably be adopted in our own country …"

66 See Staiti, 90.

67 See also *Christians Evening* (March 1850), 215-16.

68 See also Ella Foshay, *Mr. Luman Reed's, Picture Gallery* (New York, 1970; displayed at the New-York Historical Society, 1997).

69 Raymond J. Steiner is currently working on a book dealing specifically with this topic.

70 See Burns, 27.

71 American Water Color Society, 1866; New York Etching Club, 1877.

72 Burns, 2.

73 Ibid., 19.

74 "Our public, in so far as it cares for the artist at all, cares only for his personality, his individual presence. It gives little heed to his ideas, and less to his expression of them. It wants to see the man itself—once; the interest is that of mere personal curiosity and is soon gratified." Henry Blake Fuller, "Art in America," *The Bookman*, no. 10 (November 1899): 220.

75 First issued in 1855 by William James Stillman and John Durand, and published until 1861.

76 See for example "Studio-life in New York," *Art Journal*, no. 5 (December 1879) or "The Studios of New York" in *The Cosmopolitan*, no. 7 (May 1889).

77 Many studio pictures were produced (Beard 1860, Read 1866, Church 1866, etc.).

78 Lilian B. Miller, *Patrons and Patriotism: The Encouragement of Fine Arts in the United States, 1790–1860* (Chicago, 1966), 98ff; Towner, 69.

79 This also had financial repercussions. The French received $37,355 for 39 works; by comparison, 120 Düsseldorf works were acquired for only $7,978.

80 To what extent this meant that the works of American artists could be treated in critiques and literature with respect to the catchword "influence" is discussed by Barbara Weinberg in this book.

81 E.T. Clarke, *Brush and Pencil*, no. 7 (1900): 36.

82 In the same year, Henry Reisinger presented selected works by German artists in the Metropolitan Museum of Art, New York. Not until 1981 did the Metropolitan Museum of Art again exhibit a comprehensive selection of nineteenth-century "German Art."

83 Cited according to Robin Lenman, *Artists and Society in Germany, 1850–1914* (Manchester and New York, 1997), 159.

84 Compared to certain prominent faces from German politics (Kaiser Wilhelm, Bismarck, etc.), Böcklin's *Selbstporträt mit fidelndem Tod* has a pleasant quality. The Swiss painter, who once taught in Weimar, quickly became naturalized.

85 Fourteen graphics by Menzel alone were exhibited. A Liebermann exhibition is planned for 1999, in New York.

86 C. Lewis Hind, "American Paintings in Germany," *The Studio* 50 (1910): 178–90. I am indebted to Stephen Koja for making this article available to me.

87 Ibid., 189.

88 "Thus all originality is relative." R.W. Emerson, "Shakespeare or the Poet," in *Representative Man, Seven Lectures* (Boston, 1876), 187.

Italy: Images and Ideas

When Benjamin West stepped ashore at Leghorn in 1760, he became the first American artist to arrive in Italy. The young colonial from Pennsylvania was, however, the latest in a long line of pilgrims to the enchanted Mediterranean land, continuing a tradition that had begun generations earlier. That propensity to travel, and particularly to the storied lands that had been the cradle of the Roman Empire, culminated in the eighteenth century with the Grand Tour. The Tour had brought countless travelers from many lands to the fabled home of Caesar and Augustus, of Raphael and Michelangelo, of Dante and Bocaccio. It was there, in Italy, that Benjamin West sought to "pursue the higher Excellencies in the Art" in the place "from whence true taste in the arts have flow'd."[1] That West chose Italy, and specifically Rome, as his initial destination, and that he stayed and studied there for three years before proceeding to London, suggests that the influence of the Grand Tour and of the Enlightenment, of which the Tour was a manifestation, had made itself felt even in the rude backwater of colonial Pennsylvania.

In West's wake, numerous American artists made the Italian pilgrimage during the next century and a half. While their destination remained similar, the attraction and the motivation varied over the generations, suggesting changes in American art and in the broader culture of which it is a part.

Classical Lessons

Awaiting the final surrender of the British, George Washington spent the winter and spring of 1783 encamped at Newburgh, New York. His restless and unpaid troops were eager to return to their villages and farms. Even some of the officers under Washington's command shared the discontent, out of which arose the concept for a fraternal organization by which their ranks could maintain solidarity in the newly created nation during the peacetime so impatiently awaited. On 13 May 1783, in the quarters of Major General Baron von Steuben, the officers of the victorious American army set signatures to the "Institution," or charter of their new organization. In lofty terms they expressed their "high veneration for the character of the illustrious Roman, Lucius Quintus Cincinnatus," and pledged to "follow his example, by returning to their Citizenship."[2] Thus was born the Society of the Cincinnati, whose first president was George Washington, he who, Cincinnatus-like, would lay down his sword to return to his plowing. The veneration for the ancient hero, who had left his plow to save Rome and then returned to his fields, was but one instance of the pervasive fascination with antique history and legend that, in America as elsewhere, shaped late eighteenth-century life.

It was not modern Rome that drew artists to Italy or soldiers into fraternity, for by that time the glory of the ancient culture was widely perceived as having fallen into decay. In contrast to "young, vigorous, and growing" America, Rome in West's day was "old, infirm, and decaying—the autumn of a people who had gathered their glory, and were sinking into sleep under the disgraceful excesses of the vintage."[3] Well into the nineteenth century, reactions remained the same: "The degeneracy of modern Rome is a subject ever forced upon the thoughtful resident," complained Henry Tuckerman in 1848.[4] The modern city provided a striking contrast to the capital of the ancient republic, where, according to the American statesman Alexander Hamilton, Romans had "attained to the utmost height of human greatness."[5]

Benjamin West's paintings from the initial period of his European residence betray sentimental attachment to such ancient ideals. In his *Agrippina Landing at Brundisium with the Ashes of Germanicus* (fig. 1), one of West's early classicizing compositions, the Roman widow personifies virtuous fidelity and stoic courage. Agrippina occupies the center stage, compositionally and emotionally, of a tableau whose debt to ancient form—the procession from the Ara Pacis—is as evident as its attachment to classic sentiment and Roman character.

Beyond artistic inspiration and uplifting exemplars of virtuous character, ancient Rome provided Americans with manifold instruction in diverse fields, ranging from law and systems of justice, to military science, to politics and the rules of the empire. Its example provided special inspiration to the generation that led the nascent American nation, whose revolution was indebted to classical principles. Rome was "the nurse of freedom," said Alexander Hamilton, co-author of *The Federalist Papers*; it was home to "the noblest people and the greatest power that has ever existed," as described by John Adams, second President of the United States.[6]

Thomas Jefferson, drafter of the Declaration of Independence and the third U.S. President, as well as a masterful architect, was also a devotee of Roman precedent. His design for the Virginia Capitol at Richmond (1785–89) was derived from a famous Roman landmark, the Maison Carrée at Nîmes; in the classical temple's symmetrical balance and rational order, Jefferson found an architectural corollary for the balanced division of powers in the new American governance.

American institutions as well as monuments owed much to Roman precedent, as Jefferson's case suggests. The upper legislative body, the U.S. Senate, was named after the elders' council of the Romans and met in a building, the Capitol, whose designation derived from one of the fabled seven hills in the seat of the ancient empire. In American settlements christened Athens or Rome, Syracuse, Ithaca or Troy, Greco-Roman temples were erected to accommodate banks, courts, schools; education in those schools was fashioned along the lines of the ancient classics, ultimately making Rome "the mother country of every boy who devoured Plutarch."[7]

For American artists arriving in Italy from a country innocent of history—a timeless New World landscape, "un-islanded by the recorded deeds of man," as painter Thomas Cole poetically phrased it[8]—the time-full vistas of ancient Italy provided inspiration as well as instruction. "How the soul fills at this sight [of the Campagna] with a thousand contrary emotions and reflections," wrote one American visitor in 1805, eliciting "admiration for the past—indignation for the present—the rise and fall of empires—the

1 Benjamin West, *Agrippina Landing at Brundisium with the Ashes of Germanicus*, 1768, oil on canvas, 163.8 x 240 cm, Yale University Art Gallery, New Haven, CT, gift of Louis M. Rabinowitz

instability of human affairs—the effects of superstitions and ignorance." His ruminations concluded on a typically moralizing note: "Oh! what a lesson for a citizen of America."[9]

The lessons afforded by Roman imperial experience fueled the imagination of other Americans in Italy at that time, most notably that of the painter John Vanderlyn. In Rome, he found "better models and specimens of the human form and character than [in] our own country."[10] While models might vary in their externals—costume or complexion, for instance—the human form is universal; what is more striking about Vanderlyn's claim is the discovery of "better character" in the Roman arena. Vanderlyn's *Caius Marius amid the Ruins of Carthage*, painted in Rome in 1807 (fig. 2), was praised by a leading mid nineteenth-century critic as the very embodiment of "the Roman character in its grandest phase, that of endurance; and suggests its noblest association, that of patriotism."[11] Such attributes greatly appealed to Napoleon, who awarded the picture a gold medal at the 1808 Paris Salon, as well as Vanderlyn's compatriots in Europe and at home, who were stirred by the painting's antique subject and emotional content.

A generation later, Thomas Cole also took admonitory lessons from his excursions in Italy's historic landscape, reminiscences of which inform his series *The Course of Empire* of 1835 (figs. 3–7, pp. 25–27). Over the course of five canvases, the painter described the evolution from a primitive state of civilization, through an Arcadian state, to the consummation of empire, which is followed by its eventual destruction and extinction. For citizens of the young American nation, who, like the Society of Cincinnati, anticipated "the future dignity of the American empire,"[12] the lessons provided by Roman precedent were clearly pertinent, if not always heartening.

Romantic Dreams

"Art is in its utmost perfection here," John Singleton Copley reported from Rome in 1775; "a mind susceptible of the fine feelings which art is calculated to excite, will find abundance of pleasure in this country." Copley, who followed West's footsteps to Italy in 1774, the second American artist to work there, found in Rome much to indulge his appetite for art: "there is a kind of luxury in seeing, as well as there is in eating and drinking; the more we indulge, the less are we to be restrained; and indulgence in art I think innocent and laudable...."[13] What whetted Copley, however, overwhelmed others. "There is something," Henry Tuckerman found, "almost oppressive to the sense, and confusing to the mind, in the immense collections of paintings in Italy."[14] Clearly, visitors to Italy responded in individual ways to the immense artistic banquet spread before them.

Perhaps the one issue on which Americans were, for the most part, united was in their reaction to contemporary Italian art. From West's time forward, it had been the example of the ancients and the Renaissance masters that offered the greatest inspiration. Although West also valued the work of some of his contemporaries in Rome, artists such as the classicist Anton Raphael Mengs or the portraitist

Pompeo Batoni, a half century later Thomas Cole found nothing to redeem contemporary Italian painting, which he thought "perhaps worse than the French, which it resembles in its frigidity. In landscape it is dry, and, in fact, wretched." He complained that his hosts knew nothing of glazing. "Indeed," he concluded, "of all meagre, starved things, an Italian's palette is the perfection."[15] By mid-century, George Hillard, author of a popular American guide to Italian travels, cautioned his readers that "Italian painting is at a very low point of degeneracy" and judged an 1848 exhibition by native artists "incredibly bad."[16] To James Jackson Jarves, among the most influential of American commentators at mid-century, the problem was that "the Italian schools are too much of the past, too exclusively an expression of classicism and medievalism, to give a positive direction to ours."[17]

While the traditional, retrospective imagery was not inspirational to Jarves and his contemporaries, other aspects of the Italian tradition were newly so. Thomas Cole, who first visited Italy in 1831, developed there a fascination for the works of the seventeenth-century landscapists Salvator Rosa and Claude Lorrain. The former's dramatic compositions stimulated a taste for wildness in landscape and perhaps fueled Cole's and the Hudson River School's views of American wilderness. The devotion to Claude—which extended to Cole's occupancy of the master's former studio in Rome—led him to conclude that Claude "is the greatest of all landscape painters, and indeed I should rank him with Raphael or Michaelangelo."[18]

To West, Copley, and an earlier generation of artistic pilgrims, such a pairing would have been incomprehensible. The elevation of landscape altered the hierarchy of artistic themes, which traditionally prized human subjects and historical associations above all else. Although Sir Joshua Reynolds, first president of Britain's Royal Academy and chief arbiter of its artistic taste in the late eighteenth century, admitted that, "Like the history-painter, a painter of landscapes ... sends the imagination back into antiquity," it was primarily the associative value, rather than the scenic, which was paramount in his index.[19] When Roman scenery did occasionally appear in earlier works, its role was generally to designate place rather than to document or romanticize the ruin.

For Cole and his contemporaries, landscape assumed a new importance, and with it came new interest in Claudean precedent and the subjective or romantic potential of Arcadian landscape motifs. "All the eighteenth-century travellers had in common a fresh, clear-eyed determination to look at the new lands they saw unfolding before them," explained historian Cesare de Seta, "and to describe what they saw with as much precision as possible. Their grandchildren, making the journey after the advent of Romanticism, were more self-absorbed. The analytical and descriptive objectivity of the eighteenth-century texts [or paintings] is transformed into a study of the traveller's own temperament."[20]

As early as 1805, John Vanderlyn had presaged the change. In "this seat of the arts," Rome, he spent his time "copying from the works in the Vatican, [and] making sketches from nature," suggesting the

2 John Vanderlyn, *Caius Marius amid the Ruins of Carthage*, 1807, oil on canvas, 221 x 174 cm, The Fine Arts Museums of San Francisco, CA, gift of M. H. de Young

dual sources of inspiration for the second and subsequent generations of painters in Italy.[21] For them, nature increasingly offered inspiration, whether viewed through Claude's or other eyes. Washington Allston was Vanderlyn's companion in Rome when the two were the only American artists working there early in the century. His *Italian Landscape* (fig. 3), is redolent of the dream of Arcadia to which many would succumb in the coming decades. It is less a human drama than a landscape idyll, despite the immobile staffage in the foreground; not a topographer's transcription of nature and ruins but rather a romantic's dream, Allston's painted reminiscences of Italy, which here conflates Claudean revery with Poussin's orderly landscape arrangement, suggest the transformation of artistic attitudes in the new century. His views anticipated the romantic interests that flourished at mid-century in the Italian views by Worthington Whittredge, Albert Bierstadt, George Inness (figs. 4, 5), and a host of other painters who spent fruitful years in that storied land.

Responses to the environs varied with each visitor. As travelers anywhere have often done, many visitors sought to convey their impressions of the local scene through analogy to familiar surroundings at home. Mark Twain waggishly described Venice as "an overflowed Arkansas town ... [with] nothing the matter here but a spring freshet."[22] More probable was novelist James Fenimore Cooper's comparison of the Roman Campagna to "a prairie of the Far West," an estimation echoed by others who thought its "wheatfields, extending far and wide, are like those of Illinois."[23] Sometimes the comparison worked in reverse, as when Albert Bierstadt, freshly returned from his Italian sojourn (fig. 5) and introduced to the American West, wrote that "the color of the mountains and of the plains ... reminds one of

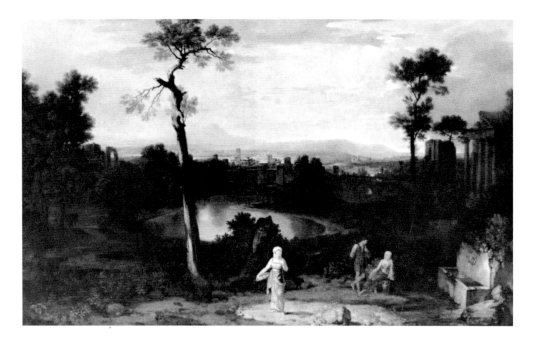

3 Washington Allston, *Italian Landscape*, 1814, oil on canvas, 111.8 x 183 cm, The Toledo Museum of Art, Toledo, OH, purchased with funds from the Florence Scott Libbey Bequest in memory of her father, Maurice A. Scott

the color of Italy; in fact, we have here the Italy of America in primitive condition."[24]

What "primitive" America lacked, of course, were the historic associations in the landscape so bountifully evident in Italy and frequently portrayed by visitors. While the entire peninsula, from Etna to the northern lakes, was rich in such reminders, it was Rome and the surrounding Campagna that particularly inspired American artists, providing ample motifs for their brushes. Many canvases were produced, and these were eagerly acquired by their compatriots abroad as well as in the United States, where Italian scenes enjoyed a tremendous vogue at mid-century. By the 1860s, critic Jarves could securely identify landscape as the "thoroughly American branch of painting ... surpass[ing] all others in popular favor, and ... reach[ing] the dignity of a distinct school."[25] In no small measure, the Italian experience and the views produced there were responsible for advancing this taste.

Italy provided not only artistic inspiration, but also escape from the quotidian demands of modern life in America. Cole was typical of many when he admitted that the enjoyment of Italy is due to "the delightful freedom from the common cares and business of life—the vortex of politics and utilitarianism, that is forever whirling at home."[26] Later, having returned to America, he recovered his nationalist spirit and seemed to repent his Italian thrall: "Must I tell you that neither the Alps nor the Apennines, no, nor even Aetna itself, have dimmed in my eyes the beauty of our own Catskills."[27] For others, however, the spell of Italy continued unabated, leading to the establishment of expatriate communities, in Rome and Florence particularly. Sculptor William Wetmore Story, a longtime resident in Italy, reacted to a friend's reservations about indolence in the seductive Italian clime: "Such a summer as we have had I never passed and never believed in before. Sea and mountain breezes all the time, thundershowers,

varying with light and shade the Campagna, donkey-rides and rambles numberless—a long, lazy, luxurious *far niente* of a summer.... Every day that I live here I love Italy better and life in America seems less and less satisfactory."[28] Thus was expatriation born.

Italomania flourished among cultivated Americans well into the nineteenth century; so pervasive was the thrall that Ralph Waldo Emerson worried about his countrymen, "infatuated with the rococo toy of Europe. All America seems on the point of embarking."[29] By the late 1840s, however, Italy and much of the Continent for which they departed were undergoing revolutionary change. The political struggles in modern Italy, leading to the eventual

unification of the country, attracted the involvement of some Americans, most notably Margaret Fuller Ossoli. She survived the French siege of Rome in 1849, in which her Italian husband fought with the Civic Guard of the Republic, for whose cause she became a prime advocate in the American press. Most foreigners in Italy, however, were bystanders rather than participants in these momentous events; as Henry James wryly noted, they "'assisted' as in an opera-box.... They arrived in time to set themselves well, as it were, for the drama, to get seated and settled before it begins...."[30] Seated and settled, they clung to their romantic dream of an Arcadia undefiled by discomforts and inconveniences of the modern era, including warfare.

The willful disregard deepened the American visitors' reliance on an imaginative fiction, a mythos of place, which provided them a refuge from the calamities of the era, both Italy's own birth pangs and, slightly later, the upheavals of Civil War in their own country. For American artists abroad at mid-century, Italy's struggles for political union, or those for its preservation in the United States, were subjects that rarely intruded in their repertoire of idyllic, indeed escapist subjects.

Modern Impressions

"How I wish you were here again as in the olden times, and that we again could wander about the streets of the city, and through the mountain towns," the expatriate Story wrote from Italy late in the century. He plaintively asked a Boston friend, "Has the wild love of travel gone out of your blood as it has of mine? Are you growing respectable, solemn, professional and dignified?"[31]

Story's nostalgia for their Italian adventures of mid-century, doubtless fueled in part by sentiments of old age, suggests a changed character of Americans' attraction to Italy in the waning years of the

4 George Inness, *The Monk*, 1873, oil on canvas, 97.8 x 160 cm, Addison Gallery of American Art, Phillips Academy, Andover, MA, gift of Stephen C. Clark, Esq., in recognition of the 25th Anniversary of the Addison Gallery

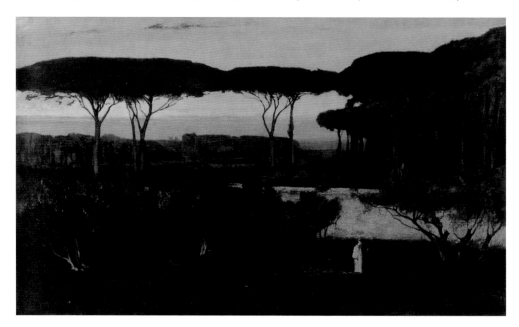

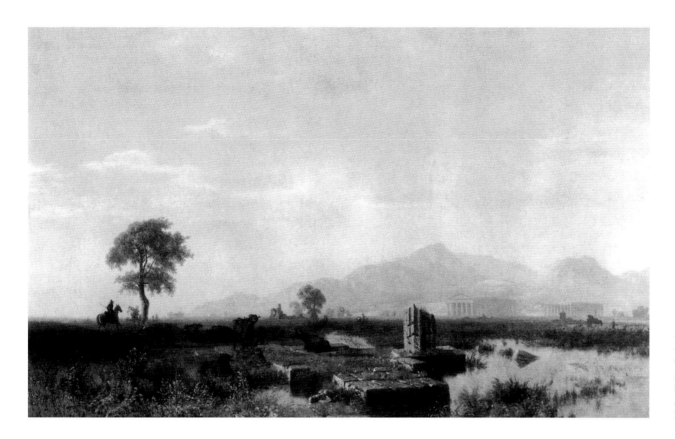

5 Albert Bierstadt, *Ruins of Paestum*, 1858, oil on canvas, 55.9 x 91.4 cm, The Minneapolis Institute of Arts, MN, The Putnum Dana McMillan Fund

century. The Napoleonic Wars and America's conflict with Britain in 1812–15 had interrupted traffic from the New World to the Old and marked a passage from classical quests to romantic sojourns. So, too, did the protracted struggle for Italian unification, the American Civil War of 1861–65, and the Franco-Prussian conflict punctuate a change from the American pilgrimages of mid-century to the adventures of later travelers in Europe. After 1870, aided by a booming economy, particularly in those northern urban centers of the victorious Union cause, and covetous of acquiring the patina of Continental culture, American tourists embarked for Europe in unprecedented numbers. But there were significant changes in motivation and destination.

Like Story, the novelist William Dean Howells lamented the changes that political union and innovations in travel had wrought on the Italian tour. With the opening of frontiers, the advent of rail travel, and the construction of modern accommodations, "all moisture of romance and adventure has been well nigh sucked out of travel in Italy," he complained. "Much of local life and color remains, of course; but the hurried traveler sees little of it, and, passed from one grand hotel to another, without material change in cooking of the methods of extortion, he might nearly as well remain at Paris."[32]

By the late nineteenth century, and particularly after the conclusion of Franco-Prussian hostilities, Paris was the primary European attraction for American tourists, including artists. In earlier years, London, Düsseldorf, Munich, and various Italian centers had each drawn its fair share of artists from the United States. But from the 1870s, they were all to be eclipsed by the French capital whose ascendancy in the tourist itinerary fulfilled the hope of Théophile

Gautier, who, twenty years earlier, marveled that "People now come to Paris as they used to go to Rome."[33]

Parisian fashions captured Americans' fancy, in art as in many other aspects of modern life. By the end of the century, Henry James, whose artistic insights were as keen as his social ones, noted: "It sounds like a paradox, but it is a very simple truth, that when to-day we look for 'American art' we find it mainly in Paris. When we find it out of Paris, we at least find a great deal of Paris in it."[34] Indeed, many of the painters who resorted to Italy in the waning decades of the century brought to the local scene eyes schooled in Parisian aesthetics; while Italy remained an important destination for them, their travels and their brushes were differently propelled. Rather than a destination for classical study or romantic reverie, the trip to the historic peninsula was for many Americans part of a whirlwind tour of the Continent, generally with Paris as its hub. For instance, Childe Hassam's brilliant views of Rome and Florence (fig. 6), or the sun-struck landscapes at Posillippo, the presumed site of Virgil's tomb, and elsewhere in the Naples region—suggest preoccupation with modern aesthetics rather than ancient history, any references to the sites' classical connotations being lost beneath stitcheries of the Impressionist stroke.

Such tourism had a goal apart from that of earlier generations. Ralph Waldo Emerson recalled his travels in Europe in the 1830s as a journey to "this last schoolroom," where the American's classical education would be completed.[35] By the 1870s, however, there was a remarkable change when, as one historian noted, "American intellectuals ceased to believe the classics."[36] Post-Civil War travelers sought to wed

6 Childe Hassam, *Piazza di Spagna, Rome*, 1897, oil on canvas, 74.3 x 58.5 cm, Newark Museum, NJ, gift of the Misses Lindsley

themselves to history not through emulation of classical ideals, nor through the abandonment of some Arcadian dream, but by physical possession of its remains. In lieu of enlightenment, travelers sought adventurous entertainment; instead of expatriation to the Old World, these prosperous and acquisitive tourists competed to amass art and artifacts to decorate their American chateaux and recently founded museums.

The traffic to the Italian peninsula moved toward new centers that had not previously been such magnets for tourism. Chief among these newer attractions was Venice, which had only been united with the kingdom of Italy in 1866 after nearly three-quarters of a century of foreign rule. Five years later, according to one American visitor, Venice already "swarm[ed] with artists."[37]

The fantastic Byzantine and Gothic city—which James Whistler called a "fairy land"[38]—had scarcely been innocent of earlier visitors or influence. Indeed, as early as the first decade of the nineteenth century, Washington Allston had fallen under the spell of Venetian painting, whose sumptuous colors and rich glazes figured importantly in his development. The color and light of Venetian painting attracted other admirers among early artists and critics. "The more I saw of this peculiar school of painting called Venetian," wrote Henry Tuckerman in the 1840s, "the more was I captivated with its unrivalled richness

and depth of coloring." Yet he remained "regretful of its frequent lack of powerful expression"; unlike the memorable compositions of the revered Raphael, the Venetian works left only the impression of "the splendor of their own gorgeous hues."[39]

It was precisely those gorgeous hues that attracted new admirers in the waning years of the century. Among them was Bernard Berenson, the famed historian of Renaissance art, who in the 1880s succumbed to the spell: "one soon forgets to think of form here," he wrote excitedly from Venice, "going almost mad on color, thinking in color, talking color, almost living on color. And for one that enjoys color this certainly is paradise."[40]

Berenson was part of a legion of visitors who, from the 1870s onward, found inspiration no longer offered by "threadbare" Rome (in Frederic Edwin Church's dismissive phrase).[41] Henry James was typical of the affection: "I don't care, frankly, if I never see vulgarized Rome or Florence again, but Venice never seemed more loveable."[42]

The Venetian thrall led to new appreciation of its artistic legacy, leading to Americans' acquisitions of its Old Masters by the boatload. The legendary collector Isabella Stewart Gardner, with the able advice of Berenson, captured perhaps the greatest trophy of all, Titian's *Rape of Europa*. Not content with portable paintings, she also acquired fragments of derelict palaces which she shipped home to Boston

where they were incorporated into her own Boston palazzo, Fenway Court. When Thomas Jefferson had copied the Maison Carrée as the Virginia Capitol, it was with reverence for the ancients, his neoclassical design reflecting Roman principles fundamental to the young republic. A century later, Mrs. Gardner's Venetian confection, owing nothing to those principles, bespoke an utterly different attitude toward Italy's heritage among modern Americans.

The enthusiasm that led her to possess tangible portions of Venice led others to possess the city in paints, pastels, or prints. Perhaps surprisingly, this venerable site inspired some of the most modern of pictorial expressions among nineteenth-century painters. It was not the historic stones of Venice acclaimed by John Ruskin that attracted their attention so much as the general ambience of sky and water, which in Whistler's views was reduced to near abstraction. His pastels and etchings were miracles of abbreviation; remarkable subtleties also characterized his subsequent oil paintings of the city, such as *The Lagoon, Venice: Nocturne in Blue and Silver*, 1879–80 (fig. 7), to which the prints and sketches were parent. John Singer Sargent's dusky palazzo interiors, peopled with working-class women, employ different means yet are equally evocative of the precinct. Like Whistler, he eschewed traditional style and familiar tourist motifs in these genre subjects. He returned to Venice often, from the mid-1890s to the eve of World

7 James A. McNeill Whistler, *The Lagoon, Venice: Nocturne in Blue and Silver*, 1879–80, oil on canvas, 52.7 x 65.4 cm, Museum of Fine Arts, Boston, MA, Emily L. Ainsley Fund

War I, and in that aqueous realm depicted the canals and architecture in dazzling watercolors and oils (see plates 129, 130). By focusing intensely on his motifs, he effectively un-sited them, emphasizing qualities of light and reflected color rather than the historic associations to which more conventional artists might be drawn. And, at the turn of the century, Maurice Brazil Prendergast discovered in his Venetian watercolors a medium and motifs that ideally suited his modernist tendencies: shimmering surfaces of sea or wet pavement, reflecting colorful architecture, flags and banners, crowds of tourists or lanterned gondolas (fig. 8), dissolving them in stylized designs that won acclaim for the painter and augured dramatic changes in art's new century.

Speaking of the pioneering generation of American travelers, curator Theodore Stebbins noted that "[t]he artist went to Italy to discover himself, and to find out what it would mean and what it would take to create an American art."[43] Judging from the evidence produced over the long century between West and Prendergast, they succeeded.

8 Maurice Brazil Prendergast, *Umbrellas in the Rain, Venice*, 1899, oil on canvas, 35.6 x 53 cm, Museum of Fine Arts, Boston, MA, Charles Henry Hayden Fund

1 Benjamin West to John Singleton Copley, 6 January 1773; quoted in Theodore E. Stebbins, Jr., *The Lure of Italy: American Artists and the Italian Experience, 1760–1914* (New York: Abrams, 1992), 34.

2 Minor Myers, Jr., *Liberty without Anarchy: A History of the Society of the Cincinnati* (Charlottesville: University Press of Virginia, 1983), 259.

3 John Galt, *The Life and Studies of Benjamin West* (1816), excerpted in John McCoubrey, ed., *American Art, 1700–1960: Sources and Documents* (Englewood Cliffs, New Jersey: Prentice-Hall, 1965), 37.

4 Henry T. Tuckerman, *The Italian Sketch Book* (New York: J.C. Riker, 1848), 84.

5 Alexander Hamilton, James Madison, and John Jay, *The Federalist*, no. 34 (1788; New York: Dutton, 1970), 159.

6 Hamilton, quoted in Stebbins, *Lure of Italy*, 35; Adams, quoted in Wendell Garrett, *Neo-Classicism in America: Inspiration and Innovation, 1810–1840* (New York: Hirschl & Adler, 1991), 10.

7 James Russell Lowell quoted in Otto Wittmann, "The Attraction of Italy for American Painters," *Antiques* 85 (May 1964): 553.

8 Thomas Cole, "Essay on American Scenery" (1835), in McCoubrey, 108.

9 Joseph Carrington Cabell, Diary, 10 February 1805; quoted in Stebbins, 42.

10 Vanderlyn quoted in Henry T. Tuckerman, *Book of the Artists: American Artistic Life* (1867; New York: James F. Carr, 1966), 129.

11 Ibid.

12 Myers, 259.

13 Copley quoted in William Dunlap, *History of the Rise and Progress of the Arts of Design in the United States*, vol. 1 (1834; New York: Benjamin Blom, 1965), 129.

14 Tuckerman, *Italian Sketch Book*, 32.

15 Dunlap, *Arts of Design* 3, 155.

16 George Hillard, *Six Months in Italy*, vol. 2 (Boston: Ticknor, Reed, and Fields, 1853), 253.

17 James Jackson Jarves, *The Art-Idea* (1864), Benjamin Rowland, Jr., ed. (Cambridge, Massachusetts: Harvard University Press, 1960), 178.

18 Dunlap, *Arts of Design* 3, 156.

19 Joshua Reynolds, Discourse XIII, in Elizabeth Gilmore Holt, ed., *A Documentary History of Art*, vol. 2 (Garden City, New York: Doubleday Anchor Books, 1958), 281.

20 Andrew Wilton and Ilaria Bignamini, eds., *Grand Tour: The Lure of Italy in the Eighteenth Century* (London: Tate Gallery, 1996), 18.

21 Dunlap, *Arts of Design* 2, 161.

22 Mark Twain, *Innocents Abroad* (1869; New York: Library of America, 1984), 173.

23 James Fenimore Cooper, *Gleanings in Europe: Italy* (1838; Albany: State University of New York Press, 1981), 213; Henry P. Leland, *Americans in Rome* (New York: Charles T. Evans, 1863), 198.

24 *The Crayon* 6 (September 1859): 287.

25 Jarves, 189.

26 Dunlap, *Arts of Design* 3, 154.

27 Louis L. Noble, *The Course of Empire, Voyage of Life, and Other Pictures of Thomas Cole* (New York: Cornish, Lamport & Co., 1853), 333.

28 Henry James, *William Wetmore Story and His Friends*, vol. 2 (1903; New York: DaCapo Press, 1969), 4.

29 Emerson quoted in Otto Wittmann, "The Italian Experience (American Artists in Italy 1830–1875)," *American Quarterly* (Spring 1952): 5.

30 James, *Story and His Friends* 1, 103.

31 Story to Charles Eliot Norton, quoted in Erik Amfitheatrof, *The Enchanted Ground: Americans in Italy, 1760–1980* (Boston: Little, Brown and Co., 1980), 81.

32 William Dean Howells, *Italian Journeys* (Boston: Houghton Mifflin Co., 1867), 157–58.

33 Gautier (1855), quoted in Yvon Bizardel, *American Painters in Paris*, trans. Richard Howard (New York: Macmillan, 1960), 137.

34 Henry James, "John S. Sargent" (1893), in John L. Sweeney, ed., *The Painter's Eye: Notes and Essays on the Pictorial Arts by Henry James* (London: Rupert Hart-Davis, 1956), 216.

35 Emerson, quoted in Stebbins, 51.

36 W.E. Calder, quoted in Stebbins, 38.

37 Charles Coleman to Elihu Vedder, 5 October 1871; quoted in Regina Soria, *Elihu Vedder: American Visionary Artist in Rome (1836–1923)* (Rutherford, New Jersey: Fairleigh Dickinson University Press, 1970), 84.

38 Whistler, undated letter to his mother, quoted in Margaretta M. Lovell, *Venice: The American View, 1860–1920* (San Francisco: The Fine Arts Museums of San Francisco, 1984), 134.

39 Tuckerman, *Italian Sketch Book*, 313.

40 Berenson to Isabella Stewart Gardner, 11 October 1888, quoted in Stebbins, 123.

41 Daniel Huntington, *The Landscapes of Frederic Edwin Church* (New York: George Braziller, 1966), 91.

42 Henry James to Edith Wharton, 11 August 1907, quoted in Stebbins, 60.

43 Stebbins, 20.

"An exhaustless store for the imagination to feed upon"

Reflections on American Art and Photography

1 Samuel F. B. Morse, *Portrait of a Young Man*, 1840, daguerreotype, 5 x 4.2 cm, Gilman Paper Company, New York, NY

On 20 April 1839, the American painter Samuel F.B. Morse wrote a letter from Paris to the New York *Observer*, describing a new system of representation, called the "daguerreotype."[1] He recounted his meeting with Louis-Jacques-Mandé Daguerre, the inventor of this early photographic process, and previously a painter of dioramas. Morse, the inventor of the telegraph, looked with awe at Daguerre's specimens. He held the silver-plated metallic surface of the daguerreotype in one hand, studying the minute details of the world, surprised at such a faithful record. Using a magnifying glass, he roamed a street scene, seeing every little sign, brick, and line, "clearly and distinctly legible." He felt empowered by the experience, like a man studying nature with a telescope, seeing distant parts of the world. He knew that "no painting or engraving ever approached"[2] this type of description.

Morse believed that the veracity of the daguerreotype image could assist the work of painters. Back in New York, he wrote to Washington Allston, his friend and mentor: "Art is to be wonderfully enriched by this discovery. How foolish and narrow the idea which some express that it will be the ruin of art, or rather artists, for everyone will be his own painter.... Our studies will be now enriched with sketches from nature which we can store up during the summer, as the bee gathers her sweets for the winter, and we shall thus have rich materials for composition and an exhaustless store for the imagination to feed upon."[3]

American photography was founded on Morse's belief that technology could enrich American art. The daguerreotype, a small and detailed image, seduced Morse to copy, incorporate, alter, and transform the world. Like the telegraph, Daguerre's invention provided the American nation with a new instrument apt to make a "neighborhood of the whole country."[4] It offered truthful pictures for the design of mythical canvases.

This essay reflects on the impact of photography on American art and culture. It elaborates on Morse's description of the daguerreotype, pointing out that photographs were not merely "sketches from nature," but particular representations which acted on the American mind for the creation of a national myth. Moving from the painter's studio to a variety of sites (galleries, parlors, hotels), this essay illustrates the labor of American photographers in assimilating a vast and heterogeneous "new world" of languages, races, and cultural beliefs into a homogeneous representation and national heritage. With their truthful depictions, photographers introduced a new type of "authority over imagination."[5] Like modern wizards, they manufactured an "imaginary

geography and history, help[ing] the [American] mind to intensify its own sense of itself between what was close and what was far away."[6]

As a painter, Morse had been able to reproduce and incorporate paintings of Old Masters in his 1832 grand canvas of *The Gallery of the Louvre* (fig. 3, p. 34). After a careful selection and observation of his favorite paintings in the Louvre, he had decontextualized those paintings from their original locations, altered their relative sizes, and patiently montaged those miniature canvases into his own "gallery."[7] The little tiles of the Old Masters were the "sweets," or the aesthetic predilections, which Morse had refined through the years, and discussed in his *Lectures on the Affinity of Painting with the Other Fine Arts* (1826).[8] As the author and protagonist of his own museum, Morse stood in the foreground, mentoring a female student, and suggesting the possible assimilation of the French gallery into an American workshop.

Morse's *Louvre* was his last grand statement as a painter. Even though he remained active as the founding president of the National Academy of Design in New York (1826–45), Morse had become disillusioned about the promotion of American art.

2 Unknown photographer, *Telegrapher*, c. 1853, quarter-plate daguerreotype, 8 x 10.5 cm, Collection of W.B. Becker

His failure had caused him to say: "My life of poetry and romance is gone; I must descend from the clouds and look more at the earth."[9] In those critical years, the daguerreotype helped him to "look more at the earth," granting a truthful and detailed image of nature.

To this day, the knowledge of Morse's photographic production is limited to one daguerreotype. It is a humble portrait of a young man (fig. 1), whose blank and spontaneous look conveys the strenuous and mechanical collaboration between the sitter and the photographer. There is no flattery, nor heroism, in this face; only a faint surprise and sense of unease. Like the young Henry James posing with his father in Brady's studio, in 1854, the young man in Morse's studio seems preoccupied with not being adequately dressed and not quite ready for the "exposure" of his persona.[10]

This young man is the peer of many other ordinary people who inhabited American towns and villages in the mid-nineteenth century, posing in front of the daguerreotype camera with a feeling of inadequacy and surprise. Their social persona is often identified with their instruments of work, like symbols of their new crafts. An anonymous daguerreotype of a telegrapher (fig. 2) indicates this experience: with a gentle smile, the young man exposes to the photographer's camera the scroll of an electromagnetic message, thus functioning as a human connection between two machines.

Morse's skylit studio on Nassau Street, in New York, became a catalyst for artists and craftsmen alike, who desired to learn the daguerreotype process. One of them, Mathew Brady, met Morse in the early 1840s, through a common friend, the painter William Page. All three men maintained close ties with the art world: Page, like Morse, was a follower of the romantic painter Washington Allston, and Brady received from Page his first art education.[11]

Recent investigations have raised questions about Morse's introduction of the daguerreotype process to Brady and Page.[12] Nonetheless, Brady carried forward Morse's ambitious project in American art, using photography as a source for national pride. Through the mass-production of portrait photographs, Brady manufactured an American myth, built upon legendary characters and idealized virtues. As Mary Panzer has noted, "Brady was the first to understand how photographic images could become historical art."[13]

Like Morse, Brady dreamed of making "one neighborhood" of the whole American nation. Having this goal in mind, he created a portrait gallery of illustrious Americans, and moved this gallery to increasingly prestigious locations in New York, between 1845 and 1872, and in Washington, in Willard's Hotel, from 1858. Like Morse's *Louvre*, Brady's photographic gallery was "a miniature world, or symbolic America"[14] which incorporated seemingly authentic portraits of a mythical nation (fig. 3). Brady sought to emulate his eighteenth-century ancestors, transforming the glorious portraits of the American Founding Fathers into the photographs of his contemporary heroes. He agreed upon the stylistic codes of American painters Charles Willson Peale and John Singleton Copley, assimilating these codes, and diffusing them via his photographic enterprise.

Brady's studio attracted many celebrities hoping to be immortalized as American statesmen, artists, and historians. Among them, the painter Thomas Cole, "the founding father of a national school of landscape art,"[15] had his daguerreotype made a few years before his death in 1848. Brady portrayed him as a romantic figure (fig. 4), wrapped in a soft and dark mantle, with his visionary face turned at a three-quarter angle. The light falls from above, emphasizing the expression of a superior human being, and inspiring the viewer with his distant gaze.

With their historical truthfulness, Brady's photographs inspired other portrait painters of his time to emulate his style. Among them were William Page, George P. A. Healy, Charles Loring Elliott, Thomas Sully, Francis Carpenter, Alonzo Chappel, and Henry F. Darby.[16] Painters admired Brady's portraits not only for their faithful record, but for their clear representation of two key ideas of their time: that of national unity (soon to be disrupted by the Civil War) and the preservation of American history for present and future generations.

Brady was not alone in assimilating the heroic style of national portrait painting into photography, showing these iconic pictures inside a gallery. Among many other practitioners, Albert Sands Southworth and Josiah Johnson Hawes formed a very successful partnership in the mid-1840s in Boston, producing precious daguerreotypes of American statesmen, poets, and their milieu, and exhibiting these portraits in their Daguerrean gallery. Southworth, a student of Morse for a short period,[17] was educated in the aesthetics of Sir Joshua Reynolds, and firmly believed that his work ought to find a legitimate position with that of master artists.

Southworth and Hawes' national pride and creative ambition is reflected in particular in their reproductions of the American paintings and statues in the collection of the Boston Athenaeum. One of these studies presents an enigmatic confrontation between the painter's and the photographer's portrait, showing a

3 *Brady's Gallery at Tenth Street and Broadway, New York*, Frank Leslie's *Illustrated Newspaper*, 5 January 1861

4 Mathew Brady,
Thomas Cole, daguerreo-
type, c. 1846, National
Portrait Gallery,
Washington, D.C.

In the global mosaic of the American nation, nature presented sublime and picturesque tiles that were unique to the "new world." In the East, the Niagara Falls became an American icon, as "a prodigy of nature, which seemed to prove that American Nature expressed itself on a grander scale than elsewhere."[21] Photographers contributed to the diffusion of Niagara Falls as a spectacle for the tourist's gaze, and an amusement park interacting with a tamed wilderness.

In the mid-1850s, the daguerreotypist Platt D. Babbitt had a private concession for his studio and open pavilion on Prospect Point, on the American side of the falls. He produced whole-plate daguerreotypes, adopting Horseshoe Falls as a natural backdrop for his group portraits (fig. 8). Babbitt's daguerreotypes were precious mementos of a visit to the Falls. Protected in leather cases, they contained the tourist experience, transforming real life into a surrogate image and bringing a glamorous national scenery into people's private houses.

The photographic technology incorporated nature, as did the modern works of architects and engineers. One daguerreotype taken at Niagara exemplifies this point. Attributed to Southworth and Hawes, but most likely made by Babbitt,[22] this whole-plate daguerreotype presents a fraction of the suspension bridge over the falls (fig. 9). Completed in 1855, the bridge was a magnificent structure, designed by John Augustus Roebling (also the architect of the Brooklyn Bridge) to connect the Canadian and American railways. It was built with two decks, one for railway traffic and, eighteen feet below it, another for carriage and foot traffic.

Suspended in midair, the bridge in the daguerreotype looks like a crisp silhouette against the blurred view of the Niagara River and Falls.

5 Southworth & Hawes,
Self-Portrait, c. 1855,
half-plate daguerreotype,
George Eastman House, Rochester, NY

young girl standing in front of Gilbert Stuart's iconic portrait of George Washington (see frontispiece). The girl's reflection is superimposed onto the image of Washington, a particular portrait which had "assumed a cult status in sentimental culture" during the 1850s.[18] Beside its clearly patriotic message, this staged portrait intrigues the viewer for its double reflection, on its surface and inside its image. Like the flickering image of the daguerreotype, the historical effigy of Washington is transformed into a young girl, and this transformation appears magically. In this image, the past is reflected into the present. Similarly, in Brady's studio, the sitter was invited to re-enact American history.

A portrait of Southworth (a self-portrait, or a portrait staged with the help of Hawes) shows the photographic performance in all its splendor (fig. 5). With naked chest, plunged into dramatic light and gazing into the distance, Southworth looks like a heroic bust of Classical antiquity and matches an ideal likeness. He is no longer a real photographer with a studio in Boston, but an artist who has become his own creation. This image explains Southworth's belief that "nature is not all to be represented as it is, but as it ought to be, and might possibly have been; and it is required of and should be the aim of the artist-photographer to produce in the likeness the best possible character and finest expression of which that particular face or figure could ever have been capable."[19]

The incorporation of the photographer's visual rhetoric as proof of American cultural identity took other forms as well. From the same context of Southworth, in 1850, the Harvard naturalist Louis Agassiz asked the daguerreotypist J. T. Zealy to represent black slaves in Columbia, South Carolina. These images were used as scientific evidence in support of Agassiz's theory of racial polygenesis, or separate origins, of the human species.[20] This theory intended to justify black slavery, owing to the inevitable racial separation between (inferior) Negroes and (superior) Whites. Unlike Southworth's symbolic portrait of the photographer as an artist, Zealy's portrait of Jack from Guinea (fig. 6) is an indexical illustration of the black man as a prisoner of his own flesh. Framed within a code different from the classical representation of Southworth, this portrait reflects another history and "nature" from the monolithic interpretation of Brady and of the Bostonian "artist-photographers."

One further sign of photographic assimilation of an American multi-racial community is offered by a daguerreotype of a Native American Kansas chief, Kno-Shr (fig. 7), portrayed by John Fitzgibbon, a daguerreotypist operating in St. Louis, Missouri. Kno-Shr poses in his bare chest, decorated with a grizzly bear claw necklace. His fierce attitude and wild ornaments speak of the pride of his race. His noble gaze, straight into the camera, suggests his resistance to the domestication of the American white colonies.

The photographer's camera stands on an invisible location, giving the impression that the machine-operator, like the engineer of the suspension bridge, has control over nature. Furthermore, tourists were able to view this daguerreotype through the lenses of the Grand Parlor Stereoscope, a viewing apparatus purchased by Babbitt from Southworth and Hawes[23] and placed in the hall of a nearby hotel. Looking at the suspension bridge through the lenses of this apparatus, visitors saw a pair of daguerreotypes in stereo, perceiving the bridge as three-dimensional, almost like in real life.

Between 1859 and 1863, the American essayist Oliver Wendell Holmes wrote three enthusiastic articles for the *Atlantic Monthly*, describing photography as an empowering and all-encompassing instrument of modern life. In particular, he noted that the stereoscope made "surfaces look solid ... as to produce an appearance of reality which cheat[ed] the senses with its seeming truth."[24] The effect of solidity dematerialized the photographic surface and enhanced the experience of reality, which Holmes described as a "dream-like exaltation, in which [the viewers] seem[ed] to leave the body behind and sail away into one strange scene after another, like disembodied spirits."[25] The Niagara Falls enhanced the virtual experience of the stereoscope, presenting spectacular tightrope walks across the gorge and dangerous navigational maneuvers in the *Maid of the Mist* boat along the river.

As Holmes noted, the illusionism of the stereoscope caused "a surprise such as no painting ever produced."[26] While tourists at Niagara Falls toyed with photographic technology, gazing and possessing a place through its seemingly perfect replicas, a few painters used photographs to construct other types of illusion. The American scenery seemed an

7 John H. Fitzgibbon, *Kno-Shr, Kansas Chief*, 1853, daguerreotype, 17.9 x 14.8 cm, Gilman Paper Company, New York, NY

ideal ground to the Ruskinian artist, who aimed at encompassing God's creation. Photographs could contribute to the painter's grand oeuvre, offering meticulous details and topographical accuracy for the study of nature. Through this process, the painter felt like a transcendental instrument, or a mediator between art and nature, man and God.

Thus, if Frederic Edwin Church used daguerreotypes and photographs to construct his first "heroic landscape" of Niagara, in 1857, this representation was topographically impossible, even though it looked real.[27] This paradox revealed the complex relationship between two systems of belief—the painter's and the photographer's. Church's student, William J. Stillman, embodied the contradiction, opting for photography as a faithful record, but leaving to the painter the achievement of higher truths. Conflicted between real and ideal, Stillman was critical of his teacher for being "a camera obscura,"[28] with a good photographic vision but not enough imagina-

tion. But Stillman's response was not so clear-cut. The photographer's camera obscura was accurate in incorporating an imaginary world, as Church's "lens" contributed to the creation of fabulous scenes.

In the West, the "discovery" of California's Yosemite Valley attracted both photographers and painters to represent and imagine the American "virgin land." In December 1862, people in New York admired an exhibition of photographs of the Yosemite Valley, installed at Goupil's Gallery. The photographer of these "mammoth views" was Carleton Watkins, a man from upstate New York who had settled in California in 1851.[29] Made in 1861, the views represented an immaculate Garden of Eden, where trees framed sensuous waterfalls and massive mountains protected a pristine valley.

One of Watkins' photographs of Yosemite Falls illustrates a soft mass of water descending from a mountain, framed inside a picturesque scene with trees. The tender foliage in the foreground embraces

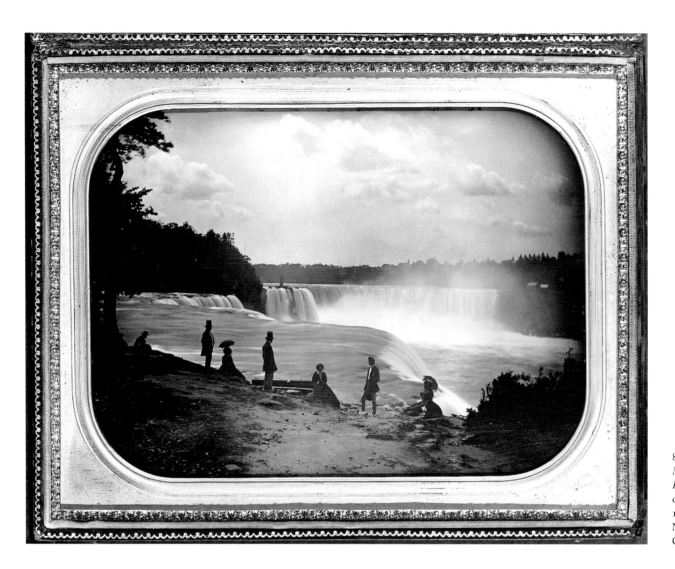

8 Platt D. Babbitt,
*Niagara Falls from
Prospect Point*, c. 1855,
daguerreotype,
16.6 x 21.7 cm,
National Gallery of
Canada, Ottawa

9 Attributed to Southworth & Hawes, *The Niagara
Suspension Bridge*, c. 1856, whole-plate daguerreotype,
George Eastman House, Rochester, NY

Yosemite's pastoral garden, soon preserved as a national park (1864). Another photograph shows the imposing volumes of a mountain named by the white explorers "Cathedral Rock"[30] (fig. 10). Like those explorers, Watkins conflated the distant valley of Yosemite into a familiar and historical site from European heritage. He presented the mountain as a natural monument, transforming the memory of European architecture into the image of an exclusive American wilderness. Watkins did with American landscape what Brady did with illustrious Americans. Both photographers created a myth from a young and precarious tradition and let the urban center of New York test and reinforce this myth.

One of the viewers at Goupil's Gallery, the Reverend H. J. Morton, made a comment about those photographs that recalled Holmes' observations about the stereoscope. He noted that the photographs could virtually bring him to remote sites: "[Watkins'] photographic views ... open before us the wonderful valley whose features far surpass the fancies of the most imaginative poet and eager romancer ... without crossing the continent by the overland route in dread of scalping Indians and waterless plains; without braving the dangers of the

sea by the Chagres and Panama [sea] route; nay, without even the trouble of the brief land trip from San Francisco, we are able to step, as it were, from our study into the wonders of the wondrous valley, and gaze at our leisure on its amazing features."[31]

Watkins' photographs prompted two artists of the time, painter Albert Bierstadt and writer Fitz Hugh Ludlow, to see Yosemite with their own eyes and represent it with their own tools. Seven years later, Ludlow contributed to the success and publicity of Bierstadt's paintings, writing his account of the trip in *The Heart of the Continent* (1870), where he commented: "We were going into the vale whose giant domes and battlements had months before thrown their photographic shadow through Watkins' camera across the mysterious wide Continent, causing exclamations of awe at Goupil's window, and ecstasy in Dr. Holmes' study ... we had gazed on them by the hour already, I, let me confess it, half a Thomas-a-Dydimus to Nature, unwilling to believe the utmost true of her till I could put my finger in her very prints."[32]

As Ludlow "put his finger" into nature, Bierstadt attracted his audience to "put their fingers" into his paintings. He composed his grand views of Yosemite back East, using his sketches and the stereo views of

his brothers, Charles and Edward[33] (fig. 11). As noted for Church, Albert Bierstadt's representation of American scenery implied a different type of authority and imagination than the one caused by Watkins' photographs. Looking at the photographs from their parlors and galleries, viewers were carried far away through memories and associations. Standing in front of Bierstadt's paintings, they marveled at the artist's theatrical display. Visiting the real site, they feared "scalping Indians and waterless plains." Even though writers, painters, and photographers contributed to the ideal construction of the Western landscape, and they supported one another in this endeavor, their representation and their reception implied a variety of experiences.

Photographers pictured the travelers' experience with a topographic intent, mapping American trajectories and ideal tours. Often, they worked side by side with railroad commissioners, illustrating the tracks reaching into new territories and incorporating the man-made landscape into the mythical American wilderness. Significantly, Watkins' traveling companion to the West was Collis Porter Huntington, who later became the president of the Central Pacific Railroad. Like Watkins, Weed, his precursor in Yosemite (in 1859), was employed by the earliest tourist operator in the valley, James Mason Hutchings, to make photographs which contributed to the success of Yosemite as a tourist attraction.[34] Weed also photographed sections of the Central Pacific Railroad. His photograph of the bridge over the Truckee River, in Nevada (fig. 12), visualizes the traveler's trajectory through the massive iron structure of a bridge, bringing the imagination of an ideal American Arcadia into the distance. This picture is contained in the small format of a *carte de visite*, rendering the viewer's experience intimate and portable, like that of a contemporary postcard.

The private consumption of tourist views grew in the last two decades of the nineteenth century. Photographs became incorporated into commercial albums that were distributed in American hotels and

10 Carleton Watkins, *Cathedral Rock, Yosemite,* c. 1866, albumen print, Miriam and Ira D. Wallach Division of Art, Prints & Photographs, The New York Public Library, Astor, Lenox, and Tilden Foundations

mail steamers. In the 1880s, the studio of Isaiah West Taber in San Francisco published an album entitled *California Scenery and Industries.* The album presents the full range of activities in California (crafts, agriculture, tourism), combining photographs, commercial ads, and images of the local products of nature. One of these pages shows a montage of views along the "scenic route" of the Denver and Rio Grande railway; another page, the business of J. Grundlach and California wines, with real grapes and leaves surrounding five views of wineries.

The montage of photographs and advertisements inside these pages recalls the trompe-l'oeil paintings of Harnett, as well as of Peto and Haberle: it "erodes the distinction between reality and representation,"[35] laying pictures and real objects across a flat photographic surface and attracting the consumers to illusive products and photographic tours. Through a combination of art

and advertising, the album aimed to reach a large group of people "in America, England, and Australia," distributing the American myth of beauty and plenty overseas.

In the same decade when Taber published this album, an American amateur photographer living in Berlin, Alfred Stieglitz, formulated a new "idea of photography,"[36] rebelling against the production of commercial studios and of Kodak amateur snapshots. Stieglitz cut across the experiences outlined in this essay and stressed the importance of photography as an art form—neither a copy of nature, nor a surrogate experience. In 1890, he carried this "idea" to his country, feeding "the fairytale of America"[37] with photographs as artistic expressions.

Stieglitz, like Morse, took on the mission to shape the course of American art, promoting its native talents. Unlike Morse, he let photography lead this mission, and did not confine it to the auxiliary role of

11 Charles Bierstadt, *"Our Party,"* Yosemite *Valley,* c. 1855, albumen print, stereo, George Eastman House, Rochester, NY

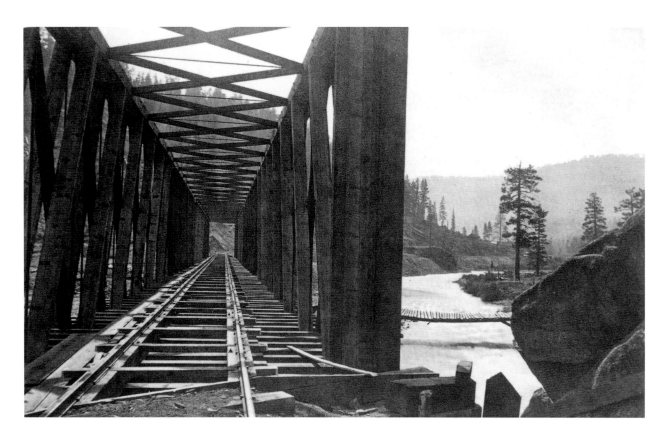

13 Alfred Stieglitz, *The City of Ambition*, 1910, photogravure, 1910, 34 x 26 cm,
National Gallery of Art, Washington, D.C., Alfred Stieglitz Collection

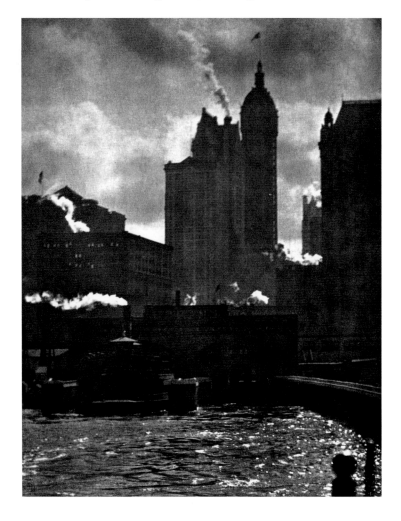

a sketch for painters. In 1902, Stieglitz founded the movement of the "Photo-Secession," echoing the Vienna Secession, and supporting photography for photography's sake. A magazine, *Camera Work*, was issued by him between 1903 and 1917, following the publication of his previous *Camera Notes* (1897– 1902). Photographs were exhibited like paintings and sculptures of avant-garde European and American art in New York, in the Little Galleries of the Photo-Secession at 291 Fifth Avenue (1905–17), in The Intimate Gallery (1925–29), and at An American Place (1929–46). Activities of exhibition, publication, and aesthetic promotion were intertwined in the "construction of an institutional framework which certified the pictures as art."[38]

Like the National Academy of Design and Morse's virtual Louvre, Stieglitz's first gallery "291" was "a laboratory for testing the taste of the public."[39] Stieglitz was the arbiter of American high culture and the interpreter of modern art. For him, photography defined the modern experience; the city of New York was the ideal backdrop for photographic experimentation; his photographs of New York were important in defining the myth of modernity.

Stieglitz portrayed New York at the turn of the century, taking a picture of the city's skyscrapers and ferry boats and calling it *The City of Ambition*, 1910 (fig. 13). He gave another symbolic title, *The Hand of Man*, 1902, to a picture of a locomotive entering a New York railway station. If the black smoke from the locomotive and the heavy overcast diffused the dark mood of the industrial landscape (similar to

George Bellows' New York scenes), the title of this picture indicated the photographer's humanistic and positive vision of the machine.

But the machine was, for Stieglitz as for most photographers examined in this essay, a means to an end. The end for Stieglitz was reflected on to the machine itself. Photography incorporated the American myth, becoming itself a myth and bringing full circle the real-ideal dichotomy that had puzzled Morse. Stieglitz insisted on the ideal essence of photographs. He encouraged Americans to collect and preserve photographs, in order to build a sense of tradition in American art, waiting for "the day … when American photography [would] become a legend, a myth."[40] Like Brady, Stieglitz viewed photographs as objects for the preservation of American history. He went further than Brady, considering the objects mythical and legendary in themselves.

One picture taken by Stieglitz in Berlin, in 1889, reflects the photographer's own myth-making (fig. 14). This picture shows a room, a woman writing a letter at a table, an open window with sunlight streaming through the shutters, and, on the wall, some photographs by Stieglitz, pinned up like travel sketches. Two of these photographs illustrate an approaching storm on Lake Como in Italy, as he had seen it in 1887. The other photographs are portraits of Paula,[41] and a *carte-de-visite* portrait of a man who looks like the photographer.

This picture is reminiscent of Dutch paintings: the open window, the sun's rays streaming into the room, the woman absorbed in her private space, are all elements of Vermeer's interiors. The artist is an invisible voyeur of a woman's correspondence,[42] and his gaze is diffused in the room through his photographs. Pinned on the wall, these pictures feed Stieglitz's imagination. They recall his early travels, and an intimate friend of his youth. They are fragments of a bigger picture (now a photograph), and they feed the photographer's imagination.

Like the photographs examined in this essay, Stieglitz's photographs on the wall are not faithful records of a specific time and place. They are fragments of histories and geographies, "sweets" for the American world, vehicles for a national myth. They are kept inside a room, cherished by an artist, transformed by an audience. They create their own legend, bringing into the art of the "new world" the fragile essence of memory and the empowering effect of imagination.

14 Alfred Stieglitz, *Sun Rays— Paula, Berlin*, 1889, platinum print, 1916, 23.2 x 18.5 cm, National Gallery of Art, Washington, D.C., Alfred Stieglitz Collection

For their comments and suggestions, I am grateful to Julie K. Brown and David Wooters. My thanks also to Grant Romer, Joseph Struble, Rebecca Simmons, James Borcoman, Julia Van Haaften, Sharon Frost, Peter Palmquist, and William B. Becher for their research assistance.

1 Robert Taft, *Photography and the American Scene: A Social History, 1839–1889* (New York: Dover Publications), 8–12.

2 Ibid., 12.

3 Paul J. Staiti, *Samuel F.B. Morse* (Cambridge: Cambridge University Press, 1989), 226–28.

4 Ibid., 223.

5 See Nathan Lyons, "… the outline of its mountains, will be made familiar to us," in *The Great West: Real/Ideal* (Boulder: University of Colorado, 1977), n. p.

6 Edward W. Said, *Orientalism* (New York: Random House, 1978), 55.

7 Staiti, 188–90.

8 Staiti, 190. See also Nicolai Cikovsky, Jr., ed., *Lectures on the Affinity of Painting with the Other Fine Arts by Samuel F.B. Morse* (Columbia and London: University of Missouri Press, 1983).

9 Staiti, 202.

10 Susan Williams, *Confounding Images: Photography and Portraiture in Antebellum American Fiction* (Philadelphia: University of Pennsylvania Press, 1997), 1–6.

11 Alan Trachtenberg, *Reading American Photographs: Images as History, Mathew Brady to Walker Evans* (New York: The Noonday Press, 1989), 35.

12 Trachtenberg, *American Photographs*, 35; Mary Panzer, *Mathew Brady and the Image of History* (Washington, D.C.: Smithsonian Institution Press, 1997), 9.

13 Panzer, 7.

14 Trachtenberg, *American Photographs*, 38.

15 Angela Miller, *The Empire of the Eye: Landscape Representation and American Cultural Politics, 1825–1875* (Ithaca: Cornell University Press, 1993), 21.

16 Panzer, 71–91; Van Deren Coke, *The Painter and the Photograph from Delacroix to Warhol* (Albuquerque: University of New Mexico Press, 1964), 27–43.

17 Taft, 38.

18 Williams, 19.

19 Merry A. Foresta, John Wood, *Secrets of the Dark Chamber: The Art of the American Daguerreotype* (Washington, D.C.: Smithsonian Institution Press, 1995), 297.

20 Trachtenberg, *American Photographs*, 53–56; Gwyniera Isaac, "Louis Agassiz's Photographs in Brazil: Separate Creations," *History of Photography* 21, no. 1 (Spring 1997): 3–11.

21 John F. Sears, *Sacred Places: American Tourist Attractions in the Nineteenth Century* (Oxford: Oxford University Press, 1989), 13.

22 I owe this information to Grant Romer.

23 Charles LeRoy Moore, "Two Partners in Boston: The Careers and Daguerreian Artistry of Albert Southworth and Josiah Hawes" (Ph.D. dissertation, The University of Michigan, 1975), 205–206.

24 See Alan Trachtenberg, "Photography: The Emergence of a Keyword," in Martha A. Sandweiss, ed., *Photography in Nineteenth-Century America* (New York: Harry N. Abrams, Inc., 1991), 38–39.

25 Ibid., 39.

26 Ibid., 38.

27 Franklin Kelly, "A Passion for Landscape: The Paintings of Frederic Edwin Church," in *Frederic Edwin Church* (Washington, D.C.: Smithsonian Institution Press, 1989), 50–51. For information on Church's use of photographs, see Elisabeth Lindquist-Cock, "The Influence of Photography on American Landscape Painting, 1839–1880" (Ph.D. dissertation, New York University, 1967); Van Deren Coke, 200.

28 Linda S. Ferber, "'The Clearest Lens': William J. Stillman and American Landscape Painting," in *Poetic Localities: William J. Stillman, Photographs of Adirondacks, Cambridge, Crete, Italy, Athens* (Millerton: Aperture, 1988), 93.

29 Peter E. Palmquist, *Carleton E. Watkins: Photographer of the American West* (Albuquerque: University of New Mexico Press, 1983).

30 Trachtenberg, *American Photographs*, 126–27.

31 Palmquist, 19.

32 See Nancy K. Anderson, "'Wondrously Full of Invention': The Western Landscapes of Albert Bierstadt," in *Albert Bierstadt: Art & Enterprise* (New York: The Brooklyn Museum of Art, 1990), 79.

33 Ibid., 106.

34 Sears, 124–27.

35 Paul J. Staiti, "Illusionism, Trompe l'Oeil, and the Perils of Viewership," in *William M. Harnett* (New York: Harry N. Abrams, Inc., 1992), 43.

36 See Sarah Greenough, *Alfred Stieglitz: Photographs & Writings* (Washington, D.C.: National Gallery of Art, Callaway Editions, 1983), 13.

37 Alfred Stieglitz, "Four Happenings" (1942), in Nathan Lyons, *Photographers on Photography*, 113.

38 Ulrich F. Keller, "The Myth of Art Photography: A Sociological Analysis," *History of Photography* 8, no. 4 (October-December 1984): 256.

39 Trachtenberg, *American Photographs*, 168.

40 "A Stieglitz Talk at a New York Art Center" (c. 1924), *The Archive*, no. 1 (Tucson: The University of Arizona, March 1976), 8.

41 Dorothy Norman, *Alfred Stieglitz: An American Seer* (1960) (Millerton: Aperture, 1990), 31.

42 Svetlana Alpers, *The Art of Describing: Dutch Art in the Seventeenth Century* (Chicago: The University of Chicago Press, 1983), 201–206.

Appendix

Historical Maps

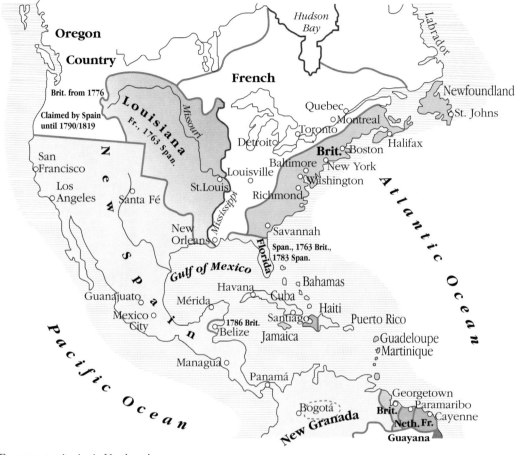

Oregon

Country

Brit. from 1776

Claimed by Spain
until 1790/1819

San
Francisco

Los
Angeles

Santa Fé

Guanajuato

Mexico
City

Belize

Managua

Pacific Ocean

Louisiana
Fr., 1763 Span.

Missouri

N e w S p a i n

St. Louis

New
Orleans

Mississippi

Gulf of Mexico

Havana

Mérida

1786 Brit.

French

*Hudson
Bay*

Quebec

Montreal

Toronto

Detroit

Brit. Boston

Louisville

Baltimore
New York
Washington

Richmond

Savannah

Florida
Span., 1763 Brit.,
1783 Span.

Bahamas

Cuba

Santiago

Haiti

Jamaica

Puerto Rico

Guadeloupe
Martinique

Labrador

Newfoundland

St. Johns

Halifax

A t l a n t i c O c e a n

Panamá

Bogotá

New Granada

Georgetown
Paramaribo
Cayenne

Brit.
Neth. Fr.
Guayana

European territories in North and
Central America in the eighteenth
century

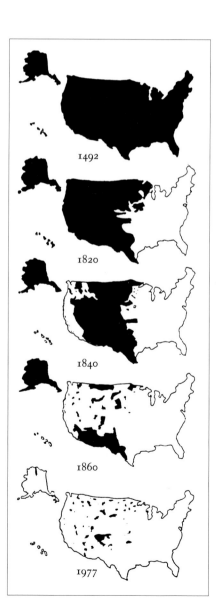

1492

1820

1840

1860

1977

The decimation of the Native
Americans by the whites

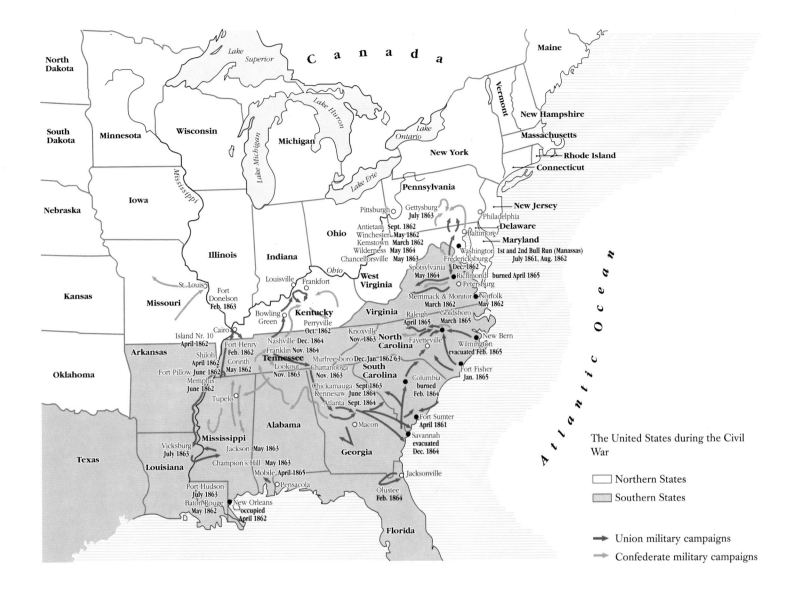

North Dakota

South Dakota

Nebraska

Kansas

Oklahoma

Texas

Minnesota

Iowa

Missouri

Arkansas

Louisiana

Wisconsin

Illinois

Lake Superior

Lake Michigan

Michigan

Lake Huron

Lake Ontario

Lake Erie

C a n a d a

Maine

Vermont

New Hampshire

Massachusetts

Rhode Island

Connecticut

New York

Pennsylvania

Pittsburgh

Gettysburg
July 1863

Philadelphia

New Jersey

Delaware

Maryland

Baltimore

Indiana

Ohio

West Virginia

Louisville

Frankfort

Ohio

Antietam **Sept. 1862**
Winchester **May 1862**
Kemstown **March 1862**
Wilderness **May 1864**
Chancellorsville **May 1863**

Washington 1st and 2nd Bull Run (Manassas)
July 1861, Aug. 1862
Fredericksburg
Dec. 1862
Spotsylvania
May 1864
Richmond burned April 1865
Petersburg

Merrimack & Monitor
March 1862
Norfolk
May 1862

Mississippi

St. Louis

Fort Donelson
Feb. 1863

Cairo

Bowling Green

Kentucky

Perryville
Oct. 1862

Virginia

Raleigh
April 1865

Goldsboro
March 1865

Knoxville
Nov. 1863

North Carolina

Fayetteville

New Bern

Island Nr. 10
April 1862

Fort Henry
Feb. 1862

Nashville **Dec. 1864**
Franklin **Nov. 1864**

Tennessee

Corinth
May 1862

Murfreesboro **Dec./Jan. 1862 63**
Chattanooga
Nov. 1863

Lookout
Nov. 1863

South Carolina

Wilmington
evacuated **Feb. 1865**

Fort Fisher
Jan. 1865

Missouri

Arkansas

Oklahoma

Shiloh
April 1862
Fort Pillow **June 1862**
Memphis
June 1862

Tupelo

Chickamauga **Sept 1863**
Kennesaw **June 1864**
Atlanta **Sept. 1864**

Columbia
burned
Feb. 1864

Fort Sumter
April 1861

Alabama

Macon

Georgia

Savannah
evacuated
Dec. 1864

Texas

Mississippi

Vicksburg
July 1863

Louisiana

Jackson **May 1863**

Champion's Hill **May 1863**

Mobile **April 1865**

Pensacola

Jacksonville

Olustee
Feb. 1864

Port Hudson
July 1863
Baton Rouge
May 1862

New Orleans
occupied
April 1862

Florida

Atlantic Ocean

The United States during the Civil War

☐ Northern States

▢ Southern States

→ Union military campaigns

→ Confederate military campaigns

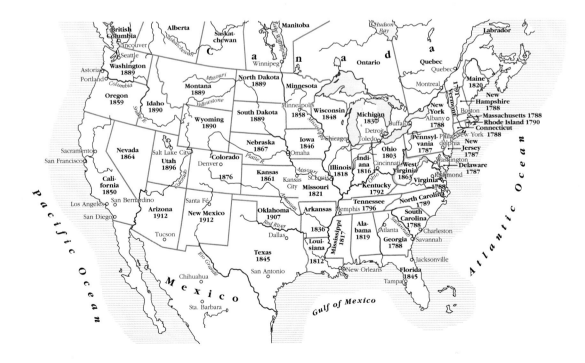

British Columbia

Vancouver

Seattle

Astoria

Portland

Washington
1889

Oregon
1859

Idaho
1890

Alberta

Saskat-chewan

Manitoba

Hudson Bay

Labrador

C a n a d a

Winnipeg

Ontario

Quebec

Quebec

Montreal

Montana
1889

North Dakota
1889

Minneapolis

Minnesota
1858

Wyoming
1890

South Dakota
1889

Wisconsin
1848

Michigan
1830

Detroit

Buffalo

Toledo

Chicago

Sacramento

San Francisco

Nevada
1864

Salt Lake City

Utah
1896

Colorado
1876

Denver

Nebraska
1867

Omaha

Iowa
1846

Illinois
1818

Indi-ana
1816

Cincinnati

Ohio
1803

Cali-fornia
1850

Los Angeles

San Bernardino

San Diego

Arizona
1912

New Mexico
1912

Santa Fe

Tucson

Kansas
1861

Kansas City

St. Louis

Missouri
1821

Memphis

Kentucky
1792

Tennessee
1796

West Virginia
1863

Virginia
1788

Richmond

Washington

Pennsyl-vania
1787

Philadelphia

New York
1788

Albany

Boston

Vermont

New Hampshire
1788

Massachusetts 1788

Rhode Island 1790

Connecticut 1788

New York 1788

New Jersey
1787

Delaware
1787

Maine
1820

Oklahoma
1907

Arkansas
1836

Dallas

Mississippi
1817

Louisiana
1812

San Antonio

Texas
1845

Alabama
1819

Atlanta

Georgia
1788

North Carolina
1789

South Carolina
1788

Charleston

Savannah

Jacksonville

Florida
1845

Tampa

New Orleans

Gulf of Mexico

Chihuahua

M e x i c o

Sta. Barbara

Pacific Ocean

Atlantic Ocean

The States and their entry
to the Union

Artists' Biographies

Cecilia Beaux
1855–1942

Born in Philadelphia in 1855, Cecilia Beaux attributed much of her success to the support she received from her family; they had recognized her talent early on and arranged for her to train in the studio of a distant cousin, Catherine Ann Drinker, a successful artist, writer, and teacher. At eighteen, Beaux took over Drinker's drawing lessons at Mrs. Sanford's School in Philadelphia and embarked on a career in the decorative arts, painting porcelain, making portrait sketches from photographs, and experimenting with lithography.

Beaux also attended classes at the Pennsylvania Academy of the Fine Arts, and studied privately under William Sartain. Influenced by her teacher, as well as by the work of Thomas Eakins (1844–1916) and James McNeill Whistler (1834–1903), she developed an early portrait style characterized by strong textural effects, a preference for deep, rich colors, and an appreciation of the strength and simplicity of the human form.

In 1883–84, Beaux executed her first major portrait, *Les derniers jours d'enfance*, a Whistler-influenced image of her sister and nephew that won the Mary Smith Prize in 1885 at the Pennsylvania Academy's annual exhibition. Two years later, the portrait's entry in the 1887 Salon exhibition in Paris inspired Beaux to continue her training in France.

In January 1888, Beaux arrived in Paris and spent the next year and a half studying at the Académies Julian and Colorossi and copying works by Old Masters at the Louvre. While spending her summers on the Brittany coast, she became fascinated with memory studies and *plein-air* painting and began experimenting with pastel.

Returning to Philadelphia in 1889, Beaux resumed her portrait career. In the 1890s she progressed toward a more colorful and painterly style, and her ability to capture what she called the "measure of the individual" found a ready clientele among upper-class Philadelphians. Around 1898, Beaux commenced the first of an important series of double portraits, in a style reminiscent of John Singer Sargent's (1856–1925) full-length society portraits. They brought her tremendous critical acclaim; one of them, *Mother and Daughter*, received more honors than any other single work by Beaux, including first prize at the 1899 Carnegie Institute Annual Exhibition and the gold medal at the Pan-American Exposition in 1901.

By the turn of the century, Beaux was a leader in her profession, and to keep up with the demand she moved to New York. She continued to teach at the Pennsylvania Academy, however, where she was the first woman instructor of portraiture, a post she held from 1895 to 1916. In 1919, Beaux was selected by the National Art Committee as one of a number of artists to paint leading figures of World War I.

Following a hip injury in 1924, Beaux found it increasingly difficult to paint and devoted most of her attention to writing her autobiography, *Background with Figures*, published in 1930. In 1935, she was honored by the American Academy of Arts and Letters, which had elected her as a member two years earlier, with her first retrospective exhibition. In 1942, the National Institute of Arts and Letters awarded her a gold medal for her lifetime achievements. She died in 1942 at the age of eighty-seven. *CB*

Further Reading

Henry S. Drinker, *The Paintings and Drawings of Cecilia Beaux*, Philadelphia 1955; Tara Leigh Tappert, *Cecilia Beaux and the Art of Portraiture*, Washington, D.C. and London 1995.

George Wesley Bellows
18820–1925

George Bellows' life and work have for many come to epitomize America's exuberance and self-confidence in the first decades of the twentieth century. Born into a comfortable middle-class home in Columbus, Ohio, in 1882, he was the only child of middle-aged, conservative-minded parents. Bellows demonstrated an early talent for both art and athletics, interests that would vie for his attention throughout his youth. He attended Ohio State University from 1901 to 1904, where he played baseball and basketball, and illustrated the yearbook. Intent on a career as an illustrator, Bellows withdrew from college at the end of his junior year to pursue training in New York.

Arriving in the fall of 1904, Bellows enrolled in William Merritt Chase's (1849–1916) New York School of Art. There he met Robert Henri (1865–1929), the teacher and mentor whose artistic philosophy he would come to share. Henri believed that art must be created from life. Transforming Chase's revered principle "art for art's sake" into "art for life's sake," Henri challenged his students to immerse themselves in the life of the city and paint what they experienced. The result of this direct involvement with life, Henri believed, would be a "democratic art" that would be truly American. For many critics of the time,

however, the willingness of Henri's circle to paint what they considered the unseemly side of life earned them the sobriquet "The Ashcan School." A formidable talent, Bellows quickly became an astute observer of the complexities of urban America and arguably the artist of his generation who best met Henri's challenge.

Bellows' life was a classic American success story. Within five years of his arrival in New York, he had developed a distinctive realist style and was creating masterworks. He painted the first of four memorable depictions of the excavation for Pennsylvania Station in 1907 (plate 140) and two years later *Stag at Sharkey's*, perhaps his best-known work. (Indeed, the painting is still regarded as such an icon that the United States Post Office recently honored it with a commemorative stamp.) The phenomenal course of Bellows' career is partially attributable to the almost universal appeal of his work, which garnered acclaim from the conservative art establishment, the avant-garde, and the public. In 1909, he was elected the youngest associate member of the National Academy of Design. Although not a member of The Eight, who Henri led to exhibit in protest against the National Academy of Design in 1908, Bellows did participate in the Independent Artists Exhibition, which Henri helped organize in 1910. In 1913, the year that Bellows became a full academician of the National Academy of Design, he also helped install the controversial Armory Show. Socially, Bellows was welcome in an equally wide circle of friends and colleagues, who admired his zest for life and his generous human spirit. In 1910, he married Emma Story, and the first of the couple's two daughters was born the following year.

Bellows was a highly prolific artist, known for his vigorous brushwork and the physical vitality of his canvases. The breadth and power of Bellows' work earned him a reputation as one of the most versatile artists of the era. In addition to his genre scenes of urban America, he was a gifted portraitist and landscape painter. Beginning in 1911, Bellows began regular summer visits to Monhegan Island, off the Maine coast, where he created seascapes inspired by Winslow Homer (1836–1910), whom Bellows acknowledged as an important formative influence, along with Thomas Eakins (1844–1916) and James McNeill Whistler (1834–1903). Although usually identified with a gut-driven, spontaneous approach to painting, Bellows was also deeply involved with various color and compositional systems. Around 1909, Henri introduced Bellows to the paints and corresponding color system developed by paint manufacturer and theorist Hardesty Maratta. Bellows' adoption of the Maratta system contributed significantly to the transformation of both the palette and structure of his paintings. Other contemporary systems that would successively influence Bellows, include Denman Ross'

Rubens Palette and, most notably, Jay Hambridge's theory of Dynamic Symmetry, of which Bellows became an ardent exponent in 1918.

Bellows was also an active graphic artist. He worked as an illustrator throughout his career, accepting commissions, and contributing to a wide variety of publications including *Collier's, Harper's Weekly, Vanity Fair, Metropolitan Magazine,* and the socialist periodical *The Masses.* In 1916, he took up lithography, which at the time was regarded in the United States almost exclusively as a commercial medium, and played an integral role in its revival as a fine-art medium. His prints were highly regarded and were compared favorably with those of Daumier and Goya. He worked successively with two master printers—George Miller and Bolton Brown—and created over 170 lithographs that address the same range of subjects as his paintings (with the notable exception of landscape).

In 1920, Bellows visited Woodstock, New York, for the first time. Two years later he built a home and studio there, where he began to spend more time. Immediately following the new year in 1925, Bellows suffered a ruptured appendix while in his New York studio. He died from peritonitis on 8 January at the age of forty-two. The following October the Metropolitan Museum of Art honored the artist with a memorial exhibition of his work. *NM*

Further Reading
Marianne Dozema, *George Bellows in Urban America,* New Haven 1992; Jane Myers and Linda Ayers, *George Bellows: The Artist and his Lithographs, 1916–1924,* exhib. cat., Amon Carter Museum / Los Angeles County Museum of Art, New York 1992.

Albert Bierstadt
1830–1902

Albert Bierstadt was born in Solingen, Prussia, on 7 January 1830, but he spent his early years in New Bedford, Massachusetts, where his parents settled two years after his birth. In the city that had become the capital of America's whaling industry, Henry Bierstadt, the artist's father, found work as a cooper.

Primarily self-taught, Albert Bierstadt began his professional career in 1850 when he advertised his services as a drawing instructor. Three years later, he departed for Europe, hoping that Johann Peter Hasenclever (1810–1853), a distant relative and a prominent member of the Düsseldorf school of artists, would help him obtain formal instruction. Unfortunately, Hasenclever died suddenly, shortly before Bierstadt's arrival. When Emanuel Leutze (1816–1868) and Worthington Whittredge (1820–1910) came to his aid, Bierstadt found, unexpectedly, American rather than German mentors.

After nearly three years in Düsseldorf, Bierstadt joined Whittredge on an extended sketching tour through Germany, Switzerland, and Italy. Following

a winter in Rome and a sketching tour to Naples and Capri, Bierstadt returned to New Bedford in the autumn of 1857. The "timid, awkward, unpolished specimen of a Yankee" who had arrived in Düsseldorf in 1853 returned to New Bedford a socially poised and technically mature painter.

In the spring of 1858 Bierstadt made his New York debut when he contributed a large painting of Lake Lucerne and the Swiss Alps to the annual exhibition at the National Academy of Design. Critics were dazzled by his technical expertise; within weeks he was elected an honorary member of the Academy.

Bierstadt's European apprenticeship served him well the following spring when he journeyed west for the first time, joining Frederick W. Lander's survey party bound for the Rocky Mountains. Although not the first artist to see or even paint the Rockies, Bierstadt was the first to bring with him superior technical skills and considerable experience in painting European alpine peaks. For Americans eager finally to see the mountains that a generation of travelers had described as "America's Alps," Bierstadt's credentials were near perfect.

By late September 1858, Bierstadt had returned to New Bedford laden with field sketches, stereo photographs, and Indian artifacts. Within three months, he moved to New York, established himself in the Tenth Street Studio Building, and began to exhibit the western paintings that would soon make his reputation. He completed the most important of these, *Rocky Mountains* (fig. 3, p. 44), in the spring of 1863, just weeks before he set off on his second journey west.

Accompanied by Fitz Hugh Ludlow, a celebrated writer who later published a book on their overland adventure, Bierstadt traveled to the Pacific Coast. He spent several weeks in Yosemite Valley, completing the *plein-air* studies he would later use to compose several of his most important paintings. Following a trip north through Oregon to the Columbia River, Bierstadt and Ludlow returned east. Using studies gathered during all stages of his journey, Bierstadt completed, by the end of the decade, a remarkable series of large-scale paintings, including *Looking Down Yosemite Valley, California* (fig. 5, p. 18), *Storm in the Rocky Mountains, Mt. Rosalie* (1866, The Brooklyn Museum of Art), *The Domes of the Yosemite* (1867, St. Johnsbury Atheneum, Vermont), and *Among the Sierra Nevada Mountains, California* (1868, National Museum of American Art, Washington, D.C.), that not only secured his position as the premier painter of the western American landscape but also offered a war-torn nation a golden image of their own promised land.

In 1867, Bierstadt and his bride, Rosalie Osborne (1841–1893), set sail for London. It was a triumphant return for the emigrant's son who had arrived in Europe fourteen years earlier an eager but impoverished student. Six months later he was invited to exhibit two of his most important paintings, *Rocky Mountains* and *Storm in the Rocky Mountains, Mt. Rosalie* (both had been purchased by English railroad entrepreneurs), privately before Queen Victoria. During the more than two years he remained abroad, Bierstadt traveled, sketched, and cultivated the friendships that would sustain a European market for his work for many years.

In July 1871, Bierstadt and his wife journeyed to San Francisco aboard the recently completed transcontinental railroad. Apart from the artist's brief return to New York that autumn, they remained in California until October 1873. As he had since his days in Düsseldorf, Bierstadt spent much of his time traveling in remote regions making field studies that he would later use to compose studio paintings.

In the autumn of 1876, Rosalie, who had been diagnosed as consumptive and advised to spend the winter months in a warm climate, made the first of several increasingly lengthy trips to Nassau. Although Bierstadt continued to maintain his New York studio and travel widely in the west and Canada, he found new subject matter in the tropics during visits with his wife. In 1880, he exhibited one of the most successful of these pictures, *The Shore of the Turquoise Sea* (1878, private collection), at the National Academy of Design. Though praised by some, the painting drew fire from critics who had found fault with Bierstadt's "theatrics" as early as the 1860s.

Critical disfavor and a falling market plagued Bierstadt during his later years. The most telling blow came in 1889 when the American committee charged with selecting works for the Exposition Universelle in Paris rejected Bierstadt's entry, *Buffalo Trail: The Impending Storm (The Last of the Buffalo)* (plate 50). Described as too large but more likely judged old-fashioned, the painting marked the end of Bierstadt's remarkable series of monumental western landscapes. On canvases that matched in scale the landscapes they depicted, Bierstadt's Rocky Mountain and Sierra views mirrored the ambitions of a nation that celebrated with equal fervor the beauty of the land and the commercial potential of its resources.

Bierstadt died suddenly in New York on 18 February 1902, largely forgotten. Ironically, renewed interest in his work was sparked by a series of exhibitions in the 1960s, highlighting not the great western paintings but rather the small oil sketches he had used as color notes for the panoramic landscapes that had brought him such success in the 1860s. *AP*

Further Reading
Gordon Hendricks, *Albert Bierstadt: Painter of the American West,* New York 1973; Nancy K. Anderson and Linda S. Ferber, *Albert Bierstadt: Art & Enterprise,* exhib. cat., The Brooklyn Museum of Art, 1990.

George Caleb Bingham
1811–1879

George Caleb Bingham was born on 20 March 1811 in Augusta County, Virginia. In 1819 the Bingham family migrated to Franklin in the Missouri Territory. Using art instruction books and engravings, Bingham taught himself to draw and compose and by 1834 was painting portraits in St. Louis. In 1838

Bingham traveled to Philadelphia and New York to further his career and that year submitted six paintings to the National Academy of Design's annual exhibition. From 1841 to 1844, he resided in Washington, D.C., where he was commissioned to paint the portraits of many of the leading political figures of the day, including Daniel Webster and John Quincy Adams.

Upon returning to Missouri in 1844, Bingham began creating the classically ordered depictions of frontier life for which he is best known. Among the twenty paintings he submitted to the annual exhibitions of the American Art-Union from 1845 to 1852 were many of his greatest western scenes such as *Fur Traders Descending the Missouri* (1845, The Metropolitan Museum of Art, New York), *The Jolly Flatboatmen* (fig. 9, p. 29), and *Country Politician* (1849, The Fine Arts Museums of San Francisco). In addition to its annual shows, the Art-Union further secured Bingham's reputation by engraving many of his works and distributing thousands of prints to subscribers around the country.

After the demise of the Art-Union in 1852, Bingham personally directed the production of lithographs and engravings of his paintings. That year *The Emigration of Daniel Boone* (1851–52, Washington University Art Gallery, St. Louis) was published by Goupil and Co. in New York and Paris. Bingham commissioned John Sartain of Philadelphia to engrave a copy of *The County Election* (1851–52, The Saint Louis Art Museum, St. Louis) in 1852 while he toured the south with the original version (1852, Boatmen's National Bank of St. Louis).

In 1856, supported in part by a commission from the Missouri state legislature for portraits of Washington and Jefferson, Bingham traveled to Paris to oversee the engraving of his works there. In November he established a studio in Düsseldorf with the assistance of the American expatriate painter Emanuel Leutze (1816–1868). Among the paintings Bingham executed in Germany from 1856 to 1859 were the Washington and Jefferson commissions as well as *Jolly Flatboatmen in Port* (1857, The Saint Louis Art Museum), his last important depiction of the subject, which, in contrast to the classicizing treatment of the 1846 version, he rendered in the more polished, dramatic style of the Düsseldorf school.

In addition to his painting career, Bingham also had a lifelong interest in politics and government service. In 1848, he was elected as the Whig candidate to the Missouri state legislature, and during his final years he capitalized on his reputation as the "Missouri artist" to obtain various government positions. In 1862, he was appointed Treasurer of Missouri and in 1875 was designated adjutant General of Missouri and given a professorship in art at the University of Missouri. Bingham's last major work was a Civil War subject, *Order No. 11* (fig. 9, p. 231). He died in Kansas City, Missouri on 7 July 1879. *CB*

Further Reading

E. Maurice Bloch, *The Paintings of George Caleb Bingham: A Catalogue Raisonné*, Columbia 1986; Michael Shapiro et al., *George Caleb Bingham*, St. Louis and New York 1990.

George Catlin
1796–1872

George Cat0lin was born in Wilkes-Barre, Pennsylvania, on 26 July 1796. After studying law in Litchfield, Connecticut, and practicing for two years, Catlin moved to Philadelphia to become an artist. Self-taught, Catlin worked as a portrait and miniature painter in Philadelphia, New York, and Richmond, Virginia, between 1823 and 1829. Based on his success in these early endeavors, he was elected to membership in the Pennsylvania Academy of Fine Arts in 1824.

Inspired by an encounter with a delegation of Plains Indians in Philadelphia, Catlin decided to devote his career to the documentation of the appearance and customs of Native Americans. In 1830, he began working in and around St. Louis, where he was introduced to several tribes by General William Clark, co-leader of the Lewis and Clark Expedition and then Superintendent of Indian Affairs for the western tribes. During six years of travel, Catlin visited some forty-eight tribes and produced nearly 500 portraits and scenes of American Indian life west of the Mississippi, including dances, religious cermonies, and buffalo hunts. He also collected costumes, weapons, and other Indian objects. Catlin's extensive and realistic depiction of the physical and cultural distinctions between members of different tribes resulted in works of art that are also invaluable historical and ethnographic documents. In his published works, he asked that his paintings be judged not on the basis of their artistic merit, but "as a record of a vanishing race."

In 1837, Catlin began to exhibit and lecture on his "Indian Gallery," first in New York, and later in Washington, D.C., Baltimore, Philadelphia, and Boston. Two years later, Catlin took his collection to London, where he also published an account of his travels, entitled *Letters and Notes on the Manners, Customs, and Condition of the North American Indians.* While in England, Catlin organized staged re-creations of Indian rituals, first using white men, and later, Ojibwa and Iowa warriors. In 1845, Catlin took his show to Paris, where King Louis-Philippe offered him gallery space in the Louvre for several weeks and commissioned Catlin to create a series of paintings commemorating LaSalle's seventeenth-century exploration of North America.

By 1852, following many unsuccessful attempts to convince the United States government to buy his collection, Catlin had fallen deeply into debt and was forced to sell his Indian Gallery to the American manufacturer Joseph Harrison, whose heirs later donated the paintings to the Smithsonian Institution. In the mid-1850s, Catlin journeyed to South America, where he completed a number of paintings of South American Indians as well as landscapes. During the 1860s, Catlin lived in Brussels, where he continued to publish accounts of his travels and where he created a second collection of almost 600 paintings, which included images of both North and

South American Indians derived from his travel in South America, and also from notes and sketches for his North American Indian studies of the 1830s.

After an absence of thirty-two years, Catlin returned to America in 1870. He exhibited his new collection in New York and then in Washington, D.C., until he fell ill in the fall of 1872. He died in Jersey City, New Jersey, on 23 December 1872, at the age of seventy-seven. *HA*

Further Reading

Harold McCracken, *George Catlin and the Old Frontier*, New York 1959; William H. Truettner, *The Natural Man Observed: A Study of Catlin's Indian Gallery*, Washington 1979.

William Merritt Chase
1849–1916

William Merritt Chase was born in Williamsburg (later Ninevah), Indiana, on 1 November 1849, the oldest of the six children of Sarah Swaim Chase and her husband, David Hester Chase. The family moved to Indianapolis when William was twelve years old. His father had hoped that the young man would follow him into the women's shoe business, but Chase, who said "the desire to draw was born in me," resisted his father's commercial ambitions in favor of his own artistic ones. His artistic training began in 1867, when he received instruction from Indianapolis artist Barton S. Hays, and was followed two years later with study at the National Academy of Design in New York under Lemuel P. Wilmarth (1835–1918). In 1871, Chase moved to St. Louis, where he painted still lifes professionally. He attracted the attention of local patrons, who, in the autumn of 1872, offered to send him abroad to further his education. In his response, Chase expressed an essential aspiration of his artistic generation when he said, "My God, I'd rather go to Europe than go to heaven." He chose to study at the Royal Academy in Munich, and his time there formed the most decisive part of his artistic training. The bold and brilliant painterly style he learned in Munich was permanently influential, as were the Old Master paintings he had seen for the first time in Europe, which he compared to "being converted to a religion." Chase was one of a sizable group of Americans then studying in Munich, including Frank Duveneck (1848–1919) and later John Twachtman (1853–1902). After an extended visit to Venice with Duveneck and Twachtman in 1878, Chase returned to New York, where he began teaching at the newly founded Art Students League. He devoted much of his time and energy to teaching—at, in addition to the league, the Brooklyn Art Association, the Pennsylvania Academy of the Fine Arts, as well as the Shinnecock Summer School of Art and the New York School of Art, both of which he founded—and was the most celebrated teacher of his time. As a leader of the insurgent younger painters who challenged the authority of the

National Academy of Design, he was a founding member of the Society of American Artists and, in 1880, was elected its president. His large, sumptuously decorated studio in the Tenth Street Studio Building, which he occupied soon after his return to New York, was the most famous artist's studio in America and an arena for his and his generation's artistic practices and beliefs, and evidence of the dignity of artistic calling. In 1886, he married Alice Gerson, who frequently served as his subject (in *A Friendly Call* for instance), as did their many children. Working with equal brilliance in oil and pastel, Chase painted a wide range of subjects, figures, landscapes and cityscapes, studio interiors, still lifes, and, increasingly later in life, portraits.

Chase died in New York City in 1916. *AP*

Further Reading
Keith L. Bryant, *William Merritt Chase: A Genteel Bohemian,* Columbia 1991; Barbara Gallati, *William Merritt Chase,* New York 1995.

Frederic Edwin Church
1826–1900

Frederic Edwin Church was born in Hartford, Connecticut, on 4 May 1826, the only son of a wealthy businessman. Although his father had hoped he would become a physician or enter the world of business, Church persisted in his early desire to become a painter. In 1842–43, he studied in Hartford with Alexander H. Emmons (1816–1879), a local landscape and portrait painter, and Benjamin H. Coe (1799–after 1883), a well-known drawing instructor. In 1844, Church's father, at last resigned to his son's choice of career, arranged through his friend, art patron Daniel Wadsworth, two years of study under Thomas Cole (1801–1848). Church was thus the first pupil to be accepted by America's leading landscape painter, a distinction that immediately gave him an advantage over other aspiring painters of his generation. Early on, Church showed a remarkable talent for drawing and a strong inclination to paint in a crisp, tightly focused style. In 1845, he made his debut at the annual exhibition of the National Academy of Design in New York, where he would continue to show throughout his career. Two years later, four of his paintings were shown at the American Art-Union, which established him as one of the most promising younger painters in New York. In 1849, at the age of twenty-three, he was elected to full membership in the academy, the youngest person ever so honored.

During the late 1840s and early 1850s, Church experimented with a variety of subjects, ranging from familiar views of American scenery (*West Rock, New Haven,* 1849, New Britain Museum of American Art, Connecticut) to highly charged scenes of natural drama (*Above the Clouds at Sunrise,* 1849, Warner Collection of Gulf States Paper Corporation,

Tuscaloosa) to imaginary creations based on biblical and literary sources and much indebted to Cole (*The Deluge,* 1854, location unknown). Gradually, however, he began to specialize in ambitious works that combined carefully studied details from nature in idealized compositions that had a grandeur and seriousness beyond the usual efforts of his contemporaries.

Church traveled widely in search of subjects, first throughout the northern United States and then, in 1853, to South America. Inspired by the writings of the great German naturalist Alexander von Humboldt, he spent five months in Colombia and Ecuador. His first full-scale masterpiece, *The Andes of Ecuador* (1855, Reynolda House Museum of American Art, Winston-Salem), a 48 x 72-inch canvas depicting a vast tropical mountain panorama, astounded viewers with its combination of precise foreground detail and sweeping space. Two years later, the exhibition of *Niagara* (fig. 2, p. 44) in New York, London, and other cities secured Church's reputation as America's most prominent landscape painter. A second trip to South America took place in 1857 and resulted two years later in Church's most famous painting of the tropics, *Heart of the Andes* (1859, The Metropolitan Museum of Art, New York).

During the 1860s Church was at the height of his powers and created a remarkable series of large landscapes, including *Twilight in the Wilderness* (plate 45), *The Iceberg* (plate 48), *Cotopaxi* (1862, Detroit Institute of Arts), *The Aurora Borealis* (1865, National Museum of American Art, Washington, D.C.), and *Rainy Season in the Tropics* (1866, The Fine Arts Museums of San Francisco). He continued to travel, with important works resulting from trips to Jamaica in 1865 (*The Vale of St. Thomas, Jamaica,* 1867, Wadsworth Atheneum, Hartford) and to Europe and the Near East in 1867–68 (*Jerusalem from the Mount of Olives,* 1870, Nelson-Atkins Museum, Kansas City).

By the early 1870s, Church's reputation was in decline; American critics and patrons increasingly faulted his detailed and grand style as being out of touch with the times. Church devoted more and more of his time and energy to his family and to the construction and furnishing of Olana, his palatial home set high on a hill overlooking the Hudson. He painted relatively few important works after 1880, although he continued to produce wonderfully fresh oil sketches of the view from Olana in changing weather and light conditions into the 1890s. When he died on 7 April 1900, he was largely forgotten, and interest in his work only revived in the 1960s. He is now once again generally considered one of the most important proponents of landscape painting in mid-nineteenth-century America. *AP*

Further Reading
Franklin Kelly et al. *Frederic Edwin Church,* exhib. cat., National Gallery of Art, Washington, D.C. 1989; Gerald L. Carr, *Frederic Edwin Church: Catalogue Raisonné of Works of Art at Olana State Historic Site,* Cambridge and New York 1994.

James Goodwyn Clonney
1812–1867

James Goodwyn Clonney was probably born in Liverpool, England, on 12 January 1812. By about 1830, he had emigrated to America and was producing work for the lithographic firm of Mesier in New York and Childs and Inman in Philadelphia, including several contributions to the periodical *Cabinet of Natural History and American Rural Sports* (Childs and Inman, 1830 and 1832). In 1833, he won the second premium at the National Academy of Design for a drawing. The following year, he was made an associate member of the Academy and from 1834 to 1841 exhibited portraits, landscapes, and miniatures in their annual exhibitions. None of the works exhibited at the National Academy from 1834 to 1841 nor any paintings before 1830 by the artist have been identified. From 1841 to 1852 Clonney's genre paintings were shown at the National Academy of Design, as well as the Apollo Association, the American Art-Union, and the Pennsylvania Academy of the Fine Arts.

Clonney was married to Margaret Mesier of the lithographic firm's family in 1836 and obtained his naturalization papers in 1840. Between 1834 and 1852, the year the American Art-Union was dissolved and the final year he participated in the National Academy of Design's annual exhibition, he lived in Peekskill and New Rochelle, New York. By July 1852, Clonney had moved to Cooperstown, New York, where he purchased property. At the time of his death in 1867, he was residing in Binghamton, New York.

While the nature of Clonney's early training and the influence of other painters is not well understood, works such as *In the Woodshed* (1838, Museum of Fine Arts, Boston) and *Waking Up* (plate 25) find clear parallels in the genre paintings of William Sidney Mount (1807–1868). (A critic for the *Knickerbocker* in June 1847 noted that "Clonney is treading in the footsteps of Mr. Mount.") Clonney may also have been familiar with the work of American genre painters such as George Caleb Bingham (1811–1879) and Richard Caton Woodville (1825–1855), as well as British genre scene painters such as George Cruikshank (1792–1878) and David Wilkie (1785–1841) through widely distributed engravings of their work. The M. and M. Karolik Collection of American Paintings at the Museum of Fine Arts, Boston, with six paintings and sixty-seven drawings, is the most important repository of his work. *CB*

Further Reading
M. and M. Karolik Collection of American Paintings, 1815–1865, Boston 1949.

Thomas Cole
1801–1848

Thomas Cole, America's leading landscape painter during the first half of the nineteenth century, was born on 1 February 1801 in Bolton-le-Moor, England.

Before emigrating with his family to the United States in 1818, he served as an engraver's assistant and as an apprentice to a designer of calico prints. Cole worked briefly as an engraver in Philadelphia before joining his family in Steubenville, Ohio, in 1819. While in Ohio, he apparently learned the rudiments of oil painting from an itinerant portrait painter named Stein. In 1823, during a stay in Pittsburgh, Cole began drawing from nature, creating closely observed, intensely expressive images of trees and branches. Later that year, he returned to Philadelphia, where he studied at the Pennsylvania Academy of the Fine Arts and worked in a variety of art-related jobs.

His family relocated to New York, and after joining them in April 1825 Cole spent the summer on an extensive sketching tour up the Hudson River and into the Catskill Mountains. In late October 1825, three of his landscapes—*Lake with Dead Trees* (1825, Allen Memorial Art Museum, Oberlin College, Oberlin, Ohio), *View of Fort Putnam* (location unknown), and *Falls of Kaaterskill* (fig. 2, p. 24)—were sold to three prominent figures in the young nation's art community, John Trumbull (1756–1843), William Dunlap (1766–1839), and Asher B. Durand (1796–1886). In January 1826, Cole was a founding member of the National Academy of Design, and his works were increasingly in demand with leading patrons such as Daniel Wadsworth (1771–1848) of Hartford and Robert Gilmor, Jr. (1774–1848) of Baltimore.

Although Cole had ample commissions in the late 1820s to paint pictures of American scenery, his ambition was to create a "higher style of landscape" that expressed moral or religious meanings. His first major efforts in this vein, *The Garden of Eden* (1827–28, Amon Carter Museum, Fort Worth) and *The Expulsion from the Garden of Eden* (1828, Museum of Fine Arts, Boston), met with mixed reviews, and he decided that study and travel in Europe were necessary. In June 1829, Cole sailed for England, where he studied the works of Old Masters and met Joseph Mallord William Turner (1775–1851) and John Constable (1776–1837), before continuing on to France and then Italy, with lengthy stays in Rome and Florence. While in Italy he conceived of a multipart landscape series, tracing the rise and fall of an archetypal civilization. Although he failed to interest Gilmor in commissioning the series, upon his return to America in 1832, Cole convinced retired New York merchant Luman Reed (1785–1836) to support his grand project. The result, the five-canvas *The Course of Empire* (figs. 3–7, pp. 25–27), was completed in 1836 and received considerable popular attention and generally favorable reviews.

Cole continued to paint American landscapes in the 1830s and early 1840s, but much of his energy went into the creation of complex imaginary works such as *Departure and Return* (1837, The Corcoran Gallery of Art, Washington, D.C.) and the two versions of *The Voyage of Life*. In 1836, he married Maria Barstow and settled in Catskill, New York, a small village on the west side of the Hudson and close to the mountains. That same year Cole, who was a prolific writer of prose and poetry throughout his career, published his "Essay on American Scenery" in the *American Monthly Magazine*, in which he expressed many of his most deeply felt convictions about landscape painting.

In 1841, Cole made a second trip abroad, with extensive travel in Italy, including a memorable visit to Sicily that resulted in several views of Mount Etna. He returned to Catskill in 1842; in 1844, on Daniel Wadsworth's recommendation, he accepted the young Frederic Edwin Church (1826–1900) as a pupil. In the mid and late 1840s, Cole painted many impressive American landscapes, such as *View of the Falls of Munda* (1847, Museum of Art, Rhode Island School of Design), which are notable for an increased accuracy in the depiction of atmosphere and light. At the same time he labored, ultimately without success, to complete a five-part series called *The Cross and the World*, in which he endeavored to portray the individual's quest for spiritual knowledge and salvation.

Cole's death on 11 February 1848 at the age of forty-seven was universally mourned, and a comprehensive memorial exhibition of his work was quickly organized in New York. His influence on the course of American landscape painting was profound and his works influenced numerous young painters who matured in the late 1840s and early 1850s, most notably Jasper F. Cropsey and Frederic Edwin Church. *AP*

Further Reading
Ellwood C. Parry, *The Art of Thomas Cole: Ambition and Imagination*, Newark 1988; William H. Truettner and Alan Wallach, *Thomas Cole: Landscape into History*, exhib. cat., The National Museum of American Art, Washington, D.C. 1994.

John Singleton Copley
1738–1815

Boston-born John Singleton Copley was the most talented artist in colonial America. He was trained in the arts by his step-father Peter Pelham (c. 1697–1751), an English engraver who emigrated to Massachusetts in 1727 and married Copley's widowed mother in 1748. Copley's artistic talents were extraordinary: he was a bold colorist, and portrayed faces and fabrics in such a realistic style that the sitters seem alive today. His earliest paintings, dating from the mid-1750s, reveal the influence of English mezzotint portraits as well as the work of local and itinerant artists. As he became experienced with composition, he combined elements of poses and backgrounds to produce his own versions of English portraiture. His ambitions, fed by reading European literature on art, led him to experiment with several media in addition to oil on canvas, notably oil on copper, watercolor on ivory, and pastel. By the late 1750s, he was well established as a portrait painter.

Copley's boldest American portraits date from the ten-year period beginning in the mid-1760s. Eager to compare his work with that of contemporaries in England, he sent *Boy with a Squirrel* (fig. 5, p. 212), a portrait of his half-brother Henry Pelham, to London in 1765 to the annual exhibition of the Society of Artists of Great Britain. It was so similar to the work

of Joseph Wright of Derby, an English contemporary, that the painting was at first thought to be Wright's. Benjamin West (1738–1820) and Joshua Reynolds (1723–1792) praised Copley's achievement and advised that a trip to Europe would be beneficial, particularly to his technique, which, with its emphasis on contours and details, was judged to be hard.

With the exception of a six-month painting trip to New York City in 1771, Copley worked in Boston until 1774. At a time of political unrest that would soon culminate in the outbreak of fighting between the British and the colonists, he left for London. He went almost immediately to Italy, where he spent more than a year studying art and painting commissioned copies and portraits. When he returned to London in 1775, he rejoined his wife and three of his children, who had left Boston to escape the hostilities of the American Revolution. By then he had decided to settle permanently in England, for artistic as well as, apparently, for political reasons.

The year 1776 marks the beginning of the English half of Copley's life. In 1777, he exhibited *The Copley Family* (fig. 6, p. 213) as his first work at the Royal Academy of Arts, followed by *Watson and the Shark* (plate 4) in 1778. The success of these paintings brought him the praise of reviewers and earned him full membership in the Academy. His ambition to produce large history paintings of contemporary events, like those by Benjamin West, led him to paint *The Death of the Earl of Chatham* (1779–81, Tate Gallery, London), *The Death of Major Peirson* (1782–84, Tate Gallery, London), and *The Siege of Gibraltar* (1783–91, Guildhall Art Gallery, London). All three works were exhibited independently of the Royal Academy, and all three involved patronage from merchants in the City of London, a fitting source of support for the American painter who had initially found his clientele among the mercantile class of Boston. He also painted portraits in England, many on a much larger scale than his American work. Throughout his English career, he retained the ability to depict faces and fabrics with great immediacy, while he learned to compose more complex paintings. The brightness of the colors in his work may be due to his continued practice of using an untinted white or off-white ground.

Copley's American work so epitomizes the colonial era that his shift to an English manner is difficult for many American viewers to accept. This is due to the outstanding quality of his American portraits and to the political significance of his sitters, many of whom were among the most famous people of their era, including Paul Revere, John Hancock, Samuel Adams, and Mercy Otis Warren. It is easier to understand his transformation if his move to London is viewed as an indication of his ambitions as a painter. His letters to his half-brother and other family members, written in 1774–75, reveal the excitement of the discoveries about painting that he made in Europe. Like other artists who began their careers in provincial English cities, Copley was attracted to London because of its sophisticated patronage and its competitive arena. His decision to remain there stemmed primarily from his artistic ambitions.

AP

Further Reading
Jules David Prown, *John Singleton Copley*, 2 vols., Cambridge 1966.

Thomas Wilmer Dewing

1851–1938

Thomas Dewing was born on 4 May 1851 in Newton Lower Falls, Massachusetts. As a child, he was interested in both drawing and playing the violin; this early interest in music would later reappear in the themes of many of his paintings. By 1872, after a period of apprenticeship in a lithography shop, Dewing was listing his profession as "artist." He studied paintings in the collection of the Museum of Fine Arts, Boston, especially the works of Jean-Baptiste Siméon Chardin (1699–1779), and attended student-organized life classes at the Boston Art Club and possibly the lectures on anatomy given in Boston by artist William Rimmer (1816–1879) in 1874–75. After working briefly in Albany, he sailed for Europe in July 1876 and entered the Académie Julian. There the course of instruction under Gustave Boulanger (1824–1888) and Jules-Joseph Lefebvre (1836–1911) centered on anatomical drawing and modeling. While in Paris, Dewing became acquainted with William Merritt Chase (1849–1916), who was studying at the Royal Academy in Munich, and both men shared a developing interest in Spanish painting.

Dewing returned to America early in 1878, stopping first in New York, and subsequently became an assistant at the newly founded school of the Museum of Fine Arts, Boston. In the late 1870s, he participated in several Boston exhibitions, showing paintings that recalled the fashionable academic works of French artists such as Jean-Léon Gérôme (1824–1904) and Jean-Louis Hamon (1821–1874). Deciding that New York provided greater opportunities for an aspiring artist, Dewing moved there in 1880, took a studio on Fifty-Seventh Street, and soon came into contact with many of the young artists who had formed the Society of American Artists out of dissatisfaction with the National Academy of Design. He was elected a member of the society in 1880 and in 1881 began teaching at the Art Students League, where he renewed his friendship with Chase. In 1881, he married artist Maria Oakey, through whom he had been introduced to an active cultural circle that included painters Abbott H. Thayer (1849–1921) and John La Farge (1835–1910). In 1886, the Dewings moved to the famous Tenth Street Studio Building; his works were exhibited regularly in New York shows and elsewhere.

By the late 1880s, Dewing had formed his basic style and subject matter—elegant, refined women portrayed with an extremely limited range of colors and placed in sparse interiors or outdoors in soft green fields. He drew inspiration from the lyrical paintings of Johannes Vermeer (1632–1675) and from the aesthetics of James McNeill Whistler (1834–1903) and English artist Albert Moore (1841–1893). His brushwork became increasingly soft and blurred.

In December 1897, Dewing resigned from the conservative Society of American Artists and joined a group of Boston and New York painters who formed The Ten. Most of The Ten worked in an Impressionist style that had little in common with Dewing's more subdued technique. Dewing continued to paint in the early years of the twentieth century, receiving several awards and enjoying the patronage of such noted collectors as Charles L. Freer and John Gellatly. He did little work during the last decade of his life and died at the age of eighty-seven in New York on 5 November 1938.

AP

Further Reading
Susan Hobbs, "Thomas Wilmer Dewing: The Early Years, 1851–85" in *American Art Journal* 13 (Spring 1981): 4–35; Susan Hobbs, "Thomas Dewing in Cornish, 1851–1905" in *American Art Journal* 17 (Spring 1985): 3–32.

Asher Brown Durand

1796–1886

Asher B. Durand was born on 21 August 1796 in Jefferson Village (present-day Maplewood), New Jersey, and studied engraving with his father, a watchmaker and silversmith. Following a five-year apprenticeship with New Jersey engraver Peter Maverick (1780–1831), he and Maverick formed a partnership in 1817 and opened a branch of the firm in New York. Around 1818, Durand began informal study at the American Academy of Fine Arts, where he made drawings of plaster casts. His work came to the attention of the Academy's president, John Trumbull (1756–1843), who in 1820 commissioned Durand to engrave his painting *The Declaration of Independence* (fig. 1, p. 33). Durand became a leading engraver and enjoyed considerable success producing bank notes, book illustrations, portraits, and copies after other artists' works.

In the 1820s and 1830s, Durand opened a series of printmaking firms and was active in New York cultural circles. In 1825, he helped organize the New York Drawing Association, which in 1826 became the National Academy of Design, with Durand as one of fifteen founding members. In these same years he was also involved with several other arts groups, including James Fenimore Cooper's Bread and Cheese Club and the Sketch Club.

In the early 1830s, Durand worked less frequently as an engraver and began painting portraits. Around 1835, inspired by Thomas Cole (1801–1848) and encouraged by prominent New York merchant and art patron Luman Reed (1785–1836), Durand ended his career as an engraver in favor of painting. Continuing to produce portraits, he also created in the mid-1830s a number of paintings based on historical subjects and genre themes. In 1837, he accompanied Cole on a sketching trip to the Schroon Lake region in the Adirondacks, and the following year he contributed nine landscapes to the annual National Academy of Design exhibition. In 1838 and 1839, he again made summer sketching trips and contributed landscapes to the Academy exhibitions. In 1840, he exhibited *Landscape, Composition, Morning* and *Landscape, Composition, Evening* (both National Academy of Design, New York), an allegorical pair inspired by Cole.

In the summer of 1840, Durand went with fellow artists John F. Kensett (1816–1872), John Casilear (1811–1893), and Thomas P. Rossiter (1818–1871) to Europe, where he studied the works of Old Masters, especially Claude Lorrain (1600–1682). Upon his return to New York in July 1841, he exhibited paintings of European scenery, but soon resumed summer sketching tours in the Catskills and the Hudson River Valley. In 1845, Durand was elected president of the National Academy, a position he would hold until 1861. He increasingly believed that direct study of nature should be the primary inspiration for American artists and began producing meticulously painted works such as *The Beeches* (fig. 8, p. 214) that were much admired for their faithful depictions of light, atmosphere, and natural forms. These works also expressed sentiments similar to those of the poetry of his friend William Cullen Bryant, several of his paintings of the 1850s being directly inspired by Bryant's poems.

Following Cole's death in 1848, Durand assumed a leading role in the American landscape school and exerted a considerable influence on younger painters. His *Kindred Spirits* (1849, New York Public Library), painted in memory of Cole, almost immediately became one of the best-known paintings in the country. By the 1850s, Durand had perfected the two compositional types that became basic to Hudson River School painting, the vertical forest interior—epitomized by *In the Woods* (fig. 10, p. 30)—and the landscape panorama—a typical example is *View toward the Hudson Valley* (1851, Wadsworth Atheneum, Hartford). With the publication of nine "Letters on Landscape Painting" in *The Crayon* in 1855, Durand codified the tenets and practices of the Hudson River School as instructions addressed to an imaginary student. Espousing theories similar to those held by influential British critic John Ruskin (1819–1900), he advised American painters to work directly from nature and to give precedence to New World subjects over European ones.

In April 1869, Durand moved from New York to a new house and studio built on family property in Maplewood, where he lived for the rest of his life. He continued to paint, and most of his works of the 1870s (his last picture was completed in 1878) repeated compositions from earlier decades, although often with a more atmospheric and tonal handling of light. He died on 17 September 1886.

AP

Further Reading
Daniel Huntington, *Asher B. Durand: A Memorial Address*, New York 1887; John Durand, *The Life and Times of A.B. Durand*, New York 1894; David B. Lawall, *Asher B. Durand: His Art and Theory in Relation to His Times*, New York 1977.

Thomas Eakins
1844–1916

Although today Thomas Eakins is considered one of the foremost American realists of the nineteenth century, he spent the greater part of his long career struggling for critical and public recognition. Born in Philadelphia on 25 July 1844, Eakins lived and worked in the city his entire life. He studied art at the Pennsylvania Academy of the Fine Arts and simultaneously attended anatomy classes at Jefferson Medical College in Philadelphia. From 1866 to 1870, Eakins took the obligatory artist's trip to Europe, where he studied painting and sculpture with several French academicians, most notably Jean-Léon Gérôme (1824– 1904), Augustin Dumont (1801–1884), and Léon Bonnat (1833–1922). During his last winter in Europe, he traveled to Madrid and Seville to study the Spanish Old Masters and was particularly impressed by the naturalism of works by Velázquez.

Shortly after his return to the United States, Eakins began a series of paintings of men engaged in outdoor athletics, the most celebrated of which is *The Champion Single Sculls (Max Schmitt in a Single Scull)* (fig. 9, p. 224) from 1871. Eakins' portrayals of athletes were among the first depictions of urban-recreational scenes in American art and may be related to the increasing popularity of physical exercise at the time. These paintings reveal Eakins' considerable interest in perspective and structural form and provided him with an opportunity to study and paint the human figure.

Eakins was a painter of objective realities firmly grounded in his own values and personal experiences. His portraits rarely idealize the sitter, a fact that often made his contemporary viewers uncomfortable and attracted few commissions. In 1876, he submitted *The Gross Clinic* (fig. 10, p. 49), an ambitious composition of Dr. Samuel Gross operating on a patient in the surgical amphitheater of the Jefferson Medical College, to the Centennial Exhibition in Philadelphia. Although Eakins intended the painting to be a portrait of a scientific hero (a theme in keeping with the Centennial's celebration of the nation's progress in science and technology), the painting's graphic portrayal of an unconventional contemporary subject resulted in the work being rejected for the art exhibition and hung instead amidst a display of modern medical equipment in the U.S. Army Post Hospital pavilion. Most critics of the day lambasted the painting; one reviewer remarked that the work was "decidedly unpleasant." Shortly thereafter Eakins finished *William Rush Carving His Allegorical Figure of the Schuylkill River,* which featured a female nude with her back to the viewer. Although in the painting the model is accompanied by a chaperone, a nude such as this was nearly unprecedented in American art, and the critics again lashed out at Eakins' choice of subject. While critics often objected to Eakins' subjects, however, they praised his technical ability, especially his expressive brushwork.

A renowned teacher, Eakins taught at the Pennsylvania Academy of the Fine Arts from 1873, until he was forced to resign in 1886 over his radical teaching methods, which included removing the loincloth of a male model in a life-drawing class attended by women. The intervening years were extremely productive for Eakins. Possibly as a result of the negative reception of *The Gross Clinic,* Eakins painted a series of nostalgic genre pictures of women engaged in domestic chores and toga-clad youths in Arcadian landscapes that were completely devoid of controversy. However, his masterful painting *The Swimming Hole,* which provided the logical narrative context that Eakins demanded for his nudes, also dates from this period. Beginning in 1880, Eakins began to experiment with photography, both independently and as part of his painting process. He also experimented with watercolor, as well as plaster and bronze sculpture. In 1884, Eakins married fellow artist Susan MacDowell, who became one of her husband's most steadfast advocates.

In an effort to escape the scandal surrounding his departure from the Pennsylvania Academy of the Fine Arts, Eakins traveled to the Dakota territories in 1887. Following this trip, his painting style changed dramatically. Thin washes of nearly monochromatic paint replaced his earlier lush palette. In addition, a new level of abstraction characterizes these works; Eakins often painted whole backgrounds brown or gray, totally isolating his subject. After 1886, Eakins taught for six years at the Art Students League of Philadelphia. He also taught at the Drexel Institute until 1895. During the last decade of the century, Eakins concentrated on painting penetrating psychological portraits of friends and acquaintances, often working from photographs he had taken of his subjects. He frequently titled his portraits according to the sitter's profession or defining characteristic, such as *The Veteran, The Singer,* or *The Cello Player.*

Around 1900, Eakins again turned to sporting pictures, this time concentrating on boxing and wrestling scenes. He also returned to the subject of the sculptor William Rush (1756–1833) and the nude female model. Critical recognition came only at the close of Eakins' career. He was finally elected to the National Academy of Design in 1902. Two years later he won the Temple Gold Medal, the highest honor bestowed by the Pennsylvania Academy of the Fine Arts. Although the award was not well known outside Philadelphia, critics who had virtually ignored him to date began to pay closer attention to his work, eventually calling him "the Dean of American Painting" and the "foremost living American painter." Other artists, including John Singer Sargent (1856–1925) and Robert Henri (1865–1929) (the leader of a new generation of American realists), also wrote his praises. And for the first time in his career, collectors were interested in his work.

Eakins painted little after his health began to fail in 1910. He died in Philadelphia in June of 1916. The following year, the Metropolitan Museum of Art and the Pennsylvania Academy of the Fine Arts held separate memorial exhibitions in his honor. Thomas Eakins realized early in his career the importance of creating an art that was distinctly "American" and little dependent on the ideals of European art. Yet it was not until after 1930 that his work was compared to that of Winslow Homer and acknowledged as being both American and modern.

NM

Further Reading

Elizabeth Johns, *Thomas Eakins: The Heroism of Modern Life,* Princeton 1983; John Wilmerding, *Thomas Eakins (1844–1916) and the Heart of American Life,* exhib. cat., National Portrait Gallery, London 1993.

De Scott Evans
1847–1898

During his lifetime, De Scott Evans achieved modest acclaim as a genre and portrait painter. The course of his career as well as the character and diversity of the body of the work he created mirror the experiences of countless American painters who reached maturity immediately following the Civil War. Born David Scott Evans in Boston, Indiana, in 1847, Evans was the fifth of six children born to a country doctor and his wife. A cousin of Ohio painter Edward Edmondson, Evans seems to have received his first formal training in 1864 in the studio of a Cincinnati artist named Albert Beaugureau. In 1872, he married a young Ohio woman named Alice Josephine Burk(e) with whom he would have two daughters. Evans spent the early years of his career working as a teacher, beginning in 1872 as an instructor of music and art at Smithson College in Logansport, Indiana, and then from 1873 to 1875 as chairman of the Fine Arts Department of Mt. Union College in Alliance, Ohio. It was while at Mt. Union that Evans first adopted De Scott Evans as his professional name.

In 1874, Evans moved to Cleveland, Ohio, and opened a studio. He became a founding member of the city's first art club and served as the first teacher of future American Impressionist Otto Bacher. In 1877, Evans went to Paris to study with the renowned master of French academic painting, William Adolphe Bouguereau (1825–1905). After his return to Cleveland the following year, Evans established himself as a successful portrait and genre painter and in 1882 helped found the Cleveland Academy of Art, where he served as a co-director and instructor. As a painter, Evans was particularly well known for his portrayals of elegant young women at leisure and his consummate skill at painting the "stuffs" of costume. Inspired by leading painters of the era, most notably Winslow Homer (1836–1910), Eastman Johnson (1824–1906), and William Merritt Chase (1849– 1916), Evans worked in a number of mainstream styles. His career in Cleveland culminated in a commission to paint *Winter Evening at Lawnfield* (Western Reserve Historical Society, Cleveland), a commemorative portrait of President Garfield and his family.

In 1887, Evans moved to New York, where he joined the prestigious Salamagundi Club. He continued

to exhibit at the National Academy of Design as he had done since 1881. Evans also maintained ties to Cleveland and returned regularly to exhibit and to sell his work. In the summer of 1898, Evans accepted a commission that was to take him to Paris. He and his daughters drowned on July 4 when the steamer *La Bourgogne* collided with another ship and sank. After his death, his works quickly slipped into obscurity.

Current interest in the artist is centered almost exclusively on the attribution to Evans of a group of related, but variously signed, trompe l'oeil still lifes with which he is not known to have been publicly connected during his lifetime. The initial attribution in 1971 by art historians William Gerdts and Russell Burke was based on the discovery of a pair of nearly identical trompe l'oeil paintings of pears hanging from a string, one of which is signed De Scott Evans and the other Scott David. Unable to identify a late nineteenth-century artist named Scott David, Gerdts and Burke postulated that the two paintings were both by Evans and that "Scott David" was a witty pseudonym created from an inversion of the artist's given names to protect his reputation from the critical disdain trompe l'oeil painters often received.

The subsequent discovery of two still lifes of hanging apples, signed Stanley David and Scott David, and a pair of paintings depicting a hatchet hanging on a wall, signed D. Scott Evans and Stanley S. David, seemed a further substantiation of the link between Evans and David. The name S.S. David is also found on a number of trompe l'oeil paintings depicting almonds or peanuts trapped behind broken glass in a narrow wooden niche. One such almond picture is signed Stanley S. David, circumstantially suggesting that S. S. David, Stanley S. David, and Scott David were one and the same and that all three names were pseudonyms used by De Scott Evans as part of a clever game of deception.

The attribution, though generally accepted, is not as secure as it once seemed. The trompe l'oeil still lifes associated with this distinctive body of work now number more than fifty, with six versions of the David signature known. On one work, *Washington's Hatchet* (private collection), the name Stanley David even appears stamped or stenciled on the original canvas, raising the question why any artist would go to such lengths to preserve a ruse. Although the paintings continue to be linked by an original inventiveness and conceptual integrity, stylistic differences among the works have become apparent, suggesting that the hand of more than one artist was involved. Paintings by imitators and followers have also surfaced. Despite continued research, no external evidence to establish Evans as a trompe l'oeil painter has been discovered.

The image of Evans that has emerged from this research, however, is that of an artistic follower. To propose him as a trompe l'oeil innovator and the originator of an elaborate intellectual conceit that shielded a secret career seems increasingly inconsistent with what is known about Evans. Although no trompe l'oeil artist named Stanley S. David has been located either, the current inconclusive evidence leaves open the possibility that such an artist did exist and that he was one of the elusive practitioners of trompe l'oeil who are known to have worked unnoticed on the fringes of the official art world. *NM*

Further Reading
William H. Gerdts and Russell Burke, *American Still-Life Painting*, New York 1971; Nannette V. Maciejunes, *A New Variety Try One: De Scott Evans or S.S. David*, exhib. cat., The Columbus Museum of Art, 1986.

Sanford Robinson Gifford
1823–1880

Born in Greenfield, New York, on 10 July 1823, Sanford Robinson Gifford was raised in Hudson, New York, where his father established his own iron business. Gifford attended Brown University before moving to New York City in 1845 to study drawing and anatomy under John Rubens Smith. In 1846, Gifford toured the Catskills and Berkshires. Although he had had no specific training in the subject, he decided to devote himself to landscape painting.

The early influence of Thomas Cole on Gifford's work can be seen in paintings such as *Solitude* (1848, Art Complex Museum, Duxbury, MA) and *Summer Afternoon* (1853, The Newark Museum). Gifford did not, however, pursue Cole's interest in religious and allegorical subjects, but concentrated instead on the subtle effects of light. In 1847, Gifford began exhibiting his landscapes at the National Academy of Design, to which he was elected an associate in 1851 and an academician in 1854.

From 1855 to 1857, Gifford traveled throughout Europe. He met John Ruskin and studied the works of Turner and Constable while in England, and encountered French Barbizon painting at the Exposition Universelle in Paris. He toured northern Europe, Germany, and Switzerland before heading to Italy. Following a winter spent in Rome with Worthington Whittredge and Albert Bierstadt, Gifford traveled with Bierstadt to Naples and Capri, and then throughout northern Italy.

After returning to New York in 1857, Gifford rented space at the Tenth Street Studio Building in New York, which he occupied until his death. During the Civil War, Gifford served for three years in the Seventh New York Regiment in defense of Washington, D.C. In 1868, he made a second trip abroad, returning to Italy and continuing on to Egypt, Syria, Greece, and Turkey. Works produced during this trip, such as *Tivoli* (1869, The Metropolitan Museum of Art, New York) and *Siout, Egypt* (1874, National Gallery of Art, Washington, D.C.), demonstrate Gifford's fully developed interest in the luminous and unifying effects of light, color, and atmosphere. Gifford's mature works also indicate that, although often allied with the Hudson River School, he was less naturalistic and more open to experimentation with invented and expressive effects than his colleagues. As Gifford said himself,

"The really important matter is not the natural object itself, but the veil or medium through which we see it."

In 1870, Gifford traveled with Worthington Whittredge and John F. Kensett to the Colorado Rocky Mountains, where he joined Colonel Ferdinand Hayden's geological and geographical survey of Wyoming. He returned to the West in 1874, visiting California, Oregon, British Columbia, and Alaska. Gifford also spent time each year painting and fishing in Maine and Canada.

In 1880, Gifford's health began to fail. He and his wife of just three years were forced to return to New York from a trip made to Lake Superior in July of that year. Gifford died of malarial fever and pneumonia on 24 August. *HA*

Further Reading
Nicolai Cikovsky, Jr., *Sanford Robinson Gifford*, exhib. cat., The University of Texas, Austin 1970; Ila Weiss, *Poetic Landscape: The Art and Experience of Sanford Gifford*, Newark 1989.

John Haberle
1856–1933

John Haberle was perhaps the wittiest of the trompe l'oeil painters who gained popularity in the last quarter of the nineteenth century. The son of German immigrants, Haberle was born in 1856 in New Haven, Connecticut, the city in which he would spend most of his life. At the age of fourteen, he was apprenticed to a local lithography firm. From 1874 to 1880 he worked as a lithographer for various companies, first in New Haven and then in Montreal, Providence, Rhode Island, and New York City. In 1880, Haberle returned to New Haven and for the next four years worked as an exhibition preparator for the noted paleontologist Othniel Charles Marsh at Yale University's Peabody Museum. A gifted draftsman, Haberle continued to work as a freelance lithographer during this period and is believed to have contributed illustrations to Marsh's publications. In 1883, Haberle became a founding member of the New Haven Sketch Club and the following year enrolled at the National Academy of Design in New York. His single year of study there seems to have been the only formal training Haberle was ever to receive. By 1885, he had returned to New Haven and opened a studio in his home. He returned to work at the Peabody, but also attempted to make a living as an artist, advertising his services for "artistic and commercial drawing and designing—illustrating, lithographing, drawing in wood, and instruction."

Haberle's fascination with trompe l'oeil illusionism dates from the first years of his career. Two of his earliest surviving drawings and his first oil, a self-portrait, all dated 1882, include prominent trompe l'oeil elements. His reputation as a trompe l'oeil

painter was established in 1887 when his painting *Imitation*, an illusionistic still life of paper money, coins, postage stamps, and other paper ephemera, was exhibited at the National Academy of Design and purchased by the noted American art collector Thomas Clarke. By 1890, Haberle was recognized as the creator of some of the era's cleverest and most humorous trompe l'oeil paintings. After his debut at the National Academy of Design, he exhibited at other annuals, including the Art Institute of Chicago, the Pennsylvania Academy of the Fine Arts, and in six of James D. Gill's annuals in Springfield, Massachusetts. Like most trompe l'oeil painters of his day, however, his works were more likely to be found in the saloons, restaurants, hotels, theaters, and private homes of the businessmen who enjoyed the sly visual tricks on which the paintings were predicated. Around 1890, for example, Frederick McGrath, the owner of a Boston liquor store, held a public exhibition in his store of his own collection of Haberle paintings.

Haberle's works are distinguished by their use of visual and verbal puns, as well as their strong self-referential and autobiographical character. Major paintings such as *Changes of Time* (The Metropolitan Museum of Art) and *Bachelor's Drawer* (private collection) are subtle works with layers of meaning interwoven into dense, intricate compositions. At their best Haberle's canvases become telling commentaries on contemporary life in America at the close of the nineteenth century.

Haberle preferred to portray two-dimensional objects and was a master of painting the ephemera of the world—ticket stubs, playing cards, photographs, receipts, and newspaper clippings. Paintings from the height of the artist's career are characterized stylistically by an amazing precision that reveals barely a trace of brushwork. Haberle was responsible for some of the period's most ambitious trompe l'oeil conceits including *Grandma's Hearthstone* (The Detroit Institute of Arts), a life-size depiction of a colonial fireplace decorated with his patron's family heirlooms, and *The Clock* (The Newark Museum), a painting of a mantel clock with a painted stretcher so deep that the artist was able to transform a two-dimensional illusion into a three-dimensional object.

Haberle's career as a trompe l'oeil painter lasted only thirteen years. From the early 1890s on, failing eyesight increasingly forced the artist to abandon the precision of trompe l'oeil in favor of traditional still life and mural decoration. Ironically the necessity to accommodate his weakening eyesight also resulted in one of Haberle's most original trompe l'oeil subjects. *Torn in Transit* features a broadly-painted landscape depicted as if it were a canvas exposed beneath the remnants of the paper and string in which it had been wrapped. Haberle's paintings of blackboard slates with intriguing, partially erased messages are also believed to date from this period. With the creation of his last trompe l'oeil work, *Japanese Corner* (private collection) in 1898, Haberle's public career as an artist came to an end. He died in obscurity in New Haven in 1933. *NM*

Further Reading

Haberle Retrospective Exhibition, exhib. cat., New Britain Museum, 1962; Grace Gertrude Sill, *John Haberle: Master of Illusion*, exhib. cat., Museum of Fine Arts, Springfield, 1985.

William Michael Harnett

1848–1892

William Michael Harnett was the central figure responsible for popularizing trompe l'oeil still life in the last quarter of the nineteenth century. He was born in Clonakilty, County Cork, Ireland, in 1848, but emigrated with his family to the United States the following year, settling in Philadelphia. After his father's death in the early 1860s, the young Harnett went to work to supplement the family income. In 1865, he became an engraver, working first in steel, copper, and wood, and later in silver. The linear precision necessary for his craft had a lasting influence on the painting style Harnett would subsequently develop. In 1866, he attended his first classes at the Pennsylvania Academy of the Fine Arts, while continuing to work as an engraver.

Harnett moved to New York in 1869. Employed as an engraver, he pursued his studies at the Cooper Union in 1870 and then at the National Academy of Design from 1872 to 1876. He completed his first known oil in the fall of 1874 and the following spring began to exhibit his still lifes at the National Academy of Design. In 1875, Harnett abandoned his occupation as an engraver, opened a studio and committed himself fully to painting. That same year he began to create illusionistic still lifes in the precise, meticulously detailed style that would become his signature as a trompe l'oeil painter.

Harnett returned to Philadelphia in 1876 and continued his training at the Pennsylvania Academy of the Fine Arts. It was probably there that he first encountered the aspiring young painter John F. Peto (1854–1907), whom he would befriend and on whose career he would exert a major influence. Although important critics of the day generally ignored or dismissed Harnett's work, as did the New York Times in 1878 when it declared that his painting shows "great dexterity, but nothing more," Harnett's extraordinary skill at illusionism already met with popular success in the late 1870s. Most critics outside the major art centers also embraced Harnett's work with enthusiasm. The stories of viewers tricked by the artist's painted deceptions soon became legend. In 1877, Harnett became the first American artist to paint trompe l'oeil images of paper money. When he exhibited one such painting entitled *A Bad Counterfeit* (the image of a ten-dollar bill painted on panel and encased behind glass) at the National Academy of Design in 1878, the jury was supposedly so incredulous that they insisted on removing the glass to make sure that the bill was a painted image and not a real ten-dollar bill simply pasted on to a panel.

In the fall of 1880, Harnett departed on a six-year sojourn to Europe, financed by the sale of his paintings. After traveling to London and Frankfurt, Harnett lived principally in Munich from 1881 to 1884. He spent 1885 in Paris and London. From Europe, Harnett continued to submit work regularly to exhibitions in the United States, particularly those at the National Academy of Design and the Pennsylvania Academy of the Fine Arts, although his paintings also appeared in exhibitions in Brooklyn, Boston, Chicago, and Louisville, Kentucky. Harnett received a warmer critical reception in Europe than he had in either Philadelphia or New York. Although some German critics considered his work retardiere and Harnett failed to gain admittance to the prestigious Munich Academy, he did become a member of the Kunstverein, which provided the camaraderie of other artists as well as exhibition opportunities. In 1883, he was included in what was arguably the most prestigious exhibition of his career—an important show of American art at Munich's Glaspalast. In the spring of 1885, he exhibited with some critical success at both the Paris Salon and the Royal Academy of Art in London. While in Europe, Harnett refined his illusionistic technique, gaining even greater control of his brush. He also began to explore the broader range of compositions and themes that would redefine American still-life painting and make Harnett the most influential American still-life painter of the last quarter of the nineteenth century. Most notably he began to paint his vertical still lifes of hanging objects, including perhaps his best-known suite of works, the four versions of his monumental *After the Hunt* (one of which he exhibited at the Paris Salon; see plate 91).

Harnett returned to the United States in 1886, settling in New York. Soon after his arrival, Theodore Stewart, the proprietor of two of the city's most popular and lavishly decorated saloons, became one of Harnett's best-known patrons. He purchased for his Warren Street saloon an *After the Hunt* for $4,000 and commissioned four more works from Harnett. Stewart's patronage also lead to Harnett's infamous brush with the law when the paintings of trompe l'oeil money on display in the saloons were temporary confiscated by the Secret Service and the artist was questioned about his possible activities as a counterfeiter. The incident ended Harnett's career as a money painter, but added to his legend as a master of illusionism and influenced a host of aspiring trompe l'oeil artists.

Harnett's work was exhibited more widely in the 1880s to increasing popular acclaim, although he continued to be under-appreciated by the official art world. In 1887, the Tuchfarber Company in Cincinnati further popularized Harnett's work by publishing a chromolithograph of his painting *Old Violin*, which had been wildly successful in Industrial Expositions in both Cincinnati and Minneapolis.

Harnett's health deteriorated rapidly beginning in late 1888, when he was first hospitalized for crippling rheumatism. He returned to Europe in the summer of 1889 to take a cure at Carlsbad and Wiesbaden, and sought a second unsuccessful cure at Hot Springs, Arkansas, in the fall of 1892. Although Harnett continued to exhibit his work through 1891 (and was planning to submit a painting to the Chicago World's Columbian Exposition), he found it increasingly difficult to paint. There are only ten known paintings executed by Harnett after 1888. On 27 October 1892, Harnett was admitted to New York Hospital, where he died two days later at the age of forty-four. A memorial exhibition of his work was held at Earle's Galleries in Philadelphia in November.

After his death Harnett was soon forgotten. Interest in the artist was revived only in 1939 by an exhibition at Edith Halbert's Downtown Gallery in New York and by Alfred Frankenstein's subsequent research on the artist in the late 1940s, which culminated in the publication of *After the Hunt: William Michael Harnett and Other American Still Life Painters, 1870–1900* in 1953. Scholars have only recently begun to study the content of Harnett's still lifes and understand how his paintings reflect the preoccupations of his era. *NM*

Further Reading
Alfred V. Frankenstein, *After the Hunt: William Michael Harnett and Other American Still Life Painters, 1870–1900*, Berkeley 1953; Doreen Bolger et al., *William Michael Harnett*, exhib. cat., The Metropolitan Museum of Art and Amon Carter Museum, New York 1992.

(Frederick) Childe Hassam

1859–1935

One of the most prolific artists of his generation, Childe Hassam was a leading American Impressionist and worked with equal skill in oil, watercolor, pastel and printmaking. Born in Dorchester, Massachusetts, in 1859 into a prominent mercantile family, Hassam was apprenticed to a wood-engraver. Through the mid-1880s he worked as freelance illustrator, especially for children's books. Hassam pursued formal training during the early 1880s by attending classes at the Boston Art Club and the Lowell Institute. He had his first one-man show of watercolors at a Boston gallery in 1882 and by the following year had established a studio on Tremont Street in Boston. His first trip to Europe in 1883 resulted in a second body of watercolors, which he exhibited in Boston upon his return. It was around this time that Hassam abandoned the professional use of his first name "Frederick" in favor of his more exotic sounding middle name "Childe."

By the mid-1880s, Hassam had established a reputation as an oil painter with his street scenes of Boston, such as *Rainy Day in Boston* and *Boston Common at Twilight*. Although painted in a predominately tonalist style, these paintings already reveal the fascination with light and weather conditions that would characterize Hassam's œuvre. In 1886, Hassam and his bride of two years traveled to Paris, where the artist enrolled in the Académie Julian, studying with Gustave Boulanger and Jules Lefebvre. In 1889, Hassam exhibited four paintings in the American section of the Paris Exposition Universelle and was awarded a bronze medal. Under the influence of French Impressionism, Hassam developed a hybrid style that enabled him to lighten his palette and employ Impressionism's broken brushstroke, but allowed him to retain solid, well defined human figures in his paintings. Although the compromise Hassam struck became closely identified with what

is known as American Impressionism, Hassam himself resisted being identified as an "Impressionist," insisting that the origins of his style really lay in eighteen century English landscape painting.

Hassam returned to the United States in 1889, settling in New York and summering in art colonies and resorts in New England. Around 1884, he visited Appledorf Island, Isle of Shoals for the first time. Hassam would return to the Island (which inspired him to create some of his most accomplished Impressionist paintings) throughout the early 1890s, becoming close friends with Celia Thaxter, a poet and art patron who lived there. Hassam's depictions of Thaxter's colorful flower garden were among the artist's purest Impressionist works stylistically.

During the 1890s, Hassam achieved notable acclaim as an artist, actively exhibiting and selling his paintings, and participating in numerous artist's organizations, including the Society of American Artists, the American Watercolor Society, the Society of Painters in Pastel and the New York Watercolor Club. Numerous awards, including a medal at the 1893 World's Columbian Exposition, also marked the decade. Hassam concentrated primarily on urban scenes during the 1890s. His beloved painting *Fifth Avenue in Winter*, which later became the first work by Hassam to enter a museum collection when it was acquired by the Carnegie, was heralded by his contemporaries as a quintessential American painting. Indeed the recognition of his distinctly American subjects was a point of pride for the artist. Hassam's primary concern, however, remained the visual beauty of any subject that he could capture through his skillful manipulation of light and color. Beginning in 1896, he and his wife traveled through Europe for eighteen months, visiting England, France, and Italy. Hassam's works from this time reveal a new awareness of both Post-Impressionism and Symbolism. After 1900, his paintings exhibited greater simplification and decorative flatness. He also began periodically to paint symbolic nudes and mythological subjects, which were poorly received compared to his highly popular landscapes and idyllic genre scenes.

A close friend of Julian Alden Weir and John H. Twachtman, Hassam joined his Impressionist colleagues in resigning from the increasingly conservative Society of American Artists and founding the Ten American Painters in 1898. Beginning in the mid-1890s, Hassam visited and painted with other Americans regularly in Cos Cob, Connecticut. After Twachtman's death in 1902, Hassam began to frequent the artist's colony at Old Lyme, Connecticut, which became a favorite haunt for Impressionists after Hassam's arrival. He spent the summers of 1904 and 1908 in Oregon at the invitation of his friend and patron, Colonel Charles Wood, who commissioned Hassam to paint a mural for his home. The artist made his last trips to Europe in 1910 and 1911.

In 1906, Hassam became a full academician of the National Academy of Design. By 1910, he had achieved almost mythic stature as an artist and was repeatedly honored with awards. Although he later denounced the more extreme forms of modernism, Hassam was included in the Armory Show in 1913. In 1915, at the age of fifty-five, Hassam took up printmaking with a zeal that resulted in the creation

of over 350 etchings and 40 lithographs. The subjects of his prints are closely associated to those of his paintings and his etchings were particularly praised for what his contemporaries viewed as their impressionistic technique. Between 1916 and 1918, Hassam executed a series of dazzling paintings of flags, inspired by New York's patriotic war parades. Exhibited to great acclaim, the flag paintings are still considered the culmination of Hassam's achievement as a painter.

In 1916, Hassam purchased an eighteenth century cottage in East Hampton, New York, as a summer home. In 1920, he was elected to the American Academy of Arts and Letters and was awarded a gold medal for lifetime achievement from the Pennsylvania Academy of the Fine Arts. Beginning in the mid-1920s, Hassam was honored with major retrospectives at several American museums. In 1932, the Metropolitan Museum of Art made a documentary film of his life. Hassam died in 1935 in East Hampton. In a final gesture of support for the American art community, Hassam bequeathed his artistic estate to the American Academy of Arts and Letters for the establishment of an acquisition fund for museums to purchase for their collections work by young American and Canadian artists. *NM*

Further Reading
Ilene Susan Fort, *Childe Hassam's New York*, New York 1993; Ulrich W. Hiesinger, *Childe Hassam: American Impressionist*, Munich 1994.

Martin Johnson Heade

1819–1904

Landscape and still-life painter Martin Johnson Heade did not paint a notable picture until he was over forty. Born in 1819 in a small village in Bucks County, Pennsylvania, Heade began his career as a portrait painter. After studying briefly under Edward (1780–1849) and Thomas Hicks (1823–1890), Heade spent three years traveling and studying in Europe. The trip was the beginning of a peripatetic existence that would characterize the artist's life. Heade took a second trip to Europe in the late 1840s, after which his painting style became more sophisticated and he began to paint genre and neoclassical figure subjects. During the 1840s and 1850s, Heade lived in no fewer than six American cities—Philadelphia, New York, St. Louis, Chicago, Trenton, and Providence.

Heade's 1859 move to New York proved to be the turning point of his career, leading him to abandon portraiture in favor of landscape. Working in the newly opened Tenth Street Studio Building, Heade also met many leading painters of the day, including Frederic Edwin Church (1826–1900), who became a lifelong friend. In 1860, Heade painted his first marsh landscape, the subject for which he is now best known. He quickly developed his mature style, characterized by precisely rendered details and a

view of the distance that is painted with a sharp-focused clarity. Beginning in 1863, his style, which has been identified by past scholars with luminism, may have been influenced by his awareness of the work of Fitz Hugh Lane (1804–1865), whose work Heade in turn may have influenced.

Heade painted over 100 depictions of the salt marshes located along the eastern seaboard, in particular favoring stormy marshes and scenes dotted with haystacks. Many of Heade's marshes also include vignettes of men toiling on farms in the far distance. As a landscape subject, the flat, anonymous marshes represented the very opposite of the dramatic, picturesque vistas of the Hudson River School. For Heade, the subject provided a seemingly inexhaustible opportunity to paint the constant changes in weather, light, and times of day that fascinated him.

From 1861 to 1863, Heade worked in Boston, painting dramatic marine views. *Thunderstorm over Narragansett Bay*, 1868, is considered the culmination of this theme in Heade's oeuvre. Although regarded today as one of the artist's masterworks, the painting was poorly received when Heade exhibited it at the National Academy of Design. The foreboding scene, which sought to portray the frightening calm before the storm, was at variance with American taste for serene, sunlit coastal scenes. Heade's interest in exploring the complexities of nature in his landscapes has been seen by scholars as foreshadowing the work of Albert Pinkham Ryder (1847–1917) and Thomas Eakins (1844–1916). Scholars have also considered certain elements of Heade's style to be proto-Impressionist.

Heade traveled to South America at least three times between 1860 and 1870–to Brazil in 1863, to Colombia in 1866, and to Colombia, Panama, and Jamaica in 1870. In 1863, Heade took up still life, beginning with small, exquisite paintings of various flowers in vases, which were then often placed on satin tablecloths. While in Brazil that same year, Heade executed a series of small paintings depicting different species of hummingbird, which he entitled *The Gems of Brazil*. Although his intention to publish the series as a book in London was never realized, Heade remained a lifelong aficionado of the subject. His third trip to South America inspired him to begin to paint combinations of orchids and hummingbirds arranged in lush tropical settings. These unique still-life compositions are now recognized as among the most original and evocative American paintings of the nineteenth century.

In 1883, at the age of sixty-four, Heade married and moved to St. Augustine, Florida. He continued to paint marsh landscapes and began a new series of sumptuous floral still lifes, replacing the roses and apple blossoms of his earlier still lifes with Southern flowers, such as orange blossoms, oleanders, cherokee roses, and magnolias. In his late still lifes, Heade continued to prefer the horizontal compositions that he had first explored in 1870, which depict the flower lying alone on a cloth-covered surface rather than in a vase. The quintessential late still life by the artist is a warm lush portrait of a magnolia lying on a piece of velvet.

Heade never achieved more than a modest reputation during his life. Once he moved to Florida, where he died in 1904, he was largely forgotten. His work was rediscovered in the 1940s by collector Maxim Karolik of Newport, who amassed more than fifty Heades and subsequently donated his collection of nineteenth-century American painting to the Museum of Fine Arts, Boston. *NM*

Further Reading

Theodore E. Stebbins, Jr., *The Life and Works of Martin Johnson Heade*, New Haven 1975; Theodore E. Stebbins, Jr., Carol Troyen, and Trevor J. Fairbrother, *A New World: Masterpieces of American Painting, 1760–1910*, exhib. cat., Museum of Fine Arts, Boston 1983.

Winslow Homer
1836–1910

Winslow Homer was quite possibly nineteenth-century America's most gifted artist. He excelled not only in painting in oil, but also in watercolor, illustration, and printmaking, producing over 300 oils and nearly 600 watercolors during his fifty-year career. Born into an old New England family in early 1836, Homer was apprenticed at Bufford's Lithography Shop in Boston at the age of nineteen. Beyond a few life-drawing classes at the National Academy of Design and a brief period studying painting with Frédéric Rondel in 1861, this would be the only formal training Homer would receive. After 1859 he worked for the magazine *Harper's Weekly* in New York City, first as a freelance illustrator and then as a regular contributor. Homer would remain an active commercial illustrator until the mid-1870s. During the Civil War, he received his first public acclaim for his forthright illustrations of soldiers and battle scenes, many of which he created at the front.

As the Civil War drew to a close, Homer turned his energies to oil painting. In 1865, he was elected a full academician of the National Academy of Design. The following year the young artist's fame increased when an article on him appeared in the periodical, *Our Young Folks*, the first of hundreds of articles on the artist that appeared during his lifetime. Homer's reputation as a painter was established with his 1866 *Prisoners from the Front* (fig. 4, p. 44). Exhibited to huge success, the painting heralded the power of Homer's vision as an artist and was described by one of the many contemporary writers who praised the work as "a truly Homeric reminiscence of the war." In late 1866, Homer used a trip to Paris to attend the Exposition Universelle (in which two of his paintings—*Prisoners from the Front* and *The Bright Side* [plate 63]—were included) for an extended visit to Europe. The extent of the influence this year-long sojourn exerted on Homer's style, particularly his exposure and response to French Impressionism at this time, is a matter of some scholarly debate. He does seem to have been influenced by Barbizon painting, especially by Jean-François Millet, and Homer's palette did lighten, possibly in response to the paintings of Eugène Boudin.

After his return from Europe, Homer settled in New York and in 1871 opened a studio in the Tenth Street Studio Building. He began a series of genre paintings devoted primarily to the subject of women and children in bucolic settings, notable examples of which include *Snap the Whip* (plate 65), *The Morning Bell*, and his depictions of elegant croquet players. The authenticity of Homer's images resonated with his contemporaries as an expression of the same democratic spirit that they found in the poetry of Walt Whitman.

In 1870, Homer made his first trip to the Adirondack Mountains in New York State, where he would return numerous times over the next thirty-five years to enjoy and to paint the world of the outdoorsman. In 1873, while summering in Gloucester, Massachusetts, Homer began to work seriously in watercolor, a medium soon integral to his artistic vision and in which he was eventually recognized as a leading American master. In 1877, he joined the American Society of Painters in Watercolors.

In 1881, Homer went to England, settling for nearly two years in the North Sea coast fishing village of Cullercoats, where an artist's colony was also located. During his residence, Homer devoted himself almost entirely to watercolor, achieving a wide-ranging mastery of the medium that equaled the expertise he had achieved in oil during the 1870s. His experience in England had a profound impact on Homer as an artist. It was there that he discovered the power of classical antiquity (most likely from the Greek and Roman sculpture at the British Museum) and was first inspired to explore the theme of man's confrontation with nature.

In 1883, Homer moved permanently to Prout's Neck, Maine (a remote part of the state usually inhabited only during the summer months), and built a studio on the shore of the Atlantic. There Homer abandoned his earlier idyllic subjects and began to concentrate on man's heroic struggle with nature in such acclaimed paintings as *The Life Line*, *The Fog Warning*, and *Eight Bells*. In 1884, *Century Magazine* commissioned Homer to create a series of paintings of the Bahamas to accompany an article on the subject. Over the next two years the artist spent considerable time in the Caribbean. Winter fishing and painting trips to the Bahamas, Florida, and Cuba continued until 1909. Between 1884 and 1889 Homer made his first etchings, inspired by his own painted seascapes.

Although the sea had been an increasingly frequent subject of the artist, in 1890 Homer began to paint pure seascapes such as *Northeaster* from 1895. These powerful expressions of the elemental force of nature, which were acclaimed by critics for their virile American spirit, became Homer's most celebrated paintings. The drama of mortality dominated Homer's late oils, epitomized in such extraordinary paintings as *The Fox Hunt* and *Right and Left*.

In the last years of his life, Homer was revered as the nation's foremost painter. In 1893, fifteen of Homer's works were included in the World's Columbian Exposition in Chicago. The following year, *Fox Hunt* became the first work by the artist to enter a public collection when it was purchased by the Pennsylvania Academy of the Fine Arts. In 1900, Homer was awarded a gold medal at the Paris Exposition, leading to the French government's purchase

of his 1890 painting *A Summer Night*. By the time of his death, Homer's works were represented in more public collections than any other living American artist. In 1906, Homer's health began to fail and in the spring of 1908, he had a mild stroke. Although he regained his strength, he died in his studio at Prout's Neck in September 1910. Homer's death was marked with several memorial exhibitions, including a large retrospective at the Metropolitan Museum of Art. *NM*

Further Reading
Nicolai Cikovsky, Jr., Franklin Kelly, et al., *Winslow Homer*, Washington , D.C. 1995; Helen Cooper, *Winslow Homer Watercolors*, Washington, D.C. 1986.

George Inness
1825–1894

At the time of his death in 1894, George Inness was considered by many to be America's greatest living landscape painter. He was a contemporary of the Hudson River School painters, Frederic Edwin Church and Jasper Cropsey, but did not come to prominence until late in his career when his evocative, highly personal landscapes found a sympathetic audience. Born in 1825 in Newburgh, New York, Inness grew up between Newark, New Jersey, and New York City. In Newark he studied painting briefly with the itinerant artist John Jesse Barker. In New York he was apprenticed to the engravers Sherman and Smith from 1841 to 1843, after which he studied painting for a short time with Règis-François Gignoux, a recent French immigrant who had been a student of Paul Delaroche. Throughout his life, Inness himself asserted that he was primarily a self-taught artist. He began to exhibit his works at the National Academy of Design in 1844 and at the American Art-Union in 1845.

Inness made his first European sojourn in 1851–1852, visiting Italy, where he deepened his appreciation for Europe's Old Masters. In 1853, he returned to Europe for two years, this time visiting France and Holland. Strongly influenced by the works of the seventeenth-century classical landscapist Claude Lorrain and those of the contemporary French Barbizon school, Inness began to develop a new approach to landscape. His paintings, the style of which increasingly differed from that of the prevailing Hudson River School, were at first harshly received by American critics, who did not prize their broad brushwork, eccentric palette, loosely structured composition and flattened compressed picture space. Inness was particularly criticized for his marked disinterest in a literal interpretation of the American landscape in favor of what were considered at the time to be "studio concoctions." The height of Inness' achievement in the 1850s is represented by his now famous work *The Lackawanna Valley*, an example of what Inness called a "civilized landscape" because it included signs of human activity.

A frail man with epilepsy, Inness suffered from ill health throughout much of his life. In 1860, he left New York and moved to the relative isolation of Medfield, Massachusetts, for his health. His paintings that year, such as *Clearing Up* (plate 104) and *A Passing Shower* (plate 102), exhibit a new authority, signifying an artist who had come into his own. An ardent supporter of the Union cause, but unable to serve due to his poor health, Inness devoted his energies during the Civil War to the creation of allegorical landscapes related to the conflict, such as *The Light Triumphant* and *Peace and Plenty*. In 1863, Inness met the painter William Page, who introduced him to the spiritual teachings of Emanuel Swedenborg of which Inness became a disciple. After a brief residence in Eaglewood, New Jersey (the home of the Raritan Bay Union utopian community), Inness returned to New York in 1867. The following year he was finally made a full academician of the National Academy of Design, an honor that Church and Cropsey had received nearly two decades earlier. Not surprisingly, Inness later became a founding member of the Society of American Artists, which organized in opposition to the conservative practices of the National Academy of Design.

In 1870, Inness visited Europe for a third time, living mostly in Rome until his return to the United States in 1875. Three years later, Inness moved to a farm in Montclair, New Jersey, where he would live for the remainder of his life, with seasonal visits to California, Florida, Virginia and Massachusetts for his health. Inness' first article about his own work, "A Painter on Painting," also appeared in 1878 in *Harper's New Monthly Magazine*. Through the 1870s, Inness refined his style, heightening the poetic quality of his landscapes. Little interested in painting specific locations, Inness increasingly suppressed topographic details and concentrated on evoking a highly personal mood or feeling in his landscapes. As the artist himself explained, "A work of art does not appeal to the intellect. It does not appeal to the moral sense. Its aim is not to instruct, not to edify, but to awaken an emotion."

Beginning in the late 1870s, Inness' paintings were profoundly intertwined with his spiritual beliefs as a Swedenborgian. Inness believed that the natural world was spiritually charged and that it was connected to the spiritual realm by certain "correspondences" through which an individual could experience a transcendent state. He even began to attach poems to the frames of some of his paintings to make their meaning more evident. The artist, however, never intended his landscapes to be viewed as literal interpretations of Swedenborgian principles. In the 1880s and 1890s, Inness landscapes become increasingly ethereal. Indistinct forms are enveloped in a palpable atmosphere as the artist attempts to capture on his canvas what he described as the "indefinable:" "There is such a thing as the indefinable which hides itself that we may feel after it." A simplicity and abstraction of design that foreshadows early twentieth-century expressionism characterize Inness' spiritualized landscapes from the 1890s, typified by works such as *The Home of the Heron* and *The Old Farm, Montclair*, both from 1893.

With the emphatic change in American taste in the 1870s, Inness' tireless commitment to painter-

liness and emotional expressiveness brought him new acclaim in the last decades of his life. In 1884, a retrospective of his work was held at the American Art Galleries in New York. Inness died on a visit to Scotland in 1894, at the height of his critical and popular success as a landscapist. *NM*

Further Reading
Nicolai Cikovsky, Jr. and Michael Quick, *George Inness*, Los Angeles 1985; Nicolai Cikovsky, Jr., *George Inness*, exhib. cat., National Museum of American Art, 1993.

Eastman Johnson
1824–1906

For many years, the foremost genre painter in the United States, Eastman Johnson, was among the first American artists of his era to receive extensive training abroad. His oeuvre thus serves as an important link between two generations, combining traditional, domestic subjects with more advanced technique and expression.

Johnson was born in Lovell, Maine, but he grew up in nearby Fryeburg. In 1834, his family moved to Augusta, where his father was involved in state government. There he opened a crayon-portrait studio at age eighteen, after working briefly in a Boston lithography shop. About two years later, he moved to Washington, D.C., to make black-and-white likenesses of eminent national figures, such as Dolly Madison and John Quincy Adams, in the hope of building a gallery of famous personages. By 1846, he had returned to Boston, where he received a good deal of patronage from the family of Henry Wadsworth Longfellow.

His artistic education began in earnest in 1849, when he traveled to Düsseldorf and received rigorous training in drawing at that city's academy. More congenial to the artist was the time he spent in the studio of Emanuel Leutze (1816–1868), where he concentrated on painting. In 1851, he went to London to see the Great Exposition of All Nations and then moved to The Hague, remaining there for more than three years. A lengthy stay at The Hague was somewhat unusual for American artists, but Johnson apparently found much inspiration there in the Dutch Old Masters as well as ready patronage through U.S. Ambassador August Belmont. His European education continued with several months spent in the Paris studio of Thomas Couture (1815–1879) until the death of Johnson's mother brought him home in 1855.

For the next few years Johnson looked for work, traveling to Lake Superior to visit a sister and sketch members of the Chippewa Tribe, painting in Cincinnati, renting a studio in New York, and spending time with his family in Washington, D.C. The turning point came in 1859 with the exhibition in New York of his *Old Kentucky Home—Life in the South* (plate 71). This politically ambiguous picture of the leisure activities of a group of slaves was a sensation at a time

when the topic of slavery was being universally debated; it resulted in his election as an associate member of the National Academy of Design. For two decades thereafter, Johnson explored themes of national life in a number of humble interior scenes and larger rural tableaux, each picture usually the result of careful study through numerous drawings and oil sketches.

Johnson exhibited widely and was active in the National Academy, the Century and Union League clubs, the Metropolitan Museum of Art, and even the Society of American Artists, a group normally associated with a younger generation of painters. He was comfortable in upper-class society, owned a large home in Manhattan, and spent his summers on the island of Nantucket, the scene of many of his paintings. During the last twenty years of his life, his work changed distinctly. Although quite successful in the field of genre painting, he gave it up for unknown reasons and returned to portraiture, the artistic activity of his youth. Able to command extremely large fees, he painted the likenesses of prominent gentlemen of New York City until his death. *AP*

Further Reading
Patricia Hills, *Eastman Johnson*, New York 1972.

John Frederick Kensett
1816–1872

John Frederick Kensett was born on 22 March 1816 in Cheshire, Connecticut, the son of Thomas Kensett, an English engraver who had emigrated to America, and Elizabeth Daggett, a New Englander. By 1828, Kensett had begun studying engraving and drawing in his father's firm in New Haven, and in 1829 he worked briefly for the engraver Peter Maverick (1780–1831) in New York. Earning his living as an engraver during the 1830s, Kensett began to experiment with landscape painting, in which he was encouraged by his friend John Casilear. In 1838, he exhibited a work entitled *Landscape* at the National Academy of Design in New York, and by 1840 he had decided to become a full-time painter. In that year, he sailed for Europe with fellow artists John Casilear (1811–1893), Asher B. Durand (1796–1886), and Thomas P. Rossiter (1818–1871). After an extended stay in Europe, with visits to London, Paris, Germany, Switzerland, and Italy, Kensett returned to New York in 1847. He rapidly established a name as a landscape painter and was elected an associate of the National Academy in 1848. In 1849, he was named a full member of the Academy and was also elected to membership in the prestigious Century Club, which brought him into contact with leading artistic and literary figures of the day.

Kensett's early works were generally richly painted and owed much to the works of Thomas Cole (1801–1848) and English landscape painters such as

John Constable (1776–1837). Works from the early 1850s, such as *A Reminiscence of the White Mountains* (1852, Manoogian Collection) and *Conway Valley, New Hampshire* (1854, Worcester Art Museum, Massachusetts) combined vigorous and expressive brushwork with carefully observed details of rocks, vegetation, and atmosphere in a strikingly effective manner, and were well received. By the mid and late 1850s, his style had become more precise and meticulous, reflecting the influence of Durand, and he began to favor more tranquil and simplified compositions, as in *Shrewsbury River, New Jersey* (1859, New-York Historical Society). Kensett was at the height of his powers in the 1860s and in works such as *View on the Hudson* (1865, Baltimore Museum of Art) he created some of the most accomplished American landscapes of the nineteenth century.

Although he occasionally painted large works, Kensett generally preferred to work on small to medium-size canvases. Unlike such contemporaries as Frederic Edwin Church (1826–1900) or Albert Bierstadt (1830–1902), who traveled to exotic and far-off locales in search of inspiration, Kensett returned again and again to favorite spots that were easily accessible from New York. Never tiring of these places, Kensett produced a substantial body of works that are superficially similar yet possess subtle, but significant, variations in composition, lighting, and atmosphere. He became so well known for painting certain places—including Bash-Bish Falls and Lake George, the coastal areas of Newport, and Beverly (Massachusetts)—that many of his contemporaries invariably associated them with his name.

Kensett maintained a high profile in the artistic and cultural circles of New York and was respected and well liked by his fellow artists. In 1859, he was appointed a member of the National Art Commission, which was charged with overseeing the decoration of the Capitol in Washington. He was a founder of the Metropolitan Museum of Art in 1870 and served as a member of its board of trustees. In the late 1860s and 1870s, he experimented with simpler and more austere, even reductive, compositions. Many of his works from 1870–72 remain unfinished, but examples such as *Eaton's Neck, Long Island* (1872, The Metropolitan Museum of Art, New York) are remarkable for their powerful arrangements of a few boldly simplified shapes representing earth, sea, and sky.

On 14 December 1872, Kensett died at the age of fifty-six of complications from pneumonia contracted while trying to retrieve the body of a friend's wife from the waters off Contentment Island, Connecticut. His demise was considered virtually a national tragedy, and when the contents of his studio were auctioned in 1873, they brought more than $136,000, an astonishing sum for the period. For many of his contemporaries Kensett's art had epitomized landscape painting. As was observed of his art in an obituary published in *The Aldine*: "It is pastoral poetry in painting. Regarded technically, we should say it was almost perfect of its kind." *AP*

Further Reading
Mark White Sullivan, *John F. Kensett: American Landscape Painter*, diss., Bryn Mawr College, 1981; John Paul Driscoll and John Howat, *John Frederick Kensett: An American Master*, exhib. cat., Worcester Art Museum, Worcester and New York 1985.

Fitz Hugh Lane
1804–1865

Fitz Hugh Lane was born Nathaniel Rogers Lane in the fishing port of Gloucester, Massachusetts, on 18 December 1804; his family subsequently changed his first and middle names. Paralyzed as a young child, probably by infantile polio, Lane was obliged to use crutches. He learned the rudiments of drawing and sketching while in his teens and in 1832 worked briefly for a lithographic firm in Gloucester. Later that year, he moved to Boston for formal training and an apprenticeship under William S. Pendleton, owner of the city's most important lithographic firm. Lane remained with Pendleton until 1837, producing illustrations for sheet music and scenic views.

While in Boston, Lane became acquainted with the work of English-born artist Robert Salmon (1775–c. 1845), who was the most accomplished marine painter in the area. Salmon's paintings, with their meticulously detailed ships and crisply rendered effects of light and atmosphere, had a decisive influence on Lane's early style. By 1840, Lane had produced his first oils; two years later he was listed in a Boston almanac as a "Marine Painter." His *Scene at Sea* (location unknown) was exhibited at the Boston Atheneum in 1841 and, after 1845, his works were regularly shown there. During the mid-1840s, Lane continued to produce both oils and lithographs, concentrating on landscapes, harbor views, and ship portraits. In 1848, he sold a painting to the American Art-Union in New York, which would subsequently purchase several more of his works. That summer he visited Maine with his life-long friend, Gloucester merchant Joseph Stevens, Jr., whose family had a home in Castine. Lane would make many more visits to Maine during the rest of his life, and the distinctive scenery of the state became an increasingly important part of his artistic vocabulary.

In 1848, Lane moved permanently back to Gloucester, and with his sister and brother-in-law designed and constructed an impressive granite home overlooking the harbor. Although he traveled in the 1850s to locations such as Baltimore, New York, and, possibly, Puerto Rico, the scenery of Gloucester and Cape Ann would remain, with that of coastal Maine, at the very center of his artistic production.

Lane's inconsistency in dating his works makes it difficult to determine a strict stylistic evolution, but he seems to have reached a new maturity in the early 1850s, as is evident in works such as *Entrance of Somes Sound from Southwest Harbor* (1852, private collection). In an important series of images of the Boston harbor, presumably from the mid-1850s (for example, *Boston Harbor at Sunset*, Jo Ann and Julian Ganz, Jr.), Lane perfected a style characterized by carefully balanced, calmly ordered compositions and radiant effects of light and atmosphere. Modern historians have seen these paintings as part of a

luminist style said to have been employed by many other American artists of the 1850s and 1860s. Lane's art seems to have been primarily personal in nature, and there is little evidence that he took notice of other painters' works or was much involved in wider artistic circles.

During the 1860s, Lane produced what are perhaps his most poignant paintings, again focusing on familiar scenes around Gloucester and in Maine. He left little in the way of written or otherwise recorded statements about his art, but works such as *Owl's Head, Penobscot Bay, Maine* (1862, Museum of Fine Arts, Boston) and *Brace's Rock* (1864, private collection) are markedly different from works of just a few years earlier. Highly reductive in format, refined in execution, and intense in effect, these works suggest some new expressive intent on Lane's part, the nature of which has been the subject of much modern speculation.

In 1864 and 1865, Lane was in poor health and, following a bad fall in August 1865, apparently suffered a heart attack or stroke; he died on the 13th of that month. Although one Boston paper characterized his passing as "a national loss," during his lifetime Lane was known locally; following his death, he and his works were largely forgotten outside Gloucester. With the revival of interest in nineteenth-century American painting during the 1940s, and, particularly with the large number of fine works by Lane presented to the Museum of Fine Arts, Boston, by Maxim Karolik in 1948, he has been gradually reinstated as a key figure. *AP*

Further Reading
John Wilmerding, *Fitz Hugh Lane*, New York 1971; *Paintings and Drawings by Fitz Hugh Lane at the Cape Ann Historical Society*, Gloucester 1974.

Willard Leroy Metcalf
1858–1925

Willard Leroy Metcalf was born 1 July 1858 in Lowell, Massachusetts. His family moved to a farm in Maine in 1863, but eventually returned to Massachusetts, purchasing a home in Cambridgeport in 1872. Metcalf's parents, themselves artistically inclined, recognized their son's talents early on and encouraged his proper training.

As a youth, Metcalf served an apprenticeship to a wood engraver and later became a student of George Loring Brown (1814–1889), a portrait and landscape painter of considerable reputation at the time. He also took evening classes in life drawing at the Lowell Institute and was the first student to receive a scholarship to the school of the Museum of Fine Arts, Boston, which he attended from 1877 to 1878.

The careful draftsmanship that Metcalf learned as a student in Boston served him well when he was commissioned to illustrate a series of stories about

the Zuñi Indians of the Southwest. This necessitated trips to New Mexico and Arizona. The results of his travels appeared in *Harper's Magazine* and *Century Magazine* in 1882 and 1883. For the next twenty years, he continued to earn a portion of his living as an illustrator of books and magazines.

From 1883 to 1889, Metcalf lived in France, where he studied at the Académie Julian under Gustave Boulanger (1824–1888) and Jules-Joseph Lefebvre (1836–1911). He traveled through Brittany and Normandy beginning in 1884, sketching and painting near the villages of Pont-Aven and Grez-sur-Loing. Within a few years, he began to frequent Giverny with several American colleagues, including Theodore Robinson (1852–1896). Visiting North Africa during the winter of 1887, Metcalf discovered the subject that inspired him to paint *Marché de Kousse-Kousse à Tunis* (location unknown), which received honorable mention at the Paris Salon the following year.

Upon returning to the United States, Metcalf lived briefly in Boston, then settled in New York City. In addition to painting and illustrating, he taught for a short time at the Art Students League and for ten years at the Cooper Union. On the advice of Childe Hassam (1859–1935), Metcalf visited Gloucester, Massachusetts, in 1895. One of the paintings produced at that time, *Gloucester Harbor* (Mead Art Museum, Amherst College, Massachusetts), was awarded the prestigious Webb Prize when it was included in a group of Metcalf's works shown at the Society of American Artists the following year.

By 1896, in addition to his experiences in France, Metcalf had had considerable exposure to the light-filled, loosely brushed landscapes of Hassam, John Twachtman (1853–1902), and Julian Alden Weir (1852–1919) and was beginning to move away from his more academic style. These artists, along with Metcalf and six others, withdrew from the Society of American Artists in 1897 to exhibit together as a group that became known as The Ten.

In 1904, disenchanted with his personal and professional life, Metcalf retreated from the city and went to stay with his parents in Clark's Cove, Maine. This productive visit proved to be a turning point in the artist's career. He developed a greater sensitivity to the natural world around this time and began producing the lush New England landscapes for which he became best known. Although not as poetic or ethereal as those of his friend Twachtman, Metcalf's paintings of the woods and fields captured the serenity of his surroundings in every season and under varied climatic conditions. Despite his use of the divided brushstroke and the bright palette of the Impressionists, his images continued to emphasize three-dimensional form and fidelity to the natural subject.

By the end of 1904, Metcalf once more had a studio in New York City, from which he traveled to several locations in the Northeast. A favorite working area was Old Lyme, Connecticut, with its thriving artist's colony. Many of the painters gathered there at the boardinghouse of Miss Florence Griswold, depicted in Metcalf's *May Night* (1906, The Corcoran Gallery of Art, Washington, D.C.), a painting that won him a gold medal when it was first exhibited at the Corcoran Gallery. The hills of Cornish, New Hampshire, were another preferred subject, a location first visited

by the artist in 1909 and to which he returned several times in the next decade. Metcalf continued to receive numerous awards as a mature artist, including a gold medal at the Panama Pacific Exposition in 1915.

Metcalf married late in life, wedding his companion of several years, Marguerite Beaufort Haile, in 1903. The couple was divorced in 1909. In 1911, he married Henriette Alice McCrea, had two children and was divorced a second time, in 1920. He was also involved for many years with the actress Pauline French. Although he was plagued by poor health, excessive drink, and personal failure toward the end of his life, he produced some of his strongest works in these years. Metcalf died on 8 March 1925 in New York City. *AP*

Further Reading
Elizabeth De Veer and Richard J. Boyle, *Sunlight and Shadow: The Life and Art of Willard L. Metcalf*, New York 1987.

Charles Willson Peale
1741–1827

Of the three most talented painters born in the British colonies of North America—Charles Willson Peale, Benjamin West (1738–1820), and John Singleton Copley (1738–1815)—only Peale lived in America after the Revolution. Born in Maryland and trained as a saddler, he became a painter in the 1760s by studying the work of other artists, especially John Hesselius (1728–1778) and Copley, whom he had met in Boston in 1765. Several merchants and lawyers, including John Beale Bordley, financed a two-year trip to London (1767–69), where Peale studied under West. On his return, he became a portrait painter in Maryland, Virginia, and Philadelphia, where he moved with his family in 1776. His early style is characterized by graceful poses, subtle coloring, and meticulous attention to detail. Professing to paint only "by mear immatation of what is before me," Peale in fact had steeped himself in English painting theory and practice when he was in London, and he corresponded with West for many years after his return.

During and after the Revolution, Peale combined his artistic career with Whig politics. He served with the Pennsylvania militia against the British, carrying his miniature case to paint portraits of fellow officers. In 1779, the Supreme Executive Council of Pennsylvania commissioned him to paint the first official portrait of George Washington, a full-length that commemorated the victories at Princeton and Trenton (Pennsylvania Academy of the Fine Arts, Philadelphia). Peale's idea of a Gallery of Great Men next led him to paint a series of head and shoulder "museum" portraits of the heroes of the war and the new republic; the first were completed by 1782. Peale was a friend of the intellectual and political leaders of the day and painted portraits of

Thomas Jefferson, David Rittenhouse, the Marquis de Lafayette, and Benjamin Franklin (Independence National Historical Park, Philadelphia), to name only a few of his illustrious sitters. He trained his brother James (1749–1831), his nephew Charles Peale Polk, and his sons Raphaelle (1774–1825), Rembrandt (1778–1860), and Rubens Peale to be painters, and he was a founder of the Columbianum, the first American artists' society, which held its only public exhibition in Philadelphia in 1795.

By that time, Peale had opened a museum of natural history. Although he continued to paint portraits, he turned the business of miniature painting over to James Peale so that he could increasingly concentrate on his museum. Its collections, which he moved to Independence Hall in 1802, were primarily scientific and included the mastodon bones that he exhumed from a bog in upstate New York in 1801. He helped found the Pennsylvania Academy of the Fine Arts in 1805 but painted fewer and fewer portraits, primarily of close friends and family. One of his last works was his full-length self-portrait, *The Artist in His Museum* (fig. 5, p. 36). He wrote to his son Rembrandt on 23 July 1822 that he intended this painting to be "a lasting ornament to my art as a painter, but also that the design should be expressive that I bring forth into public view the beauties of nature and art, the rise and progress of the Museum."

Peale's diaries and letters reveal his lifelong energy and curiosity. His painting style combined close observation, invention, and a personal interest in his sitters' lives. His role as a painter and teacher was equal to his interests in natural science and invention. His Whig political views placed him at the center of the formation of the new American republic, a role unlike that played by his contemporaries Benjamin West and John Singleton Copley.

AP

Further Reading
Charles Colman Sellers, *Charles Willson Peale*, 2 vols., Philadelphia 1947; Lillian B. Miller (ed.), *The Collected Papers of Charles Willson Peale and His Family*, Millwood 1980.

Raphaelle Peale

1774–1825

Raphaelle Peale, the eldest son of the American painter Charles Willson Peale (1741–1827), was born in Annapolis, Maryland, on 17 February 1774. As a boy he was taught to work in oils and later painted many of the backgrounds for the dioramas in the elder Peale's natural history and art museum in Philadelphia. In 1794, in an effort to launch their careers, Charles Willson Peale retired as a portrait painter in deference to Raphaelle and his brother Rembrandt. While Rembrandt flourished as a portraitist, Raphaelle's predilection for still-life painting became apparent at the Columbianum exhibition in Philadelphia in 1795, where he submitted seven still lifes.

Unable to compete in the relatively lucrative portrait business, Raphaelle's career was characterized by a series of ill-fated ventures that were often supported by his father. Sometime after 1796, father and son developed a patent for a fireplace device. In 1797, Raphaelle and Rembrandt established a museum and gallery in Baltimore modeled after their father's in Philadelphia. In 1802, Charles Willson Peale acquired the use of a physiognotrace for the production and sale of silhouettes and profiles on behalf of his son. While initially successful, all these enterprises ultimately failed to provide Raphaelle with a sustainable income.

With the exception of 1820 and 1821, Raphaelle exhibited at the annual exhibition at the Pennsylvania Academy of the Fine Arts from 1811 to 1825. The majority of these works were still lifes that were praised by critics who compared them to the works of the seventeenth-century Dutch masters. In academic theory, however, still life was considered the lowest form of painting and hence did not command high prices and rarely sold. In addition to his still lifes, Raphaelle intermittently exhibited deceptions or trompe l'oeil subjects, including the masterful *Venus Rising from the Sea—A Deception* (plate 16).

Raphaelle, who struggled throughout his life to meet his accomplished family's expectations of success, died in Philadelphia on 5 March 1825, beset by gout and alcoholism. Despite his desultory career, his exquisitely ordered and textured still lifes, along with those of his uncle James Peale (1749–1831), established an important school of still-life painting in Philadelphia, and in the modern era Raphaelle has been recognized as perhaps the Peale family's most sensitive and accomplished painter. *CB*

Further Reading
Nicolai Cikovsky, Jr., *Raphaelle Peale Still Lifes*, Washington, D.C. 1988.

Rembrandt Peale

1778–1860

Rembrandt Peale, the son of Philadelphia artist and museum proprietor Charles Willson Peale (1741–1827) and his first wife Rachel Brewer, was born in February 1778, probably on the twenty-second of the month. Rembrandt and his siblings, Rubens, Raphaelle, Titian Ramsay, Sophonisba Angusciola, and Angelica Kauffmann, born during the most productive years of their father's painting career, were named after European artists. Rembrandt was precocious, painting his first work, a self-portrait, at the age of thirteen. During his long career of almost seventy years as a portrait and history painter, he made more than one thousand paintings. His most original work dates from the first three decades of the nineteenth century.

Although Philadelphia was his hometown, Rembrandt at various times visited and worked in most of the other major cities of the eastern United States. As

a young artist, he benefited from his father's friendships and patronage. He studied the work of contemporary painters, including Gilbert Stuart (1755–1828) and Robert Edge Pine (1720/1730–1788), as well as paintings by European artists that could be found in local private collections. His father made it possible for him to paint life portraits of George Washington (1795, Historical Society of Pennsylvania, Philadelphia) and Thomas Jefferson (1800, The White House; and 1805, New-York Historical Society).

Charles Willson Peale's ambitions also made Rembrandt a sometime museum director. In 1795–98, for example, when he went to Charleston, Baltimore, and New York City to paint portraits, he also exhibited more than sixty copies of his father's museum portraits, painted by himself and Raphaelle. For part of that time, he managed the first Peale family museum established outside of Philadelphia, which opened in Baltimore in 1796. In 1801, he assisted his father in excavating the bones of prehistoric mammals in Newburgh, New York, and the following year he and Rubens took the skeleton assembled from these remains to England for exhibition. From 1813 to 1822, he re-established and managed the Peale Museum in Baltimore. On some of his longer stays away from Philadelphia, Rembrandt was accompanied by his wife Eleanor Mae Short, daughter of the Peale family's housekeeper, whom he married in 1798. By 1801, they had two daughters, Rosalba Carriera and Angelica; their third, Augusta, was born in England in 1803. When the family moved to Baltimore, it included seven children; the two youngest, Michael Angelo and Emma, were born there.

Although his early marriage and need to support his growing family required him to concentrate on income-producing activity, Rembrandt benefited as an artist from several long stays in European capitals. He studied briefly at the Royal Academy while in London in 1802–03. He traveled to France in 1808 and again in 1809–10, painting portraits in Paris of French scientists, artists, and writers for his father's collection. On his third visit to Europe, in 1828–30, when he was accompanied by his son Michael Angelo, he copied Old Master paintings in Italy for American collectors. On his last European trip, in 1832–33, he returned to England.

As a result of such experience, Rembrandt's style of painting changed when he was still a young artist from the tight, closely observed, eighteenth-century manner of his father, to a style strongly influenced by French neoclassicism and the work of Jacques-Louis David (1748–1825).

His first attempt at a grand manner history painting was *The Roman Daughter* (1811, National Museum of American Art, Washington, D.C.). Even more ambitious was his enormous, multifigured painting *The Court of Death* (1820, The Detroit Institute of Arts), whose theme of individual choice in creating a happy and rational life expressed the tenets of the new and still controversial Unitarian sect. Next he turned his attention to creating a heroic portrait of Washington, the painting known from its inscription as the "Pater Patriae" portrait, Washington as father of his country (1824, U.S. Senate). Later, in the 1840s and 1850s, Rembrandt painted replicas of this portrait of Washington, capitalizing on the fact that he was then the only living

artist to have painted the first president's portrait at live sittings. Beginning in 1854, he also lectured on Washington and his portraits, using as illustrations his own portraits of George and Martha Washington, as well as copies of portraits by his father and other artists.

While Rembrandt's ambitions and opportunities derived largely from his father's energy and drive, the results were his own. After Rembrandt's trips to England and Paris, his father turned to him to learn new painting techniques. His creation of an idealized portrait of Washington was a response to the nationalism of the 1820s. His subject pictures of the 1830s and 1840s reflected the sentiments of the Victorian era. In 1840, four years after the death of Eleanor Peale, he married Harriet Cany, an artist.

Rembrandt also promoted his theories of art and its role in a democracy by publishing brochures, articles, and books. Some, like his *Description of the Court of Death; an Original Painting by Rembrandt Peale* (1820), were written to accompany exhibitions of his work, held in several U.S. cities. *Graphics; A Manual of Drawing and Writing for the Use of Schools and Families* (1835) was intended as a drawing and painting manual for mechanics and art students. He also wrote autobiographical accounts, poems, and accounts of his travels. From 1855 to 1857, he offered a personal history of American art in his "Reminiscences" and "Notes and Queries" published in *The Crayon*, a popular art periodical of the day. Rembrandt died on 4 October 1860, after a heart attack. His second wife and several daughters survived him. *AP*

Further Reading
Carol Eaton Herner, *Rembrandt Peale (1778–1860): A Life in the Arts*, Philadelphia 1985; Lillian B. Miller, *In Pursuit of Fame: Rembrandt Peale, 1778–1860*, Washington 1992.

John Frederick Peto
1854–1907

Trompe l'oeil painter John Frederick Peto achieved neither popular success nor critical acclaim during his own lifetime. Indeed, until Alfred Frankenstein's pioneering research on trompe l'oeil painting in the late 1940s, Peto's artistic identity had become so obscured that his still lifes were regularly attributed to his well-known colleague William Michael Harnett (1848–1892). Today it is the differences between the two artists that has contributed to Peto's current recognition as Harnett's most original follower and one of nineteenth-century America's more important still-life painters.

Peto was born in Philadelphia in 1854, one of four children of Thomas Hope and Catherine Ham Peto. Although seemingly devoted to his father in adulthood, Peto was raised by his maternal grandmother, with whom he lived until his mid-twenties. Peto's earliest painting dates from 1875, and he

listed his occupation as a painter in the 1876 Philadelphia city directory. The young artist was also an active amateur photographer and a talented cornet player, who at times throughout his life performed professionally to supplement his income. Peto seems to have been largely self-taught, receiving his only known formal training at the Pennsylvania Academy of the Fine Arts in 1877. He remained close to the Academy through the mid-1880s, however, and the institution exerted a more profound influence on the artist than his brief enrollment and his sporadic participation in its exhibitions through 1887 would suggest. The strong still-life tradition in Philadelphia and the recent success of fellow Philadelphian William Michael Harnett served as other important formative influences.

From 1879 to 1889, Peto maintained a studio at various locations on Chestnut Street in Philadelphia's art district. His friendship with William Michael Harnett, the era's leading trompe l'oeil painter, seems to date from the late 1870s, although few details of the relationship are known. Inspired by Harnett's example, Peto borrowed and then made his own several familiar Harnett themes—beginning with his tabletop still lifes of newspapers, pipes, and mugs. Peto created his own version of Harnett's *Job Lot Cheap*, his own still lifes of desktops and book shelves, and his own arrangements of objects hanging on walls and doors. The traditional trompe l'oeil theme to which Peto made the most innovative contribution (and an instance in which Peto may have inspired Harnett), are his office boards and rack pictures, which he began to paint in 1879.

Peto's style and interests differed markedly from that of Harnett. His paintings are less insistently illusionistic and far more painterly. Always less concerned with capturing the literal texture and weight of the objects he painted, Peto became increasingly interested in the act of painting itself as he matured. His emphasis on pictorial qualities in his works created canvases distinctive for their muted tones, luminous light, and subtle design. Peto refused to prettify his subjects, preferring to paint the worn, familiar objects of ordinary life. The result is a strong undercurrent of nostalgia and romantic longing in many of his paintings, which have been described as eloquent meditations on the mortality of things. The mood of his paintings vary, however, ranging from the brooding and melancholic to the whimsical. His iconography is frequently autobiographic and so intensely personal that it is enigmatic, if not hermetic. Peto commonly reused his canvases, painting on top of several layers of abandoned compositions. He dated few of his paintings and left many of them unsigned.

In 1887, Peto married a young woman, Christine Pearl Smith, whom he had met on a trip to Ohio. Two years later, he and his wife moved to the coastal resort community of Island Heights, New Jersey. There he built a house with a studio and settled permanently. His only child, a daughter Helen, to whom he was a devoted father, was born in 1893. The Peto household eventually came to include two maiden aunts whose presence added considerable emotional strain to the family. Isolated from the artistic mainstream, Peto continued to paint but became an increasingly reclusive artist and rarely exhibited his works in public. A sufferer from Bright's

Disease (a chronic inflammation of the kidneys), Peto's last years were beset with chronic pain, family turmoil, and relative poverty. He died in New York in 1907 at the age of fifty-three from complications after an operation to relieve his kidney condition. Even before his death, Peto's paintings had begun to appear on the market as the work of William Michael Harnett. *NM*

Further Reading
John Wilmerding, *Important Information Inside: The Art of John F. Peto and the Idea of Still-Life Painting in Nineteenth-Century America*, exhib. cat., National Gallery of Art, Washington, D.C. 1983.

John Singer Sargent
1856–1925

John Singer Sargent was the leading society portrait painter on both sides of the Atlantic at the turn of the century. Few of the artist's contemporaries would have disagreed with Auguste Rodin's 1902 assertion that Sargent was "the van Dyck of our times." The child of American parents who lived abroad, Sargent was the quintessential expatriate. He was born in Florence in 1856, trained in Paris in the 1870s, and died in London in 1925, having known the United States only as an occasional visitor.

Sargent began his formal training in 1874, in the Paris studio of Carolus-Duran, one of the foremost European portrait painters of the day. Velázquez's tonal values and Frans Hals' brushwork, to which the young artist was introduced in his teacher's studio, were decisive formative influences on Sargent's emerging style. A trip between 1879 and 1880, which included visits to Spain and Holland, allowed Sargent to study works by these Old Masters firsthand. By the late 1870s, Sargent had already begun to spend his summers painting in a succession of picturesque locations, including Brittany, Capri, Spain, Venice, Giverny, and the Alps. Inspired by the example of the Barbizon School and the Impressionists, Sargent worked outdoors and created remarkable, fresh *plein-air* paintings of increasing freedom and experimental verve. The artist's work in watercolor, highly prized today but little known during the artist's life, is particularly closely associated with his summer sojourns.

Sargent made his first trip to the United States in 1876, visiting the nation's centennial exhibition in Philadelphia. He made his debut at the Paris Salon in 1877. His 1878 Salon entry, *Oyster Gatherers of Cancale*, earned the young artist acclaim for his keen eye, facile hand, and nascent bravura style. With the success of his portrait of Carolus-Duran at the Salon the next year, Sargent began to attract distinguished French patrons as sitters. Sargent quickly became popular with American patrons as well. In 1882, he executed his first important American portrait,

Daughters of Edward D. Boit, the psychological nuances of which made it pivotal in the evolution of the artist's portrait style.

In 1884, Sargent's success was interrupted by a scandal that altered the course of his career. His provocative, uncommissioned portrait of the prominent socialite and celebrated beauty Mme. Gautreau, which he exhibited under the suggestive title *Madame X*, was castigated at the Salon as an example of decadent modernism. In the years following the scandal, Sargent spent increasing time in England, finally relocating his home and studio to London in 1886. There, Sargent flourished as a portrait painter, refining his gift at capturing his fashionable sitters in their natural milieu with a singular immediacy that revealed his clients' distinct personalities rather than their mere social standing. His summer experiments with Impressionism also resulted in enchanting studio creations, such as *Carnation, Lily, Lily, Rose* (fig. 10, p. 216) which was exhibited to wide popular acclaim at the Royal Academy in 1887.

A true cosmopolitan, Sargent was equally at home in the English, French, and American art worlds. He cultivated a distinguished group of friends and colleagues from the leading figures of the day, including Augustus Saint-Gaudens, Henry James, Claude Monet, and Isabella Stewart Gardner. Sargent never married, however, remaining close to his sisters throughout his life. He was an enthusiastic patron of other artists, acquiring works by such painters as Manet and Monet for his personal collection. In 1889, Sargent and Monet were active in the effort to raise funds to purchase Manet's *Olympia* for the Louvre. In the United States, Sargent was associated with the Society of American Artists, which elected him a member of its selection committee in 1886. Sargent made his second visit to America in 1887, and a third in 1890, both of which resulted in a flood of highly lucrative portrait commissions. In England during the late 1880s and 1890s, Sargent aligned himself with the New English Art Club and other avant-garde groups.

Sargent was an extraordinarily prolific artist, executing a prodigious number of works that included almost 600 oil portraits, over 1,600 watercolors, and more than 600 landscapes and genre pictures in oil. He was also commissioned to paint mural cycles in Boston (first at the Boston Public Library and then at the Boston Museum of Fine Arts), which he began in the 1890s and would not complete until the last years of his life. Awards, honors, and commissions marked the progress of Sargent's highly successful career. In 1889, he was awarded the grand prize at the Exposition Universelle in Paris. In 1897, he was made a full member of both the Royal Academy and the National Academy of Design. In 1899, he was honored with a major retrospective at Copley Hall in Boston. In 1915, the Panama-Pacific Exposition in San Francisco featured fifteen works by Sargent, including *Madame X* in its American debut. The painting, which is still Sargent's best-known work, was acquired by the Metropolitan Museum of Art the following year.

Sargent's bravura style, often imbued with the vivid light, color and atmosphere of Impressionism, continued to dazzle patrons, critics, and the public alike. By 1900, he was by far the most renowned portrait painter of the era. Beginning in the late 1890s, he adopted a new repertory of poses and sittings for his clients, inspired by the great English portraits of Joshua Reynolds, Anthony van Dyck, and Thomas Lawrence. His haunting portrait of the *Wyndham Sisters* dates from this period. After 1900, Sargent devoted more of his energies to watercolor, choosing to exhibit this aspect of his work for the first time only in 1905. In 1909, the Brooklyn Museum of Art, one of the first American museums to collect modern American watercolors actively, acquired eighty-three of Sargent's watercolors.

In 1907, Sargent retired from portrait painting, making few exceptions in the ensuing years, although he did execute a number of charcoal portraits (referred to by Sargent as his "mug shots"), which he could complete at a single sitting. Sargent spent the last years of his life completing his murals, returning again and again to Boston to do so. He also continued the atmospheric landscape studies, in which he had become increasingly involved since the turn of the century. During World War I, Sargent even traveled to the Western Front in France in order to paint. His death in 1925 was commemorated on both sides of the Atlantic with memorial exhibitions in Boston, New York, and London.

NM

Further Reading
Warren Adelson, Donna Seldin Janis, et al., *Sargent Abroad: Figures and Landscapes*, 1997; Trevor J. Fairbrother, *John Singer Sargent*, New York 1994.

John Sloan

1871–1951

Although an active artist until his death in 1951, John Sloan is best known as a prominent member of Robert Henri's circle and a participant in the revolutionary 1908 exhibition of The Eight at New York's Macbeth Gallery. Born in 1871 in Lock Haven, Pennsylvania, Sloan grew up in Philadelphia. There he went to work in 1888 for the noted book and print dealers Porter and Coates, where he was able to study the fine prints and illustrated books that he sold for his employer. Sloan taught himself to etch from a book in 1888 and the following year taught himself the rudiments of oil painting the same way. By 1890, Sloan was working for A. Edward Newton, etching calendars, greeting cards, and book illustrations. In 1892, he began working full time in the art department of the *Philadelphia Inquirer*, providing drawings for the newspaper's features and Sunday supplements. That same year, Sloan enrolled in an evening drawing class taught by Thomas Anshutz at the Pennsylvania Academy of the Fine Arts. The class would be the only formal fine-art training Sloan would ever receive.

1892 was also the year Sloan first met Robert Henri (1865–1929), who would become his mentor and friend. Henri promoted a new realism in American art, championing painting that was "saturated with life" and drew its subjects from the artist's immersion in the life of the city. Sloan enthusiastically embraced Henri's philosophy. His experience as an artist-reporter gave his mentor's convictions a particular resonance for Sloan, whose willingness to paint the seamier side of city life caused the critics of the day to dub him and other members of Henri's circle "the apostles of ugliness" or the Ashcan School. Sloan later described himself as the quintessential "spectator of life." Stylistically, Henri initially encouraged Sloan to paint in a dark, nearly monochromatic style inspired by Frans Hals, Velázquez, and Edouard Manet. Sloan's painting career began in earnest in 1897 with Henri's return from a two-year sojourn to Europe.

In the spring of 1904, after losing his job at the *Philadelphia Press*, Sloan joined Henri in New York, where he was teaching at the New York School of Art. In New York, Sloan continued to make his living as an illustrator. The more than 100 illustrations he executed from 1902 to 1905 for a deluxe edition of the novels of Charles Paul de Kock served as a pivotal influence on Sloan's groundbreaking 1906–07 series of etchings on New York city life. The etchings, which were also inspired by Sloan's new appreciation of the prints of Goya and Daumier, were the first of their kind in America and portrayed the daily lives of ordinary city dwellers with an intimacy and specificity that shocked the contemporary art establishment. The same "slice of life" vignettes became the focus of Sloan's genre paintings in 1906, resulting in his first masterworks such as *Hairdresser's Window*, 1907, *McSorley's Bar* (plate 133), and *Sunday; Women Drying Their Hair* (plate 137). The expanded palette of these paintings also reveal Sloan's new interest in color. In 1909, Henri introduced Sloan to the paints and color system of Hardesty Maratta. Sloan's adoption of the Maratta system inaugurated his lifelong exploration of the formal elements of color and form.

The most political member of Henri's circle, Sloan joined the Socialist Party in 1909. He was an active member (even running for elected office) and contributed graphic work to Socialist publications such as *The Call* and *The Coming Nation*. In 1912, he became the art editor for *The Masses*. Although Sloan's political beliefs are often evident in his graphic work, he consciously tried not keep his paintings apolitical. Unlike George Bellows, whose work was also inspired by Henri, Sloan was never financially successful as a painter. He did not sell his first painting until he was forty years old. Beginning in 1916, when he became an instructor at the Art Students League, Sloan's income came primarily from teaching.

Sloan remained close to Henri through the Armory Show in 1913. A notable participant in Henri's revolt against the conservative art establishment, Sloan was one of the eight artists who declared their independence from the National Academy of Design by exhibiting together at Macbeth Gallery in 1908. In 1918, Sloan became the president for life of the Society of Independent Artists. The Armory Show deeply affected Sloan's thinking as an artist. Inspired by the formal concerns of the European modernists, particularly those of Vincent van Gogh, Sloan became increasingly dissatisfied

with the limitations of Henri's approach to painting and determined to concentrate on the abstract problems of picture-making.

This second and final phase of Sloan's career, dating from 1914, is identified as the artist's Post-Impressionist period. In it, Sloan devoted himself almost exclusively to the formal issues of painting, seeking to perfect a style in which he could maximize the power of his palette and enhance the solidity of form within a limited field of depth. He worked in Gloucester, Massachusetts during the summers of 1914–18, painting nearly 300 landscapes and genre paintings. From 1919 on, he also made summer painting trips to Santa Fe, New Mexico, where he developed an abiding appreciation for Native American culture. He painted landscapes and scenes of Indian life, and served as president for an Exposition of Indian Tribal Arts in the early 1930s. From 1927 to 1936, Sloan concentrated on portraiture and figure painting, particularly the nude. Around 1928, he completely changed his method of painting, adopting the use of transparent oil glazes over underpainting, all of which he then overlaid (beginning in 1930) with a network of red lines designed to unify and animate the painting's surface. Beginning in 1940, his paintings reveal renewed interest in Renaissance painting, particularly in the the Italian primitives, Piero della Francesca, and Andrea Mantegna.

Neither the public nor the critics appreciated Sloan's later paintings. The artist began to suffer periodic difficulties with his health, beginning in the early 1930s. He was named director of the Art Students League in 1931. He retired in 1938 and published his treatise on art and teaching, *The Gist of Art*, the following year. In 1939, he also painted a sixteen-foot mural, *The First Mail Arrives in Bronxville, 1846* for the post office in Bronxville, New York. In 1943, his wife of over forty years, Anna "Dolly" Wall, died, and in early 1945 Sloan married a former student Helen Farr, whom he had known since 1928. He continued to paint regularly until the end of his life. Sloan died in 1951 at the age of eighty from complications after surgery. *NM*

Further Reading
Rowland Elzea, *John Sloan's Oil Paintings: A Catalogue Raisonné*, Delaware 1991.

Gilbert Stuart
1755–1828

Gilbert Stuart, the pre-eminent portraitist of Federal America, combined a talent for recording likeness with an ability to capture a sitter's personality or character through his choice of pose, clothing, and setting. He introduced to America the loose, brushy style used by many of the leading artists of late eighteenth-century London. Lawyers, politicans, diplomats—all had their likenesses recorded by Stuart. His sitters included prominent Americans, among them the first five presidents, their advisors, families, and admirers. He is known especially for his portraits of George Washington.

Born in North Kingstown, Rhode Island, Stuart was baptized with his name spelled "Stewart." His father, an immigrant Scot, built and operated a snuff mill, which contributed to the artist's lifelong addiction to snuff. He grew up in the trading city of Newport, where itinerant Scottish portraitist Cosmo Alexander (1724–1772) gave him his earliest training in painting. In 1771, Stuart accompanied Alexander to Scotland, but he returned home after Alexander died the following year. Three years later, on the eve of the American Revolution, he went to London, where he worked for five years (1777–82) as an assistant to Benjamin West (1738–1820). Stuart began exhibiting work at the Royal Academy of Arts in 1777, at first using the name Gilbert Charles Stuart. The success of *The Skater* in 1782 enabled him to establish his own business as a portrait painter. In 1786, he married Charlotte Coates, and the following year they went to Dublin, where Stuart painted portraits for over five years.

Stuart returned to the United States in 1793, planning to paint a portrait of George Washington that would establish his reputation in America. After about a year in New York City, he moved to Philadelphia, then the capital of the United States, expressly to paint the president. Washington sat for Stuart in the winter or early spring of 1795. Martha Washington commissioned a second portrait, and Mrs. William Bingham a third. Stuart's success led immediately to many commissions, including those for replicas of his second portrait of Washington, now known as the "Atheneum" portrait. Politically prominent and wealthy sitters sought his skills. In December 1803, Stuart moved again, this time to Washington, the new national capital, where he painted portraits of the Madisons, Thomas Jefferson, the Thorntons, and others from Jefferson's administration. In the summer of 1805, Stuart settled permanently in Boston, where for the next two decades he continued to paint the politically and socially prominent.

Never adept at painting large compositions, Stuart produced primarily waist-length portraits. He painted over a thousand portraits during his long career, excluding his many copies of the images of George Washington. Younger American artists, including Thomas Sully (1783–1872), Rembrandt Peale (1778–1860), and John Vanderlyn (1775–1852), sought his advice and imitated his work. Among his students were his children Charles Gilbert (1787–1813) and Jane (1812–1888). In 1816, another pupil, Kentucky painter Matthew Harris Jouett (1787–1827), jotted down "Notes Taken by M.H. Jouett while in Boston from Conversations on painting with Gilbert Stuart Esqr," which today constitute one of the most lively and enlightening descriptions of an early American portrait painter at work.

As a young artist, Stuart employed a tightly controlled technique imitative of Cosmo Alexander and other painters working in New England. When he studied in England, he imitated Benjamin West's technique and gradually adopted the looser style of Joshua Reynolds and George Romney. Thus his technique changed from one characterized by an evenly painted surface to one relying on energetic brush strokes, impasto touches of highlighting, thin shadows, and subtle variations of color for its representation of the warmth of flesh and the softness of fabric. Even after his return to America, Stuart preferred English twill canvases, and from 1800 used wood panels that were scored with parallel grooves to imitate twill's rough surface. Both the twill canvases and the grooved panels enabled him to apply paint so that it left an uneven mark. One indication of his lasting popularity is the number of copies that other artists made of his portraits. In addition, his sitters, fascinated by his personality and talent, recorded lengthy descriptions of their sittings, leaving an unusually rich written record about an American portraitist. *AP*

Further Reading
Hugh R. Crean, *Gilbert Stuart and the Politics of Fine Arts Patronage in Ireland, 1787–1793*, diss., City University of New York, 1990.

Thomas Sully
1783–1872

Thomas Sully was born on 19 June 1783 at Horncastle, Lincolnshire, England, the youngest son of nine children born to the actors Matthew and Sarah Chester Sully. At the suggestion of a relative who was a theater manager in Virginia and South Carolina, the Sullys emigrated to the United States in 1792. Thomas attended school in New York until his mother's death in 1794, when he went to live with his family in Richmond, Virginia. From there they moved to Charleston, South Carolina, where the future artist performed on stage with his family.

Following the example of his older brother, the miniaturist Lawrence Sully, Thomas resolved to become a painter. He first received art lessons from his young schoolmate Charles Fraser. After an unsuccessful attempt at learning the insurance business, Thomas was apprenticed to his brother-in-law, a French émigré miniaturist named Jean Belzons. After a violent quarrel with his teacher in 1799, Thomas left Charleston and joined his brother Lawrence in Richmond. Inspired by the sight of portraits by Henry Benbridge (1744–1812), he continued to study art and opened his first studio in 1804. When Lawrence died in September 1804, Thomas assumed responsibility for the family and eventually married Lawrence's widow Sarah.

In 1806, Sully accepted a commission to paint at a theater in New York, where he met such notables as William Dunlap (1766–1839), John Wesley Jarvis (1781–1840), and John Trumbull (1756–1843). He spent one hundred dollars to have Trumbull paint a portrait of his wife so that he could benefit from firsthand observation of the older artist's technique. In the summer of 1807, Sully spent three weeks in Boston studying under Gilbert Stuart (1755–1828). Later that year, Sully moved to Philadelphia, where

he remained for the rest of his life. It has been justly noted that there was "probably no name on the roll of famous artists which is more closely connected with the city of Philadelphia than that of Thomas Sully."

Sully's portrait practice flourished, and in May 1809 he entered into an agreement with a group of prominent citizens that enabled him to embark on a year-long trip to study art in London. Sharing a room there with Charles Bird King, he studied under Benjamin West (1738–1820) and Henry Fuseli (1741–1825), met the circle of British artists who were active at the Royal Academy of Art, and familiarized himself with collections of Old Master paintings. When Sully returned to Philadelphia in 1810, he quickly set about building his reputation by painting important full-length works, beginning in 1811 with *George Frederick Cooke in the Role of Richard III*. In 1812, when Sully's friends and admirers presented the painting to the Pennsylvania Academy of the Fine Arts, the artist was elected to an honorary membership in the organization, in which he played an active role until resigning from its board of directors in 1831.

From 1819 to at least 1846, Sully and his partner, the restorer and framemaker James S. Earle, ran a successful commercial art gallery. Sully's artistic activity was not confined to Philadelphia, and throughout his long career he made numerous trips to Washington, Baltimore, Boston, New York, and West Point. At the height of his fame, in 1837, a Philadelphia association of British expatriates called the Society of the Sons of St. George sent him to England to paint a full-length portrait of Queen Victoria. Sully's professional stature was such that he attracted many pupils, most notably among them Charles Robert Leslie, John Neagle, and Jacob Eichholtz; he also trained several of his six children to become competent artists. In 1851, he prepared a short practical guide for portraitists entitled *Hints to Young Painters and the Process of Portrait Painting*. He revised this work in 1871, a year before his death on 5 November 1872; it was published posthumously in 1873.

Sully was the foremost American exponent of the romanticized, painterly, and fluid style of portraiture practiced by the two contemporary British artists he had most admired during his year of study in England, Sir Henry Raeburn (1756–1823) and Sir Thomas Lawrence (1769–1830). Although he painted many of the most prominent politicians, clergymen, and military heroes of his era, Sully's fame rests mainly on his exaggeratedly elegant and idealized portraits of fashionable society women and to a lesser extent on his sentimental group portraits of children and "fancy pictures." Often painted with a nearly flawless technique, these ultra-refined images are fundamentally decorative. The deliberately self-conscious affectations of the sitters create a sense of artificiality that precludes any penetrating insight into their characters. This aesthetic was extremely popular among Sully's patrons and earned him status as the most successful American portrait painter from the death of Gilbert Stuart in 1828 until his own gradual decline in the 1850s. *AP*

Further Reading
Monroe H. Fabian, *Mr. Sully, Portrait Painter: The Works of Thomas Sully*, exhib. cat., National Portrait Gallery, Washington, D.C. 1983.

Arthur Fitzwilliam Tait
1819–1905

The artist was born near Liverpool, England. At the age of about twelve, he started work for an art dealer in Manchester. In his free time, he spent many hours at the Royal Manchester Institute, where he taught himself from works of art and plaster casts. In 1850, he emigrated to America and settled in New York. He soon became a member of the National Academy of Design, where he regularly exhibited his work. In his first years in New York, Tait was particularly interested in the American West and life on the frontier. Presumably, his interest in the American wilderness had already been awakened in England by George Catlin, when Tait saw the latter's Indian show in Liverpool in 1843. Although Tait undertook extended trips into the Adirondacks in the northern part of New York State, he never went further west than Chicago, which he visited for the first time in 1893. For his depictions of hunters and trappers, he used his ideas of English hunters, as well as other artists' pictures, and travelers' tales that he had read. Many of the costumes and props in his works are taken from the paintings of William Ranney, with whom he was friendly until the latter's death, and he was able to study Catlin's prints in the New York Library. Tait's portrayals of the American wilderness were in great demand in the mid-nineteenth century, and their lithographic dissemination made him better known than any other artist of his time in America during the Victorian era. His first series on this theme was produced as early as 1852 for Currier & Ives in New York. From 1865, Tait began to turn to still lifes based on birds and game, and later also to portraits of domesticated animals. His representations of dead game hanging up introduced this subject into America; a quarter of a century later it was taken up again by William Michael Harnett and his school. Tait was a lifelong devotee of realism. He was a good observer and had a sound technique. His sense of detail, but also of the dramatic, made him a popular painter in his day. *EH*

Further Reading
Arthur Fitzwilliam Tait: Artist in the Adirondacks. An Account of His Works by Warder H. Cadbury, A Checklist of His Works by Henry F. Marsch, Newark 1986; Patricia C.F. Mandel, "The Animal Kingdom of Arthur Fitzwilliam Tait," *Antiques* (October 1975).

John Vanderlyn
1775–1852

John Vanderlyn was born on 15 October 1775 in Kingston, Ulster County, New York, the son of house and sign painter Nicholas Vanderlyn and his second wife Sarah Tappan; his grandfather was the Dutch immigrant and limner Pieter Vanderlyn. After completing his education at the prestigious Kingston Academy, he went to New York City and worked at an art supply and engraving shop. He studied at Alexander and Archibald Robinson's Columbian Academy of Painting.

Vanderlyn soon attracted the attention of Aaron Burr, who provided him with financial support and patronage until 1804. Burr arranged for him to study briefly under Gilbert Stuart (1755–1828) in Philadelphia, and then sent him to Paris in 1796. Vanderlyn was the first American artist to study in France. He enrolled at the Ecole des Beaux-Arts under the history painter and portraitist François-André Vincent (1746–1816). He copied works by the Old Masters at the Louvre and met Robert Fulton, who stimulated his interest in panorama painting.

Vanderlyn returned to the United States in 1800. He made sketches of Niagara Falls for a series of engravings and practiced portraiture in New York and Washington, D.C. In 1803, he returned to Paris to procure casts of antique statues and paint copies of Old Masters for the newly founded American Academy of the Fine Arts. He met Washington Allston (1779–1843) during a visit to London, and the two artists later traveled through Europe together. In 1804, Vanderlyn painted his first historical subject, *The Death of Jane McCrea* (plate 5), commissioned by Joel Barlow as an illustration for his epic poem *The Columbiad*. In Rome he painted the powerful *Caius Marius amid the Ruins of Carthage* (fig. 2, p. 235), which was awarded a gold medal and admired by Napoleon at the Salon of 1808. His *Ariadne Asleep on the Isle of Naxos* (fig. 2, p. 221) was the first academic nude subject by an American artist.

Vanderlyn returned to the United States in 1815 and exhibited his works in several major cities. *Ariadne* scandalized unsophisticated and prudish American audiences unaccustomed to nudity in art. He settled in New York and obtained permission from the authorities to erect a rotunda in City Hall Park, where he planned to exhibit a large panorama of Versailles (fig. 8, p. 38). The venture failed, and the artist declared bankruptcy. He spent the remaining years of his life in unsuccessful attempts to promote his panoramic views and regain control of the rotunda.

In 1837, after receiving a prestigious commission to paint *The Landing of Columbus* for the Capitol Rotunda in Washington, D.C., he went to Havana to sketch the appropriate topography and foliage. Two years later, he sailed for Paris to execute the painting, but work progressed slowly, and rumors circulated that it was largely the work of assistants. When the artist brought the painting back to his native country, it received little attention. His finances exhausted, Vanderlyn was forced to paint portraits to earn a living, and many of these late works are of extremely poor quality. Shortly before his death he unsuccessfully attempted to persuade the Senate to establish a national gallery and art school. He died embittered, destitute, and alone in Kingston on 23 December 1852 at the age of seventy-seven.

Vanderlyn was a proponent of the French neo-classical style long after its popularity had been exhausted. The figures in his most significant historical and narrative subjects were derived from classical statuary. At a time when most of his American

contemporaries were attracted to the painterly style associated with London's Royal Academy, Vanderlyn worked in a highly finished manner, characterized by the precise drawing and emphasis on human anatomy that was taught at the Ecole. Like Allston and Samuel F.B. Morse (1791–1872), Vanderlyn attempted in vain to elevate the aesthetic sensibilities of his countrymen by exposing them to the traditions of formal European academic art. *AP*

Further Reading
William Oedell, *John Vanderlyn: French Neoclassicism and the Search for an American Art*, diss., University of Delaware, 1981; Salvatore Mondello (ed.), *The Private Papers of John Vanderlyn (1775–1852), American Portrait Painter*, Lewiston 1990.

Julian Alden Weir
1852–1919

Leading American Impressionist Julian Alden Weir came from a family of artists. His father was the painter Robert W. Weir (1803–1889) and his elder brother was John Ferguson Weir (1841–1926), the noted painter who served as director of Yale University's School of Fine Arts from 1869 until 1913. Weir was born in 1852 at West Point, New York, where his father was a professor at the U.S. Military Academy. After preliminary training under his father, Weir went to New York to study at the National Academy of Design. He continued his education in Europe from 1873 to 1877, studying principally in Paris under the French academician Jean-Léon Gérôme (1824–1904). Weir made his debut in the 1875 Paris Salon with *A Brittany Interior*, a painting that reflected in its choice of subject Weir's admiration and new friendship with French painter Jules Bastien-Lepage. Weir's initial reaction to Impressionism while in Paris was negative, as was his response to the work of James A.M. Whistler (1834–1903), whom he met for the first time in 1877 in London. In both instances, Weir criticized the work for its lack of form and attention to drawing. It would be nearly a decade before Weir adopted an Impressionist style in his own work.

Weir returned to the United States in the fall of 1877 but made frequent visits to Europe over the next several years. Upon settling in New York, Weir became an active member of the art community. He was a founder of the Society of American Artists in 1877 and became its president in 1882. He began to work as a teacher in 1878, first at the Cooper Union and later at the Art Students League, where he taught for twenty years. During much of the 1880s he worked as a portrait and genre painter, and also won acclaim for his still lifes of flowers and elegant bric-a-brac, which critics of the day compared favorably to the floral still lifes of John La Farge (1835–1910). The influence of Edouard Manet (1819–1877) on Weir also became increasingly apparent, beginning in 1883. In 1886, a New York exhibition of Impressionist paintings inspired Weir to reverse his earlier opinions. He began to paint landscapes with the broken brushwork and heightened color of Impressionism. After 1887, Weir also became an active printmaker, working primarily in etching and drypoint.

Beginning in 1883, Weir and his wife divided their time between New York and their farm in Branchville, Connecticut. Many of the landscapes (which increasingly became the focus of the artist's attention from the late 1880s) were of Branchville, where his friend and colleague John Henry Twachtman (1853–1902) also settled in 1887. In 1888, Weir's prize-winning painting *Idle Hours* was acquired by the Metropolitan Museum of Art. The following year he was awarded a silver medal at the Paris Exposition Universelle.

Over the course of the next thirty years, Weir refined his own Impressionist style. By the mid-1890s he was actively incorporating the influence of the Japanese prints he collected into the compositions of his paintings. *The Red Bridge* (see fig. 10, p. 225), one of Weir's best-loved landscapes, epitomizes the artist's highly personal approach to Impressionism. The painting's subject—a newly painted iron bridge set in a serene landscape—also reveals Weir's willingness in many of his works to find beauty in contemporary industrial subjects. Weir would always reserve his most daring work as an artist for his landscapes, retaining the darker palette and more conservative approach of his early style for his portraits and figure studies. In addition to his oils, Weir worked extensively in pastel and watercolor. In 1893, he completed a successful mural commission for the Liberal Arts Building at the World's Columbian Exposition in Chicago.

Widowed in 1892, Weir remarried in 1893 and began once again to make frequent trips to Europe. Recognized as a knowledgeable authority on modern art, Weir served as an advisor to several important American collectors of the time. He frequently encouraged them to buy works by modern painters such as Gustave Courbet (1832–1883) and Edouard Manet. Weir was in fact one of the first to introduce Manet in the United States. Frustrated with the conservatism of the Society of American Artists, Weir joined his artist-friends Childe Hassam (1859–1935) and John Henry Twachtman in 1898 in founding The Ten American Artists, an Impressionist group whose exhibitions together sought to promote greater independence for American artists. Weir's prominent role in The Ten led to his involvement with the Association of American Painters and Sculptors (for which he served very briefly as president) and his early support of the 1913 Armory Show, which included twenty-five of his own works. An advocate of progressive American art through much of his career, Weir had increasing difficulties coming to terms with the radical changes in American art after 1900. His late paintings continue to be poetic Impressionist studies. In 1904, Weir was awarded a gold medal for painting and a silver medal for engraving at the Universal Exposition in St. Louis. In 1911, a major retrospective of his work traveled through the east and midwest. Weir became the president of the National Academy of Design in 1915. He died four years later and was honored five years after his death by a memorial exhibition at the Metropolitan Museum of Art.
 NM

Further Reading
Doreen Bolger, *J. Alden Weir: An American Impressionist*, Delaware 1983.

Benjamin West
1738–1820

Born in the American colonies, Benjamin West became one of the most prominent artists of late eighteenth-century London. President of the Royal Academy of Arts almost every year from 1792 until his death, he received many commissions from George III and other English patrons and at the same time served as teacher and advisor to three generations of American artists. West was born in Springfield, Pennsylvania, near Philadelphia. His earliest paintings were portraits of two children, Robert and Jane Morris (c. 1752, Chester County Historical Society, West Chester, Pennsylvania). His early work was influenced by that of John Wollaston, Robert Feke, John Valentine Haidt, and William Williams. His exceptional talent was quickly recognized, and he painted portraits in eastern Pennsylvania and briefly in New York City before going to Italy in 1760 to study painting. After three years, which he spent primarily in Rome, Florence, and Venice, he settled to London.

West was a painter of historical and religious subjects and, as patronage required, a portrait painter. The first works he exhibited in London, at the Society of Artists in 1764, were of subjects from Renaissance literature—*Cyman and Iphigenia* (1763, location unknown) and *Angelica and Medoro* (c. 1763–64, University Art Gallery, State University of New York at Binghamton)—and a full-length portrait of General Robert Monckton (Trustees of Lady Galway's Chattels Settlement, England). Within the next few years he painted several classical subjects, including *Agrippina Landing at Brundisium with the Ashes of Germanicus* (fig. 1, p. 234), which was commissioned by Robert Hay Drummond, Archbishop of York, and exhibited at the Society of Artists in 1768. George III then commissioned *The Departure of Regulus from Rome* (1769, Her Majesty Queen Elizabeth II), marking the beginning of royal patronage of West, who painted some sixty pictures for the king between then and 1801.

West is best known for his influential history painting *The Death of General Wolfe* (fig. 4, p. 211), which he exhibited at the Royal Academy of Arts in 1771. The painting, a milestone in English and American art, was the first major depiction of a contemporary event whose figures were dressed in modern, rather than classical, clothing. Its subject was the heroic death of an English general in a major battle against the French in Canada. Two subsequent paintings with American subjects were *Penn's Treaty with the Indians* (1771–72, Pennsylvania Academy of the Fine Arts) and the unfinished *Signing of the Preliminary Treaty of Peace in 1782* (1783–84, The Henry Francis du Pont Winterthur Museum, Delaware).

In the 1770s, West's subject matter began to include the religious themes that dominated his work of the late 1770s and 1780s. Most notable were his paintings of the Progress of Revealed Religion for the Royal Chapel and design for stained glass for

St. George Chapel, both at Windsor Castle. Other commissions for Windsor included family portraits and eight English history paintings for the Audience Chamber. After George III withdrew his support of West in the 1790s, William Beckford, who commissioned religious paintings and portraits for his gothic Revival country house, Fonthill Abbey, became an important patron.

During most of his career West painted complex multifigure compositions and employed sophisticated techniques that differed dramatically from the painting methods he had learned in Pennsylvania. The extraordinary stylistic and compositional differences betwenn West's American and English work are largely due to his three years of study in Italy, when he absorbed the painting styles and compositions of Italian Renaissance and Baroque painters, as well as those of his contemporaries. Later, as West became a pivotal figure in educating American-born artists in England, this knowledge in turn transformed the work of his pupils. Americans who studied with West before and during the Revolution included Matthew Pratt, Charles Willson Peale, and Gilbert Stuart. Among his students in the 1780s were Ralph Earl and John Trumbull. These and later Americans, including Washington Allston and Thomas Sully, brought West's ideas and techniques back to the United States, providing a foundation for the growth of the arts in America in the Federal period and creating a late eighteenth- and early-nineteenth century American style of considerable sophistication. *AP*

Further Reading
Dorinda Evans, *Benjamin West and His American Students*, exhib. cat., National Portrait Gallery, Washington, D.C. 1980; *Benjamin West: An American Painter at the English Court*, exhib. cat., The Baltimore Museum of Art, 1989.

James Abbott McNeill Whistler

1834–1903

James Abbott McNeill Whistler was the archetypal American expatriate artist; his paintings and prints are as much a part of the history of European modernism as they are of American art. Although Whistler's career was anchored in Europe, his style and aesthetic philosophy, which sought to liberate art from the confines of sentimental narrative and academic illusionism, exerted a profound influence on subsequent generations of American artists. The son of a railway engineer, Whistler was born in Lowell, Massachusetts in 1834 and spent part of his childhood in St. Petersburg, Russia, where he received his initial art training. From 1848 to 1851, Whistler attended school in England, where he became close to his step-sister's husband, the printmaker and collector Francis Seymour Haden, who furthered Whistler's art education and encouraged his interest in etching. After his father's death in 1849, Whistler returned to the United States and enrolled in West

Point Military Academy, where he studied drawing under the painter Robert Weir. In 1854, after his dismissal from West Point, Whistler briefly joined the drawing division of the U.S. Coast and Geodetic Survey in Washington, D.C., where he worked as a draftsman and learned to etch.

Determined to become a professional artist, Whistler moved to Paris at the age of twenty-one. There, he enrolled in the Ecole Impériale et Spéciale de Dessin and entered the atelier of Charles Gleyre. Whistler, however, was soon drawn to more avant-garde circles, befriending Henri Fantin-Latour and Alphonse Legros, with whom he formed the Société des Trois. Like them, Whistler was a great admirer of the realist tradition, particularly Velázquez, seventeenth-century Dutch painting, and his own contemporaries Courbet and Manet, both of whom Whistler soon came to know personally. Whistler's first important oil, *At the Piano*, painted in 1858, reflects the pervasive influence of these artists. The painting's rejection from the 1859 Paris Salon was a contributing factor to Whistler's decision that same year to relocate to London. England would become Whistler's primary home for the rest of his life, although he never lost touch with the Paris art world, and traveled frequently and widely throughout Europe to visit and work with friends and colleagues. Soon after his arrival in London, Whistler executed the etching series, *Sixteen Etchings of the Thames* (better known as the *Thames Set*), which would establish his reputation as a master etcher.

In 1861, Whistler painted his most controversial early work, *The White Girl (Symphony in White)* (plate 125). Although the Royal Academy had accepted *At the Piano* the previous year, it rejected *The White Girl* for being both incomprehensible and crudely painted. The painting, which Whistler later reworked between 1867 and 1872, joined Manet's *Le Déjeuner sur l'herbe* as a triumph in scandal at the Salon des Refusés in 1863. The title *Symphony in White* was actually bestowed on the painting by Paul Mantz in the *Gazette des Beaux-Arts* and became the first reference to the affinity between music and Whistler's art. Whistler would later use this affinity to assert the importance of the aesthetic aspects of a painting for their own sake. Discussing his misunderstood 1872 portrait of his mother, *Arrangement in Grey and Black no.1, Portrait of the Painter's Mother* (fig. 6, p. 223) as an embodiment of his aesthetic philosophy, Whistler explained, "To me it is interesting as a picture of my mother; but what can or ought the public to care about the identity of the portrait?... As music is the poetry of sound, so is painting the poetry of sight, and subject matter has nothing to do with harmony of sound and color." Like much of his earlier work, *Arrangement in Grey and Black no.1* shocked contemporary critics, who were disturbed not only by the painting's peculiar formal element but also its depersonalized image.

Whistler's alliance with the English Aesthetic Movement began in 1862 when he met the Pre-Raphaelite painter Dante Gabriele Rossetti and the poet Algernon Swinburne. His fascination with *Japonisme*, of which he would become a leading proponent, became evident in his paintings beginning in 1863, with the introduction of Japanese objects (most drawn from his own personal collection) into paintings such as *La Princesse du pays de la porcelaine.* The

influence of Japanese woodcuts on Whistler's compositions is evident by the following year. Whistler's primary concern as an artist was with abstract structure and the tonal relationships of his palette, formal elements which he then manipulated to achieve an evocative sense of color and mood in his paintings. His works are distinguished by a preference for decorative flatness, asymmetrical compositions, exoticism, a tonal palette, and a vaporous atmosphere. The quintessential expression of Whistler's philosophy, and indeed of the whole Aesthetic Movement, is the total decorative environment that Whistler created for the dining room of his English patron F. R. Leyland in 1876–77. Called *Harmony in Blue and Gold: The Peacock Room,* the entire room was later acquired by another major patron of the artist, Charles Lang Freer, and is now part of the Freer Gallery of Art in Washington, D.C.

Whistler's flamboyant personality and dandified persona were an integral part of his aesthetic philosophy and public career, often making his life-style as controversial as his art. Whistler was notorious for ignoring social conventions and living well beyond his means. Indeed, in 1879, he was forced to declare bankruptcy. Witty, sophisticated, and highly literate, Whistler was an articulate lecturer and writer, as demonstrated by his famed "Ten O'Clock Lecture" in 1885, and his 1890 book *The Gentle Art of Making Enemies.* Whistler, however, was also fiercely belligerent when provoked and had very public squabbles with numerous friends, colleagues, and patrons throughout his life. His brief presidency of the Society of British Artists in the mid-1880s, for example, ended typically with a forced resignation. He could be particularly antagonistic to critics. Whistler's most spectacular public dispute occurred in 1877, when John Ruskin called him "a coxcomb" and accused him of "flinging a pot of paint in the public's face" for asking 200 guineas for his *Nocturne in Black and Gold: The Falling Rocket* (fig. 9, p. 215). In retaliation, Whistler sued for libel, answering the charge made in court that he was asking too much for only two days' work with the now famous retort, "No, I asked it for the knowledge which I have gained in the work of lifetime." Although Whistler won his suit, the cost of the case deepened the artist's chronic debt, since the court awarded Whistler only one farthing in damages. The court award was symptomatic of how deeply misunderstood Whistler's work was throughout most of his life. His night scenes, which he had produced since 1866 and which had acquired the title "Nocturnes" beginning in 1872, were arguably the most abstract work created in the history of Western art up to that time.

Whistler was a highly prolific artist, executing approximately 550 oils, 1,700 watercolors, pastels, and drawings, and more than 450 etchings and 170 lithographs in the course of his career. Beginning with his 1880 visit to Venice to complete an important etching commission, Whistler worked increasingly in watercolor, pastel, and the graphic arts. In 1888, he married one of his pupils, Beatrice Godwin, who encouraged Whistler to take up lithography. The Whistlers moved to Paris in 1892, where they lived until shortly before Beatrice's untimely death in 1896. After his wife's death, Whistler attempted unsuccessfully to establish a company in London, which he called the Company of the Butterfly, to sell

his own work. He also helped one of his favorite models found an art school in Paris, at which he taught from 1898 until the school closed in 1901. One of Whistler's most successful endeavors from these years was his presidency of the International Society of Sculptors, Painters, and Gravers, which held an outstanding series of modernist exhibitions under his direction. Whistler's health declined steadily beginning in 1900. A premature obituary published in July 1902 temporarily revived his combative spirit. Whistler died in London a year later, in July 1903. Fame and widespread recognition came only in the very last years of Whistler's life, when he began to be heralded as a forerunner of Symbolism and Art Nouveau, and a prophet of modernism.

NM

Further Reading
R. Anderson and A. Koval, *James McNeill Whistler: Beyond the Myth*, London 1994; R. Dorment and M.F. MacDonald, *James McNeill Whistler*, exhib. cat., Tate Gallery, Musée d'Orsay, National Gallery of Art, Washington, D.C. 1994.

Edwin White
1817-1877

Edwin White was born on 21 May 1817 in South Hadley, Massachusetts, where he began to paint at an early age. He received his first formal training at age twenty in Hartford, Connecticut, with the portrait painter Philip Hewins. White exhibited at the National Academy of Design in 1840, while still living in Connecticut, and, in 1843, he moved to New York City to study with John R. Smith. He also attended classes at the National Academy of Design, to which he was elected an associate in 1848 and an academician in 1849.

White traveled to Paris in 1850 to study under François Edouard Picot, a pupil of Jacques Louis David, and to take classes at the Académie des Beaux-Arts. In 1852, he went to Düsseldorf, where he studied under genre painter Carl Wilhelm Hübner. During this first trip abroad, White also visited Florence and Rome, and he became friends with fellow Americans Eastman Johnson and George H. Hall. He returned to the United States in 1855, taking a studio in the New York University Building. In the winter of 1857, White journeyed again to Paris, where he painted his best-known work, *Washington Resigning his Commission*, for the Maryland State Senate Chamber in Annapolis.

Back in New York in 1859, White spent the next ten years painting from his studio at New York University. He served on the National Academy of Design's committee of instruction and lectured there from 1867 to 1869. In 1869, he again went to Europe, and after a brief stay in Antwerp, White settled in Florence, where he painted studies of architecture and scenes from the lives of famous Old Masters, including Titian, Giotto, and Leonardo da Vinci.

White returned to New York in the autumn of 1875. Soon thereafter, his health began to decline, and he moved with his wife to Albany for treatment. He died of lung disease at Saratoga Springs in June of 1877. Known primarily for his genre scenes and depictions of events from American history, White also painted portraits. He exhibited his work at the Boston Atheneum, the Pennsylvania Academy, the American Art-Union, and the Washington Art Association, in addition to the National Academy of Design. *HA*

Further Reading
Henry W. French, *Art and Artists in Connecticut*, Boston and New York 1879; Natalie Spassky, *American Paintings in the Metropolitan Museum of Art*, New York 1985.

(Thomas) Worthington Whittredge
1820-1910

(Thomas) Worthington Whittredge was born on 22 May 1820 near Springfield, Ohio. In 1837, he apprenticed himself as a sign painter to Almon Baldwin, his brother-in-law in Cincinnati. After opening a daguerreotype studio in Indianapolis, Indiana, in 1842, Whittredge moved to Charleston (present-day West Virginia) to work as a portrait painter in partnership with B.W. Jenks. Around this time, he also began to paint picturesque landscapes in the style of the Hudson River School. From 1839 to 1842, he exhibited landscapes at the Cincinnati Academy of Fine Arts and the Society for the Preservation of Useful Knowledge. In 1846, Whittredge probably began sketching in oils outdoors and submitted *View on the Kanawha, Morning* (now lost) to the National Academy of Design.

In May 1849, Whittredge left Cincinnati to further his training in Düsseldorf. He was attracted to the city by the fame of the expatriate painter Emanuel Leutze, who encouraged and mentored the many American artists who came to study there, including Albert Bierstadt (1830–1902), Sanford Robinson Gifford (1823–1880), and William Stanley Haseltine (1835–1900). In the summer of 1856, Whittredge traveled through Switzerland with Bierstadt and that fall was in Rome with Bierstadt, Gifford, and Haseltine. Whittredge remained in Italy for three years painting landscapes in the Düsseldorf style before returning to America around 1859.

Following an initial period of uncertainty about how best to reconcile his European and American experiences, Whittredge was soon playing an important role in the cultural life of the country. After settling in New York, he took a studio in the Tenth Street Studio Building, where he worked with many of the most prominent American artists of the day. In 1860, he was elected an associate of the National Academy of Design and in 1861 became a full member of the Academy and joined the prestigious Century Association. In 1866 Whittredge visited the far west for the first time, exploring the Missouri Territory

with General John Pope and in 1870 traveled to Colorado with John Frederick Kensett (1816–1872) and Gifford. From 1874 to 1877, he acted as President of the National Academy of Design and in 1876 served as a member of the paintings committee for the Centennial Exhibition in Philadelphia.

Whittredge's later years were marked by experimentation. In the late 1870s and early 1880s, he produced paintings inspired by Charles-François Daubigny (1817–1878) and the Barbizon School. After moving to Summit, New Jersey, in 1880 he came under the influence of George Inness, whose studio was nearby. His paintings of the 1890s, while primarily in his earlier Hudson River School style, also reveal a knowledge of Impressionism. Whittredge continued to paint until his death in Summit on 25 February 1910. *CB*

Further Reading
Anthony F. Janson, *Worthington Whittredge*, Cambridge and New York 1989.

Charles Ferdinand Wimar
1828-1862

Charles Ferdinand Wimar was born in Siegburg near Bonn, Germany, on 19 February 1828. In 1843, he emigrated to St. Louis, Missouri, and from 1846 to 1850 worked in the studio of the French émigré painter Léon de Pomarede. Pomarede designed elaborate panoramas of western scenes and encouraged Wimar to specialize in frontier subjects. Around 1850 Wimar established his own business as a portrait painter and began experimenting with genre scenes based on prints.

In 1852, inspired by the example of Emanuel Leutze (1816–1868), the expatriate American who had just exhibited *Washington Crossing the Delaware* (1851, The Metropolitan Museum of Art, New York) to great acclaim in New York, Wimar traveled to Düsseldorf to further his artistic education. He joined the Malkasten, a club for Düsseldorf's artists that Leutze had helped to establish and quickly created a place for himself in the local artistic community. In 1854, Wimar was invited to work in the studios of Leutze, Joseph Fey, and Oswald Achenbach (1827–1910). *The Captive Charger* (1854, The Saint Louis Art Museum, St. Louis) was finished under Leutze's guidance that year.

Wimar was the first Düsseldorf artist to paint American frontier subjects. He became known as the "Indian Painter" and his exotic persona and paintings captured the imagination of the German public and confirmed their highly romanticized views of the American West. Among his most successful and important works from the Düsseldorf period are *The Abduction of Daniel Boone's Daughter by the Indians* (plate 60) an ancillary episode from the life of the great hero of western expansion, and *The Attack on*

the Emigrant Train (1856, University of Michigan Museum of Art, Ann Arbor), a prototype for later depictions of the subject.

After returning to the United States in 1856, Wimar journeyed from St. Louis to the Upper Missouri River and Yellowstone on the steamboat "Twilight" from 1858 to 1859. In search of new subjects for his paintings, Wimar collected souvenirs, made sketches, and, using an Ambrotype apparatus, took some of the earliest photographs of Native American tribes in their natural surroundings. No examples of Wimar's photographs from the expedition are extant. A second voyage up the Missouri provided him with material for *Buffalo Crossing the Yellow-stone* (1859, Washington University Gallery of Art, St. Louis), *Buffalo Crossing the Platte* (1859, The Thomas Gilcrease Institute of American History and Art, Tulsa), and *The Wounded Buffalo* (1859, Washington University Gallery of Art), which were shown at the Fine Art Hall of the Annual Agriculture and Mechanical Fair in 1859. In 1860, Wimar exhibited nineteen paintings in the inaugural exhibition of the Western Academy of Art, including *The Buffalo Hunt* (1860, Washington University Gallery of Art).

Wimar's last important work was an elaborate scheme of mural decorations for the Saint Louis Courthouse, executed in 1862. One of the earliest examples of fresco decoration in nineteenth-century America, his design depicted four stages of western conquest and settlement: *De Soto Discovering the Mississippi, Landing of Laclede, The Year of the Blow*, and *Westward the Star of Empire*. After completing the commission Wimar died of tuberculosis in St. Louis on 28 November 1862. *CB*

Further Reading
A. Harding (ed.), *America Through the Eyes of German Immigrant Painters*, Boston 1975; Rick Stewart et al., *Carl Wimar: Chronicler of the Missouri River Frontier*, Fort Worth 1991.

Richard Caton Woodville

1825–1855

Richard Caton Woodville was born in Baltimore on 30 April 1825. The sources for his early training as an artist are difficult to determine. In addition to the widely distributed engravings and art books of the day, he may have had access to the private collection of Robert Gilmor, which included Dutch and Flemish painters and genre scenes by William Sidney Mount. By 1842, he was working as a portrait painter. He also briefly entered medical school that year. In 1845, he exhibited *Scene in a Bar-room* (location unknown) at the National Academy of Design. Married that year, he went abroad for further training in Düsseldorf where, after enrolling at the Düsseldorf Academy, he studied privately under Carl Ferdinand Sohn.

Beginning in 1847, Woodville's work became widely known and appreciated in America through engravings after his paintings and exhibitions organized under the direction of the American Art-Union. In 1850, sixteen thousand prints of *The Card Players* (1846, The Detroit Institute of Arts) from an engraving by Charles Burt were distributed to the Art-Union's list of subscribers. Exhibited at the Art-Union in 1849, *War News from Mexico* (1848, The Manoogian Foundation) was offered to subscribers as a magnificent large folio engraving by Alfred Jones in 1851.

After his departure for Düsseldorf in 1845, Woodville resided in Europe for the duration of his career. It is believed he returned to the United States on at least two occasions, although there is little documentation concerning these visits. In 1851, he traveled to Paris, where he painted *Waiting for the Stage* (1851, The Corcoran Gallery of Art, Washington, D.C.). A death certificate confirms his death on 13 August 1855 in London. *The Burial at Sea* (location unknown) was his last painting.

While Woodville painted portraits and created Romantic period costume pieces such as *Cavalier's Return* (1847, New-York Historical Society), he is known primarily for his paintings of contemporary American polititians. *War News from Mexico* and *Politics in an Oyster House* (plate 26) are chief among these. Both are meticulously constructed works in which Woodville keenly observed how topical events, transmitted through newspaper accounts, affected the nation's mood. *CB*

Further Reading
Richard Caton Woodville: An Early American Genre Painter, exhib. cat., The Corcoran Gallery of Art, Washington, D.C. 1967.

The authors of the biographies

HA Heidi Applegate
CB Charles Brock
EH Elisabeth Hülmbauer
NM Nannette V. Maciejunes with Norine Hendricks
AP *American Paintings of the Nineteenth Century.*
 The Collections of the National Gallery of Art: Systematic Catalogue, vol. 1: Franklin Kelly (ed.), Washington 1996, vol. 11: Robert Torchia (ed.), Washington 1998;
 American Paintings of the Eighteenth Century.
 The Collections of the National Gallery of Art: Systematic Catalogue, Ellen G. Miles (ed.), Washington 1995 (Copley/C. W. Peale/Stuart/West)

Glossary

Abolitionism The beginnings of the anti-slavery movement go back to the 1770s, but abolitionism did not gain momentum until the beginning of the reform movement in the nineteenth century. In 1831, William Lloyd Garrison published the radical abolitionist journal *The Liberator*, and two years later he founded the American Anti-Slavery Society. In 1840, the abolitionist movement split into two factions: the moderates under James Birney favored gradual emancipation and organized the Liberty Party, while militants such as John Brown considered violence a justified course of action. Abolitionists finally achieved their goal with the emancipation of slaves in 1863.

American Academy of Fine Arts Founded in 1802 in New York, it was named American Academy of Fine Arts in 1817. The institution's goal was to exhibit copies of classic works of art, cultivate the public taste, and enable artists to deal critically with important works of art. John Trumbull, the academy's president from 1817 and 1836, reorganized the institution after the example of the English Royal Academy. In 1825, a more progressive splinter group founded the National Academy of Design. Fire destroyed the American Academy of Fine Arts' building in 1839, and two years later the academy closed.

American Art-Union A New York organization for the promotion of American art. Founded in 1838 as Apollo Gallery and renamed Apollo Organization the following year, the society provided artists with exhibition space and made a special effort to integrate members by providing them with one engraving annually and giving them the opportunity to win an original painting in a lottery. In 1844, the organization was named American Art-Union and became increasingly popular (five years later it had 18,960 members). Lotteries were outlawed in 1851, and this legislation meant the end of the Art-Union.

Arcadian Arcadia is a Greek landscape in the middle of the Peloponnese with mountains of up to 6,500 feet and wide valleys. Due to its unspoiled nature, it was considered a model land of virtue and self-sufficiency and became the traditional, idealized rural setting in Greek and Roman bucolic poetry and later in the literature of the Renaissance. The shepherds' idyll also became the main theme of an art movement that propagated visions of a virginal landscape.

Armory Show This first comprehensive exhibition of modern art in the United States (officially entitled the *International Exhibition of Modern Art*) was held in New York at the Sixty-Ninth Regiment Armory and from there traveled to Chicago and Boston. The Armory Show presented about 1,300 works by European and American artists, documenting the development from Neoclassicism and Romanticism to the new and controversial art movements Cubism, Fauvism, and Expressionism. More than a quarter of a million visitors came to see the show, and it had an enormous impact on American art.

Art Students League of New York In contrast to the Academy School, this art school, founded in 1875, renounced rigid curriculum and admission standards. The progressive methods attracted many students, and by the early twentieth century it had become the country's most important art school, counting William Merritt Chase, Thomas Eakins, and Robert Henri among its teachers.

Ashcan School A group of American painters active from about 1908 until World War I. Its core was formed by the artist group The Eight, which was founded by Robert Henri. Next to John Sloan, William Glackens, Everett Shinn, and George Luks, George Bellows and Edward Hopper were also associated with the group. In their gloomy paintings, the Ashcan artists captured scenes of daily life in New York, but even though they often painted outcasts and life in the slums, they were more interested in the picturesque aspects of these subjects than in social issues.

Brady, Matthew B. American photographer (1822–1896) who gained prominence during the Civil War for his extensive photographic documentation and his portraits of Abraham Lincoln.

Brown, John Radical abolitionist (1800–1859). In 1859, he captured the federal arsenal at Harper's Ferry in an effort to secure a supply of arms for a major slave insurrection. Brown and his followers were captured and hanged for treason. After the executions, the North made a martyr of Brown.

Bryant, Willam Cullen American poet and journalist (1794–1878). His melancholy elegy *Thanatopsis* and his sensitive poems about nature and the transitoriness of life made him famous.

Burke, Edmund British politician, orator, and publicist (1729–1797). He served as a Whig in the British House of Commons (1765–1794) and wrote an influential work on aesthetics, *A Philosophical Enquiry into the Origin of our Ideas of the Sublime and Beautiful*.

Colonial Revival Style of architecture and interior design in America, Australia, and other countries in the late nineteenth and early twentieth centuries. Architects such as Arthur Little, Donald G. Mitchell, and McKim, Mead & White borrowed the simple, clean stylistic elements of colonial architecture for their buildings.

Cooper, James Fenimore American author (1789–1863). In novels such as *Leather Stockings* (1823) and *The Last of the Mohicans* (1826) he romanticized the adventurous life of Native Americans and pioneers.

Corliss Engine In the middle of the nineteenth century, George Henry Corliss (1817–1888) developed a new, more precise control mechanism for steam engines, thus increasing their efficiency. At the 1876 World Fair in Philadelphia, he presented the world's largest steam engine, which was more than forty-two feet high.

Dred Scott Case This controversial Supreme Court decision of 1857 ruled that the slave Dred Scott, who had been taken to the free state of Illinois, could not sue for his freedom because, as a slave, he could not be a plaintiff. More importantly, the Supreme Court decided that the Missouri Compromise was unconstitutional and legalized slavery in the Northern territories. Although a victory for the South, it heightened the antagonism with the North, which finally led to the Civil War.

Düsseldorf Gallery From 1849 to 1861, the Düsseldorf Gallery in New York exhibited paintings by artists associated with the influential Düsseldorf School. Founded by the German-born wine dealer John Godfrey Boker, it initially exhibited his private collection of important works by the Düsseldorf School but soon became increasingly popular with American artists such as Alfred Bierstadt, George Bingham, and Eastman Johnson.

Emancipation Proclamation On 22 September 1862, Abraham Lincoln issued the Emancipation Proclamation, which did not free slaves immediately but stipulated that slaves in states in rebellion should be liberated on 1 January 1863. The Emancipation Proclamation was mainly a strategic measure that rallied support for the Union cause in Europe. Slavery was officially ended when the Thirteenth Amendment took effect in 1865.

The Eight A group of American painters who exhibited together at the Macbeth Gallery in New York in 1908, united by their opposition to the National Academy of Design, which had rejected their works, and a determination to bring painting back into direct touch with life. The original group consisted of Robert Henri, John Sloan, George Luks, William Glackens, Everett Shinn, Arthur B. Davies, and Maurice Prendergast.

Emerson, Ralph Waldo American philosopher and writer (1803–1882) who celebrated a life in harmony with nature and supported America's spiritual and intellectual independence from the European tradition.

Federal Style Neoclassicist architectural style in the United States, which dominated between 1720 and 1820 mainly in New England, influenced by the Classicist buildings of Robert Adams and William Chambers in England. Porticos, cupolas, columns, and oval rooms were typical for this style.

Genteel Tradition Since America in the nineteenth century was not able to look back on its own traditions the way the European nations could, American artists and architects decided to use European roots and adapt them to their native conditions.

Gilded Age The decades between the 1870s and the early twentieth century were a time characterized by corruption, the forming of trusts, monopolies, and cartels, and the concentration of resources and capital in the hands of a few. The men who dominated American industry were also famous art patrons: Rockefeller (oil), Carnegie and Frick (steel), Vanderbilt (rail), Gould, Astor, Fisk, and Morgan (banking).

Homestead Act Federal law issued in 1862 that provided settlers with 160 acres of land in the West if they were willing to live on and till that land for a minimum of five years. The Homestead Act promoted the settlement of the West, and the frontier rapidly moved westward.

Hudson River School A loosely connected group of American landscape painters, active from about 1825 to 1875, who were inspired by pride in the beauty of their homeland. The early leaders and the most important figures in the group were Thomas Cole, Thomas Doughty, and Asher B. Durand, who painted the Hudson River Valley, the Catskill Mountains, and other remote and untouched areas of natural beauty.

Humboldt, Alexander, Freiherr von German explorer, natural historian, and geographer (1769–1859). From 1799 to 1804, he explored the areas of what today are Venezuela, Cuba, Colombia, Ecuador, Peru, and Mexico, returning to Europe via the United States. In the following years, he analyzed his findings and published them in the thirty-six-volume work, *Journey to the Equinoctial Regions of the New Continent*, the largest travel publication in history.

Impressionism, American Art style of the late nineteenth and early twentieth centuries, which after some delay was the American answer to the achievements of French Impressionism. Mary Cassatt, William Merritt Chase, Childe Hassam, John H. Twatchman, and Julian Alden Weir were the most prominent American Impressionists.

Indian Removal Act The Indian Removal Act of 1830 was the legal basis for deporting all Native Americans to land west of the Mississippi. Until 1835, all tribes, with the exception of the Seminoles, had given up resistance and their land east of the Mississippi.

Limner A word for a painter that has been used in different ways according to time and place. In American usage, it denotes the anonymous and often itinerant painters, particularly portraitists, of the seventeenth and eighteenth centuries. Sometimes limners are given invented names after the person or family they portrayed.

Luminism Term coined in 1954 by John Baur, director of the Whitney Museum in New York, to describe an aspect of mid nineteenth-century American landscape painting in which the study of light was paramount. Characteristically, Luminist painters were concerned chiefly with the depiction of water and sky. Leading Luminists included George Bingham and Asher B. Durand, and aspects of this style can be seen in the work of the Hudson River School.

"Malkasten" (German for "paint-box.") Liberal-democratic association of Düsseldorf painters, founded in 1848. Its members were opposed to the preferential treatment of academic art and favored an art form that was more closely connected to reality.

Manifest Destiny The editor John Louis O'Sullivan coined this term in the *United States Magazine and Democratic Review* in 1845 to refer to the apparent destiny of the United States to expand to cover the whole of North America.

McCormick Reaper In 1832, the American inventor Cyrus Hall McCormick (1809–1884) developed the first mechanical reaper, which was patented in 1834. After improving the machine's design, he opened a factory in Chicago in 1847 and began the large-scale manufacture of mechanical reapers. This innovative harvesting technique contributed significantly to the development of modern agriculture by reducing the cost and increasing the growth of American wheat production.

Mexican War War between Mexico and the United States (1846–1848) that broke out over Texan independence. Expansionist Southern farmers demanded the annexation of Texas, California, and areas which are today Arizona and New Mexico. After Texas declared its independence and joined the Union, relations between the United States and Mexico deteriorated, and border disputes finally led to war. After two years of fighting, Mexico surrendered. The Treaty of Guadalupe-Hidalgo required Mexico to cede California and New Mexico, and the United States to pay Mexico $15 million in compensation.

Modernism Term describing the progessive tendencies that appeared in American art during the first decades of the twentieth century. Many artists turned away from traditional academic standards, searching for new modes of expression. While some artists encountered radical new trends during their education in Europe, others were inspired by exhibitions of modern French and American art in Alfred Stieglitz's Little Galleries of the Photo-Secession in New York. The famous Armory Show of 1913 is considered a turning point in the history of American modernism.

Monroe Doctrine In a written message to Congress on December 2, 1823, President James Monroe laid down the three fundamental principles of American foreign policy. The doctrine stated that America was no longer open to colonization by European nations, that the United States would not interfere in the local affairs of European nations, and that it would not tolerate any interference of European nations in American affairs.

Muybridge, Eadweard Originally called Edward James Muggeridge (1830–1904). The American photographer and motion-picture pioneer worked as a photographic surveyor for the United States Coast and Geodetic Survey, gaining attention with his large composite photographs of Yosemite Valley in 1867. He became famous for his photographic studies of motion, taking more than 100,000 photographs of animals in motion. He also invented the zoopraxiscope, which reproduced moving images on a screen, and thereby became a pioneer of cinematography.

National Academy of Design This artists' organization was founded in New York in 1825 in opposition to the conservative American Academy of Fine Arts. During most of the nineteenth century, the National Academy of Design was America's leading art institution, renowned for its annual art exhibition. At the end of the century, the National Academy of Design fell behind in new artistic developments, often refusing the works of progressive young artists, who responded by founding new societies such as the Society of American Artists or The Eight.

Northwest Ordinance In 1787, this act of the Continental Congress set a precedent for the organization of territorial government and the admission of new states. It stipulated that the Northwest Territory would be divided into three to five territories, which would have to go through three successive stages of government as the population increased. Initially, the unorganized territory would be governed by appointed officials. After the population reached 5,000, inhabitants could elect a two-house territorial legislature and send a delegate to Congress. After attaining a population of 60,000, the territory could draft a constitution and apply to Congress for statehood.

O'Sullivan, Timothy American photographer (1840–1882). Between 1867 and 1875, he led several expeditions for the American government in areas of the West which, until that time, had been inaccessible. O'Sullivan documented, for example, the pueblos of the Zuni Indians and the old ruins in the Canyon de Chelly in Arizona.

Pennsylvania Academy of the Fine Arts This society was founded in Philadelphia in 1805 by local businessmen for the advancement of the arts and for creating copies of paintings and sculptures for the use of local artists. From 1810, it cooperated with the Society for Artists of the United States, which had been founded with the purpose of exhibiting contemporary art and operating an art school. Around 1816, the Pennsylvania Academy of the Fine Arts began collecting contemporary art and, over the decades, created one of the most important art collections in America.

Photo-Secession Group of photographers around Alfred Stieglitz who wanted raise photography to the level of the other fine arts and who saw the medium as a means of personal expression. Among the founding members were Edward Steichen, Gertrude Käsebier, and Clarence H. White. From 1903 to 1917, Stieglitz published the magazine *Camera Work*, which served as the group's organ and forum. The group regularly exhibited their works in Stieglitz's Little Galleries of the Photo-Secession.

Picturesque Term covering a set of attitudes towards landscape, real and painted, that was popular in the late eighteenth and early nineteenth centuries. The ideal picturesque landscape painting celebrated the irregularity, roughness, and variety of nature, though in scenes deliberately composed to evoke these qualities.

Progressive Movement Economic, political, and social reform movement between the end of the 1890s and World War I. As a consequence of the growing industrialization in the United States, problems such as monopolization, corruption, and terrible working and urban living conditions developed. At the end of the nineteenth century, middle-class reformers, termed "progressives" in 1905, began their crusade against these problems.

Republicanism The ideology of the leaders of the American Revolution. Republicanism not only called for the abolition of monarchy, but criticized the patriarchal, luxurious, and corrupt lifestyle associated with it. The basic Republican principle was the equality of all men, an idea that was influenced both by the Roman Republic and Renaissance political humanism.

Riis, Jacob August The Danish-born photojournalist (1849–1914) came to the United States in 1870. He worked for the *New York Times* and the *Evening Sun*, where his photo documentaries of the living conditions in New York slums made him a forerunner of the muckrakers.

Robber Barons A term used for a small group of extremely rich industrialists during the Gilded Age (Rockefeller, Frick, Vanderbilt, Morgan, and others), who were said to have made their fortunes by unscrupulous and corrupt means.

Ruskin, John The foremost English art critic of the Victorian age, as well as a social reformer and talented water-colorist (1819–1900). The publication of his first book, *Modern Painters* (1843), founded his reputation as an influential art critic, and he became the most important supporter of the Pre-Raphaelites. He belonged to the Romantic School in his conception of the artist as an inspired prophet and teacher. Greatness in art, he thought, was the expression of the mind of a God-made man. He advocated a revival of the Gothic style, because he felt that art and architecture should mirror man's wonder and delight before the visual creation of God.

Spanish War An armed conflict in 1898, which made the United States a world power. Among the causes of the war were American imperial endeavors and disapproval of Spanish presence in Cuba. After American military intervention in Cuba, Spain declared war. American troops were victorious in several decisive battles. The Treaty of Paris required that Spain cede the Philippines, Puerto Rico, and Guam, and renounce all claims to Cuba. The war sparked a strong anti-imperial movement in the United States, but it also strengthened the nationalist sentiment in many people.

Sublime A term that came into general use in the eighteenth century to denote a new aesthetic concept that was held to be distinct from the beautiful and the picturesque and was associated with ideas of awe and vastness. The outstanding work on the concept of the sublime in English was Edmund Burke's *Philosophical Enquiry into the Origins of our Ideas of the Sublime and Beautiful* (1757), in which he developed the term in contrast to the beautiful. By depicting the overwhelming greatness of nature, the artists of the Hudson River School managed to achieve this aesthetic of the sublime.

Sullivan, Louis Henry American architect (1856–1924), who created the basis of the modern skyscraper by developing steel skeleton construction. He strove for organic form in buildings and became famous for his demand that form had to follow function. His ideas, furthered by his student and collaborator, Frank Lloyd Wright, influenced European architecture as well.

The Ten A group of American painters from New York and Boston who exhibited together for about twenty years from 1898. The name derived from the title of their first exhibition, *Show of Ten American Painters*. The group was led by Childe Hassam, John H. Twatchman, and Julian Alden Weir, who left the Society of American Artists, disappointed by the size and quality of its exhibitions, and were followed by other artists. The Ten, which favored small, private exhibitions without a jury and acted independently of official institutions, became an example for other groups such as The Eight.

Tenth Street Studio Building A studio building for artists that James B. Johnston commissioned architect Richard Morris Hunt to build in Tenth Street in New York in 1857. Many important painters such as Frederic Edwin Church, Albert Bierstadt, Stanford R. Gifford, Winslow Homer, and William Merritt Chase used the building to work, hold discussions, and to exhibit and sell their art.

Tocqueville, Charles Alexis Henri Clérel French historian and politician (1805–1859) who served as a judge in the court of Versailles before the French government sent him to the United States from 1831 to 1832 to study the penal system. Following his visit, he recorded his reflections on the young democratic society in America and about democracy in general in *De la démocratie en Amérique* (published in two volumes, 1835–40).

Trompe-l'oeil painting (French for "deceives the eye.") A term applied to a painting or a part of it that is intended to deceive the spectator into thinking that it is a real object rather than a two-dimensional representation of it.

Victorian Style A style in English art, primarily in architecture, from about 1840 to 1900, which was named after Queen Victoria (reigned 1837–1901). Historical elements dominated the Victorian style, but the beginnings of industrialization also initiated functional forms. In reaction to the simple, symmetric forms of classicism, Victorian artists preferred the use of light and shadow and rich decoration, drawn from various styles.

World Fairs Since 1851, world fairs have been held as universal exhibitions with the participation of countries from all over the world. Their main purpose has always been to present and support technical and scientific progress as well as the self-promotion of the participating countries. Important world fairs of the nineteenth century took place in London (1851, 1862), Paris (1855, 1867, 1889, 1900), Vienna (1873), Philadelphia (1876), and Chicago (1893).

World Colombian Exhibition World Fair in Chicago in 1893, celebrating the 400th anniversary of the discovery of America. Major American achievements in the fields of art, industry, technology, and agriculture were presented with great extravagance in a field of international exhibitors. One of the major attractions was the "White City," built by major American designers, including Louis Henry Sullivan. Overall, a conservative taste dominated, and the exhibition failed to spark the kind of artistic renaissance many had desired.

Historical Overview: America and Europe

	American History		Art & Culture		European History		Art & Culture
1770	Boston Massacre	1770	Benjamin West: *The Death of General Wolfe*				
1773	Boston Tea Party						
1775–1781	War of Independence against England			1775	Turkey cedes Bukovina to Austria		
1776	The 13 British colonies declare their independence from England Virginia Bill of Rights: Civil rights are laid down for the first time					1776	Jean Honoré Fragonard: *The Washerwomen* James Cook: third journey around the world (discovers the Hawaiian Islands)
1777	In Paris, Benjamin Franklin tries to win support for the American cause War is declared against England						
1778	France and Spain enter the war, supporting America	1778	John Singleton Copley: *Watson and the Shark*	1778	Bavarian war of succession	1778	Joshua Reynolds: *The Marlborough Family*
		1780	Founding of the American Academy of Arts and Sciences in Boston	1780	Maria Theresia dies and is succeeded by Joseph II (until 1790)		
1781	British troops surrender after the capture of Yorktown			1781	Reforms under Joseph II: abolishment of serfdom, reformation of the church, patent of tolerance	1781	Immanuel Kant: *Critique of Pure Reason* Heinrich Fuseli: *The Nightmare*
		1782	First English edition of the Bible published in the United States			1782	Friedrich Schiller: *Die Räuber*
1783	Peace of Paris Canada remains part of the British Empire Florida and Louisiana west of the Mississippi are returned to Spain Great Britain recognizes the 13 United States as free, independent, and sovereign New York becomes the provisional capital	1783	The first daily newspaper of the United States, the *Pennsylvania Evening Post*, is published			1783	Jacques Louis David: *Oath of the Horatii*
1785	Virginia Statute of Religious Liberty			1785	Friedrich II of Prussia founds the Alliance of Principalities		
		1786	Opening of the Charles Willson Peale Museum	1786	Friedrich II dies and is succeeded by Wilhelm II		
1787	Ratification of the Constitution by 55 delegates from the 13 founding states One territory is created in the unorganized western land, out of which 2–5 new states will be formed					1787	Johann Wolfgang von Goethe: *Egmont, Iphigenie*
1788	The new Constitution takes effect						
1789	George Washington becomes the first president of the United States (until 1797) The federal government, Supreme Court, and two houses of Congress (Senate and House of Representatives) are formed			1789	The French Revolution breaks out The Bastille is stormed	1789	Heinrich Friedrich Füger: *Tod des Germanicus*
1790	The first official census determines a population of 3,929,000 Alexander Hamilton develops his program for a currency and finance reform Thomas Jefferson turns against him			1790	Joseph II dies Leopold II succeeds him as German Emperor	1790	Wolfgang Amadeus Mozart: *Così fan tutte*
1791	Establishment of the Bill of Rights Founding of the Bank of the United States (BUS)	1791	The first opera house in the USA opens in New Orleans	1791	France becomes a constitutional monarchy	1791	Wolfgang Amadeus Mozart: *The Magic Flute*

American History	Art & Culture	European History	Art & Culture
	1792 Benjamin West becomes president of the Royal Academy in London	1792 France becomes a republic Leopold II dies and is succeeded by Franz II First Coalition War (until 1797)	
1793 Founding of the city of Washington, D.C.		1793 Louis XVI and Marie Antoinette are executed Jean Paul Marat (French Jacobin) is murdered	1793 Jacques Louis David: *The Death of Marat*
		1794 Georges Danton and Maximilian Robespierre are executed	
	1795 First exhibition of the American Academy of Fine Arts in Philadelphia Charles Willson Peale: *The Staircase Group*	1795 New French Constitution appoints a Directorate (until 1799) Peace of Basel between France and Prussia	1795 Friedrich Schiller: *Letters on the Aesthetic Education of Mankind*
	1796 Gilbert Stuart: *George Washington*	1796 Napoleon Bonaparte is victorious in his campaign in Italy	1796 Francisco de Goya: *Caprichos*
1797 2nd President: John Adams (until 1801)		1797 Treaty of Campoformio: Lombardy and Belgium are annexed to France from Austria Venice is given to Austria	1797 Friedrich W. J. Schelling: *Ideas on a Natural Philosophy* Aloys Senefelder invents lithography
		1798 War of the coalition between England, Austria, Russia, Turkey, and the Neapolitan Church State against France (until 1801) Napoleon's campaign in Egypt (until 1799)	1798 Antonio Canova: *Tomb of the Archduchess Marie Christine* in the Augustinerkirche in Vienna
		1799 Second Coalition War (until 1805)	1799 Jacques Louis David: *Napoleon Crossing the Alps*
1800 The Convention of 1800 ends the alliance with France Washington, D.C. becomes the seat of the President and the government Population: 5,308,000	1800 Founding of the Library of Congress	1800 Victory of Napoleon over Austria at Marengo	
1801 3rd President: Thomas Jefferson (until 1809)	1801 Rembrandt Peale: *Rubens Peale with a Geranium*	1801 Treaty of Luneville between Austria and France	1801 Francisco de Goya: *The Naked Maja, The Clothed Maja* Joseph Haydn: *The Four Seasons*
	1802 Founding of the New York Academy of Fine Arts	1802 Napoleon Bonaparte becomes Consul for life Treaty of Amiens between England and France	1802 François Gérard: *Mme. Récamier* Philipp Otto Runge: *Triumph of Amor*
1803 Louisiana Purchase: Livingston und Monroe purchase the Louisiana territory (c. 319,000 square miles between the Mississippi and the Rocky Mountains) for 15 million dollars from Napoleon			1803 Thomas Bruce, Seventh Earl of Elgin, procures and transports marble sculptures from the Parthenon in Athens to England
1804 Expedition undertaken by Lewis and Clark to explore the West for Jefferson	1804 John Vanderlyn: *The Death of Jane McCrea*	1804 Napoleons is crowned emperor Franz II becomes Franz I of Austria (until 1835)	1804 Ludwig van Beethoven removes his dedication to Napoleon in his *Symphony No. 3 (Eroica)*
		1805 Napoleon, King of Italy Napoleon is victorious at Austerlitz over Austria and Russia Battle of Trafalgar: Lord Nelson defeats the French-Spanish fleet	
		1806 Founding of the Confederation of the Rhine Continental blockade against England (until 1813) Emperor Franz II abdicates: end of the Holy Roman Empire	1806 Johann Wolfgang von Goethe: *Faust I*
		1807 Treaty of Tilsit between France, Russia, and Prussia Napoleon occupies Spain England bans the trade of black slaves	1807 Heinrich von Kleist: *Amphitryon*
1808 US Congress outlaws the import of slaves		1808 Spanish rebellion against the French (liberation in 1813 with the help of England)	1808 Caspar David Friedrich: *Cross in the Mountains* Ludwig van Beethoven: *Symphony No. 5* and *No. 6 (Pastoral)*

American History		Art & Cultur		European History		Art & Culture	
1809	4th President: James Madison (until 1817)	1809	Washington Irving: *History of New York*	1809	Napoleon is defeated by Austria for the first time in the Battle of Aspern by Austria, but he is victorious again some weeks later at Wagram Prince Metternich becomes Austrian Foreign Minister (until 1848) Rebellion of Tirol against the French	1809	Johann Wolfgang von Goethe: *Elective Affinities* Francisco de Goya: *Third of May, 1808*
				1810	Napoleon marries Marie Louise, daughter of Franz I	1810	Wilhelm von Humboldt founds the University of Berlin
1812–1814	War of 1812 against England as a consequence of England's sea blockade and trade restrictions Peace of Ghent restores the pre-war status			1812	Napoleon's campaign in Russia	1812	The Brothers Grimm compile their *Fairy Tales*
				1813	German war of liberation against Napoleon Battle of the Nations at Leipzig Austria, Prussia, and Russia win a decisive victory	1813	Johann Gottlieb Fichte: *Staatslehre*
				1814	Treaty of Paris Napoleon is exiled Congress of Vienna (until June 1815) Political reorganization of Europe	1814	William Turner: *Frosty Morning* Jean Dominique Ingres: *Grande Odalisque*
				1815	Napoleon's 100-day-rule Battle of Waterloo Second Treaty of Paris: Napoleon is exiled again Holy Alliance between Austria, Russia, and Prussia	1815	Franz Schubert: *Lieder auf Goethetexte*
1817	5th President: James Monroe (until 1825)	1817	Corner-stone ceremony for the Univerity of Virginia after plans by Thomas Jefferson John Trumbull: decoration of the rotunda in the Capitol			1817	E.T.A. Hoffmann: *Nachtstücke* (short stories)
1819	The United States purchases Florida from Spain					1819	Théodore Géricault: *Raft of the Medusa*
1820	Missouri Compromise: Slavery is only permitted below the latitude 36°30' north					1820	William Blake: *Jerusalem* John Constable: *Hampstead Heath*
				1821	Prince Metternich becomes Austrian State Chancellor (until 1848) Greek war of independence against Turkey	1821	Carl Friedrich Schinkel: Schauspielhaus (National Theater) Berlin
1823	The Monroe Doctrine warns Europe from interfering in American affairs	1823	James Fenimore Cooper: *The Pioneers*			1823	Ludwig van Beethoven: *Symphony No. 9*
1825	6th President: John Quincy Adams (until 1829)						
1828	Founding of the Democratic Party						
1829	7th President: Andrew Jackson (until 1837) Establishment of the system of rotation of public officials after the electoral victory of a party	1829	Edgar Allan Poe: *Tamerlane*	1829	Russian-Turkish Treaty: Greece gains independence from Turkey	1829	Honoré de Balzac: *La comédie humaine* Giacomo Rossini: *William Tell*
1830	Trail of Tears: Native Americans east of the Mississippi are driven from their land and put into Indian reservations			1830	July Revolution in Paris: Charles X abdicates Louis Philippe crowned king of France (until 1848)	1830	Eugène Delacroix: *Liberty Leading the People*
		1831–1833	Samuel F.B. Morse: *Gallery of the Louvre*				
		1834–1836	Thomas Cole: *The Course of Empire*			1834	Franz Grillparzer: *Der Traum ein Leben*
				1835	Franz I dies and is succeeded by Ferdinand I (until 1848) First German railway from Nuremberg to Fürth	1835	Georg Büchner: *Dantons Tod*
1837	8th President: Martin Van Buren (until 1841)	1837	Ralph Waldo Emerson: *The American Scholar* George Catlin exhibits his Indian Gallery	1837	Victoria ascends British throne (until 1901): The Victorian Age and the period of middle-class expansion begins	1837	Charles Dickens: *Oliver Twist* First daguerreotypes

American History		Art & Cultur		European History		Art & Culture	
		1838	Edgar Allan Poe: *Arthur Gordon Pym* Founding of the American Art-Union	1838	Great Britain begins the Opium War against China (until 1842)	1838	Eugène Delacroix: *Entry of the Crusaders into Constantinople* William Turner: *The Fighting Temeraire Tugged to her Last Berth to be Broken up*
1841	9th President: William Harrison 10th President: John Tyler (until 1845)						
				1842	Treaty of Nanking: China cedes Hongkong to England	1842	Annette von Droste-Hülshoff: *Die Judenbuche*
		1844/ 1845	George Catlin: *The White Cloud*			1844	Honoré Daumier: *The Blue Stockings* Eugéne-Emanuel Violett-le-Duc begins restoration of Notre Dame Cathedral in Paris
1845– 1848	Mexican War. For $ 15 million compensation Mexico cedes New Mexico, Arizona, Utah, Nevada, California and parts of Wyoming and Colorado to the United States 11th President: James K. Polk (until 1849)					1845	Adolf Menzel: *Room with a Balcony* Friedrich Engels: *The State of the Working Class* Richard Wagner: *Tannhäuser*
		1847	George Caleb Bingham: *Raftsmen Playing Cards*			1847	Moritz von Schwind: *The Morning of the Wedding*
1848– 1849	Gold is discovered in Califonia The migration of new settlers through Indian territory leads to violent conflicts			1848	February Revolution in Paris March Revolution in Germany and Austria tries to achieve a democratic constitution October Revolution in Austria Ferdinand 1 abdicates Franz Josef 1 becomes Emperor of Austria (until 1916)	1848	Dante Gabriel Rossetti founds the Pre-Raphaelite Brotherhood Karl Marx: *The Communist Manifesto*
1849	12th President: Zachary Taylor (until 1850)	1849	Opening of the Düsseldorf Gallery in New York Asher B. Durand: *Kindred Spirits*			1849	Gustave Courbet: *The Stonebreakers, A Burial at Ornans* Charles Dickens: *David Copperfield*
1850	13th President: Millard Fillmore (until 1853) Population: 23,192,000	1850	Nathaniel Hawthorne: *The Scarlet Letter*	1850	The German Confederation is restored Hungary falls under the Austrian crown	1850	Ferdinand Georg Waldmüller: *Praterlandschaft*
		1851	John Frederick Kensett: *Mount Washington from the Valley of Conway* Herman Melville: *Moby Dick* Founding of *The New York Times*	1851	Bismarck is the Prussian delegate at the Diet of the German Confederation	1851	First World Fair in London (Crystal Palace)
1852	Large numbers of political immigrants from Europe	1852	Harriet Beecher Stowe: *Uncle Tom's Cabin*	1852	Napoleon 111 is elected hereditary emperor of France Beginning of the Second Empire (until 1870)	1852	The Grimm Brothers: *Deutsches Wörterbuch* Theodor Storm: *Immensee*
1853	14th President: Franklin Pierce (until 1857)	1853	Charles Wimar: *The Abduction of Daniel Boone's Daughter by the Indians*	1853	Crimean War (until 1856)	1853	Richard Wagner: *The Ring of the Nibelung* Giuseppe Verdi: *La Traviata*
1854	The Missouri Compromise is repealed: The Kansas-Nebraska Act permits slavery in both territories The Republican Party is founded					1854	Cologne Cathedral is completed Construction of the Munich glass palace (destroyed by fire in 1931)
		1855	Walt Whitman: *Leaves of Grass*	1855	Alexander 11 tsar of Russia Serfdom is abolished	1855	World Fair in Paris Charles François Daubigny: *Lock in the Valley of the Optevoz* Theodore Rousseau: *Edge of the Forest of Fontainebleau*
1857	15th President: James Buchanan (until 1861)	1857	Frederic Edwin Church: *Niagara Falls from the American Side*			1857	Ferdinand Georg Waldmüller: *On the Morning of Corpus Christi*
1858	Lincoln-Douglas debates on the slavery issue					1858	Wilhelm Busch: *Max and Moritz* Jacques Offenbach: *Orphée à l'enfer*
				1859	Giuseppe Garibaldi leads the Italian war of liberation Austria has to cede Lombardy, Nice, and Savoy to France	1859	Richard Wagner: *Tristan and Isolde*
1860	A convention in Columbia concludes the secession of South Carolina from the United States In 1861, Mississippi, Florida, Alabama, Georgia, Louisiana, and Texas follow suit	1860	Frederic Edwin Church: *Twilight in the Wilderness* Fitz Hugh Lane: *Lumber Schooners at Evening on Penobscot Bay*	1860	England and France occupy Peking; special rights for the white powers in China	1860	Jean Dominique Ingres: *Turkish Bath*

	American History		Art & Culture		European History		Art & Culture
1861-1865	16th President: Abraham Lincoln (until his assassination in 1865) Civil War between the Union and the Confederates The seven secession states later eleven) elect Jefferson Davis as President and found the Confederacy	1861	Matthew B. Brady: Photo documentary about the Civil War Winslow Homer works as an illustrator for *Harper's Weekly* on the battlefield			1861	Fyodor Dostoyevsky: *Insulted and Injured* Charles Garnier: Paris opera
1862	The Homestead Act regulates the settlement of the West	1862	James Abott McNeill Whistler: *The White Girl (Symphony in White)*	1862	Bismarck becomes Prussian Prime Minister and Foreign Minister	1862	Victor Hugo: *Les Misérables* Anselm Feuerbach: *Iphigenie* Ludwig Köchel: register of Mozart's complete works
1863	Emancipation Proclamation: President Lincoln proclaims the slaves in the South to be free			1863	England, France, and Spain recognize the Austrian Archduke Maximilian as Emperor of Mexico (executed in 1867)	1863	Edouard Manet: *Luncheon on the Grass* Gustave Courbet: *Horse in the Forest*
1865	Unconditional surrender of the South General Lee is defeated by General Grant at Appomattox 17th President: Andrew Johnson (until 1869) The 13th Amendment abolishes slavery in the United States White Southerners found the Ku-Klux-Klan	1865	Worthington Whittredge: *Twilight on the Shawangunk Mountains* Walt Whitman: *Drum Taps*			1865	Camille Corot: *Algerian Girl Reposing* Adolph Menzel: *Coronation of King William in Königsberg*
1866	Civil Rights Act: Blacks get citizenship and equal civil rights	1866	Founding of the Metropolitan Museum of Art in New York Winslow Homer: *Prisoners from the Front*	1866	War of supremacy in Germany at same time as the Austro-Italian war Treaty of Prague Austria secedes from Germany, the German Confederation is dissolved		
1867	Alaska is bought from Russia for 7.2 million dollars			1867	Emperor Franz Joseph 1 becomes King of Hungary: Austro-Hungarian Dual Monarchy (until 1916)	1867	World Fair in Paris Karl Marx: *Das Kapital*
1869	The Union-Central-Pacific railway is completed (Chicago—San Francisco) 18th President: Ulysses S. Grant (until 1877)					1869	Edouard Manet: *Execution of the Emperor Maximilian* Leo Tolstoy: *War and Peace*
				1870	Franco-Prussian War (until 1871)	1870	Richard Wagner: *The Valkyrie*
		1871	Thomas Eakins: *The Champion Single Sculls*			1871	Giuseppe Verdi: *Aida*
		1872	Winslow Homer: *Snap the Whip*				
				1873	Three Emperor Alliance: Germany, Austria, and Russia (until 1886)	1873	World Fair in Vienna Arthur Rimbaud: *A Season in Hell* Gottfried Semper: Burgtheater in Vienna (until 1888)
		1874	Thomas Eakins: *The Schreiber Brothers*			1874	First exhibition of the French Impressionists (including Claude Monet's *Impression—Sunrise*)
		1875	Albert Bierstadt: *El Capitan, Yosemite Valley, California*			1875	Hans Makart: *Die fünf Sinne* Adolph Menzel: *The Foundry*
1876	Sioux War in South Dakota Battle of Little Big Horn	1876	Mark Twain: *The Adventures of Tom Sawyer* Centennial Exhibition, Philadelphia			1876	The Bayreuth festival hall opens with the first staging of the entire *The Ring of the Nibelung*
1877	19th President: Rutherford B. Hayes (until 1881) Gold rush in Colorado Thomas Edison invents light bulb					1877	Edouard Manet: *Nana* Auguste Rodin: *The Age of Bronze*
						1878	World Fair in Paris
		1880	John Singer Sargent: *El Jaleo*			1880	Anton Romako: *Admiral Tegetthoff in the Sea Battle near Lissa*
1881	20th President: James A. Garfield 21st President: Chester A. Arthur (until 1885)					1881	Anton Bruckner: *Symphony No. 4*
				1882	Secret Triple Alliance Pact between Germany, Austro-Hungary, and Italy	1882	Wilhelm Leibl: *Three Women in the Village Church*
		1883	Opening of the Metropolitan Opera in New York			1883	Paul Cézanne: *Landscape with Bridge*
		1884	John Singer Sargent: *Madame X*				
1885	22nd President: Grover Cleveland (until 1889)					1885	Hans von Marées: *The Golden Age*
		1886	World Fair in New Orleans George Inness: *October* Improvised jazz popular in New Orleans			1886	Auguste Rodin: *The Kiss*

	American History		Art & Culture		European History		Art & Culture
		1887	John Singer Sargent: *A Gust of Wind*	1887	Secret treaty of mutual protection between Germany and Russia	1887	Claude Debussy: *The Spring*
		1888	William Michael Harnett: *Violin and Music*			1888	Theodor Storm: *Der Schimmelreiter* Gustav Mahler: *Symphony No. 1*
1889	23rd President: Benjamin Harrison (until 1893)			1889	The social democratic parties are founded in Austria and Switzerland	1889	World Fair in Paris (Eiffel Tower) Pierre Auguste Renoir: *Bathers*
1890	Battle of Wounded Knee The massacre of Sioux Indians by the US cavalry puts an end to the Indian wars	1890	John Haberle: *Twenty Dollar Bill*	1890	Emperor Wilhelm II dismisses Bismarck	1890	Claude Monet: *The Grainstacks* (15 variations until 1895) Pyotr Ilich Tchaikovsky: *Pique Dame*
						1892	Founding of the Munich Secession Gerhard Hauptmann: *Die Weber*
1893	Collapse of the stock market and depression (until 1897) 24th President: Grover Cleveland (until 1897)	1893	World Fair in Chicago Thomas Moran: *The Grand Canyon of the Yellowstone* Columbia University built by McKim, Mead, White			1893	Edvard Munch: *The Scream* Anton Dvořák: *Symphony No. 5 (From the New World)*
		1894	Winslow Homer: *Weatherbeaten* John Singer Sargent: *Madame Dankmar Adler and Louis Henry Sullivan:* *Buffalo Guaranty Building*	1894	Dreyfuss affair	1894	Adolf Loos visits the United States and sees the buildings of the Chicago School (1893–96) Paul Gauguin: *Paris in the Snow* Anton Bruckner: *Symphony No. 9* (unfinished)
1897	25th President: William McKinley (until 1901)			1897	First Zionist Convention in Basel	1897	Founding of the Vienna Secession Founding of the Tate Gallery in London
1898	Spanish-American War The Treaty of Paris dictates that Spain cede Cuba, Puerto Rico, Guam, and the Philippines to the United States Annexation of Hawaii (becomes 50th state only in 1959)	1898	First exhibition of the artists' group "Ten American Painters"			1898	Max Liebermann: *Boys Bathing* Henri Toulouse-Lautrec: *She*
1900	Population: 75,995,000					1900	World Fair in Paris
1901	26th President: Theodore Roosevelt (until 1909)	1901	Frank Lloyd Wright: first designs for residential houses in the so-called "prairie style"			1901	Ferdinand Hodler: *Spring*
		1902	Alfred Stieglitz founds the Photo-Secession in New York			1902	Max Klinger: *Beethoven*
1903	Henry Ford founds his company	1903	Jack London: *Call of the Wild*			1903	Gustav Klimt: Pictures of the faculty for Vienna University Otto Wagner: Postsparkasse Vienna (until 1912)
						1905	Founding of the artists' group "Die Brücke" in Dresden Exhibition of the "Fauves" at the Paris Fall Salon
		1907	George Bellows: *Club Night*			1907	Pablo Picasso: *Les Demoiselles d'Avignon* Oskar Kokoschka: *Mörder, Hoffnung der Frauen*
		1908	Independent exhibition of the artists' group "The Eight" as a reaction to their exclusion from the exhibition at the National Academy of 1907			1908	Gustav Klimt: *The Kiss* Gustav Mahler becomes director of the Metropolitan Opera in New York
1909	27th President: William H. Taft Assembly line used for production at the Ford automobile company	1909	Georges Bellows: *Pennsylvania Station Excavation*			1909	Franz Marc: *Deer in the Twilight*
		1912	John Sloan: *McSorley's Bar*	1912	The Triple Alliance is renewed: Austria, Germany, and Italy	1912	Marc Chagall: *Cavalry* Marcel Duchamp: *Nude Descending a Staircase* Founding of "Der Blaue Reiter" (Blue Rider) in Munich
1913	28th President: Woodrow Wilson (until 1921)	1913	Armory Show in New York			1913	Kazimir Malevich: *Black Square on White*
				1914	Thr Austrain heir to the throne, Archduke Franz Ferdinand, is assassinated Austro-Hungary declares war on Serbia (until 1918) Beginning of World War 1 (until 1918)	1914	Oskar Kokoschka: *Bride of the Wind (The Tempest)*
1917	The United States enters World War 1					1917	Egon Schiele: *Four Trees*

List of Plates

1
Benjamin West
Charles Willson Peale
1767/69
Oil on canvas, 71.4 x 58.7 cm
Collection of the New-York Historical
Society, New York, NY, gift of Thomas
J. Bryan, 1867

2
John Singleton Copley
Mary and Elizabeth Royall
c. 1758
Oil on canvas, 146 x 121.9 cm
Museum of Fine Arts, Boston, MA,
Julia Knight Fox Fund

3
John Singleton Copley
Nicholas Boylston
c. 1769
Oil on canvas, 127.3 x 101.6 cm
Museum of Fine Arts, Boston, MA,
bequest of David P. Kimball

4
John Singleton Copley
Watson and the Shark
1782
Oil on canvas, 91.4 x 77.5 cm
Signed and dated lower left: Painted by
J. S. Copley R. A. London 1782
The Detroit Institute of Arts, Detroit,
MI, Founders' Society purchase,
Dexter M. Ferry Jr. Fund

5
John Vanderlyn
The Death of Jane McCrea
1804
Oil on canvas, 82.6 x 67.3 cm
Inscription on the back of the original
canvas: J. Vanderlyn. Faciebat/1804
Paris
Wadsworth Atheneum, Hartford, CT,
The Ella Gallup Sumner and Mary
Catlin Sumner Collection Fund

6
Gilbert Stuart
George Washington
after 1796
Oil on canvas, 73.5 x 61.1 cm
Sterling and Francine Clark Art
Institute, Williamstown, MA

7
Thomas Sully
Mary McKean Hoffman
1821
Oil on canvas, 76.2 x 63.5 cm
Signed and dated upper right:
TS. 1821.
Courtesy of the Pennsylvania Acad-
emy of the Fine Arts, Philadelphia,
PA, bequest of Fredericka Mary Kerr

8
Thomas Sully
Major Thomas Biddle
1818
Oil on canvas, 92.7 x 71.3 cm
Courtesy of the Pennsylvania Acad-
emy of the Fine Arts, Philadelphia,
PA, bequest of Ann E. Biddle

9
Thomas Sully
Mary Anne Heide Norris
1830
Oil on canvas, 77 x 64.1 cm
Signed and dated lower left: TS 1830
Philadelphia Museum of Art, Philadel-
phia, PA, bequest of G. Heide Norris

10
Charles Willson Peale
*Portrait of Governor Thomas McKean
and His Son, Thomas McKean, Jr.*
1787
Oil on canvas, 128.6 x 104.5 cm
Signed and dated right center:
C. W. Peale, 1787
Philadelphia Museum of Art, Philadel-
phia, PA, bequest of Mrs. Phebe
Warren McKean Downs

11
Charles Willson Peale
*Mother Caressing her Convalescent
Daughter (Angelica Peale
[Mrs. Alexander] Robinson and her
Daughter Charlotte)*
1818
Oil on canvas, 76.2 x 63.2 cm
Private collection

12
Charles Willson Peale
James Peale Painting a Miniature
1789/90
Oil on canvas, 76.2 x 62.5 cm
Mead Art Museum, Amherst College,
Amherst, MA, bequest of Herbert
L. Pratt, class of 1895

13
Charles Willson Peale
Self-Portrait
1822
Oil on canvas, 74.3 cm x 61.3 cm
The Fine Arts Museums of San Fran-
cisco, San Francisco, CA, gift of
Mr. and Mrs. John D. Rockefeller III

14
Raphaelle Peale
Still Life with Peach
c. 1816
Oil on wood, 18.7 x 22.9 cm
Signed lower right: Raphaelle Peale
San Diego Museum of Art, San Diego,
CA, museum purchase with funds
provided by the Earle W. Grant
Acquisition Fund

15
Raphaelle Peale
Still Life with Peach
c. 1816
Oil on wood, 18.7 x 21.3 cm
Signed lower right: R. Peale
San Diego Museum of Art, San Diego,
CA, museum purchase with funds
provided by the Earle W. Grant
Acquisition Fund

16
Raphaelle Peale
Venus Rising from the Sea—A Deception
1823
Oil on canvas, 74.3 x 61.3 cm
Signed and dated lower right:
Raphaelle Peale 1823/Pinxt
The Nelson-Atkins Museum of Art,
Kansas City, MO (purchase, Nelson
Trust)

17
Raphaelle Peale
Still Life with Orange and Book
c. 1815
Oil on wood, 22.86 x 27.94 cm
Inscription on the back: By Peale
Private collection

18
Rembrandt Peale
Rubens Peale with a Geranium
1801
Oil on canvas, 71.4 x 61 cm
Signed lower right: Rem Peale/1801
National Gallery of Art, Washington,
D.C., Patrons' Permanent Fund

19
Thomas Cole
*Summer Twilight: A Recollection of
a Scene in New England*
1834
Oil on wood, 34.6 x 49.7 cm
Signed on bottom edge left of center:
T. Cole; inscription on the back:
T. Cole/Catskill/1834
Collection of the New-York Historical
Society, New York, NY, gift of the
New York Gallery of Fine Arts,
1858

20
Thomas Cole
*Autumn Twilight: View of Corway Peak
(Mount Chocorua, New Hampshire)*
1834
Oil on wood, 35 x 49.5 cm
Signed lower right (on the rock):
T. Cole; inscription on the back:
T. Cole/Catskill/1834
Collection of the New-York Historical
Society, New York, NY, gift of the
New York Gallery of Fine Arts,
1858

21
Thomas Cole
Catskill Creek, New York
1845
Oil on canvas, 67.3 x 91.4 cm
Signed and dated lower right:
T. Cole/1845
Collection of the New-York Historical
Society, New York, NY, Robert L. Stu-
art Collection, on permanent loan
from the New York Public Library,
1944

22
Asher Brown Durand
*Study from Nature, Stratton Notch,
Vermont*
1853
Oil on canvas, 45.7 x 60.3 cm
Dated lower right: Vt/1853; inscrip-
tion on the back: To John/from his
Father/Jany. 1st 1854/Stratton Notch,
Vermont.
Collection of the New-York Historical
Society, New York, NY, donation of
Mrs. Lucy Maria Durand Woodman,
1907

23
Asher Brown Durand
Landscape—Composition: In the Catskills
1848
Oil on canvas, 76.2 x 107.3 cm
Signed and dated lower right (on the
rock): A.B. Durand 1848
San Diego Museum of Art, San Diego,
CA, gift of Gerald and Inez Grant
Parker Foundation

24
Asher Brown Durand
The First Harvest in the Wilderness
1855
Oil on canvas, 81.5 x 122 cm
Signed and dated bottom center:
A B Durand pt./1855; inscription at
bottom center: GRAHAM
The Brooklyn Museum of Art, Brook-
lyn, NY, gift of the Brooklyn Institute
of Arts and Sciences

25
James Goodwyn Clonney
Waking Up
1851
Oil on canvas, 68.6 x 55.9 cm
Signed and dated lower right:
Clonney 1851
Courtesy of Museum of Fine Arts,
Boston, MA, gift of Martha C. Karolik
for the M. and M. Karolik Collection
of American Paintings, 1815–1865

26
Richard Caton Woodville
Politics in an Oysterhouse
1848
Oil on canvas, 40.6 x 33 cm
Signed and dated lower left: R.C.W.
1848
Walters Art Gallery, Baltimore, MD,
gift of C. Morgan Marshall

27
Martin Johnson Heade
Marsh Scene: Two Cattle in a Field
1869
Oil on canvas, 36.5 x 76.8 cm
Signed and dated lower right:
M/Heade 69
The Columbus Museum of Art,
Columbus, OH, acquired through
exchange, bequest of J. Willard Loos

28
Martin Johnson Heade
Hazy Day on the Marshes, New Jersey
1862
Oil on canvas, 34.5 x 65.1 cm
Signed lower right: MJ Heade
Catherine and Severn Joyce

29
Martin Johnson Heade
Sunset, Haywagon in the Distance
c. 1875
Oil on canvas, 35.7 x 81.5 cm
Signed lower left: MJ Heade
Collection of the Birmingham
Museum of Art, Birmingham, AL,
museum purchase with funds pro-
vided by the Friends of the Museum
through Vulcan Materials

30
John Frederick Kensett
White Mountain Scenery
1859
Oil on canvas, 115 x 92 cm
Signed and dated lower left: JFK '59
Collection of the New-York Historical
Society, New York, NY, Robert L.
Stuart Collection

31
John Frederick Kensett
*Camel's Hump from the Western Shore of
Lake Champlain*
1852
Oil on canvas, 79 x 114.8 cm
Signed and dated lower right: JFK '52
High Museum of Art, Atlanta, GA,
gift of Virginia Carroll Crawford

32
Sanford Robinson Gifford
Early October in the White Mountains
1860
Oil on canvas, 35.9 x 61 cm
Signed lower left: S. R. Gifford
Washington University Gallery of Art,
Saint Louis, MO, gift of Charles
Parsons, 1905

33
John Frederick Kensett
*The White Mountains (Mount Washing-
ton from the Valley of Conway)*
1851
Oil on canvas, 102.5 x 153.3 cm
Signed lower right: J.K.
Davis Museum and Cultural Center,
Wellesley College, Wellesley, MA, gift
of Mr. and Mrs. James B. Munn (Ruth
C. Hanford, class of 1909) in the name
of the class of 1909

34
Fitz Hugh Lane
Light House at Camden, Maine
1851
Oil on canvas, 58.4 x 86.4 cm
Signed and dated lower right:
F. H. 1851
Yale University Art Gallery, New
Haven, CT, gift of the Teresa and
H. John Heintz III Foundation

35
Fitz Hugh Lane
Off Mount Desert Island
1856
Oil on canvas, 61.4 cm x 92.5 cm
Signed and dated lower left:
FH Lane 1856
The Brooklyn Museum of Art,
Brooklyn, NY, Museum Collection
Fund

36
Fitz Hugh Lane
*Lumber Schooners at Evening on
Penobscot Bay*
1863
Oil on canvas, 62.6 x 96.8 cm
Signed and dated lower right:
F. H. Lane/1863
National Gallery of Art, Washington,
D.C., gift of Mr. and Mrs. Francis
W. Hatch, Sr.

37
Frederic Edwin Church
The Abandoned Skiff
1850
Oil on wood, 28 x 43.2 cm
Signed and dated lower right:
Mt. Desert 1850
Museo Thyssen-Bornemisza,
Madrid

38
Frederic Edwin Church
New England Scenery
1851
Oil on canvas, 91.4 x 134.6 cm
Signed and dated lower right:
F Church '51
George Walter Vincent Smith Art
Museum, Springfield, MA

39
Frederic Edwin Church
A Country Home
1854
Oil on canvas, 81 x 127 cm
Seattle Art Museum, Seattle, WA,
gift of Mrs. Paul C. Carmichael

40
Albert Bierstadt
*Moat Mountain, Intervale, New
Hampshire*
c. 1862
Oil on canvas, 48.3 x 65.7 cm
Signed lower right: ABierstadt
The Currier Gallery of Art, Manches-
ter, NH, Currier Funds

41
Thomas Cole
*Landscape Composition, St. John in the
Wilderness*
1827
Oil on canvas, 91.4 x 73.5 cm
Signed and dated lower left:
T Cole/1827
Wadsworth Atheneum, Hartford, CT,
bequest of Daniel Wadsworth

42
John Frederick Kensett
A Woodland Waterfall
c. 1855
Oil on canvas, 101.6 x 86.3 cm
Signed lower right: JFK
The Nelson-Atkins Museum of Art,
Kansas City, MO (purchase, Nelson
Trust through the generosity of Mrs.
George C. Reuland through the
W. J. Brace Charitable Trust and by
exchange of Trust properties)

43
John Frederick Kensett
Niagara Falls
1851/52
Oil on canvas, 43.1 x 62.2 cm
Signed left: J.F. Kensett
Mead Art Museum, Amherst College,
Amherst, MA, purchase

44
Frederic Edwin Church
Twilight Mount Desert Island, Maine
1865
Oil on canvas, 79.4 x 123.2 cm
Signed and dated lower left:
F.E. Church '65
Washington University Gallery of Art,
Saint Louis, MO, gift of Charles
Parsons, 1905

45
Frederic Edwin Church
Twilight in the Wilderness
1860
Oil on canvas, 101.6 x 162.6 cm
Signed and dated lower right:
F.E. Church/-60-
The Cleveland Museum of Art,
Cleveland, OH, Mr. and Mrs. William
H. Marlatt Fund

46
Frederic Edwin Church
Niagara Falls from the American Side
1867
Oil on canvas, 260.4 x 231.1 cm
Signed and dated lower right: F.E.
Church 1867
The National Gallery of Scotland,
Edinburgh

47
Frederic Edwin Church
Cayambe
1858
Oil on canvas, 76.2 x 121.9 cm
Signed and dated lower left:
F. E. CHURCH / 1858
Collection of the New-York Historical
Society, New York, NY, The Robert L.
Stuart Collection on permanent loan
from the New York Public Society

48
Frederic Edwin Church
The Iceberg
1891
Oil on canvas, 50.8 x 76.2 cm
Signed and dated lower right:
F.E. Church 1891
Carnegie Museum of Art, Pittsburgh,
PA, Howard N. Eavenson Memorial
Fund, for the Howard N. Eavenson
Americana Collection, 1972

49
Thomas Worthington Whittredge
Twilight in the Shawangunk Mountains
1865
Oil on canvas, 114.3 x 172.7 cm
Signed and dated lower left:
T.W. Whittredge / 1865
Manoogian Collection, Taylor, MI

50
Albert Bierstadt
*Buffalo Trail: The Impending Storm
(The Last of the Buffalo)*
1869
Oil on canvas, 74.9 x 125.7 cm
Signed and dated lower left:
ABierstadt / 1869
The Corcoran Gallery of Art,
Washington, D.C., museum purchase
through the gift of Mr. and Mrs.
Lansdell K. Christie, 1960

51
Albert Bierstadt
El Capitan, Yosemite Valley, California
1875
Oil on canvas, 81.7 x 122.2 cm
Signed lower left: ABierstadt
The Toledo Museum of Art, Toledo,
OH, gift of Mr. and Mrs. Roy Rike

52
George Catlin
*Steep Wind, a Brave of the Bad Arrow
Points Band*
1832
Oil on canvas on aluminum,
73.7 x 60.9 cm
National Museum of American Art,
Smithsonian Institution, Washington,
D.C., gift of Mrs. Joseph Harrison, Jr.

53
George Catlin
*Whirling Thunder, Eldest Son of Black
Hawk*
1832
Oil on canvas on aluminum,
73.7 x 60.9 cm
National Museum of American Art,
Smithsonian Institution, Washington,
D.C., gift of Mrs. Joseph Harrison, Jr.

54
George Catlin
Bód-a-Sin, Chief of the Tribe
1830
Oil on canvas on aluminum,
73.7 x 60.9 cm
National Museum of American Art,
Smithsonian Institution, Washington,
D.C., gift of Mrs. Joseph Harrison, Jr.

55
George Catlin
Two Crows, the Younger
1832
Oil on canvas on aluminum,
73.7 x 60.9 cm
National Museum of American Art,
Smithsonian Institution, gift of Mrs.
Joseph Harrison, Jr.

56
George Catlin
*The White Cloud, Head Chief of the
Iowas*
1844/45
Oil on canvas, 71 x 58 cm
National Gallery of Art, Washington,
D.C., Paul Mellon Collection

57
George Catlin
Little Bear, a Hunkpapa Brave
1832
Oil on canvas on aluminum,
73.7 x 60.9 cm
National Museum of American Art,
Smithsonian Institution, Washington,
D.C., gift of Mrs. Joseph Harrison, Jr.

58
George Caleb Bingham
Raftsmen Playing Cards
1847
Oil on canvas, 71.3 x 96.7 cm
The Saint Louis Art Museum, Saint
Louis, MO, purchase, The Ezra
H. Linley Fund

59
Arthur Fitzwilliam Tait
Trapper Looking Out
1853
Oil on canvas, 61.3 x 92.1 cm
Signed and dated lower left:
A. F. TAIT / 1853 NY
The Philbrook Museum of Art, Tulsa,
OK, gift of Mr. and Mrs. Bailie
W. Vinson

60
Charles Ferdinand Wimar
*The Abduction of Daniel Boone's
Daughter by the Indians*
1853
Oil on canvas, 101.6 x 127 cm
Signed lower left:
C. Wimar Düsseldorf
Washington University Gallery of Art,
Saint Louis, MO, gift of Mr. John
T. Davis, Jr.

61
Albert Bierstadt
Evening on the Prairie
c. 1870
Oil on canvas, 81.3 x 123 cm
Signed lower left: ABierstadt
Museo Thyssen-Bornemissza, Madrid

62
Winslow Homer
Sharpshooter
1863
Oil on canvas, 31.1 x 41.9 cm
Signed and dated lower left:
W. Homer 63
Portland Museum of Art, ME, gift of
Barbra and Bernard Osher

63
Winslow Homer
The Bright Side
1865
Oil on canvas, 33.7 x 44.5 cm
Signed and dated lower left:
Winslow Homer NY 65
The Fine Arts Museums of San Fran-
cisco, San Francisco, CA, gift of
Mr. and Mrs. John D. Rockefeller III

64
Winslow Homer
Army Boots
1865
Oil on canvas, 35.5 x 45.7 cm
Signed and dated lower right:
HOMER NY 65
Hirshhorn Museum and Sculpture
Garden, Smithsonian Institution,
Washington, D.C., gift of the Joseph
H. Hirshhorn Foundation, 1966

65
Winslow Homer
Snap the Whip
1872
Oil on canvas, 30.5 x 50.8 cm
Signed and dated lower right:
Homer 1872
The Metropolitan Museum of Art,
New York, NY, gift of Christian
A. Zabriskie, 1950

66
Winslow Homer
Man with a Scythe
c. 1867
Oil on canvas, 43.4 x 56 cm
Courtesy Cooper Hewitt Museum,
Smithsonian Institution, New York,
NY, gift of Mrs. Charles Savage
Homer

67
Winslow Homer
Milking Time
1875
Oil on canvas, 61 x 97.1 cm
Signed and dated lower left:
Winslow Homer 1875
Delaware Art Museum, Wilmington,
DE, gift of the Friends of Art and
other donors

68
Winslow Homer
Watermelon Boys
1876
Oil on canvas, 61.3 x 96.8 cm
Signed and dated lower left:
Homer 1876
Courtesy Cooper Hewitt Museum,
Smithsonian Institution, New York,
NY, gift of Mrs. Charles Savage
Homer

69
Edwin White
Thoughts of Liberia: Emancipation
1861
Oil on canvas, 43.5 x 53.3 cm
Signed and dated left center:
Edwin White / N.Y. 1861.
Collection of the New-York Historical
Society, New York, NY, The Robert
L. Stuart Collection, on permanent
loan from the New York Public
Library, 1944

70
Eastman Johnson
The Boyhood of Abraham Lincoln
1868
Oil on canvas, 117.9 x 94.8 cm
Signed and dated lower left:
E. Johnson 1868.
The University of Michigan Museum
of Art, Ann Arbor, MI, bequest of
Henry C. Lewis

71
Eastman Johnson
Old Kentucky Home—Life in the South
1859
Oil on canvas, 92 x 115.6 cm
Signed and dated lower right:
E. Johnson / 1859
Collection of the New-York Historical
Society, New York, NY, Robert L.
Stuart Collection, on permanent loan
from the New York Public Library

72
Eastman Johnson
Back From the Orchard
1876
Oil on canvas, 50.7 x 30.2 cm
Signed and dated lower right:
E. Johnson 1876
inscription on the back: Painted by
Eastman Johnson /New York
Hood Museum of Art, Dartmouth
College, Hanover, NH, purchased
through the Katharine T. and Merrill
G. Beede 1929 Fund; the Mrs. Harvey
P. Hood '18 Fund; a gift from the
estate of Russell Cowles, class of
1909; and a gift from Jose Guerrero,
by exchange

73
Eastman Johnson
In the Hayloft
c. 1877/78
Oil on canvas, 67.9 x 83.7 cm
San Diego Museum of Art, San Diego,
CA, gift of Mrs. Herbert S. Darlington

74
Winslow Homer
Portrait of Helena de Kay
c. 1873
Oil on wood, 31 x 47 cm
Signed and dated lower right:
June 3rd 1874/WH
Museo Thyssen-Bornemissza, Madrid

75
Thomas Worthington Whittredge
A Window, House on the Hudson River
1863
Oil on canvas, 68.6 x 49.5 cm
Signed and dated lower right:
W. Whittredge/1863
Collection of the New-York Historical
Society, New York, NY, The Robert
L. Stuart Collection, on permanent
loan from the New York Public
Library, 1944

76
Winslow Homer
Beach Scene (On the Beach)
1869
Oil on canvas, 38.1 x 62.23 cm
Signed lower right: HOMER
Canajoharie Library and Art Gallery,
Canajoharie, NY

77
Winslow Homer
Promenade on the Beach
1880
Oil on canvas, 50.8 x 76.5 cm
Signed and dated lower right:
WINSLOW HOMER 1880
Museum of Fine Arts, Springfield, MA,
gift of the Misses Emily and Elizabeth
Mills, in memory of their parents, Mr.
And Mrs. Isaac Mills

78
Winslow Homer
An Adirondack Lake
1870
Oil on canvas, 61.6 x 97.2 cm
Signed and dated lower left:
Winslow Homer 1870
Henry Art Gallery, University of
Washington, Seattle, WA, Horace
C. Henry Collection

79
Winslow Homer
Huntsman and Dogs
1891
Oil on canvas, 71.1 x 121.9 cm
Signed and dated lower right:
Winslow Homer 1891
Philadelphia Museum of Art, Philadel-
phia, PA, The William L. Elkins
Collection

80
Winslow Homer
To the Rescue
1886
Oil on canvas, 60.9 x 76.2 cm
Signed lower left: HOMER
The Phillips Collection, Washington,
D.C.

81
Winslow Homer
Weatherbeaten
1894
Oil on canvas, 71.2 x 122.1 cm
Signed and dated lower right:
HOMER /1894
Portland Museum of Art, Portland,
ME, bequest of Charles Shipman
Payson

82
Winslow Homer
West Point, Prout's Neck
1900
Oil on canvas, 76.3 x 122.2 cm
Signed and dated lower right:
HOMER 1900
Sterling and Francine Clark Art Insti-
tute, Williamstown, MA

83
Winslow Homer
Summer Squall
1904
Oil on canvas, 61.6 x 76.8 cm
Signed and dated lower left:
HOMER 1904
Sterling and Francine Clark Art
Institute, Williamstown, MA

84
Thomas Eakins
Sailboats Racing on the Delaware
1874
Oil on canvas, 61 x 91.4 cm
Signed and dated lower right:
Eakins 74 and T. E.
Philadelphia Museum of Art, Philadel-
phia, PA, given by Mrs. Thomas Eakins
and Miss Mary Adeline Williams

85
Thomas Eakins
The Oarsmen (The Schreiber Brothers)
1874
Oil on canvas, 38.1 x 55.9 cm
Signed and dated right center:
Eakins 1874
Yale University Art Gallery, New
Haven, CT, John Hay Whitney. B. A.
1926, M.A. (Hons.) 1956, Collection

86
Thomas Eakins
Portrait of Charles Linford, The Artist
c. 1895
Oil on canvas, 122 x 92.5 cm
Signed on the back: T.E.
Private collection

87
Thomas Eakins
Portrait of Henry O'Tanner
1902
Oil on canvas, 60.2 x 81.3 cm
Signed lower right: EAKINS
The Hyde Collection, Glens Falls, NY

88
Thomas Eakins
Music
1904
Oil on canvas, 100.3 x 126.3 cm
Signed and dated lower left:
EAKINS/1904
Albright-Knox Art Gallery, Buffalo,
NY, George Cary, Edmund Hayes and
James G. Forsyth Funds, 1955

89
William Michael Harnett
Plucked Clean
1882
Oil on canvas, 86.7 x 51.4 cm
Signed and dated lower left: WM
(ligature) HARNETT/1882
The Corcoran Gallery of Art, Wash-
ington, D.C., museum purchase
through the William A. Clark Fund

90
William Michael Harnett
Merganser
1883
Oil on canvas, 86.7 x 52.1 cm
Signed and dated lower right:
WMHarnett/München/1883
San Diego Museum of Art, San Diego,
CA, gift of the Gerald and Inez Grant
Parker Foundation

91
William Michael Harnett
After the Hunt
1883
Oil on canvas, 133.3 x 91.4 cm
Signed and dated lower left:
WMHarnett/München/1883
The Columbus Museum of Art,
Columbus, OH, bequest of Francis S.
and Mary Sessions 1919

92
William Michael Harnett
Still Life —Violin and Music
1888
Oil on canvas, 101.6 x 76.2 cm
Signed and dated lower right:
W.M. Harnett 1888
The Metropolitan Museum of Art,
New York, NY, Catharine Lorillard
Wolfe Fund, 1963

93
William Michael Harnett
*With the Staatszeitung (With the Staats
Zeitung)*
1890
Oil on canvas, 35.9 x 51.5 cm
Signed and dated lower left: WM
[ligature] HARNETT./1890
The Saint Louis Art Museum, Saint
Louis, MO

94
John Frederick Peto
Still Life with Lanterns
after 1889
Oil on canvas, 126.8 cm x 76.6 cm
The Brooklyn Museum of Art,
Brooklyn, NY, Dick S. Ramsay Fund

95
William Michael Harnett
The Faithful Colt
1890
Oil on canvas, 57.2 x 47 cm
Signed and dated lower left:
WMHarnett/1890
Wadsworth Atheneum, Hartford, CT,
The Ella Gallup Sumner and Mary
Catlin Sumner Collection Fund

96
John Haberle
A Favorite
c. 1890
Oil on canvas, 36.8 x 29.2 cm
Signed lower right: J.HABERLE
Gift of Charles T. and Emilie Shean,
Museum of Fine Arts, Springfield, MA

97
John Frederick Peto
The Cup We All Race 4
c. 1900
Oil on canvas on wood, 64.8 x 54.6 cm
Engraved on metal plate top center:
JOHN F. PETO
The Fine Arts Museums of San Fran-
cisco, San Francisco, CA, gift of Mr.
and Mrs. John D. Rockefeller III

98
John Haberle
The Slate Memoranda
c. 1895
Oil on canvas, 30.5 x 23.8 cm
Signed upper left: HABERLE
Museum of Fine Arts, Boston, MA,
Henry H. and Zoë Oliver Sherman
Fund

99
John Haberle
One Dollar Bill
1890
Oil on canvas, 20.3 x 25.4 cm
Signed and dated lower right:
J. Haberle./1890
Berry-Hill Galleries, Inc., New York,
NY

100
John Haberle
Twenty Dollar Bill
1890
Oil on canvas, 19.1 x 24.1 cm
Signed and dated lower right:
J. Haberle. 1890.
Gift of Charles T. and Emilie Shean,
Museum of Fine Arts, Springfield, MA

101
De Scott Evans
A New Variety, Try One
c. 1890
Oil on canvas, 30.8 x 25.4 cm
Signed lower right: S.S. David
The Columbus Museum of Art,
Columbus, OH, gift of Dorothy
Hubbard Appleton

102
George Inness
A Passing Shower
1860
Oil on canvas, 66. x 101.6 cm
Signed and dated lower left:
G. Inness 1860
Canajoharie Library and Art Gallery,
Canajoharie, NY

103
George Inness
Landscape with Farmhouse
1869
Oil on canvas, 76.9 x 115.3 cm
Signed and dated lower right:
G. Inness 1869
Mead Art Museum, Amherst College,
Amherst, MA, museum purchase

104
George Inness
Clearing Up
1860
Oil on canvas, 38.7 x 64.5 cm
Signed and dated lower left:
G. Inness 1860
George Walter Vincent Smith Art
Museum, Springfield, MA

105
George Inness
The Coming Storm
1878
Oil on canvas, 66 x 97.8 cm
Signed and dated lower right:
G. Inness 1878
Albright-Knox Art Gallery, Buffalo,
NY, Albert H. Tracy Fund, 1900

106
George Inness
Saco Ford: Conway Meadows
1876
Oil on canvas, 96.5 x 165 cm
Signed and dated lower left:
G. Inness 1876
Mount Holyoke College Art Museum,
South Hadley, MA

107
George Inness
Morning, Catskill Valley (The Red Oaks)
1894
Oil on canvas, 89.9 x 136.5 cm
Signed and dated lower right:
G. Inness 1894
Santa Barbara Museum of Art, Santa
Barbara, CA, gift of Mrs. Sterling
Morton to the Preston Morton
Collection

108
George Inness
A Breezy Autumn
1887
Oil on canvas, 76.5 x 127 cm
Signed and dated lower right:
G. Inness 1887
Manoogian Collection, Taylor, MI

109
George Inness
October
1886
Oil on wood, 50.6 x 75.9 cm
Signed and dated lower left:
G. Inness 1886
Los Angeles County Museum of Art,
Los Angeles, CA, Paul Rodman
Mabury Collection

110
William Merritt Chase
Prospect Park, Brooklyn
c. 1887
Oil on wood, 41 x 61.3 cm
Signed lower left: Wm M Chase
The Parrish Art Museum, Southamp-
ton, NY, Littlejohn Collection

111
Willard Metcalf
The Ten Cent Breakfast
1887
Oil on canvas, 38.7 x 55.9 cm
Signed and dated lower right:
Wil-Metcalf-Giverny 1887
Denver Art Museum, Denver, CO,
Edward and Tullah Hanley memorial
gift to the people of Denver and the area

112
Cecilia Beaux
Ernesta (Child with a Nurse)
1894
Oil on canvas, 128.3 x 96.8 cm
Signed and dated lower left:
Cecilia Beaux/94
The Metropolitan Museum of Art,
New York, NY, Maria DeWitt Jesup
Fund, 1965

113
William Merritt Chase
The Lone Fisherman
1890 or later
Oil on canvas, 38.1 x 30.1 cm
Signed lower left: WM Chase
Hood Museum of Art, Dartmouth
College, Hanover, NH, gift of Mr. and
Mrs. Preston Harrison

114
William Merritt Chase
Shinnecock Landscape with Figures
c. 1895
Oil on canvas, 58.4 x 83.2 cm
Signed lower left: W. M. Chase.
Marie and Hugh Halff

115
William Merritt Chase
Over the Hills and Far Away
c. 1897
Oil on canvas, 60.5 x 83.3 cm
Signed lower left: WM. Chase.
Henry Art Gallery, University of
Washington, Seattle, WA, Horace
C. Henry Collection

116
Childe Hassam
Dock Scene, Gloucester
1894
Oil on canvas, 54.6 x 52.7 cm
Signed and dated lower left: Childe
Hassam./Gloucester—1894
Private collection

117
Childe Hassam
Sunset at the Sea
1911
Oil on canvas, 86.4 x 86.4 cm
Signed and dated lower right:
Childe Hassam 1911
Rose Art Museum, Brandeis Univer-
sity, Waltham, MA, gift of Mr. and
Mrs. Monroe Geller, New York

118
Childe Hassam
Columbus Avenue, Rainy Day, 1885
1885
Oil on canvas, 43.5 x 53.7 cm
Signed and dated lower left:
Childe Hassam/1885
Worcester Art Museum, Worcester,
MA, bequest of Charlotte E. W.
Buffington

119
William Merritt Chase
Still Life with Fish
c. 1908
Oil on canvas, 74.3 x 92.1 cm
Signed lower right: WM Chase
The Philbrook Museum of Art, Tulsa,
OK, gift of the Tulsa Art Association

120
Thomas Wilmer Dewing
Before the Mirror
1916
Oil on canvas, 65.9 x 48.2 cm
Signed lower right: TWD
Private collection

121
Julian Alden Weir
*The Bridge: Nocturne (Nocturne:
Queensboro Bridge)*
1910
Oil on canvas on wood,
73.7 x 100.4 cm
Signed lower right: Alden Weir
Hirshhorn Museum and Sculpture
Garden, Smithsonian Institution,
Washington, D.C., gift of the Joseph
H. Hirshhorn Foundation, 1966

122
Childe Hassam
Flags on 57th Street, Winter of 1918
1918
Oil on canvas, 91.7 x 60.9 cm
Signed and dated lower right: Childe
Hassam./1918
Collection of the New-York Historical
Society, New York, NY, bequest of
Julia B. Engel, 1984

123
Childe Hassam
*Lower Manhattan (View down Broad
Street)*
1907
Oil on canvas, 76.8 x 40.6 cm
Signed and dated upper left: Childe
Hassam/June 1907
Herbert F. Johnson Museum of Art,
Cornell University, Ithaca, NY, lent by
Williard Straight Hall, gift of Leon-
hard K. Elmhirst, class of 1921

124
James Abbott McNeill Whistler
The Little Rose of Lyme Regis
1895
Oil on canvas, 51.4 x 31.1 cm
Courtesy of the Museum of Fine Arts,
Boston, MA, William Wilkins Warren
Collection

125
James Abbott McNeill Whistler
*The White Girl
(Symphony in White, no. 1)*
1862
Oil on canvas, 214.7 x 108 cm
Signed and dated upper right:
Whistler. 1862
National Gallery of Art, Washington,
D.C., Harris Whittemore Collection

126
John Singer Sargent
*Portrait of a Boy (Homer Saint-Gaudens
and His Mother)*
1890
Oil on canvas, 151.8 x 142.2 cm
Carnegie Museum of Art, Pittsburgh,
PA, Patrons Art Funds, 1932

127
John Singer Sargent
*Portrait of Two Children (The Forbes
Brothers)*
1887
Oil on canvas, 74.9 x 89.5 cm
Signed upper right: John S. Sargent
Private collection

128
John Singer Sargent
A Gust of Wind
c. 1883–85
Oil on canvas, 61.6 x 38.1 cm
Private collection

129
John Singer Sargent
Street in Venice
c. 1880–82
Oil on canvas, 75.1 x 52.4 cm
Signed lower right: John S.
Sargent/Venice
Sterling and Francine Clark Art
Institute, Williamstown, MA

130
John Singer Sargent
*Santa Maria del Carmelo and Scuola
Grande dei Carmini*
1910
Oil on canvas, 71.1 x 55.9 cm
Signed lower left: John S. Sargent;
dated lower right: 1910
Adelson Galleries, Inc., New York, NY

131
John Singer Sargent
Val d'Aosta—A Man Fishing
1910
Oil on canvas, 56.2 x 71.8 cm
Stamp on the back: JSS
Addison Gallery of American Art,
Phillips Academy, Andover, MA

132
John Singer Sargent
Portrait of James Whitcomb Riley
1903
Oil on canvas, 90.2 x 77.5 cm
Signed upper left: John S. Sargent
Indianapolis Museum of Art,
Indianapolis, IN, painted on com-
mission from the Art Association of
Indianapolis

133
John Sloan
McSorley's Bar
1912
Oil on canvas, 66 x 81.3 cm
Signed lower right: John Sloan
The Detroit Institute of Arts, Detroit,
MI, gift of the Founders' Society

134
John Sloan
Walnut Street Theater, Philadelphia
1900
Oil on canvas, 63.8 x 81.3 cm
Signed lower right: JS
Collection of Helen Farr Sloan, lent
through the courtesy of Kraushaar
Galleries, New York, NY

135
George Wesley Bellows
Club Night
1907
Oil on canvas, 109.2 x 134.6 cm
National Gallery of Art, Washington,
D.C., John Hay Whitney Collection

136
John Sloan
Red Kimono on the Roof
1912
Oil on canvas, 61 x 50.8 cm
Signed lower left: John Sloan
Indianapolis Museum of Art, Indi-
anapolis, IN, James E. Roberts Fund

137
John Sloan
Sunday: Women Drying Their Hair
1912
Oil on canvas, 66 x 81.3 cm
Signed lower right: JOHN SLOAN;
inscription on the back: Joan Sloan
1912 NYC
Addison Gallery of American Art,
Phillips Academy, Andover, MA

138
George Wesley Bellows
Snow Dumpers
1912
Oil on canvas, 91.8 x 122.2 cm
Signed lower left: Geo. Bellows.
The Columbus Museum of Art,
Columbus, OH, museum purchase,
Howald Fund

139
George Wesley Bellows
Excavation at Night
1908
Oil on canvas, 86.4 x 111.8 cm
Signed lower right: Geo. Bellows
Shein Collection

140
George Wesley Bellows
Pennsylvania Station Excavation
1909
Oil on canvas, 104 x 121.3 cm
The Brooklyn Museum of Art, Brook-
lyn, NY, A. Augustus Healy Fund

141
George Wesley Bellows
North River
1908
Oil on canvas, 83.5 x 109.2 cm
Signed lower left: G. Bellows
Courtesy of the Pennsylvania Acad-
emy of the Fine Arts, Philadelphia,
PA, Joseph E. Temple Fund

142
George Wesley Bellows
Winter Road
1912
Oil on canvas, 86.4 x 111.8 cm
Inscription lower right: Geo. Bellows,
E.S.B. (by Mrs. Bellows)
San Diego Museum of Art, San Diego,
CA, museum purchase with funds
from the Gerald and Inez Grant
Parker Foundation Fund and Earle
W. Grant Acquisition Fund

143
George Wesley Bellows
Portrait of Anne
1915
Oil on canvas, 122.2 x 92.1 cm
Signed lower left: Geo Bellows
High Museum of Art, Atlanta, GA,
museum purchase, Henry B. Scott
Fund

144
George Wesley Bellows
The Grey Sea
1913
Oil on wood, 32.7 x 49.2 cm
Signed lower right: Bellows
The Columbus Museum of Art,
Columbus, OH, gift of Jessie Marsh
Powell in memory of Edward Thomp-
son Powell

145
George Wesley Bellows
Approach of Rain
1913
Oil on wood, 33.7 x 49.5 cm
Portland Museum of Art, Portland,
ME, private collection

146
George Wesley Bellows
From Rock Top, Monhegan
1913
Oil on wood, 38.1 x 49.5 cm
Portland Museum of Art, Portland,
ME, Chris Huntington and Charlotte
McGill Collection

Selected Reading

Matthew Baigell, *A History of American Painting*, New York/Washington 1971

Matthew Baigell, *Dictionary of American Art*, New York/Hagerstown/San Francisco 1979

Matthew Baigell, *A Concise History of American Painting and Sculpture*, New York 1984

John I. H. Baur, "The Peales and the Development of American Still Life," in *Art Quarterly*, 3, 1940

John I. H. Baur, "Peto and the American Trompe-l'oeil Tradition," in *Magazine of Art*, 43, May 1950, pp. 182–185

G. W. Benjamin, *Art in America. A Critical and Historical Sketch*, New York 1880

F. Berens, *Providence and Patriotism in Early America 1640–1815*, Charlottesville, 1978

Albert Boime, *The Art of Exclusion: Representing Blacks in the Nineteenth Century*, Washington 1990

Albert Boime, *The Magisterial Gaze: Manifest Destiny and American Landscape Painting, c. 1830–1865*, Washington 1991

Wolfgang Born, *Still Life Painting in America*, New York 1973

Milton W. Brown, *American Art. Painting, Sculptures, Architecture, Decorative Arts, Photography*, New York 1979

Milton W. Brown, *American Art to 1900*, New York 1977

George Catlin, *Letters and Notes on the Manners, Customs and Conditions of the North American Indian*, 2 vols., London 1841

Larry Curry, *The American West: Painters from Catlin to Russell*, Los Angeles 1972

Célestine Dars, *Images of Deception. The Art of Trompe-l'oeil*, New York 1979

Marshall B. Davidson, *Life in America*, 2 vols., Boston 1951

William Dunlap, *A History of the Rise and Progress of the Arts of Design in the United States*, 3 vols., New York 1834, Reprint New York 1969

John Dillenberger, *The Colonial Period through the Nineteenth Century*, Chico 1984

Charles C. Eldredge, *American Imagination and Symbolist Painting*, New York 1979

Suzanne L. Epstein, *The Relationship of the American Luminists to Caspar David Friedrich*, Columbia University 1964

James Thomas Flexner, *That Wilder Image. The Painting of America's Native School from Thomas Cole to Winslow Homer*, Boston/Toronto 1962

James Thomas Flexner, *America's Old Masters*, New York 1980

Alfred Frankenstein, *After the Hunt. William Harnett and other American Still Life Painters 1870–1900*, Berkeley/Los Angeles/London 1975

T.W. Gaehtgens & H. Ickstadt (ed.), *American Icons: Transatlantic Perspectives on Eighteenth- and Nineteenth-Century American Art*, Santa Monica 1992

William H. Gerdts, *American Impressionism*, New York 1984

William H. Gerdts, *Art Across America: Two Centuries of Regional Painting, 1710–1920*, New York 1990

William H. Gerdts, Russel Burke, *American Still Life Painting*, New York 1971

William H. Gerdts, Mark Thistlethwaite, *Grand Illusions. History Painting in America*, Fort Worth 1988

Frank Getlein, *The Lure of the Great West*, Waukesha 1973

John Grafton, *New York in the Nineteenth Century*, New York 1977

Wayne Graven, "The Grand Manner in Early Nineteenth-Century American Painting," in *American Art Journal*, 2, April 1979, pp. 4–43

Neil Harris, *The Land of Contrasts 1880–1901*, New York 1970

Neil Harris, *The Artist in American Society*, Chicago 1966

Peter Hassrick, *The Way West. Art of Frontier America*, New York 1977

Ulrich W. Hiesinger, *Impressionism in America. The Ten American Painters*, Munich 1991

Hugh Honour, *The New Golden Land. European Images of America from the Discoveries to the Present Time*, London 1975

Donelson F. Hoopes, *The Düsseldorf Academy and the Americans: An Exhibition of Drawings and Watercolors*, Atlanta 1972

John K. Howat, *The Hudson River and its Painters*, New York 1972

William S. Hudson (ed.), *Nationalism and Religion in America. Concepts of American Identity and Mission*, New York 1970

Robert Hughes, *American Visions. The Epic History of Art in America*, New York 1997

Samuel Isham, *The History of American Painting*, new expanded edition by Royal Cortissoz, New York 1927

Elizabeth Johns, *American Genre Painting. The Politics of Everyday Life*, New Haven/London, 1991

Michael Kammen, *The American Revolution and the Historical Imaginative*, New York 1988

Oliver W. Larkin, *Art and Life in America*, New York 1949

David M. Lubin, *Act of Portrayal: Eakins, Sargent, James*, New Haven 1985

David M. Lubin, *Picturing a Nation. Art and Social Change in Nineteenth-Century America*, New Haven/London 1994

Russell Lynes, *The Art-Makers of Nineteenth Century America*, New York 1979

John Walker McCoubrey, *American Art, 1700–1960: Sources and Documents*, Englewood Cliffs 1965

John Walker McCoubrey, *American Tradition in Painting*, New York 1963

J. F. Maclear, "The Republic and the Millennium," in *The Religion of the Republic*, ed. by Elwyn A. Smith, Philadelphia 1971

Katherine Manthorne, *Tropical Renaissance: North American Artists Exploring Latin America, 1839–1879*, Washington 1989

Leo Marx, *The Machine in the Garden. Technology and the Pastoral Ideal in America*, London/Oxford/New York 1967

Angela Miller, *The Empire of the Eye. Landscape Representation and American Cultural Politics, 1825–1875*, Ithaca/London 1993

Lillian B. Miller, *Patrons and Patriotism: The Encouragement of the Fine Arts in the United States, 1790–1860*, Chicago 1966

Miriam Milman, *Trompe-l'oeil Painting. The Illusions of Reality*, Geneva 1982

Miriam Milman, *Trompe-l'oeil Painting. Painted Architecture*, New York 1986

Paul C. Nagel, *One Nation Indivisible. The Union in American Thought, 1776–1861*, New York 1964

Mark E. Neely, Harold Holzer, Gabor S. Boritt, *The Confederate Image. Prints of the Lost Cause*, Chapel Hill 1987

Barbara Novak, *American Painting of the Nineteenth Century. Realism, Idealism, and the American Experience*, New York 1979 (2nd ed.)

Barbara Novak, *Nature and Culture. American Landscape and Painting 1825–1875*, New York 1980

Ellwood C. Parry, *The Image of the Indian and the Black Man in American Art, 1590–1900*, New York 1974

Ronald Paulson, *Representations of Revolution, 1799–1820*, New Haven 1983

Jessie Poesch, *The Art of the Old South*, New York 1983

Jules David Prown, *American Painting: From its Beginnings to the Armory Show*, Geneva 1969

Kathleen A. Pyne, *Immanence, Transcendence and Impressionism in Late Nineteenth-Century American Painting*, Ann Arbor 1988

Edgar Preston Richardson, *Painting in America: The Story of 450 Years*, New York 1956

Martha A. Sandweiss, *Photography in Nineteenth-Century America*, Fort Worth/New York 1991

G.W. Sheldon, *Hours with Art and Artists*, New York 1882

Kenneth Silverman, *A Cultural History of the American Revolution*, New York 1976

Albert Smith, *European Influence on American Painting of the Nineteenth Century*, Huntington 1947

Henry Nash Smith, *Virgin Land: The American West as Symbol and Myth*, Cambridge/London 1950

Linda Joy Sperling, *Northern European Links to Nineteenth Century American Landscape Painting. The Study of American Artists in Düsseldorf*, Santa Barbara 1985

Raymond L. Stehle, "The Düsseldorf Gallery in New York," in *New-York Historical Society Quarterly*, 58, no. 4, October 1974, pp. 305–314

Roger B. Stein, *Seascape and the American Imagination*, New York 1975

Cushing Strout, *The American Image of the Old World*, New York 1963

Joshua C. Taylor, *America as Art*, New York/Hagerstown/San Francisco/London 1976

Joshua C. Taylor, *The Fine Arts in America*, Chicago 1979

Ruthven Todd, "The Imaginary Indian in Europe," in *Art in America*, July/August 1972, pp. 40–48

Patricia Trenton, Peter Hassrick, *The Rocky Mountains: A Vision for Artists in the Nineteenth Century*, Normon 1983

Henry T. Tuckerman, *Book of the Artists. American Artist Life*, New York 1966 (1st ed. 1867)

Aloysius G. Weimer, *The Munich Period in American Art*, Ann Arbor 1940

H. Barbara Weinberg, *The American Pupils of Jean-Léon Gérôme*, Fort Worth 1984

Rush Welter, *The Mind of America, 1820–1860*, New York 1975

John Wilmerding, *American Art (Pelican History of Art)*, Harmondsworth 1976

John Wilmerding, *American Marine Painting*, New York 1987 (1st ed. 1968)

John Wilmerding, *American Views. Essays on American Art*, Princeton 1991

John Wilmerding (ed.), *The Genius of American Painting*, New York 1973

Bryan Jay Wolf, *Romantic Re-Vision: Culture and Consciousness in Nineteenth-Century American Painting and Literature*, Chicago/London 1982

Lucille Wrubel-Grindhammer, *Art and Public. The Democratization of the Fine Arts in the United States, 1830–1860*, Stuttgart 1975

James L. Yarnall, William Gerdts (eds.), *Index to American Art Exhibition Catalogues: From the Beginning Through the 1876 Centennial Year*, Boston 1986

Exhibition Catalogues

Cat. Berkeley 1970, Alfred Frankenstein, *The Reality of Appearance. The Trompe-l'oeil Tradition in American Painting*, University Art Museum, Berkeley 1970

Cat. Boston 1975/76, *America through the Eyes of German Immigrant Painters*, Goethe Institut, Boston 1975/76

Cat. Boston 1983, Theodore E. Stebbins Jr., Carol Troyen, Trevor J. Fairbrother, *A New World. Masterpieces of American Painting 1760–1910*, Museum of Fine Arts, Boston 1983

Cat. Brooklyn 1985, Linda Ferber, William H. Gerdts, *The New Path. Ruskin and the American Pre-Raphaelites*, The Brooklyn Museum of Art, New York/Museum of Fine Arts, Boston, 1985

Cat. Brunswick 1987, John W. Coffey, *Twilight of America. American Landscape Painters in Rome 1830–1880*, Bowdoin College Museum of Art, Brunswick 1987

Cat. Canberra 1998/99, *New Worlds from Old. 19th-Century Australian & American Landscapes*, National Gallery of Australia, Canberra, Wadsworth Athenaeum, Hartford 1998/99

Cat. Cody 1987/88, *American Frontier Life. Early Western Painting and Prints*, Buffalo Bill Historical Center, Cody/Amon Carter Museum, Fort Worth/Pennsylvania Academy of the Fine Arts, Philadelphia 1987/88

Cat. Columbus 1985, E. Jane Connell, William Kloss, *More than Meets the Eye. The Art of Trompe-l'oeil*, The Columbus Museum of Art, Columbus 1985

Cat. Dallas 1986, *Visions of the West*, Dallas Museum of Art, 1986

Cat. Dallas 1998/99, Eleanor Johns Harvey, *The Painted Sketch. American Impressions From Nature*, Dallas 1998

Cat. Dayton 1976, Michael Quick, *American Expatriate Painters of the Late Nineteenth Century*, Dayton Art Institute, 1976

Cat. Giverny 1992, *Lasting Impressions. American Painters in France 1865–1915*, Musée Américain, Giverny 1992

Cat. New York 1966, Goodrich Lloyd, *Art of the United States, 1670–1966*, Whitney Museum of American Art, New York 1966

Cat. New York 1970, *19th-Century America: Painting and Sculpture*, The Metropolitan Museum of Art, New York 1970

Cat. New York 1987, *American Paradise. The World of the Hudson River School*, The Metropolitan Museum of Art, New York 1987

Cat. New York 1987, H. Barbara Weinberg, Doreen Bolger, David Park Curry, *American Impressionism and Realism. The Painting of Modern Life, 1885–1915*, The Metropolitan Museum of Art, New York/Amon Carter Museum, Fort Worth 1994

Cat. New York 1990, Abigail Booth Gerdts, *An American Collection: Paintings and Sculpture from the National Academy of Design*, New York 1989

Cat. New York 1990, Charles C. Eldredge et al., *American Originals: Selections from Reynolda House*, New York 1990

Cat. New York City 1993/94, William Eyres (ed.), *Picturing History. American Painting 1770–1930*, Fraunces Tavern Museum, New York 1993

Cat. Sacramento 1978, *Munich and American Realism in the Nineteenth Century*, Sacramento 1978

Cat. Seattle 1990, *Myth of the West*, Henry Art Gallery, University of Washington, Seattle 1990

Cat. Southampton 1997, *The Tenth Street Studio Building. Artist-Entrepreneurs from the Hudson River School to the American Impressionists*, Southampton 1997

Cat. Washington 1974, *American Self-Portraits, 1670–1973*, National Portrait Gallery, Indianapolis Museum of Art, Washington 1974

Cat. Washington 1980, John Wilmerding (ed.), *American Light. The Luminist Movement 1850–1875, Paintings-Drawings-Photographs*, National Gallery of Art, Washington 1980

Cat. Washington 1980, *Post-Impressionism. Cross-Currents in European and American Painting 1880–1906*, National Gallery of Art, Washington 1980

Cat. Washington 1989, *American Paintings from the Manoogian Collection*, National Gallery of Art, Washington 1989

Handbooks and Guides to Collections

William C. Agee et al., *The American Collections*, The Columbus Museum of Art, Columbus 1988

American Art in the Newark Museum: Paintings, Drawings, Sculpture, Newark 1981

American Painting, London 1986

American Painting Collection of the Montclair Art Museum, Montclair 1977

Linda Ayres et al., *American Paintings: Selections from the Amon Carter Museum*, Birmingham 1986

Catalogue of American Portraits in the New-York Historical Society, 2 vols., New Haven 1974

Catalogue of the Collection of American Paintings in the Corcoran Gallery of Art, 2 vols., 1966 ff.

Collections of the National Gallery of Art, American Naïve Paintings, 1992, ed. by Deborah Chotner et al.

Collections of the National Gallery of Art, American Paintings of the 18th Century, 1995, ed. by Ellen G. Miles et al.

Collections of the National Gallery of Art, American Paintings of the 19th Century, 2 vols., 1996, ed. by Franklin Kelly et al./1998 ed. by Robert Torchia et al.

Ilene Susan Fort, Michael Quick, *American Art: A Catalogue of the Los Angeles County Museum of Art Collection*, Los Angeles 1991

Katherine Harper Mead (ed.), *The Preston Morton Collection of the American Art*, Santa Barbara Museum, Santa Barbara 1981

William Kloss, *Treasures from the National Museum of American Art*, Washington 1985

Richard J. Koke, *American Landscape and Genre Paintings in the New-York Historical Society*, 3 vols., Boston 1982

Judy L. Larson u. a., *American Paintings at the High Museum of Art*, New York 1994

Kathleen Luhrs (ed.), *American Paintings in the Metropolitan Museum of Art*, 3 vols., New York 1980–1994

Elizabeth Mankin Kornhauser, *American Paintings before 1945 in the Wadsworth Atheneum*, 2 vols., New Haven 1996

Barbara Novak, Elizabeth Garrity Ellis, *The Thyssen-Bornemisza Collection: Nineteenth-Century American Painting*, London 1986

Edgar P. Richardson, *American Paintings and Related Pictures in the Henry Francis du Pont Winterthur Museum*, Charlottesville 1986

Nancy Rivard Shaw et al., *American Paintings in the Detroit Institute of Arts*, 2 vols., 1991 ff.

Paul D. Schweitzer (ed.), *Masterworks of American Art from the Munson-Williams-Proctor Institute*, New York 1989

Marc Simpson et al., *The American Canvas: Paintings from the Collection of the Fine Arts Museums of San Francisco*, New York 1989

Marc Simpson, Patricia Junker, *The Rockefeller Collection of American Art at the Fine Arts Museums of San Francisco*, New York 1994

Diana Strazdes, *American Paintings and Sculpture to 1945 in the Carnegie Museum of Art*, New York 1992

Irene Sweetkind, *Master Paintings from the Butler Institute of American Art*, New York 1994

David B. Warren et al., *American Decorative Arts and Paintings in the Bayou Bend Collection*, Princeton 1998

Worcester Art Museum, 3 vols., 1976–1978

Index

Photo Credits

Addison Gallery of American Art, Phillips Academy, Andover
Adelson Galleries Inc., New York
Albright-Knox Art Gallery, Buffalo
American Antiquarian Society, Worcester
Archiv der Österreichischen Galerie, Belvedere, Vienna
Archives of American Art, Smithsonian Institution, Washington, D.C.
Wm. B. Becker, Huntington Woods
Berry-Hill Galleries Inc., New York
Birmingham Museum of Art, Birmingham
The Brooklyn Museum of Art, Brooklyn
The Brooklyn Museum of Art Archives, Brooklyn
Canajoharie Library and Art Gallery, Canajoharie
Cape Ann Historical Association Collection, Gloucester, MA
Carnegie Museum of Art, Pittsburgh
Charles Lang Freer Papers, Freer Gallery of Art Archives, Smithsonian Institution, Washington, by Ferd. Stark Co.
The Cleveland Museum of Art, Cleveland
Columbus Museum of Art, Columbus
Cooper Hewitt National Design Museum, Smithsonian Institution, New York
The Corcoran Gallery of Art, Washington, D.C., by Edward Owen
The Currier Gallery of Art, Manchester
Davis Museum and Cultural Center, Wellesley College, Wellesley
Delaware Art Museum, Wilmington
Denver Art Museum, Denver
The Detroit Institute of Arts, Detroit
The Evergreen Company, Wyndmoor
The Fine Arts Museums of San Francisco, San Francisco
George Eastman House, Rochester
George Walter Vincent Smith Art Museum, Springfield
Gilman Paper Company, New York
Henry Art Gallery, University of Washington, Seattle, by Richard Nichol
Herbert F. Johnson Museum of Art, Cornell University, Ithaca
Susan Herzig & Paul Hertzmann, Paul M. Hertzmann Inc., San Francisco
High Museum of Art, Atlanta
Hirshhorn Museum and Sculpture Garden, Washington, D.C., by Lee Stalsworth
Hood Museum of Art, Dartmouth College, Hanover, New Hampshire
The Hyde Collection, Glens Falls
Indianapolis Museum of Art, Indianapolis
Isabella Stewart Gardner Museum, Boston
Landesbildstelle Rheinland
Los Angeles County Museum of Art, Los Angeles, Museum Associates
Manoogian Collection, Taylor, Michigan
Marie and Hugh Halff
Mead Art Museum, Amherst College, Amherst

The Metropolitan Museum of Art, New York
Mount Holyoke College Art Museum, South Hadley
Museo Thyssen-Bornemisza, Madrid
Museum of American Art of the Pennsylvania Academy of the Fine Arts, Philadelphia
Museum of Fine Arts, Boston
Museum of Fine Arts, Springfield
National Academy of Design, New York
National Gallery of Art, Washington, D.C.
National Gallery of Canada, Ottawa
The National Gallery of Scotland, Edinburgh, by Antonia Reeve
National Museum of American Art, Washington
National Portrait Gallery, Smithsonian Insitution, Washington
The Nelson-Atkins Museum of Art, Kansas City, by Robert Newcombe
New-York Historical Society, New York
The New York Public Library, The Research Libraries, New York
New York State Office of Parks, Recreation and Historic Preservation, Olana State Historic Site, Waterford
Old Dartmouth Historical Society, Whaling Museum, New Bedford
The Parrish Art Museum, Southampton, by Richard P. Meyer
Philadelphia Museum of Art, Philadelphia, by Graydon Wood
The Philbrook Museum of Art, Tulsa
The Phillips Collection, Washington
Portland Museum of Art, Portland, by Melville McLean
President & Fellows of Harvard College, Cambridge, Massachusetts
Redwood Library and Atheneum, Newport
Rose Art Museum, Brandeis University, Waltham
The Saint Louis Art Museum, St. Louis
San Diego Museum of Art, San Diego
Santa Barbara Museum of Art, Santa Barbara
Seattle Art Museum, Seattle, by Paul Macapia
Shein Collection
Sterling and Francine Clark Art Institute, Williamstown
Terra Museum of American Art, Chicago
Tim Thayer
The Toledo Museum of Art, Toledo, Image Source Inc.
The University of Michigan Museum of Art, Ann Arbor, by Patrick J. Young
University of Pennsylvania School of Medicine
Wadsworth Atheneum, Hartford
Walters Art Gallery, Baltimore
Washington University in Saint Louis, Gallery of Art, St. Louis
Worcester Art Museum, Worcester
Yale University Art Gallery, New Haven